Annapolis

City on the Severn

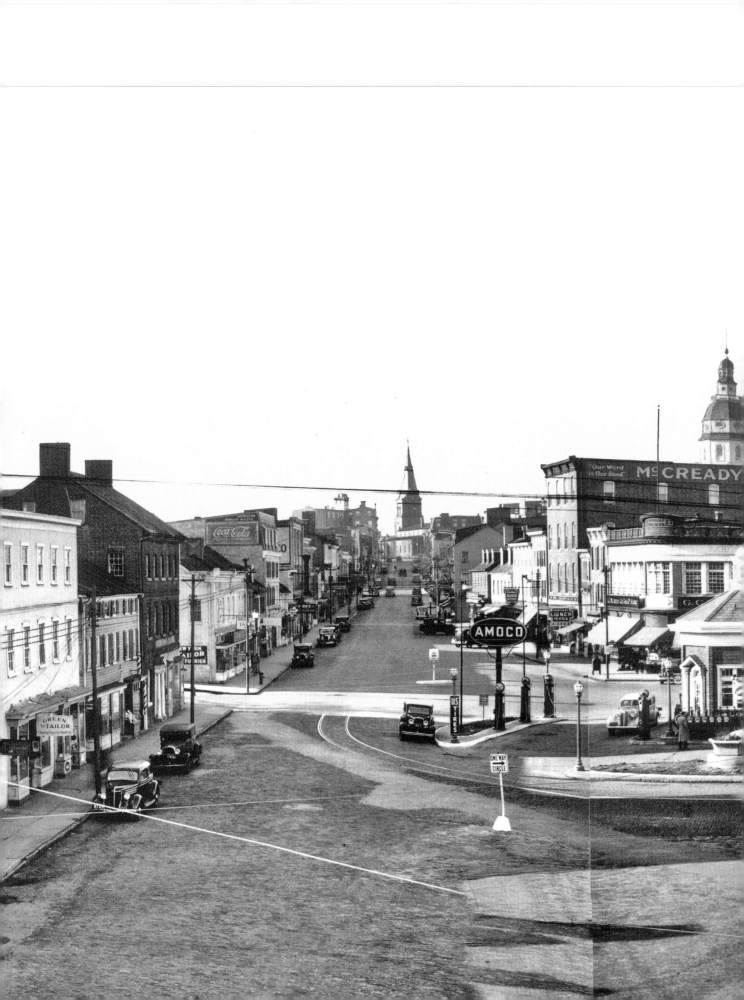

Jane Wilson McWilliams

Annapolis
City on the Severn
A HISTORY

THE JOHNS HOPKINS UNIVERSITY PRESS *Baltimore*

THE MARYLAND HISTORICAL TRUST PRESS *Crownsville*

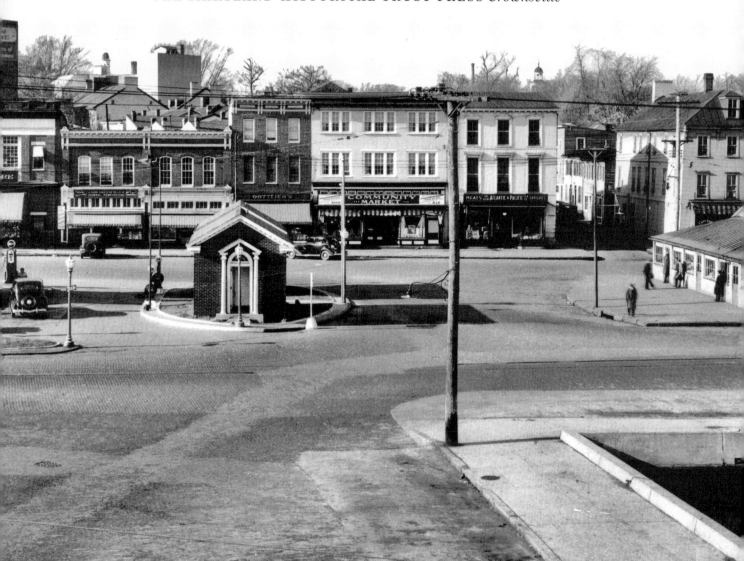

This publication has been financed in part with state funds from the Maryland Historical Trust, an instrumentality of the State of Maryland as a part of the Department of Planning. However, the contents and opinions do not necessarily reflect the views or policies of the Maryland Historical Trust or the Department of Planning.

Additional support for this work came from the Four Rivers Heritage Area and the Annapolis Maritime Museum, both of which administered grants from the Maryland Historical Trust. The Asgard of Maryland, Inc., contributed to the publication of this book.

The Johns Hopkins University Press
2715 North Charles Street
Baltimore, Maryland 21218-4363
www.press.jhu.edu

Maryland Historical Trust Press
100 Community Place
Crownsville, Maryland 21032
www.mht.maryland.gov

Library of Congress Cataloging-in-Publication Data
McWilliams, Jane Wilson.
 Annapolis, city on the Severn : a history / Jane Wilson
McWilliams.
 p. cm.
Includes bibliographical references and index.
ISBN-13: 978-0-8018-9659-0 (hardcover : acid-free paper)
ISBN-10: 0-8018-9659-2 (hardcover : acid-free paper)
1. Annapolis (Md.) — History. I. Title.
F189.A657M39 2010
975.2'56 — dc22
 2010007503

A catalog record for this book is available from the British Library.

Special discounts are available for bulk purchases of this book. For more information, please contact Special Sales at 410-516-6936 or specialsales@press.jhu.edu.

The Johns Hopkins University Press uses environmentally friendly book materials, including recycled text paper that is composed of at least 30 percent post-consumer waste, whenever possible. All of our book papers are acid-free, and our jackets and covers are printed on paper with recycled content.

Illustrations: Title page, intersection of Main Street and Market Space, 1930s (Maryland State Archives, MSA SC 1885-1-834). *Table of contents*, the oyster fleet in Annapolis harbor, c. 1879 (MSA SC 985-277). *Maps preceding Preface*, by Bill Nelson

In memory of

Phebe Robinson Jacobsen (1922–2000)

historian, archivist, mentor, friend

who encouraged the curious and required

their attention to all members of society

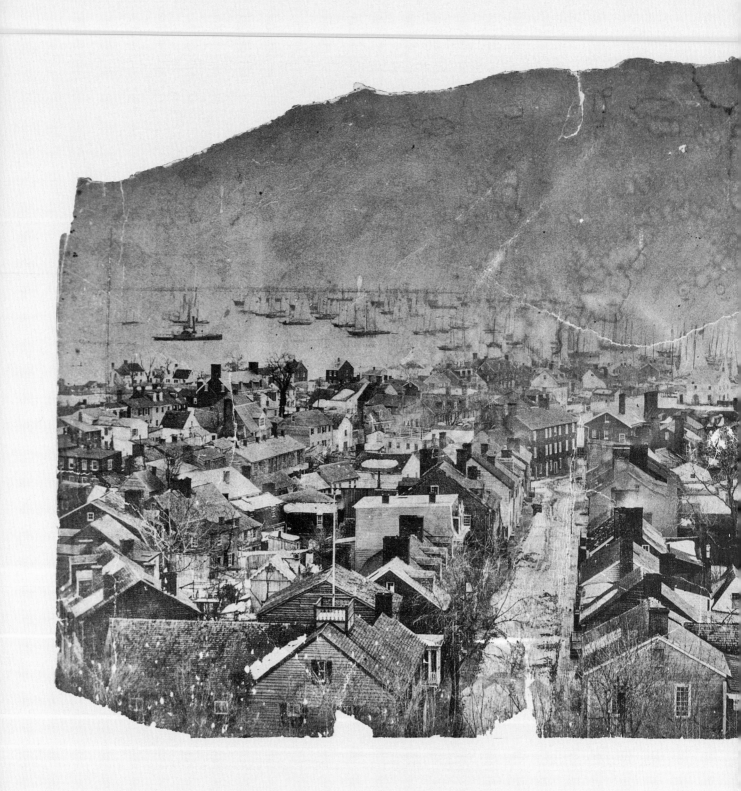

Contents

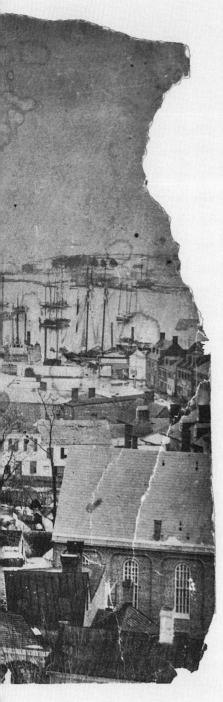

Color illustrations follow page 150

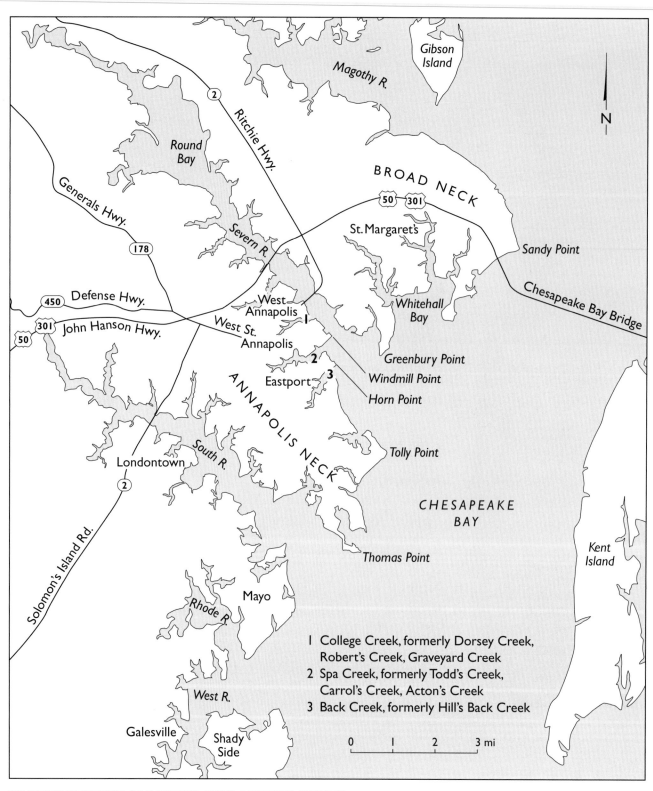

SELECTED FEATURES OF EASTERN ANNE ARUNDEL COUNTY

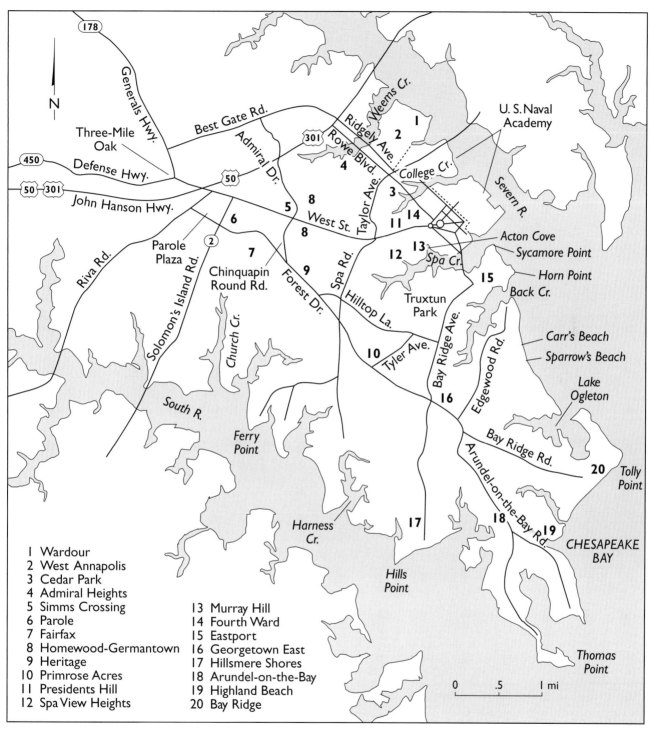

178

N

Generals Hwy.

Weems Cr.

U. S. Naval
Academy

Best Gate Rd.

Three-Mile
Oak

Ridgely Ave.

Rowe Blvd.

301

1

2

450

Defense Hwy.

Admiral Dr.

College Cr.

50

4

Severn R.

50 301

John Hanson Hwy.

Taylor Ave.

3

5

West St.

8

14

Acton Cove
Sycamore Point

6

8

11

Riva Rd.

Parole
Plaza

2

7

Spa Rd.

12

13

Spa Cr.

Horn Point
Back Cr.

Solomon's Island Rd.

Chinquapin
Round Rd.

9

Truxtun
Park

15

Church Cr.

Forest Dr.

Hilltop La.

Bay Ridge Ave.

Carr's Beach
Sparrow's Beach

Edgewood Rd.

Lake
Ogleton

South R.

10

Tyler Ave.

16

Bay Ridge Rd.

Ferry
Point

Arundel-on-the-Bay Rd.

20

Tolly
Point

Harness
Cr.

17

18

19

CHESAPEAKE
BAY

Hills
Point

Thomas
Point

0 .5 1 mi

1 Wardour
2 West Annapolis
3 Cedar Park
4 Admiral Heights
5 Simms Crossing
6 Parole
7 Fairfax
8 Homewood-Germantown
9 Heritage
10 Primrose Acres
11 Presidents Hill
12 Spa View Heights

13 Murray Hill
14 Fourth Ward
15 Eastport
16 Georgetown East
17 Hillsmere Shores
18 Arundel-on-the-Bay
19 Highland Beach
20 Bay Ridge

ANNAPOLIS NECK C. 1970

Preface

One of the oldest cities in the United States, Annapolis prides itself on its colonial heritage. Never grand enough in commerce or population to compete with Boston, New York, or Philadelphia, the port city on the Severn River still held a unique position in the early history of our country, and today it shines as a treasure of that lost era. Downtown Annapolis presents a charming mix of brick and frame buildings, many dating from the eighteenth century; its streets retain the design and character of horse-and-buggy days. Annapolis is a walkable city on a human scale. It boasts two colleges, both of which claim ties to the first years of our nation, and the State House, where Maryland's General Assembly meets today, is the same building that welcomed revolutionary leaders more than two hundred years ago.

The modern city of Annapolis covers three peninsulas along the south side of the Severn River, on the western shore of the Chesapeake Bay. The creeks that border those peninsulas and the river itself have compelled the city's dependence on maritime occupations and activities. What was an essential transportation route in the colonial period became the basis of a thriving seafood industry in the nineteenth century and brought recreational boating to the city in the twentieth. The city's location encouraged military attention from its earliest days, with the United States Naval Academy being the most lasting and beneficial result of that attention. Today, this venerable port continues to count its waterfront the center of city life.

At no time was Annapolis a city in a vacuum. From inception, its fortunes were tied to events in the world around it. Politics in Europe, America, and elsewhere in Maryland have influenced the city throughout its existence. The original settlement on the Severn had its roots in the English Civil Wars of the mid-seventeenth century, as Cecilius Calvert, second Lord Baltimore and first proprietor of the province of Maryland, tried to preserve his province in the midst of Puritan and Anglican dissension. Ultimately successful, at least for a time, Cecilius named a small section of that settlement an official port in the third quarter of the century. After the Calverts lost their province to the English crown, following the Glorious Revolution, royal governor Francis Nicholson moved the government of the colony from St. Mary's City, where it had been since 1635, to the port village on the Severn and named the new capital after England's Princess Anne. The town became a chartered city in 1708 in the name of the same Anne, then queen. Under restored proprietary control in the early eighteenth century, Annapolis achieved prominence as Maryland's center of colonial culture. Meetings of the General Assembly and provincial courts, theatrical productions, horse racing, lavish entertainments, and purveyors of delicacies and luxury attracted wealthy families to the city. A remarkable number of their homes remain today, windows into that long-ago time.

After years of political and social success, and even a few months as capital of the new country, Annapolis refused to accept anonymity when industrial Baltimore eclipsed it after the American Revolution. Early in the nineteenth century, fearing that the great economic movement of the time would pass them by, city fathers brought forth elaborate schemes for shipyards, canals, railroads. They failed to attract anything more than a single rail line.

Then, in the mid-nineteenth century, the United States Navy bestowed upon the city an officers' training school, a gem of benefit beyond the dreams of the most enthusiastic city booster.

What manufacturing there was in Annapolis during the nineteenth century and first decades of the twentieth tended toward the packing of seafood, oysters primarily, and created little lasting effect other than large piles of shells. Because Annapolis had no intrusive industrial presence — no massive multistory warehouses, no dry docks or construction cranes to mar its waterfront — visitors could easily imagine themselves back in the days of the city's eighteenth-century splendor. When destination tourism became popular in the mid-twentieth century, Annapolis did not have to reconstruct its colonial waterfront, stately homes, or public buildings. They were still there, enhanced by the Naval Academy just beyond.

The search for economic stability constitutes one of the themes of this biography of Annapolis. Another focus is the change in city government as it assumed greater responsibility for public safety, infrastructure, and quality of life factors such as zoning, parks, and harbor management. In the early years of the city, public works, when done at all, were usually carried out by private companies or funded through private lotteries. Only as the city's residents reevaluated the concept of municipal obligation, and accepted the necessity of property taxes, did such improvements come under the purview of city government.

Geography and legal structure form only the parameters of city development. It is a city's residents who bring it life. It is their dreams and disappointments, their aspirations and struggles and celebrations that make city life appealing and worth recording in a history. The early people of Annapolis were white Europeans and black Africans. Most residents, regardless of race, were bound labor: servants for a finite period if white, slaves for life if black. Old Annapolis families were joined by other European and Asian newcomers in the nineteenth and twentieth centuries. More recently, immigrants from Mexico and Latin America have added their culture to the mix. Over the years, an increasing number of people have chosen to move from other parts of the United States to Annapolis. While most of these decisions result from employment in the Baltimore-Washington area, the charm and cultural opportunities of Annapolis have played an important role in drawing new residents to the shores of the Severn.

The story of Annapolis is the story of subsets of culture remarkably different from each other, be those differences racial, cultural or ethnic, religious, or regional. For a small city, its people and the relationships among them are remarkably diverse. It is important to acknowledge both the pride and the inequities of this diversity. Annapolis has had its crooks and scoundrels, to be sure, but it also has had heroes and visionaries and decent, honorable citizens who worked hard and did their best for their families and neighbors. Through all its stages, from pioneer settlement to glistening colonial capital, from quiet market town to home of the Naval Academy, from preservation battleground to popular tourist destination, it is the people of this ancient city who give it history and meaning. This is the story of their town.

For a hundred years or more Annapolis has celebrated milestones in its history and the illustrious events in which it took part. The last quarter of the twentieth century offered several such opportunities. National bicentennials of the American Revolution, the Annapolis Convention, the United States Congress's session in Annapolis, and Maryland's ratification

of the U.S. Constitution all received local attention. Equally popular were city-specific celebrations marking Annapolis's 300th year as capital of Maryland, in 1995, and the 350th anniversary of the first English settlement on the Severn, in 1999.

As the 1995 commemoration approached, the Annapolis History Consortium, an informal organization of professional and amateur historians, decided that a series of booklets presenting recent scholarship on topics of local interest would be an appropriate recognition of this important anniversary. The Maryland State Archives and Maryland Historical Trust provided financial support for Studies in Local History, which began with a monograph by state archivist Edward C. Papenfuse entitled *"Doing Good to Posterity": The Move of the Capital of Maryland from St. Mary's City to Ann Arundell Towne, Now Called Annapolis* (1995). Over the next seven years, four additional booklets examined other facets of the city's early history. In contrast to most local-history publications at the time, Studies in Local History aimed for both popular appeal and academic respectability.

When it came time to mark the 350th anniversary of settlement on the Severn, Eric Smith, then a columnist and cartoonist for the city's only newspaper, *The Capital*, called for a "definitive history" of Annapolis in his column of 22 March 1999. Nineteenth-century histories of the city had been written at logical points in the city's development but were by then woefully out of date. David Ridgely published *Annals of Annapolis*, the first history of Annapolis, in 1841 when the city's dire economic straits prompted citizens to lobby the U.S. government for establishment of a naval facility of some kind, any kind. Success arrived four years later when the new, land-based naval school opened on the grounds of Fort Severn, adjoining the city. Ridgely's nephew Elihu Riley wrote *The Ancient City* in the 1880s when city residents were beginning to sense the economic advantage of being old.

The few twentieth-century attempts were, Smith complained, anecdotal, not "full-blown" histories. *Annapolis, Anne Arundel's Town*, by William Oliver Stevens, glorified the city's colonial past in 1937, when the Committee for the Restoration of Colonial Annapolis (CRCA) determined to preserve the city's eighteenth-century architectural gems. Evangeline Kaiser White collected her memories in *The Years Between* shortly after Historic Annapolis, Inc., successor to the CRCA, formed with the same intent.

When Eric Smith called for a new history in 1999 there were several recent authoritative publications on the city's colonial and early national period and on a few modern institutions and neighborhoods, but no one had ever linked those years and topics to the whole three-and-a-half centuries of habitation on the Severn. The lack of a comprehensive look at the city frustrated people interested in other aspects of the city's story. Themes were difficult to discern, turning points elusive. The History Consortium proposed that I apply the objectives of Studies in Local History — interesting, accurate information carefully referenced — to a comprehensive city history. Surely such a book could be ready for the next event, the 300th birthday of the 1708 city charter. It wasn't.

I began working on this book in 1999 and quickly realized that my task would be neither easy nor quick. Like Tristram Shandy, I found that the writer of history "will have fifty deviations from a straight line to make with this or that party as he goes along, which he can nowise avoid: he will have views and prospects to himself perpetually soliciting his eye, which he can no more help standing still to look at than he can fly." I came to call these prospects "rabbit holes," and I have spent a good bit of the past decade going down them, one after another.

Biographies of human subjects recount the early development and influences, physical appearance, relationships, exceptional behavior and occurrences, decline and death, in an

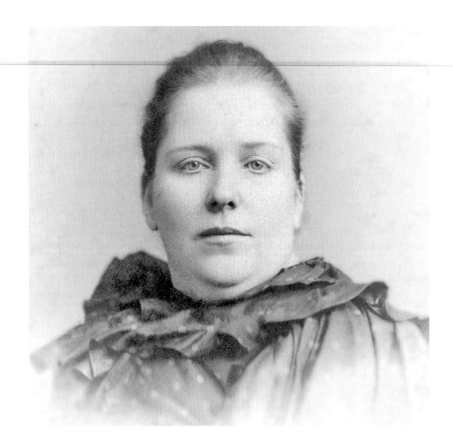

Mary Ellen Redmond Taylor (1853–1924) wrote "Annapolis, the City on the Severn" in 1908 to commemorate the bicentennial of the Annapolis city charter. An elementary school teacher, wife, and mother, Taylor composed and copyrighted at least two other songs in the early 1900s. Courtesy of her grandson Lemuel Kennerly Taylor IV.

(opposite)
With posthumous thanks to M. E. Taylor, I have applied her song title to this book, as recognition of the three hundredth anniversary of the Annapolis charter in 2008. Courtesy of the Sands House Foundation.

attempt to explicate the character and achievements of that individual. In like manner, the biography of a city must investigate its origins and background, examine its economy, its government, its physical changes, and evaluate the most critical issues in the development of its society. In each case, the writer is responsible for ascertaining the overall context of the subject's life and importance and for presenting this to the reader. I have taken that responsibility seriously and hope that I have done well by my native city. This account ends in 1975, a date by which I believe the factors that influence the present city were in place.

Annapolis, City on the Severn is the culmination of a decade of research into this ancient but still vigorous city. As I worked, I followed Elihu Riley's objective, expressed in his Preface to *The Ancient City*:

> To gather the rays of light from their varied sources
> and to form them into one prism of information.

As Annapolis ventures into its fourth century as a chartered city, its residents again review their options for the future. I hope that in this "prism of information," they find useful stories, advice, and, perhaps, comfort as they plan for the centuries ahead.

DEDICATED TO
DAUGHTERS OF AMERICAN REVOLUTION.

ANNAPOLIS

the City on the SEVERN

WORDS AND MUSIC BY

M. E. TAYLOR.

PUBLISHED BY
M. E. TAYLOR
ANNAPOLIS MD.

5

Annapolis

City on the Severn

Out of the Wilderness, a Town 1649 to 1708

Sailors entering the Severn River today reference their position by the three Eiffel-like radio towers reaching high above Greenbury Point to their right. Dead ahead are an arched bridge across the river and the massive gray stone buildings of the United States Naval Academy. To the left rise the slate gray–and–white tiered dome of Maryland's state capitol and the thin church spires of the old city. On the south side of the Severn a mix of marinas, private homes, and multistory residential compounds edges the shore. And all along the waterfront of the river and its creeks are boats — hundreds of boats, big and small, sail and power, some on land, most in the water. With few exceptions these are the sleek boats of recreation and competition or the no-nonsense vessels of intracoastal travel and military training. Across the riverscape there is bustle and life, daytime traffic rumble, nighttime lights, games on the Naval Academy fields, airplanes overhead.

It might be difficult for the modern skipper, dodging small watercraft and elegant yachts, attending to channel markers and the whoosh of an oncoming wake, to imagine the same river in 1650, with no boats, no buildings, no sign of human occupation, and only the dense, relentless forest that welcomed the first English settlers. Here, then, cupped within the graceful curve of the long, narrow peninsula on the north was a natural environment of great promise for human habitation. Along the deep river that penetrated far into the mainland, banks rose sixty feet or more in gently undulating ridges and valleys. Creeks extended the river as miniature estuaries on either side, the result of spring-fed streams meeting river saline. Marshy shoreline wetlands waved with grasses and cattails. Inland, bushy thickets and an understory of low trees flourished beneath a canopy of gum, pine, chestnut, tulip poplar, hickory, and red and white oak.[1] The water teemed with terrapin, crabs, oysters, mussels, sturgeon, and bass. Geese, ducks, swans, and passenger pigeons flew overhead, while hiding in the forest were deer, rabbit, squirrel, fox. Tiny, nectar-seeking hummingbirds and the mockingbirds' variegated lyricism fascinated the immigrant Englishmen.[2]

Hospitable though this prehistoric river scene may have seemed, it sustained no seventeenth-century Native American village. At one time, a thousand or more years before, Indians speaking an Algonquin dialect had begun visiting chosen campsites along the river, often returning to the same spots year after year to feast on oysters dug from the river's shallows. They left behind them thick layers of discarded shells and little else.[3] At some point in the late sixteenth century, incursions of warlike Iroquoian Susquehannocks from the northern Chesapeake Bay drove the more placid Algonquin tribes down into Southern Maryland, and the upper-Bay western shore became a no man's land. When John Smith and his men from Jamestown explored the Bay in 1608, they reported no Indian villages near the Severn River.[4]

The first people to settle permanently on the river they named Severn were Englishmen, many of whom abandoned cleared land and homes in Virginia to tame a wilderness on Maryland's northern frontier. To understand why these Puritan-leaning Protestants came to settle in a province owned by the Catholic Calvert family requires a bit of background in the politics and religious disputes of the mid-seventeenth century.

The tale begins with George Calvert, secretary of state to King James I and first baron of the Irish manor of Baltimore. After a successful quarter-century career as a conforming Protestant at court, Calvert saw the New World as an opportunity both to extend the realm of England and to further the fortunes of his family. Openly acknowledging his Roman Catholic faith, in 1625, Calvert sought to establish a colony where loyal English Christians could worship freely, without the restrictive laws of the mother country. When his first attempt at colonization, in the inhospitable climate of Newfoundland, failed, Calvert lobbied King Charles I, James's son and successor, for land to the south, adjoining Virginia.[5]

George Calvert did not live to receive the charter for his new province. Two months after his death, King Charles granted Maryland to George's son Cecilius, Second Lord Baltimore, on 20 June 1632. The charter gave Cecilius and his heirs almost kinglike powers over a vast, uncharted territory bounded roughly by the Delaware Bay, Atlantic Ocean, and the Virginia colony to the headwaters of the Potomac River, and then by the fortieth parallel eastward back to the Delaware Bay. Land, water, fish, whales, precious metals, "Gemmes"—all belonged to the Calverts in exchange for two Indian arrows a year and one-fifth of any gold and silver found. To them as well went the right to establish the Christian religion in the province, to organize a government, to appoint justices and other public officials, and to make laws, with the assent of freemen residing in the province. Cecilius and his successors could declare war, secure peace, enact martial law, erect towns and establish ports, set and collect taxes and fees, and grant parcels of their land to others upon terms of their own choosing.[6]

Although the majority of Maryland's settlers were Protestant and Cecilius Calvert perpetuated his father's "recklessly innovative" concept of religious toleration, positions of power within the province were held by Calvert relatives and friends, almost all of them Catholic. Thus, seen as a Catholic haven anathema to Anglicans and Puritans alike, Maryland became embroiled in the grim reality of seventeenth-century English politics. Cecilius Calvert, determined to protect his charter and his Maryland settlement in the face of men equally determined to sabotage it, stepped carefully through the political and legal landscape.[7] As the Puritan movement gained adherents in England, Calvert realized that he needed to attract some of their number to Maryland.[8]

In August 1648, Cecilius Calvert dismissed the Catholic serving as acting governor of Maryland and commissioned in his place William Stone, an Anglican from the eastern shore of Virginia with ties to Puritans in London and New England. Stone agreed to bring five hundred immigrants to Maryland. The unwritten understanding was that the majority would have religious beliefs compatible with the growing factions in English government. Calvert's decision was timely: in January 1649, Puritan parliamentary forces in England beheaded his family's royal benefactor, King Charles I.[9]

Lord Baltimore continued his new policy with two additional steps in 1649. The first codified his intent that Maryland should be religion-neutral by proposing the now-famous "Act concerning Religion," known generally as the Toleration Act. Passed by the Assembly in April, it assured religious freedom to anyone expressing belief in the Trinity. The act prohibited the use of terms such as "heritick, Scismatick, Idolator, puritan, Independant,

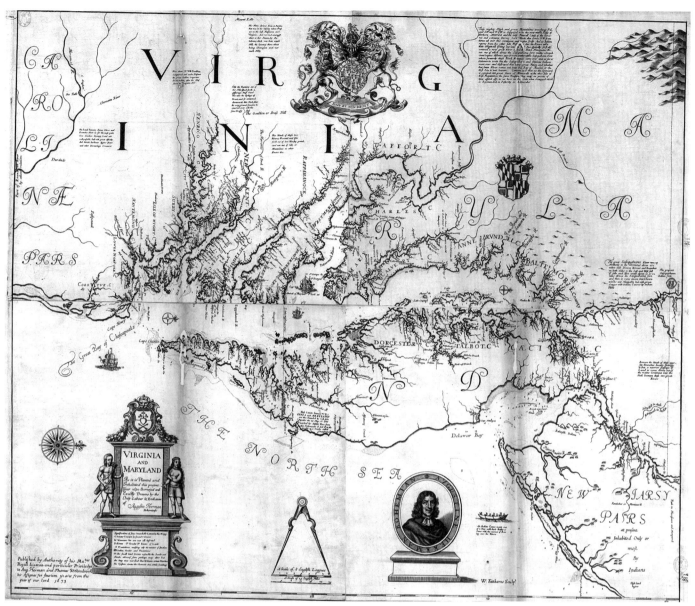

Augustine Herrman's map of Virginia and Maryland, drawn in 1670 for Cecilius Calvert and published three years later, gives English place names and shows Anglo-American plantations and Native American settlements on both shores of the Chesapeake. Herrman had emigrated from Bohemia to Dutch New Netherland, but when Calvert offered to reward his cartographic skills with land in Maryland, he readily assented and moved to Cecil County. Courtesy of the Geography and Map Division, Library of Congress.

Prespiterian[,] popish prest, Jesuite, Jesuited papist, Lutheran, Calvenist, Anabaptist, Brownist, Antinomian, Barrowist, Roundhead, Sepatist," all of which are a good indication of the various religious distinctions of the day.[10]

Calvert's second step was a new statement of the Conditions of Plantation, the terms under which a settler might acquire land grants, which he issued in July. In his introduction to the Conditions, Cecilius Calvert said frankly, "we are informed that our Conditions of plantation bearing date the 20th of June [1648] . . . are not like to Give sufficient encouragement to many to adventure or Plant there." The major difference between the two Con-

ditions was in the amount of land granted for each person transported into the province: fifty acres in 1648 increased to one hundred acres in 1649.[11]

Scattered along the southern estuaries of the James River in the late 1640s were tobacco planters and their families who refused to conform to Church of England beliefs and rituals. In Virginia, as in England, the Anglican Church was the official church, government sanctioned and supported. Those who rejected its principles and practices did so at their peril, for they threatened the political establishment as well as the religious one.[12] In an era that saw religion as central to one's being, what people believed and where they went to church determined their life, often literally.[13]

A few of these Virginia Independents were prominent landowners who had been cited recently for nonconforming worship and were facing the threat of banishment from the colony. Lord Baltimore's offer of toleration and land in Maryland impelled them to move their families and households up the Bay, to settle across from Kent Island, where fellow Virginian William Claiborne had opened an Indian trading post in 1631 and where a few Protestant families remained after years of conflict between Claiborne and the Calvert government.[14] Joining the Independents on the Severn River were other Virginians of similar bent, Puritans already living in Maryland, and eventually immigrants from Cromwell's England as well.[15]

The James River contingent began arriving at the Severn sometime after December 1649. These nonconformists, and the "well-affected people" who joined them in the journey north, were not naïve adventurers.[16] They would endure no year of starvation and suffering, no decimation of the population by disease or "seasoning," as had been the fate of so many English immigrants to Jamestown, Plymouth, and even St. Mary's City.[17] The people and livestock of the new Severn settlement were accustomed already to the climate, diseases, and foodstuffs of the Chesapeake. They could, and probably did, bring seed corn with them, along with tobacco seedlings to replant from the marginal soils of the south James into the rich, loamy earth of southern Anne Arundel, which "produced some of the finest oronoco tobacco in Maryland."[18] Although they needed to clear new fields, plant new orchards, and build new houses and outbuildings, the Virginians had improved their lot by moving, which gives credibility to one Calvert supporter's claim that "it was not religion . . . it was that sweete, that rich, that large Country they aimed at."[19] Whatever their reasons, the new residents on the Severn were just the first of generations of Americans who would forsake the known environment for an everbeckoning frontier.

Leaders among the Severn settlers were not the typical Chesapeake immigrant: "young, single, and poor," with men outnumbering women three to one.[20] Of the eighty-seven free adult men who settled in Anne Arundel County from 1650 through 1652, roughly two-thirds came with family and half of them surveyed a plantation within those first three years. Forty-five of the eighty-seven almost certainly came from south of the James River; because Virginia county records are not complete, that number may have been greater. These freemen paid the passage for, or "transported," just over two hundred indentured servants, most of whom would pay off this debt through a set number of years of labor. Some of the servants certainly came from Virginia, but for the vast majority of them all we know is their name and who paid their passage. The servants do fit the norm in gender; only a quarter were women or girls, of whom only one or two were married. They joined another fifty adult women, wives of the freemen. Added to these numbers were seventy-five children, boys and girls of varied ages, who came with their parents or guardians. All told, some four hundred men, women, and children, free and servant, can be identified as

residing in the county for at least a part of those first three years.[21] Because their numbers roughly equaled the entire population of Maryland in 1648 and they had been specifically invited by the governor, the Severn settlers could well expect to have some influence on the affairs of the province.[22]

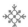

The story of the Virginian nonconformists' move to Maryland, their settlement along the coast of Anne Arundel County, and their troubles with Lord Baltimore's government has been the principal topic of at least eight books, articles, and papers and has been treated, often in great detail, in many more.[23] Perhaps this extent of attention results from their migration, like that of the Pilgrims, being seen as romantic, a courageous journey into the unknown by people in search of freedom and peace. But the Virginians brought Maryland neither religious freedom nor peace.

Believing that the hand of God had guided them to their new home, the emigrants named their settlement Providence, and one of their first acts was to build a meeting house, at the head of the long creek on the south side of Greenbury Point.[24] That creek, known as Town Creek, and the peninsula itself seem to have been their immediate base of operations. Although the records refer to "Town Creek," "Town Path," and "town land" on the peninsula, there is no evidence that an actual town ever existed there — at least not in the traditional English sense of town. Eight of the immigrants did take up 250 acres in small, adjoining parcels of land on Greenbury Point "for their mutual securerity"; but by 1658, these men and their families were either dead or living elsewhere. Small pieces of "town land" were also carved out on the south side of the Severn, indicating that those first settlers saw their "town" as something more like a "dispersed hamlet-type settlement."[25]

Much to the consternation of colonial administrators back in England, including Lord Baltimore, the tobacco economy of the Chesapeake tidewater did not lend itself to towns. Successful cultivation of tobacco required extensive acreage, and owners of those large tracts of land shipped their packed hogsheads from the nearest wharf. They did not need a town for commerce. The Severn immigrants selected land for their plantations using generally accepted criteria: fertile, well-drained soils; access to navigable water; and availability of drinking water, usually a spring.[26] During the first three years of the Providence settlement, 1650–1652, the settlers surveyed fifty-four plantations along the rivers and creeks of Anne Arundel County. Their plantations ranged in size from 100 to 660 acres, the average being 300 acres. Tract names carry the surname of the owner — Beard's Dock, Homewood's Lot — or a clue to the environment — Locust Neck, Selby's Marsh — or, rarely, some expression of emotion — Justice Come at Last, Hard to Get and Dear Paid.[27]

Three of these early plantations lay on an upward sloping peninsula between two long, narrow creeks on the south side of the Severn. Here Richard Acton and Thomas Todd each surveyed 100 acres. Adjoining their tracts was a 20-acre parcel claimed by Thomas Hall as his town land. All three men had lived south of the James River in Virginia. Acton was a carpenter and Todd a shipwright, but little is known of Hall, who died in 1655. These three men and their families and servants were the first residents of what became the city of Annapolis.[28]

The freemen at Providence sent two representatives to the Assembly in St. Mary's City in April 1650.[29] This session established "that part of the Province of Maryland on the west side of the Bay of Chessopeack over against the Isle of Kent formerly called by the name of Providence by the Inhabitants there resideing and inhabiting this yeare" as a county and

First Plantations 1651

DEEP COVE

RIVER

RICHARD ACTON'S LAND

TODD

[THIS IS THOMAS TODD'S HOLDING
ACCORDING TO HIS CERTIFICATE OF SURVEY
OF 1651, THOUGH AT THE TIME TODD
BELIEVED HE ACTUALLY OWNED THE LAND
OUT TO THE RIVER AND UP TO DEEP COVE.]

THOMAS HALL'S LAND

OYSTER SHELL POINT

TODD'S CREEK

Anthony DiPaul Lindauer

named it "Annarundell" in memory of Lady Anne Arundel, the recently deceased wife of Cecilius Calvert, Lord Baltimore.[30]

Apparently anxious to be good Marylanders, the settlers accepted this name change for their county and most of them seem to have taken the oath of fidelity to Lord Baltimore as required by the Conditions of Plantation. Governor Stone visited Providence in July 1650 to appoint Edward Lloyd "commander" of the county and seven other men as "commissioners," or justices, of the county court.[31] Lloyd could register warrants, or claims for land, and he apparently deputized Robert Burle to record them in "Burles 2 Bookes of Rights from 1649 to 1657."[32] These books, which might answer so many questions about the early people of Providence, went missing between 1680 and the move of provincial records from St. Mary's City to Annapolis in 1695.[33]

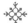

Lord Baltimore's revolutionary strategy for maintaining his provincial authority came to naught in 1651 when the English Council of State named Richard Bennett and William Claiborne commissioners to "reduce" Virginia to parliamentary control.[34] Perhaps exceeding their authority, the pair decided to reduce Maryland, too. In March 1652, Bennett, a supporter of the Providence settlement who was then governor of Virginia, and Claiborne,

Anne Arundel Calvert, daughter of Sir Thomas Arundel of Wardour and wife of Cecilius Calvert. Settlers on the Severn agreed to name their new county for her shortly after her death in 1649. Photograph courtesy of the Anne Arundel County Lost Towns Project.

his deputy governor, voided the commissions of Governor William Stone and the Provincial Council and took over Maryland's government. Three months later, citing the "desire of the Inhabitants," the two Virginians reinstated Stone and also three Protestant members of the council, all of whom had agreed to act under parliamentary control. Usurping the Lord Baltimore's right of appointment, Bennett and Claiborne named three other Protestants to the council. These men would govern Maryland, said Bennett and Claiborne, "until the pleasures of the State of England be further known."[35]

One of the first acts of the new government was to deputize the ubiquitous Bennett, Edward Lloyd, and three other Providence men to meet with the Susquehannock Indians, who had requested "peace with the Government and Inhabitants."[36] The result was a

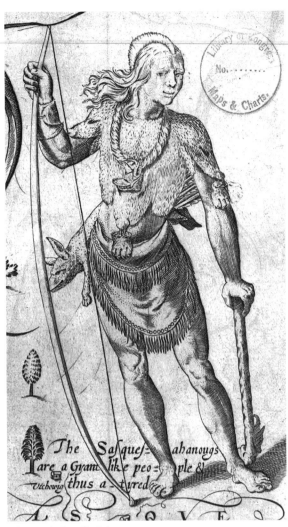

The Sasque=ahanougs are a Gyant like peo=ple & thus a=tyred

John Smith described the Susquehannocks as "Giant like people" and pictured this impressive, warlike man on his map of Virginia in 1612. Severn settlers and Susquehannocks signed a peace treaty forty years later. Courtesy of the Geography and Map Division, Library of Congress.

declaration of "Peace and friendship . . . Between the English Nation in the Province of Maryland and the Indian Nation of Sasqueahanogh," signed by five representatives of each side on 5 July 1652. Also signing was Jasper Peter, representing Governor Johan Printz of New Sweden, on the Delaware River. The treaty provided for reparation in case of damages done by either side and the return of all servants and runaways. The Indians agreed not to visit English settlements by land or in groups of more than eight or ten. Tokens to be used by official envoys were exchanged. The participants pledged their people to "walke together" as friends and "to assist one another accordingly." Should either side wish to break the peace, a warning would be sent, in writing, twenty days before an attack.[37] The treaty signing almost certainly took place on Greenbury Point, perhaps near the meeting house, but probably without the elaborate ceremonies described in James Moss's novel *Providence, Ye Lost Towne at Severn.*[38]

Peace between races may have been negotiated in Providence, but across the Atlantic there was little peace between political and religious enemies. As Lord Baltimore continued to defend his chartered rights before parliamentary officials in 1653, Oliver Cromwell assumed control of Great Britain. The Puritans in Maryland seem to have seen that as confirmation of their righteousness. No longer even pretending to be loyal to Lord Baltimore, Edward Lloyd and "77 persons of the House-keepers, and Freemen, Inhabitants" of "Severne, alias Ann Arundel County" complained in January 1654 to Commissioners Bennett and Claiborne that the oath of fidelity they had taken to Lord Baltimore's [Roman Catholic] government offended their consciences.[39] Caught between the increasingly aggressive Puritans and his duty to Calvert, Governor Stone resigned.[40]

In July 1654, Bennett and Claiborne replaced the temporary council with ten commissioners to govern Maryland. Five of the ten were associated with the Providence settlement. Bennett and Claiborne also called for an October assembly composed only of men who had not "borne Arms in Warr" against Parliament and were not Roman Catholics.[41] Perhaps it was no surprise when that assembly repealed the 1649 Toleration Act. In keeping with the anti-Calvert stance of this government, Anne Arundel County's name reverted to Providence.[42]

In London, it seemed that, as the matter progressed through levels of British officialdom, Lord Baltimore's position was not without support. Cromwell himself reprimanded Bennett in a January 1655 letter, saying that control of Maryland was still under discussion and he was to "forbear disturbing the Lord Baltimore or his Officers and people in Maryland."[43] But it was too late. Returned as governor by Lord Baltimore, Stone decided to assert Calvert's authority, by force if necessary. He gathered a number of armed men, possibly including some sympathetic Piscataway Indians, and sailed up the Bay.[44]

There are five contemporary accounts, by four authors, of what happened next. Two authors, John Langford and John Hammond, wrote from Stone's perspective; the other two,

Leonard Strong and Roger Heamans, presented the Puritans' side. Their accounts agree on a few aspects, from which we can get a general picture of the confrontation.[45] Stone and his men reached the Severn River late on Saturday 24 March 1654/55 (the eve of the new calendar year). Already lying in the river were the ocean-going ship, *Golden Lyon*, under command of Captain Roger Heamans, and a small coaster from New England, commanded by Captain John Cutts. Both vessels carried arms — and both were quickly preempted by the Puritans. When vessels bearing Stone's men came into the Severn, cannon fire from *Golden Lyon* forced them into a creek, and the New England vessel then blocked the entrance. The next day, Sunday 25 March 1655, Governor Stone and his soldiers appeared on a neck of land. The Puritan force, commanded by Captain William Fuller, crossed the river and marched some distance by land so as to come up on them from behind. Shouting battle cries — "Hey for Saint Maries" by Lord Baltimore's men; "In the name of God fall on; God is our Strength" by Fuller's — the men fought until Stone, with no option for escape, surrendered.[46]

It is revealing that neither Strong nor Heamans tells the rest of the story, which is substantiated by sources other than Lord Baltimore's loyalists. After the fighting ceased, Fuller and his men ferried the survivors of Stone's force back across the river and imprisoned them. A day or so later, Fuller and other Puritan leaders, sitting as a council of war, condemned ten of the prisoners to death. Four were shot "in cold blood" before the pleas of women and Providence soldiers succeeded in saving the rest. One of the executed men was a former member of Lord Baltimore's council. The provincial secretary had been killed in the battle.[47] Thirty-two prisoners received treatment for their wounds. On the Puritan side, the father of four young children was one who died on the field, and a leader of the Providence faction since their days in Virginia received wounds that later resulted in his death.[48] All accounts agree that Stone's force lost more men than Fuller's, but because the figures given for both fighters and dead vary so greatly depending on the author, it is not possible to say more than that the battle involved a total of perhaps two to three hundred men.[49]

Could the battle have taken place on Todd's or Acton's land, now downtown Annapolis, or perhaps on the plantation of Robert Clarkson, now Eastport? Not one of the contemporary accounts is clear about where the battle took place, with the result that for years historians, both amateur and professional, have argued over the location.[50] From the details given in these accounts, it seems likely that the battle took place on the river's south side, but probably not on the peninsula that became downtown Annapolis.

There are several "firsts" associated with this battle. While it is not really a continuation of the English Civil Wars (Stone had proclaimed Oliver Cromwell's election as Lord Protector in May 1654), it stands as the only Puritan battle victory on American soil and the only battlefield use of the English Commonwealth colors in this country. This was probably also the first use of Lord Baltimore's black and gold banner as a battle flag.[51] And, although the people of Annapolis feared in each successive war, for the next three hundred years, that they would be invaded by one enemy or another, the Battle of the Severn remains the only official conflict between armed government forces fought on the Severn River.

The parliamentary commissioners and their fellow Puritans may have secured control of Maryland government, but religious dissension within their own ranks threatened their existence as a political faction. Feeling that leaders had strayed too far from established Puritan doctrine, Robert and Mary Burle wrote to ministers in New England for advice and prayed for a pastor who would use the familiar rites and sacraments.[52] But, instead of a Puritan minister, they got Elizabeth Harris, Quaker missionary.

A disciple of George Fox, founder of the Society of Friends (often called Quakers), Elizabeth Harris arrived at the Providence settlement a year or so after the Battle of the Severn. She was one of several female "Publishers of Truth" who journeyed to America about this time and the first to spend time in Maryland.[53] During her stay, Elizabeth Harris converted, or "convinced," nonconforming men and women along the shores of Anne Arundel County, creating what would become a center of Quakerism in colonial America.[54] A letter written by Severn landowner Robert Clarkson after Harris's departure for England in 1657 describes the continuance of her work and names twenty or so of the men and women in the Severn area who remained Quakers. Among them was William Fuller, former Puritan military commander. Robert Clarkson and his wife, Milcah, encouraged devotion to Harris's teachings during meetings at their house and welcomed new Friends, such as Richard Beard, who had been convinced by a "clap of thunder" during a violent summer storm.[55]

In England, agencies of Cromwell's government continued to debate the question of who would control Maryland. Would the Calvert family prevail under their charter of 1632? Would Bennett and Claiborne and their parliamentary commissioners succeed in having that charter overturned? Immediately following the Battle of the Severn, spokesmen from both sides raced to London printers to get their accounts of the affair out on the street and into the halls of the English government. Both factions recognized that the welfare of Maryland depended on a peaceful resolution of the conflict. Not only was a stable government necessary for the security of its citizens, the advancement of trade, and the rule of law, it was essential for property rights.[56] Denied administration of his province, Lord Baltimore had issued few land patents since 1652, none of them in Anne Arundel. Residents might have cleared land, built houses, and harvested crops, but without a patent giving them legal ownership, they could neither sell that property nor pass it to their heirs.

Finally, even with no formal decision by Cromwell and his council, Cecilius Calvert and representatives of the Bennett-Claiborne government agreed in November 1657 to a settlement. Calvert would regain control of Maryland in exchange for his guarantee of amnesty to those who had sided with the parliamentary faction and his promise that the province would adhere to the Toleration Act, the very act the Parliamentary Assembly of 1654 had revoked. Calvert also agreed to reinstate the land grant process. When the document reached Maryland, local leaders of the two factions met at St. Leonard's Creek on the Patuxent River. Josias Fendall, Lord Baltimore's choice as governor, and Philip Calvert, his brother, stood for the Calvert side, and William Fuller, Edward Lloyd, and four others for the opposition.[57] Not content with the result of months of negotiations in London, Fuller presented several changes, one of which required indemnity on both sides for any act "don in the transactions of the affaires of this Province" since 1 December 1649. Another allowed current residents of Maryland to simply "promise & Engage to submitt to the Authority" of Lord Baltimore and his officers. Only new immigrants would have to take the oath of fidelity set out in the Conditions of Plantation. The final, amended document was signed on 24 March 1658, three years to the day after William Stone and Lord Baltimore's men made their unfortunate arrival in the Severn.[58]

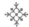

With the restoration of his proprietary authority in Maryland in 1658 and the Restoration of the monarchy in England in 1660, political dissension abated on both shores. Cecilius Calvert turned his attention to measures he believed would advance the prosperity of his province, such as the establishment of ports of entry where trade in Maryland could

be controlled and monitored, and taxed. He and the other English colonial administrators just could not understand why towns didn't develop in the Chesapeake region. Towns brought civilization and order to wild lands; they provided a central location for government, religion, and commerce. Towns were normal; the Chesapeake system was not.[59] And so, in 1668, Calvert ordered all ships to and from Maryland to load and unload goods only at designated "Sea Ports, Harbours, Creekes & other places." One of the places named was "Att Richard Actons land in Arrundell County."[60]

The reason for the selection of Acton's land, on the south side of the Severn a third of the way up a narrow creek, rather than the original Providence settlement across the river is unclear. The choices were made by Cecilius's son Charles, then the governor, and members of the council, one of whom was Edward Lloyd.[61] Perhaps the deep, sheltered creek attracted their notice.[62] Or perhaps the Calverts simply refused to honor in any way the former Puritan base — the ground on which their friends and supporters had been executed thirteen years earlier.

Whatever the reason, provincial officials bought nineteen acres of land from Richard Acton on the cove that continues to bear his name. When Lord Baltimore issued his second ordinance for the erection of ports, in 1669, Anne Arundel locations included "the Town Land purchased of Richard Acton."[63] In his third such ordinance in 1671, the same site is described as "At Richard Actons Land."[64] The issuance of three port orders within four years is clear evidence that ports received little enthusiasm from provincial planters. Yet there may have been some activity at the town site on Acton Cove. When Augustine Herrman drew his authoritative map of the Chesapeake in 1670, he placed a town symbol on the south side of the "Ann Arundel als Seavorn R[iver]" and labeled it "Arundelton." (Herrman also marked twelve other designated towns in Maryland, although this may have reflected more the wishful thinking of his patron, Lord Baltimore, than the reality on the ground.)[65]

Arundelton and the rest of its peninsula on the south side of the Severn seem to have attracted little interest in the 1670s. None of the three original settlers on the peninsula — Thomas Todd, Richard Acton, and Thomas Hall — remained. Todd's eldest son patented the land his father had surveyed twenty years earlier as a 120-acre tract covering the end of the peninsula, which he named Todd's Harbour. He also acquired Thomas Hall's land and found with a resurvey that it contained forty-eight-acres. In addition to Thomas Todd, Jr., and his two brothers, their families and servants, only a few people resided on the peninsula during the 1670s. Dr. Robert Busby bought some of Todd's Harbour and lived there for a few years, briefly giving his name to a cove near the end of Todd's (now Spa) Creek. When he died, his land was sold to Richard Hill, a sea captain who had married Milcah Clarkson, widow of Quaker Robert Clarkson, and taken up residence on Horne Neck across the creek. The Todds and Busby grew corn and tobacco and raised cattle and horses on their land, most of which was probably cleared by the end of the decade. Structures dotted the landscape: homes for the landowners' families and servants, Thomas Todd Jr.'s milkhouse, tobacco barns, other outbuildings, fences, and possibly the Todds' boatyard, assuming they continued to work as shipwrights.[66]

Despite Lord Baltimore's call for a port on Acton's land, the peninsula north of the Severn seems to have remained the focus of the community. The English tobacco ship *Constant Friendship* arrived in the Severn in 1672 and landed her passengers and goods at Town Creek (now Carr's Creek), not Acton's Cove.[67] When Quaker leader George Fox visited later that year, he gathered worshipers on Greenbury Point "where there was a Meeting-Place,

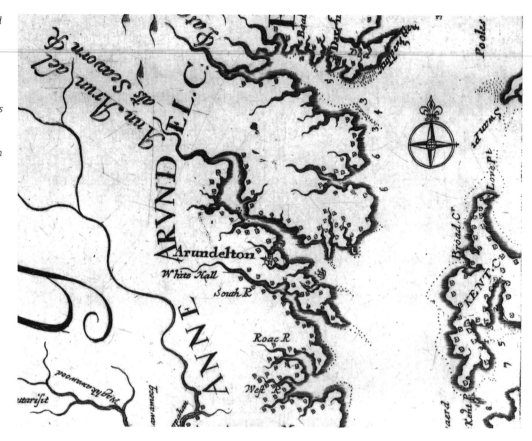

but not large enough to hold the People by many." Some of the county justices attended and "many other considerable People," and Fox spent another couple of days visiting and meeting with Friends on the north side of the Severn before crossing the river and heading south.[68]

On the other hand, what we now call Spa Creek, then Acton's Creek or Todd's Creek, had the advantage of probing farther into the interior than other creeks on either side of the Severn's mouth. Sheltered by high banks and with deep water close to shore, this creek offered a safer harbor than Town Creek. Local boats and lighters transferring goods to and from large ships could land easily at Acton's Cove.[69] Whether it was this natural harbor or some other attribute, Arundelton caught the interest of innholder Robert Proctor, who owned an ordinary at the head of South River. Sometime before September 1681, Proctor acquired land near Acton's Cove that had once belonged to Thomas Hall and told his correspondents to send messages to him at "Towne," meaning Arundelton.[70]

In the fall of 1683, when the Assembly met "at the Ridge in Ann Arundel County," legislators considered yet another town act. The Act for the Advancement of Trade passed that November designated "the Towne Land att Proctors" as one of three ports of entry in Anne Arundel County. The others were the Town Land at Herring Creek (later Herrington), designated in the earlier town ordinances, and at Colonel William Burgess's land on South River (later London Town), near where the legislators met for that session.[71] Cecilius Calvert's eldest son Charles, resident governor of Maryland and, after his father's death in 1681, also Lord Baltimore, realized that population growth on the upper Bay made St. Mary's City too remote to continue as provincial capital. South River was more centrally

Seventeenth-Century Tobacco Fleet and Trade on the Severn River

In 1672 a wooden, square-rigged sailing ship named the *Constant Friendship* arrived at the Severn River, the last stop on her two-and-a-half month journey from London to the Chesapeake. It was January and the night wind was brisk from the south. The *Constant Friendship* was one of about seventy vessels that sailed to Maryland each year in the late seventeenth century to load tobacco for the European market. They brought new settlers, household goods, and news from England, and were the critical link to civilization for the young colony.

Tobacco was colonial Maryland's dominant cash crop, amounting to fully three-fourths of its economy. The trade prospered because land was available for cultivation and there was a growing market for tobacco in the Old World. Tobacco was so profitable that the colonists focused their energy on planting, cultivating, harvesting, curing, and selling the "sot weed," while giving only minimal attention to other crops and products. Grown on plantations lining the rivers and creeks feeding the Chesapeake Bay, tobacco was easily accessible to ships that then sailed back across the Atlantic Ocean to London and smaller out ports. Once there, the precious cargo was sold in England or transshipped to the Continent.

Almost all tobacco vessels were built, owned, and crewed in England. They were usually rigged as two-masted brigs or three-masted pinks or ships, like the *Constant Friendship*. Depending on the size and rig of the vessel, each might be crewed by twelve to twenty men. Trading patterns, directed by London owners, were based on the availability, demand, and price of the commodities being produced in the American colonies. A vessel carrying tobacco one year might be redirected the next year to Caribbean islands, such as Barbados or Jamaica, to load sugar.

Losses at sea from weather, fire, and enemy action were risks that the shippers in London recognized. In the 1690s, with pirates and privateers increasingly troublesome, shipping interests established a convoy system to protect the fleet's spring return to England.

JOHN F. WING
Naval Architect and Maritime Historian

located, and Calvert intended to move the government to the land of Colonel Burgess, a member of his council and kin by marriage.[72]

 The 1683 legislation, in contrast to the earlier declarations and ordinances, provided specifics for town creation. It named commissioners to purchase and survey land, gave detailed procedures for the subdivision and acquisition of lots, stated that after 31 August 1685 all trade, imports and exports, must go through one of the thirty-one designated towns, and set penalites for noncompliance.[73] Predictably, the act still was not popular with tobacco planters, who preferred to ship their product from their own wharf or another nearby. Subsequent legislation and proclamations through the 1680s modified and delayed the act, but only a few towns actually emerged. One of them was the town at "Proctors," which was known for the next decade as Severne or Seavern (spelling was not an exact science at that time).[74]

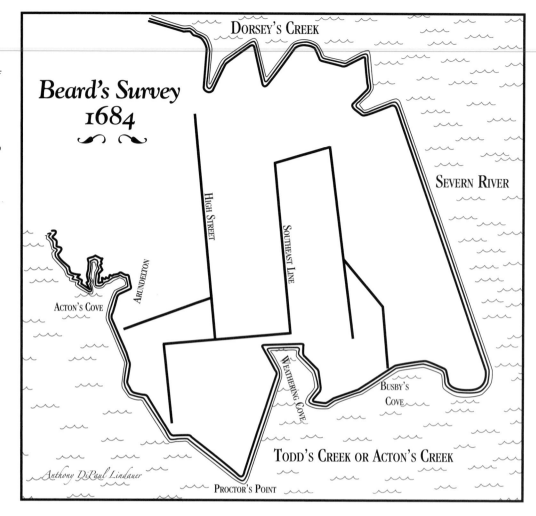

DORSEY'S CREEK

Beard's Survey 1684

HIGH STREET

SOUTHEAST LINE

ARUNDELTON

SEVERN RIVER

ACTON'S COVE

WEATHERING COVE

BUSBY'S COVE

TODD'S CREEK OR ACTON'S CREEK

Anthony DiPaul Lindauer

PROCTOR'S POINT

Edward Dorsey and Captain Richard Hill, an Anne Arundel County delegate to the 1683 Assembly, were among the men named as commissioners for the Anne Arundel County towns. Dorsey, who had come to Providence from Virginia as a child with his parents, owned ninety acres of Todd's Harbour on the creek that came to be known as Dorsey Creek (now College Creek).[75] The act directed town commissioners to purchase one hundred acres at each specified site and hire a surveyor to divide the acreage into one hundred lots, with "Convenient streets, Lines & allies, with Open Space places . . . for Church or Chapell, & Markett house, or other publick buildings." To encourage people in the area to move to town, lot sales in the first four months were restricted to county residents. To attract as diverse and numerous a population as possible, potential townspeople could buy only one lot each. Purchase money was paid to the previous owner of the land, who was given first choice of a lot. But potential owners couldn't just buy a lot; in order to gain title, each had to build a house twenty feet square by the end of August 1685 and pay a penny annual rent to Lord Baltimore.[76]

The Anne Arundel County town commissioners took Robert Proctor's forty-eight acres, added it to thirty-three acres owned by Richard Hill, and combined this with the nineteen acres of Acton's town land to make the required hundred acres. Then they engaged county surveyor Richard Beard, son of the thunderstruck Quaker, to lay out the town, stake the

lots, and draw up a plat. Given some existing houses to accommodate and only paths to work with, Beard constructed a street system he hoped would serve the needs of current residents as well as future ones and marked off the beginnings of a grid-type subdivision.[77] If Beard actually drew a plat of his town plan, it does not survive. All that remains today is his written description — eighteen lines of not-so-legible handwriting — which has puzzled even the most expert Annapolis land historians. It is generally agreed that Beard focused his plan on the hillside north of Acton's Cove and staked house lots along the streets that survive today as Shipwright, Market, and Duke of Gloucester.[78]

The town at Severne was not an immediate success, but it didn't disappear. Richard Hill took up his allotted town lot on the point between Weathering Cove (now City Dock) and Busby's Cove (later Governor's Pond, but now filled in). This had been his own property before it was taken for the town, and it almost certainly included a house built by either Thomas Todd or Dr. Busby.[79] (Hill may have built an eighty-ton ship, *Ann Arundell*, on Weathering Cove.) Richard Hill was appointed town officer in 1686 and charged with keeping a record of all shipping to and from the town and checking to be sure planters did not trade from their private wharves.[80] At least some of the ships coming into the river probably obeyed the law and unloaded cargo in Acton Creek, where seamen could enjoy food and drink at Robert Proctor's ordinary on his chosen lot near the point that came to bear his name. There may also have been some industrial activity in the 1684 town. A 1994 archaeological investigation of ground north of Cathedral Street, between Franklin and South Streets, found evidence of a forge, probably operated by a blacksmith, and indications of a small-scale foundry.[81] Another industry of the decade between 1684 and 1695 was brickmaking. Late in the decade, town commissioner Edward Dorsey constructed a brick kiln west of the present State House and used bricks from that kiln to build his own forty-foot house.[82]

When the next threat to Lord Baltimore's government came, in 1689, it wasn't instigated by people of the Severn area. Almost all of the first-generation Providence leaders were dead. Their offspring were scattered throughout Anne Arundel, Calvert, and Baltimore Counties and the Eastern Shore, and a number of them were Quakers who had retreated from public life.[83]

This time it was John Coode and his Protestant Associators, in Southern Maryland, who took advantage of political and religious dissension in Britain to create trouble for Lord Baltimore in Maryland. In the fall of 1688 Protestants in England asserted their power over King James II, an acknowledged Roman Catholic, and welcomed his Anglican daughter Mary and her Dutch husband, William of Orange, to the throne. James II fled to France. This coup, achieved with little bloodshed, came to be called the Glorious Revolution. Later that winter, acts of Parliament stipulated that successors to the crown be Protestant.[84] News of the revolt in England reached Maryland in the spring of 1689, and certain Protestant agitators saw this as an opportunity to seize the province from the Third Lord Baltimore, who had returned to England in 1684.[85]

Anne Arundel County residents were reluctant to participate in this latest power shift, probably because one of their most respected leaders opposed Coode openly and vehemently.[86] Richard Hill — mariner, merchant, town officer, legislator, and chief justice of the county court — was a man even his friends described as "apt to talk what others tho' of his opinion dare hardly think." Although a Protestant, Hill not only didn't think much of

Coode's takeover of the provincial government, he apparently also questioned the legitimacy of the Glorious Revolution that had put William of Orange on the English throne.[87] When Coode called for an assembly in the summer of 1689, Anne Arundel did not immediately send delegates.[88] The next year, after Coode and his Protestant Associators had received a message from King William approving their takeover of the province, Coode set out to silence the men who had spoken out against him. When a troop of armed men showed up at Hill's house on Horn Neck to take him "alive or dead," he fled—first to the woods, then to Virginia (where he met that colony's lieutenant governor, Francis Nicholson), and finally to London, where he pleaded his case, successfully, before crown authorities. King William cleared Hill to go home in January 1691.[89]

The Protestant Associators' rebellion, legitimized by the king, ended with the British crown's formal assumption of political and administrative control over Maryland in 1691. Sixty years of negotiations and placating and careful politics by successive Lords Baltimore had not ensured Calvert domination over the province. The Calvert family retained its rights to the land, land rents, and some other fees, but lost all other chartered rights.[90] No longer would Maryland be the tolerant home for all religious expression so desired by George and Cecilius Calvert. It was a bitter blow to the proprietary family and their supporters on both sides of the Atlantic.

Lionel Copley, loyal supporter of William of Orange and loyal Protestant, arrived in Maryland as its first royal governor in April 1692.[91] The first royal Assembly met the next month in St. Mary's City and established the Church of England as the official religion of Maryland. County justices were directed to meet with freeholders and divide their county into parishes, each of which would be overseen by a six-man vestry elected by the freeholders. Each vestry would, in turn, build a church in its parish. To provide for the support of Anglican clergy and churches, legislators placed an annual tax of forty pounds of tobacco on all taxable residents, no matter their religious beliefs. New required oaths that included religious terms and statements abhorrent to Catholics and Quakers prohibited men of those beliefs from holding any appointed or elected public office for the remainder of the colonial period.[92]

Governor Copley died after less than a year and a half in Maryland. His replacement, Francis Nicholson, presented his credentials to Maryland's provincial council in July 1694. A thirty-eight-year-old Yorkshireman of cloudy parentage but prodigious patronage, Nicholson was a sharp-tongued army officer turned colonial administrator, with experience as lieutenant governor of New England and, more recently, of Virginia.[93] He would place his stamp on Maryland and, most specifically, on the tiny settlement on Acton's Cove.

At Nicholson's first assembly in September 1694, at St. Mary's City, the legislature established "the Town Land att Seavern in Ann Arundell County where the Town was formerly" as a port of entry named the "Town and Porte of Ann Arundell" with procedural instructions almost identical to those in the town act of 1683. The same act applied to Oxford, in Talbot County, which was renamed Williamstadt.[94] Then, implementing Lord Baltimore's intent of a decade before, the legislature moved the capital of Maryland up the Bay. Not to South River, as Charles Calvert had intended, but to the newly revived and renamed town of Ann Arundell. Citizens of St. Mary's City rose up in horror. They fully understood the effect that losing the Provincial Court and Assembly meetings and the attendant bureaucracy of government would have on their livelihoods. But they protested in vain. With

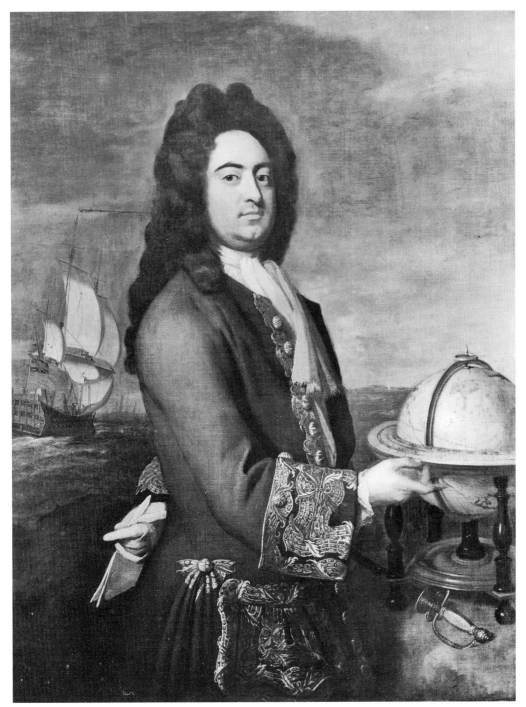

Governor Francis Nicholson is thought to be the subject of this portrait, which features a globe and ship to illustrate his experience as a colonial administrator in the New World. Courtesy of the Maryland State Archives, MSA SC 1621-590.

increased settlement of the upper Bay, St. Mary's City had become an inconvenient anachronism. And, although not mentioned publicly at the time, St. Mary's Catholic proprietary heritage was inappropriate for Maryland's new status as an Anglican royal colony.[95]

All of the four landowners of the new "Town and Porte of Ann Arundell" were linked to the Providence settlers resident there a half-century before: Edward Dorsey and Lancelott Todd were second-generation sons of Virginia emigrants. Hill had married Quaker Milcah Clarkson, and innkeeper Robert Proctor was, at that time, the third husband of

Rachel Beard Clark Stimpson, daughter of Richard Beard, Sr., and sister of surveyor Richard Beard. In the late fall of 1694, they, and their rudimentary village, were about to be overrun.[96]

When those first government functionaries from St. Mary's City stepped off the boat at Acton's Cove, they must have been shocked to find that their new capital had only a few houses on a couple of rough streets. Edward Dorsey's brickmaking establishment was probably going full blast, as it seems likely that he built his forty-foot house with rental to the government in mind. We can only hope that the savvy Rachel Proctor had added a room or two to her husband's inn.[97] Archaeological investigations in the late twentieth century proved that at least two of the newcomers built houses oriented to Richard Beard's 1684 town plan. Government clerk William Taylard chose the northern side of Beard's grid for his house, which, although it eventually sat in the shadow of the State House, was not aligned with the circle.[98] Margaret Freeman and Elizabeth Proster bought a lot on Beard's High Street (now Duke of Gloucester Street) and built an ordinary so that "they might have some employment . . . whereby to Get a penny." Margaret's husband, John Freeman, was recorder of the Chancery Court and came up to the new capital with the provincial records in February 1695. Whether he had a role in running the ordinary is not known. The records refer to it as "Mr. Freeman's house," but this may have been a formality. As only the second ordinary in town, Freeman's did good business, especially with workmen building the new state house nearby.[99]

Although the 1694 legislation establishing the town and port of Ann Arundell named commissioners to lay out the town, that job was quickly taken over by Governor Nicholson. It seems certain that only Nicholson had the experience and authority to place upon the land the baroque design that to this day defines the city. Applying his personal knowledge of European cities, his reading in garden design, and his probable familiarity with John Evelyn's proposal for rebuilding London after the 1666 fire, Nicholson imposed upon Beard's 1684 grid a plan of circles with radiating streets. The larger circle, atop the highest hill he saw, would encompass the State House; the smaller circle, on a slightly lower hill, would embrace the Anglican parish church. Diagonal streets, most of them on cardinal compass points, led to each circle, providing the vistas so beloved by Continental landscape architects and accenting the importance of church and state. Nicholson relied on Richard Beard to put his glorious plan on the ground, a challenging task for someone more accustomed to laying out the broad outlines of wilderness plantations. Modern urban planners have pointed out problems with the design: radiating streets if extended into the center of the circles would not intersect properly; the proportion and number of open spaces was not optimal; and some of the lots created were awkward in shape. Nicholson and Beard have been criticized for producing "something of a caricature of [baroque] urban design," but even the most critical observer acknowledged that for an amateur planner and a surveyor working with an existing street plan, the end result "possessed a character distinctly superior" to other Chesapeake towns of the period.[100]

With typical appreciation for patronage, Nicholson named streets for the Danish husband (Prince George) and one surviving child out of eighteen (Duke of Gloucester) of Princess Anne, presumptive heir to the throne.[101] Dean, Temple, Bishop, and Church Streets expressed his regard for the Church of England and hinted that he expected Annapolis to be an important ecclesiastic center. The honoree of Francis Street is obvious, especially considering that the street bounded one side of a trio of lots at the base of the State House hill claimed by Nicholson in accordance with the privilege granted him in the 1694 town

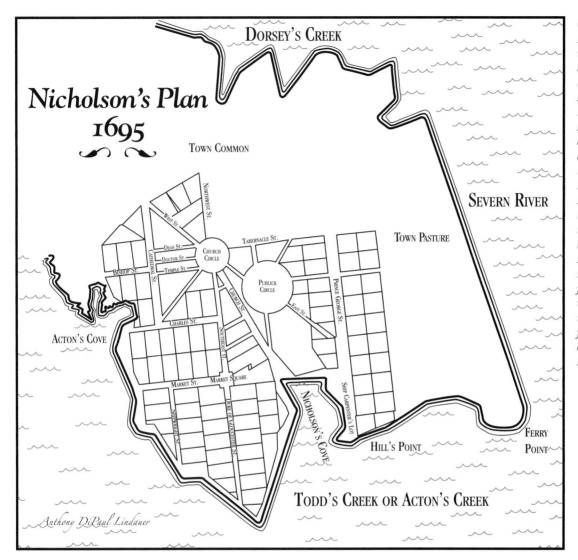

Nicholson's Plan 1695

DORSEY'S CREEK

TOWN COMMON

NORTHWEST ST.

WEST ST.

DEAN ST.

DOCTOR ST.

CHURCH CIRCLE

TABERNACLE ST.

CATHEDRAL ST.

TEMPLE ST.

BISHOP ST.

CHURCH ST.

PUBLICK CIRCLE

PRINCE GEORGE ST.

EAST ST.

CHARLES ST.

SOUTHEAST ST.

SHIP CARPENTER'S LOT

MARKET ST.

MARKET SQUARE

SHIPWRIGHT ST.

DUKE OF GLOUCESTER ST.

NICHOLSON'S COVE

ACTON'S COVE

SEVERN RIVER

TOWN PASTURE

HILL'S POINT

FERRY POINT

TODD'S CREEK OR ACTON'S CREEK

Anthony DiPaul Lindauer

Governor Francis Nicholson's plan for the new provincial capital in 1695 (reconstructed from surveys of individual lots made in 1718) shows new streets and circles that he and Richard Beard imposed over the latter's 1684 plan. Neither the notes nor the drawing made for Nicholson by surveyor Richard Beard survived the 1704 State House fire, with the result that town land remained in dispute for decades. Courtesy of Anthony DiPaul Lindauer.

act. Within his city plan Nicholson intended to place the buildings he considered essential for a royal colonial capital — state house, Anglican church, and school.

The first meeting of the Assembly in the new capital opened on 28 February 1695 in Edward Dorsey's brick house, which probably also housed the governor and the provincial records while the legislators squeezed into Rachel Proctor's inn. Fortunately the session lasted only two days and only thirty-four of the fifty-four delegates and council members showed up. The delegates hoped to look at the new town plan, but Richard Beard told them, "[F]or want of some Large Paper to draw the same on, it is not yet done." They did apparently approve the bricks being produced by Dorsey's kiln, probably anticipating their use in construction of the State House. Realizing the disadvantages of travel to the town's peninsula, this Assembly authorized public support for ferries on the Patuxent, South, and Severn Rivers.[102]

During its second session on the Severn, in May 1695, the legislature changed the name of the new capital, which was "for ever hereafter" to be called the "Porte of Annapolis," in honor of the future Queen Anne. Legislators also ordered the Anne Arundel County Court

moved from London Town, where it had met since at least 1689, to Annapolis.[103] Here also the parish church would be erected on a site chosen by the governor "and one or more places laid out . . . for the building of Ships and other Vessels."[104] Acceding to the governor's request for a "publick Post," the delegates agreed to pay John Perry £50 sterling a year to make eight round trips between the Potomac and Philadelphia with packets and letters from and to residents of the province.[105] And, most important, they engaged Casparus Herrman, delegate from Cecil County and son of mapmaker Augustine Herrman, to oversee construction of the State House.[106]

"An Act for keeping good Rules & Orders in the Porte of Annapolis," passed during the September 1696 session of the Assembly, set up a municipal government for the capital. This act named "Commissioners and Trustees" for the town and gave them corporate as well as limited legislative and judicial rights. The commissioners included Governor Nicholson; two local members of his council, Nicholas Greenberry and Thomas Tench; and Anne Arundel County Assembly delegates John Hammond, Edward Dorsey, Richard Hill, and James Saunders. Should a commissioner die or leave the area, "the freemen and inhabitants" of the town would elect his replacement. Town commissioners were directed to buy land adjacent to the town for a town common for the use of lot owners. If the owner of a lot adjoining land set aside for wharves and warehouses did not build the requisite structure on that land within eighteen months, the commissioners could give title to the wharfage land to someone else. At his request, Nicholson was given the right to select a parcel of land in the town pasture for his "Garden Vineard or Somerhouse," and should the practice of any trade — brewing, tanning, dyeing, or the like — annoy residents within the city, the tradesman could move his operation to a lot in the pasture. This legislation also provided for a weekly market and annual fair, during which no one would be arrested except for major crimes — a real boon for debtors and small-time crooks. And so that all could see the new town plan, Beard's plat, adorned with Maryland's new royal seal and "with his Excellencys Seale att Arms on a red Cross with red Tape," was to hang in the State House.[107]

Over the next few years, Annapolis began to take on the trappings of a town. As authorized by the 1694 town act, the commissioners bought the rest of Todd's Harbour at the end of the peninsula for the town pasture and commissioned a fence. When horses continued to escape, Governor Nicholson suggested an eight-foot-wide ditch along what later became King George Street, which seemed to solve the problem. Land to the west of the town was purchased for the town common, where residents could keep cattle and sheep.[108] The county's "Cage, Whipping post, pillory, and Stone" were brought up from London Town and a prison was erected, probably near the "handsome pair of gates" built on West Street to mark the landward entrance to the town.[109] A small frame market house took shape in the little square that separated Duke of Gloucester from Southeast Street, although it was removed sometime after 1698 when Postman Perry complained that it blocked his view.[110]

One can only imagine Governor Nicholson's frustration as his public building program ran into one obstacle after another. After trying the patience of the governor and the Lower House of the Assembly with his delays, Casparus Herrman died halfway through construction of the State House, workmen got drunk in local ordinaries, and the work proceeded slowly. In the meantime, the government had to contract for rental space. The Provincial Court met in Richard Hill's house at the end of Prince George Street, and Rachel Proctor was paid for committee meetings held at her inn. In March 1698, the State House was far enough along to allow the Assembly to sit in their new chamber. The Assembly allotted space within the new building for the council and the Provincial and Chancery Courts.

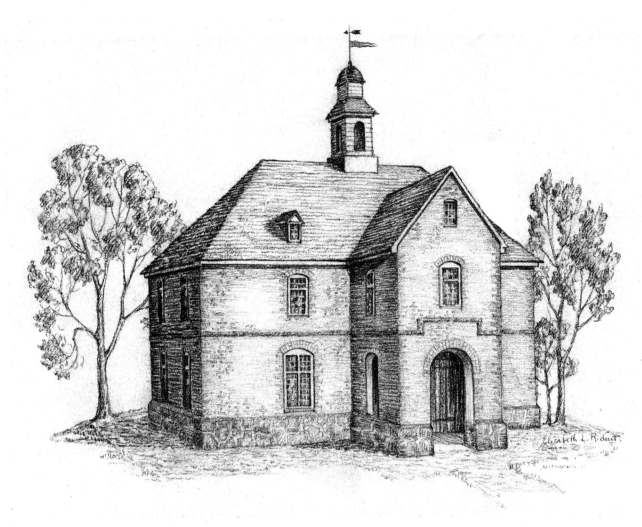

Maryland's first State House c. 1700 as drawn by Elisabeth L. Ridout from contemporary descriptions, with weather vane and pennant added by Edward C. Papenfuse. Courtesy of the Maryland State Archives, MSA SC 1444.

They also set aside two loft rooms where the clerks of the Anne Arundel County Court and the town of Annapolis could keep their records.[111]

Government agencies shared their space in the State House with the first public circulating library in the colonies. The Reverend Dr. Thomas Bray, commissary of the bishop of London to Maryland, had been sending books to Annapolis since 1697 as part of his plan to make appropriate reading material available to Anglican clergy and colonial laymen, who he believed would benefit from learned treatises on mathematics, natural history, law, and medicine. One of more than fifty libraries established by Bray in the English colonies, the Annapolis library eventually numbered almost 1,100 volumes and was open to perusal by any interested citizen. The Bray library moved to nearby King William's School in 1704 and passed, with other possessions of that school, to St. John's College in 1786.[112]

King William's School was another Nicholson priority to fall behind schedule in the late 1690s. Soon after the governor's arrival in Maryland, legislators approved Nicholson's request for a publicly supported school, and even added their own contributions to the governor's generous promise of funding. Although the Assembly envisioned public schools in every county, they established first the Annapolis school, which they named for King William, in 1696. (Queen Mary had died two years earlier.) King William's School was a

grammar school "for the Propagation of the Gospell and the Education of the Youth of this Province in Good Letters and manners." For a fee, as many as a hundred male teenagers would study "Latine Greek Writeing and the like" under the watchful eyes of a master, his assistant, and a writing master or scribe.[113] The trustees of the school, led by Governor Nicholson himself, hired one of their number, Edward Dorsey, to oversee construction of the brick school building on land within the State House circle. Dorsey, whose intentions far outweighed his abilities, made slow work of the project, and it was not until 1701 that the structure could be occupied. By that time the school was already under way, its students studying the prescribed subjects and also "arithmetic, navigation, and all useful learning."[114] Presumably the scholars used their new school building, but if so they shared it with the provincial council and, for a time, with the provincial weaponry as well. Somehow, a meeting room for the council had not been included in the new State House, so the councilors rented space in the school at least until 1706 and probably much longer. A "splendid" house on State House hill designed to accommodate official public receptions, council meetings, and the armory was built in 1718.[115]

As an endowment for the school, Governor Nicholson set aside one of his lots on Francis Street and accepted the offer of Anthony Workman, of Kent Island, to have Philadelphia bricklayer William Freeman build an ordinary there. Workman would run the ordinary, which he called the Kentish House, during his life, free from the usual licensing fees; and after his death, income from the establishment would go to King William's School. When Workman died some years later, a record of this agreement could not be found, the books "being defaced and torn." The Assembly passed legislation, in 1715, to secure title to the lot and buildings to the school.[116]

When Nicholson left Annapolis in December 1698 to take up his new job as governor of Virginia, his third priority, the Middle Neck Parish Anglican church at Annapolis, to be named for St. Anne, remained hostage to Dorsey's incompetence. The overbooked contractor had received initial financing for the project but had provided neither lumber nor bricks for the construction. The parish's silver communion service, a gift from King William, sat in a government office.[117] Only the foundation of the church had been completed when, in late January 1699, Hugh Jones, the young rector of Christ Church in Calvert County, described the town in a letter to his Cambridge don:

> There are indeed severall places allotted for towns, but hitherto they are only titular ones, except Annapolis where the Governour resides. Governour Nicholson hath done his endeavour to make a towne of that. There are in itt about fourty dwelling houses, of [which] seven or eight whereof cann afford good lodging and accomodations for strangers. There is alsoe a Statehouse and a free schoole built with bricke which make a great shew among a parscell of wooden houses, and the foundation of a church laid, the only bricke church in Maryland. They have two markett daies in the week, and had Governour Nicholson continued there some years longer he had brought it to some perfection.[118]

Hugh Jones had no trouble making the journey from Calvert County to Annapolis. In his determination to attract visitors and trade to the Maryland capital, Nicholson had ordered roads cleared across each of the four major peninsulas between the Patuxent River, in Southern Maryland, and the Patapsco River to the north. As with other roads leading to ferries, churches, or courthouses, these thoroughfares were supposed to be twenty feet

wide, with trees on either side marked with two notches. When roads heading to Annapolis branched off, the intersections were marked "on the face of the Tree in a smooth place cut for that purpose with the Letter A. A. sett on with a pair of marking Irons and Coulered."[119] Jones said that the sandy soil made roads "very convenient for travelling." Horses didn't even need to be shod except in winter. "And what with the goodnesse of our little horses and with the smoothnesse of the roads, we can travell upon occasion fifty miles in a summers afternoon, and sometimes a hundred miles in a day."[120]

Tragedy marked the first Assembly session of Maryland's next royal governor, Nathaniel Blackiston. As the legislature sat in the new State House on 13 July 1699, a summer storm blew through and a "violent flash of lightning" struck the highest building in town, instantly killing Calvert County delegate James Crauford and wounding several others. The electrical charge shattered doors and windows and caused a fire on the second floor, which the legislature credited Blackiston with bravely extinguishing. Damage to the State House was apparently not enough to displace the legislators; the Assembly remained in session for another week.[121]

Another colonial bureaucrat, Governor Blackiston had previously served the king as lieutenant governor of Montserrat, where he obviously received better treatment. Annapolis was too expensive, he complained, and there was no house provided for him. "My usage in this place . . . has not been with the respect of a Common Constable in England."[122] It was a refrain the Assembly would hear from the next governor as well. All they could do was apologize and add a housing allowance of £30 sterling to his annual income of about £1,700. It might be noted that the governor of New York received only about £600 a year.[123]

Blackiston had no patience with Edward Dorsey, the over-extended contractor. During his first legislative session, the Lower House of the Assembly canceled Dorsey's contract for St. Anne's, made him pay back his advance, and fined him an additional £200 sterling. New contractors were chosen and work on the church resumed. The building was not completed when the Reverend Dr. Bray arrived in the spring of 1700 to take up his duties as senior clergyman of the Anglican Church in Maryland. Perhaps it was this lack of an appropriate pulpit, coupled with hostility from a governor who felt his power threatened by a high-ranking cleric, that prompted Bray's return to England the following year.[124] The first service in St. Anne's Church took place on 24 September 1704, with the Reverend Dr. James Wooton, the parish's third rector, presiding. For communion that day, he almost certainly used the silver communion vessels embossed with the arms of King William, that could now, finally, be stored in the church. Wooton's sermon so pleased the legislature that they ordered it published by Thomas Reading, official printer to the province.[125]

By the turn of the eighteenth century, frequent meetings of the legislature, sessions of the provincial and county courts, and the general business of the province brought visitors to Annapolis and encouraged entrepreneurs, such as Philadelphia brewer Benjamin Fordham, who came to town in 1700, set up his brewery, and opened an ordinary on the south side of Francis Street.[126] The resident population of the town in 1699 stood at about 250 people, a number that swelled temporarily during public meetings and fairs; by 1705 the population was 330.[127] The public building boom attracted skilled craftsmen and unskilled laborers, although it is unclear just how many stayed around. On the other hand, provincial officeholders from the governor and provincial secretary to minor clerks found

it convenient to spend most of their time in Annapolis, and their patronage was important to the service sector of the economy.[128]

Port records show ninety-one ships entering the Severn between 1696 and 1701, bringing to town seamen and immigrants (free, bound, and enslaved) along with cargo.[129] As the new century progressed, these ocean-going vessels and vessels from other Bay ports brought an increasing number of lawyers and merchants to Annapolis "to Get a penny" of their own. Lawyers William Bladen, clerk of the Lower House, and Charles Carroll, legal advisor to Lord Baltimore and clerk of his land office, moved from St. Mary's City to the new capital, where they were joined by a young attorney, Thomas Bordley, who had emigrated from England to Kent County as a teenager with his brother, an Anglican minister. All three would have profound effects on Annapolis. Bladen and Bordley acquired land and power as proprietary officials and legislators. The Irish Carroll's Roman Catholic faith limited his legal practice and denied him both franchise and public office, but it did not prohibit him from acquiring vast wealth through landholding and money lending.[130] English-born merchant Amos Garrett, agent to provincial secretary Sir Thomas Lawrence, rivaled Carroll as land speculator and financier. Garrett's colleague John Brice, a factor for English merchants, did not achieve such great wealth, but he quickly connected himself by marriage to venerable county families and began a dynasty that continues to this day.[131]

In a town of wooden houses, fear of fire haunted residents day and night. But, strangely, in Annapolis, the most serious fires of this period occurred in the State House, one of the town's few brick buildings. After the 1699 lightning strike, Governor Blackiston and the council ordered the purchase of several "water engines and 20 leather buckets" to fight future fires.[132] On the night of 17–18 October 1704 neither saved the State House from a second fire and virtual destruction. Although some people accused a local agitator named Richard Clarke of setting the blaze, no proof linked him or any other person to the disaster. Governor John Seymour, who had succeeded Blackiston in 1704, blamed the legislature for not listening to "my often Admonitions . . . for I never saw any publick Buildings left solely to Providence but in Maryland."[133]

Only the foundation and brick walls of the structure survived the fire, but most of the provincial records lodged in the building were saved. What was lost seemed to be largely records of Anne Arundel County and Annapolis. The county court volumes that perished included the critically important land records: deeds, leases, dower rights, cattle marks, bonds, releases, and myriad other bits of information the clerk had thought he was saving for posterity in those books. Also lost were Richard Beard's 1695 plat of Annapolis — the one made official with Nicholson's seal and the red tape — and his records of the people who had taken up town lots. City residents would pay for this disaster over decades to come when unscrupulous men attempted to profit from the lack of legal records. For the moment, it was back to Edward Dorsey's brick house for the legislature and back to King William's School for the extant record books and papers.[134] A special court met in Annapolis in December 1705 to begin re-recording county land transactions. The process continued for almost half the eighteenth century.[135]

The first decade of the new century saw names long associated with the town disappear as Edward Dorsey, Richard Hill, and Richard Beard came to the end of their lives.[136] Innkeeper Rachel Beard (married to her fifth husband) remained in town, and a few of the next generation — Joseph Hill and Matthew Beard, for instance — lived there briefly, but town living still held no promise for landed tobacco planters. They preferred to exercise

their influence in county affairs; five of ten delegates from Anne Arundel County to the General Assemblies of that decade were Providence descendants.[137]

Nor, it seemed, did Annapolis hold promise for the tradesmen and craftsmen that Nicholson had hoped would make it a "normal" English town. Aside from brewer Benjamin Fordham and tanner Thomas Dockwra, most lot owners were lawyers and merchants.[138] Royal town acts passed in 1706 and 1707, which were similar to those under Lord Baltimore in the previous century, included Annapolis in the list of towns and ports to be developed. Presumably the reality of the town on the Severn did not meet the expectations of the crown any more than it had satisfied the wishes of Lord Baltimore. To encourage the desired diversity and breadth of population, the 1706 act offered craftsmen tax advantages, citizenship if they were foreign, and male orphans as apprentices; but still there was no rush to Annapolis.[139] Governor Seymour saw as the problem the fact that "most of the Lots in the Town and Port" were "ingross'd in three or four People's Hands to the great Discouragement of the Neighbors, who would build and inhabit therein, could they have the Opportunity of taking up Lots."[140] The three or four men accumulating town lots at the expense of other, potentially more industrious townspeople were Amos Garrett, Charles Carroll, William Bladen, and Thomas Bordley — lawyers and merchants all, and men whose influence would continue to shape the eighteenth-century town.[141] All of which makes Seymour's action the following year a little odd or, perhaps, even more contrived.

Although Governor Seymour had questioned early in his tenure why St. Mary's City was still represented in the legislature and the present capital was not, nothing came of it until the summer of 1708. On 16 August that year, Seymour again brought the question to the council, which this time agreed that "this being the Seate of Government & a growing place as having the most Buildings & people Inhabiting therein," representation for Annapolis in the General Assembly would be appropriate. Their approval was a formality. Seymour had already drawn up a charter, dated that day, setting up an incorporated city government with powers of legislation, adjudication, taxation, and provincial representation.[142]

Modeled upon, and in most wording identical to, the charters granted by Lord Baltimore to St. Mary's City in 1668 and 1671, the August 1708 Annapolis charter expanded and regularized Nicholson's 1696 "Act for keeping good Rules & Orders in the Porte of Annapolis."[143] City officers now followed English precedent — mayor, recorder, aldermen, common councilmen — and their powers were adapted from English law and usage. Named in the charter were the mayor, recorder, and the six aldermen; they would choose a ten-member common council from the freemen of the town. Once in office, the aldermen, recorder, and common councilmen would serve "So long as they Shall well behave themselves." The mayor would be selected from the ranks of sitting aldermen annually by all city officers. Officeholders were self-perpetuating, with new aldermen selected by the mayor and remaining aldermen from the members of the Common Council, and new councilmen chosen by the mayor and aldermen from the "Inhabitants and freeholders" of the town. Any replacement recorder, chosen by the mayor and aldermen, had to be "a person learned in the Laws."

As the legislative arm of government, the mayor, recorder, and Common Council enacted ordinances and bylaws, which the charter said should be similar to those then in place. Executing and enforcing those ordinances and bylaws were the mayor, recorder, and aldermen, who appointed constables and other minor officers and acted as justices of the peace, with the same powers as those given county justices. The same men staffed a "Court

of Hustings" (the Mayor's Court), with jurisdiction over minor civil suits and real property issues.

The charter provided for two market days weekly and two annual fairs, and as had been the case under the 1696 act, freed fair attendees from fear of arrest for small debts. Any controversies during fairs would be handled by a court of pypowdry, an ancient English court for very minor cases. Under the new charter, the city could send two delegates to the General Assembly; but instead of having those delegates elected by qualified freemen, as had been the case in St. Mary's City, they would be chosen by the mayor, recorder, aldermen, and the five most senior common councilmen from residents of the town "haveing a freehold or visible Estate of forty pounds Sterling."[144]

The charter named Amos Garrett mayor, Wornell Hunt recorder, and William Bladen, John Freeman, Benjamin Fordham, Evan Jones, Thomas Bordley, and Josiah Wilson aldermen — two merchants, three lawyers, three innkeepers, including three of the most egregious lot hoarders in town. Upon this group Seymour bestowed total control over the city and its delegation to the Assembly. Given the governor's stated concern about the lack of tradesmen and craftsmen in town, this action seems beyond explanation today. It rankled townspeople then, too, especially when the new municipal officers promptly elected two of their number, William Bladen and Wornell Hunt, to represent the city at the next General Assembly, in September.[145]

Both Bladen, who at the time held several lucrative provincial offices, including attorney general and clerk of the council, and Hunt, who had recently arrived in Maryland but was already practicing law in two counties and before the Provincial Court, were men Seymour saw as supportive of him. By bringing them into the Lower House, he increased his influence there. By limiting city officers to those he appointed or, in the case of a common councilman, men selected by his appointees, Seymour would place municipal power in the hands of a "narrow elite" loyal to him and, by extension, to the crown.[146]

Shortly after the opening of the legislative session, Annapolis lawyer Thomas Macnemara and tanner Thomas Dockwra, with several other townspeople, brought into the Lower House a petition complaining about the charter. The delegates saw a larger issue and questioned whether Seymour had the right to grant a charter in the first place. They decided he didn't.[147] Clearly irritated, the governor responded by demanding that the House "give their immediate attendance on him" and, when they did so, censured them for challenging his power and sent them back to their chamber to "seriously reflect on what you have done." Unwilling to back down, the Lower House accused Seymour of incorporating "some Gentlemen . . . into a Body politic or Fraternity" thereby depriving the Queen's subjects of their right to vote for their representatives. Seymour dissolved the Assembly.[148]

Macnemara, Dockwra, and the other freemen of the town objected to the August charter principally because it denied them a right they had had since the founding of Anne Arundel County and in English law since 1430: the privilege of voting for their representatives in government. Freemen living in Annapolis had voted routinely in Anne Arundel County elections for delegates to the Lower House. The new charter, although it gave Annapolis two delegates of its own, provided that those delegates would be chosen by selected city officers. Worse yet, freemen of the town could not elect any of those city officers.[149] For twelve years, under the port act of 1696, "the freemen and inhabitants" had elected town commissioners. Now they were denied any say in their local government.[150]

Disenfranchisement of English citizens put Seymour in a tenuous position. Apparently, realization of this, plus the fact that his right to grant the charter in the first place was itself

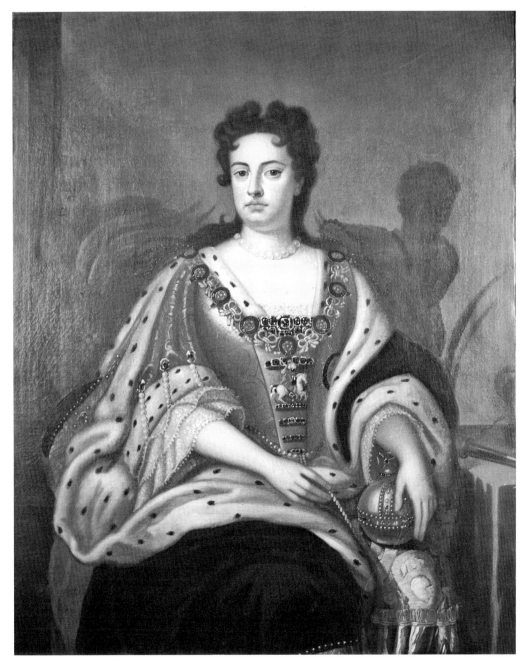

Anne, Queen of England, for whom the city of Annapolis was named and during whose reign the city charter was issued. Portrait by an unidentified British artist c. 1702 after Sir Godfrey Kneller. Courtesy of the Maryland State Archives, MSA SC 1545-1073.

open to challenge, motivated him to consider compromise.[151] During the next few weeks, the eighteen sitting city officers and seventeen other townspeople petitioned Seymour "to Enlarge" the August charter. Their most important request extended the franchise for the election of delegates and the replacement of common councilmen to freeholders of the city who owned either a lot and house or a visible estate of twenty pounds sterling. A man who had completed five years of service in a trade in Annapolis and had lived in the city at least three months since becoming a freeman would also be allowed to vote. The governor accepted the petition on 18 November and directed the officers of the corporation to draw up a new document that would satisfy the concerns set forth in the petition.[152]

The new document, Seymour's second charter for the city of Annapolis, was dated 22 November 1708. It read substantially like the August one, with the same named officers, but codified the voting rights requested by the petitioners. Qualified citizens would again have the right to elect their representatives to the General Assembly and at least one component of their municipal administration. When the common councilmen selected by the first aldermen died or left town, or behaved badly, free voters would choose their replacements and all subsequent replacements thereafter.[153]

With compromise in the air as the new General Assembly met later that month, the governor and Lower House came to an agreement that allowed the charter to stand but gave the legislators the right of confirmation. The result was "An Act Confirming and Explaining the Charter to the City of Annapolis," in which the General Assembly gave its blessing to the charter, with enough modifications to make their own power clear — halving the usual allowance to delegates for those representing Annapolis, for instance, and declaring lawyer Wornell Hunt ineligible as delegate because he had not lived in Maryland for the requisite three years (although they let him stay on as recorder).[154]

And so, the City of Annapolis dates its formal existence as a municipality from 22 November 1708. Not that it was then a city in European terms. Maryland in 1708 was still at the edge of the British world, life there was difficult and tenuous, and tobacco planters had little use for urban living. Annapolis was a village of politics, of mostly small, wooden houses gathered round a few public buildings, a place where an unpopular local lawyer could be sentenced to an hour in the stocks "bare Breeched," and which a snide London poet could satirize as

A City Situate on a Plain,
Where scarce a House will keep out Rain;
The Buildings framed with Cyprus rare,
Resembles much our *Southwark* Fair:
But Stranger here will scarcely meet
With Market-place, Exchange, or Street;
And if the Truth I may report,
'Tis not so large as *Tottenham Court*.[155]
—*The Sot-Weed Factor*, by Ebenezer Cooke

A Chartered City 1708 to 1764

At first, it seemed that Maryland's newly chartered capital city would become no more a metropolis than its predecessor in St. Mary's County. With fewer than four hundred residents in 1710 and most heads of household involved in provincial government or service industries, Annapolis seemed doomed to remain a government town — or village, if the poet Ebenezer Cooke is to be believed.[1]

Presumably the city officials named in the November 1708 charter — Mayor Amos Garrett, Recorder Wornell Hunt, and Aldermen William Bladen, John Freeman, Benjamin Fordham, Evan Jones, Thomas Bordley, and Josiah Wilson — reelected the same ten common councilmen that they had chosen under the original, August, charter. Presumably these officials met at least occasionally to conduct the business of the city corporation, and presumably the mayor, recorder, and a couple of aldermen sat as the Mayor's Court. But for the first forty-five years of city government, records exist for only twenty-one months, during 1720 to 1722, so we know very little about the city government.[2] The scanty records that survive suggest a corporation that met only sporadically and did little. No one seemed to mind.

Of greater concern to city landowners during these early years of the charter was the murkiness of their land titles, titles verified by documents and records that had been destroyed in the 1704 State House fire. And concerned they should have been, because two sharp-eyed men saw opportunity in chaos and began an exercise in greed that hangs as a backdrop to scenes of land development on the peninsula for most of the century. For convenience, let us title this drama "Bordley-Larkin and the Case of the Purloined Pasture." Starring in the original production were lawyer Thomas Bordley and surveyor Thomas Larkin. Bordley, Yorkshire born and descended from Anglican clergy, married the daughter of town surveyor Richard Beard and may thus have gained inside knowledge of the town's early history. Larkin was a south county landowner, son of an innholder, who styled himself a gentleman by 1702.[3] Together they made a formidable pair who, unlike Ebenezer Cooke, saw a great and glorious future for Annapolis — a future from which they intended to profit.

Playing supporting roles in this not-so-legitimate-theater piece were Lancelott Todd, descendant of the first Thomas Todd and claimer of rights to his 1651 survey; Henry Hill, son of Captain Richard Hill, who asserted his right to his father's land both inside and outside the town limits; Stephen Bordley, son of Thomas, because this farce did not die with the principals; and Charles Calvert, Fifth Lord Baltimore, who believed *he* owned everything anyhow. Minor but important roles were performed by various political functionaries and government officials who allowed the scam to get as far as it did and by the judges who acceded to the status quo.

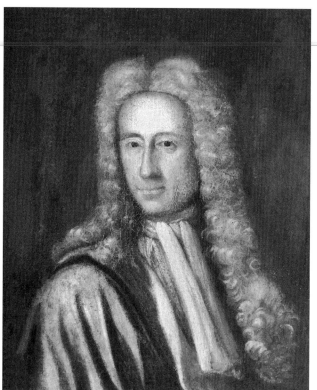

Thomas Bordley, alderman, legislator, and attorney, who claimed that he and his co-conspirator, Thomas Larkin, owned Annapolis. Portrait by Gustavus Hesselius, c. 1715. Courtesy of the Maryland Historical Society.

Central to the plot was the 1694 town act that established Ann Arundell Town. Commissioners appointed by that law were charged with buying one hundred acres on the Severn, "where the Town was formerly," laying out streets, marking locations for public buildings, and subdividing the rest into lots, which could then be taken up by potential residents. Takers up paid the landowner a fee and the proprietor an annual penny tax, but they were required to build a twenty-foot-square house within a year in order to get title to the lot. The 1694 commissioners simply recycled the hundred acres that had been acquired a decade earlier: Robert Proctor's forty-eight acres, Richard Hill's thirty-three acres of Todd's Harbor, and the nineteen acres of Acton acquired by Lord Baltimore under an earlier town act. After moving the capital up the Bay in 1695, Governor Francis Nicholson designed a new street plan and placed public buildings. Lots were then taken up, registered, and, in some cases, built upon. It was all ancient history, except the records of that history were gone and most of the participants were dead.[4]

The play began in 1713 when surveyor Larkin made a new plat of the town and Lancelott Todd, then living in Baltimore County, decided he deserved to be paid for any lots taken up that might once have been Todd land. Was Lancelott led to this conclusion by the two protagonists? Even though his claim was specious, Lancelott managed to get several lot owners to pay him ten shillings each to secure their rights. Confident now that the plot would thicken successfully, Bordley and Larkin bought Lancelott's alleged rights to his grandfather's 1651 hundred-acre survey and adjacent Todd land.[5]

As the act progresses, it is important to note the positions of trust and importance that Bordley and Larkin held during these years. Elected as a delegate to the General Assembly alternately from Anne Arundel County and Annapolis, Thomas Bordley represented the city in the Lower House during Assembly sessions from 1716 to 1719. He was appointed surveyor general of the province in 1717 and rose to the positions of both provincial attorney general and commissary general the following year. In April 1720, Governor John Hart tapped him for the governor's council, which also sat as the Upper House of the Assembly. Some time after his appointment in 1708 as one of the city's first aldermen, Bordley's colleagues elected him city recorder, a post he held by May 1720 and probably retained for life.[6]

Thomas Larkin could not boast of provincial status equal to Bordley's, but in the local arena he seems to have done well enough. Often called "Captain," probably for some unspecified military service, Larkin sat as chief justice of the Anne Arundel County court from 1716 to 1718. From 1717 to at least 1720, he was one of six commissioners appointed to examine evidence and authorize re-recording of county land records burned in the State House fire. Although he owned an 855-acre plantation in All Hallows Parish, Larkin acquired a lot on the Annapolis waterfront in 1719 and immediately parlayed it into a nicer lot on Market Street, where he built a small frame house. His rise in the city corporation progressed with astonishing alacrity, since by September 1719, he had moved from coun-

cilman to alderman to mayor. Following his year as mayor, Larkin remained an alderman until at least 1726.[7]

In 1717, Bordley and Larkin re-surveyed Thomas Todd's 1651 tract before applying for a new patent on the land. The surveyor found Todd's 100 acres to be a surprising 232 acres, covering almost all of the peninsula.[8] As the angry Henry Hill put it (after naming the three pieces of land that comprised the 1694 town), "Thus has this monstrous little dormant Survey, after a Nap of Sixty Four Years, awaked; and, as a Morsel, swallowed up all the aforesaid Parcels of Land, and with them the Metropolitan City of Maryland."[9]

That 232 acres included the land set aside for the town pasture and town common, both of which were in use at the time of the survey. A legislative committee in 1710 had determined that provincial funds had paid for the pasture and gatehouse and that townspeople had built the pasture fence; thus, in the future both government and residents would share in the maintenance of the fence and gatehouse and support of the gatekeeper. Under the 1696 "Act for keeping good Rules & Orders in the Porte of Annapolis," lot owners in town were entitled to parcels of the town common, whether or not they had asserted that right. Hill was not the only person to complain about what seemed to be a usurpation of the rights of town residents.[10] Petitions to the spring 1718 session of the General Assembly resulted in the "Act for settling all Disputes concerning the Boundaries of the several Lots" in Annapolis, which set up a commission of four men, none of whom owned property in the city, to rule on the legitimacy of the claims brought before them. James Stoddert, a Prince George's County delegate who had surveying skills, was charged with making another survey of the town.[11]

At the request of the city corporation, the 1718 act also directed that ten acres of the "Public Pasture," between the existing lots and the river, be laid out in twenty lots "for the better Encouragement of poor Tradesmen." New owners could take up these lots under the same conditions as in the 1694 law establishing the port of Ann Arundell. In an attempt to prohibit the large landowners in town from absorbing these, too, the 1718 act restricted current lot holders from taking up New Town lots for two years.[12]

Not two months after passage of this "Act for settling all Disputes," Thomas Bordley and Thomas Larkin received the patent for their new 232-acre tract. Although the patent "reserved" the claims of the proprietor and inhabitants, the fact that the document was issued before the matter had been subjected to a full investigation is inexplicable. On the other hand, the legislature was clearly uninterested in a full investigation. The commissioners' report, filed at the next assembly, in May 1719, revealed that they had interviewed only Lancelott Todd. Todd admitted he had received ten-shilling payments from a few lot holders but said he had gotten nothing from most and certainly nothing for the "publick grounds" nor, "he verily believes" from Governor Nicholson (for his vineyard). Apparently no one was concerned with Todd's actual title to the city land. In the same vein, the legislators ignored a petition from the city corporation regarding the commons and dismissed one from Joseph Hill, brother of the angry Henry, asking for acknowledgment of their father's ninety acres.[13]

Ranked at the very top of his contemporary Maryland litigators, Bordley was described by a modern judicial historian as "a combative man, . . . a skillful, though prolix, pleader, in attack not always held within the rules, and not disdaining arguments of ingratiation when they might serve." His success in the present production testifies to his skill. Bordley and Larkin published their side of the argument, and its general readers must have been as persuaded as their elected officials. Even the most important landowners in town — Charles

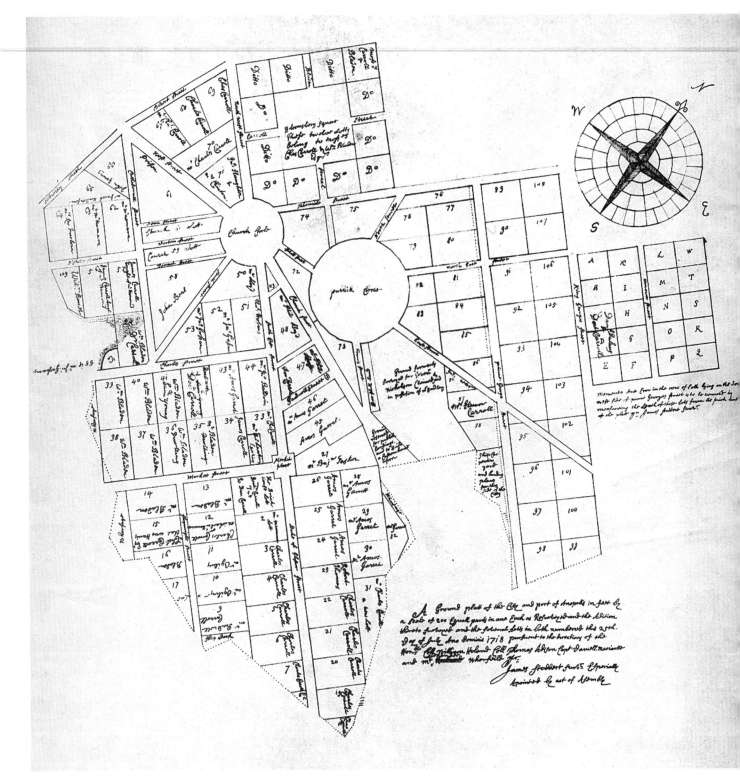

Nicholson's plan of Annapolis as re-created in 1718 by James Stoddert, who also laid out twenty lots of New Town to the northeast. King George Street and Hanover Street acknowledged England's new ruler. This drawing, which names some of the lot owners in 1718, is a copy of a Stoddert map once owned by the Carroll family. Courtesy of the Maryland State Archives, MSA SC 182-02-435.

Carroll the Settler, Amos Garrett, Benjamin Tasker (for himself and his deceased father-in-law, William Bladen)—handed over their shillings to confirm their rights to city lots. Among the land secured by payments to Bordley was Bloomsbury Square, the private block of almost thirteen acres adjacent to Northwest Street subdivided by Carroll and Bladen. Tradesmen taking up New Town lots were quick to pay the designated fee to Bordley and Larkin even though they had to delay construction of a house for want of "Necessarys in building," presumably bricks and nails. Legislation in 1720 gave them another year to conform to the requirements.[14]

Maintaining the suspense, the two stars waved the public pasture before the eyes of the dazed General Assembly. If "the publick" would pay them (again) for the pasture, the new owners would give it up. But the legislators didn't accept the offer, and in 1724, the stars divided the spoils. Larkin took the land north of the city—the pasture—and one acre outside the town gate. Bordley held on to the rest.[15]

Suffering from "the Stone"—a kidney or gall stone—Thomas Bordley left Maryland in the summer of 1726 to seek treatment from English medical experts. He died under the knife of renowned London surgeon William Cheselden in October. In his will, Bordley apportioned his part of the Bordley-Larkin patent amongst three of his sons, carefully reserving to his eldest son, Stephen, the "Beautifull Hill" behind his house.[16] After Bordley's death, when residents and the city corporation again petitioned the legislature for "their right of Commonage" and town lands, the matter was postponed for session after session until, in 1729, the Lower House gave as its opinion that the petitions "ought to be deferred" because Thomas's heir, Stephen Bordley, then about sixteen, was not "of full Age."[17]

Surveyor Larkin subdivided his pasture, creating half-acre lots to extend New Town to the riverside and setting out several two- to five-acre parcels at the end of Northeast Street (now Maryland Avenue) and at the point of land where Spa Creek meets the Severn. One large parcel at the mouth of Dorsey (now College) Creek he sold to former governor Charles Calvert. The lots sold quickly, but very few buyers were tradesmen: only three carpenters and a tailor. The rest were merchants anxious for access to the waterfront or gentlemen with an eye for a pleasant vista. One purchaser was a woman, Ariana Vanderhayden Frisby Bordley, second wife and then widow of Larkin's one-time partner. Married by 1728 to her third husband, Virginian Edmund Jennings, Ariana bought four nicely situated lots (two acres) near the mouth of Spa Creek. Legislation in 1725 granted privileges of freeholder or resident, under the charter, to owners of lots in New Town and in the land adjoining the city "commonly called, The Town-Pasture or Common." In the six years between 1725 and 1730, Larkin sold eighteen parcels of the former public pasture for a total of slightly less than £450. He died at his home on the Ridge in 1731.[18]

Aside from the financial profit and loss by residents of the town and more than two decades of uncertainty over land titles, the Bordley-Larkin production resulted in long-term gains to the city. As the first formal expansion of Annapolis, New Town and Larkin's adjacent subdivision of the former pasture increased opportunities for land ownership among middling sorts as well as the rich and powerful. Warehouses, wharfs, and dwellings constructed along the shoreline encouraged commerce and made the town appear larger and more prosperous. Perhaps most important then, and now, is James Stoddert's plat of Annapolis, the first map of the town to survive, even in copies of his long-gone original. True, Stoddert's representation may have been more wishful thinking than reality, especially as to streets that were not cut through until well into the future, but it is Stoddert's map that draws our eye to Nicholson's unique design. Also valuable then and now is Stod-

dert's notebook in which he recorded the owner, location, and dimensions of each lot. The notebook confirms the city as a landlord's dream. Stoddert surveyed 129 lots in 1718: 109 lots held under Richard Beard's 1696 layout, which Stoddert renumbered, and 20 lots in New Town. Of the 109 old-town lots, Charles Carroll the Settler owned twenty-three, Amos Garrett seventeen, and William Bladen fifteen — half the town in the hands of just three men, who expanded their fortunes by subdividing and leasing their city properties. Annapolis remained a leasehold city until after the Revolution, with craftsmen, shopkeepers, and innholders renting from a few land owners.[19]

To be fair, Bordley and Larkin were not the only men to see advantage in the burned records. John Gresham, alderman and sometime mayor, thought he could pick up the three lots set aside for St. Anne's Parish. The vestry and churchwardens stepped in quickly to obtain legislation confirming the lots to the use of the parish, except for the part on which the prison was built, which was reserved for public use. This prison, a substantial stone structure completed in 1707, was the second in the capital. It sat at the tip of Cathedral and West Streets, just within the city gates.[20]

One might wonder why, if Annapolis was a chartered city with executive, legislative, and judicial bodies of its own, matters such as land ownership were decided by the General Assembly. Anything not specifically authorized by the 1708 Annapolis charter remained under the aegis of the provincial or, later, the state legislature for almost 250 years, until passage of an amendment to the state constitution in 1954.[21] Issues that went before the General Assembly during those years included expansion and annexation, bond issues, property taxes, and revisions to the charter itself.

In 1715, following the Fourth Lord Baltimore's conversion to Protestantism, King George I restored the Calverts' full charter rights to the province of Maryland.[22] The proprietary bureaucracy in Maryland began with the office of governor and worked its way down through a myriad of provincial and county offices to the lowliest clerk in some deputy port collector's office. The top-ranking dozen or so officers — the deputy secretary, attorney general, commissary general, administrators of revenue and the land office, naval officers — received lucrative compensation. Often members of the Calvert family or related kin, the few men at the top also sat on the governor's council and, when the General Assembly was in session, became the Upper House. The Lords Baltimore and their governors meted out these lucrative offices carefully for maximum political and economic gain, and the positions were coveted for their power, profit, and prestige. The top officials and their supporters in the Lower House were referred to in English tradition as the "court" party. Their opponents, more in touch with the electorate, were the "country" party.[23]

With the proprietor back in full control of taxes, fees, and appointed offices of profit, the number of government officials and employees based in Annapolis increased, ushering in an "era of bureaucratic growth and small industrial expansion" in the capital. Government wealth beckoned others looking for opportunity — craftsmen, innholders, shopkeepers. European craftsmen such as saddler Peter Overard, painter Gustavus Hesselius, cooper Conrad Kilin, blacksmith John Mynskie from Prussia, and the shoemaking Woolf family from Germany joined Jacobite prisoners and other British immigrants to the town in the first decades of the eighteenth century. Most of these voluntary immigrants, with the exception of indentured servants, came in family groups, ready to settle permanently in the new country, and all those mentioned by name above requested naturalization.[24]

Annapolis attracted tanners as well as craftsmen working in leather. Thomas Dockwra's tanyard on Dorsey (now College) Creek dated from 1708, and after his death, it was run by Alexander Stewart. Tanning was a labor intensive business and both Dockwra and Stewart had apprentices and indentured servants in their yard. By the 1750s, there were three tanyards in or near the city. Because of the stench, residents may not have found tanning the most desirable industry, but it did provide employment and most of the owners went on to positions of prominence in city affairs.[25]

The few extant accounts of the meetings of city government in the early 1720s are concerned primarily with filling vacancies on the Common Council and preparing for the annual city fairs. Held on May Day and Michaelmas (29 September), as authorized by the charter, fairs brought country folk into town and encouraged commerce and trade. Visitors to the fall fair could also congratulate the new mayor, whose election took place that day. The featured event at both spring and fall fairs was horse racing. Races in September 1721 were held on a quarter-mile course chosen by Mayor Benjamin Tasker and Alderman Vachel Denton. Richard Young, gatekeeper, was responsible for having "a race" weeded. Prior to 1720, the fastest horse won its owner a new saddle, but in that year, the corporation decided to up the ante and offer a twelve-pound silver cup with two handles and cover. The next year, councilman and silversmith Cezar Ghiselin made twelve spoons, valued at £10 current money, to be given as prizes, eight for the winner and four for the second place horse. The city taxed booth holders at the fair and ordinary keepers in town to pay for the trophies.[26]

Other amusements in Annapolis during these first decades of the eighteenth century included the wildly illegal firing of the guns on State House hill to mark the birthday of the "Person Who is commonly called the Pretender." The pretender was James Stuart, Catholic son of the English king, James II, who had lost out to Protestants William and Mary in 1689. Irish servants were the culprits in this case, and Charles Carroll the Settler paid their fines.[27] There were also a number of Scots in town loyal to the Stuart succession, some of whom, like William Cumming and George Neilson, arrived as Jacobite prisoners after the troubles of 1715. Neilson promoted the Red House Club and the Scots Club, which held public celebrations on St. Andrew's Day.[28] Thomas Larkin named his new street adjoining New Town Scots Street.[29]

On Wednesday and Saturday mornings each week the town drummer or the bell at St. Anne's Church summoned townspeople to the market, where they could buy vegetables, meat, poultry, eggs, butter, cheeses, cider, and perishables. After Perry the Postman complained that his view was obscured by the first market on, of course, Market Street, markets were held on the State House hill, at first under the flag pole and then in a market house built for that purpose. By 1728 that location had become inconvenient, and the city fathers persuaded the General Assembly to authorize construction of a larger market on a lot at the bottom of Church (now Main) Street. The customs house originally planned for this large lot had not been built, and the city apparently thought its location near the head of the dock would serve better as a market spot. Within two years, the new "Publick Market House" was in use, although not always peacefully. Apparently some town butchers refused to share the stalls with their county counterparts, and it was necessary for the city corporation to declare formally and forcefully that the market was open to all who came to sell from it, without threat or hindrance, on pain of punishment.[30]

For thirty years or more, wealthy and powerful men in Annapolis had looked down on the town from their establishments along the ridge paralleling Acton Cove, where the High

Street of the 1684 village had become Nicholson's Southeast Street and Duke of Gloucester Street (both are now Duke of Gloucester Street). Charles Carroll the Settler and Amos Garrett faced one another across lower Duke of Gloucester. Thomas Macnemara, one-time mayor and well-known, if controversial, lawyer lived just up the street from them. The Bladen/Tasker household occupied the creek end of Market Street and Thomas Larkin the other. Recorder Wornell Hunt made his home on Shipwright Street until he relocated to the West Indies. Philemon Lloyd, deputy secretary of the province, member of the governor's council, and second husband of the entrepreneurial Margaret Freeman, held court on the old Drummer's Lot, in the triangle at the top of Southeast and Church Streets (now the site of the Maryland Inn).[31]

The move of the market to the head of the dock acknowledged a shift in the focus of the town. By that time, today's dock area had replaced Acton Cove as the center of commerce. Shipbuilding and related crafts, chandleries, and seamen's ordinaries would continue to congregate around the dock, while other commerce lined Church Street above the market house and continued down the first block of West Street. The development of New Town and the town pasture attracted people to land north of the State House, and a good bit of expensive residential construction from 1730 to the Revolution would take place in this part of town. So, by 1730, land use in Annapolis was stratified, in ad hoc zoning, into sections that would endure for centuries to come.

Three bastard sons of three different Lords Baltimore came to be closely involved with Maryland, and Annapolis. The first to arrive was a man named Charles Calvert, who was sent out as governor in 1720. His age, political position, social status, and acceptance by legitimate Calvert contemporaries suggest that his father was the Third Lord Baltimore, although that relationship was not acknowledged officially. The first member of the proprietary family to live in Annapolis, Governor Charles Calvert brought a degree of sophistication to the small town on the Severn. Two years later, he married a Prince George's County heiress, and the two lived both in Annapolis and on her family plantation. Maryland still did not have an official residence for its governor, and we don't know just where Calvert lived during most of his governorship. By the late 1720s he was living in a house on the north side of State Circle of which he assumed ownership in 1728, just after the arrival of his gubernatorial replacement, his "cousin" Benedict Leonard Calvert. It seems that this house was to serve as a Calvert family compound.[32]

If Charles was a quasi-Calvert, Benedict Leonard was the real thing. Younger brother of the Fifth Lord Baltimore, liberally educated at Oxford, product of an extensive European tour, and an acknowledged antiquarian, twenty-six-year-old Benedict Leonard "Ben" Calvert arrived in Maryland with all the advantages and expectations of English gentry. He also arrived reluctantly, as a family duty. Perhaps as a result of the "seasoning," or maybe because of the tuberculosis that eventually killed him, Ben was ill most of the time he lived in Annapolis. His sister worried about him alone in Annapolis, so far from civilization, and wrote: "I had allways a bad Iddea of those parts, but have Now a Worse Since your discription of them Both as to the company and your Station; for Pride & Ignorance which you say are the reighning quallifacations Must as you Observe make it the more Dificult to Support with Decorum the Characters of a private Gentleman & Governour."[33]

Clearly Benedict was not happy here. Writing to his Oxford tutor in March 1729, he complained, "You can not expect from me in this Unpolished part of the Universe any entertainment worthy of your consideration; Antiquities we have none; Learning is scarce known here; our Conversation runs on planting Tobacco and such other improvements of

trade, as neither the Muses inspire, nor Classic Authors treat of."[34] Another of Lord Baltimore's sons, Edward Henry "Ned," and his wife joined Benedict in 1729, but Ned died of tuberculosis a year later and his widow returned to England.[35]

During his stay in Annapolis, Governor Benedict Leonard Calvert did his best to live in the manner to which he had been accustomed and to amuse himself outside the cares of government. He worked on a history of the province and spent some time studying the language and customs of the Indians. He enlarged and may have bricked perhaps a part of the frame house on State Circle, orienting it toward the river, and designed formal gardens that fell gracefully in terraces to East Street. He entertained in genteel fashion both publicly and privately, attempting to demonstrate proper social behavior to the local gentry, who tended to have more wealth than English breeding. To commemorate Queen Caroline's birthday and the arrival of his brother and sister-in-law in February 1729, for instance, Governor Benedict arranged a "very handsome Entertainment at Dinner" for the gentlemen and a ball that evening at the State House. A visit by Pennsylvania governor Patrick Gordon later that year was another occasion for public celebration. But Ben's life in Maryland must have been, for the most part, miserable. Lord Baltimore relieved him as governor in December 1731, appointing Samuel Ogle in his stead. Ogle was shocked by Ben's poor health and the quantity of medicines he took without apparent benefit. Benedict Leonard Calvert left Maryland in the spring of 1732 and died while at sea.[36]

During the early 1720s, the General Assembly passed legislation funding free schools in each county but not King William's School in Annapolis. Scholarly governor Benedict Leonard Calvert opposed county free schools, believing "the Province too young for such a separated Scituation of Studies." He would have preferred public support for two schools, in Annapolis and Oxford, "well provided with Masters" rather than twelve "indifferently suited" in places where there were "no Towns or accommodations for Boarding Students." To this end, his will devised one-third of his assets to King William's School "for the encouragement of learning and education of the youth of this Province, as far as my abilities will permit." By midcentury, Benedict Leonard Calvert's gift of bank stock, valued at £750 sterling, funded an annual salary of more than £37 sterling for the school's master.[37]

Just a few months after learning of his brother Ben's death, Charles Calvert, Fifth Lord Baltimore, set sail for Maryland, accompanied by his wife but leaving at home their baby son, Frederick. They arrived in Maryland in early November 1732 and undoubtedly moved into the Calvert family home on State Circle. The second and last proprietor to visit Maryland during the colonial period, Calvert took control of the province from Governor Samuel Ogle for the duration of his stay. He may have intended to summon the General Assembly that winter, but bitter cold kept Annapolis iced in until March. While they waited for the weather to break, residents of the town "observed here, with all Demonstrations of Joy" and the firing of guns, the birthday of Lady Baltimore, which culminated with a ball for the ladies given by His Lordship.[38] There is no schedule of Lord Baltimore's other activities as he waited for the legislature to assemble, but he must have visited his brother Ned's grave, presumably in St. Anne's churchyard.

Assuring legislators that "the Purpose of My Voyage is to promote the Welfare of this Province," Lord Baltimore presided over one four-week session of the General Assembly in March and April 1733. What he had in mind as well was an assertion of proprietary authority and the reorganization of revenue collection to maximize the gain to his family and his appointed officials. Toward this end, Calvert set a procedure for collecting rents due him on patented lands, established a salary for his governors, and proclaimed a schedule of us-

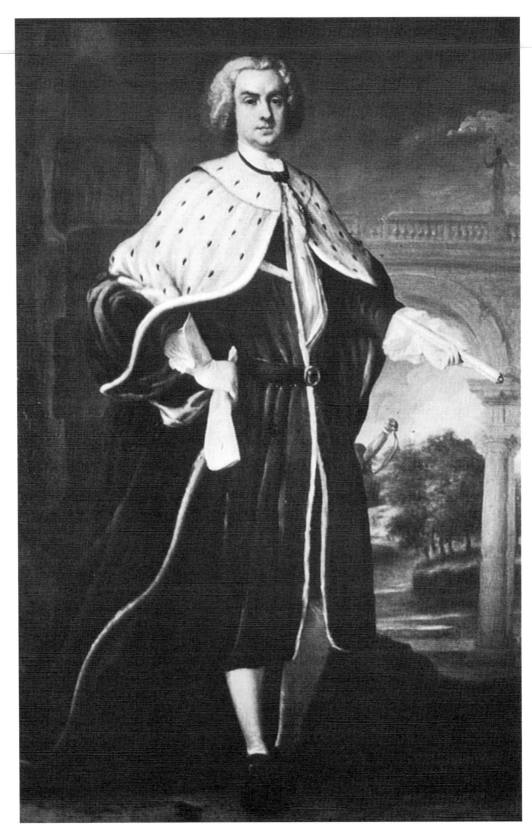

Charles Calvert, Fifth Lord Baltimore and fourth proprietor of Maryland, was the only Lord Baltimore to visit Annapolis. Portrait by Ramsey Allen. Photo courtesy of Enoch Pratt Free Library / State Library Resource Center, Baltimore.

age fees to be paid to proprietary officials.[39] He then returned with Lady Baltimore to England. It seems that Calvert left with a more positive view of the city than might have been expected given the experiences of his younger brothers. Nine years later, he shipped his teenaged natural son, Benedict Calvert, to Annapolis, setting in motion relationships that would link his province to the new state of Maryland and post-Revolutionary America.[40]

During Lord Baltimore's visit the General Assembly appropriated £3,000 to build a suitable house for Maryland's governor. Six months after Lord and Lady Baltimore left for England, provincial attorney general Daniel Dulany filed a suit in the Chancery Court challenging the rights of Bordley and Larkin to their 1718 patent. And thus began Act 2 of "Bordley-Larkin and the Purloined Pasture." Stephen Bordley, then of age and just back in Annapolis after years at school in England, admitted that Lord Baltimore's objective was the "very beautiful hill" left to him by his father, Thomas, but ascribed this desire to nefarious purposes. In a letter to an English relative, Stephen described Baltimore's "Inhuman disposition" and accused him of intending to "settle a precedent to Countenance his future Oppression of his poor Industrious tenants," the property owners of Annapolis. Sensibly, Stephen advised his correspondent to "burn this after perusal."[41]

Whatever the reason, and it's safe to assume from later events that Lord Baltimore really did think the beautiful hill would be a perfect site for his governors' house, Dulany argued the right of the proprietor in words reminiscent of Henry Hill's almost two decades earlier. The hundreds of pages of pleadings, testimony, plats, and documents submitted for the case compose the best, and in many cases the only, record of the pre-1704 history of Annapolis. For that reason, if nothing else, the case is important. After four years, Governor Samuel Ogle, sitting as chancellor, issued a decree that accepted Dulany's version of events and declared the Bordley and Larkin 1718 patent null and void.[42] Stephen had lost his beautiful hill.

Defendants in the case, aside from Thomas Bordley's heirs, were the people who had bought lots in Larkin's subdivision on the Severn. Most of them managed to secure their titles by separate agreements with Lord Baltimore or, for lots within Francis Nicholson's vineyard, with the executor of Nicholson's estate. Even Stephen's stepfather, Edmund Jennings, made a deal with the proprietor for Ariana's two acres and the two adjoining acres he owned in his own name.[43] Act 2 of the drama ends with Stephen exiting the stage in anger and disbelief, a confirmed enemy of the proprietor.

After two decades of residence in Maryland, poet Ebenezer Cooke had changed his mind about Annapolis and did not share Ben Calvert's opinion of the town as an outpost of civilization. Describing the capital city in 1730, Cooke called it

> The famous Beau Metropolis
> of Maryland, of small Renown,
> When Anna first wore England's Crown,
> Is now grown rich and opulent;
> The awful Seat of Government.[44]

At that time, Annapolis boasted a population nearly twice that of two decades earlier. The ratio of white residents to those of African descent had diminished from three to one in 1710 to two to one by 1730, a level that would persist throughout the next 275 years. An

analysis of probate inventories filed for Anne Arundel County decedents indicates that slaveholding came late to Annapolis, compared to the county, with only a few slaves recorded in inventories of city residents prior to 1715. During the next fifteen years, however, a third of the inventories for people living in Annapolis include slaves. This percentage varies from 30 to 50 percent in the decades before the Revolution. It is difficult to determine the numbers of slaves actually living in town because all of the pre-1715 decedents with slaves and most of the later ones also owned land outside the city. Where did their slaves live? It's impossible to tell without more information, but it can be assumed that because of the requirements of tobacco cultivation, most slave owners utilized the majority of their bound labor in fields outside the city. The limited number of slaves kept in town were more likely to be engaged in domestic duties or craftwork. The number of slaves in the county varied by location and time period but probably ran between 30 and 45 percent of the total population before the Revolution.[45]

As was the case in the rest of Anne Arundel County, most immigrant slaves living in Annapolis came from the region of West Africa running south from the Gambia River to what is now Ghana. They did not think of themselves as "African" but as a member of their own particular ethnic group or region, speaking a particular language and adhering to a particular set of customs and rituals. Amalgamating such peoples from different regions and tribes in a new country meant a loss of specific cultural identities but promoted development of a different identity, which may have expressed itself in ways that are only now coming to light.[46]

During the first decades of the eighteenth century, the men, women, and children who arrived by force from Africa, either directly or via the West Indies, were increasingly outnumbered in Annapolis, as in the rest of the Chesapeake, by native-born slaves. Black families in town usually lived in the same houses as white families; Annapolis did not have separate slave quarters. Slaves slept near their work—in kitchen or workroom or stable or nursery—their lives intertwined with those of their masters. When former governor Charles Calvert died in 1734, thirty-one slaves lived at the Calvert compound on State Circle, nineteen of them children. Anthropologist Anne Yentsch suggests that this large number of children might be evidence of "family formation" and "well-being." Slaves could not legally marry, but they did form family units recognized by their owners. In the more densely populated town of Annapolis, where as many as half of the white households might have at least a few slaves, there were more opportunities for alliances between black men and women than out in the country. Skilled slave craftsmen in town could command the same value as prime field hands in the county and might even be hired out by their master to work for someone else. Town slaves generally had greater freedom of movement than their county counterparts. City bylaws prohibiting the harboring and entertaining of slaves are good indications that people were doing just that.[47] On the other hand, should a slave be removed from town, whether to the master's country plantation or to a new owner, the wrench from family and friends was all the more tragic.

The abominable conditions of the Middle Passage to America killed many Africans before they set foot on Maryland soil. Those who survived the trip to the Chesapeake were usually sold from the vessel, which moved from river to creek to landing for the convenience of the purchaser. Annapolitans active in the overseas slave trade included Daniel Dulany the Elder, John Ridout, Benjamin Tasker, Jr., and Daniel of St. Thomas Jenifer. Owners, estate executors, or others offering native-born slaves for sale often chose a popular tavern in Annapolis as the venue. There was no one place specified for the sale of slaves in Annapolis.

Auctions of "A PARCEL" of "healthy Country-born NEGROES," which usually occurred when an owner was in debt or had died, almost always meant that kinship groups would be sundered. Sales of individual native-born slaves often separated spouses or removed older children from their mothers or siblings. Newspaper advertisements for slave sales during the colonial period are about equally divided between groups and individuals.[48]

The difference between life in the county and city shows up statistically in a comparison of the numbers of slaves and servants owned by people who died in the city between 1700 to 1777. In the three wealthy southern hundreds of Anne Arundel County—St. James, All Hallows, and Middleneck—where planters grew tobacco and corn on prime land, roughly 60 percent of probate inventories include slaves whereas just over 20 percent include servants. Even in Westminster Hundred, north of the Severn, where the land was not as good and farms were smaller, planters chose slaves over servants by a wide margin. But in London Town and Annapolis a third of the decedents owned slaves and a third owned servants. This is not to say that these are two separate thirds; overlap was common, with some decedents having more slaves than servants and vice versa. The point here is that servants, especially servants skilled in a craft or trade, were more useful to city freemen than to their county counterparts.[49]

As the slave population increased naturally through childbearing, reducing the need for imports, far more indentured servants than slaves were transported to Maryland during the eighteenth century. During the one period for which there are cargo records for vessels entering Annapolis (1756 to 1775), only 48 carried slaves and of these only 10 came directly from Africa. But during the same period 317 vessels arrived with white laborers from Great Britain and Germany. Of perhaps eighteen thousand laborers imported to Maryland during those years, only slightly more than 10 percent were slaves.[50]

There were three types of bound labor in eighteenth-century Annapolis: indentured servants or redemptioners, convict servants, and apprentices. As had been the case in seventeenth-century Maryland, most servants were indentured. These men, women, and even children believed that life in Maryland would be an improvement over what they experienced or expected at home, yet they could not afford to pay for their trip across the ocean. Instead, investors financed their passage and profited when the immigrants arrived in the colony and bound themselves to someone here who paid the cost specified. The descriptions applied to these immigrants—indentured servants or redemptioners—derived from the particular arrangement made to repay their transportation. The cost of transport might be £10 and the amount paid in Maryland for a skilled artisan could reach £60, making this system beneficial for all concerned—except perhaps for the immigrant who had sold his or her freedom for, usually, four or five years. In the seventeenth and very early eighteenth centuries, indentured servants could expect to do well when their period of servitude ended, if they survived.[51] Lawyers Daniel Dulany, William Cumming, and Thomas Macnemara, for instance, all arrived as servants and all achieved positions of prominence in the city or province. Later in the colonial period, this extreme rise in economic and social status was rare, even for skilled servants.[52]

The other major category of white immigrant servants, especially after Parliament's Transportation Act of 1718, were men, women, and, again, even children who had been convicted of crimes in England and sentenced to seven or fourteen years of labor in the colonies. Persons convicted of any of more than a hundred different crimes, ranging from the theft of two shillings to murder, could face execution. Almost all who were given the alternative opted to take their chances in America. As might be expected, convict servants

tended to be a rougher element than the average indentured immigrant. Although their crime might have been merely petty larceny, they were more likely to cause trouble in their new homes. Worse, they often brought with them disease contracted in the squalid jails of England and spread in the appalling conditions of shipboard life.[53]

A servant's life was often very hard, especially for city-bred men and women who found their new world strange and frightening. Many regretted their choice, even when that choice had kept them alive. Elizabeth Crowder ran away from her mistress, quilter Sarah Monro, forcing Monro to offer forty shillings reward for the return of her valuable business asset. Three Annapolis businessmen pooled their problems in a 1747 advertisement for the return of a shoemaker, a driver, and a baker, all convict servants who had last been seen on the Patapsco Road, heading northwest. John Hesselius lost not only his servant shoemaker but tools and a horse as well. The most extreme example of misery might be the man bound to ship carpenter Samuel Hastings who cut off his hand, reportedly to escape work. As with slaves, servants could be bought or sold or moved around, upsetting whatever social arrangements they might have made. And servants were classed with slaves in city bylaws prohibiting residents from entertaining or harboring them, or serving them liquor at any time. In 1766, a city bylaw prohibited servants and slaves from meeting publicly in groups of more than three.[54]

Meet they did, however, and sometimes in ways that produced children. As was the case with slaves, servants were not allowed to marry. But, while slaves could and did have children who added to the wealth of their owner, servant women who bore offspring obligated themselves, and usually their children, to additional years of service. County courts often intervened in cases of bastardy, requiring someone to assume financial responsibility for the care of the child. When the parents were servants, the child was almost always bound out, often to the owner of the mother, for some period of years. The child of a slave or servant took the mother's status, no matter who the father was; and in Annapolis, as throughout Maryland, children were born of unions between slaves and servants. The mulatto child of a slave woman was deemed a slave, even if the father was a free white man. The mulatto child of a servant woman was legally free even though he or she was placed in service by the court, usually until the age of thirty-one, or later, twenty-one years. Would that child, once an adult, understand that he was free? Would his master then, perhaps the last of several masters since his birth, allow him to exercise that freedom? In only a few cases did the mulatto children of free women sue for freedom and achieve the court's recognition of that status. More commonly, they became essentially enslaved, and should they become mothers, their children were also treated as slaves.[55]

There is no telling how many of these mulattos, free or enslaved, lived in Annapolis, but with the large number of servants (white, black, and mulatto) living in or near households with slaves, it seems likely that the city would shelter more than might be found in the county. Given the combinations of gender, race, and status, a child could be born to one of sixteen possible unions—white servant mother and slave father, mulatto servant mother and free white father, slave mother and mulatto servant father, and so forth—each of which could be treated differently by county courts over time. As the century progressed, color and status became even more complicated. The issue was not in any way black and white.[56]

Annapolis craftsmen (both men and women), tradesmen, and professionals routinely took on youngsters as apprentices. Usually a parent or guardian signed the contract binding the child for a specific period of years and describing the benefits the child would obtain

JUST IMPORTED,
in the Ship NEPTUNE, BENJAMIN DAWSON *Commander*, and to be Sold by the Subscribers on board the said Ship, lying at ANNAPOLIS, on Tuesday the Second Day of June,

A PARCEL of likely healthy CONVICTS, consisting of Men, Women and Boys; among the former of which are some Tradesmen.
STEWART *and* LUX.

THE said LUX has imported in the said Ship, a Variety of *European* and *East-India* GOODS suitable for the Season, to be Sold at his Store at *Elk-Ridge* Landing.

English men, women, and children convicted of crimes ranging from petty larceny to murder could escape death by choosing transportation to the colonies. To pay the cost of their passage, they were sold into servitude, generally for a minimum of seven years but occasionally for fourteen, depending on the severity of their offense. Maryland Gazette, 28 May 1761.

May 25, 1752.

RAN away from the Subscriber, living in *Annapolis*, on the 23d of this Instant May, a Convict Servant Woman, named *Hannah Boyer*, about 23 or 24 Years of Age, pitted much with the Small Pox, has a Scar in one of her Eye Brows, not very tall, but a very strong, fresh coloured, robust, masculine Wench. She had on and took with her, a blue Jacket, an old whitish Cloak, a brown Petticoat, a double Mobb, an Osnabrigs Shift, a small striped check'd Apron, a Plaid Petticoat, and Night Gown, no Shoes nor Stockings; but without doubt will change her Cloathing; she had a Horse Lock and Chain on one of her Legs. Whoever takes up the said Servant, and brings her home, shall have Twenty Shillings Reward, if taken in *Annapolis*; if taken 10 Miles from home, Twenty Shillings Reward, besides what the Law allows, paid by
Daniel Wells.

This advertisement for the capture and return of escaped convict servant Hannah Boyer describes typical clothing and intent, but most runaways did not have a horse lock and chain on their legs. Maryland Gazette, 28 May 1752.

by his or her service: some rudimentary education, room and board at his master's home, training in the "art and mystery" of the craft, and clothes and tools when he was released. Orphans were apprenticed through the county court, boys usually until age twenty-one, girls to sixteen, and the master taking them on was required to post bond and submit to the scrutiny of the justices. Young men apprenticing themselves to the town's lawyers tended to be older and signed their own papers. While not strictly servants, apprentices lived and worked under the supervision of their master. Although they might have more freedom of movement than an indentured servant, their activities were circumscribed by the will and whim of someone else. City fathers lumped apprentices with slaves and servants in restrictions against being entertained, harbored, and sold liquor.[57]

Much of what we know today of servants, slaves, and craftsmen in colonial Annapolis comes from the *Maryland Gazette*, for most of its life a four-page, weekly newspaper. William Parks initiated the paper in 1727 and published it off and on until 1734, but only 57 of his estimated 261 issues survive. It is to Jonas Green and his family that we owe gratitude for reviving the *Maryland Gazette* and, even more important, for archiving the printer's edition of each issue. With only two brief interruptions, in 1765 and during the Revolution, the *Maryland Gazette* ran from 1745 to 1839 under three generations of the Green family. Its importance to historians and interested researchers cannot be overstated. Jonas Green and his successors printed international and national news, most of it culled from other papers. However, they did not hesitate to report interesting news gathered from visitors to town, ship captains recently arrived in the Severn, private letters, and other personal sources. During the eighteenth century, the paper carried the proceedings and laws of the General Assembly, government proclamations, accounts of murders and unusual crimes elsewhere in Maryland, and not as much local news as we'd like. Usually advertisements filled half the paper, and they are as valuable as the news for the information they give us on the conditions and clothing of runaway slaves and servants; the locations of peripatetic tavern keepers, shopkeepers, and craftsmen; the identifying marks of lost horses; owners and fees of stud horses; merchandise imported; sales of personal and real property; the services of visiting specialists such as oculists and dentists — in short, the whole aspect of the times. Ads came in from all over Maryland, from northern Virginia, from southern Pennsylvania. When Baltimore began to develop, its shopkeepers also advertised in the Annapolis paper. Later in the century, as politics came to play a greater role in the lives of average people, the Greens printed exchanges of letters — usually passionate, often erudite — arguing the issues of the day. Read and discussed in State House and tavern, coffeehouse and parlor, the *Maryland Gazette* played an essential role in colonial Annapolis.[58]

The *Maryland Gazette*, under both Parks and Green, also reported the vessels entering and clearing the port of Annapolis. In the decade between 1749 and 1758, for example, port officials recorded an annual average of sixty-six arrivals and seventy-seven departures. Because a captain could enter or clear from any port in Maryland, not every vessel that arrived in Annapolis left from there, and vice versa; there was much travel from river to river within Maryland. For a number of reasons — weather, harvest, convoys — the transatlantic tobacco fleet arrived in spring or early summer and left in late September or October; but smaller vessels sailed in and out of the Severn every week from Virginia or Boston, Philadelphia or North Carolina, Bermuda, Barbados, Antigua, or Nevis. Annapolis did not handle the shipping volume of large American ports such as Boston, New York, and

Annapolis and the *Maryland Gazette*

The *Maryland Gazette* was the first newspaper published in Maryland and the seventh regularly published in the thirteen colonies. It was established in Annapolis in 1727 by William Parks, who had been hired by the Maryland General Assembly as the colony's official public printer, and ran irregularly as a weekly until 1734. Parks relocated to Williamsburg, Virginia, in 1737 and was succeeded as public printer in 1738 by Jonas Green of Philadelphia.

Jonas Green soon became active in Annapolis social and civic affairs, and in 1745 he revived the *Maryland Gazette*. A compilation of laws and official proceedings, the *Gazette*'s pages also contained "the freshest advices foreign and domestic." The weekly served as an important intellectual forum for political debate and a source of news and opinion about civic, military, social, and religious affairs. It also contained poems, essays, treatises, literary criticism, and advertisements of all sorts. From 1758 to 1766, Green was joined in his journalistic endeavors by William Rind (d. 1773), an Annapolis bookseller, librarian, and the first Maryland-born printer. The *Maryland Gazette* was temporarily suspended by Green in 1765 in protest against the Stamp Act. Thereafter, articles in the *Gazette* came to have significant influence on and were a reflection of local political thought concerning evolving ideas on freedom of religion, speech, and the press, which, in turn, helped form the movement for independence.

After Green's death in 1767, the *Gazette* was published by his wife, Anne Catharine Hoof Green, who also served as the public printer until her death in 1775. She was assisted and succeeded by her sons, William, Frederick, and Samuel, and a grandson, Jonas Green. In the Federal period, the newspaper continued to serve as an important source of local, national, and international news. The *Gazette* ceased publication in 1839.

ROBERT L. WORDEN
Library of Congress

Philadelphia, however it was the largest port in Maryland and compared favorably with Norfolk.[59] Collecting fees, fines, and duties, issuing certificates, and checking cargos in Annapolis were the royal deputy customs collector and the proprietary naval officer for the Annapolis district, usually the same man. In the mid-eighteenth century, Benjamin Tasker, Jr., held these lucrative positions, with assistants and clerks to do the paperwork.[60]

Today the word "dock" usually refers to a pier or wharf, but an eighteenth-century dock was the water or basin in which a boat rested while being loaded or unloaded. Once known as Weathering Cove and later as Nicholson's Cove, the Annapolis city dock of the late 1740s extended well into the present Market Space, lapping at the foot of today's Pinkney Street, down which a foul-smelling watery trickle flowed, carrying waste and debris. Marshy shoreline, broken by dirt-ramped landings, stretched below that era's market house across to the south side of the dock and fronted the warehouses of Dr. Charles Carroll and Henry Woodward. Lying in the dock might be small boats hauling goods from ships out in the harbor, sloops ready to ferry man and beast over to Kent Island, and, along the north side, vessels being rigged or repaired. Cutting the air around the dock were the sounds of saw and hammer and caulking mallet, the slap of rigging and creak of wooden hulls, the voices of men in accents Irish, English, and Scots, Prussian and African. Commonplace smells

THE Brigantine *Free-mason*, JOHN McKIRDY, Master, now lying in the Dock at *Annapolis*, is fitting out with all Expedition for Sea, and will, by the Middle of next Month, be ready to proceed to any River on the Weſtern or Eaſtern Shore, where a Certainty can be had of her getting Loaded ſoon. She will carry 350 Hogſheads, and is a prime Sailer. She will take in Tobacco at Seven Pounds Sterling *per* Ton, with Liberty of Conſignment to any Merchant in *London*. Thoſe Gentlemen who have a Mind to take the Advantage of ſo early an Opportunity to Market, are deſired to ſend a Line to the Subſcribers of the Quantity they are willing to Ship, and the Time they can be ready.

(tf) CHARLES WALLACE *&* Company.

of refuse, hemp, fish, and marsh muck were tinged with the exotic scents of foreign lands. Fragrances of imported spices and teas and lemons wafted from dockside warehouses to vie with the rich aroma of Turkish and West Indian coffees from Middleton's tavern and store at the head of the dock. And over all hung the thick redolence of rum from John Inch's ordinary on one side and yeasty scents from John Chalmers's bakery on the other.[61]

Two city-approved lotteries in the 1750s raised money to improve the city dock. Both were well subscribed, but the results were not as satisfactory. No records exist of the actions taken by the managers of the first lottery, in 1753, which also targeted the purchase of a town clock. If the dock was cleaned, as intended, it soon filled up again, since this issue persisted for years, and there is no record of a town clock for another century. The lottery managers were later accused of malfeasance, although the charge was not proved. The managers of the second lottery, in 1758, decided that a wooden wharf around the dock would be adequate. They soon found their timbers honeycombed by "the worm," the dreaded *Teredo navalis* that also ate the hulls of wooden vessels, and ceased construction.[62]

Annapolis attracted craftsmen engaged in maritime trades — carpenters, coopers, caulk-

ers, makers of blocks and pumps, sails and rope — not only because of the activity of the port, but also because in the city they could find financial capital, congenial colleagues, skilled servants, and, perhaps most important, a diverse market. Most marine crafts translated into plantation crafts or household crafts: tobacco prizing required blocks; wells used pumps; rope and twine were as essential to everyday life on land as they were at sea. Even ship's carver Henry Crouch found home-based patrons for his decorative wood sculptures. Successful craftsmen did not depend only on the income from their training and skill. Almost every craftsman who attained some degree of financial security had his hand in other activities.[63]

Many of the craftsmen specializing in marine goods located near the dock, but the city's colonial ropemaking establishments required more land and were situated outside the town. Ashbury Sutton, shipwright as well as ship owner and master, lived in the house now known as the Shiplap House on Pinkney Street but operated a ropewalk on the other side of town, probably on four and a half acres of Bloomsbury Square he leased in 1745 from Daniel Dulany and Charles Carroll. Clerk Thomas Williamson and barber Barton Rodget set up a ropewalk, probably near the head of Dorsey Creek, in the late 1740s, which London Town ropemaker Andrew Thompson and Annapolis cabinetmaker and tavern keeper John Golder acquired a decade later. The Thompson-Golder partnership ended with the ghastly deaths of John Golder, his toddler son, and town constable Francis Keys from eating toadstools in August 1765. Thompson, who seems to have been the only craftsman-owner linked to these ropemaking businesses, then allied himself with Newington Ropewalk, probably the best-financed ropeyard in town. A partnership of merchants James Dick of London Town, Anthony Stewart and Thomas Richardson of Annapolis, and ship captain William Strachan, Newington Ropewalk opened in 1765 with £500 sterling capitalization. This facility may have occupied the same site used by the Williamson-Rodget and Thompson-Golder works, in the neighborhood of today's Taylor Avenue and the headwaters of the creek. Newington Ropewalk produced cordage until about 1775, when demand slowed and the participants became embroiled in the politics of the time. Stewart apparently considered the land his plantation and lost it when the state confiscated Loyalist properties toward the end of the Revolution.[64]

Shipbuilding itself was the most obvious maritime craft practiced in Annapolis, and although this was not the major industry that Governor Francis Nicholson had anticipated, the city's two shipyards did produce a number of vessels for coastal and transatlantic trade. When he planned his capital city, Nicholson set aside land along the northeast side of the cove that bore his name to be used for shipbuilding. First to apply for use of the Ship Carpenter's Lot was shipwright Robert Johnson, to whom the General Assembly granted 120 feet between the south side of Prince George Street and the dock in 1719. This legislation, which required Johnson to carry on the shipwright business and pay an annual rent to the city, might be considered the city's first maritime zoning.[65] Johnson built a couple of houses before he died three years later, but probably did not set up a shipyard. In 1723 the lot was transferred to merchant Robert Gordon, who hired ship carpenter Samuel Hastings to work on the lot. The first vessel that can be identified as built in Annapolis is Hastings's snow *Annapolis Adventure*, launched in December 1730 "to the great Joy and Satisfaction of all the Spectators." Ashbury Sutton bought Gordon's right to the lot in 1742, but shortly thereafter, the city government canceled the maritime zoning for this upper section of the Ship Carpenter's Lot because of the danger of accidents "from Building Breaming or Graveing Ships Sloops Boats and other Vessels" in a section of the city that "had greatly

increased in it's [*sic*] Inhabitants who had good Houses and Improvements." Sutton's son-in-law, Horatio Samuel Middleton, didn't want to build ships anyhow. He took over the upper section of the lot, built a wharf, ran a ferry across the Bay, and expanded his tavern. Middleton's Tavern became a popular gathering place for locals and visitors.[66]

Annapolis entrepreneur Patrick Creagh settled his shipyard on the outer end of the Ship Carpenter's Lot in the mid-1730s and built a tobacco inspection warehouse nearby in the late 1740s. Ignoring the city's rights, he obtained a patent for about two acres along Prince George Street, which he subdivided into eight lots interrupted by Creagh (now Craig) Street. Creagh's was a complex and diverse organization, of which his maritime business was only a part. At his shipyard he employed a variety of marine craftsmen, who turned out at least seven vessels between 1740 and 1753. His largest vessel, the 150-ton ship *Hanbury*, was built by shipwright Sowell Long and launched into the city dock in August 1753. Described by her owner as "staunch, strong, and well fitted," *Hanbury* joined the London tobacco trade the next year.[67]

The largest ship built in Annapolis was not a product of the Ship Carpenter's Lot. Instead, the 400-ton *Rumney & Long*, built in 1746 by ship carpenters Sowell Long and Edward Rumney, slid into the waters of Dorsey Creek from ways located on the cove just downstream from today's St. Anne's Cemetery. Owner of the shipyard and the *Rumney & Long* was William Roberts, "perhaps one of the most financially diversified individuals in Annapolis." Roberts began his multifaceted career as a saddler, bought a tanyard, and then went into shipbuilding. He employed craftsmen, servants, and slaves, and could supply workers in most maritime trades.[68] By 1763 Roberts was importing and selling "European and India" goods, rum by the hogshead, black oakum, and livestock.[69] He lived at the intersection of Church Circle and Northwest Street in Bloomsbury Square, conveniently near his shipyard.[70]

Seventeen vessels can be identified from official records and the *Maryland Gazette* as having been built in Annapolis between 1730 and 1763. They range in size from Ashbury Sutton's eight-ton schooner *Samuel* to the *Rumney & Long*, with the larger snows and ships outnumbering schooners two to one. This seventeen averages out to less than one vessel a year, but other sources suggest that the total should be higher. The Reverend Andrew Burnaby visited Annapolis in 1759 and thought the annual output was two "but seldom more." When Benjamin Mifflin explored the town three years later, he saw five boats under construction. The discrepancy may be explained by the fact that only vessels that sailed outside Maryland waters made it into the port records.[71]

Cargo carried on vessels arriving and clearing at the port of Annapolis varied with the size and destination of the vessels. Sutton's small schooner *Samuel* carried lumber and hemp to Virginia in the spring of 1749 and 1750, for instance. Patrick Creagh's 100-ton ship *Speedwell* set out for London in July 1750, under the command of his son James Creagh, loaded with wheat, tobacco, grain, staves, and planking. The 100-ton snow *Enterprise*, built in Annapolis in 1754, made voyages from Annapolis to both Barbados and Newry, Ireland, in the mid-1750s. On each trip, she left the Chesapeake with flour, bread, herrings, and lumber, returning from Barbados with rum and sugar and from Ireland with European goods, tea, fish, and beef.[72]

Records do not mention the names of crew members, unless something dreadful happened to them, so it is not possible to determine how many city residents manned the Annapolis-built vessels. Ship captains are another matter, and those with close connections to the town included Ashbury Sutton and his son-in-law Horatio Samuel Middleton, Patrick

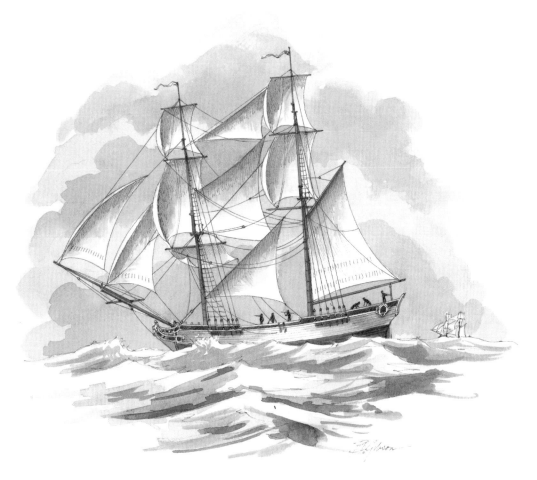

Drawn by a modern artist from contemporary design, this brig is typical of the eighteenth-century sailing vessels—ships, schooners, snows, sloops, and brigs—that brought settlers, servants, slaves, and cargo to Annapolis from other colonies, the Caribbean, Africa, and Europe. Drawing by Barbara Leonard Gibson. Courtesy of John F. Wing.

Creagh's son James, alderman William Cumming's son Alexander, and Robert Bryce, who lived on Northwest Street when he wasn't at sea on the brig *Nancy*.[73]

In addition to his maritime activities on the Ship Carpenter's Lot, Patrick Creagh contracted to build a new jail nearby on Prince George Street. The building was completed in 1739 and seemed at first to be satisfactory. But within a decade the foundation was failing, the floors needed repair, the well was useless, and prisoners had chopped up parts of the interior for firewood. The deplorable physical plant, coupled with the rats and the limited rations supplied by the sheriff—one pint of corn or peas and two pounds of meat per prisoner per week—made the complaints of inmates understandable. When the sheriff decided to give a cash allowance instead of food, prisoners had to cajole passersby to buy meals for them.[74] Thus, we can add to the cacophony flowing from the north side of the dock, the cries and pleas of prisoners, hungry and miserable in their filthy jail.

Patrick Creagh's construction of public buildings in Annapolis was not limited to the prison. He contracted with the provincial government to build an office (now known as the Old Treasury) for the Commissioners of Paper Money on State House hill in 1735 and a brick Powder House, or Magazine, on the former town pasture near the Severn in 1743. His

most visible, celebrated project remains the mansion intended as a residence for provincial governors.[75]

Lord Baltimore's attempt in 1733 to provide an official residence for his governors came to naught under Governor Samuel Ogle. When Ogle's replacement, Thomas Bladen, arrived in Maryland in 1742, the Lower House of the Assembly agreed to reinstitute the project and authorized £4,000 for the purchase of "Four Acres of Land within the Fence of the City of Annapolis" and construction of a "Dwelling House and other Conveniences for the Residence of the Governor of Maryland." Bladen turned to Patrick Creagh, then working on the Powder House, and arranged for 400,000 bricks and 6,000 bushels of lime to be delivered to the hill behind Stephen Bordley's house. Construction of the foundation for this "very fine House" was under way on this "Beautiful Spot" by May of 1744.[76] And so begins the third and final act of "Bordley-Larkin and the Purloined Pasture."

For some reason, Stephen Bordley did not react publicly to the activity on the beautiful hill behind his house until March 1744, when he delivered a letter to Governor Bladen stating his claim of ownership to the land, under his father's will. Bladen said later that he had offered to buy rights to the hill by deed, but Bordley had refused the terms. Instead, Bordley presented his claim to the speaker of the Lower House at the beginning of the next Assembly session in May. Whether encouraged in this nonsense by antiproprietary factions in the Lower House or just determined to create trouble on his own, Stephen affirmed his determination to appeal the Chancery Court verdict and even "to carry the same Home for a final sentence, before his Majesty in Council." Should he win, of course, he would take the house and any other buildings on the property. The Lower House asked Governor Bladen for his opinion on the matter, and Bladen responded with assurances that the Chancery Court decision held firm. Still, he said, he'd be happy to buy Bordley's "insignificant" rights if the house approved.[77]

The situation might have ended there, and today's governors might reside in a magnificent colonial mansion, but Bladen over-reached himself and the Lower House called him on it. Descendant of families prominent on both sides of the Atlantic, product of English schooling, and married to the sister of Lady Baltimore, Thomas Bladen quite logically saw Maryland's governors' house as a statement of political and social power. This was a gentleman of wit who, during the May 1744 legislative session, entertained guests "in the most Elegant way," with the "Choicest Wines" and a dessert of "fine Ice Cream which, with the Strawberries and Milk, eat most Deliciously." Clearly the £4,000 appropriated by the Lower House was not adequate for the building he envisioned, and so, later that session, he asked for £2,000 more. Perhaps he didn't yet understand the dynamics of contention between the country and court parties. Perhaps he wasn't paying attention to the fact that his relationship with the Lower House had deteriorated markedly over issues of Indian treaties, fees, and taxes.[78] The Lower House reacted firmly: It said no. "Tho' the House may not be so ornamental," said the legislators, surely with Bladen's "prudent Management" it could be finished satisfactorily for £4,000.[79]

But it wasn't. Within three years, Bladen's dream house was deteriorating. Bricks (presumably those supplied by Creagh) were "moulter'd and Decayed"; one wall had cracked from top to bottom; construction materials littered the grounds; shingles rotted in the basement; plants grew out of the mortar. The legislature refused to reimburse Creagh and Bladen for moneys expended.[80]

Stephen Bordley did sign a deed in October 1744 extinguishing his rights to the four acres for a token £200, but the transaction was not recorded until 1747, after Bladen had

returned to England and Samuel Ogle was back as governor. That Bladen acknowledged Bordley's claim at all may be taken as refutation of proprietary power, but it's hard to see how that would have been more than a Pyrrhic victory for Bordley. Thus, for Stephen Bordley the long play — thirty-four years long — ended with a whimper. It was Larkin who had the last laugh (offstage). Edmund and Ariana Vanderhayden Frisby Bordley Jennings had built a large brick house on their combined four acres of Larkin's subdivision, looking out over the mouth of Spa Creek to the Bay. When Jennings returned permanently to England in 1753, long after Ariana's death, the new governor, Horatio Sharpe, rented their house. Called the "Capital Mansion house" in 1769 when it was bought by Sharpe's successor, Robert Eden, the Jennings house remained the official residence of Maryland's governors until after the Civil War.[81]

The drama even had an epilogue. Shortly before her death in 1789, Thomas Bordley's by-then-very-elderly daughter, Elizabeth, gave "her" land, once part of the town common, to St. Anne's Parish for a burying ground.[82] Regarded for many years as the municipal cemetery, it became the final resting place for hundreds of city residents from that date to this.

Bladen's unfinished mansion became a tourist attraction. What other colonial capital had a moldering ruin within a block of its state house testifying to the antipathy between its elected legislative body and appointed governor? It was quite the fashion for gentlemen of the time to write accounts of their travels, and it seems that every journal keeper who came to Annapolis in the mid-eighteenth century had something to say about the disaster known as Bladen's Folly. The Reverend Mr. Burnaby described the house in detail, noting rooms and windows and its "beautiful view of the town and environs," but said, "only the shell of the house has been finished, which is now going to ruin." Benjamin Mifflin, visiting in 1762, remarked on the building's nickname "as the Inhabitants Call it" and said it "would have been a Beautiful Edifice" if finished. Military man Lord Adam Gordon, passing through in 1765, complimented the location and lamented the structure's extensive damage from the elements so "as never again to be in a condition, to be repaired or finished." Stopping in Annapolis on his way to Philadelphia the following year, Thomas Jefferson sneered to a friend that the town had "no publick buildings worth mentioning except a governor's house, the hull of which after being nearly finished, they have suffered to go to ruin."[83]

The Lower House dismissed a suggestion by the Upper House in 1751 that the building be fixed up and used for something, saying, "We apprehend the Loss cannot be retrieved, nor the Public benefitted, by being at any further Expense about it."[84] Perhaps the legislators saw the public relations advantages of this demonstration of their power.

Generally, visitors approved of the situation and aspect of the town but didn't think much of its public buildings, considering them "indifferent," "antiquated," or "poor." (Perennial royal colonial administrator Thomas Pownall considered the entire town "poor.") They also described the town's "irregular" plan with limited success.[85] No one seems to have grasped Nicholson's grand design, probably because some of his intended streets were not cut through by midcentury and all were unpaved, rutted, and ill-defined. Plus, roadways on the ground didn't always conform to the plan anyhow. Dr. Charles Carroll created Green Street in 1752 "for the reasonable convenience of others, as well as his own." The outer end of East Street was jogged to accommodate a prominent landowner who didn't want a street through his lot, and the Tasker family's front garden spilled over Market Street and blocked all access to the creek.[86]

Occasionally visitors mentioned the town guns: cannons located at the end of the pen-

insula between the north side of the dock and the cove known as the Governor's Pond. Discharged for ceremonies, celebrations, and other occasions that called for a loud noise, such as the birth of royal or proprietary children, the ten cannon in place during the early decades of the city would have been of little use in time of war. In 1749, Governor Samuel Ogle and his council ordered fifteen "Great Guns" purchased for the town, along with small arms, trumpets, drums and sticks, and "a black and yellow Flag"—Lord Baltimore's colors—for the use of provincial militia. The new cannon, which arrived in 1750 lay useless in the sand until after 1754, even though one of the old guns had split and broken a man's thigh. By the time Reverend Burnaby came through four years later, the new six-pounders had been fixed in a half-moon battery that he called "miserable."[87]

Had French and Indian enemies attacked the city from the west, as "alarming accounts" predicted in November 1755, the guns would have been little help. During the few days that they believed their city to be the target of a band of hostile Indians rampaging east from Western Maryland, Annapolis residents began digging entrenchments, almost certainly across the narrow isthmus between Dorsey and Spa Creeks—the line their great-grandsons would dig just a little more than a hundred years later, in another war. Folks came in from the county to help, and the *Maryland Gazette* reported that "near two thousand resolute Men" would have "gone against the Enemy" had the rumor been true. This scare was the first of many over the next two centuries when nervous Annapolitans assumed their beloved city would be attacked.[88]

Great Britain's Seven Years' War (the French and Indian War in the colonies) had come to Annapolis earlier in 1755 with rumor, increased anti-Catholic bigotry, and visits from worried colonial dignitaries come to confer with Governor Horatio Sharpe, who was for a time commander of British colonial forces.[89] In April, HMS *Centurion*, commanded by Commodore Augustus Keppel, anchored off the harbor, with General Edward Braddock and Virginia's lieutenant governor Robert Dinwiddie aboard. Townspeople probably sailed out to take a close look at the sixty-gun ship *Centurion*, which, a decade before, had been the first ship of the Royal Navy to circumnavigate the globe. After a few days in Annapolis, the men went on to Braddock's headquarters in Alexandria, Virginia. Governors William Shirley of Massachusetts and Robert Hunter Morris of Pennsylvania and New York's lieutenant governor James Delancy came into town a few days later, and Sharpe accompanied them to Alexandria, where the men planned that summer's expeditions against the enemy.[90]

Of more impact on the city than alarming rumors and illustrious visitors was the arrival of several hundred French-speaking Roman Catholic refugees from Nova Scotia, who had been hustled from their homes by British troops and loaded onto vessels headed south. Four of these vessels, carrying some nine hundred men, women, and children, came into the Chesapeake Bay in late November 1755. These were the descendants of families once governed by perennial royal administrator Francis Nicholson, but that seems to have been the only thing they had in common with the majority of Marylanders. Described by Jonas Green as "French (falsely called) Neutrals," the Acadians had refused to fight against their French and Canadian countrymen, even though for more than forty years they had taken oaths required of British citizens. Now, removed from their farms and homes to colonies where few spoke their language, allowed to bring with them only a few possessions, they were poor and miserable. Henry Wadsworth Longfellow's tragic tale of Evangeline rings true in a reading of Maryland's struggle to accommodate its own Acadian refugees.[91]

The four transport vessels arrived in the Annapolis harbor separately in late November and early December 1755. While the unfortunate passengers remained cramped in their shipboard quarters, the city corporation called for residents to donate money and provisions for their care. But, as Jonas Green noted in the *Maryland Gazette* of 4 December, although the townspeople had been "very liberal" in their charity, they could not support "such a Multitude" for much longer. Daniel Dulany, who was collecting money and bread for the ship-bound exiles, wrote on 9 December, they had "almost eat us up." Finally, shortly before 11 December, three vessels of Acadians sailed for the Wicomico, Patuxent, and Choptank Rivers, leaving in the Severn only the *Leopard*, a schooner with about 175 passengers aboard. Had the British allowed Roman Catholics to take in their co-religionists, Charles Carroll of Annapolis believed, they would have been well cared for. As it was, they were thrown on the charity of people and county courts over most of Maryland. Horatio Samuel Middleton and others ferried some of the *Leopard*'s passengers to Baltimore, but twenty-two Acadian families (seventy-nine people) were still living in Annapolis in 1763. Colonial Annapolitan Rebecca Key said years later that they lived on Hanover Street and on Duke of Gloucester in wooden buildings of "ruinous condition" that were destroyed as "a nuisance" before the Revolution.[92]

Carroll did what he could for the Acadians, but when the legislature taxed the land of Maryland Catholics at a rate twice that of Protestants, he considered selling his real property—40,000 acres of land and thirty Annapolis lots—and leaving the province permanently. A 1758 list of "reputed Papists" in Anne Arundel County subject to the double tax named only Charles Carroll, James Creagh, and Patrick Creagh.[93]

Less romanticized than the Acadians' travail but of greater temporary impact on the townspeople of Annapolis was the presence of five companies of the Second Battalion of Royal Americans. Anyone who has wondered why the Third Amendment to the U.S. Constitution was so important to post-Revolutionary Americans might consider Maryland's capital city in the winter of 1757–1758, when five hundred red-coated soldiers came to town. City fathers had known for some time that Annapolis, along with other Maryland towns, would be required to house British troops, but when they discovered that their allotment amounted to five companies, the mayor, recorder, and aldermen petitioned the General Assembly, then in session, for assistance. The Lower House suggested a measly £200. Could their attitude have been affected by the fact that Annapolis Mayor Benjamin Tasker was also president of the Upper House? Were the delegates, yet again embroiled in disagreements with the governor and his party, influenced by the number of Annapolis residents who held lucrative provincial offices? Governor Sharpe thought so. "The Burgesses were not displeased at seeing them distressed, especially as they themselves were thereby exempted from bearing the least share of the Burthen," he wrote.[94]

The soldiers arrived in town shortly before the first of December 1757, and it wasn't long before they were no happier in their new quarters than the citizens who had taken them in. The city corporation appealed to Governor Sharpe directly. There were, they said, only "about Eighty Familys" in town "and some of them hardly able to Support themselves" much less accommodate troops. They begged Sharpe to ask the overall command to have some of these men "Quartered elsewhere in this Province, whereby the expense Allowing this Duty May be more Diffused," and the troops better provided for, "more to their Convenience and Satisfaction." Sharpe sent the city's request up the line, noting that the number of town families "are far short of a hundred" and agreeing that some of them could not

"provide Lodging Fire & necessaries for 15 or 20 men each." Perhaps, he suggested, their commander could "quarter them on the [Gentleman] that resides at a small Distance from Annapolis & can easily accommodate them."[95]

A relatively new component of the British army, the Second Battalion of the 60th (Royal American) Regiment of Foot was made up of Germans recruited in Pennsylvania and a mix of German-speaking and Irish mercenaries. The commander, a thirty-nine-year-old Swiss-born colonel named Frederick Haldimand, made his headquarters in Annapolis. Colonel Haldimand spoke fluent French but little English. Fortunately city residents Ann Rivers and William Clajon taught French — and local shopkeepers and craftsmen had been practicing their French for two years on the Acadians.[96]

After a stay of almost four months, most of the men "who took up their Winter Quarters here" left for Philadelphia, shortly before 23 March 1758, with the rest "soon to follow." There is little information on the activities of the troops in Annapolis, but when he reached Philadelphia, Colonel Haldimand wrote a nice thank you (in French) to Governor Sharpe asking him to "give my respects to the beautiful widow and to the other ladies with my obedience to the gentlemen" to whom he was indebted "for their kindness." So, it seems that he enjoyed Annapolis hospitality. The widow is almost certainly Anne Tasker Ogle, daughter of Benjamin Tasker and much younger wife of the by-then-deceased former Governor Samuel Ogle, whose reputation as a town beauty was remarked on by others over the years.[97]

Given that the population of the town in 1755 was less than a thousand, of whom fewer than six hundred fifty were white, and some significant number of those were women, children, and indentured servants or apprentices, the estimated eighty to a hundred householders was probably not far off the mark. The burden of five hundred soldiers on the town is almost beyond imagination. Later, seventy-five townspeople applied to the government for reimbursements. The highest bill, for £164.10.0, came from the executors of Philip Hammond, an Anne Arundel County delegate who died in 1760. Hammond owned Richard Acton's land on Todd's (now Spa) Creek, adjoining the town. It seems certain that Hammond was the gentleman mentioned by Governor Sharpe and that Colonel Haldimand did move at least a portion of his men to Acton, where they had ample room to pitch their tents and still be close to the amenities of town.[98]

Other large accounts were presented by innkeeper Horatio Samuel Middleton and craftsmen–tavern keepers James Chalmers, William Reynolds, John Inch, and John Golder. On the list for reimbursements are eight members of the Common Council, five aldermen, the mayor, the recorder, both Annapolis delegates to the legislature, and two of the four Anne Arundel County delegates, both of whom lived in town. Widows, shopkeepers, merchants, carpenters, smiths, butcher, shoemaker — rich (Charles Carroll of Annapolis, who billed for £25.12.6) or poor — free householders of the city had supported the troops out of their own pockets to a total of more than £1,800. It is not clear that they were reimbursed beyond the £200 allotted by the legislature.[99]

Had the Royal Americans come to Annapolis the preceding winter, of 1756–1757, they almost certainly would not have stayed, because that winter the city suffered an epidemic of smallpox that lasted from December through May. Scourge of ages, smallpox was no respecter of wealth, rank, or education. Both Barbara Janssen Bladen, wife of Governor Thomas Bladen, and Dr. Alexander Hamilton bore its scars. And, like all infectious diseases that confer immunity to their survivors, it preyed on the young and unexposed. Jonas Green, Jr., fifteen-month-old son of Anne Catharine and Jonas Green, died of smallpox

the day after Christmas 1756, and his father had to assure readers of the *Maryland Gazette* that the press and paper were "always kept at a good Distance from the Rooms where that Distemper was." William Sligh, the young man recently elected city clerk, died in March, leaving a widow and infant child. The General Assembly moved to Baltimore Town for its April–May 1757 session, and finally, in late May, the city corporation passed a bylaw restricting travel into the town.[100]

Whenever they surfaced, rumors of smallpox spread quickly, and town businesses suffered if people feared to leave their country homes. Usually the *Maryland Gazette* sought to reassure patrons that there was no cause to boycott the town. But sometimes the rumors were true, as in 1765, when Annapolis experienced the worst smallpox epidemic of the colonial era. In that case, the newspaper kept readers apprised of the progress of the disease, usually more optimistically than might have been warranted, from its first victim in February to the last declaration that the "Town is clear of smallpox" in September. The weather was unusually cold that winter, and ice blocking Annapolis's and other harbors might have staved off the disease for a time, but by mid-March smallpox ran rampant over most of Maryland.[101]

At this point, the city government jumped on inoculation, instead of quarantine, as the solution to its epidemic. Town doctors agreed to inoculate everyone who requested it, and the city appropriated money to cover the cost for poor patients. Jonas Green wrote a rare editorial encouraging inoculation by citing statistics from Boston's epidemic the previous year. There, only 1 of the 116 inoculated persons died from the disease compared to one death in five for those who eschewed the procedure. To encourage participation in the experiment, the corporation passed a bylaw allowing residents to shelter strangers who came to Annapolis to "receive the Benefit and Advantage of Inoculation, before the Second of April."[102]

Inoculations may have reduced the impact of the disease in some households, but not everyone took advantage of this method of prevention, probably because it was not without danger. In order for the procedure to be successful, the patient had to suffer a light case of the virus during which he or she was contagious and in need of nursing. Some died; some infected others. Anne Denton, widow of alderman and delegate Vachel Denton, died of smallpox at the house of her brother, John Brice, on Prince George Street in July 1765. Perhaps she refused inoculation because John's mother-in-law, Ariana Vanderhayden Frisby Bordley Jennings, had died of the procedure in London in 1741. Inoculated or not, judges of the Provincial and Prerogative Courts did not meet in Annapolis during the epidemic, and the town's economy lagged.[103]

Catastrophic though it might be to local families, smallpox was not the constant worry that fire was. Fires could spread quickly through a town built mostly of wood. An overfired chimney, hot coals dropped onto a carpenter's debris, candles knocked over or placed too close to fabric, any of a hundred mishaps could start a conflagration with disastrous results. The memory of the State House fire of 1704 must have been ever-present in the minds of old-timers. The General Assembly addressed the issue of fire control in public buildings in the 1720s and purchased leather buckets and a hand-pumped fire engine. The city corporation's way of preventing fire was to fine the householders and landlords who allowed soot or other deposits in chimneys to catch fire or did not provide the required two (1754) or three (1766) buckets and one ladder per house. But the large number of people fined 40 shillings by the Mayor's Court for chimney fires suggests that it was a miracle the town didn't suffer more fires than it did.[104]

A potential disaster was averted in 1754 when the house and shop of blockmaker Thomas Fleming, at the Sign of the Top-Sail Sheet Block near the dock, went up in flames. Fortunately calm weather and alert citizens saved the neighborhood, which was "very thick built." It may have been this narrow escape that prompted townspeople to put up the money to order a fire engine from London. On 8 May 1755, the *Maryland Gazette* announced proudly, "This Day was landed here . . . for the Use of this City, a very fine Engine (made by Newsham and Ragg, No. 1800). . . . It will throw Water 156 Feet perpendicular." Not surprisingly, the engine attracted a number of men anxious to see to its maintenance, and in 1757 the corporation divided these volunteers into three groups — the city's first fire companies — headed respectively by Jonas Green, Lancelot Jacques, and Richard Maccubbin. The companies were later assigned responsibility for specific areas of the city named Western, Middle, and Northern Divisions.[105]

The engine was called into service on a cold, windy evening in 1764 for a chimney fire in the house on State Circle where Governor Benedict Leonard Calvert had once lived. Described by Jonas Green as "high, old, and built of wood," the house caught in several places, but the engine and "the extraordinary Vigilance and Activity" of residents extinguished the fire before it could spread to buildings at the upper end of the dock.[106]

Disease and fire were only two of the dangers to citizens that roused a sense of responsibility from their municipal government. When a child narrowly escaped death after being attacked by a dog in 1753, the city corporation passed a bylaw that the *Maryland Gazette* hoped would "soon lessen the Number of those fierce and dangerous Animals in Town" now "so numerous and troublesome" to people in the streets at night. Although the newspaper doesn't spell out the bylaw, it was probably similar to one passed several years later imposing a tax of 5 shillings on male dogs and 10 shillings on female dogs. Residents were to register their dogs, and the gatekeeper was instructed to make an annual dog census. The fine for not registering an animal was 40 shillings, half of which went to the city and half to the informant. Nonetheless "large and fierce Dogs" continued to run free, and subsequent bylaws required them to be confined. Cows and horses kept in town were also taxed and, along with sheep, hogs, and geese, had to be housed in some sort of enclosure. Most eighteenth-century Annapolis households had a horse, cow, and either sheep or pig.[107]

The corporation's fire prevention and animal control methods — fines after the fact — extended to most other behaviors it wished to curtail: letting filth lie on the street, selling rum to prohibited imbibers, "blowing" meat (injecting air under the skin of meat to make it look plump or fat), buying wood without having it corded, driving a cart without five inches of tread to prevent ruts, throwing ballast in the dock, and so forth. Fines were supposed to be a deterrent and, incidentally, fed city coffers. Rewarding the informer for reporting infractions of the law was common in city bylaws during this and the next century, but the city government's repeated attempts to control the dangers and nuisances disturbing townspeople suggest that neither the incentive nor the fines really worked.[108]

As had been the case in the first half of the century, the location of the city market followed development of the town. By midcentury, having the market house at the head of the dock was no longer convenient and the operation moved back to State House hill. In 1752, bids went out for the city's fourth market house, a structure forty by twenty feet, with a brick floor, three doors six feet wide by eight feet high along each side and end, and a loft

with windows. Red-painted weatherboarding provided a cheery appearance, and cypress shingles covered the roof and the small bell turret. The building sat on the north side of the public circle, facing Maryland Avenue.[109]

One of the reasons why the dock-oriented market had become "of very little use" probably had to do with increasing development in the western part of town. Promoting this development was the vestry of St. Anne's Church, made up of savvy men, such as Dr. Charles Carroll and Philip Hammond, who were anxious to ensure that the parish would benefit from the town's growth. In 1742 the General Assembly allowed the vestry to grant twenty-one-year leases on the three original town lots set aside as glebe land, for the support of the parish. The lots were vacant at that point, and the vestry found that potential tenants were unwilling to build and improve a lot with such a short commitment. A change in the law five years later allowed leases of sixty-three years renewable for another twenty-one years "or three Lives," which proved more popular. Hatter William Reynolds took the first lease on Lot 60 and half of Lot 61, from what is now Franklin Street around Church Circle and about halfway down West Street, and built his shop and tavern on the circle. Shoemaker Thomas King leased the other half of Lot 61, down to the city gates.[110]

Within a decade or two a multilayered network of leases, subleases, sub-subleases, and informal tenancy arrangements on the glebe land produced a busy streetscape boasting taverns, craftsmen, small shops, and residences. And, as the south side of West Street grew, fee-simple owners subdivided and improved lots on the north side. Short-term leases attracted craftsmen to small houses where they could keep a shop, and often a tavern, on the first floor and live with their family upstairs. Among the attractions of West Street was William Rind's bookstore and lending library, the latter being the first secular lending library in the colonies, which although short-lived, drew in "the wits and the literary." Catering to travelers arriving by land, John Golder's Sign of the Waggon & Horses announced his cabinetmaking shop and tavern near the town gates until his sad run-in with the toadstools. Across the street, curious passersby, looking over the fence next to William Faris's clockmaking shop and tavern at the Sign of the Crown and Dial, might be rewarded with a springtime glimpse of Faris's elaborate flower beds and tulips by the thousands in every hue and style. In the 1760s, cordwainer Allen Quynn acquired large sections of the Stoddert lots on both sides of West Street and parlayed them by subdivision and lease into the base for his rise in wealth and position over the next forty years. Mariner Robert Bryce, tailor Alexander Ferguson, and shopkeepers William Currie and Henry Merony all rented from Quynn in the 1760s.[111]

Visitors to the town arriving by land, like Benjamin Mifflin in 1762, passed "under an Old Frame Building to which is Fixt a Swing Gate to Keep the Cattle out of the Town." Just outside the gate on land set aside for the commons, north of West Street, was the fairground where throughout the colonial period, horse races were held during the spring and fall fairs for ever-increasing purses. In fact, while in the 1720s the city had encouraged horse racing as a sideline incentive to fair attendance, within a few decades the races had eclipsed the fair. The *Maryland Gazette* usually carried announcements and reports of the seasonal races, but there was little or no mention of the fair. By the 1740s, the Jockey Club had taken control of the races; its members set the rules and awards. Said to be a mile in length, the racecourse by midcentury was probably an oval marked by poles and protected by a fence when not in use. Races were often run in three heats, with a half-hour break between each heat. Horses were not the only creatures to compete on the track. On at least

Annapolis craftsman John Inch made this silver bowl as the prize for a horse race in May 1743. Grand prizes such as this encouraged owners of fine horses to compete in events at the race ground, just outside the city gates at West and Calvert Streets. Courtesy of the Baltimore Museum of Art, gift of Sarah Steuart Hartshorne and Alice Key Montell, BMA 1936.45. Photograph by Mitro Hood.

one occasion, in the 1750s, two young girls ran the course. The Jockey Club offered "A fine smock" as the prize, but the *Maryland Gazette* noted that the victor, Jenny Parker, "had a good deal of Money given her beside."[112]

The probate inventories of roughly half of all the men and women who died in Annapolis during the colonial period listed at least one horse, but few people owned the sort of fast-running horse that could win a Jockey Club race, and only the wealthiest invested in Thoroughbreds. Thoroughbred racing probably began in Annapolis with Governor Samuel Ogle's bay gelding Spark, who won a 50-guinea match race against Colonel George Plater's horse at the fall fair in 1747. Ogle had returned to Maryland from England that summer to replace Governor Thomas Bladen and brought with him Spark, a gift of Lord Baltimore, and the mare Queen Mab, who had been bred at Hampton Court. A few years later, Ogle's brother-in-law, Benjamin Tasker, Jr., shipped to Maryland the famous mare Selima, sired by the Godolphin Arabian, whose blood flows even today in the veins of treasured Thoroughbreds. Horses with fine pedigrees also were raced in Annapolis during the 1750s and '60s by Henry Woodward, Daniel Wolstenholme, Samuel Galloway, Benedict Calvert, and Horatio Sharpe.[113]

It might take wealth and determination to breed and run racehorses, but most freemen could enjoy the thrill of the race, and maybe bet a little cash on the outcome. As Annapolis grew and prospered in the second half of the eighteenth century, with an increasing middling class of craftsmen and tavern owners, shopkeepers and government employees, more of its residents had time and money for amusements. Filling a cultural gap was the traveling Company of Comedians, who brought theater to the capital city for the first time in June 1752 with a performance of *The Beggar's Opera*. Under the direction of Walter Murray and Thomas Kean, the players' repertoire included nine full-length plays and six short farces or

after-pieces by well-known playwrights William Shakespeare, Henry Fielding, and David Garrick. Their theater was probably a vacant warehouse somewhere in town, with a pit (7 shillings, 6 pence), boxes (10 shillings), and within a few weeks by popular demand, a gallery (5 shillings). At a time when a semiskilled workman might make 5 shillings a day, an evening at the theater would be a stretch but not impossible. And attendance must have been high, because the players stayed until mid-August, before leaving for Upper Marlborough, and then returned for the fall race week and again for a week in December.[114]

There followed a theatrical hiatus of almost eight years until the American Company of Comedians, directed by Lewis Hallam, Jr., and David Douglass, showed up in March 1760. Over the next two months, the company gave twenty-eight performances, including productions of *Richard III*, *Romeo and Juliet*, and *Othello*, featuring Mrs. Douglass, the "acknowledged star of the American stage" of that period. This time, the company played in a building erected for the purpose on Acton Cove near the end of Charles Street. It was not convenient, and it seems that no matter how enthusiastic the audiences, the Hallam-Douglass company didn't put the town on its A list. It was another nine years before they returned.[115]

The orchestral accompaniment for the 1752 performance of *The Beggar's Opera* was probably provided by musicians of the Tuesday Club of Annapolis. Inspired by Scottish expatriate and local physician Alexander Hamilton in 1745, the Tuesday Club gave men of wit an outlet for their talents and companionship in their curiosity. Members crossed social and economic lines, celebrating intellect above riches, although many of the regulars and visitors had both. The gentlemen met in members' homes or, occasionally, in the

Colonel Benjamin Tasker's imported Thoroughbred mare Selima won high-stake races in Annapolis and Virginia in 1752 before being retired for breeding. Her bloodline descends to modern American Thoroughbreds. Detail from "Selima at Belair Mansion," a modern interpretation by William Wilson. Courtesy of Maryland Racing Art.

The Second grand. Anniversary Procession.

Townspeople watch as members of the Tuesday Club, wearing their club medals around their necks, parade through Annapolis in the "Second grand anniversary Procession" of the club on 15 May 1750. This drawing of the event by club founder and historian Dr. Alexander Hamilton shows the second Annapolis State House in the background. Courtesy of the John Work Garrett Library, Sheridan Libraries, Johns Hopkins University.

tavern of Horatio Samuel Middleton, who attended meetings of the club. Interesting visitors to Annapolis often were invited to share their stories and expertise with the members. Among them was Ebenezer Kinnersley, in town in 1749 to thrill locals with his experiments with "the newly discovered ELECTRICAL FIRE." For a few shillings townspeople could see electricity kill small animals and fire guns. "A representation of the seven Planets, shewing a probable Cause of their keeping at a Distance" was also popular. Some of Kinnersley's experiments were duplicates of Benjamin Franklin's, and when Franklin himself came to town five years later, he, too, was invited to a Tuesday Club meeting. Hamilton kept minutes of the meetings and wrote an apocryphal history, all of which, along with Hamilton's correspondence, survive. As a result, the club has received much attention by modern historians and is generally felt to have made an important contribution to culture in Annapolis.[116]

Other gentlemen's clubs of the period not so well documented were the Ugly Club, which preceded the Tuesday Club and whose members included Hamilton, and the Lunatick Club, which met only at the full moon. A Masonic lodge met in Annapolis from at least 1749, when thirty brothers gathered for ceremonies on St. John's Day. Similar festivities were held at Brother Middleton's tavern in the 1760s. Local Masons also included Daniel Dulany, Edward Dorsey, Samuel Galloway, and silversmith John Inch, who was given a Masonic funeral in 1763.[117] Six serious "young Gentlemen" formed the Forensic Club in 1759, which had as its purpose "the Improvement and Advancement of their Knowledge." At five-hour bimonthly meetings, with supper and "generous libations of wine and rum," members debated issues of mutual interest, primarily "politics, morality, and natural law." Among the charter members were printer and bookseller William Rind, law clerk William Paca, and staymaker Charles Wallace.[118] Clubs tended to appeal to an exclusive society, but men of all ranks could entertain themselves at billiards or backgammon, cards or dice in local taverns.[119]

While the men were convivial over pipes and bowls of punch, the ladies of mid-eighteenth-century Annapolis enjoyed a more private society. Music was important to the well-bred lady, and local girls learned to play the harpsichord or spinet, or perhaps the metal-stringed "English" guitar. After St. Anne's installed an organ in 1761, singing teachers focused on psalmody, and women may have sung in a choir at the church for a brief time. Such public display would have been unusual for the period, because aside from dancing at balls, women exhibited their talents only at home. Card games — whist was popular — helped pass the time, and fancy needlework could occupy hands during an exchange of news and gossip. Genteel ladies advertised their skills as teachers of needlework and other accomplishments, French for instance, proper for young girls.[120]

Free men and women who lacked leisure time and disposable income had fewer opportunities for recreation, but they could enjoy the public celebrations of notable occasions. Servants, apprentices, and sometimes even slaves whose masters allowed such pleasantries came out as well. Usually the town guns were fired and there was punch (an alcoholic punch) for the "populace." At the event marking the close of the Assembly in July 1747,

Working Women in Eighteenth-Century Annapolis

Throughout the colonial period, women worked for pay or operated businesses separate from their domestic duties. *Maryland Gazette* advertisements illustrate the wide range of women's work in the mid-eighteenth century: "Wanted: A Sober careful Woman, to take charge of a Family as a Housekeeper . . . "; "Any young Woman, disengaged, that is willing to wait on a Gentlewoman in her Passage to Great Britain . . . "; "A Woman that understands the Business of a Cook . . . "; " . . . Performs all sorts of Quilting, in the best Manner, and at the most reasonable Rates"

There were many reasons why colonial women took on gainful employment in addition to their household work. For some it was an absolute necessity, to help support a family or to maintain one after a husband's death. Others assisted in the family's business. Indentured women who did not marry when their service was completed needed employment of some kind to provide for themselves.

Women of the "lower sort" often found employment centered around needlework and housekeeping, skills taught to most girls and for which there was both demand and little overhead expense. Middling women frequently operated taverns in their homes. Elizabeth Marriott ran the popular tavern, The Sign of the Ship, at the corner of Southeast and Charles Streets, during and after her two marriages; Jane Inch continued both her husband's tavern and his silversmithing business near the dock after his death. Women with the necessary funds and skills taught dancing, singing, or fancy needlework, or sold specialty goods—coffee, chocolate, and raisins—from home. As a port town, Annapolis undoubtedly had its share of women working in brothels, but the only public reference to one occurs in the history of the Tuesday Club, which identified Ann Burman as a woman who "heaps up Gains, By joining gentle nymphs and amorous swains."

Annapolis is unique for having two women, Dinah Nuthead Devoran Oley Asa and Anne Catharine Hoof Green, who ran colonial printing establishments. Both businesses had been started by the husband, but the widow continued the work. Although Dinah moved her press to Annapolis shortly after it became the capital of Maryland and received a provincial license to print, no imprints can be directly attributed to her. Anne Catharine took over both the position of public printer and publication of the *Maryland Gazette* when her husband, Jonas, died, and she worked at both jobs until her own death.

HEATHER E. ERSTS
Historic Annapolis Foundation

the people "made loud Acclamations of Joy," although it is unclear from the *Maryland Gazette* account whether the joy resulted from the end of the Assembly or the distribution of punch. The twenty-first birthday of Frederick Calvert, Sixth Lord Baltimore, in 1753, called for "a Hogshead of Punch given to the Populace" as well as a bonfire near the dock, many toasts, and a ball that evening. Similar festivities marked his next birthday, when not only was there a bonfire on the common, but "the Town was beautifully illuminated" with candles in every window. In an age of fearsome black nights, bonfires and, especially, illuminations impressed eighteenth-century observers in much the way that major fireworks displays do today, only more so. Children stayed up late and townspeople dared to venture

out onto city streets brightened by the miracle of light. Illuminations also marked popular political events, diverse though they might be: the crown's victory in the Jacobite Rebellion in 1746 and the repeal of the royal Stamp Act twenty years later.[121]

Annapolitans loved to dance. From governors to servants and slaves, jigs to cotillions, dancing was a popular social activity. Public balls seemed to be a standard feature of city festivities, and Jonas Green invariably commented on the "splendid Appearance of Ladies," and a "great Number of Gentlemen." Eighteenth-century dance was not improvised; it required instruction and practice. Thirteen dancing and singing teachers advertised in the *Maryland Gazette* in the 1750s and 1760s. Both middling and gentry classes attended the public balls, although only the elite danced the rigorously formal minuet.[122] Most public balls and official gatherings were held in the Council Chamber on State House hill. Also referred to as the Armory, Council House, and Conference Chamber, this multipurpose structure was built in 1718 to house the provincial arms and to serve as the meeting place for the council and a reception area for visiting dignitaries. Hundreds of muskets, carbines, pistols, swords, pikes, and daggers were mounted on the walls, and one local resident remembered that the "wooden gilt chandelier depended from the vaulted roof and the lights interspersed among the arms gave it on ball nights a very splendid appearance."[123]

By the early 1760s, with an increasing number of residents able to indulge in social diversions, the city decided it needed a new, larger building for public amusements. A group of twelve men, headed by Benedict Calvert and John Ridout and including county residents as well as city ones, announced a lottery in April 1763 to raise $2,400 to erect "a commodious Building in the City of Annapolis, for the Accommodating of Company at BALLS, CONCERTS, etc." The drawing was held a year later and plans were ready by August 1764. Benjamin Tasker sold part of the lot on the north side of Southeast Street (now Duke of Gloucester Street) once designated by Francis Nicholson for the city market to Governor Horatio Sharpe and his successors in office for the "Use of the Public Ball House or Assembly Room thereon to be Built." The ballroom was completed by March 1768 when Tasker sold the rest of the market house lot to Lord Baltimore, who by that time had built a proprietary office there. Described by William Eddis as of "elegant" construction, the new single-story, brick building had a large room for dancing and smaller rooms at either end with card tables, allowing the gamers to play "without having their attention diverted by the sound of fiddles and the evolutions of youthful performers."[124]

As the century progressed, Annapolitans craved lasting representation of themselves and their loved ones. Those who traveled to England could have an established artist paint their portrait, but until midcentury, there were few such options for stay-at-homes. The first portraitist who may have visited Annapolis was Justus Engelhardt Kühn, who worked in Maryland from about 1708 until his death in 1717. His subjects included Daniel Dulany the Elder and both Charles Carroll, Settler and Charles Carroll of Annapolis.[125] The second itinerant artist to come through town was former resident Gustavus Hesselius, who had settled permanently in Philadelphia in the late 1720s. Hesselius is credited with a portrait of Thomas Bordley. An Annapolis exhibition of paintings by British artist John Wollaston in 1753 moved a "Dr. T. T." to rhapsodize, in the *Maryland Gazette*, upon that painter's talent. Wollaston painted portraits for the Carroll, Calvert, Bordley, and Dulany families of Annapolis before moving on.[126]

Artist John Hesselius (1728–1778), son of Gustavus, may have visited the city briefly in 1751 on his way to and from commissions in Virginia, but it wasn't until a decade later that he stayed long enough to be included in the parish tax on bachelors and to make friends

Son of one of the city's wealthiest landowners, Charles Carroll of Annapolis was painted with his pet deer by Justus Englehardt Kühn, c. 1712. Courtesy of the Maryland Historical Society.

amongst the townspeople. One of those friends, Mary Young Woodward, widow of Henry Woodward, became his wife in 1763. John lived with Mary and her four daughters on the Woodward plantation, Primrose Hill, at the head of Spa Creek. Although now a gentleman planter, and eventually father of seven children of his own, Hesselius continued to travel to paint subjects in Maryland and Virginia. He died at Primrose Hill in 1778.[127]

Only a small percentage of people could afford to grace their homes with family por-

traits; a slightly larger number could invest in maps or landscape paintings. Fourteen percent of Annapolis residents who died before 1775 had art on their walls; six of them had portraits. Owners of art were, predictably, men such as Thomas Bordley, Daniel Dulany the Elder, and Judge John Brice. An exception was innkeeper Horatio Samuel Middleton, whose customers could gaze upon maps and landscapes while they drank. By way of comparison, only three percent of Anne Arundel County residents died in the same period with art in their inventories, and most of them owned maps.[128]

In the political microcosm that was Annapolis in the mid-1760s, young leaders practiced their skills on principles that a decade later would propel their country toward revolution. The issues in Annapolis were twofold: first, a challenge to the city's entrenched government and second, the local version of a much wider protest. Each fed upon the other, with, as far as can be determined, many of the same participants. Each had two distinct camps, and each resulted in victory for a constituency that formerly had had little power.

The challenge to the municipal government began with the showmanship that characterized the politics of this new era. According to Rebecca Key, who was a child at the time, Thomas Jennings, Samuel Chase, and some young law students of a "frolicsome character" stood in the State House one day admiring a portrait of Queen Anne that showed her holding the city charter granted under her auspices in 1708. As they read the charter, said Mrs. Key, these budding attorneys realized that "it was violated in almost every particular by those in authority." Wags that they were, they placed a copy of the charter in a "neat little walnut wood coffin" with a "witty epitaph stating its death and burial" and called in townspeople to view their prank. Mrs. Key's recollection overlooked the fact that as prosecutor for the Mayor's Court, Samuel Chase had a very good sense of the workings of the city corporation. He didn't need to read the charter in Queen Anne's hand, even had that been possible, to decide that city officials had become careless of the charter's purpose and procedure, and he intended to do something about it.[129]

"Frolicsome character" and theatrics aside, Chase and his associates had a valid argument. A check of city officials in those few years for which there are corporation records indicates that, beginning with Governor Seymour's appointees in 1708, officers of the municipal government tended to be men connected by family, employment, or political leanings to the proprietary, or court, party. They were generally men of privilege, accustomed to power. Most of the aldermen served in the legislature, some as members of the Upper House, and many sat on the vestry of St. Anne's Parish. Even common councilmen were more likely than most citizens to hold offices of profit under the provincial government. There appears to have been little turnover in the first half-century of city government; once elected to office, a common councilman might remain in place for years or move up to alderman, from which position he could serve a year as mayor from time to time.[130] These entrenched officials had little incentive to address the concerns of the residents. Mayor's Court grand juries in 1759, 1760, and 1761 complained about blocked and rutted streets, the dilapidated city fence, and debris in the city dock, but the city government took no action.[131]

In September 1764, Mayor John Ross, Recorder Daniel Dulany, and five of the six aldermen—Walter Dulany, Stephen Bordley, Michael Macnemara, George Steuart, Benjamin Tasker, Sr., and John Brice—held proprietary offices of profit. Of the nine common councilmen who can be identified from the sparse records, two, Upton Scott, and Benedict

Calvert, had proprietary connections. Councilmen William Roberts, Lancelot Jacques, Thomas Hyde, and Nicholas Maccubbin were successful businessmen. Only printer Jonas Green and staymaker-turned-merchant Charles Wallace might have been considered more in touch with the artisans and small shopkeepers of the town.[132]

Determined to shake up the status quo and advance his own career, attorney Samuel Chase almost certainly joined forces with nascent property developer Allen Quynn to control two important elections in the fall of 1764. Both men had ability and ambition and were willing to do what was necessary to realize their expectations. In an October election to fill two vacancies on the Common Council, Quynn and innkeeper Horatio Samuel Middleton ran for the positions and won. The next month, Chase challenged court-party incumbents George Steuart and Walter Dulany for one of the two seats from Annapolis to the Lower House in an election that introduced an era of very public politics. Not to say that elections in the city had not been raucous before. When Alexander Hamilton had run for the Common Council in 1743, the polls had to be closed because "the partisans went to Cudgelling and breaking of heads." Several years later, a man was killed in a tavern brawl following a county election. The election in November 1764 may not have caused physical harm, but it did set a record for political threats and public demonstrations. Saddler and sign painter Charles Willson Peale described what happened: "At this hard-contested election every engine was employed that each party could supply. The court dependents of office were threatened to be put out if they voted for Chase. On the other hand, banners were displayed to designate the freedom of tradesmen, and parades of this nature were made through all the streets with the friends of Chase at the head of them." Peale's support for Chase enraged his court party creditors and he was forced to flee the province to avoid suits for debts he couldn't pay. Also supporting Chase over Steuart were Charles Carroll, Barrister, John Beale Bordley, and even the other candidate, Walter Dulany, but it was the small tradesmen and artisans who determined the outcome. If every voter cast the allowed two ballots, the results imply that 140 qualified freemen went to the polls. Dulany received 132 votes, Chase 88. Steuart came in third with 59 votes and lost his seat. Steuart never again ran for the Lower House.[133]

In February 1765, following the death of Alderman Stephen Bordley and the move of common councilman Benedict Calvert to his plantation in Prince George's County, the remaining members of the corporation raised Upton Scott from the Common Council to alderman. City voters returned to the polls and filled the two vacant seats on the council with blacksmith Isaac Harris and tailor John Campbell. Common councilman Jonas Green took the unusual step of printing the names of all city officers in the *Maryland Gazette* issue for 14 February.[134] But there was little time for the four new councilmen to bask in victory.

News of a new tax imposed on colonists by Parliament arrived in the spring of 1765 and pushed city government issues into the background. Born of the British government's desire to make its American colonies pay for their protection, both in the recently concluded French and Indian War and in any future conflicts along their borders, the Sugar Tax of 1764 and the Stamp Act of 1765 were the first direct taxes levied on the colonists. Americans in general were not pleased. Marylanders were especially disturbed because they believed that their provincial charter protected them from royal taxation. Realizing that the additional cost of stamped paper could well jeopardize his newspaper's survival, that it "must soon Droop and Expire," Jonas Green immediately began to campaign against the tax, which was scheduled to take effect 1 November 1765. Along with reports on the smallpox epidemic over the next four months, the *Gazette* carried whatever news Green

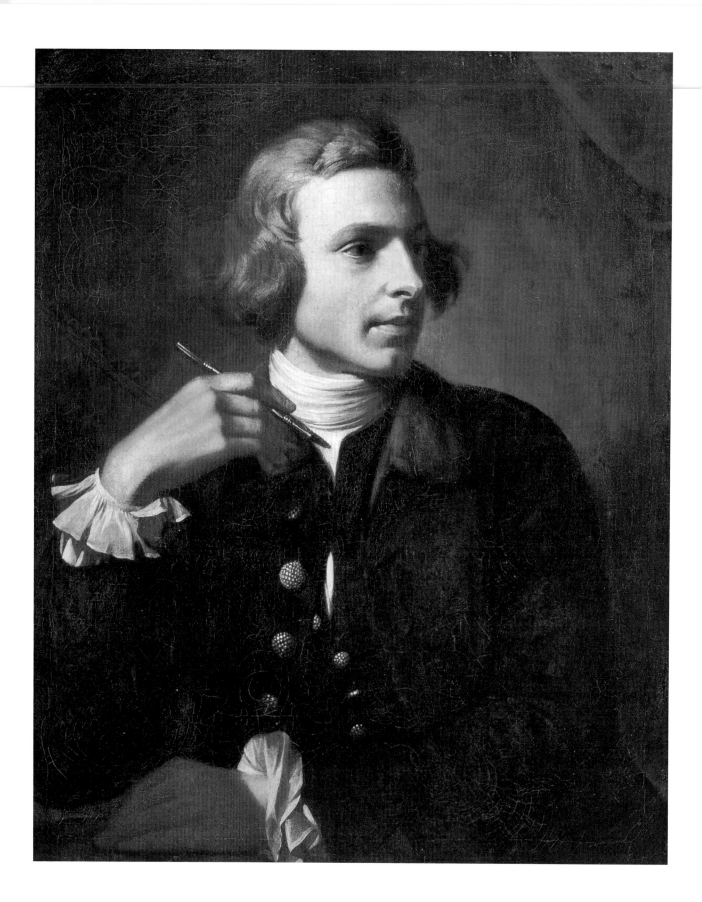

could pick from England and other colonies on reactions to the Stamp Act. By the time Maryland's stamp distributor, Zachariah Hood, arrived in Annapolis in August 1765, locals were primed to act.[135]

Hood, a Maryland merchant, just happened to be in London when the Stamp Act was passed and lobbied for the distributor's position, figuring it would be profitable. Viewed as a traitor by his countrymen, he quickly learned there would be little profit in this job. In fact, there might be worse consequences. On 26 August, a "considerable Number of People, ASSERTORS of BRITISH-AMERICAN-PRIVILEGES," in the words of the *Maryland Gazette*, gathered in Annapolis to express their opinion of Hood and his office. They made an effigy of the distributor and paraded it through the streets in a small cart, "the Bell at the same Time Tolling a solemn Knell." The procession ended on the State House hill, where the effigy was placed in the Pillory and then hung from a "Gibbet there Erected for that Purpose." The perpetrators "then set Fire to a Tar-barrel underneath, and Burnt it, till it fell into the Barrel."[136]

Burning an effigy was a relatively minor demonstration — Stamp Act protesters in other cities were doing the same thing — but the next Monday, 2 September, the situation became more serious. That night "a Number of People unknown, assembled in this Town, and pulled down a House lately Rented by a certain unwelcome Officer." Green's sparse account of the violence may reflect his awareness that his months of propaganda might bear some responsibility for the mob's actions. He certainly downplayed what Governor Horatio Sharpe described as the "three or four hundred" men involved; a "Populace," Sharpe said, "who are really not to be restrained on this Occasion without Military Force." The damage they did was extensive. The frame house, at the lower end of Church (now Main) Street, held on long-term lease by Ann Burman Gaither, "was torn to Pieces." Hood had leased the front room on the first floor and hired carpenter Wright Mills to fit it out as a store. Mills lost tools, materials, and work already done. (A year after the event, the General Assembly allowed Gaither £100 and Mills £13.7.3 in compensation.) Refusing Governor Sharpe's offer of shelter, the terrified Hood left promptly for New York.[137]

Two days later a British warship, the sloop *Hornet*, entered the Annapolis harbor, and a few men went aboard to see if she carried stamped paper. They spoke with an officer, a Lieutenant Mewbray, who refused to answer their questions. Later, when Mewbray and a couple of passengers made the unfortunate decision to have dinner at a local tavern, someone entered the room wearing a hat to which was attached a paper reading, "No Stamp Act." Mewbray ordered his armed crew to remove the man and guard the door. After much drinking, a fight broke out between one of the *Hornet*'s passengers and county delegate John Hammond. Roused by cries in the street, a number of local men got involved. Mewbray was wounded, and the passenger who had fought with Hammond had to swim to the safety of the *Hornet*.[138] These events of September 1765 were probably the first occurrences of politically motivated mob violence in Annapolis history. They would not be the last.

As the Stamp Act controversy continued into the fall, it became clearer that the protesters fell into two distinct camps: one of action, the other of reason. The mob had acted, and their violence persuaded Sharpe that when the stamped paper arrived, it could not be landed. The side of reason expressed itself in a call for the General Assembly to meet in late September and send representatives to the Stamp Act Congress in New York. At the September session, the Lower House adopted eight resolutions asserting the rights of Marylanders as British citizens and stating their opinion that only the legally elected representatives of the freemen of the province could impose a tax upon its inhabitants. A

(opposite)
With financial support from John Beale Bordley and other local men who saw promise in his talent, Charles Willson Peale studied art with Benjamin West in London for more than two years. West painted this portrait of Peale during his stay, 1767 to 1769. Collection of the New York Historical Society, 1867.293.

few weeks later, Samuel Chase's antithesis, Daniel Dulany, published a "lively," "powerful," and closely reasoned argument against Parliament's right to impose taxes on the colonists. Basically what he said, although unfortunately he didn't quite get the phrase out, was no taxation without representation. To achieve this goal, Dulany advocated "continual, but orderly, protest and economic pressure on England." Relying on colonial manufactures, not imported goods, would, he believed, make the point with the English people. Dulany's *Considerations on the Propriety of Imposing Taxes in the British Colonies, For the Purpose of Raising a Revenue, by Act of Parliament* circulated quickly to great acclaim throughout the colonies and Britain, where his words were picked up by William Pitt, the elder, and Lord Camden in their speeches before Parliament successfully opposing the Stamp Act.[139]

Business in Maryland ceased abruptly on 1 November, and courts closed in all counties except Frederick. Jonas Green could not have printed his newspaper on stamped paper even had he so desired. There wasn't any. Fearing the consequences, Governor Sharpe refused to allow the stamped paper to be landed, and in late January 1766, His Majesty's Sloop *Hawke* lay off Annapolis with the stamped "Vellum, Parchment, paper, etc." still on board. But by that time the ports of Annapolis and Oxford were operating as usual — without stamped paper. In Baltimore, the newly formed Sons of Liberty called for the opening of all provincial offices and enlisted William Paca and Samuel Chase to form a similar group in Annapolis and meet with officials in the capital. The Sons were cautioned by the reasoning men to be patient, but as Charles Carroll of Carrollton remarked to an English correspondent, "The clamour of the people out of doors proceeds from their ignorance, prejudice and passion; it is very difficult to get the better of these by reasoning." And so meetings were held, officials were intimidated, and, on 1 April, judges and clerks of the land office and provincewide courts capitulated. Four days later news of Parliament's repeal of the Stamp Act reached Annapolis and "the Afternoon was spent in Mirth; and all Loyal and Patriotic Toasts were Drank."[140]

The number of men who asserted their rights as freemen by parading and voting for Samuel Chase in November 1764 and then participated in the Stamp Act mobs or the local Sons of Liberty cannot be proved today. By his own account, Chase helped burn the Hood effigy and "openly disputed the Parliamentary Right to Tax the Colonies." He did not admit to tearing down Ann Gaither's house, but even if he did not participate directly, his vehement advocacy of the general protest could not have been missed by the men who did.[141]

In March 1766, at the same time that the Sons of Liberty were plotting their actions against proprietary officials in Annapolis (who included John Brice, chief justice of the Provincial Court; Dr. George Steuart, judge of the Land Office; and Daniel Dulany, deputy secretary of Maryland), a grand jury of the Mayor's Court published in the *Maryland Gazette* its "Remonstrance" to Mayor Walter Dulany, brother of Secretary Dulany, and the city aldermen, among whom were the same John Brice and George Steuart. The grand jury accused city officials of the "frequent Abuse of the Charter," echoing Jennings and Chase in the Queen Anne portrait caper. Their complaints were "essentially a civic protest against a regime which had grown lazy and careless, if not downright abusive, in carrying out the responsibilities of representative government laid down in the 1708 charter." Aldermen didn't come to meetings, said the jury; the Mayor's Court didn't sit regularly and when it did its justice was uneven; people had taken over public landings, and Market Street was "entirely stopped up" by Alderman Tasker's front lawn; the dock was filling up with waste; and, by the way, where was the lottery money raised to build wharves? Most vexing was the fact that bylaws had been amended to the point that "Inhabitants of this City offend

The *MARYLAND* GAZETTE,

EXPIRING:

In uncertain Hopes of a Refurrection to LIFE again.

[XXIᵗ Year.] Thursday, *October* 10, 1765. [Nᵒ. 1066.]

WE are forry, heartily forry, to acquaint the Public in general, and our good Cuftomers in particular, That this GAZETTE will not any longer be Publifhed [for fome Time] for Reafons already given, which cannot but be known. It is true, it might have liv'd Three more Weeks, before that Dooms=Day, the dreadful Firft of *November*; but as this Week's Paper [℞°. 1066,] compleats the Year with all our old Cuftomers, as well as finifhes the Seven Years PARTNERSHIP in it, between the *PRINTERS*, and that Difmal Day being near at Hand, it ceafes Now.

☞ A Paper by Way of Poft-script, Supplement, or Appendix, to this GAZETTE, is defign'd to be Printed each Week, (without any Charge to the Cuftomers, in order to Publifh fome Advertifements, &c. &c.) until the above Time.

BOSTON, *September* 23.

IN Capt. Hulme from London, is come about 14 Boxes of ftamped Paper, defigned for the Ufe of this Province, New-Hampfhire, and Rhode-Ifland; —— thofe for Connecticut 'tis faid were to be forwarded in a Veffel bound to New-York. Capt. Hulme was guarded in by the Jamaica Sloop of War and Gafpee Cutter, and now remains at Anchor in King Road under their Protection: 'Tis faid thofe deteftable Stamps are to be lodged at the Caftle, and there to remain till further Orders from Home, there being at prefent no Demand here for fuch a fuperfluous Commodity.

On a Motion made and feconded, it was unanimoufly Voted, That the Hon. James Otis, Efq; the Moderator, the Hon. Samuel Welles, Efq; the Honourable Harrifon Gray, Efq; the Honourable Royall Tyler, Efq; Jofhua Henfhaw, Efq; John Rowe, Efq; and Mr. Samuel Adams, be a Committee to draw up and tranfmit, by the firft Opportunity, to the Right Honourable General CONWAY, now one of his Majefty's Principal Secretaries of State, and to Colonel ISAAC BARRE, a Member of Parliament, feveral Addreffes, humbly expreffing the fincere Thanks of this Metropolis of His Majefty's ancient and loyal Province of the Maffachufetts-Bay; for their noble, generous, and truly patriotic Speeches, at the laft Seffion of Parliament, in Favour of the Colonies, their Rights and Privileges: And that correct Copies of the fame be defired, that they may be depofited among our moft precious Archives. Alfo voted, That thofe Gentlemens Pictures, as

foon as they can be obtained, be placed in Faneuil-Hall, as a ftanding Monument, to all Pofterity, of the Virtue and Juftice of our Benefactors, and a lafting Proof of our Gratitude.

Atteft. WILLIAM COOPER, Town Clerk.

It is reported that Sir GEORGE SAVILLE, Sir WILLIAM BAKER, and fome others, Members of Parliament, fpoke in Favour of the Colonies as well as General CONWAY and Mr. BARRE, but it is only the Speeches of the latter Gentlemen that have as yet been feen in Print.

The happy Profpect of the great PITT's being again, under His Majefty, at the Head of Affairs, affords the ftrongeft Hopes, that the Grievances, which the Nation and her Colonies are under, will be redreffed, and that the Liberties of America will be reftored. It is the Opinion however of fome, that we ought to rejoice with Caution, for until the Eyes of the People at Home can be cleared from the Duft which has of late been thrown into them, the Stamp-Act, fo truly fhocking to the Colonies, will remain a Favourite with them. A Repeal of the Act is not certainly to be depended upon, therefore every prudent, juftifiable Expedient in our Power, muft ftill be ufed, to bring on, if poffible, fo neceffary an Event.

NEWPORT, *September* 23.

A Gentleman of Veracity and Knowledge in England writes, that he is affured, from undoubted Authority, that the new Miniftry are determined to be very favourable to the Colonies, in particular with Regard to the Extenfion of their Commerce.

HARTFORD, *September* 23.

Laft Wednefday Afternoon, a large Company of able-bodied Men came to Town (on Horfe-back) from the Eaftern Parts of this Government, and informed thofe who were willing to join them, that they were on their Way to New-Haven, to demand of the Stamp Officer of this Colony to refign his Office, that a Number of their Companions, were gone on the lower Roads, and that they had all agreed to rendezvous at Branford, the next Day [Thurfday] and that they fhould tarry in Town that Night; they then difperfed to different Parts of the Town for Lodging. In the Evening, Advice was received, that Mr. Ingerfoll was on the Road to this Place, that he would be in Town the next Day, and that he intended to apply to the Affembly for their Protection; and it being conjectured, that he might come to Town in the Night, to fhun the Mob (who he had heard were on their Way to pay him a Vifit) it was agreed that a Watch fhould patrole the Streets all Night, to prevent his coming in unnoticed, but they made no Difcoveries. On Thurfday Morning, the whole Body, including a confiderable Number from this Town, fet off, on their intended Expedition, and in about an Hour met Mr. Ingerfoll, at the lower End of Weatherfield, and let him know their Bufinefs; he at firft refufed to comply, but it was infifted upon, that he fhould refign his Office of Stamp-Mafter, fo difagreeable to his Countrymen; after many Propofals, he delivered the Refignation mentioned below, which he read himfelf in the Hearing of the whole Company; he was then defired to pronounce the Words, LIBERTY AND PROPERTY, three Times, which having done, the whole Body gave three Huzzas; Mr. Ingerfoll then went into a Tavern, and dined with feveral of the Company: After Dinner the Company told Mr. Ingerfoll, as he was bound to Hartford, they would efcort him there, which

they did, to the Number of a moft Five Hundred Perfons on Horfeback. After they arrived in Town, Mr. Ingerfoll again read his Refignation in Public, when three Huzzas more were given, and the whole Company immediately difperfed without making the leaft Difturbance.

Mr. Ingerfoll's (alias *Negrofoul's*) Refignation.

 Weatherfield, September 19, 1765.

I DO hereby Promife, that I will never receive any Stamp'd Papers, which may arrive from Europe, in Confequence of an Act lately paffed in the Parliament of Great-Britain, nor officiate in any Manner as Stamp-Mafter, or Diftributor of Stamps, within this Colony of Connecticut, either directly or indirectly. And

I do hereby notify the Inhabitants of this his Majefty's Colony of Connecticut, (notwithftanding the faid Office or Truft has been committed to me) not to apply to me, ever after, for any fuch ftamped Papers, hereby declaring, that I do refign faid Office, and execute thefe Prefents of my own free Will and Accord, without any Equivocation, or mental Refervation.

In Witnefs whereof I have hereunto fet my Hand. J. INGERSOLL.

PHILADELPHIA, *October* 3.

We hear that the STAMP'D PAPER for this Province is arrived in Capt. Holland, who lies at New Caftle under the Protection of one of his Majefty's Sloops of War. It is impoffible to conceive the Confternation this melancholy News has diffufed thro' this City——Rage, Refentment and Grief, appeared painted in every Countenance, and the mournful Language of *one and all* our Inhabitants feems to be FAREWELL! FAREWELL LIBERTY!——*AMERICA, AMERICA!* Doomed by a premature Sentence to SLAVERY! ——Was it thy Loyalty——Thy Filial Obedience——Thy Exhaufted Treafures——and the Rivers of Blood fhed by Thy Sons, in extending the GLORY OF THE *BRITISH* ARMS, provoked Thy Mother-Country thus UNJUSTLY to involve Thee in Diftrefs, by Tearing from Thee, the Darling Privileges of Thy Children?——Or, was it the Perfidy?——But I cannot proceed ——Tears of Vexation and Sorrow Stop my Pen! —Oh! MY COUNTRY, MY COUNTRY!——

At a Meeting of the Lawyers at the Supreme Court, held at Perth-Amboy, on the 20th ult. like true born Sons of Liberty, and Lovers of their Country, the Chief Juftice having propofed the following *Queries*, agreed and came into the under mentioned *Refolves*, which will always redound to their Honour.

Firft. Whether if the Stamps fhould arrive, and be placed at the City of Burlington, by or after the firft of November, they would, as Practitioners, agree to purchafe them, or any of them, for the neceffary Proceedings in the Law?

Refolved, by the whole Body N. C. they would not, but rather fuffer their private Intereft, to give Way to the Public Good, protefting at the fame Time againft all indecent or riotous Behaviour, which they will Difcountenance, by every Means in their Power, to preferve Order, and by an abfolute Refufal to make Ufe of the Stamps, and other quiet Methods, endeavour to obtain a Repeal of the Law.

The fatal STAMP!

Second.

THE
BYE-LAWS
OF THE CITY OF
ANNAPOLIS
IN
MARYLAND

TO WHICH IS PREFIXED THE

CHARTER of the said CITY

GRANTED BY HER LATE MAJESTY

QUEEN ANNE

In the Year of our LORD 1708

ALSO

THREE ACTS OF ASSEMBLY

Passed in 1708 1718 and 1725

Published by Order of the CORPORATION

ANNAPOLIS
Printed by ANNE CATHARINE GREEN.

more through Ignorance than Design"; the city clerk had the only copy of the bylaws. Not egregious complaints, but then again, it wasn't the first time they'd been made. Municipal officials had heard them from grand juries in 1759, 1760, and 1761.[142]

This time, the Mayor's Court had tried to avoid the grand jury's protest by adjourning before it could be presented to them. Made public in the *Gazette*, the "Remonstrance" touched off an argument in the newspaper that pitted certain grand jury members, including recently elected common councilmen Allen Quynn and John Campbell, against the mayor and four aldermen: Steuart, Brice, Upton Scott, and Michael Macnemara. Aldermen Benjamin Tasker, Sr., who hadn't exercised his city responsibilities in years, and John Ross, then nearing the end of his life, did not take part in the public dispute, nor did five of the thirteen grand jurors. In the four exchanges that followed, the aldermen tended to attack the logic and form of the remonstrance; the jurors pressed the financial malfeasance issue. The aldermen, and probably everyone in town, knew that the man who was composing the jurors' texts was Samuel Chase — a fact he admitted with pride. John Brice and Daniel Wolstenholme, who had managed funds from the dock lottery and believed they had been libeled by the jurors, made separate replies, explaining why wharves at the end of Northeast Street and around the dock had not been built. The rhetoric was pretty civilized until the officials lost their collective tempers in June and attacked Chase directly, mocking him with scornful sarcasm and calling him a "highly restless incendiary — a Ring leader of Mobs — a foul-mouth'd and inflaming Son of Discord and Faction — a common Disturber of the public Tranquility." Chase's response was an over-the-top, far too personal attack on the aldermen, accusing them of incompetence, avarice, drunkenness, desertion of children, and, in the case of Macnemara, partaking in the pleasures of "Harlots Embraces." When Green quite rightly refused to touch it, Chase found a printer somewhere and published it as a handbill. The public argument stopped abruptly.[143]

In the end, a citizenry made aware of their rights and freedoms did effect improvement in their municipal government. During the year following the grand jury's remonstrance, the personnel of the corporation changed dramatically. Deaths or resignations removed five of Lord Baltimore's ruling circle. Only Lancelot Jacques represented the proprietor's interests when he and Jonas Green, Charles Wallace, and William Roberts moved up to aldermanic positions. Country party leader John Hall became recorder. Newcomers to the Common Council included the men who had started it all: William Paca, Thomas Jennings, and Samuel Chase himself, as well as Richard Tootell and John Bullen, Jr., whose politics were less definite. Among the newcomers, only Walter Dulany's young half-brother Lloyd was a confirmed court party man. Thus, by 1767 the balance of power had shifted from the establishment to a new breed of men who had little or no involvement in Lord Baltimore's circle. Showing more concern than their predecessors for the common good, new councilmen revised the bylaws, deleting those the townspeople found harsh — the tax on female dogs, for instance, and the prohibition against selling rum to any freeman except householders (a really big issue) — and passed some new ones. They doubled the fines for not showing up at the Mayor's Court, and, with a bow to Samuel Chase, still in office, they granted an annual salary for the city prosecutor. Most important, they authorized Anne Catharine Green, Jonas's widow and successor, to print the charter and bylaws of the city, making them available to everyone.[144]

Annapolis and the Nation 1764 to 1790

The years between the French and Indian War and the American Revolution have been called the golden age of Annapolis, a lustrous time of richness and promise, the fulfillment of New World dreams. In this city gleamed the culmination of art and craft, of entertainment and society, of genteel education applied to gracious living — and all made evident in mansions and mercantile establishments and public buildings unique to Maryland's capital. It was the persistence of so much of that physical environment into the twentieth century that elevated the city and its late-colonial image to the status of golden, though the term itself was not used at the time.[1] An immigrant letter writer mentioned the "polished society," the large number of "fashionable and handsome women," the "several modern edifices which make a good appearance."[2] It was, said a newly arrived Anglican minister in 1770, "[t]he genteelist town in North America, and many of its inhabitants were highly respectable, as to station, fortune, and education. I hardly know a town in England so desirable to live in as Annapolis then was."[3]

That one brief moment in the long history of Annapolis did glisten with exuberant expectations, expectations that, when realized, resulted in an exciting upward spiral of opportunity for many residents, be they craftsmen or tavern keepers, lawyers or public officeholders, merchants or tradesmen. The spiral began with the construction of several large and important homes by young men who had married well or whose fathers had accumulated wealth. Money placed in circulation by the building boom benefited the craftsmen, suppliers, and laborers directly involved, and they in turn spent their wages in local taverns and shops. With a thriving economy, Annapolis became a magnet for all sorts of outsiders — purveyors of entertainment, artisans offering luxury items or services, and immigrants willing to sell years of their lives for the chance to rise in status and wealth. It was a heady time.[4]

Setting the stage for this expansion of residential construction was Upton Scott, Governor Horatio Sharpe's physician and a provincial official, who began his Georgian-styled house on Shipwright Street in 1762. An Irishman born in the mid-1720s and married to the daughter of John Ross, another provincial official and owner of Belvoir plantation just up the Severn River from Annapolis, Scott was an establishment figure.[5] Following in his footsteps were men who had come of age just before or during the French and Indian War and, by war's end, were ready to marry and build homes in their chosen city. John Ridout was, like Scott, a man of the proprietor's establishment, who immigrated as secretary to Governor Sharpe and continued to hold provincial offices under his successor. The rest — William Paca, Charles Carroll of Carrollton, John Brice, Matthias Hammond, and Samuel Chase — would lead the revolutionary movement in Maryland. John Brice's younger brother James was the anomaly of the group; the foundation and plans for his

mansion were the dying gift of his father, and James completed the house while still in his twenties and unmarried.[6]

The brief economic depression following the French and Indian War seems not to have affected the construction plans of William Paca and John Ridout, both of whom married women with substantial fortunes. Nor did it impinge upon the expansion of the Carroll family home on Spa Creek by the young Charles Carroll of Carrollton, whose father's wealth outdid all others in the province. The sons of Judge John Brice also benefited from family wealth, as did Matthias Hammond. Of these young men, born between 1732 and 1746, three had had some schooling in Europe. Ridout, the only immigrant in the group, was an Oxford man. Carrollton had spent most of his childhood years in foreign schools and returned to Maryland with the sophisticated tastes of a well-educated gentleman. John Brice had studied more briefly in England, preparing for a career in law.[7] William Paca, a native of Harford County, attended the Philadelphia Academy and graduated with a Bachelor of Arts degree from the College of Philadelphia.[8] The other three — Matthias Hammond, James Brice, and Samuel Chase — were schooled less formally in Maryland.[9]

Only Samuel Chase began marriage, career, and house with no family wealth and no conjugal dowry. And only Chase was forced to give up his dream house for lack of money to complete it. Two years into the project, Chase sold the shell of his impressive, three-story town house to Edward Lloyd IV, scion of a prominent Eastern Shore family and great-great-grandson of the first Edward Lloyd of Providence. Lloyd finished the house in magnificent style.[10]

His own home completed in 1765, John Ridout turned to a new project in the early 1770s: a three-unit, three-story row house just down the street, unique for its period. The center, slightly larger residence he planned for his mother-in-law, Anne Tasker Ogle. Ridout managed to complete his ambitious building before the war, but at least two other builders were not as fortunate. To the west of the Ridout compound, up Duke of Gloucester Street, John Griffith, son of an Anne Arundel County planter, began a mid-sized brick town house facing Conduit Street. Griffith died in 1774, before it was finished, devising the house and lot to his ten-year-old nephew. And, on Charles Street, Somerset County legislator William Adams, confident in a future that didn't deserve it, began a fashionable town house on three lots. The house must have been habitable during the war, because continental troops occupied it during the Revolution. However, when he rented it to Annapolis merchant Thomas Brooke Hodgkin in 1786, Adams specified in detail the work he expected on the grounds and house, some rooms of which were "impaired."[11]

These grand houses were not the only substantial brick residences built or modified in and around Annapolis before the Revolution. Perhaps not so well known today, but important to our story, were one of the two houses in New Town advertised for sale by merchant Thomas Rutland in 1771 and the house on West Street built by tailor Alexander Ferguson just prior to his death in 1770. Lord Baltimore's brother-in-law Robert Eden, who arrived as governor in 1769, bought the old Jennings house from his predecessor, Horatio Sharpe, and altered it to suit his family's needs and style. Deciding to stay in Maryland, the dispossessed Sharpe enlarged Whitehall, his country retreat across the Severn, as a permanent residence. Just outside the town, on land originally settled by Richard Acton, Matthias Hammond's older brother John built Acton Hall, another fine Georgian house.[12]

Charles Wallace, staymaker turned entrepreneur, saw the need for less expensive housing in the city. In 1770 he bought roughly five and a half acres between the State House and the head of the dock, which had been set aside for Governor Francis Nicholson in the 1690s

and later claimed by Thomas Bordley. Wallace subdivided his property into lots facing the two new streets he had named Cornhill and Fleet. His lots were snapped up quickly by artisans and shopkeepers willing to take on a ninety-nine-year lease at about £3 a year. At least five brick houses on Cornhill extant today date from the 1770s.[13]

All of this new residential construction made the city's public buildings look shabby by comparison. Visitors to town had remarked for years that the State House, free school, and other government buildings were "Old antiquated Buildings without Elegance or Taste," "going fast to decay."[14] The State House, especially, was termed "indifferent" and old enough to have been, in the words of Thomas Jefferson, "built in the year one." At its November 1769 session, the first for newly arrived Governor Eden, the General Assembly authorized funding and appointed superintendents for a new "Stadt House," which the law described in detail. Charles Wallace undertook to oversee construction, and the cornerstone of the new building was laid 28 March 1772.[15]

Aside from being pleased at yet another project to keep their economy growing, Annapolitans must have been happy to learn that the Upper House would have special rooms in the new State House and that the city corporation and county court could share the old Council House. In 1771 the legislature set aside money to spruce up the free school and fit up the Council House for its new occupation as meeting room and archive for the local governments. Provincial legislators, on the other hand, utilized the city's Assembly Rooms for sessions and committee meetings while their own chambers were under construction. There is some question as to whether the city availed itself of the new meeting room in the Council House. Records show the Mayor's Court and corporation meeting in the State House (1789) and the ordinaries of William Reynolds and John Ball.[16]

Much has been written about the building of the State House, including a good deal of speculation about the architect or master builder who designed it. Most would agree today that Joseph Horatio Anderson drew the early State House plans, but there were at least three other men in Annapolis in the early 1770s who were described in various records as an architect. Each has buildings attributed to him with varying degrees of authority. The point, however, is not which architect did what but that there were, in this small town, during this brief period, four men whose talents, training, and experience led them to be designated with an appellation not common at the time even in England.[17]

It was Edward Lloyd IV who persuaded master craftsman William Buckland to leave Virginia for Maryland in 1772 to finish the structure that Chase had begun. Buckland brought at least five workers with him, including his apprentice John Randall, and hired additional workmen, both servants and slaves, in Annapolis. Working from a busy shop at the northern edge of Bloomsbury Square, Buckland and his carvers and joiners, plasterers and painters added grace and polish to the interior of Lloyd's house, and possibly the State House. The master's major work remains the exquisite town house of Matthias Hammond, which he designed and worked on until his death in 1774. Buckland himself probably did not work on other homes in Annapolis during his two years in town, but his genius, executed by the men of his shop, extended well beyond what he touched directly.[18]

Demand for workers in the building and furnishing trades energized local craftsmen and brought artisans to Annapolis from other colonies and across the Atlantic. Cabinetmaker Francis Hepbourne came from London (1769) and advertised his Venetian window blinds "the same as the Governor's." Brickmaker Michael Krips from Philadelphia (1771) offered a selection of bricks at James Maccubbin's store. John Rawlings and James Barnes, plasterers and stucco workers from London (1771), advertised their designs for ceilings and

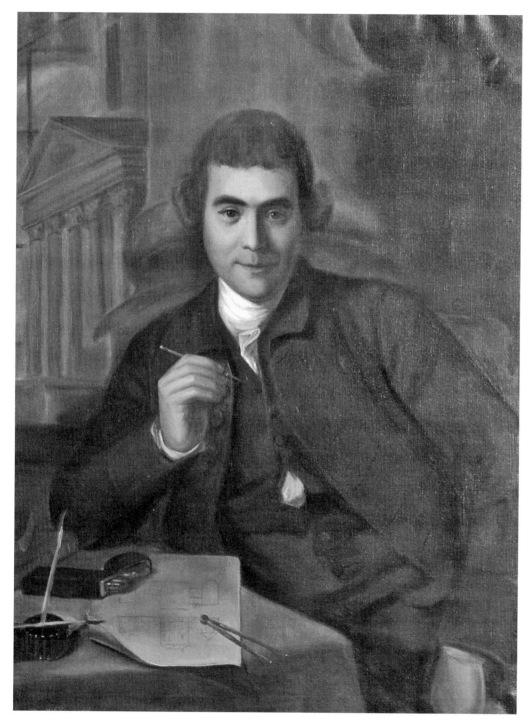

cornices; they later worked for George Washington at Mount Vernon. Daniel King, a brass founder, announced in 1772 that he would arrive from Philadelphia with a supply of fire dogs, fenders, and tongs.[19]

The enticement of their new physical environment, and at least a bit of disposable income, encouraged people of the town to seek goods and services of the highest possible status. Historian Lorena Walsh notes, "At all levels of wealth — and very markedly among

families of low and middling wealth — town residents consistently purchased more amenities and luxuries than did rural folk."[20] With greater opportunities for social contact and entertaining, town dwellers owned more tables and chairs and candlesticks than did their country cousins. Even poorer householders might indulge in a porcelain punch bowl or tea cups and saucers, writes curator Stephen Patrick, so they could "include themselves in the fashionable habit and exotic display of punch, tea, coffee, and chocolate drinking."[21] With this wide and eager market, the artisans migrating to Annapolis emphasized their European connections. As Jean Russo notes, "Only Annapolis offered the concentration of population and wealth that attracted artisans seeking to exploit their status as transmitters of metropolitan standards and arbiters of the latest fashions."[22] London milliners Maria Hume, Catharine Rathell, and Jane and Anne Nelson carried the latest in ladies' bonnets, trims, gauzes, and slips. The Nelsons also made the fashionable overdresses called mantuas, as did tailors Jervis Burford, David Jones, and Joseph Browning, all from London. Charles Jacob and Abraham Claude, watchmakers from London, opened a shop on West Street near clockmaker William Faris, in 1772, and were quickly joined by William Allen from Birmingham. Coachmaker Thomas Pryse arrived from London; tailor Peter Sinnott from Dublin; and saddler Henry Merony came up from Charleston, South Carolina. At first almost all of these men and women rented space from established town craftsmen, ordinary keepers, or, in case of the women, from widows who kept boarding houses or small shops. As their fortunes improved, they bought or leased shops of their own.[23]

Free immigrants willing to serve as bound labor were usually advertised by their importers as skilled artisans and tradesmen. They arrived in Annapolis in droves — 134 from London, Bristol, and Dublin in July 1767, 108 in February 1770, for instance — but even of those who served their time in Annapolis, it is unlikely that very many stayed in town after achieving their freedom. A few slaves were still being imported from Africa, but again, they may not have lived in town. More accustomed to town life were native-born slaves with artisan skills, some of whom were hired out by their owners. Daniel of St. Thomas Jenifer offered two carpenters and a blacksmith in 1773 for a month's or year's employment; a Mr. Maccubbin hired out his slave Toby to Edward Lloyd and received payment for his work. James Brice employed a "Negro carpenter" for five years at £36 a year, and apparently paid him directly, whether or not he was a slave. Critical to construction were the carters who hauled bricks, sand, wood, and other materials to the job site. And, at the bottom of the work force were the laborers, bound and free, white and black, semi-skilled and unskilled, all of them indispensable to any builder.[24]

The number of vessels arriving in the Annapolis district each year increased steadily from 90 in 1768 to 269 in 1774. They brought lobsters, nuts, cranberries, and cheese from New England, pork and tar from North Carolina and Virginia, limes and pineapples from the Caribbean. Molasses, rum, and sugar came in from Caribbean colonies, Rhode Island, and Philadelphia. Transatlantic cargo included Irish linen, candles, salt, manufactured tools, elephants' teeth, and great quantities of wine from Lisbon and Madeira. In 1774, a record number of servants arrived in the district — almost 2,200 men, women, and children come to seek their fortune in the New World. These were in addition to more than 550 convicts, whose passage was less voluntary. No slaves were imported that year.[25]

Townspeople and visitors with good credit or money in their pockets could patronize jewelers, goldsmiths, silversmiths, and engravers, have their hair cut by an expert barber, or select the latest in fashionable wigs from a peruke maker. Ladies could choose a personal staymaker, buy notions, and shop for the perfect fabrics to be made up by their dressmaker.

TO THE LADIES AND GENTLEMEN, SAMUEL RUSBATCH, late pupil to Robert Maberly Esq; coach and herald painter, and varnisher to their majesties and the royal family; proposeth (under the direction of Joseph Horatio Anderson, architect in Annapolis) to carry on all the various branches of coach and herald painting, varnishing and guilding; as well plain as in the most decorated taste. Also painting in fresco, cire-obscure, decorated ceilings for halls, vestibules, and saloons, either in festoons of fruits, flowers, figures, or trophies. Carved ornaments in deception, guilding and burnishing in the neatest manner. As well house-painting, in distemper as dead whites, as in the common colours, &c. Those ladies and gentlemen who please to favour him with their commands, may depend on his speedy execution: which he flatters himself will soon recommend him to the favour of the public.

N. B. All letters and orders, sent or directed to Mr. Anderson, (as above) will be particularly attended to.

Samuel Rusbatch believed that Annapolis was ready for a London-trained craftsman able to execute the most elaborate architectural details on their new homes and even paint heraldic decorations on their carriages. Maryland Gazette, 30 December 1773.

September 26, 1769.

JUST IMPORTED,
FROM LONDON,

In the good Ship CHARMING ISABELLA, *Captain* WILLIAM JOHNSON, *now lying at* ANNAPOLIS,

ABOUT Seventy Servants, Men and Women (Freewillers or Redemptioners) amongst them are many exceeding good Tradesmen, *viz.* House-Carpenters, Joiners, Cabinetmakers, Stone-Masons, Bricklayers, Black and White-Smiths, Silver-Smiths, Jewellers, Tailors, Weavers, Hatters, Gardeners, and many other useful Tradesmen. Attendance is given every Day on board the said Ship, to agree and dispose of their Times to serve.

N. B. The Ship will lay at *Annapolis* 'til next Tuesday. WILLIAM WEATHRALL.

Men and women willing to indenture themselves for a period of years to pay for their passage to Maryland included a variety of craftsmen experienced in specialty trades such as cabinetry, jewelry, and smithing. Maryland Gazette, 28 September 1769

Annapolis, Sept. 29, 1767.

JUST IMPORTED,
In the Ship LORD LIGONIER, *Capt.* DAVIES, *from the River* GAMBIA, *in* AFRICA, *and to be sold by the Subscribers, in* ANNAPOLIS, *for Cash, or good Bills of Exchange, on Wednesday the 7th of* October *next,*

A CARGO of CHOICE HEALTHY SLAVES. The said Ship will take TOBACCO to LONDON, on Liberty, at 6*l.* Sterling per Ton.

/X JOHN RIDOUT,
 DANIEL of St. THO'. JENIFER.

N. B. Any Person that will contract for a Quantity of Lumber, may meet with Encouragement, by applying to D. T. JENIFER.

Discovery of this advertisement for the sale of slaves imported on the ship Lord Ligonier *prompted twentieth-century author Alex Haley to link his story of Kunta Kinte to Annapolis and Gambia. Maryland Gazette, 1 October 1767.*

Pursuing Opportunity in Colonial Annapolis

The brother and sister team of Charles and Mary Wallace symbolize the entrepreneurial and independent spirit of many Americans in the years before the Revolution. Born in Annapolis in 1727, Charles was a stay maker who supplied corsets to some of the richest women in the colony, among them the wealthy, socially connected Anne Bladen Tasker. In this capacity of trust, Charles benefited from the considerable investment capital at the disposal of his clients, who assisted his business ventures. He quickly moved from stay maker to storekeeper, importing luxury goods from British merchants to retail to his corset clients and others who were becoming increasingly affluent from the tobacco trade and the business of government in the capital city.

Charles's sister Mary wed Cornelius Howard and established the Annapolis Coffee House, on Church Street (now Main). After her husband's death in 1771, Mary ran the coffeehouse on her own. There her brother attended club meetings of prominent citizens, including Maryland governor Robert Eden, and feted the rich and politically connected who came to town for court days and the races, George Washington among them.

At both his store and Mary's coffeehouse, Charles Wallace plotted to unseat English and Scottish merchants from their domination in the colonial market for fine European goods. Forming a partnership with John Davidson and Joshua Johnson, Charles took steps to cut out foreign middlemen and keep the profits for his new firm. He sent Joshua Johnson to England to buy goods directly with capital borrowed from Charles's patrons. When Charles, who had added construction oversight to his enterprises, contracted to build the new State House, he gained access to government money, some of which he applied to the firm's purchases abroad. Wallace also built four fine connected stores on the new wharf at the head of the Annapolis dock, reserving one for the mercantile firm of Wallace, Davidson, Johnson.

In at least one instance, Wallace and Davidson used clandestine political pressure to outmaneuver their competitors. When Joshua Johnson's spy on the London docks discovered that Anthony Stewart, an Annapolis merchant allied with some of the largest English firms, had secreted tea in bales of cloth loaded onto his brig *Peggy Stewart*, Johnson got the news to partner John Davidson, who happened also to be a customs official in Annapolis. *Peggy Stewart* got a warm reception in October of 1774, when her owner was forced to burn and sink her for the offense of attempting to import tea illegally. Charles Wallace went on to be a prominent supporter of the Revolution, even leading raids on Loyalist plantations to obtain supplies for local defense and Washington's army.

Ironically, Mary and Charles Wallace succeeded too well in their revolutionary activities. Independence was achieved, but with the war's end, economic growth stalled and the rich withdrew from Annapolis. Mary spent years attempting to collect the unpaid prewar debts of fleeing Loyalists like Governor Eden, and her coffeehouse closed. Charles Wallace did buy the mansion of one of his former clients, Anne Bladen Tasker, and wisely invested his earnings with a new partner, John Muir, who opened Farmers Bank, the first bank in Annapolis, in 1805. But Charles spent years fighting the claim of his former partner, Joshua Johnson, for a greater share of the firm's profits.

In all, the story of Charles and Mary Wallace is the story of Everyman and Everywoman in America, a story that in outline has been repeated with great frequency over the course of American history. They found opportunity. They seized opportunity. They flourished for a

time until adverse economic conditions caused by unsustainable optimism, and their own overreaching, halted their success and brought their entrepreneurial activities to a close. Theirs is a tale, both inspirational and cautionary, that reaches beyond the confines of Maryland's capital city.

EDWARD C. PAPENFUSE
*Archivist of the State of Maryland
and Commissioner of Land Patents*

Imported foodstuffs, wines and liquors, spices, window glass, candles, and medicinal drops and powders were available in shops large and small all over town.[26]

Wealthy Annapolitans desiring the highest in quality and latest in styles or, perhaps demonstrating their social status by refusing to buy where their less advantaged neighbors did, ordered goods directly from Europe. Charles Carroll of Carrollton furnished his renovated home with luxurious fabrics, a "fashionable Sopha," fine tables and chairs, a marble mantle. If the preferred "Turky carpet" was unavailable, an English-made "Axminster" or "Wilton" would do. His father reminded their London agents that the goods had to be of the best quality and the selections made by someone whose "Judgement & Taste" Carrollton approved.[27]

Until 1771 most of those orders went through local factors of tobacco agents in England, but in that year, Charles Wallace, Joshua Johnson, and John Davidson joined in a partnership to create an Annapolis-based mercantile firm with its own London agent, ships, and retail store in town. At the foot of his newly laid out Fleet Street, facing the dock, Wallace built a four-part, three-story brick building, the largest commercial structure in town. In the years before the war, the partnership was enormously successful, attracting even the Carrolls as customers. Historian Edward Papenfuse figures that Johnson, who spent those years in the partnership's London office, shipped to Maryland goods worth almost £48,000 sterling, nineteen times the £3,000 investment the three men had made in 1771.[28]

Testimony to the wealth and sophistication in town was the experience of aspiring painter Charles Willson Peale. Where else in America at that time would he have found men able and willing to send him to Europe to learn with masters? Peale had come to Annapolis from the Eastern Shore as a child with his widowed mother and siblings and been apprenticed to saddler Nathan Waters. Upon completion of his service, the young man set up his own saddler's shop on Church (now Main) Street, in 1762. Within a year he added sign painting to his business, and when portraitist John Hesselius came in for a saddle, Peale bartered him one of his best for three painting sessions. Forced by angry creditors to leave town abruptly after he electioneered for Samuel Chase in 1764, Peale made his way to Boston and spent some time in the studio of John Singleton Copley. Peale's promise in portraiture persuaded eleven men, eight of them current or recent Annapolis residents, to put up more than £85 sterling in 1766 to send him to London for study with Benjamin West. After more than two years in England, Peale returned to Annapolis and began his formal career as a painter. Through Peale's talent, we can get a sense of these Annapolitans of a long-gone time, among them the families of his patrons John Beale Bordley, Charles Carroll, Barrister, Benedict Calvert, and Charles Carroll of Carrollton, and of his friends

and associates William Paca, Samuel Chase, and William Buckland. Not everyone who commissioned a portrait paid promptly.[29] In 1774, Peale had to embarrass provincial official Elie Vallette in the *Maryland Gazette* before receiving his fee for painting the Vallette family. A year or so after that experience, Peale moved permanently to Philadelphia.[30]

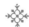

The city's population rose more than 25 percent in the decade before the Revolution, with the greatest increase being from 1768 to 1775. One of the outsiders who paid attention to the expanding market was theater mogul David Douglass. After a nine-year hiatus, members of his American Company of Comedians returned in February 1769 for a four-month run. Advertisements for performances in May hint that the players might not have been the company's senior troop. Mr. Darby, starring in *The Way to Keep Him*, told the audience, "[You] may be assured of each Performer's being Perfect in their Parts." The main event seems to have been rope walking by a Mr. Malone, who, among other feats, was able to balance on a slack rope while holding a pyramid of thirty glasses of jelly in each hand. Sharing the entertainment spotlight with Mr. Darby and Mr. Malone in May were Thoroughbred horses vying for purses of sixty guineas and £100 at the city's spring races. Both purses were won by out of town horses, but Samuel Galloway's Selim, son of the famous Selima, came in second for the £100 subscription purse. Annapolis women, unfortunately unnamed, contributed to the excitement. The fall 1769 race week featured a "LADIES Purse of FIFTY POUNDS" offered by lady racing fans. Dr. Thomas Hamilton's Primrose won the prize.[31]

Over the next five years, Douglass's players returned for the fall races, and the week of festivities became ever more splendid and entertaining. Visitors from other Maryland counties and adjoining colonies came to Annapolis to enjoy this premier event on their social calendars. Letter-writing William Eddis, who emigrated to Annapolis in 1769 with the patronage of Governor Eden, expressed his satisfaction with the local theater scene following performances of the American Company of Comedians in September 1770: "When I bade farewell to England, I little expected that my passion for the drama could have been gratified in any tolerable degree at a distance so remote from the great mart of genius. . . . My pleasure and my surprise were therefore excited in proportion on finding performers in this country equal at least to those who sustain the best of the first characters in your most celebrated provincial theatres." Not London, perhaps, but pretty close.[32] Eden, a man for whom "hospitality and good living were to be dispensed with lavish hand," quickly offered his endorsement when David Douglass announced a plan to raise money to build a new theater in Annapolis.[33]

The new brick theater on West Street, next door to William Faris's shop, opened to acclaim on 9 September 1771 with a production of *The Roman Father*. Eddis thought the building too narrow for its size but approved it generally as "not inelegant." The scenes, probably painted by a Mr. Doll, "reflect great credit on the ability of the painter," he said, and the "performers are considerably above mediocrity." Jonas Green did not stint in his own editorial praise, calling the building "as elegant and commodious, for its Size, as any Theater in America." Race week began two weeks later, and crowds poured in from the countryside to see the plays and watch their favorite horses compete for the Jockey Club's hundred-guinea purse. For a dollar a ticket, gentlemen could attend one of that week's three balls at the city's "Ball Room," to dance or perhaps to play a few hands of cards in the rooms set aside for that purpose.[34]

That year, a country gentleman from Virginia came to Annapolis to see the sights and

spend some time with his stepson, who was at school with the Reverend Jonathan Boucher, recently named rector of St. Anne's. Warned by young Jackie Custis that it would be "almost impossible to get a Room at any of the ordinaries," George Washington lodged with Boucher at the rectory on Hanover Street. During the eight days Washington stayed in Annapolis, he dined at the homes of Dr. George Steuart, John Ridout, Charles Carroll of Carrollton, and Daniel Dulany the Younger. He also had meals with the governor, Lloyd Dulany, and Daniel of St. Thomas Jenifer and spent a couple of evenings at the coffeehouse. Although Washington noted in his diary that he was coming to Annapolis for the races, he didn't mention them. What he did record were the plays he saw (four), the balls he attended (all three), and the money he lost at cards (£13.4.3).[35]

Douglass's company was back in September 1772 and played through Race Week in early October. Drumming up enthusiasm for the races, the *Maryland Gazette* promised that "good sport" was expected, "as a great number of Horses are already come from the Northward and Southward" to run for prizes that included the Jockey Club purse of one hundred guineas and the Give and Take and American Theatrical Company purses of £50 each. This year Edward Lloyd IV came over from his plantation in Talbot County with his Thoroughbred mare Nancy Bywell, fresh from her win in a three-hundred-guinea match race against New Yorker James Delancy's horse Lath in Cecil County. Among the Virginians in town that week were George Washington and Jackie Custis, perhaps watching closely as Nancy Bywell ran away with the Jockey Club purse. Reverend Boucher had married and moved to Prince George's County, so Washington stayed with Governor Eden. The Virginia gentleman dined with Lloyd one night, although certainly not at his new house, still under construction on Northeast Street (now Maryland Avenue), and went to three plays and one ball. He lost a little more than a pound at the races.[36]

When Washington returned in 1773, he again stayed at Eden's and followed his usual pattern of theatergoing and dancing. This year he dined with Benjamin and Henrietta (Henry) Margaret Ogle at their residence on King George Street and with Richard Sprigg, who had bought Dr. Alexander Hamilton's house just down the street from the Ogles.[37] No one knew then that the next time he came through town it would be on his way to Philadelphia to attend the first Continental Congress.

Among the familiar faces Washington would have seen in Annapolis in 1773 was his Williamsburg dentist, Dr. John Baker. Baker was one of several medical specialists in town, taking advantage of the Race Week crowds. A self-described "surgeon dentist," Baker treated scurvy, sold dentifrices in containers "sealed up with his Coat of Arms, to prevent fraud," and performed surgical procedures on teeth and gums. For patients who had lost teeth, Baker made artificial replacements or transplanted natural teeth from someone else. Dr. John McGinnis, a surgeon dentist from Europe, was also in town that week. McGinnis advertised his success in curing "scurvy in the gums" and offered a money-back guarantee

Charles Willson Peale painted many portraits of George Washington, but this one, done in 1772, shows the Virginia colonel in his uniform as a British colonial officer, during the period when he visited Annapolis to enjoy the social events of Race Week. Courtesy of the Washington-Custis-Lee Collection, Washington and Lee University, Lexington, Va.

for his toothpaste.[38] Neither of the dentists grasped the value of advertising with the force of James Graham, "oculist and aurist," who placed a unique column-long notice of his expertise in the *Maryland Gazette* in mid-August. Graham assured readers that his treatments would benefit "those persons who have had the unspeakable misfortune of being born deaf and dumb" as well as those with speech impediments. Graham also advertised his successes in curing diseases of the eye, including cataracts and glaucoma. The advantages of Race Week drew him from New York City to Annapolis, where he arrived on the first day of the races. Two weeks later, he was still in town when the *Maryland Gazette* printed testimonials from Graham's patients in New York designed to promote his practice.[39]

The recounting of the city's amusements implies a contented, happy citizenry, which, of course, was not necessarily the case. There were poverty and theft and disease and death in this glittering town as there had always been. A city bylaw in 1768 established a neighborhood watch to curtail a spate of break-ins and robberies, but the duration and success of the operation are unclear. Thieves stole engraved silver and linens from Daniel of St. Thomas Jenifer in 1770, and two of the convicted men were hanged at the gallows outside the town.[40] By the late 1760s, most people seem to have accepted smallpox inoculation as the best way to prevent death from the disease. Several physicians in Annapolis and Baltimore Town offered the procedure and the requisite follow-up care as a package deal. Governor Eden's two youngest children survived their inoculations in 1771 by Dr. John Shuttleworth, who made sure this was noted in the newspaper. Usually inoculations were given during the winter months, but Dr. Richard Tootell cautioned local residents against receiving the procedure advertised by a Baltimore physician in November 1772 because of an outbreak of measles in that town and the threat of "hooping cough," either of which could compromise recovery of the inoculated.[41] Winters were especially hard for poor citizens. William Eddis noted that, while food was generally affordable, labor costs made fuel expensive in urban centers. One correspondent to the *Maryland Gazette* suggested that a "Poor's Box" be placed where the more fortunate, whiling away the cold months pleasurably at clubs or dancing or card playing, might contribute a small amount each evening.[42]

Care of the poor was a problem not only in Annapolis. In 1768, Anne Arundel County was one of five counties authorized by the General Assembly to purchase land near their "principal town" and to build a dual-purpose building: an almshouse for the poor and a workhouse "for the Reception of Vagrants." Unable to find land in Annapolis, the Anne Arundel trustees of the poor (at that time all residents of Annapolis) purchased, in 1772, nine acres at the head of Dorsey (now College) Creek, probably near the Newington Ropewalk. The almshouse-workhouse was finished in the spring of 1774 and the county justices were granted permission by the legislature to assess taxable residents of Anne Arundel up to ten pounds of tobacco per poll [head] to provide for the poor housed there.[43]

Something else that might, or at least should, have concerned Annapolis residents was the growth of that small town on the Patapsco River. Annapolis jeweler William Whetcroft had shops in both towns as early as 1767, with arrangements for goods to be shipped back and forth. Communication between the two was made easier in the spring of 1773, when Patrick Tonry, who had a "neat commodious" tavern in East Street, initiated a stage route to Baltimore Town. His coach left Annapolis three days a week and returned the next day for ten shillings a trip, half price for "Outside passengers" and children. Baltimore businessmen had routinely advertised in the *Maryland Gazette*, but those advertisements diminished in August 1773 when William Goddard published the first issue of the *Maryland Journal and Baltimore Advertiser*. No longer was the *Gazette* Maryland's only newspaper,

and the rivalry between the two cities would soon extend well beyond newspapers.[44] The observant William Eddis quickly picked up on the future of Baltimore. He saw the Annapolis harbor as too small and shallow for that city's success as a center of commerce, "but," he said, "the province has been amply compensated for this disappointment by the rise of a settlement which in the memory of many persons now in being has increased with the most astonishing rapidity, and promises, by an equal progress, to rank with the most populous and opulent establishments on this side the Atlantic."[45]

Throughout the capital city's golden age, the specter of political dissension hung over its citizens like a pall descending slowly but inexorably upon the town, the province, the country. Whether in conversation at the Howards' coffeehouse on Church Street, gossip at the balls held twice a month during the winter, exchanges on the street corners, arguments in sitting rooms — Annapolitans reacted to decisions made in England and at home. And those reactions, expressed in broadsides or in lengthy letters replete with classical allusions and snide remarks, swamped the *Maryland Gazette* for months at a time.[46]

Some of the dissension was private, such as the nastiness between the Dulany family and the Reverend Bennett Allen, recently ordained friend of Frederick, Sixth Lord Baltimore, who sent him to Maryland in 1766 with expectations of wealth and success. Allen hated the weather, was not much impressed with St. Anne's, where he had been installed as rector, and anticipated the assistance of deputy provincial secretary and councilor Daniel Dulany in finding a better post. When disappointed, he attacked the Dulanys in the *Maryland Gazette* in such libelous terms that publisher Anne Catharine Green finally refused to print his letters unless he posted bond to indemnify her from suits. Eventually Allen moved to a prosperous parish in Frederick County. After thoroughly offending his parishioners there as well, he ended up in Philadelphia, still blaming the Dulanys publicly for his misfortunes. Returning to Annapolis in the fall of 1768, he met Daniel Dulany's brother Walter on the street, and passersby were treated to a curious spectacle as the two men fell upon each other, brandishing their canes. Although described as "a heavy, gouty and clumsy man," Dulany got the best of Allen on that occasion and again when Allen renewed the fight some days later. Allen went back to Frederick and kept his head down. Ultimately the disreputable preacher got the last word when he mortally wounded Walter's younger half-brother, Lloyd Dulany, in a duel in London in 1782, and was punished with only six months in prison and a one shilling fine.[47]

More public were the arguments that surfaced when Parliament passed the Townshend Acts in 1767, less than a year after the repeal of the Stamp Act. Among the articles taxed this time were tea, paper, glass, and paint imported into the colonies. Even though the *Maryland Gazette* printed news of the reactions in other colonies, little happened in Annapolis until the spring of 1769, when merchants in several counties pushed for a meeting in the capital in June.[48] Governor Robert Eden arrived in Annapolis two weeks before the meeting, apprehensive that he would face a hornet's nest of organized resistance. But, as he wrote home, "they met at a publick House . . . and could hardly agree among themselves" what should be boycotted. He decided to ignore it.[49]

The resolutions passed after three days of discussion, ostensibly by forty-three of "His Majesty's loyal and dutiful subjects, the Merchants, Traders, Freeholders, Mechanics, and other Inhabitants" of Maryland, appeared to follow the advice of Daniel Dulany four years earlier in his *Considerations on the Propriety of Imposing Taxes in the British Colonies.*

Dulany had suggested that "instead of moping, and puling, and whining to excite compassion," the colonies ought to manufacture their own goods and in this way show "the consequence of oppression in the colonies to the inhabitants of Great Britain." This "would strike home, and immediately," he assured his readers; "None would mistake it." Now, the merchants agreed not to import a long list of items, including horses, various liquors and wines, meats, fabrics, wigs, gloves, cutlery and china, certain leather goods, and so forth. And, should anyone import these items, he would be considered an enemy "to the Liberties of America." The Anne Arundel men present were north-county planter John Dorsey, planter-merchant Brice T. B. Worthington, and prominent Annapolis merchants James Dick and Charles Carroll, Barrister. How many of the other attendees were merchants, traders, and mechanics is suspect. Most of the forty-three men in attendance were lawyers and country party delegates from the just-adjourned session of the General Assembly. Worse, the list of boycotted items was mitigated by so many exceptions — "Oil, except Salad-Oil," millinery "except Wig Ribbon," East India goods "except Saltpetre, Black Pepper, and Spices" — as to be less a statement of belief than an attempt to avoid scorn from the Pennsylvania merchants who had pushed their Baltimore colleagues to protest in the first place.[50]

Over the next six months or so, cargoes imported into other counties were seized by committees of the vigilant, enforcing the boycott. In Annapolis, the firm of James Dick and Anthony Stewart admitted in late September 1769 that they had purchased some recently arrived items on the restricted list, but since that "is thought by many Gentlemen to be repugnant to the general Spirit of the Association," they had put them in storage for the duration. The next time Dick and Stewart were not so lucky. When the brigantine *Good Intent* sailed into the harbor in January 1770 with European and East India goods consigned to merchants in Anne Arundel, Prince George's, and Baltimore Counties, committees from those counties met and decided that the goods should be sent back to England. Dick and Stewart protested that their part of the cargo was "ordered within the Letter of the Association." If anything had slipped by, they would put it in storage as they'd done before. But the pressure upon them and the other consignees was too severe; *Good Intent* stayed just long enough to take on provisions and returned to London, her £10,000 cargo intact. Later in the year, England repealed the tax on all items except tea, and Maryland's nonimportation association fell apart.[51] For the leaders of the committees, and for Dick and Stewart, it had been the dress rehearsal for a later drama.

Politics continued to rule conversation and the newspapers throughout the early 1770s, although now people focused inward, upon issues unique to Maryland. Two disputes stand out as indicative of the ideas circulating in the province at the time. Both stemmed from a proclamation made by Governor Eden in late 1770 continuing the fees paid to certain provincial officials, including Anglican clergy, which had been set by Lord Baltimore during his visit to Maryland in 1733. (The details of the proclamation, its background, and its effect on Marylanders are covered extensively in the sources cited in note 52.) What concerns us specifically is the effect on Annapolis. Almost all of the participants in the two principal debates were or had been residents of the capital city. In the first debate, which went on for most of 1772 and 1773, Jonathan Boucher, one-time rector of St. Anne's, took his case for increased clergy fees and the establishment of an American bishopric to the public. In opposition were Samuel Chase and William Paca, who argued that the poll tax was too high to start with and, perhaps thinking of the less than churchly behavior of Bennett Allen, also suggested that the province would benefit from some lay oversight of members of the

clergy. The second and more important debate pitted Daniel Dulany, who signed himself "Antilon," against Charles Carroll of Carrollton, "First Citizen," in a series of letters published in the *Maryland Gazette* that articulated arguments between the proprietary establishment (Dulany) and its challengers (Carroll). Dulany, now taking the opposite tack from his *Considerations*, defended Eden's right to set the fee schedule. Carroll held that fees were taxes, and taxation was the prerogative of the legislature. Since the concept of taxation now carried associations well beyond the fee schedule, Marylanders followed the argument closely. Locals also knew of the longstanding animosity between the two families and probably enjoyed seeing how it played out in the newspaper. Those with the good fortune to be in Annapolis on the day another installment came out crowded editor Anne Catharine Green's offices on Charles Street for copies. Other writers entered the debates in defense of either side, sometimes taking a harsher or more personal stand than the protagonists. There was a lot to read and a lot to discuss. Most of the populace thought Carrollton's first foray into the public arena a success; when acknowledged leaders like Chase and Paca hailed him, he was accorded a place in the pantheon of country party leaders.[52]

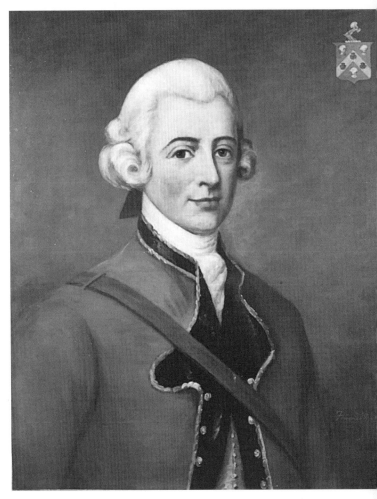

Socially popular Robert Eden, governor of Maryland from 1769 to 1776, set off a flurry of political controversy with his fee proclamation of 1770. Arguments aired in the Maryland Gazette *helped focus pre-Revolutionary opinion in Annapolis. Portrait by Florence Mackubin after Charles Willson Peale. Courtesy of the Maryland State Archives, MSA SC 1545-1108.*

What makes these partisan debates especially remarkable for Annapolis is the fact that they were going on at the same time the participants were socializing together at dances, cards, plays, dinner parties, and horse races. The Homony Club provides a keen example of how some of these men were able to maintain civil discourse in times of uncivil division. From December 1770 until March 1773, seventeen regular members and perhaps six honorary members, joined by visitors, met at the coffeehouse on Church Street for five or six hours every week during the three-month winter season. They played whist and backgammon, ate dinner, performed mock ceremonies and trials, read poems, told jokes. Participants over the three years tended to be aligned almost equally with the court and country parties. Court party stalwarts Jonathan Boucher, William Eddis, and Anthony Stewart showed up regularly to drink and laugh with country party leaders William Paca, Charles Wallace, and John Brice. Charles Willson Peale and Richard Sprigg were regular members; Governor Eden, Benedict Calvert, and Horatio Sharpe attended as honorary members. Samuel Chase wanted to join but was refused, possibly as a political exercise rather than a comment on his notoriously boorish behavior. These evenings were more than just successful men getting together to have a good time. Deliberately or not, Homony Club meetings were an opportunity for "ongoing social interaction between people of differing political opinions as an aid to discussion and compromise on the eve of the Revolution." As long as they could diffuse tensions and enjoy themselves, it worked; but when a new General Assembly election approached in the spring of 1773, the meetings ceased.[53] As Boucher explained, the club "was finally broken up only when the troubles began and put an end to everything that was pleasant and proper."[54]

The troubles began when Anthony Stewart decided to run for one of the Annapolis seats in the Lower House. John Hall and William Paca had been the delegates from the city in the 1771 assembly, but the death of Frederick Calvert, Sixth Lord Baltimore, that year and the installation of his teenaged illegitimate son, Henry Harford, as proprietor necessitated a new election. Hall decided to bid for one of the county seats, leaving his city seat vacant. Politicking before the polls opened in May 1773 harkened back to the 1764 election, with parades, signs, public meetings, and hurled invectives. "A Tradesman," writing in the *Maryland Gazette* the day before the election, reminded voters hopefully, "it is the noblest privilege of humanity to think, and speak for ourselves," not as influenced by party passions. It was not to be. Stewart's "private character justly recommended him," said Anne Catharine Green in her report on the election, but "as a strong suspicion was entertained of his political principles and court connexions," country party leaders persuaded political neophyte Matthias Hammond to challenge him. On the morning of the election, with sentiment clearly against him, "Mr. Stewart thought it prudent to decline" his candidacy. As soon as the polls closed, the victors and their followers staged an elaborate funeral procession through town with flags labeled "LIBERTY" and "NO PROCLAMATION," fifes, muffled drums, small cannon, and a copy of Eden's 1770 fee proclamation in a coffin. In what was becoming customary fashion, the coffin was suspended from the gallows, then buried "under a discharge of minute guns." John Hall, Samuel Chase, Thomas Johnson, and Brice T. B. Worthington won unanimously in the county election later in the month and staged another parade with another, larger coffin, which they burned "in imitation of the ancient mannor of performing funeral rites." Even though country party delegates held a clear majority in the Lower House, the two legislative branches managed to work out compromises over the next three sessions of the General Assembly. By the end of 1773 it appeared that calm had been restored to Maryland.[55]

The *Maryland Gazette* printed news from other colonies through the winter of 1773–1774, keeping locals up to date with the activities in Boston, where citizens had dumped imported tea into their harbor in late December. But, although Eddis had written in November 1773 that "on this side of the Atlantic a spirit of discontent universally prevails," folks in Annapolis seem to have taken a break from politics that winter. Instead they decided to replace the dilapidated St. Anne's Church with a new, larger edifice. Several years earlier Jonathan Boucher had addressed townspeople with a very funny "Petition of their OLD CHURCH," mourning its sad state:

> How chang'd the Times! for now, all round,
> Unnumber'd stately Piles abound,
> All better built, and looking down
> On Me quite antiquated grown.

In Annapolis, he said, "GOD has the meanest house in Town." Private subscriptions had raised almost all the money thought necessary when the legislature authorized an assessment in the parish for the rest and agreed to contribute bills of credit with the assurance that pews would be reserved in an "airy and agreeable" part of the sanctuary for the use of provincial officials.[56]

Under way that winter was the house of newly elected delegate Matthias Hammond, the last of the golden age mansions and termed by modern architectural historians one of "the finest classical dwellings in America." Across Northeast Street, workmen were finishing

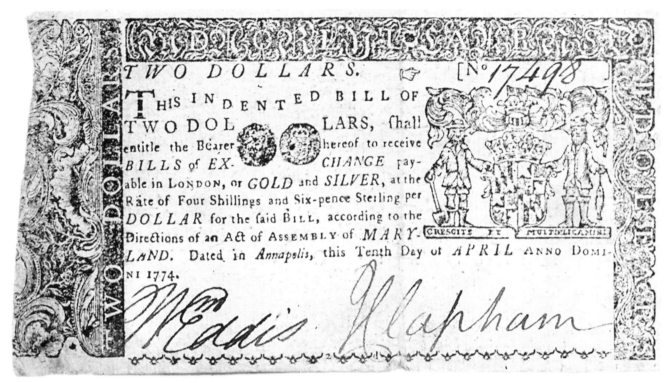

up the last details on Edward Lloyd's house. Perhaps the Lloyds were in residence in time to entertain the Countess of Dunmore, who spent eleven days in Annapolis on her way to join her husband, the governor of Virginia. She left, with her children and entourage, in Lloyd's yacht in late February to a twenty-one-gun salute from the town battery. Governor Eden's brother, Captain Thomas Eden, accompanied her to the Virginia line with his ship *Annapolis*.[57] In mid-April a young tutor to the Carter family of Virginia rode the four miles from South River ferry to Annapolis, along the "piny sandy road" and through the thirty-two gates that crossed it. Waiting to catch the Bay ferry to Rock Hall, he stopped at the coffeehouse, had a shave and some coffee, and then "roved through the Town." He thought the inhabitants "gay & cheerful."[58] Not for long.

A successful political movement needs charismatic leaders, a compelling message, and a crisis. Country party leaders in Annapolis had cut their teeth on the charter challenge and the Stamp Act protest and honed their rhetoric in the fee proclamation debates. All they needed was a crisis, and that burst into life in May 1774 with news of the Boston Port Act. "All America is in a flame!" wrote Eddis in horror. "The colonists are ripe for any measures that will tend to the preservation of what they call their natural liberty." The *Maryland Gazette* had printed news from London with the reactions of king and Parliament to the Boston Tea Party, so people here must have realized that the Massachusetts city would not escape reprisal. However, the complete blockade of the port, called for in the Boston Port Act, was a broadside shot. Boston fired off a letter to the other colonies asking for support. In Annapolis at least seventy-eight men gathered on 25 May to state their belief that Boston "is now suffering in the common cause of America." They resolved to join with other Maryland counties and "the principal colonies in America" to boycott all goods shipped to and from Great Britain. John Hall, Charles Carroll, Barrister, Thomas Johnson, Wil-

Maryland began issuing paper money in 1733. When England prohibited colonial paper currency in 1764, Maryland legislators authorized bills of credit in dollar denominations, the first in the world. Jonas Green printed Maryland dollar bills until his death in 1767. His widow continued to print money, the only colonial woman to do so. Anne Catharine Green illustrated these two-dollar bills with the Maryland seal designed by Annapolis silversmith Thomas Sparrow. Paper currency commissioners William Eddis and John Clapham, Anne Catharine's son-in-law, signed each note. Courtesy of Willard R. Mumford.

liam Paca, Matthias Hammond, and Samuel Chase were selected to correspond with other counties and Baltimore Town.[59]

Only the proposal that lawyers should refuse to bring suit for recovery of debts owed by any Marylander to anyone in Britain did not receive unanimous agreement. That attracted just 16 votes out of 78 and was quickly challenged. At a second, much larger meeting a few days later, 161 men, "inhabitants of the city of Annapolis," signed their names in public protest to the no-suit resolution. Such a move would, they maintained, be disastrous for trade and irrevocably damage their commercial credibility. At the top of the list of signatories were Lloyd Dulany and Anthony Stewart. Others can also be identified as incipient Loyalists, but there were many — artisans, ordinary keepers, small businessmen — who seem to have been shocked by the extreme to which more radical members of the community were willing to go.[60] Clearly there was an element in town that would bear watching.

On 4 June citizens of both Annapolis and Anne Arundel County gathered and passed the same resolutions proposed by city residents on 25 May, including the one calling for no suits against Marylanders for English debt. They also named thirteen men from across the county to attend a provincewide meeting later that month, to handle correspondence, and "on any emergency to call a general meeting." The Annapolis men named to that committee were the same ones chosen at the city meeting ten days earlier.[61]

Similar informal groups gathered in other counties to pass similar resolutions, and on 22 June 1774, the five-year anniversary of the last provincial nonimportation meeting, ninety-two men representing all fifteen Maryland counties, Annapolis, and Baltimore Town assembled in Annapolis. They chose as chairman Lower House Speaker Matthew Tilghman, of Talbot County. Over the next three days the meeting considered the Boston Port Act and acts then pending in Parliament that would subvert the Massachusetts Bay charter and allow the colony's citizens to be tried outside Massachusetts. These acts, the delegates believed, were against the "constitutional rights of English subjects," and if Parliament could do this to one colony, all were at risk, even Maryland, a proprietary province. They passed a series of resolutions pledging their constituents to action, with the caveat that only if the tobacco colonies of Virginia and North Carolina united in the boycott would Maryland stop its own tobacco exports. Calling for a "general congress of deputies from the colonies" in Philadelphia on 20 September, the meeting named five men, including Annapolitans Thomas Johnson, William Paca, and Samuel Chase, to communicate these resolutions to other colonies and attend the general congress. The resolutions passed by this body did not mention the no-suit provision.[62]

No matter how radical their politics, neither the men who attended the meeting on 22 June 1774 nor the other citizens of the province could have realized that this marked the beginning of the Revolution in Maryland. That meeting was the first of nine meetings, or conventions, over the next two and a half years that would govern the province, "*de facto* if not *de jure*," until a state constitution was written and adopted in the fall of 1776. The last session of the last proprietary General Assembly had adjourned 19 April 1774. Subsequent sessions were postponed by Governor Eden until he left the province, and "the proprietor's control of Maryland was officially denied" by the Eighth Convention on 25 June 1776.[63]

Boston sympathizers in Chestertown had tossed imported tea off the brig *Geddes* on 15 May 1774, and the same month, Virginians threatened to burn not only imported tea but the vessel that had transported it. Given the radical element in central Maryland, it was only a matter of time before something similar happened in Annapolis or Baltimore. Annapolis got the honor.[64]

The brig *Peggy Stewart* arrived in the Annapolis harbor on Friday 14 October 1774 carrying fifty-three indentured servants and a cargo of goods consigned to the Annapolis merchant firm Thomas Charles Williams & Co. Wrapped in blankets and hidden away in the hold were seventeen and a half chests of tea (2,320 pounds), which had been smuggled on board without the knowledge of the captain, Richard Jackson, possibly by Thomas Charles Williams himself, who was then in London. Anthony Stewart, one of the vessel's owners, acknowledged to port authorities that there was tea aboard and attempted to have it sequestered while the rest of the cargo and passengers were off loaded. Told that was not possible, Stewart paid the tax. The vessel was "leaky," he said, and the passengers had been at sea nearly three months.[65]

Stewart's vessel was not the only one bringing tea to Maryland in quiet defiance of the 1769 nonimportation association. Nor were Thomas Charles Williams & Co. the only merchants in Annapolis and Baltimore advertising and selling it openly.[66] James Dick and Stewart had managed to avoid trouble five years before by storing the forbidden goods or, in the worst case, sending the brigantine *Good Intent* back to England. Stewart assumed he could finagle his way out of this situation as well. But by paying the tea tax in October 1774, with Boston in trouble, the first Continental Congress in session in Philadelphia, and county committees watching closely, Stewart made a mistake that could have cost him his life.

Exactly what happened over the next six days is, today, not clear. Witnesses do not always concur, some details may be rumor not fact, the *Maryland Gazette*'s reporting is frustratingly incomplete. Most accounts agree that only four members of the Anne Arundel County committee appointed the previous June were in town on the 14th. When they found that Stewart had paid the tax, they realized — some no doubt with pleasure and some with apprehension — that this could become a cause célèbre. They called a meeting that evening at the playhouse. There was talk of burning the tea at the gallows, but some say it was Matthias Hammond who persuaded them to delay until a larger number could weigh in on the decision. Another meeting was set for the following Wednesday, 19 October. Twelve men were selected to supervise the landing of the passengers and cargo, except, of course, for the tea. Stewart used the intervening days to issue a handbill telling his side of the story, and Thomas Charles Williams's brothers in town, James and Joseph, whom he had left holding the bag, penned a public explanation of their role, or lack thereof.[67]

Alerted by handbills, which must have been inflammatory, contingents from the Elk Ridge area of Anne Arundel, Baltimore Town and County, and Prince George's County jostled locals in Annapolis on the morning of the 19th. The Anne Arundel committee called the crowd together, from the porch of Lancelot Jacques's store at the corner of Market Space and Church Street, and had Anthony Stewart and James and Joseph Williams read statements of abject apology and concession, attributed to Matthias Hammond, offering to burn the tea. When Charles Carroll, Barrister called for a decision on the fate of the tea, "it was the unanimous opinion of all present that it should be burnt," said Samuel Galloway's son John, who was there. But "some of the Mob called out that . . . the vessel should share the same fate. Matters began to run very high and the people to get warm," he continued. Muttered threats against Stewart became loud and specific — burn his brig, burn his house, tear it down, tar and feather him, hang him. Stewart's wife, Jean, was "then ill in Child Bed" at their home on Hanover Street, and her husband feared "the Consequences to Her and His Family" from "the Fury of a lawless Mob." Jean Stewart's father, the very frightened James Dick, told Carroll to just burn the brig.[68]

Trying to salvage reason, Allen Quynn called for a formal vote. The result was still to destroy the tea—but only the tea. William Eddis's account agrees that the citizens generally were "averse to violent measures," except for a minority, "chiefly persons who resided at a distance from Annapolis," who threatened to call in like-minded men and "proceed to the utmost extremities." It appeared that the vessel would have to be sacrificed to prevent greater harm. Carried aboard by the "Ringleaders of the Mob," Stewart directed that the brig be "run on ground near the windmill point." There he and the Williams brothers set the fire even as Charles Wallace and others ran to the shore to intervene. The *Peggy Stewart* "was burnt with all her Sails and Riggin standing and Colours flying," said Captain Richard Jackson.[69]

Reaction to the destruction of the vessel was quick and heated. John Galloway probably spoke for most when he wrote to his father, "I think Sir I went to Annapolis yesterday to see my Liberty destroyed which was done when fire was put to the brig." But his brother-in-law, Thomas Ringgold, who was not there, thought Stewart had set the whole thing up to "endear himself to the Ministry [of England] and I am glad the people have shown so much spirit." A Scotsman named Alexander Hamilton, factor in Piscataway for a Glasgow firm, reported that the affair was "Generally exclaimed against by every prudent man" and called the action of rabble-rousers from out of town a "scandalous insult" to the county committee. Galloway thought the committee would have a hard time "putting the affair in print as they cannot say it was with the Consent of the major part of the people that the Vessel was burnt," and Eddis agreed. The *Maryland Gazette* report in its 20 October issue is certainly a sanitized version of the event. Commenting on the report, Eddis described the gap between what he had witnessed and the Greens' account: "Every step that Messrs. Stewart and Williams took in this transaction to the prejudice of their property, seems, in that publication, to proceed from a voluntary election, unawed and unintimidated by the multitude; but I need not comment on the absurdity of such an opinion. The truth is they destroyed property of great value to prevent worse consequences."[70]

Granted, Eddis and Hamilton were loyal to the establishment, but the Quaker Galloway was not, nor was Ringgold, who served from Kent County in meetings of the extralegal conventions until his death in 1776. On the other hand, Charles Carroll of Annapolis, in an uncharacteristic dismissal of property rights, "wholeheartedly endorsed the action as a symbol of what those who opposed the patriot cause might expect." Certainly, merchants were going to be a lot more careful what they shipped to Maryland.[71] For the leaders of the popular party in Annapolis, this second occurrence of mob violence must have given them pause. Tearing down Ann Burman Gaither's house in 1765 had shocked them. Destroying a vessel nine years later fostered a fear of mob rule that may help explain their conservatism as the province progressed to revolution over the next two years.

Stewart stayed around for a while and then, feeling harassed and unwelcome, he took off for England, leaving Jean and the children in Annapolis. In his 1777 request to the Commissioners of His Majesty's Treasury for reparation, Stewart placed the value of the *Peggy Stewart* at her cost to him of £1,500 sterling, "as it was her first Voyage." Jean sold the house on Hanover Street in 1779 and a few months later received permission to cross American lines into British-occupied New York City, where her husband was then active in Loyalist affairs. The Stewarts later moved to Nova Scotia. In a final, fitting irony, their house on Hanover Street was sold in 1783 to Thomas Stone, a signer of the Declaration of Independence.[72]

The same issue of the *Maryland Gazette* that recounted the tale of the *Peggy Stewart* also

carried an advertisement from the Jockey Club for the fall races and "Assemblies as usual." Two weeks later, the paper printed the association entered into by "his majesty's most loyal subjects" at the First Continental Congress in Philadelphia, in which the colonies pledged that no citizen would import goods from Great Britain, Ireland, or other countries under British influence after 1 December 1774. Exports to Britain, Ireland, and the West Indies would cease on 10 September 1775. Among the activities discouraged in the forthcoming time of "frugality, economy, and industry" were "every species of extravagance and dissipation, especially horse racing . . . plays, and other expensive diversions and entertainments." The Jockey Club canceled Race Week.[73] The second Maryland Convention ordered balls discontinued "during the present time of public calamity."[74] The golden age of Annapolis was over.

Governor Robert Eden returned to Annapolis in early November 1774 "to a land of trouble" after five months in England on family business. In the capital city, talk on the street was of arms and militia musters, while in drawing rooms and kitchens women discussed the difficulty of life without imported foods, fabrics, and household goods. Storekeepers advertised country beer; artisans turned to gun manufacture and repair. The county Committee of Observation met regularly to enforce the dictates of the extralegal conventions. When news of battles at Lexington and Concord reached Annapolis, Eden released provincial ammunition to county militias at the request of the Fourth Convention, even though he believed that most Marylanders remained "Friends to Government. . . . We have talked American Treason openly in this Town for some Time," he said.[75]

But talking treason in Maryland, at least openly, ceased with passage of the Association of Freemen of Maryland by the Fifth Convention on 26 July 1775. This document endorsed "opposition by arms to the British troops" deployed in America. Associators pledged themselves "to promote and support the present opposition," to adhere to the "continental association restraining our commerce," and to support civil authorities "until a reconciliation with Great-Britain on constitutional principles is effected (an event we most ardently wish may soon take place)." The civil authorities named to enforce the association and to restrain the zeal that might produce "anarchy and confusion" were "the continental congress, our convention, council of safety or committees of observation." Inking their names at the bottom of the document with the Anne Arundel County delegation to the Fifth Convention were Annapolitans Samuel Chase, Thomas Johnson, John Hall, William Paca, Charles Carroll, Barrister, Charles Carroll of Carrollton, and Matthias Hammond.[76] Copies of the association were distributed to every county for signing by free adult males. Men who did not sign, "non-associators," would suffer financial and social punishment. The fact that the Convention reserved to itself the right to oversee those punishments did not always deter zealots who threatened to force compliance. Such a group meeting under the Liberty Tree in Annapolis in September 1775 intended to force non-associators to leave the city. Governor Eden took credit for quietly making sure that there were enough "judicious and reasonable" men present to prevent this "mad-headed Scheme." The city corporation agreed that citizens could sell provisions to any British ship that might be stationed in the harbor and urged that there be no contentious contact with the crew.[77] The majority on both sides clearly realized that violence would only make matters worse.

For many British sympathizers in Annapolis, as in the rest of Maryland, the Association of Freemen was the straw that compelled them to leave. The last tobacco ships to England

had to clear by 10 September; there wasn't much time. Suddenly, a flurry of notices appeared in the *Maryland Gazette* from businessmen dissolving partnerships or asking for accounts to be settled. People began to pack, to say good-bye. Annapolis had reached the height of its colonial population — an estimated 1,326 people — in 1775, briefly.[78]

Among the native Annapolitans getting ready to depart was Elizabeth Brice Dulany, eighteen-year-old wife of Lloyd Dulany. For the two years of her marriage, she had lived in Lloyd's grand mansion on Church Street, just a few blocks from the much smaller brick house on Prince George Street built by her father, John Brice, long before she was born. Now she was headed off to London. Betty Dulany probably visited friends and family before she left, and maybe she took an hour or so to walk around her town. From the ballroom windows of her brother James's new house, Betty could have looked out over William Paca's carefully planned gardens behind his house next door. Inside the brick wall, formal parterres fell to a channeled stream that flowed east to Governor's Pond and separated the formal plots from the wilderness garden and pond. Paca's fanciful summer house would have caught her eye, just as he had intended.[79]

If Betty walked up Prince George Street from her childhood home, she might have taken a moment to stop by the brick dwelling across from Bladen's Folly, once the residence of her aunt Francina Augustina Stephenson, and take a look at the octagonal ballroom that Henry Margaret and Benjamin Ogle were adding on to the back. Too bad they waited so long to build — formal dances would not be on anyone's calendar for several years to come. On her way home to Church Street, Betty would have admired the new State House with its proud copper roof shining in the summer sun and would have passed Church Circle, which at that time was missing its church. Demolition of the old, dilapidated St. Anne's had begun right after the organ was removed in March, and by summer must have been well under way. The vestry intended to reuse what they could salvage but had also advertised for five hundred tons of good Susquehanna or Severn stone. Great piles of bricks and stone littered the circle. Services were held in the theater on West Street for what everyone thought would be only a year or so, but which became almost two decades.[80]

Betty might have paused near the old Dulany house across the circle at South Street to look down Duke of Gloucester to the chimneys of her own house and, beyond, to the Ridout and Carroll houses flanking the street near the creek. Although much younger than both Mary (Molly) Ogle Ridout and Mary (Molly) Darnall Carroll, Betty, too, had been the teenaged bride of a man almost twice her age. Perhaps the two Mollies might have been sympathetic friends. But Lloyd Dulany would not have been welcome in the Carroll household; he and Charles Carroll of Carrollton had been enemies for years. Betty might not have ventured down the street far enough to enjoy the gardens that Carrollton had plotted mathematically to afford his recently renovated mansion maximum impact from both land and water.[81] A visitor in 1777 noted that "some of the Gentlemen's Houses & Gardens are elegant" and described Carroll's garden as "most delightfully situated."[82]

At the end of August, Elizabeth and Lloyd Dulany and her brother Edmund Brice joined Dr. George Steuart and his son William and Annapolis lawyer Alexander Contee Hanson aboard the ship *Annapolis*, Captain James Hanrick commander. Just two days out of port, they were hit by a massive storm sweeping up the Bay. Dubbed the "Independence Hurricane," this storm blew down the market house and ripped the new copper sheathing off the State House roof. Once at sea, *Annapolis* was dismasted by a second storm about two hundred miles off the Virginia capes. Nine harrowing days later, passengers were picked up by a passing brig and taken to Philadelphia, from whence they later made their way

to England. Captain Hanrick and his crew managed to jury rig masts on *Annapolis* and continued on to London, where they arrived in mid-November to happy financial reward from relieved underwriters.[83]

Other familiar faces missing from Annapolis that fall and winter included storekeeper Robert Buchanan, bookseller William Aikman, Cornhill Street resident John Hepburn, regular visitor Jonathan Boucher, and the Nelson sisters, milliners. Fortunate not to have secured passage on the *Annapolis*, William Eddis's wife and young son left from the Patuxent River in mid-September. Eddis noted in November, "Annapolis is daily more and more deserted," as people moved inland to escape a feared British invasion or, in the case of proprietary officials such as Daniel Dulany and John Ridout, to keep a low profile.[84] Henry Margaret Ogle lamented that the city was "vastly dull. . . . we must all turn industrious in our defence and amuse ourselves with a spinning wheel. Goods of all sorts very scarce & high priced."[85]

Turning to defense in the winter of 1776, drum beats and fife tunes brought men to Annapolis to enlist in Colonel William Smallwood's battalion of the Continental Army. The Seventh Company, commanded by Captain John Day Scott, attracted a number of local men, among them Charles Willson Peale's youngest brother, James Peale, ensign; William Sands, sergeant; drummer John Meek; and Francis Fairbrother, private. The Council of Safety, executive branch of the provisional government, ordered a chart made of the harbor of Annapolis; and a company of artillery men, called matrosses, commanded by Captain John Fulford, took up station in the town.[86]

News of the attacks by Virginia's former governor Dunmore on the cities of Hampton and Norfolk alarmed residents of Annapolis in January and persuaded the Council of Safety to move provincial records to Upper Marlborough. News that there was actually a British warship heading up the Bay from the Patuxent sent everyone into full, grab-the-baby-and-get-out-of-town panic in March. Militia units manned the shoreline as His Majesty's Sloop of War *Otter*, with a couple of tenders, came in sight in a light breeze on the afternoon of 7 March 1776. Off the harbor, a midshipman from *Otter* burned a small boat loaded with oats before the warship sailed on up the Bay. The very anxious Governor Eden and Council of Safety president Daniel of St. Thomas Jenifer sent William Eddis out to *Otter* under a flag of truce to find out what was going on. As it turned out, *Otter*'s captain had no designs on Annapolis; he was looking for Maryland's newly armed vessel, *Defense*, out of Baltimore, and any prizes he could capture. He assured Eddis that his men had been ordered "not to fire under any pretext" at anyone on shore. After an inconclusive standoff with *Defense* at the mouth of the Patapsco, *Otter* returned to the Severn the next day. Her captain sent a message under flag of truce to Eden, asking for supplies, which the governor turned over to the Council of Safety. Burning the oat-laden boat "in full View of the People of this City as if meant to add Insult to Misfortune already too severely felt by the People of the Province, who were always attached to his Majesty and his Family" had not endeared the captain to the Council of Safety. They refused to provision the British vessel, saying, "the Time has been, when we should have thought it an Honor, and would with pleasure have supplied any of His Majesty's Ships with Provision; and are still not destitute of Hope, a Time may yet come, when we can enjoy that satisfaction." *Otter* headed back down the Bay on 10 March under the still-watchful eyes of militiamen along the shore.[87]

Although the Council of Safety commended Governor Eden for "the Paines you have taken to preserve the Peace of this Province," his time in Maryland was coming to an end. In April 1776, letters to Eden from British colonial secretary, Lord George Germain, were

intercepted in Virginia. Germain's orders to Eden to join with Lord Dunmore in assisting a planned British invasion of the southern colonies sealed Eden's fate. No doubt because the Baltimore Committee of Observation was less attached by sentiment and proximity to Eden than men in Annapolis, the Virginia patriots forwarded the letters to that body with the advice that Eden be seized. The Council of Safety, still headed by Eden's old friend Jenifer, took a more moderate approach, but when the Seventh Convention met, in May, it was forced to address Eden's situation. Understanding that their governor would have no choice but to accede to Germain's command "or hazard the displeasure of the king, which it cannot be expected he will do," the Convention decided that for everyone's safety and honor Eden had to go. Because the president of his council would, technically, replace him, Eden's departure would not, said the Convention, "occasion a dissolution or suspenson of the present established form of government within this province, which this convention doth not think ought now to be changed." On 24 May 1776 Jenifer, William Paca, Thomas Johnson, and two others were delegated to convey the Convention's decision to Eden with a letter complimenting him on his actions on behalf of the "real interests of both countries" and asking him, while in England, "to promote a reconciliation upon terms that may be secure and honorable both to Great Britain and America." They looked forward to his return to office "whenever we shall happily be restored to peace."[88]

While Eden waited for transport home, his position in Maryland became even more precarious. Criticism from Virginia of the Convention's handling of Germain's letters encouraged criticism within the province. The Whig Club in Baltimore snarled their intent to seize Eden and hold him hostage "for the public safety." Eddis wrote in mid-June, "The governor appears rather anxious for [his ship's] arrival, and his friends are solicitous for his immediate departure." Finally, late on 22 June, HMS *Fowey* anchored off Tolly Point. The next morning, Captain George Montagu sent a flag of truce in to Eden, expressing his desire that the governor's departure take place without incident on either side. The Council of Safety warned vessels bound out of the upper Bay to stand off until *Fowey* had gone. After exchanging fond good-byes with friends who had escorted him to the dock, Eden boarded *Fowey* late on 23 June to a thirteen-gun salute. Montagu planned to leave the next morning. During the night, five servants from West River and a local militia deserter sought asylum on his ship, and the captain took them aboard. Predictably, the council reacted strongly to what they saw as a violation of the truce. For three days, with Eden's baggage still sitting on the dock, the council and Montagu exchanged increasingly angry messages: if the servants remained on *Fowey*, the baggage remained in Annapolis. Three small, armed vessels manned by excited local militiamen patrolled the mouth of the Severn, and the council ordered *Defense* to sail down from Baltimore — with the injunction that she "should not attack" *Fowey*. It was a good thing that everyone followed the council's caution. What the Americans did not know was that Montagu carried very definite instructions from the commander of the British fleet in the lower Bay. Should Eden be held in Annapolis against his will, "you are in that case to use your utmost endeavours to destroy the Town and otherwise distress the enemy by every means in your power." Presumably Montagu would not have reacted well to instigation from *Defense* either. With the baggage versus servants argument stalemated, Montagu gave up and on the 26th turned back down the Bay with Eden, the servants, and the deserter on board and Eden's luggage left behind.[89] This was probably the closest Annapolis ever came to attack in that war or any other, but

anxiety engendered by a hostile British fleet in the Bay became part of the city's genetic memory and haunted its residents for years to come.

The temper of the times changed radically between the Convention's expressed desire for reconciliation in May and Eden's departure a month later. Whether because of frustrated appeals from independence-minded men like Samuel Chase and Charles Carroll of Carrollton, or the compelling words of Thomas Paine in *Common Sense*, or the fact that almost every other colony had officially broken with Great Britain, on 28 June 1776 Maryland's Eighth Convention released its delegates in Congress to vote for independence.[90]

With this authorization, Maryland's delegates attending the Second Continental Congress, William Paca, Thomas Stone, and John Rogers, voted on 2 July that the colonies were "free and independent States" no longer under the control of Britain. Two days later, these three delegates approved the formal statement of the colonies' Declaration of Independence, written by Thomas Jefferson. But during the month that it took for Jefferson's draft to be written out on parchment, ready for signing, Maryland elected new delegates to Congress. When the Declaration was presented to members of the Continental Congress for signing on 2 August 1776, Maryland's representatives in Philadelphia were William Paca, Thomas Stone, Samuel Chase, and Charles Carroll of Carrollton, all four of whom appended their signatures to the document. For Paca and Chase, this act was the culmination of a decade of political protest. For Carrollton, the only Roman Catholic signer and one of the wealthiest, it was a pledge of faith in a new nation.[91]

In Annapolis, the delegates to the Eighth Convention had adopted their own "Declaration of the Delegates of Maryland" on 6 July, formally severing ties to both crown and proprietor. Maryland's Declaration was printed in the *Maryland Gazette*, along with the Philadelphia Declaration, on 11 July.[92]

War was a reality, ready or not, and Annapolis needed to get serious about its defense. With an appropriation of £10,000 by the Convention, the cooperation of the Council of Safety and most city residents, and advice from French engineer Monsieur Peticuson Dhugé, Captain Fulford set about constructing fortifications. Forts on Horn Point, Windmill Point, and across the Severn on Beaman's Point would enable cross fire that everyone hoped would make the enemy think twice about an invasion. Locals agreed either to work at the fortifications themselves or pay a substitute, and matrosses turned their attention from cannon to entrenchments. Bricks and stone intended for the new church were appropriated for other, more immediate needs.[93]

Dr. Richard Tootell set up a military hospital in the free school building on State House hill and put out a call for old sheets and linens, bee and myrtle wax, sassafras, sarsaparilla, and dogwood berries (properly cured). Governor Eden's former gardener, James Lillycrap, received permission from the Convention to supply the hospital and troops in Annapolis with vegetables raised in the hospital garden behind Daniel of St. Thomas Jenifer's house in New Town. Accidents and disease sent more patients to the hospital than the staff could handle, and Lillycrap reluctantly turned from gardening to attending the sick. When the hospital burned during the winter of 1777, the Council of Safety rented a house, probably near the dock. Neighbors complained, and three years later the operation was moved to the county's poorhouse. Dr. James Murray stepped in after Tootell died in 1780 and ran the facility until the end of 1783.[94]

Colonel Smallwood's battalion left for New York in July 1776, and news in September

(left)

Charles Carroll of Carrollton. Portrait by Joshua Reynolds, c. 1763. Courtesy of the Yale Center for British Art, Paul Mellon Collection.

(right)

Charles Carroll House, Duke of Gloucester Street. Evening Capital Historical and Industrial Edition, *May 1908. Courtesy of the Special Collections and Archives Department, Nimitz Library, U.S. Naval Academy.*

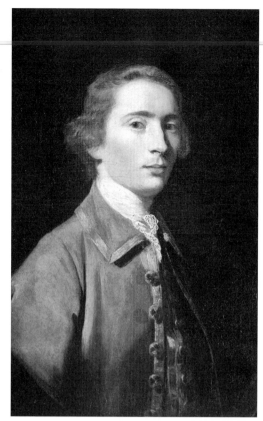

(left)

William Paca. Portrait by Charles Willson Peale, 1823. Courtesy of the Maryland State Archives, MSA SC 1545-1056.

(right)

William Paca House, Prince George Street. Evening Capital Historical and Industrial Edition, *May 1908. Courtesy of the Special Collections and Archives Department, Nimitz Library, U.S. Naval Academy.*

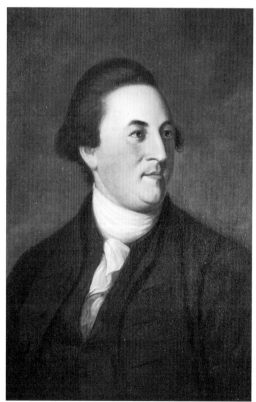

(left)
Samuel Chase. Portrait by Charles Willson Peale, c. 1773.
Courtesy of the Maryland Historical Society.

(right)
Chase-Lloyd House, Maryland Avenue. Evening Capital Historical and Industrial Edition, *May 1908. Courtesy of the Special Collections and Archives Department, Nimitz Library, U.S. Naval Academy.*

(left)
Thomas Stone. Portrait by John Beale Bordley, 1836.
Courtesy of the Maryland State Archives, MSA SC 1545-1116.

(right)
Peggy Stewart House, Hanover Street, bought by Thomas Stone in 1783.
Evening Capital Historical and Industrial Edition, *May 1908, drawing modified by Phyllis Saroff. Courtesy of the Special Collections and Archives Department, Nimitz Library, U.S. Naval Academy, and the author.*

made the war personal and tragic for households whose sons and husbands, brothers and fathers, had not survived the dreadful carnage on Long Island. Ordered to help cover the American retreat from Brooklyn, Captain Scott's Seventh Company joined a small force of other Marylanders who attacked a British stronghold valiantly again and again while their comrades swam to safety across a wide, fast-running creek. Of the 350 men of the First Maryland Regiment — the Maryland Line — fewer than a third survived that day. Will Sands and his captain were among the dead; drummer Meek and Private Fairbrother lived and continued to fight through the war. James Peale's older brother Charles found him on the Delaware shore in December so dirty and stricken he almost didn't know him.[95]

In the fall of 1776, the Ninth Convention prepared and adopted a constitution for the new state of Maryland. Written by a committee that included Charles Carroll, Barrister, Paca, Chase, Charles Carroll of Carrollton, and Thomas Johnson, the new "Form of Government" was "the most conservative of all state constitutions developed during the Revolutionary era," with property requirements for voters and officeholders alike. Annapolis retained its two delegates to the General Assembly, a privilege it now shared with Baltimore Town. What Annapolis did not get was the assurance that it would remain Maryland's capital. Article 9 of the Declaration of Rights called for a fixed place for meetings of the legislature, "most convenient to the members thereof." Article 23 of the Constitution ignored location altogether, saying only that the General Assembly shall "meet annually, on the first Monday in November."[96] The city would regret this omission.

A bright spot in the first year of the war was the inauguration of the new state's first governor. In ceremonies at the State House just after noon on Friday 21 March 1777, Annapolis lawyer Thomas Johnson, Jr., took the oath of office before a mass of spectators. Following a salute of three volleys of small arms fire and thirteen cannon rounds, Governor Johnson and the assembled dignitaries, officials, citizens, and "Gentleman Strangers" recessed to the coffeehouse for dinner and thirteen toasts. The first toast? "Perpetual union and friendship between the states of America." An elegant ball concluded the festivities. Only the death of a matross, who ran through the smoke in front of a cannon when it fired, marred the day.[97]

By the summer of 1777 there were cannon, mostly eighteen-pounders, installed in a battery along the shoreline from Windmill Point to Eden's garden. A covered way ran from Eden's wharf to upper Cornhill Street for protected access to the seat of government and the populous dock area. Across the Severn, on a high promontory, a few cannon overlooked the harbor. Horn Point received the greatest attention. There, on the easternmost end of the peninsula about thirty feet above the water, Captain Fulford's men built a very substantial, traditional French fortification, with a ditch studded with pointed logs, a parapet, firing platforms, and parade. Trenches and zigzagged covered ways reached back into the interior of the peninsula for access to supplies and communication across Spa Creek. Three companies of matrosses, about 180 men, manned the forts, and Eddis reported that, "in spite of Experience" (or the lack of it), "they talk confidently of making a vigorous Resistance in Case of Attack."[98]

As the war progressed, men and matériel flowed into and out of the city. Government spending kept craftsmen and merchants afloat; soldiers kept taverns going; visitors took up lodging in ordinaries and boarding houses. "The Revolution transformed Annapolis from a town of wealthy consumers and their suppliers into an armed camp and distribution center for the war effort." Soldiers mustering in from across the state crowded dusty streets. The clack of small arms, the ever-present drum calls, the cries of carters easing

horses through the throng assaulted the ears of all. And the smells — oh, the insufferable smells! Thomas Hyde's tanyard was turning out leather for the state, and the "intolerable stench" of drying hides coupled with the ripeness of slaughtered animals being processed for army meals made life impossible for locals and troops alike. The Council of Safety, meeting in Annapolis and well aware of the problem, ordered these activities removed from the city.[99]

Housing the soldiers stationed in Annapolis or just passing through presented the same sorts of problems residents had faced in 1757. By this time, the city boasted maybe three or four hundred dwellings, but even that number could not accommodate the regiments of troops that needed quartering.[100] John Bullen, a city councilman and militia captain, was instructed to find vacant houses that could be rented cheaply and would not cost a fortune to repair if damaged. Given that a few of the largest potential billets in town, Lloyd Dulany's house for instance, were too valuable to be subjected to army use, Bullen's job could not have been simple. He probably adopted Governor Sharpe's solution in that earlier war and housed the bulk of his charges in tents on the outskirts of town. Judging from the house owners who received compensation after the war, some troops stayed in the dock area on Fleet Street and Market Space and others were lodged in Benedict Calvert's house on State Circle and in William Adams's unfinished mansion on Charles Street. The last cost the government almost £450 in rent and damages. The prison succumbed completely to several years' occupation by Continental soldiers and had to be replaced.[101]

Loyalist William Eddis, who left Annapolis in early June 1777 and wound up in British-occupied New York City, wrote admiringly of the "magnificent appearance . . . exhibited by the departure of the grand fleet," on 23 July. "Whither they are bound is to the public an impenetrable secret; but if the consequences are what might be expected from the apparent strength of the armament," he said, surely the war would soon be over. "Whither they were bound" turned out to be his former province, now state, with its valuable water route to Philadelphia. News of an estimated two to three hundred ships, armed and hostile, rounding the Virginia capes, at the mouth of the Chesapeake Bay, sent shivers of fear throughout the Tidewater. Annapolis residents pondered the likelihood that the fortifications they had worked on so diligently would save them, and most packed up and took off. Charles Wallace, still superintending construction of the State House, later excused his delays by saying, "[W]hen the British fleet appeared in our bay all my workmen left me and fled from the City to the interior parts of the State" and refused to return. On 20 August, when the British fleet was only verbal reports and handwritten alarms, Governor Johnson and his council ordered everyone out of town except men who could bear arms. Specially mentioned in that order were persons who had not signed the Association of Freemen and did not "instantly take up Arms." Those individuals were given five hours to get at least ten miles out of town. Servants and slaves could remain long enough to remove household goods if under their masters' supervision. The next day, when the largest, most impressive fleet anyone in Maryland had ever seen — some bright soul counted 260 vessels — sailed, for hours, past the mouth of the Severn, Governor Johnson and the council decided, "Annapolis cannot be defended by any force which may probably be collected against the force the Enemy may at any Time bring against it." Fulford agreed. The governor and council removed themselves to Baltimore.[102]

The British had no designs on either Annapolis or Baltimore; their objective lay farther north. After disembarking in the Elk River, men under General Sir William Howe marched on to rout the Americans near the banks of the Brandywine River on 11 September and oc-

cupy Philadelphia fifteen days later. Their cargo unloaded, a few warships cruised back down to lie off the Patapsco and Severn in early September, but when joined by the rest of the fleet in midmonth, they all proceeded swiftly down the Bay.[103]

Municipal business during the war years included adjustments to the reality of city development and attempts to increase city income. The town fence, "found to be entirely useless" and too expensive to repair in 1775, was torn down and the posts and rails auctioned off "for the use of the Corporation."[104] With improvements and growth around the dock, the corporation admitted that the old Ship Carpenter's Lot was no longer used for shipbuilding. Legislation in 1777 allowed the city to sell or lease the lot for whatever activities the corporation thought advantageous. The same act also gave the corporation the right to impose a property tax to fund city government — constables, clerks, the Mayor's Court prosecutor, meetings of court and corporation — and repairs to streets and dock. Whatever fines and fees had reached city coffers until this time were inadequate for expenses. This, the first citywide tax, allowed the corporation to collect six pence on each one hundred pounds worth of property. Of course it was not enough, and the city went back to the legislature in 1779 for an increase to five shillings per hundred pounds of property value. The 1779 law also gave the municipal government more power over the regulation of liquor sales and the licensing of ordinaries and allowed the corporation to sell Temple and Dean Streets. Whether either of these streets had ever been cut through is unclear, but in 1779 they were "stopped up and useless to inhabitants."[105] The city did not act on Temple and Dean Streets until the summer of 1784, when a bylaw authorized the sale. The same bylaw warned citizens to beware persons attempting to sell parts of the Ship Carpenter's Lot. After years of ignoring encroachment on the Ship Carpenter's Lot — Patrick Creagh's 1748 patent, for instance — a more rigorous city government needed to assert its rights to the land. The result was a frustrating and acrimonious court fight that continued for almost forty years and ended with acknowledgment of the city's authority to dispose of the land by lease or deed.[106]

As the war dragged on through 1778, 1779, and 1780, Annapolis continued its role as military supply depot. Hundreds of barrels of food; thousands of items of clothing, bedding, shoes; knapsacks, medicines, ammunition, weapons — all went through Annapolis in fact or on paper. And paper was in short supply. Printer Frederick Green, who had taken over the *Maryland Gazette* when his mother died in 1775, cut the *Gazette* to a single sheet of paper in August 1777 and ceased publication entirely at the end of the year. For the next sixteen months, the city had no newspaper. When the printer of a Baltimore newspaper threatened to expand to Annapolis in April 1779, Frederick Green revived his family's paper in partnership with his brother Samuel.[107] During the late 1770s, with war action removed from the upper Bay, the Severn forts fell into disuse and artillery men were transferred to other units. A few men remaining at Fort Horn, most of them invalids, occupied their time testing gunpowder, probably under the supervision of state armorer John Shaw. By 1780, Fort Horn had passed into civilian control, and Captain Fulford resigned his commission.[108]

Blockades, which interrupted accustomed trade routes, and the diversion of locally produced foodstuffs to army use meant hardship for people in Annapolis. In the spring of 1779, groups of armed men went out into the county looking for farmers who had food-

stuffs to sell. Should the farmer not agree to the price offered, his stores might be taken by force and sent to Annapolis for distribution. One county planter angrily named Charles Wallace, William Faris, and the Middleton brothers as leaders of a "mob" of more than a hundred "lower class" men intent upon plundering "the country people" "until their savage appetites are satisfy'd."[109] This did nothing for city-county relations.

Families who could escape the dirty dreariness of the town did so as often as possible. Women whose husbands were away from home on military or government work found country plantations, whether their own or those of relatives or friends, safe if sometimes a bit dull. The perennially pregnant Molly Carroll, wife of Charles Carroll of Carrollton, spent months at her father-in-law's estate, Doughoregan, but on occasion she visited Molly Ridout at Whitehall, former governor Sharpe's impressive country villa. Sharpe had traveled to England in 1773, leaving the estate in the care of his former secretary. He never returned. Writing to her mother, Anne Tasker Ogle, in 1778, Molly Ridout assured her that America was "not at all disagreeable[,] and as to our little town I believe I may . . . say you would like it as well as ever you did[,] tho there are not so many people in it as when you left it." Anne Ogle had sailed with Sharpe to put her Ridout grandson in school and visit another daughter, then living in England. During the war, the Annapolis-born Anne moved her household to France, where she felt more comfortable as an American expatriate. Molly Ridout also enjoyed summer vacations at Bath, the new resort in the Virginia hills that George Washington had talked about on his visits to Annapolis before the war. Restorative warm springs may have been the ostensible draw for Maryland and Virginia gentry, but the dancing, suppers, teas, games, and visiting were particular attractions. Charles Carroll of Annapolis, Molly and Charles Carroll of Carrollton, and Daniel of St. Thomas Jenifer were other Annapolitans who made the trek to the mountains.[110] Molly Ridout's sister-in-law, Henry Margaret Ogle, may not have gone to Bath, but she did spend time at the Ogle estate, Belair, in Prince George's County, and on her own family land on the Annapolis Neck peninsula. Henry Margaret, descendant of the seventeenth-century captain Richard Hill, had inherited Hill land across Spa Creek and at Tolly Point.[111]

The majority of local men and women, however, remained in town, either involved with the war effort or coping with its effect on business. Very few left journals or letters recording their lives for later generations. More typical of the town's women than Molly Ridout or Henry Margaret Ogle was Frances Bryce, whose sea captain husband, Robert, died in 1772, leaving her seriously in debt. With two young children to care for and her house and lot on Northwest Street mortgaged to Henry Margaret's husband, Frances needed income. She began taking in boarders, first probably in her home and later in larger houses elsewhere in town.[112] Frances was not the only widow to keep a boarding house in Annapolis during this period. Mary Ghiselin, living in Alexander Ferguson's fine brick house on West Street, opened a boarding house after the death of her husband, Reverdy. Ann Middleton ran Horatio Samuel's tavern and ferry business for six months after his death and then notified customers that she would keep the ferry going but would accept only boarders, not taverngoers.[113] Ann Burman Gaither took boarders into her house at the bottom of Church Street, which had been rebuilt after the Hood incident.[114] Widow Sarah Flynn advertised "private lodgings" for ladies and gentlemen at her home, also near the dock.[115] Other boarding house keepers, such as the widow Maw, can be identified only when they are mentioned in other people's *Maryland Gazette* ads, and there were no doubt more who helped support themselves and their families by renting out a room or two, especially when the town over-

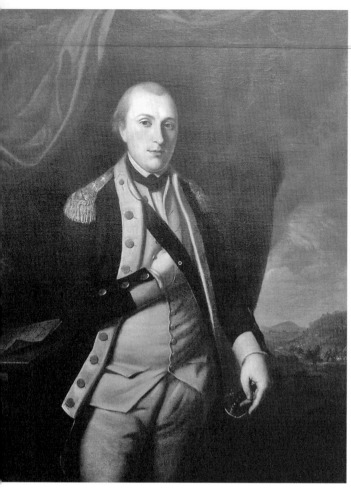

The dashing young Frenchman Gilbert du Motier de La Fayette enlivened the Annapolis social scene during the Revolution. Charles Willson Peale's 1779 portrait did not disguise the fact that the hardships of war had cost the twenty-two-year-old marquis much of his hair. Courtesy Washington-Custis-Lee Collection, Washington and Lee University, Lexington, Va.

flowed with transients. With the exception of Mary Howard, who continued the coffeehouse after the death of her husband and ran it successfully for many years, women seem to have distanced themselves from tavern keeping by the Revolutionary period.[116]

It was on Henry Margaret Ogle's land that the next wave of military excitement landed, in March 1781. Twelve hundred American troops under command of Major General Gilbert du Motier, Marquis de Lafayette, the young Frenchman who had volunteered for American freedom and won the confidence and friendship of General Washington, were headed south to intercept the traitor Benedict Arnold and end the war. When the expected French ships did not arrive at Head of Elk (now Elkton) to transport Lafayette's men to victory, Maryland mustered every available small boat and brought them to Annapolis. There they camped on the Ogle farm across Spa Creek from the city about a mile from the Hesselius plantation, Primrose Hill. While Lafayette scouted down the Bay for a rendezvous with his countrymen, his soldiers drilled and relaxed on the banks of the creek. Gentlemen of the town held a ball for the officers, some of whom were French, and Henry Margaret probably expressed the sentiments of most of her friends when she gushed, "I like the French better every hour. . . . We abound in French officers, and some of them are very clever." The troops were from New England and New Jersey, and they amused themselves with duck hunting and fishing. One party caught "three hundred fish of different kinds" off Tolly Point in a day's sport.[117]

For the three weeks that Lafayette's regiments were in Annapolis, two armed British sloops, *Hope* and *Monk*, stood off the mouth of the Severn, watching, but not idle. Raiding parties from the vessels sailed to West River in late March and destroyed the shipyard owned by Stephen Steward and Samuel Galloway. Lafayette's reconnaissance trip ended when he learned of the French fleet's loss at the first Battle of the Capes and decided to return his men to the safety of the upper Bay. Henry Margaret Ogle had described Lafayette to her mother-in-law, Anne Ogle, as "everything that is clever." Would he be clever enough now to get his men out of the Severn past *Monk* and *Hope* and back to Head of Elk? Yes, he was. Calling upon Maryland's privateer brig *Nesbit* and a few small armed vessels under Commodore James Nicholson to convoy and protect them, Lafayette embarked his men and headed out the river, expecting a fight. "I expect every moment to hear the cannon," wrote Henry Margaret. "Everybody seems quite anxious to know the fate of this day." But the British hauled off. The Americans returned safely to the head of the Bay, only to be ordered south again — this time by land.[118]

As the war in the lower Bay heated up in the fall of 1781, Annapolis tensed at each invasion rumor, even as hurriedly gathered regiments marched from town to join the Southern Army. Regular army battalions arriving from Head of Elk on transport vessels loaded to the gunnels with men, arms, ammunition, and supplies, stopped in the Severn to take on water and provisions.[119] Dr. James Thacher, a surgeon in the Continental Army whose

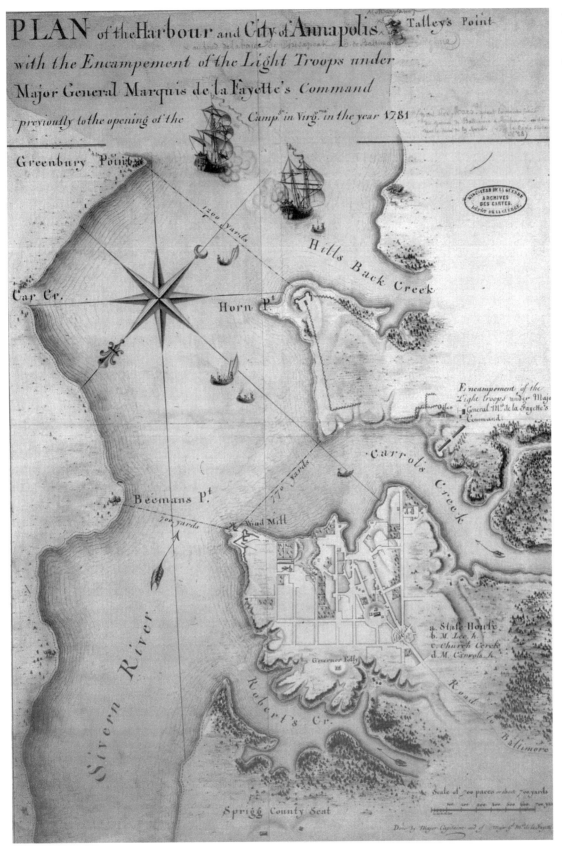

"Plan of the Harbour and City of Annapolis" by Major Michel Capitaine du Chesnoy, aide to Major General Lafayette, 1781, looking southeast down the Severn River from Robert's (now College) Creek to Talley's (now Tolly) Point. This remarkably accurate map locates Revolutionary forts, the encampment of Lafayette's troops, and major structures in the city, including "Governor Folly." Courtesy of the Maryland State Archives, MSA SC 1399-1-333, from the original in the library of the ministry of defense, Dépôt de la Guerre, Paris.

journey south was delayed by a sea battle at the capes in mid-September, took advantage of the hiatus and toured Annapolis. It was, he wrote in his journal, "a very inconsiderable city, but the buildings are chiefly of brick, and many of them are in a style of elegance and grandeur." He especially approved of the State House, "a most splendid and magnificent piece of architecture." City residents treated him "with much politeness and hospitality," and he was invited to dine "at the house of a respectable gentleman," whom he unfortunately does not name. The evening ended with an amusing performance at the theater.[120]

Following Admiral Comte de Grasse's decisive victory at the Chesapeake capes, which ended the British blockade of the Bay, four thousand men under General Comte de Rochambeau made an abrupt left turn on their march from Baltimore to Alexandria and arrived in Annapolis to take passage on French warships that had sailed up the Bay to get them. Traveling with the troops was Rochambeau's chaplain, Abbé Robin, who was overwhelmed by the opulence he saw in this town, even though he, too, termed it "inconsiderable." The "riding machines" he saw around the town, "light and handsome, and drawn by the fleetest couriers, managed by slaves richly dressed" impressed him, and he thought the State House the most beautiful of any building he'd seen in America. But it was the "Female luxury here" that awed him most. Robin is the source of that oft-repeated, and no doubt apocryphal, gem: "a French hair dresser is a man of importance among them, and it is said, a certain dame here hires one of that craft at a thousand crowns a year salary." Rochambeau's men camped briefly on the western approaches to the city, along the edge of Dorsey Creek.[121] Local historian David Ridgely, writing in 1841, identified the back campus of St. John's College as the site of the French encampment and mentioned the burial mounds of soldiers who died there. His nephew, Elihu S. Riley, wrote seventy years later that the "long and sunken rows" of their graves were visible until the Civil War. In 1911, the Sons of the American Revolution erected a monument near the creek in memory of the Frenchmen who helped win the war for America.[122]

News of Cornwallis's surrender at Yorktown 19 October 1781 reached Annapolis by "express boat" the next day, and Governor Thomas Sim Lee sent Jonathan Parker, the "State House messenger and janitor," to Congress, sitting in Philadelphia, with the report. Townspeople reacted with "joyful acclamations." Two days later, after Washington's aide-de-camp, Marylander Tench Tilghman, had stopped by on his own way to Philadelphia with the official dispatches, the artillery and militia fired a *feu de joie* and householders illuminated the town in celebration. When General George Washington himself came through Annapolis a month later, also en route to Philadelphia, Frederick and Samuel Green enthused on his outstanding character, feats, and reception by the city for a whole column, in poetry and prose, in the *Maryland Gazette*. "People of every rank and every age eagerly pressed forward to feed their eyes with gazing on the man, to whom, under Providence, and the generous aid of our great and good ally, they owed their present security, and their hopes of future liberty and peace." For two days Washington was feted at public and private events, including an assembly, "to afford [the ladies] an opportunity of beholding their friend and thanking their protector with their smiles." The *Gazette* also printed the formal messages of praise and thanks from the General Assembly and the citizens of Annapolis with the general's modest and appreciative replies. Washington probably stayed with the governor in the house he knew well from Race Week visits with his friend Robert Eden less than a decade before.[123]

In the winter of 1781, the General Assembly passed the first legislation confiscating the property of British citizens who had left Maryland before the war. Anyone returning prior

to March 1782 and taking the oath of allegiance to the new state would be excepted. Specifically excepted by name in the law was the property of Anne Tasker Ogle, who was still in France.[124] In Annapolis, more than fifteen Stoddert lots, many with houses, plus Walter Dulany's windmill, the old Tasker house on Market Street, and warehouses on the dock, all the properties of Loyalists Lloyd Dulany and his nephews Daniel Dulany of Daniel and Daniel Dulany of Walter, were sold at auction between 1781 and 1783. Samuel Chase contracted to buy quite a lot of Dulany land on West Street but never paid for it, and the lots had to be resold later. Established innkeeper George Mann bought Lloyd Dulany's large house facing Church Street on the east side of Conduit and turned it into the city's premier banquet facility and guest house. The state appropriated Eden's house for continued use as the governors' residence. Proprietary land in Annapolis, also confiscated, included the Revenue Office, three Stoddert lots, and some unspecified acreage. The couple of individual lots or leases titled to deceased residents whose only heirs were in England were also confiscated. Proprietary official John Clapham had hedged his bets by making a deal in 1779 with his brother-in-law and Charles Street neighbor Frederick Green. If the British won, ownership would not change. If the Americans won, Clapham would sell his house and lots to Frederick, which he did in 1784, when he returned from exile in England.[125]

Bennett Allen, Jonathan Boucher, Lloyd Dulany, Daniel Dulany of Daniel, Daniel Dulany of Walter, and Anthony Stewart were indicted in May 1781 for high treason. Presumably because their Maryland property had been seized and sold, their names were struck off the indictment the following year. All made claims to the British government for compensation, but the amounts received could never cover their losses. The other Annapolis Loyalists, like most in Maryland, remained in the country, kept a low profile, and paid the treble taxes required of men who did not take the oath of allegiance. Their property was not seized.[126]

Cornwallis's surrender was not the end of the war. Hostile actions continued in the lower Bay, and provisions and men for the state's navy continued to pass through Annapolis. But townspeople appeared to relax a bit and indulge in a few prewar pleasures. Horse racing returned to the Annapolis course in October 1779 and 1782, although the Jockey Club did not reorganize until March 1783. Advertisements in the newspaper picked up, with craftsmen again placing ads for goods and services: musical instruments sold and repaired, tailoring done, sales of fine leather gloves and breeches "as good as any in Baltimore Town." That last enticement, by Jonathan Brewer, signals the shift that would relegate Annapolis to the backwaters of commerce for two centuries.[127] A French officer, visiting in 1782, caught the situation immediately: "Annapolis was very commercial before the war, but, for some years all the commerce has gone to Baltimore."[128] Another European traveler the next year was even more blunt: "There is little or no trade," he said. Farmers preferred to sell in Baltimore and Annapolis merchants got "most of their stocks from Baltimore."[129]

But the city could put on a great celebration. And that is just what it did in April 1783 following the proclamation of peace. Annapolis residents, state officials, and visitors (among them a number of "gallant" French officers) enjoyed several days of horse racing and theatrical productions capped by official events on 24 April. A special building was erected on Charles Carroll's point, overlooking Spa Creek, "sufficient for the Accommodation of many Hundreds" of happy people. A whole ox and some unknown number of sheep and calves were roasted to feed them, "besides a world of other things. Liquor in proportion." Thirteen cannon volleys announced the event, and gentlemen drank thirteen "truly liberal, generous, and patriotic Toasts," "each attended with Thirteen Cannon." As darkness fell, candles ap-

Annapolis councilman and silversmith John Chalmers made these silver coins at his shop on Cornhill Street in 1783, either just before or during the meeting of Congress in Annapolis. The shilling, sixpence, and threepence shown here were standard weight coins to replace the cut pieces of Spanish coins then common but of unreliable weight. Chalmers also made a shilling with thirteen stars and thirteen rings that may have been his prototype for a national coin. Courtesy of Willard R. Mumford.

peared in the windows of the State House, making it "beautifully and magnificently illuminated." A ball at the city ballroom ended the day, although Walter Dulany's widow suggested in a letter to her Loyalist son Walter, Jr., that it might better be postponed; "I am horribly afraid our gentlemen will have lighter heads than heels," she said.[130]

No sooner had the city recovered from celebrating the official end of the war than it learned of a momentous opportunity: Annapolis might be selected as the permanent meeting place of the Continental Congress! Congress had sat in several cities, including Baltimore Town, during the war, but now there was talk of settling the federal government in one city, and Maryland's delegates had put Annapolis in the running.[131] The city corporation met formally on 12 May 1783 to consider their response. Yes, they agreed that Annapolis was centrally located, accessible by water and land, healthy, and had the "capacity of Defense." Indeed, the corporation decided their city was "the Most Eligible Place in the United States" for this honor, but they felt obligated to consult the citizens before giving away the town. There was this jurisdictional consideration: Congress expected to have full authority over the people living in any location it chose for its permanent capital. A flurry of handbills called residents to a meeting the following morning, where they apparently gave their unanimous consent. On 14 May, Mayor James Brice, Recorder Samuel Chase, and ten of sixteen aldermen and common councilmen met to resolve that the General Assembly should offer the city and its precincts (of "above" three hundred acres) to Congress. Speaking for its constituents, the corporation stated firmly, "[We] [c]onsent to be subject to such Jurisdiction and Power within the City and its Precincts and over the Inhabitants and Residents thereof as the General Assembly shall think proper to grant to the United States in Congress Assembled."[132]

Members of the General Assembly seem to have had no reservations in recommending the state capital to Congress. In fact, the resolution passed by both houses offered Congress the State House, State Circle itself (except the free school, the old Council House then being used by the Anne Arundel County Court, and the Treasury Building), and the governor's house. Furthermore, the Assembly agreed to spend up to £30,000 to build residences and other buildings for the use of the thirteen states. Although Maryland's was the handsomest offer of all the states vying for the capital — each of the middle states put forth at least one town — Congress decided in late October that perhaps two new federal towns might be the best solution. As a consolation prize, Annapolis got the nod to be the temporary seat of Congress alternately with Trenton until the new capitals could be built. On 3 November 1783 Congress adjourned to meet in Annapolis three weeks later.[133]

City officials were notified of Congress's plans in a letter from Maryland delegates James McHenry and Daniel Carroll written on 23 October. They had less than a month to prepare. If every congressman showed up, there would be fifty-seven delegates, plus other officials, foreign dignitaries, servants, wives, petitioners. Meeting on 1 November, the corporation appointed a committee to check what accommodations might be available and see how

much they cost. McHenry warned them to keep prices reasonable. There was little time to spruce up the town, but the corporation did order some necessary street repairs.[134]

As it turned out, congressmen were slow to arrive and quick to depart. Only a few spent the entire session in Annapolis, and some never came at all. The Maryland legislature, then meeting, turned its Senate Chamber over to Congress and offered the governor's residence to Thomas Mifflin, president of Congress. On 26 November, the day appointed for the session to begin, there were only a handful of delegates in town. Not until 13 December were there the two delegates each from seven states required for Congress to do business. The most important event on the congressional agenda was ratification of the Treaty of Paris, but for action on that issue nine states would have to be represented. In the meantime, they would accept the resignation of General George Washington, hero of the Revolution.[135]

If ratification of the Treaty of Paris was the most important national event to take place in the Maryland State House, then the resignation of the country's military commander-in-chief was second in its significance for the future of the new nation. In a carefully scripted ceremony, Washington returned to the civilian Congress the military authority given to him in June 1775. No matter that he was, in 1783, more popular by far than the body to which he delivered his commission. It was the precedent that was important: the United States would be governed by civilian laws, not military might.[136]

General Washington rode in from Baltimore on the evening of Friday 19 December, to be met a few miles outside town by Generals William Smallwood and Horatio Gates and a number of local dignitaries.[137] A thirteen-cannon salute greeted his arrival in town, where he was escorted to rooms at George Mann's new tavern. Washington probably felt right at home at Mann's, since he had dined there in the early 1770s when the house belonged to Lloyd Dulany. Over the next three days, the legislature and members of the community treated the general to the best they could offer in food, drink, and appreciation. Among those with whom Washington dined were his old friend Robert Eden, now First Baron of Maryland, and the last proprietor of Maryland, Henry Harford, both of whom had come to Annapolis the previous summer in hope of gaining return of or restitution for their confiscated properties from the General Assembly. Harford was the third illegitimate Calvert heir to visit Annapolis, and he seems to have participated happily in the events of the winter. On Monday, Congress held an elaborate dinner at the ballroom, catered by George Mann, for some two hundred "persons of distinction." After dinner the guests drank the ubiquitous thirteen toasts, accented by "the discharge of the artillery." Washington responded with an optimistic toast of his own: "Competent powers to congress for general purposes." That night the General Assembly gave a ball at the State House, which was "beautifully illuminated" by eight pounds of candles. "A very numerous and brilliant appearance of ladies were present." Mann supplied supper, wine, a potent punch, and twelve packs of cards for entertainment at the ball. Congressman James Tilton of Delaware reported that the general "danced every set, that all the ladies might have the pleasure of dancing with him, or as has since been handsomely expressed, *get a touch of him.*"[138]

The next day, Tuesday 23 December 1783, General George Washington attended the meeting of Congress and, following the protocol devised by Thomas Jefferson, Elbridge Gerry, and James McHenry, bowed to the seated delegates as he stood to speak. They lifted their hats, but did not rise and bow to him, thus acknowledging their respect for the general while asserting their superior status. In a voice carefully controlled against emotions so clearly felt, the general delivered his speech, praising the officers and men of his com-

mand and, now, "bidding an Affectionate farewell to this August body under whose orders I have so long acted, I here offer my Commission, and take my leave of all the employments of public life." Following President Mifflin's brief remarks of acceptance, Washington again bowed, the delegates again lifted their hats, and Congress adjourned. Private citizen Washington said farewell to the assembly and left immediately for Mount Vernon, anxious to be with Martha for Christmas. Governor William Paca rode with him as far as South River.[139]

Only nineteen congressmen participated in that day's proceedings in the old Senate Chamber. But the room was packed with members of the Maryland legislature, city officials, and other dignitaries, including Sir Robert Eden and Henry Harford. Ladies crowded into the gallery. James McHenry, writing to his fiancée in Philadelphia, described the scene: "It was a solemn and affecting spectacle; such an one as history does not present. The spectators all wept, and there was hardly a member of Congress who did not drop tears." James Tilton and the *Maryland Gazette* attribute tears only to the women, with the *Gazette* reporting "few tragedies ever drew more tears from so many beautiful eyes, as were affected by the moving manner in which his Excellency took his final leave of Congress." Molly Ridout wrote to her mother, Anne Ogle, that "the General seem'd much affected himself that everybody felt for him, he addressed Congress in a short speech, but very affecting[,] many tears were shed. . . . I think the World never produced a greater Man & very few so good."[140] King George III is reported to have told American-born painter Benjamin West that if Washington won the war and returned to his farm, "he will be the greatest man in the world."[141]

Delegations from the requisite nine states finally assembled in mid-January and gave their unanimous approval to the Treaty of Paris on 14 January 1784. Because the deadline for its return to the commissioners in Paris was close and Congress feared the consequences of a lost document, three copies were shipped, each by a different route. Molly Ridout sent her letter with one of the couriers and assured her mother that it would arrive speedily. As it happened, one copy of the treaty never left the country and the other two were held up in ice-packed ports. The treaty arrived late (as did Molly's letter), but no one was inclined to quibble. Ratified documents from Congress and King George III were exchanged by their representatives on 12 May 1784.[142] It had been just ten years since the Boston Port Act pulled Maryland, and Annapolis, into the national sphere.

Congress continued to meet that miserably cold winter, but because there was rarely a quorum, it accomplished little more than an airing of opinions on how to handle the western territories. Petty irritations and arguments over delegates' credentials seem to have occupied far too much time. Outside the State House, concerts, informal hops, dinners, and tea parties made the winter pleasant for locals and for the southern delegates, most of whom were young bachelors. There was even romance. Virginia delegate John Francis Mercer courted Sophia Sprigg, daughter of Richard Sprigg, and the two were married the following year. French officials visited and improved the social scene for the smitten Henry Margaret Ogle, who wrote, "The town is very agreeable." She and Benjamin dined every week with President and Mrs. Mifflin and enjoyed the fortnightly balls. Eden and Harford kept up with the activities, although Molly Ridout noticed that Eden seemed "in bad health. He does not flirt now."[143]

With limited and often tardy per diem allowances from their states, many delegates complained that Annapolis was too expensive. A month's lodging at Mann's Tavern cost about £15; room and board at one of the city's boarding houses might run £20 a month,

not counting the cost of firewood. Travel, food, laundry, barbers, stabling for horses — it all added up, even for Thomas Jefferson. Jefferson boarded with Mary Ghiselin on West Street for a couple of months before moving with James Monroe to the old Dulany house on Church Circle. They engaged a French chef, but tried to live frugally, unless there were visitors such as George Washington, who stopped in Annapolis in April on his way north to a meeting of the Order of the Cincinnati. For delegates of modest means, the expenses and the lack of serious congressional business made their stay in Annapolis less than optimal.[144]

The New Englanders were especially unhappy in Annapolis. Generally older than their southern counterparts and almost all with wives and family at home, they were less inclined to enjoy the social festivities, even could they have afforded them. A modern historian decided that "they all seemed touched with the puritanism of the proverbial Yankee. They found the social life frivolous, if not sinful."[145] Elbridge Gerry of Massachusetts summed up New Englanders' view of the city: "The Inhabitants are almost universally disposed to enjoy themselves. Balls, Plays, dining and Tea parties, engross the Time of the Ladies, Hunting, Fishing, gaming, Horseracing, etc. that of the Gentlemen. Those of Congress who are wholly devoted to Pleasure, if there are any such, may indulge their Inclinations by being courteous and attentive to the Inhabitants; those who are for dispatching the publick Business, will never be interrupted by the Citizens of Annapolis, for the Idea of Business to them is neither agreable nor reputable, . . . this is not a place capable of administering much to my pleasure, or of promoting my Happiness."[146] It was an attitude the city would see again from New England visitors.

Congress adjourned on 3 June 1784 to meet in the fall at Trenton. The Committee of States, composed of one delegate from each state, remained in Annapolis over the summer as an administrative body; but again, attendance was spotty, and little seems to have been accomplished. The dreadfully cold weather of the winter gave way to the Tidewater's usual summer heat, and by August the New Englanders had had enough. They left. With a depleted committee, the remaining members adjourned on 13 August. Congress had had enough of Annapolis, and there was no more talk of alternating sessions with Trenton.[147]

It appears that Annapolis was not sorry to see the end of its congressional experience. Yes, the men and women who provided housing, food, transportation, and other services had benefited financially; but the bickering, complaints, and general dissatisfaction with the business of Congress must have made those boarding house dinner-table conversations pretty miserable. Aside from the excitement of Washington's visit and the pleasures of society, in which only a small percentage of city residents participated and which were little different from the city's usual social activities, the atmosphere seems to have been strained. The homesick men, far from family and with limited funds and little to do, had not been happy guests.[148]

In Annapolis, 1784 was a time of farewells, a time of change. Sir Robert Eden, after a year at Upton Scott's house on Shipwright Street, succumbed on 2 September to dropsy, complicated by fever. For some reason the *Maryland Gazette* did not print a notice of his death; Baltimore's *Maryland Journal* carried a brief obituary on 10 September. Eden's body was buried at the church of Westminster Parish (now St. Margaret's), not St. Anne's, and over the years a legend of mysterious secrecy grew up around this seemingly unusual event. Naval Academy professor Henry F. Sturdy recounted the tale in his twentieth-century guide-

books, saying that because burying the former governor in Annapolis was "deemed unwise," his slaves carried the body down Shipwright Street in the dark of night and smuggled it aboard a boat to be ferried across the Severn.[149] Eden's biographer, Rosamond Randall Beirne, debunked the legend in wonderfully elaborate detail in 1950, although that doesn't seem to have had much effect on its propagation. According to Beirne, the vestry of St. Anne's was not allowing burials in the churchyard at that time, and Westminster Church, then located near the present-day community of Winchester, offered an easily reached alternative. Remains identified as Eden's were discovered in 1925 after a long, involved search. They were reinterred within Church Circle the following year, with the approval of Eden's descendant Sir Timothy Eden and financing by the Society of Colonial Wars and the state.[150]

Henry Harford remained in Annapolis after Eden's death, pursuing his claims against the state government for the loss of proprietary revenue and confiscation of about 245,000 acres of proprietary land. The Oxford-educated young man seems to have been comfortable in Annapolis society; James McHenry described him as "governed by a discretion beyond his years." The Ogles were especially fond of him. Henry Margaret had him over for tea, and Ben took him fishing. When Henry Margaret died two decades later, among her belongings was a "miniature of Mr. Harford set with stones." The General Assembly refused Harford's appeals altogether in 1786, and he returned to England. His claim to the British government was more successful and he received some compensation over the years.[151]

In November 1784, Annapolis saw another leave-taking, this one occasioned by the return of the Marquis de Lafayette to France. Having left America after Yorktown, Lafayette had missed the conclusion of the war and the celebrations that followed. He had come back in the spring of 1784 to say a formal farewell to his troops and to visit his beloved General Washington. Finally, after months of lionization, it was time to go home. Washington traveled with his young French friend from Mount Vernon to Annapolis, where city and state officials outdid themselves in joyful recognition of the service both generals had paid America. The General Assembly provided "an elegant ball . . . for their entertainment" and proclaimed Lafayette "and his male heirs for ever . . . natural born citizens" of Maryland. Although Washington had planned to accompany Lafayette to the ship in New York, he felt tired and decided to go back to Virginia. Lafayette's biographer tells the sorrowful tale of the two men leaving Annapolis, their carriages abreast until the road divided and they waved a final goodbye. When he reached Mount Vernon, Washington wrote Lafayette a letter of foreboding, anticipating an early death, convinced they would not meet again. Lafayette responded quickly, before his ship sailed, ending, "Adieu, my dear General; it is not without emotion that I write this word, altho' I know I shall visit you again." But he didn't. By the time Lafayette could return for one last pilgrimage to America, in 1824, the country's beloved general and first president was gone.[152]

When the city returned to normal after the war and the excitement of Congress's visit, the corporation embarked on a list of municipal improvements. Perhaps city fathers had been influenced by comments from visitors from other states and countries. Perhaps they were encouraged by what seemed at first to be great economic expectations as trade resumed with Great Britain. Perhaps they acted simply because the new property taxes gave the city government a reliable, if uneven, income.[153]

The first need to be addressed was construction of a hay-weighing machine. The ingenious carpenter John Shaw designed and built the contraption, which had wooden balance

Annapolis — Convention City USA

Victory over the British in the War for Independence was wonderful, but making the United States into a real nation was a different matter entirely. The Articles of Confederation, adopted in 1781, created a loose alliance of sovereign states. During the war, the states had had to cooperate for self-preservation. But once the war ended, the states quickly went their own ways, with scant regard for the best interests of the country. Although political leaders increasingly recognized that the country needed a more effective central government, strengthening the Articles proved impossible, since all states had to agree on any change.

In March 1785, delegates from Virginia and Maryland crafted the Mount Vernon Compact. Some saw this two-state action as a way of bypassing the Articles to address important interstate issues. Taking the lead, Virginia's governor Patrick Henry invited all thirteen states to meet in Annapolis to discuss issues of trade and commerce.

The Annapolis Convention of 11–14 September 1786 was a failure. Just twelve delegates from five states attended the meeting, held at Mann's Tavern. But the delegates to the convention agreed that the country faced a crisis. They called for a new convention of all the states to be held in Philadelphia in 1787, charging it to create a framework of government "adequate to the exigencies of the Union."

The Philadelphia Convention, attended by fifty-five delegates from twelve of the thirteen states, wrote the United States Constitution, which created a national government with a broad array of powers formerly reserved to the states. Ratification required the affirmative vote of nine states. Six states quickly approved; then the ratification movement bogged down. By April 1788, when Maryland's ratification convention met in the Maryland State House, approval of the Constitution was in grave doubt, especially since William Paca and Samuel Chase, two seasoned and respected politicians, led Maryland's opposition. Paca and Chase objected to the Constitution's lack of a bill of rights. Paca proposed twenty-three amendments, the first formal proposal for a bill of rights presented in a state ratification convention.

On 28 April 1788, Maryland provided the critical seventh vote in favor of the new form of government by a 63 to 11 vote, approving the Constitution without amendments. Paca's proposal for a bill of rights was taken up by other states, and every state ratification convention after Maryland's adopted a proposed list of amendments. These amendments became the basis for the Bill of Rights, which was formally added to the Constitution in 1791.

GREGORY A. STIVERSON
Historian

scales and was housed in a weigh house next to the gatehouse. With contributions from private citizens, the city paid Shaw just under £190 for his work and supplies. After a city committee experimented with the machine and attested it would "answer exceeding well the purpose for which it was built," the corporation passed a bylaw, in August 1784, requiring all hay, straw, fodder, etc. sold in the town to be weighed. Interestingly the purchaser, not the seller, was responsible for paying the weighing tariff. Moses Maccubbin was named the first hay weigher. He and the city split the fees equally. When the gatehouse was sold and torn down in 1790, proceeds from the sale were applied to improving the weigh house,

which remained on the site. The county scales and weights, kept in the gatehouse since at least 1768, were probably moved to the new weigh house at that time.[154]

Of greater need was a new market house to replace the one blown down by the hurricane of 1775. Tax legislation in 1779 earmarked money for a new market, but nothing was done until 1784 when citizens petitioned the corporation for action. In July of that year, eight owners of properties around the head of the dock gave the city a rectangle of slightly less than one and a half acres of land between the north side of the dock and Church Street. The donors were all substantial merchants with an interest in civic improvements: Nicholas Carroll, Jacob Hurst, Charles Wallace, Joseph Williams, Thomas Harwood, John Davidson, James Mackubin, and James Williams. The conveyance required that the city build a market house sixty by forty feet in size near the bottom of Church Street and that eighty-foot-wide public streets be positioned around it. The corporation directed the treasurer, James Brice, to transfer £260 to the superintendents of the market: Isaac Harris, John Davidson, Charles Wallace, and himself, for construction.[155]

It seemed sensible that if the corporation were going to build a large, substantial market house at the head of the dock, it should also construct a wharf that would protect the building and secure the setting. Wallace, Brice, and James Williams, named wharf superintendents, brought in Marmaduke McCain and paid him £202 to "build a Wharf across the dock," connecting the north, or Ship Carpenter's Lot, side with Nicholas Carroll's wharf on the south. Materials used included locust trunnels and logs at least eleven inches in diameter at the small end. Behind the bulkhead, workers dumped cords of pine wood and load after load of pine brush. Twenty-two public-spirited men subscribed a bit more than £67 for "filling up the public Wharf"; not all of them paid. To ensure that wharves around the dock would not interfere with navigation, legislation in the spring of 1786 authorized the corporation to appoint three port wardens. Construction and placement of future wharves would require approval from the wardens.[156]

Because both projects were under way in the summer of 1786, stone pulled up from the old wharf was conveniently recycled as foundation for the market. As specified by the grantors of the land, this market sat near the end of Church Street. It was a frame structure with stalls that rented for three or four pounds a year, depending on the location. Amenities included long tables, benches, hooks, and a "tin plate to weigh butter on." John Sands supplied lumber for the butchers' blocks. The market opened the first of January 1787, with Isaac McHard as market clerk at an annual salary of £30. Market days were fixed as Wednesday and Saturday mornings. Over the next four or five years, a few improvements, such as paving the floor with bricks in 1790, made market days more pleasant. Although this building did not last, the location did. Today's market sits a few yards to the north.[157]

James Brice's careful accounts for the construction of the market house and the wharf offer insight into the city's labor force in the postwar period. At least eight African Americans, identified as "negro" and given only a first name, were paid directly for work on the wharf, in contrast to six men who were paid for the work of slaves owned by them. The accounts also list four men who did the same work at the same time but are referred to by a first and last name. Since it can probably be assumed that a worker named Matthias Kelly was white, chances are that all four of these men were Caucasian. James Brice paid them all at the same rate for the same job. Whether the worker was "negro Lewis," Mr. Hesselius's Jim, or Robert Long, they all made five shillings a day. "Negro Lewis" worked on both the wharf and the market house, and received the same wage as John Stansbury.[158] Whether the African Americans who were paid directly were free or had owners who al-

lowed them to earn wages cannot be determined from Brice's accounts. In either event, they were garnering income. If they were slaves, their chances of buying their freedom had risen, although that was rare until years later. If they were already free, they could consider freeing other family members or investing in some means to further improve their earning ability. The payments in Brice's account book illustrate the basis for the wealth and industry of free blacks in nineteenth-century Annapolis. They also demonstrate that equal pay for equal work is not a twentieth-century concept.[159]

Municipal initiative in this postwar period extended beyond infrastructure improvements, tavern licensing, and regulation of wharves. For once, the city corporation took an active role in fire control by purchasing one hundred pairs of fire buckets (lettered by John Shaw), two hundred nails to hang them on, ten axes, and ladders (supplied by "negro Elleck" and lettered by John Sullivan). Former city bylaws had required householders to provide their own buckets and ladders, but by the late 1780s, officials recognized that fining people for noncompliance was not enough to protect the city from disaster. Terrible fires on both sides of the dock — John Shaw's shop on lower Pinkney Street (1783) and Richard Fleming's bakery at the foot of Green Street (1790) — each of which destroyed neighboring structures, underscored the city government's need to move beyond just giving orders. The corporation purchased a hand pump and employed John Shaw, at an annual salary, to maintain the fire engines (one of them presumably the engine bought in 1755) and, in 1788, to repair "Miss [Elizabeth] Bordley's engine."[160]

With this outpouring of civic pride and activity, it must have been a blow to Annapolis to have Baltimore Town challenge its position as state capital. Suspicions that this might occur had been around for some time, probably since framers of the state constitution in 1776 had opted not to designate a meeting place for the General Assembly. A proposal to move the capital to Baltimore reached the floor of the House of Delegates in 1782 and was defeated by one vote. Four years later, the House again considered the issue, but this time the opposition was stronger, almost certainly because of the cogent arguments published widely under the pseudonym "Aristides." The author, Alexander Contee Hanson, was not a native of Annapolis, but he was married to the niece of Charles Wallace and in 1786 was a judge of the General Court and living on Church Street.[161] Hanson argued for reasoned deliberation by both houses of the "public good" not just the convenience of a few delegates from Baltimore. He saw no advantage to the legislature's being sited in a large commercial city. If members needed education on economics, they could summon experts to come to Annapolis, where the environment promoted "calm thought and sober deliberation" removed from the "noise and bustle of business." Yes, he said, "I am well apprized of the hatred in which Annapolis was held by almost every other part of the state under the former government; this was occasioned by the overweening insolence of a few powerful men." But they were gone in 1786, and "in spite of prejudice and detraction, Annapolis is, and ever has been, the seat of elegance, propriety, and refinement of manners. Harmony and friendship, for the most part, prevail amongst its citizens. . . . By taking from it almost the only support it ever had, it will inevitably tumble to the dust, and the fate of many meritorious citizens will be involved in its ruin." The House of Delegates voted almost two to one against the move.[162]

The idea of a public college in Maryland had been around since Governor Benedict Leonard Calvert a half-century before and had come up in the General Assembly several times since. The state chartered Washington College in Chestertown in 1782 as an outgrowth of the Kent County School. Two years later, it established St. John's College and

named the two schools, one on either shore of the Bay, the University of Maryland. The state obligated itself to pay St. John's an annual contribution of £1,750, but also provided for private support by appointing several men to raise subscriptions. Among those were Richard Sprigg and Dr. William Smith, president of Washington College, whose superior fundraising abilities had set that college on a firm financial footing. If the Board of Visitors and Governors of St. John's chose to locate the school in Annapolis, they could have the four acres Stephen Bordley had sold to Governor Thomas Bladen, "with the appurtenances" — the ruins called Bladen's Folly.[163]

Contributions for the new school came in from Western Shore men rich and not so rich, with Charles Carroll of Carrollton leading with a gift of £200. Other familiar Annapolis names on the list of subscribers included William Paca, Richard Sprigg, Thomas Stone, and Daniel of St. Thomas Jenifer. Smaller pledges from city residents totaled about £1,500. Enough money had been pledged by 1786 to allow the state Senate to appoint visitors and governors. Thomas Stone and Samuel Chase were among those who took the oath of office before Judge Alexander Contee Hanson. The first act of the new board was consideration of a proposal from the rector and visitors of King William's School, by then renamed the Annapolis School to remove any tinge of royalty. Officials of the venerable grammar school offered the new college a significant amount of money from the school's reserves if it could name two visitors to the college board. There was a bit of dickering over terms and conditions, but eventually the college agreed to accept the offer, and the Annapolis School named Alexander Contee Hanson and Thomas Jennings to the college's board. Legislation in 1786 formalized the consolidation of the two schools. The Annapolis School would continue to operate until the college opened, at which time it would become the grammar school component of the college.[164]

The second decision made by the board of St. John's College was to locate the school in Annapolis. It needed only to make habitable the building granted it by the state. And those pledges had to be collected. Neither task was easy, but by 1789 the board was ready to open the grammar school and the college in two rooms of Bladen's Folly. They engaged the Reverend Ralph Higginbotham, former master of King William's School and rector of St. Anne's Church, as head of the grammar school. To head the college they selected John McDowell, a graduate of and former teacher at the College of Philadelphia. Each was paid an annual salary of £300; tuition was set at £5 a year. St. John's College opened on 11 November 1789 with a procession from the State House to Thomas Bordley's beautiful hill and the college's only building. Dr. William Smith preached a sermon and Reverend Higginbotham gave "an oration on the advantages of a classical education." Marching with dignitaries of church, state, and city that morning were the sixteen students of the grammar school. One of them was Francis Scott Key.[165]

Among the institutions that Americanized following independence were Maryland's Anglican parishes, which in 1780 officially styled themselves the Protestant Episcopal Church of Maryland. Four years later, ministers of Methodism gathered in Baltimore to proclaim themselves and their followers a separate denomination, the Methodist Episcopal Church in America. Annapolis Methodists knew Francis Asbury, ordained as superintendent of the new church, and crowded in to hear him preach in May 1785. The enthusiastic congregation built its first meeting house in New Town, on a lot donated by John Chalmers, in 1786. At that time, members of the church included African Americans and whites in almost equal numbers. For reasons not explained in the records, the congregation decided within just two years that the Hanover Street location did not work for them. They applied

to the General Assembly for permission to move their frame building to State Circle where the old market house had stood. The legislators gave their approval and the church was moved. Perhaps at this time it was painted blue, because it was known in church records for years afterward as the "Old Blue Church." Minister in the late 1780s was the Reverend John Hagerty, known as "among the ablest preachers of this period." He must have been; membership numbered almost 275 persons by 1789, with slightly more black members than white.[166]

This many Methodists in town, following a doctrine that urged simplicity and modesty of behavior and opposed slavery in principle, began to have an effect, especially after a new preacher, the young and fiery John Cooper, took the church in 1789. Cooper exhorted against the sins of horse racing and drinking liquors, and encouraged his white flock to renounce slavery. His antislavery position reflected not only his church's strictures but also the postwar sensibilities of many Marylanders of any faith. The General Assembly considered abolition in the late 1780s and, although it did not pass such a measure, in 1790 it did reinstitute manumission by last will and testament, which had been banned since 1752. Methodists in Annapolis took the lead in emancipating their slaves and encouraging others to do so.[167]

The hand of the city's Methodist population may be seen directly in legislation, also passed in 1790, giving the municipal corporation authority "to suppress public and excessive gaming" in the city and its precincts. This act is interesting as well because for the first time the "precincts" over which the city government had control were spelled out. The western boundary of the city's authority ran from "a line drawn south from the head of Dorsey's creek, on the north-west of the said city, at or near the poor-house, to the creek on the south side thereof, called the Spa Creek." The poorhouse sat on or near the present National Cemetery; just where the boundary touched the south side of Spa Creek was not noted. This name for the creek, the only one of many over the years that stuck, probably came from the spa, or shallow bathing area, at the head of the creek, near the road to the London Town ferry (Spa Road).[168] For decades, travelers along the ferry road had stopped there for a drink of cool water.[169]

While the Methodists were building their first church, trustees for the planned replacement of St. Anne's Episcopal Church reorganized themselves with the intent of, finally, getting construction under way. Their first order of business was to retrieve or be compensated for all those building materials that had disappeared from the circle during the war. The state reimbursed the parish more than £700 for materials used in fortifications; William Paca and Charles Carroll of Carrollton were among townspeople who paid for items they had removed. Still, an advertisement in the *Maryland Gazette* bemoaned the loss of "372,400 place and 58,550 stock bricks," and trustee Thomas Hyde threatened the culprits with prosecution if they did not pay up. (Of course, there were folks who wondered if perhaps some of those bricks hadn't ended up in Hyde's own "elegant brick . . . house of entertainment" across the street.) Legislation in 1785 gave the trustees the right to open a new subscription for funding, but five years later the money had been spent and the church sat unfinished. Charles Wallace, James Brice, and John Davidson, who had managed recent city projects successfully, applied their experience to this one. By the spring of 1792, the building was ready for carpenters to supply 130 pews, two sets of stairs to the gallery, and "an elegant Altar." The new St. Anne's Church was consecrated on 24 November 1792 by the first Episcopal Bishop of Maryland, the Right Reverend Thomas John Claggett. The rector, Reverend Higginbotham, preached.[170]

In September 1790, Thomas Jefferson and James Madison stopped in Annapolis on their way home to Virginia from New York. With them was young Philadelphia lawyer Thomas Lee Shippen, who arranged for the three to tour Annapolis with local physician John T. Shaaff. Shaaff took them up in the new State House dome, which towered high above the town. A few years earlier, Annapolis architect Joseph Clark had removed the small unimpressive cupola atop the State House, along with the poorly constructed roof. To complete the building properly, he designed the graceful, distinctive dome that still highlights the city's skyline. Shippen wrote that he and his friends spent three hours at the top of the dome gazing out across the landscape while Shaaff enjoyed "opening the roofs of the houses and telling us the history of each family that lived in them." It was, said the happy Shippen, a vantage point from which they could "descry the finest prospect in the world."[171]

Annapolis Alone 1790 to 1845

lihu Riley described the mood of post-Revolutionary Annapolis with this quotation from the report of a naval commission:

A polar expedition is useless to determine the Earth's Axis. Go to Annapolis rather. It should be called the pivot-city. It is the centre of the universe, for while all the world around it revolves it remains stationary. One advantage is that you always know where to find it. To get to Annapolis you have but to cultivate a colossal calmness and the force of gravity will draw you towards the great centre — once there, there is no centrifugal force to displace you, and you stay. . . . Annapolis keeps the Severn river in its place. This will be useful when the harbour of Baltimore dries up. Annapolitans are waiting for this. They are in no hurry, they don't mind waiting. Two or three centennials will do it.[1]

Annapolis faced the new Federal era as a simple county seat, a market town for the surrounding neighborhood, enlivened only by court days and the annual winter sessions of the General Assembly. The city retained its position as capital of the state, but as a place of consequence in the affairs of state or country, Annapolis had lost out to its rival on the Patapsco. Baltimore City bloomed as the "fastest-growing city" in the country during the 1790s, fourth in population behind New York, Boston, and Philadelphia in 1790, third in rank by 1800. Baltimore boasted some 3,000 houses in 1800 and a population that year of 26,000.[2] In contrast, there were at most 228 households and 2,213 people living in Annapolis in 1800.[3] Baltimore was where the action was, and Annapolitans needed to sail only a few hours up the Bay to participate in prosperity. The population of Annapolis had actually decreased slightly by 1810.[4]

Visitors to the once bustling colonial port remarked on the town's beauty, applauded its State House, "a very handsome building with a dome," and noted the presence of the college, theater, two churches (Episcopal and Methodist), and a number of "large and handsome" brick dwellings. But they agreed that the commerce of the town had been eclipsed by Baltimore. Annapolis had no manufacturing, no industry, and little shipping, although, unlike Baltimore's, its harbor was seldom frozen in winter. The wooden-hull-eating worm *Teredo navalis*, which flourished in the salt water of the Severn but was repelled by the stream-fed waters of the Patapsco, continued to receive blame for the capital's maritime decline.[5] But even without the worm, post-Revolutionary Annapolis would have lagged behind Baltimore because of that city's larger, deeper harbor and its access to the growing population and industry of the hinterland.

The Severn's sandbars off Greenbury Point and Horn Point had increased over the years, and silting in the Annapolis harbor itself was a matter of continual concern. In March

1791, the city suffered the embarrassment of having a vessel from Rock Hall carrying the president of the United States run aground, not once but twice, on those dreaded sandbars. George Washington spent a night on Horn Point, literally on Horn Point, huddled in his great coat in a bunk too short for his large frame. A fifteen-gun salute upon his eventual arrival and a celebratory dinner with the governor and local dignitaries at Mann's Tavern (with fifteen congratulatory toasts) apparently restored his spirits.[6]

Many city artisans who had relied on private commissions in the golden age of Annapolis turned to military work during the Revolution. When that income stream ended, some left Annapolis, with the majority probably relocating in Baltimore. Those who remained often found jobs in the public sector. Renovations to the State House, for instance, became an important source of revenue. Skilled wood workers labored on Joseph Clark's magnificent State House dome from 1788 until its completion in 1795, while cabinetmakers, such as John Shaw and the Tuck brothers, William and Washington, replaced furnishings in offices and legislative chambers.[7] In the early 1820s local craftsmen presumably benefited from construction and furnishing of Anne Arundel County's courthouse on Church Circle. Begun in 1821, the building was occupied in 1823 and completed the following year.[8] When public commissions did not support them, artisans in nineteenth-century Annapolis turned to other occupations for additional income, just as they had in earlier days. Cabinetmaker Henry Thompson held the post of messenger for the governor's council. Carriage maker Jonathan Hutton was superintendent of public buildings. Both John Shaw and Washington Tuck served as state armorer and both later went into the funeral business. William Tuck ran a boarding house.[9]

Craft shops in Annapolis functioned after the Revolution in much the same way they had before, with the master craftsman in full control over his journeymen and apprentices and little competition within the shop. Annapolis did not have the artisan fraternities or mechanics' unions that were formed to protect workers' interests in larger cities.[10]

The city corporation — mayor, recorder, aldermen, and Common Council — tried in these early years of the republic to improve Annapolis by rewriting the city's bylaws to stress sanitation and fire suppression and to control what they felt to be unruly elements of the population. They considered repairs to the town's five public wells, all of which were out of service in 1801, to benefit householders without private wells and to aid in fighting fires. Rutted streets and the ever-too-shallow dock needed attention, and in 1804 the city received authority from the General Assembly to hold a $2,000 lottery to pay for repairs.[11] The corporation continued to require dog licenses and banished wandering sheep, goats, swine, and geese to enclosed pens. They levied fines on those who dumped garbage ("carrion, stinking fish, flesh, dead creatures," for instance) in streets, vacant lots, or the dock. Several bylaws addressed chimney cleaning, the approved locations for building a fire (not in wooden chimneys, iron pots, tubs of wood or dirt). Another bylaw reappointed the customary three fire companies with responsibility for deploying citizens, buckets, fire hooks, ropes, ladders, and engines at the scene of a fire. Bylaws continued to curtail the activities of servants, apprentices, slaves, and, most recently, "vagrants," defined as anyone, white or black, with no visible means of support who wandered about the streets and begged. The number of laws through the 1790s and early 1800s regulating the drinking, trade, assembly, and housing of the vagrant population indicates the extent of the problem.[12] These were people for whom there was little work in a city with no significant industry, and their presence alarmed city officials.

When contagious disease threatened the city, as in the yellow fever epidemic of 1793 or

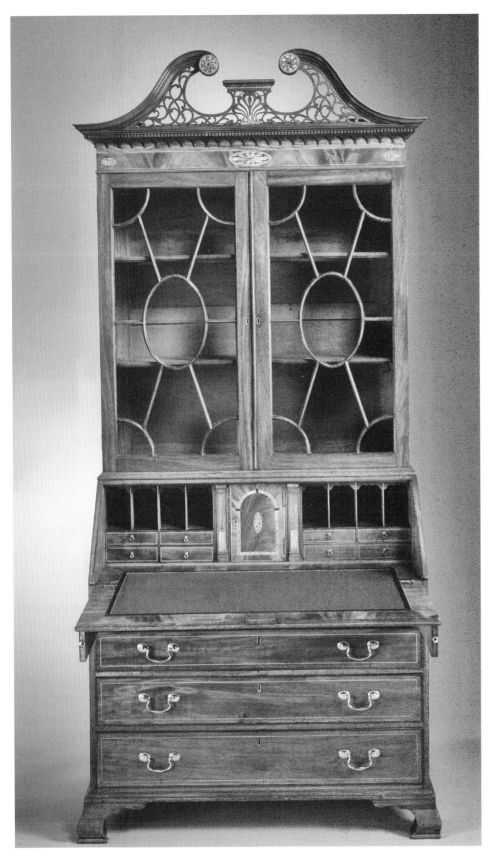

A desk with bookcase, probably made by William Tuck in John Shaw's shop, 1797. The mahogany of this massive piece is inlaid with lighter and darker woods to create elaborate patterns. It carries the Shaw label annotated with initials "W" and "T" and the date. Photograph by Bruce White. Courtesy The White House Historical Association.

Cabinetmaking in Early National Period Annapolis

Much of what is known about Annapolis furniture of the eighteenth and early nineteenth centuries is tied to the work of the city's most celebrated cabinetmaker, John Shaw (1745–1829), whose shop produced a significant body of distinctive work, much of it identified by labels. Although most surviving furniture is attributed to Shaw, a small yet highly skilled group of cabinetmakers, including the Tuck brothers, William (c. 1774–1813) and Washington (1781–1859), trained and worked in Shaw's circle and understood the intricacies of private and public patronage.

Shaw emigrated from Scotland as a carpenter in the early 1760s and partnered with Scottish cabinetmaker Archibald Chisholm (d. 1810) before purchasing property across from the State House for his own shop. Shaw utilized design templates and patterns throughout his career, and his apprentices and journeymen made the majority of furniture sold by the shop. Even some of the most complex forms, including monumental desk-and-bookcase combinations, originated as stock pieces. The work of Shaw-trained artisans William and Washington Tuck can be traced to six labeled pieces of furniture made in Shaw's shop between 1795 and 1797.

The stories of Shaw and the Tucks reveal that, at a time of economic decline in Annapolis, support from state government provided opportunities for local artisans. Shaw served as caretaker of the State House from the early 1790s until his retirement in 1820, supervising or performing all of the maintenance and renovations to the capitol and its furnishings. Shaw's most significant public commission came in 1797 when he furnished the Senate with twenty-four mahogany armchairs and eleven desks, including one for the Senate president made by William Tuck. The Tucks opened their own shop, and in 1807 they oversaw the refurnishing of the House of Delegates Chamber. Washington succeeded Shaw as superintendent of the State House and regularly received orders for work until he retired in 1838.

ALEXANDER LOURIE
Curator, Maryland Commission on Artistic Property
Maryland State Archives

the almost yearly smallpox outbreaks, the corporation passed bylaws appointing a health officer to certify all travelers and goods coming into the city as free of disease and levying fines on any resident who harbored a contagious patient. Contagious patients were confined to the smallpox hospital outside town.[13] These precautions spared Annapolis from epidemics that decimated other, more populous cities. Only "intermittent fever" (probably malaria) was a recurring problem, although, according to Dr. John Ridgely in 1811, even that was rare.[14]

Following completion of a road from Annapolis to Washington in the early 1800s, foreign dignitaries and other visitors to the new federal city on the Potomac often used Annapolis as a convenient point of debarkation. In November 1804, for instance, the forty-four-gun French frigate *Le President* arrived off the Severn with the Emperor Napoleon's minister to the United States, General Louis Marie Turreau. The frigate sailed for France a week later carrying Napoleon's brother Prince Jerome Bonaparte and his wife, the former

Betsy Patterson of Baltimore.[15] Ambassadors from Tunis and Britain stopped in Annapolis briefly in 1806. Geographer Joseph Scott visited long enough in 1807 to learn a bit of history and note that the State House was "a superb building." Usually the dignitaries stayed a night or two at an Annapolis hostelry before going on to Washington by stagecoach.[16] Commercial and naval ships from the United States and other countries called at Annapolis for repairs, supplies, or passengers. *Patriot* and *L'Eole*, seventy-four-gun frigates of Jerome Bonaparte's French fleet, limped into the Severn after the hurricane of August 1806, and the *Maryland Gazette* was pleased to report that with a diet of fresh vegetables and fruits, the scurvy-ridden crew of *Patriot* were recovering.[17]

Several visitors mentioned that the town had a large proportion of wealthy residents still ensconced in their pre-Revolutionary mansions, and for a few decades after 1790, town society attempted to continue its golden age amusements: horse racing for the Jockey Club purse in the fall, plays by the American Company of Comedians and other entertainments at the West Street theater, tea parties, dances, and social visiting. The Colts' Ball, given by newly elected delegates (the "Colts") at the beginning of each legislative session, was a major society event. Yet, as time went on, most of these pleasantries fell aside in favor of more sober pursuits. City-imposed taxes on horse racing, theater productions, circuses, "wire dancing," and other entertainments may have had a role in their demise. Shortly after its founding in 1810, the Charitable Society took over the lease for David Douglass's pre-Revolutionary theater on West Street. The society ran a school there until 1819 when the building was sold to Jonathan Hutton, who tore it down to build a carriage factory.[18]

Illustrative of the town's uncertain status is the story of the aristocratic but peripatetic Belgian émigré Henri Stier. Unsatisfied with their first situation in Philadelphia, Stier and his wife moved to Annapolis with their seventeen-year-old daughter, Rosalie, in 1795. They settled first at Strawberry Hill, on the west side of College Creek. But, finding this country home too remote, the family moved to the house built by William Paca on Prince George Street. Rosalie delighted in the dances and parties given by the Carrolls, Ogles, Lloyds, and Scotts and made social connections of her own; in 1799, she married George Calvert, a young man with close ties to both the proprietary Calverts and the republican Washingtons. A year later, citing the decline of Annapolis, Henri Stier chose to settle near Bladensburg, close to the new Federal City, where he began construction of his mansion, Riversdale.[19]

Although Maryland's first state-chartered bank was established in Baltimore City in 1790, merchants in Annapolis hoped that a local bank would spur commercial activity. Private money managers, such as John Muir and others who believed that a banking establishment would encourage agricultural investment, backed the formation of the Farmers Bank of Maryland, which received its charter in 1805.[20] In 1812, the bank purchased the

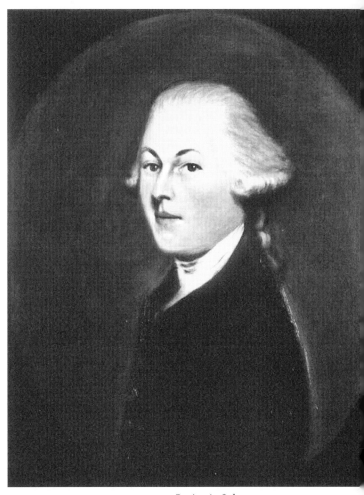

Benjamin Ogle, governor of Maryland from 1797 to 1798, and his wife, Henrietta Margaret Hill Ogle, were among those who tried to keep the city's pre-Revolutionary social scene alive even at the risk of financial embarrassment. Painting by Gregory Stapko. Courtesy of the Maryland State Archives, MSA SC 1545-1071.

tavern on Church Circle built by hatter William Reynolds and contracted with John Shaw to add a hyphen and banking room on the West Street side. The house itself became offices and a home for the bank's cashier. In keeping with its purpose and name, Farmers accepted real property as security for loans, the first bank in the state to do so. Branch banks were established in Easton (1805) and Frederick (1807).[21]

There had been some attempt in the 1790s to modernize Fort Horn as part of the nation's "First American System of Fortifications," but the project never went beyond the planning stage.[22] Following the *Chesapeake-Leopard* affair in June 1807, in which a British warship (HMS *Leopard*) fired on a United States Navy frigate (USS *Chesapeake*) off the Virginia Capes, boarded her, and forcibly removed four crew members as "deserters" from the British navy, Annapolis joined the rest of the nation in furious protest. Local citizens met in late June to pass resolutions against the "flagrant and bloody outrage lately committed by the British." Meeting participants pledged to refuse aid and supplies to British warships and called for strengthening the city's militia companies. And as they, or their fathers, had done thirty-three years earlier, these citizens appointed respected members of their number to correspond with other ports "until the government of the United States shall have prescribed the conduct and measures which it may deem expedient in the present crisis." Of the thirteen men named to this ad hoc committee of correspondence, at least seven were associated with the city's Tammany Society, which flourished about this time as a social and political organization of anti-Federalist persuasion.[23]

That summer, while volunteer infantry and artillery units drilled and paraded, local residents contemplated the poor condition of the city's defenses. Surely, should war come, their city would be a prime target. Turning to the federal government, citizens and city officials drafted resolutions outlining the importance of Annapolis to Chesapeake trade and the need for suitable fortifications in case of attack.[24]

A bit of excitement in late August 1807 gave the volunteer militia a little practice. It seems that some disaffected seamen from French frigates *Patriot* and *L'Eole*, tired of being bottled up in the Bay by the British blockade, joined a couple of their countrymen from Baltimore and turned to piracy. Or, at least they tried to. Sailing a small, fast schooner and armed only with pistols, the would-be pirates captured a heavily laden, unarmed merchant ship about thirty miles south of Annapolis. The pirate captain intended to run the blockade with his prize and ordered both vessels to turn down the Bay. After a few hours, however, adverse winds halted their flight and the pirates began to have second thoughts. Indeed, witnesses to the capture were already on their way to Baltimore, where their news galvanized the port. When a sailor from *L'Eole*, then in the Severn, admitted to authorities that five pirates had passed through Annapolis, a detachment of Captain Lewis Duvall's militia company set out after the renegades, caught them, and brought them back to the city. Rumor had it that the pirate schooner, having released the merchant ship, was hiding in the Magothy River, and Annapolis men wasted no time in setting forth in the *Holy Hawk* packet boat and a small boat from *L'Eole*. City infantry and artillery companies, armed with muskets and boarding pikes, manned the packet under command of Captain Duvall and Artillery Captain John Muir. More than thirty other volunteers, both American and French, sailed aboard *L'Eole*'s boat, armed with swivels, muskets, and cutlasses. The latter vessel was commanded by one of the French officers and Lieutenant George Washington Mann, USN.[25] Lieutenant Mann, a hero of the Barbary Wars, happened to be home

on leave visiting his mother, Mary Buckland Mann, widow of innkeeper George Mann.[26] It wasn't long before the Annapolis contingent found that the pirate vessel had already gone down the Bay, and the pursuit was called off.[27] Volunteers from Baltimore eventually captured the pirate schooner and the rest of her crew and returned to the Patapsco to an enthusiastic welcome.[28]

Perhaps the prompt, well-coordinated action by Annapolis volunteers helped persuade the federal War Department that the city deserved, and could staff, improved defenses. Included among the list of fortifications designated as the "Second System" in 1807 were two new installations to guard the Annapolis harbor: Fort Madison on the north side of the Severn and Fort Severn on Windmill Point, at the tip of the Annapolis peninsula. The federal government purchased seven acres on Windmill Point from the estate of Walter Dulany and the city, and John Randall, as agent for the United States, advertised for bricks, foundation stone, and "good shell lime." Fort Severn would be a circular fort fourteen feet high and one hundred feet in diameter, accommodating eleven cannon and one company of men.[29] When war finally did come, the two new Severn River forts, manned by proud local militia supplemented as necessary by companies from the interior of the state, may indeed have kept the city safe.

The U.S. frigate *Constitution*, on a shakedown cruise in the Bay after refitting, lay anchored off the Annapolis harbor on 18 June 1812 when Congress declared war on Great Britain.[30] She remained in Annapolis for three weeks while her commander, Captain Isaac Hull, gathered supplies, crew, and marines before sailing on 5 July to join Commodore John Rodgers's fleet off New York.[31] For the next ten months, Annapolitans waited with apprehension, watching privateers sail down the Bay from Baltimore and following the accounts of remote battles in the two local papers: the Greens' old *Maryland Gazette* and the new *Maryland Republican*, founded in 1809 by John W. Butler but published by Jehu Chandler after 1811.[32] In the fall of 1812, voters in both Annapolis and the county chose presidential electors pledged to President James Madison, and Annapolis elected Democrats to the General Assembly. There was, however, a strong Federalist antiwar component in town, supported by the *Maryland Gazette*, and peace advocates met locally throughout the war.[33]

Annapolis expected the assistance of additional troops and a gunboat or two when the British blockaded the mouth of the Bay in February 1813. Neither arrived, although Captain Charles Gordon, in Baltimore City, wrote Secretary of the Navy William Jones in March, "I believe the Enemy may without much difficulty distress Annapolis." Governor Levin Winder's pleas to the secretary of war regarding the "defenceless situation of the forts at this place" got him only the promise of a battalion of draftees.[34] Finally, in April 1813, British warships under Admiral Sir John B. Warren and Rear Admiral George Cockburn sailed north from Norfolk.[35] For anyone over forty, the sight of British warships again streaming past Tolly Point must have rekindled an anxiety from that previous war. This time, would the enemy attack?

Admiral Warren lay off Annapolis in his seventy-four-gun flagship *San Domingo*, while Cockburn continued up the Bay to sound the rivers and harass local shipping. By mid-May, Cockburn's ships and tenders had decimated Frenchtown, Havre de Grace, Fredericktown, and Georgetown on the Sassafras, scared Baltimore, and charted most of the upper Bay. Annapolis, with its small force of militia and perhaps twenty to thirty regulars with inadequate arms and ammunition at its forts, feared the worst.[36] But the British turned back down the Bay on 12 May without a further glance at the Severn.[37] The city breathed a sigh of relief.

Admiral Warren and his fleet made a second foray up the Bay in August.[38] During the three months of respite Annapolitans had reconsidered the defenses of the town, and by 3 August, when twenty-one approaching British warships could be spied from the State House dome, the *Maryland Gazette* could declare, "[E]very preparation necessary for their reception has been made, should they attempt to land their forces." As they had in 1776 and 1777, civilians fled to the interior "with the principal part of their goods," leaving the militia, local volunteers, and regular troops to defend the town. These men, said the *Gazette*, were confident that they could "measure swords" with the enemy "without any apprehension as to the result."[39] Governor Winder was not as sanguine; he asked again for experienced troops. On 12 August, Secretary of the Navy Jones dispatched Captain Charles Morris and the officers and crew of the U.S. frigate *Adams* from the Washington Navy Yard to Annapolis to supplement the force. Morris's 320 men, including the requested artillerists, stationed themselves at the forts and on the hill above Fort Madison at a small earthworks called Fort Nonsense.[40] British tenders must have taken a good look at the defenses as they sounded the entrance to the harbor, because Admiral Warren reported that "a Corps of Five Thousand men were around Annapolis . . . and the defenses of that Town much encreased." Warren took possession of Kent Island, but he decided that neither Baltimore nor Annapolis could be successfully attacked. On 22 August he reembarked his troops, now refreshed with good Eastern Shore livestock and produce, and sailed down the Bay. With the excitement over, Morris and his men, many of whom had contracted "symptoms of fever" at the low-lying Fort Madison, went back to Washington.[41]

When the bulk of the British navy arrived in the Chesapeake the following August, 1814, their plan was to attack Washington with the assistance of some three thousand combat-seasoned army veterans fresh from their victory over Napoleon. Vice Admiral Sir Alexander F. I. Cochrane, then commanding the British forces in the Bay, considered a report of possible routes to the capital from Rear Admiral Cockburn which dismissed Annapolis because that was where the Americans expected them, and it would be well-fortified. Besides, Cockburn thought, the shallow harbor would delay the invasion. Cochrane decided that the tiny town of Benedict on the Patuxent River offered the best opportunity for easy access to Washington. As a diversion, he sent a few ships up the Potomac and another squadron up the Bay under Captain Peter Parker, commander of HMS *Menelaus*, which carried thirty-six guns.[42] *Menelaus* arrived off Tolly Point on 20 August, and Parker sent two boats out to look around. One of these pulled an American boat off the beach and exchanged fire with one of the Annapolis forts. American gunboats at the entrance to the Severn made further exploration risky, and Parker weighed anchor and cruised up the Bay to Bodkin Point. The next night Parker sailed back down the Bay, and under cover of darkness, he took a party of marines out in tenders to "find the Battery situated to the left of Annapolis." The boats returned at 3:30 a.m., having been unable to locate the "object of the attack," probably Fort Horn. That night, the 22nd of August, a lieutenant and a masters mate "reconnoitered Fort Madison," apparently with no interference. Parker was pleased to report to Admiral Cochrane that "Annapolis would face a very easy conquest (Two of my Officers walked around Fort Madison in the Night without being discovered)."[43] Where were the militia troops stationed in Annapolis under Colonel William Dent Beall? Obviously not at the unhealthy Fort Madison.

By the 22nd, of course, the British were advancing on Bladensburg. Federal officials still thought the real attack would come through Annapolis, where Colonel Beall waited with 750 to 1,000 militia.[44] Once the American forces realized the British were headed for

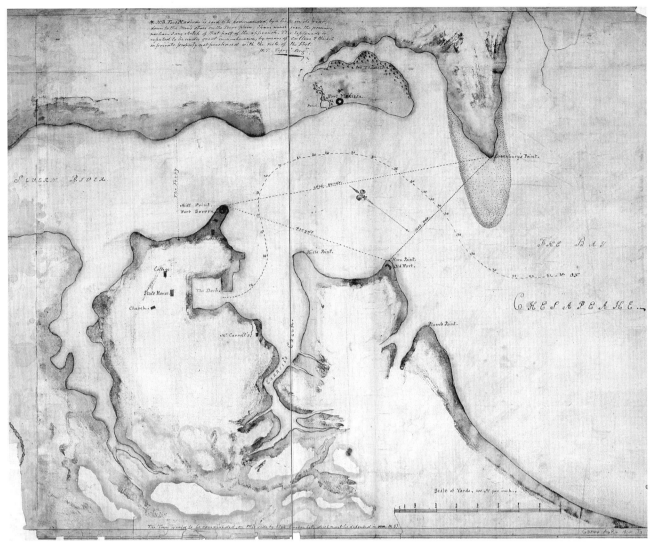

The "Rough Plan of the Defences of the Harbour of Annapolis" was made from a sketch by American topographical engineer William Tatham in August 1814. It triangulates distances from the Old Fort on Horn Point, Fort Severn on Windmill Point, and Greenbury Point and gives the soundings for the course into the Annapolis dock, which looks much larger than it should have. Tatham explained that although he had not walked around Fort Madison, he understood it was protected by hills and vegetation. Courtesy of the Geography and Map Division, Library of Congress (detail).

Washington and decided to make their stand at Bladensburg, Beall and his men made a forced march from Annapolis, arriving late in the morning of 24 August. They were placed on a hill east of the road to Washington, just to the right of Commodore Joshua Barney's men, where they watched in horror the confusion of a failed American defense.[45] When the British advanced up the Washington road, the Annapolis men "stared as if they were looking at ghosts." All their drilling had not prepared them for the reality of battle, and when an order came to retreat, they scattered. Barney accused Beall's men of deserting the field, leaving Barney's flotilla men unprotected and securing the battle to the British. Beall "insisted that his militia did not fly" but retreated under orders after firing "several rounds."[46] No matter whose account is more accurate, there is no doubt that mismanagement from the top down caused the defeat.

The Annapolis men made their way home to find their city reeling from the news of the disaster at Bladensburg and the burning of Washington.[47] What would the British do now? Which city would be the next target? General Samuel Smith, charged with the defense of Baltimore, placed lookouts along the shores of the Chesapeake to send word of British fleet movements. He assigned Major William Barney, son of Joshua, to the dome of the State House, where even "Governor Winder himself would clamber up the creaking ladder and take a turn with the glass." Barely recovered, local militia units were sent to Baltimore.[48] The *Maryland Gazette* put out a single-sheet edition, explaining that "all hands employed in the office" were "daily called out on military duty." The *Maryland Republican* suspended publication in late August because, "the mails having ceased running to and from this city, in consequence of the proximity of the enemy," Chandler had no news to print.[49]

Finally, about 7:00 p.m. on the evening of 10 September, the first of a fleet of more than sixty British vessels sailed up the Bay past the mouth of the Severn in a fresh breeze. As had been the case in the previous war, the governor and others in authority, overwhelmed by the firepower of the enemy, seem to have given up on the defense of the town.[50] A British officer later recounted the frenzy on the shore as the fleet passed: beacons blazed, signal guns fired, riders on horseback galloped off carrying intelligence, inhabitants fled into the interior. "In Annapolis, in particular, confusion and alarm appeared to prevail to an extraordinary excess. Being the capital of the State, and exposed, in a remarkable degree, to insult, its inmates doubtless anticipated nothing else than a hostile visitation; and truly, if to destroy a neat clean town, surrounded on all sides by elegant villas, had been our object, no task could have been more easily performed. We passed by it, however, unharmed; not, perhaps, quite satisfied that so fine a prize should be permitted to escape, but hugging ourselves in the idea that another and no less valuable one was before us."[51]

The battle for Baltimore began in earnest on 13 September, and for the next two days, Annapolitans, whether still hiding out in the countryside or back in town, listened to the rumble of cannon, watched the northern night sky red with rockets, and realized that there were advantages to not being Baltimore City. That city, threatened by land with British regiments fighting their way along the north shore of the Patapsco toward downtown and by sea from Vice Admiral Cochrane's fleet bombarding Fort McHenry with rockets, bombs, and cannon, refused to give in. Military and civilians alike were determined that Baltimore should not suffer the fate of Washington. And it didn't. After two days of frustration, his guns unable to overcome the Patapsco forts and his fleet still far from the heart of the city, Cochrane decided to back off. British troops on the ground, hard hit by American land forces and without sea support, had no alternative but to retreat as well. Early on the morning of 14 September, as the bombardment ceased and the smoke cleared, St. John's College graduate Francis Scott Key, then a Georgetown lawyer on a mission of mercy aboard a British vessel in the harbor, watched with joy as a huge new American flag was raised over Fort McHenry to replace the smaller flag that had flown during the battle. Overwhelmed with pride, Key was moved to sketch out a brief poem of triumph: "O say, can you see by the dawn's early light . . . "[52]

On 18 September, the bulk of the enemy fleet, except for several vessels delayed by running aground on Kent Island or Sandy Point, sailed down past the Severn. Annapolis kept a careful watch on their progress, and Jehu Chandler moved his presses out of town for safety. By 21 September all the British were at least ten miles south of the city, but locals remained uneasy. Chandler published an abbreviated *Maryland Republican* on the 24th, promising a return to normal the next week, "if they do not again molest us." They did not.[53]

Although the British focused their attention on New Orleans later that fall, a blockading squadron remained in the Bay. HMS *Menelaus* was one of the vessels cruising past the mouth of the Severn. By that time, U.S. and British commissioners were negotiating peace treaty terms in the Belgian city of Ghent, but for white residents of the Annapolis area, a British warship off their coast still meant danger. To the local enslaved population, however, it still meant opportunity. As had been the case during the Revolution, in this war the British promised freedom to any American resident who jumped sides. Adults and their families who chose to board a British warship would be received as "Free Settlers" eligible for resettlement in one of the British colonies; there was no mention of race or condition of slavery in the British proclamation.[54]

We don't know how many Annapolis-area slaves ran away to the British during the war, but twenty-six can be documented through the claims their owners made after the war. Of this twenty-six, four men escaped from Frederick Grammer and the Duvall family in the St. Margaret's area in September 1814, and one ran away from Lewis Neth in Annapolis. The other eight men, four women, and nine children left their homes early in the morning of Saturday 17 December 1814 to board HMS *Menelaus*, lying three or four miles off Tolly Point. Twenty of these people belonged to Henrietta Margaret Ogle, owner of Tolly Point Farm, and one, a man named Joe, to her neighbor Fielder Cross. Among Henry Margaret's runaways were a young blacksmith named Sam, who lived on her Horn Point property, and Tom, a house servant at her home in Annapolis. Had Sam and Tom gotten permission to visit at Tolly Point that Friday night or did they leave from their usual quarters? We don't know, but we can assume that they were connected to the farm slaves by blood or friendship and that this escape was carefully planned. Ogle and Neth went aboard *Menelaus* twice over the weeks following but were unable to effect return of their slaves; Henry Margaret was told that her people had been sent to Bermuda, but her son later believed they had been at the British base on Tangier Island.[55]

One of Frederick Grammer's men, James Hall, was killed with British troops in the Battle of Fort Bowyer, at the mouth of Mobile Bay in February 1815, after the peace treaty had been signed but before that news had reached commanders in the field. The other, James Stewart, was captured by an American near Mobile and returned to slavery. Sam and Joe were captured in February by militia in Gloucester County, Virginia, when they were discovered on a boat belonging to one of the British vessels lying in Lynnhaven Bay. As had been the case with many of the escapees from the Chesapeake during the Revolution, the eventual destination of at least some of the local men and women who yielded up their fate to the British in this war was probably Nova Scotia. There, they may have joined communities established by Loyalist slaves who had escaped to freedom a generation before.[56]

The Treaty of Ghent, ending the war, was signed by British and United States negotiators on 24 December 1814 and ratified by the crown on the 27th, but news did not arrive in Washington until 14 February. The U.S. Senate ratified the treaty on 17 February.[57] On the 17th, reacting to the news of peace, Annapolis Mayor Nicholas Brewer called for an illumination of the town the next evening. "A signal gun will be fired," he said, "that all persons may commence lighting at the same moment." Lights would be extinguished at nine o'clock. Recognizing that there were some in Annapolis whose opposition to the war might keep them from participating in the festivities, he added, "If any person should decline the illumination, no violence must be offered to his person or property."[58] The town glowed again the following week in acknowledgment of the ratification. "In the midst of this scene of light stood the State House, conspicuous for its elevation and splendour." In the main

hall, a full-length portrait of George Washington hung from the center of the dome. Various householders set up "different devices, and individual specimens of taste," which made the scene "superior to any exhibition of the kind we have ever witnessed," enthused the *Maryland Gazette*.[59] The "devices" were transparencies of paper or fabric decorated with words and images and placed in windows with candles behind them.

When the war ended, Annapolis resumed its popularity as a point of embarkation and debarkation for dignitaries, both native and foreign. The seventy-four-gun frigate USS *Washington* arrived in May 1816 from Boston to transport the new United States minister to Russia, William Pinkney, and his family to the Mediterranean. President James Madison and his wife, Dolley; Commodores John Rodgers and David Porter, naval heroes of the recent war; the secretary of the navy; distinguished generals; and other officials and interested civilians visited the ship and the town. Most of them probably agreed with Sarah Gales Seaton, wife of the copublisher of Washington's *National Intelligencer*, that "though exhibiting every symptom of decay, [Annapolis] is the most lovely spot you can conceive." For three weeks, *Washington* lay in the Annapolis Roads, just off the mouth of the Severn, and small boats from Baltimore and Annapolis made regular runs to the ship with sightseers. The citizens of Annapolis threw a "great ball in honor of the President," and he and Mrs. Madison charmed the company. Enjoying the town and the attention, they stayed two extra days to dine with Charles Carroll of Carrollton and Governor Charles Ridgely. Meanwhile, Annapolis merchants assisted in provisioning the ship and entertaining the crew. With the exception of a few xenophobic locals who complained about Pinkney's trip and the "pomp passing before our eyes as the costly equipment is flaunting in our harbour," everyone seems to have had a wonderful, and profitable, time.[60]

"Decay" notwithstanding, Annapolis provided several points of interest for the visitor. When Martha Forman of Cecil County spent a few days with the Lloyds on Maryland Avenue in July 1817, she was shown around the town, enjoyed the "Military Music" at Fort Severn, by then "enclosed by a stone wall and fine gated entrance," and climbed "the immense height" to the dome of the "noble" State House for a "view of land and water more grand and picturesque than can be imagined." She toured St. John's, "a large building but evidently on the decline," attended Sunday services at St. Anne's, "spacious building but small congregation," and made "the fashionable drive" out to the "Spaw Spring and Ferry Branch on the road leading to Washington."[61]

Mrs. Forman did not mention anything that would support Louis Gassaway's assertion to a former pastor that Annapolis was "a wicked place," a belief that encouraged his fellow Methodists to fund a new, brick church at the corner of State Circle and North Street in 1818. The General Assembly must have agreed, however, for they authorized £200 to buy seats in the church for state government officials, with the Senate noting carefully that this was for the convenience of legislators and not really support of a specific congregation.[62]

Encouraged by the firm stance of Methodist societies against slavery in the 1770s, a stance which was confirmed by the rules against slave holding issued in the founding documents of the Methodist Episcopal Church in the United States in 1784, Annapolis African Americans, both free and slave, allied themselves with the city's Methodists. By 1788, they outnumbered whites in the congregation that worshiped in the first Methodist meeting house on Hanover Street. Even after the 1816 General Conference of the church turned away from emancipation to stress the "salvation of souls rather than the libera-

tion of bodies from bondage," blacks adhered to Methodism. Through the 1840s, records of the Annapolis Station of the Methodist Episcopal Church showed a preponderance of African-American congregants and praised the work of "our coloured local preachers" for converting more each year. In 1834, for instance, the Annapolis Station reported 216 white and 252 black members.[63] However, black Methodists did not always worship with the white congregation.

Shortly after Bishop Francis Asbury ordained Philadelphian Richard Allen as the first black deacon in the Methodist Church in 1799, a group of free black men in Annapolis bought a quarter acre of land on the north side of West Street, just outside the city gates. It is likely that they intended this site for a church, although records do not confirm that one was constructed here. Four years later, in 1803, three of these men joined with four others to purchase another lot across the street. In this case, there is no doubt about the intention, because the purchasers, John Wheeler, George Martin, Samuel Hackney, Matthias Robertson, Francis Troy, John Forty, and Jacob Forty, called themselves the trustees of the First African Methodist Episcopal Church of Annapolis. They immediately built a meeting house, probably a small frame structure, which was in use by 1804, when John Wheeler devised forty dollars to the "African Meeting House." While the congregation remained technically a part of the Annapolis Station of the Methodist Episcopal Church until 1864, some of the local black Methodists allied themselves with the African Methodist Episcopal movement in Philadelphia and Baltimore, which was formalized in 1816 with the same Richard Allen as the first bishop. The AME Church rejected white oversight while keeping most of the religious philosophy of the older Methodist Episcopal organization.[64]

If they chose, African-American Methodists could worship with their white brethren at the "Old Blue Church" on the State House grounds or at the new brick church at the corner of State Circle and North Street that replaced it in 1818. However, they had their own classes and Sunday School, their own exhorters and preachers, deacons and elders.[65] Chief among black religious leaders was Henry Price, who preached at services in the West Street meeting house, led class meetings, buried his own, and attended quarterly conferences of the Methodist Church. Price's ministry and care guided black Methodists for more than forty years. He was joined by other lay preachers and exhorters, including Benjamin Drummond, Samuel Hanson, Isaac Stephens, and Samuel Hackney, and together they served their people and their congregation.[66]

The rise of Methodism in town concerned at least some loyal local Episcopalians. When the Reverend Henry Lyon Davis was offered the position of rector of St. Anne's, he visited Annapolis and was horrified: "The methodists are devouring the poor flock at that place without mercy." Confident that he could better the situation, Davis accepted the position, in 1816, even though he believed the city to be a "heedless and frolicksome place." His self-confidence not misplaced, Davis brought the number of communicants at St. Anne's from 37 to 250 in four years.[67] In 1820 Davis served very briefly and very argumentatively as principal of St. John's College. When the board fired him, he "stomped off in a huff to start his own school, taking the college telescope with him." The telescope was returned, and Davis's new school seems to have left no imprint on the "frolicksome" town.[68]

The city's Roman Catholic population, white and both free and enslaved African Americans, had worshiped for many years in the chapel of the Carroll house. In the early 1820s, when Charles Carroll of Carrollton moved permanently to Baltimore, they determined to build a separate church. Carroll donated a lot just up Duke of Gloucester Street from his former home, and his granddaughter Mary Anne Caton Patterson launched a subscription

campaign. The first St. Mary's Church, a small brick structure with a "stepped gable" facade topped by a cross, was officially blessed by Father Charles Felix Van Quickenborne, S.J., on 9 February 1823. A few years later, the congregation installed an organ in the gallery. With a rectory adjoining the church and burial grounds to the east and south, the complex gave the increasing number of Catholics a very public presence in Annapolis. As it had done for the Methodists just eight years earlier, the General Assembly directed in 1826 that $200 be given to the church to reserve seats for public officials of the state.[69]

Whether or not it was "wicked" or "heedless," the city faced some serious problems after the war. As Mrs. Forman remarked, the college was in trouble. In 1805, the General Assembly had cut off funds to the school and John McDowell left for the University of Pennsylvania. Over the next ten years, a succession of principals, curriculum changes, and the suspension of the grammar school encouraged parents to send their sons elsewhere. Even though the board persuaded McDowell to return as principal in 1815, he was a nominal head, visiting Annapolis only rarely. The school closed for seven months in 1818.[70]

Worse yet for the town, there were rumblings again in the legislature about moving the capital of the state to Baltimore. The issue had been raised in 1782 and 1786, and Annapolis had prevailed, however narrowly. It came up again during the session of 1816, and this time Annapolis was saved by its village-like condition. Baltimore's reputation as a "mob town," with influences that could adversely affect the freedom of legislative debate, worked against it. If Annapolis was "wicked," Baltimore was worse. The constitutional amendment that reorganized Maryland's government in 1836 specifically designated Annapolis as "the seat of Government," and subsequent constitutions retained the city as "the place of meeting of the Legislature."[71] Which is not to say that the question of moving the capital to Baltimore City does not still rear its head from time to time.

Given the almost universal opinion that the town had fallen on difficult times, the city fathers turned to the federal government for salvation. Some years before, when there were rumors that the navy was going to build a new shipyard, the city had sent a letter to the secretary of the navy asking that Annapolis be selected. That request came to naught.[72] After the War of 1812, the president and Congress were interested in finding a safe site on the Chesapeake for dockyards, a naval arsenal, and a supply depot as part of the "Third System of American Defense." The requested reports and surveys transmitted by the officers of the Naval Board to the U.S. Senate in January 1817 did not mention Annapolis; the northernmost port they investigated was St. Mary's City.[73] In October that year, the Annapolis corporation, sensing a prize slipping away, prepared a memorial, or petition, for President James Monroe asking that their city be included in considerations for "a Marine Hospital, Navy Yard, or Navy Arsenal, and other public works connected with the war and navy departments." Clearly they would take anything the navy had to offer. The memorial detailed the advantages of the town: its healthful climate and abundant fresh water, its accessibility to the nation's capital, the availability of good white oak and pine timber within twelve miles, the federal government's present seven acres at Fort Severn and the potential of acquiring additional land from St. John's College, the defense offered by Forts Severn and Madison, and the safety of the Severn as a refuge even in winter.[74] Daniel Murray, a member of the governor's council, and John Mercer of West River (probably former governor John Francis Mercer) presented the memorial to the president, who assured them that the commissioners appointed to make recommendations to the navy would include Annapolis in their deliberations. But they surely would not consider any port without sufficient depth to admit the largest naval vessels. The Greenbury Point sandbar loomed large

again. Murray and Mercer checked with the navy commissioners and confirmed that the harbor needed to be at least twenty-five feet deep. The depth over the sandbar was nineteen feet — at high water. They then discussed the matter with the contractor dredging the Potomac River off Georgetown and received an estimate of $21,000. If Annapolis wanted to build its own mud-dredging machine, the work might be accomplished for half that. Murray and Mercer suggested to the city that the sandbar be removed before the navy commissioners arrived.[75]

At the next session of the General Assembly, John Stephen, member of the Common Council and delegate from Annapolis, introduced a memorial from the city asking for "legislative aid" to dredge a channel through the sandbar. Members of the House of Delegates debated the amount needed, and both they and the Senate approved an expenditure of $25,000. The money could not be spent, however, without assurances that Annapolis would be chosen if the "small and inconsiderable obstruction" were removed.[76] The city applied its own resources to ensure success: the corporation authorized $200 to hire Benjamin H. Latrobe to survey the bar, and when President Monroe arrived in town to welcome William Pinkney home from Russia in May 1818, the city fathers presented him with "complimentary resolutions" and made sure there was a sumptuous banquet in his honor.[77]

Two local authors, Councilman Jeremiah Hughes and an anonymous but well-traveled writer, published fervent, detailed arguments in favor of Annapolis as a naval center. They expanded on the city's own memorial by describing the "several deep and convenient creeks [that] make from the Severn, affording admirable scites [sic] for docks, &c. — hills on every beach for wharfing with." Indeed, deep water from Windmill Point to Round Bay would allow "an inner harbour and docks" up the western side of the Severn among hills "that seem to have been excavated by nature for the purpose of docks." The city could easily be defended. In addition to the existing fortifications, "with very little labour" Spa and College Creeks could "be connected by a canal that would insulate the [town] and render it impregnable."[78] The fact that they did not acknowledge private ownership of land along the Severn is a measure of the desperation of the times. What a different city Annapolis would be today had their plans been accepted!

Through the efforts of Maryland's Senator Robert H. Goldsborough, the U.S. Senate did add Annapolis, along with some six other ports, to the list of "suitable stations" to be surveyed for arsenal ports by a commission of army engineers and naval officers.[79] Predictably, Annapolis was caught in a dilemma: the survey team wouldn't approve a harbor without access for large vessels, and the General Assembly wouldn't appropriate money to dredge the sandbar without assurance of that approval. In the end, Secretary of the Navy Smith Thompson followed the advice of Navy Board president Commodore John Rodgers and offered to rent "one or more Warehouses . . . in which to store provisions, cordage, clothing, and various articles required for Ships of War." Vessels from the Mediterranean squadron would call at Annapolis for these supplies. "It is not intended," he wrote, "to make use of the harbour for repairs of ships, as in those cases, all the conveniences of an established Navy Yard will be required." Only a little caulking or rigging work that could be done in the "Roadstead" would be permitted. Annapolis would have the advantage of "the circulation of public money," some "additional activity," and a new resident storekeeper.[80] A far cry from what the city had envisioned, and even that didn't seem to pan out. Navy records list no storekeeper in Annapolis during this period. At least twice over the next two decades the city again sent resolutions to Congress extolling its advantages as a naval depot.[81]

Citizens of Annapolis might not have been able to influence the federal government, but

they could exercise their will on a government closer to home. And in 1819 they did just that by pushing through the General Assembly revolutionary changes in the city's charter. Whether these changes were the result of desperation at the city's economic situation, frustration with the incumbent officials, or a harbinger of Jacksonian democracy is hard to tell now, but whatever the cause, the effect was a city government more responsive to its constituents than ever before.

Even after the citizen protests of the mid-1760s, the Annapolis government remained the bailiwick of relatively few men. Terms of office for all except the mayor still extended "So long as they Shall well behave themselves." Only if a vacancy occurred on the Common Council could that spot be filled with a new face chosen in an election by the "Free Voters" in the city, and vacancies came seldom because, as one wag wrote to the *Maryland Gazette*, "few die, and none resign."[82] Now, in the second decade of the nineteenth century, as a half-century before, the result of such long-term incumbency was stagnation. A very small number of men were running the city and had been doing so for years. Only a few of them showed up for corporation meetings — when the corporation *had* meetings. In 1816, it met eight times, in 1817, seven times, in 1818, four. During the six years before 1819, two men, John Randall and Nicholas Brewer, alternated each year as mayor. In the four years before 1819, only seven men were elected to the Common Council, five of them to fill vacancies in July 1817, after meetings of angry citizens that marked the beginning of the charter-change movement. Between September 1815 and September 1818, an average of three of the six aldermen routinely attended meetings; Samuel Ridout, who resigned as alderman in May 1817, hadn't been to a meeting since 1809. Attendance was better among the common councilmen. During the same three-year period, an average of 70 percent came to meetings, but all ten sat together only once, in September 1817, following that summer's citizen outcry. Sometimes Recorder Ramsey Waters showed up; sometimes he didn't. The city had had a treasurer since 1784, but there was no requirement that he make public his accounts, nor did the mayor have an obligation to report on the activities of his administration. Minutes of corporation proceedings, when they existed at all, were for many years just notes scribbled on scraps of paper.[83]

Under the 1708 charter, the right to vote for the city's two delegates to the General Assembly was extended to "freeholders" (those persons with a lot and house), to those with a "visible estate" of twenty pounds sterling, and to free tradesmen with five years residence in the city. There was no mention of gender or race.[84] The 1776 state constitution continued this franchise until 1802, when an amendment narrowed it to free white males at least twenty-one years old who had lived in the city for one year. A number of free African Americans with the proper qualifications under the charter voted for city delegates in the state election of 1800, their last opportunity to do so.[85] Technically, they could still vote for Common Council candidates, under the 1708 charter. In the two elections in 1802 to fill vacancies on the council, only ten men voted in March and five in April. None of them were blacks who had voted in the 1800 state election. There are no poll books for city elections from 1802 to 1819, so it is impossible to know if African Americans exercised their rights in elections for councilmen during those years. Local women with the appropriate credentials could have voted in state elections before 1802 and in city elections until 1819, but none are listed in the existing poll books. Given the social conditions of the times, it is extremely unlikely that they did so.[86]

On 4 February 1819, John Stephen, still one of the two Annapolis delegates, introduced into the General Assembly a memorial from "sundry citizens" of the city "praying that sev-

eral objectionable and oppressive provisions in the charter . . . may be altered." Apparently the memorial had bipartisan support in the city, for editor Jehu Chandler of the *Maryland Republican* chastised the "ten or a dozen republican gentleman on the list" as ill-advised "midnight conspirators" in the charter-revision petition. The *Maryland Gazette*, on the other hand, quickly printed a letter from "A Native Citizen" condemning the existing charter as "the only remnant of pure, unmixed, aristocracy" and lauding its revision as an attempt "to remove this foul blot from our republican land, and to promote the improvements and prosperity of our city." Clearly emotions were running high, and it is surprising that these articles were the first to appear on the issue in the local papers.[87]

In the House of Delegates, the citizens' memorial was referred to a committee composed of Stephen and two Anne Arundel County delegates. Who actually wrote the charter revision legislation is unknown; it was definitely not either of the city's delegates. Stephen tried to get the issue referred to the next assembly, and Dr. Dennis Claude, the other Annapolis delegate, proposed that the entire bill be struck out, with the exception of sentences designating an annual election of Common Council members and limiting city property taxes to one dollar per hundred dollars value. Neither attempt prevailed, and the bill passed by a vote of 37 to 18. Three of the four Anne Arundel County delegates voted in favor of the revision; John Stephen and Dennis Claude voted against it. The bill passed the Senate the next day. It should be noted that Claude had been an alderman since 1814 and Stephen a member of the Common Council since at least 1816. They apparently saw the charter-change movement as a personal rejection, and as neither of them retained their seats under the revised charter, they were probably correct.[88]

The most important change in the charter under its revision of 1819 was that for the first time in 111 years, all officers of the corporation would face regular, popular elections. The new charter reduced the number of aldermen to five, the number of councilmen to seven. The mayor and aldermen would serve three-year terms; councilmen would be elected annually. After an initial change-of-government election in April 1819, city elections would take place in October at the same time as the state elections. (City elections were returned to April in 1823.) City elections were open to inhabitants of Annapolis "qualified to vote for delegates to the general assembly of this state," who, in 1819, were free, white, male, U.S. citizens, twenty-one or older, and had lived in the city for six months. There was no requirement that the voter hold either real or personal property.[89] The new franchise effectively ended any glimmer of suffrage for African Americans and women for generations to come.

The revised charter required monthly meetings of the corporation and annual, public reports from both the treasurer and mayor. Deliberations of the corporation were to be public, and a journal was to be kept of the proceedings. Any member could request a roll call vote. Recognizing municipal responsibilities accumulated over the years, the law continued the corporation's power to appoint city employees such as commissioners, constables, hay-weighers, and market masters and to regulate the size and cost of bread, control fires and crime, and lay property taxes. The emphasis in the revised charter on establishing streets and new boundaries for the city indicates an awareness of the necessity for improving the public thoroughfares and incorporating the development outside the town. The one power denied under the revision was the right of the corporation to hold a "court of hustings"; the old Mayor's Court was abolished. The law does not mention the city sheriff. For most, if not all, of the preceding century the man elected by the corporation had been the same man appointed sheriff of Anne Arundel County.[90]

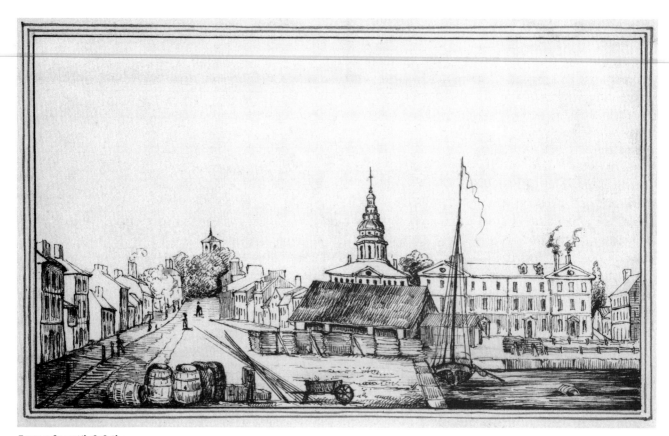

From 1784 until 1858, the market house sat closer to the foot of Main Street than the present building does. To the right in this pen and ink drawing of Market Space, made before 1858, stands Charles Wallace's impressive three-story, four-part commercial building constructed before the Revolution but then still the largest private structure in town. Artist unknown. Courtesy of the Maryland Historical Society.

In the election held in April 1819, only venerable alderman John Randall and councilmen Henry Maynadier and Joseph Sands, both elected in July 1817, were returned to office. Lewis Duvall, who had served as the city's delegate in the legislature from 1811 to 1816 (and was elected again in 1819 and 1820) became mayor and Thomas H. Carroll, recorder. All but two of these April electees were confirmed in the October election.[91]

Following the charter revolt of the mid-1760s, city officials tended to be less tied to the proprietary faction and more typical of the citizenry. Were the new city officers of 1819 more "democratic" than their predecessors? The only statistical comparison that can be made is based on the value of their real and personal property listed in the 1819 city assessment. Mayor Lewis Duvall's combined valuation is higher than that of any other city official of the period except previous councilman William Brewer's. Without their amounts, the average assessed wealth for the 1818 corporation officers is $2,345, and for the 1819 officers, it is $1,928, or roughly 18 percent less.[92] More important to the future of the town was the new corporation's attitude toward municipal responsibility. As had been the case following the 1760s restructuring, the new officers proved to be more progressive, more in touch with the needs of the people than the majority of their predecessors.[93]

The new corporation immediately set about improving the city's streets, beginning with the major commercial streets of the town: West Street, Church (now Main) Street, and Market Space. Curbing stone and red bricks for gutters were ordered and laid, and adjacent property owners were directed to pave the sidewalks with red brick at their own expense. Over the next forty years, the grading, curbing, guttering, and laying of sidewalks was extended throughout the town, and paving stones were placed at crosswalks, although the streets themselves remained unpaved. In the late 1820s, the city fathers planted "or-

namental" trees in Market Space and encouraged residents to place shade trees along the curbs in front of their property.[94] A number of the streets shown on Stoddert's 1718 town plan were still not cut through, and yards and structures continued to intrude into platted street beds. In its first year in office the new corporation addressed this problem. The worst case involved East Street, which, because of the problems with intruding structures and irate landowners, would not be cut through and curbed to Prince George Street until 1844.[95] Its extension to King George Street would not be completed until after the Civil War.[96] In addition to opening platted streets, the corporation looked at areas where new streets or alleys might improve traffic and accessibility. Again, this involved placating and compensating property owners. Dr. James Murray was approached to see if he would allow his garden to be bisected by a street from Market Space. He agreed, and Randall Street was completed and named in 1831.[97] An alley between Church Street and South East Street (now Duke of Gloucester) was created in 1826, and informal alleys, such as the one between Cornhill and Church Streets, now Hyde Alley, were targeted for acquisition by the city for public use. Other private streets, such as Cornhill and Green, were declared public and brought under the control of the city.[98]

A much later view of the building, now 211 Main Street, commissioned by city officials in 1820 to serve as fire house and city hall. The tower was added by 1841 to house the city's bell. Courtesy Maryland State Archives, MSA SC 985-266 detail.

The new government also moved to dredge the city dock, to dig additional public wells and provide pumps, and to fill in the swamp and marsh at the lower end of King George Street known as Governor's Pond.[99] As with the street improvements, work on all of these continued for many years (Governor's Pond was not fully obliterated until the 1860s), but the more publicly responsive corporation was at least working to address citizens' concerns.

In 1821, as part of its attempt to bring order to city business, the corporation built a two-story brick building on Church Street as a combined fire house and city hall. The city's three fire engines were housed on the first floor, where there was also meeting space for the fire companies. Municipal officers convened on the second floor. For many years, the corporation had met most often in the tavern on Church Circle kept by William Reynolds and, later, by William Goldsmith. Now there would be one official meeting place, with seats around the room for the comfort of citizens and outside a privy and a convenient well and pump.[100]

In the midst of this flurry of civic improvements, the city paused in December 1824 to welcome the Marquis de Lafayette, who was touring the United States at the invitation of President James Monroe and Congress as the country prepared for celebrations marking the fiftieth anniversary of the Declaration of Independence. Eager not to miss out on the festivities occasioned by this visit of "The Nation's Guest," both the state and city issued invitations to Lafayette, and the city was particularly pleased at the great man's response that Annapolis "was very dear to his heart, that he was bound to it by many ties, and that he would certainly visit it."[101]

Lafayette, his son George Washington Lafayette, and his entourage were met at Gov-

THE ELEGANT STEAM-BOAT

MARYLAND.

On and after Tuesday the 27th day of May inst. this superb and splendid boat will leave Baltimore every Tuesday and Friday for Annapolis, Cambridge and Easton, at 6 o'clock in the morning, and returning, leave Easton every Wednesday and Saturday for Cambridge, Annapolis and Baltimore, until the 1st of October next, when she will start at 7 o'clock, and touch at Castle Haven, instead of going to Cambridge.

On every MONDAY morning, she will leave BALTIMORE for CHESTERTOWN, and return the same day, leaving Chestertown at one o'-clock, P. M. touching at CORSICA (for the Centreville passengers) going and coming.

The Maryland, in order to prevent collision will leave Baltimore on Sunday morning next (and every succeeding Sunday,) at the same hour during the season, at *half past nine o'clock*, A. M. (for Annapolis.)

☞ The public are respectfully informed that the MARYLAND has been recently fitted up in the best manner, having the most approved copper boilers.

L. G. TAYLOR, Master.
May 24.

ernor's Bridge, on the Patuxent River, on Friday, 17 December, by dignitaries of all kinds and what must have been every militia unit within thirty miles. His visit had been eagerly awaited, and not even a blustery northeaster dampened the enthusiasm of the crowds that lined his route. As the old general came within sight of the town, the nation's flag was raised high above the State House and a twenty-four-gun salute rang out from the Annapolis Artillery Company on the St. John's College green. Escorted into the State House by "two ranks of beautiful young girls dressed in white, with wreaths decorating their heads, and baskets of flowers to strew [his] path," Lafayette passed under two arches of satin inscribed with mottos of praise and affection. The sixty-seven-year-old former general addressed an overflow crowd in the Senate Chamber, reflecting on his commander's resignation in that very room and his own personal memories of the city.[102] When Governor Samuel Stevens, Jr., presented Revolutionary Captain Samuel Griffith to Lafayette, the two elderly gentlemen "rushed into each others arms and wept like two children."[103]

After a visit to Fort Severn, another twenty-four-gun salute, and introductions all around, Lafayette was escorted to the governor's house for dinner. A grand ball in the hall at St. John's, with music by a marine band from Washington, followed by an elaborate sit-down supper for 150 "fitted up" by James Williamson, city councilman and proprietor of Williamson's Hotel on Church Circle, capped the evening.

The next day, Lafayette received gentlemen at the Ball Room from 11:00 a.m. to noon and ladies in the Senate Chamber from noon to 1:00 p.m. A parade and formal review of troops on the green — another opportunity for Revolutionary veterans to pay their respects — were followed by a "Citizens Dinner" and a staggering number of toasts. After dinner, the guests walked out to see the city illuminated with lights and "various fanciful devices" (more transparencies) in honor of the general. Lafayette rode through the streets, admiring the town's artistic efforts, before returning to the governor's house to dance to the music of the Fort McHenry band. Sunday seems to have been a more relaxed day. Lafayette attended services at the new Methodist Church and called upon those few living friends who remained from his Revolutionary days.

On Monday, both houses of the General Assembly welcomed Lafayette to their sessions and entertained him at yet another formal dinner, with yet more toasts. He again received ladies during the afternoon and closed the day with a party at Ogle Hall, then the home of Mary Nevett Steele. He left Annapolis on Tuesday, 21 December, to return to Washington. By all accounts, his visit was a grand success, reawakening the town's celebrated gentility and allowing a new generation of Americans a view of one of the country's most revered heroes.[104]

The experience of the African American in Annapolis in the first half of the nineteenth century depended almost entirely on whether he or she was free or slave. Slaves outnumbered free blacks in the city until 1840; but twenty years later, just before the Civil War, almost two-thirds of Annapolis's African Americans were free. It is the gradual but steady rise in the number of free blacks during these years that most affected city life and the lives of African Americans in general. With the increase in free blacks, either by manumission or natural gain or, in a few cases, by in-migration, the number of households headed by blacks also increased until in 1840, one-quarter of the city's households were headed by African Americans.[105] (See Appendix 1, Table 1.)

Throughout the period 1800 to 1850 the population of the city identified in census re-

Charity Folks and Her Family

Charity Folks was probably a second or third generation Annapolitan, but no records survive to tell us of her early life. It is possible that Charity, a slave, belonged to Governor Samuel Ogle and moved with Ogle's daughter, Mary, to her new household when she married John Ridout in 1764. We do know that the bonds tying Charity to John and Mary Ridout went beyond legal possession and were strong enough to bring freedom to Charity and her children. Charity's "faithfull service and good behaviour" moved John Ridout to provide an annuity for her in his will. Following her husband's death, in 1797, Mary Ridout executed a deed of manumission, for "faithful services" and "dutiful behaviour," that eventually freed Charity, her son James, and daughters Hannah and Charity. Documents referring to Charity describe her as a mulatto woman, indicating mixed African and European ancestry. Her certificate of freedom records her skin color as "bright," suggesting perhaps two generations of European ancestors.

During her final illness, Mary Ridout wrote to her mother, Anne Tasker Ogle, describing Charity as a "humble friend indeed" and "a comfort to me in all my affliction." Mary's will left half of her clothing to Charity, a generous bequest from a wealthy and well-dressed woman.

Once free, Charity joined a growing Annapolis community of free blacks that included her second husband, Thomas Folks. Folks had been freed by his owner, merchant John Davidson, in July 1794. As a free man, he kept a store and owned property in town. Charity's children also found spouses among this community. The younger Charity married William Henry Bishop, Jr., whose father was Irish or English and his mother an enslaved woman named Jane Minskie Ennis Bishop. Although Jane Bishop remained a slave, all of her children eventually became free.

William Bishop, Jr., worked as a carter (carrier of goods) and had a wood yard. He and Charity and their family lived on Church Circle across South Street from the courthouse. By the time he died in 1871, Bishop owned enough property in Annapolis to make him the city's wealthiest African-American resident and the twelfth wealthiest inhabitant regardless of race.

JEAN B. RUSSO
Associate General Editor, Archives of Maryland Online
Maryland State Archives

cords as "colored" held at about 40 percent of the total population. The fact that many of those people were free, be they African American or mixed race, provided benefits to their enslaved brethren beyond the usual advantages of urban life. Slaves who "lived out," or away from their owners or employers, usually lived with free blacks. Families were often mixed, slave and free, and the free members worked to purchase and manumit wives, sons, daughters.[106] In a town of fewer than 3,000 people, local slaves might not enjoy the anonymity they could have in a big city with a large free black population, like Baltimore, but as the number of free men and women increased in Annapolis, skin color was no longer an automatic sign of bondage.

Free blacks in the first years of the new century lived all over town. John and Lucy Smith

rented and later bought 160 Prince George Street; their son John, Jr., lived on Church Street near the market. Boot and shoemaker Stephen Rummells lived at 57 Cornhill Street, and Thomas and Charity Folks owned a double house at the bottom of Cornhill. John Wheeler lived at 184 Church Street; John and Henrietta Hicks owned a house in the first block of West Street. Jacob Forty rented two houses, one on Church Street, one on Green; Catherine Prout was a tenant on Carroll's Alley (now Pinkney Street) near Prince George Street. Smith Price and his family resided on lots on the south side of West Street, just outside the town, carved out of the Hammonds' Acton plantation, and in 1798 a group of free blacks lived in two large houses on "Red Row," which may have been part of Bloomsbury Square.[107]

With few exceptions, free or enslaved African Americans who "lived out" lived in rental housing. The 1845 city real property assessment listed only seven free blacks as owners of lots and houses, although several—William Bishop, Henry Price, Moses Lake, and Charles Shorter—owned as many as four dwellings. Five years later, only 12 percent of black households on the 1850 census were shown as owning real property.[108] By this time, many black families lived in attached tenements, probably similar to those erected by Dr. Dennis Claude on South Street and termed "the Seven Buildings." Nellie Owens, slave of the Brewer-Ridgely family, moved into one of these Claude houses after the death of her mistress in 1847. In the last year of his life, Elihu Riley wrote with affection his memories of "this grand old loyal woman," who lived to be nearly one hundred and who had told him that when George Washington was in Annapolis in December 1783 to resign as commander of the Revolutionary Army, she watched the future president being shaved at Caton's Barber Shop on Cornhill Street.[109]

Even though he or she might be legally free, an African American in Annapolis could not assume that that status would always be recognized. Manumission papers and certificates of freedom were recorded in county court records, but free men and women kept the originals close at hand. Freedom certificates were required after 1805 for African Americans who wished to travel outside the county. City bylaws grouped "free Negroes" with jugglers, fortune tellers, and the "common Gambler" in vagrancy laws, and authorized their arrest if they showed "no visible means of subsistence or support." Until 1805, a "vagrant" free black who could not pay the fine or give security for his "good behavior" could be sold back into bondage for up to four months. Slaves "going at large" without permission could be whipped—thirty-nine lashes was the maximum punishment for this offense in 1797.[110]

In spite of their precarious situation, free blacks became leaders within the African-American community. They trained apprentices, employed other blacks, encouraged education, and in some cases, accumulated wealth and property. They led in the religious life of the city's African Americans and participated as much as possible in the legal and economic systems of the town.[111] From at least 1810 to 1816, baker Lucy Smith held stall number 9 in the city market.[112] Other free blacks, both men and women, sold produce within the market over the succeeding years. Lucy's son, John Smith, Jr., opened an oyster house in 1819 and appealed to legislators for custom. That same year, Henry Price established "a general Fruit Shop and Confectionery" on Church Street, selling fruit, cordials, spices, toys, groceries, tobacco, and "Spanish Segars."[113] William Bishop, Jr., was superintendent of the city's chimney sweeps in the mid-1820s. Ten years later he and five other local blacks held city licenses for carts, drays, and gigs. Hauling was a growth industry during an era of civic improvements and the backbone of success for a number of black men. Bishop led the field, and by 1860 he was one of the wealthiest men in Annapolis.[114] Moses Lake, who

MOSES LAKE,
HAIR DRESSER

(SHOP ADJOINING THE BAR ROOM OF THE CITY HOTEL.)

Is at all times ready to attend to the business of his vocation.

He constantly keeps on hand a large assortment of articles of Gentlemen's wear, such as *Stocks, Collars, Suspenders, Hose.* &c. also, a variety of dress, head and tooth brushes, razors, and razor straps, and all other implements for Shaving and Head Dressing.

Annapolis, December 24th 1835.

came to Annapolis from Washington County in the late 1820s, ran the barber shop in the fashionable City Hotel, where he also sold "Gentlemen's wear" and dispensed treatments for ringworm, herpes, and other skin conditions, the success of which were testified to by appreciative customers as far away as Virginia.[115] His second wife, an accomplished seamstress, operated a dress shop and the town's first jewelry store, which were patronized by "customers from the best classes of society in Annapolis."[116] In the years before the Civil War, these families intermarried, establishing connections that sustained them in hard times and enabled them to rise to the top of black society here and, for those who moved on, to become prominent in other parts of the country as well.[117]

Not all freed slaves did well. For the majority, life was hard and often short. Removed from the care of white owners who had a financial, if not an ethical, stake in their welfare, they struggled with poverty and illness. A study in 1836 noted that free blacks in Baltimore had a death rate one-third higher than that of slaves, with old and infirm former slaves being most susceptible to illness.[118] There is no reason to believe that the situation in Annapolis was any better.

The 1850 federal census was the first to include a mortality schedule, which provides the only glimpse we have of the rates and causes of death at midcentury. The Annapolis district census taker noted that smallpox and scarlet fever had been "prevalent" in the city during the year prior to 1 June 1850, the period for which deaths were detailed. For the white population, the death rate was just under 3 percent, with more than half of the deaths occurring in children six years and under. Of those, almost half died of scarlet fever. Both free blacks and slaves had somewhat lower death rates, 2.3 and 2 percent, respectively. Almost half the deaths among African Americans occurred in people over the age of forty, and a third of the total number was attributed to smallpox. As with whites, the dead within the

slave population were predominantly children six and under, and almost all died from scarlet fever, perhaps because they lived in or near white households where the risk of contagion was great. These numbers are too small to be statistically relevant, but they do support the point that older free blacks were at greater risk than elderly slaves. They also underscore the sad fact that children were most at risk for contagious diseases.[119]

In 1837 two free black men turned to the county courts for redress of damages. One was personal in nature, the second of general effect. One man lost; the other won. That spring, the court denied Henry Matthews damages in a suit against Mayor John Miller and former mayor Dennis Claude "for alleged injury to his property in pulling down his house at a fire" in 1833, when firemen believed the burning house threatened its neighbors. (The city government paid $50 each to two attorneys for their defense of Miller and Claude.)[120] Five months later, the more fortunate Charles Shorter achieved success in what may be the city's first antidiscrimination case.

The issue was hogs. For years, the city had cited owners, black and white, for allowing their hogs to run loose in the streets.[121] While hogs were useful processors of unwanted food-stuffs and handy for keeping garbage out of streets and yards, they left behind their own waste and could be quite dangerous if annoyed on public thoroughfares. Even if penned, they tended to be odoriferous. On the other hand, because it could be easily procured and preserved, pork remained an important component of the Southern diet. Annapolis was not the only American town with hog problems. Cities from New York to Little Rock were overrun with pigs in the early part of the century.[122] In the 1830s, the Annapolis city corporation discussed measures they hoped would eliminate, or at least curb, the presence of hogs in their town. A bylaw in 1835 prohibited slaves from keeping hogs and allowed whites and "free persons of colour" to do so only if the animals were penned sixty feet from any house, street, or alley. Two years later, proposals before the corporation threatened the right of free black residents to raise hogs at all, penned or not. Charles Shorter, a free man of color and a member of the local black elite, brought suit in the Anne Arundel County court on the issue of whether the city corporation had the power "to distinguish between white and coloured persons" in the matter of hog keeping. On 11 September 1837, city officials, reacting to this case even before judgment, instructed the recorder to "wave [sic] the question" of who owned the offending hog should a violation occur and passed a new bylaw stating that anyone allowed by state law to keep hogs might do so as long as the creatures were "not permitted to run at large." Hogs were finally outlawed from the city altogether in 1849. New York City did not acquire a "pig-free zone" until 1860.[123]

When the slave Nat Turner led a bloody rebellion against slave owners in Virginia in August 1831, anxiety among whites across the South caused them to view all blacks, slave or free, with suspicion. For the next two months, Annapolis newspapers carried stories of slave revolts in Virginia and North Carolina. Anne Arundel County whites gathered in several districts to form committees of "vigilance" and to urge their legislators to pass laws that would prevent negroes from meeting, deny further manumissions, and "remove free negroes from this State."[124] "The Free People of Colour of the city of Annapolis and its vicinity" reacted publicly to this threat by gathering on 4 October 1831 at their meeting house on West Street. Henry Price chaired the meeting, with John Smith, Jr., as secretary. Resolutions passed that night and printed in both the *Maryland Republican* and *Maryland Gazette* assured their "white friends" that "our future conduct and deportment shall continue to be such as will be calculated to increase and continue their confidence and good wishes." Should anything threaten "good order, peace and tranquility," they pledged to "use every

means, and all our influence, to put it down." It was, they testified, "our highest wisdom to live soberly, righteously and godly, in this present world, that in the world to come we may be sharers of eternal life."[125] Their reassurance may have defused the situation in Annapolis, but at the next session of the General Assembly, legislators whose constituents were still frightened passed a law severely limiting the rights of "free negroes and mulattos." Among the prohibitions was the right to assemble. The only gatherings allowed in Maryland under the new law were those for religious purposes in Annapolis and Baltimore City, and then only with the permission of a white preacher.[126]

The increased racial tensions of the period probably prompted the Methodists in Annapolis to separate themselves formally along color lines. In 1838 Charles Shorter replaced the West Street meeting house with a new brick church, which the African-American congregation named for Francis Asbury. Black Methodists would remain part of the Annapolis Station, under oversight of the white pastor of the State Circle church, but their new status as an officially separate congregation would "permit a fuller participation in the worship services and a more indigenous leadership."[127]

When the American Colonization Society established its settlement in Liberia, on the western coast of Africa, in the 1820s, fewer than 15 percent of the emigrants were from Maryland. John Randall's fifth son, Richard, a physician and one of the founders of the society, traveled to Monrovia as governor of the new colony in 1828, but his tenure lasted less than four months before he died of malignant fever. The Maryland Colonization Society opened its own settlement down the coast from Monrovia at Cape Palmas and began sending black colonists there in 1833. Of the thousand men, women, and children transported by the Maryland society between 1833 and 1855, just a few gave their residence as Anne Arundel County.[128]

Public education came to be a recognized advantage in Annapolis during the early decades of the nineteenth century. In 1818, a group of women opened free, nondenominational "Female Sunday Schools" for both white and African-American girls, supported by contributions from local citizens. Students who could read studied the Bible and learned hymns and catechisms. Those who could not read were taught that basic skill before going on to Bible study. The student body was divided racially, but all of the classes met in the same building under the same administrators. By the end of the first year, perhaps thirty white students attended regularly. The twenty black students included both children and adults, most of whom were making "good progress" in reading. Teachers of the African-American classes were assisted by two "coloured" adults "of good character and attainments."[129]

Legislation passed by the General Assembly in 1825 called for the establishment of primary schools in each county under the supervision of district trustees.[130] The city's first public primary school, for white boys, opened in a new, one-story brick schoolhouse on Green Street in 1829. Almost two hundred students enrolled immediately for instruction by Henry Roe, Jr., who was paid $250 a year by the trustees of Primary School District 38. The school employed the popular monitorial system of education, in which large numbers of students were divided into small groups, each monitored by a more advanced student as it recited its lessons. A report written after a General Assembly committee visited in 1830 noted that the school admitted "all classes," which the committee believed would "elicit talents and prove in practice a felicitous accommodation to the genius and spirit of our Constitution and form of government."[131] When primary district trustees decided to open a

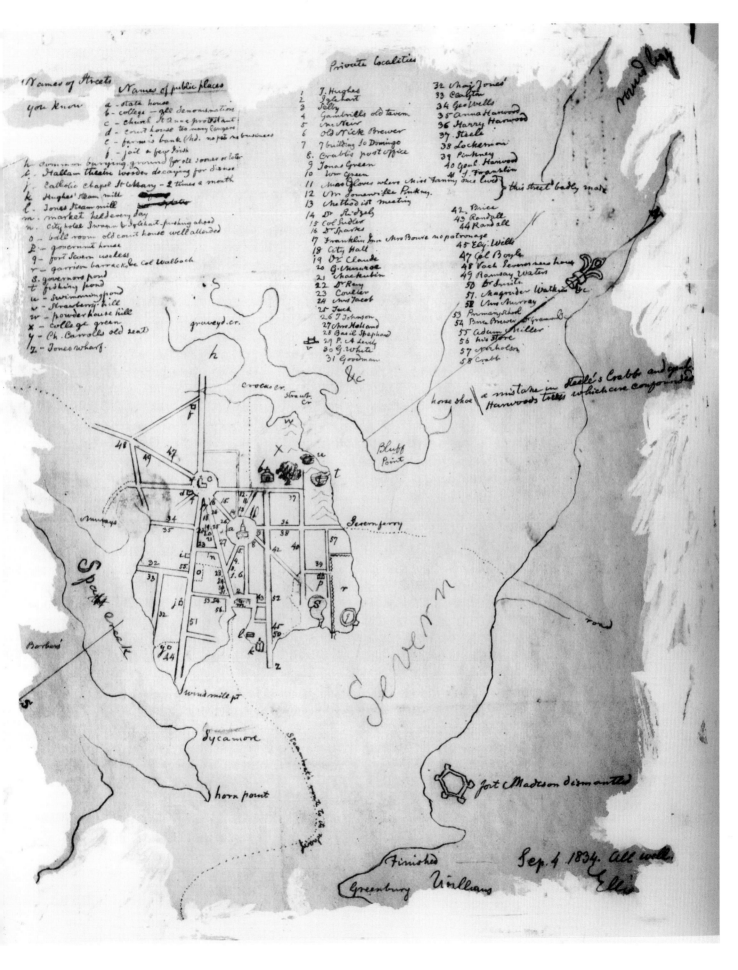

school for girls in 1840, the municipal government allowed classes to be held in City Hall as long as they did not disrupt corporation meetings.[132]

By the 1830s, Annapolis had changed in appearance and culture. The Hallam Theatre on Duke of Gloucester Street, completed in 1829, brought ballet and stock companies to town, although it never seemed to do very well and had trouble paying the city's amusement tax.[133] New "substantial and permanent" wharves surrounded the city dock, the ones facing the market and on the south side built of stone. Work to deepen the city dock by hand and by dredge, or "mud machine," continued with some success, and attempts had been made to drain and fill the swamps along Acton Cove and Governor's Pond.[134] Street grading and curbing, sidewalks and footways extended into residential districts such as Northeast and Hanover Streets, and street signs, painted on boards, were attached to corner houses.[135] Following the advice of their elected mayors — Mayor James Boyle warned in 1824 that it would be a return to the city's "old state of hobbling imbecility" not to fund civic improvements properly — citizens apparently accepted that such benefits would cost money. The corporation paid for many of the improvements, new wharves for instance, by borrowing from Farmers Bank, and the city accumulated debt; the tax rate reached 75¢ per $100 assessed property in 1831 and climbed to $1.00 in 1839.[136]

For years the city's fire engines had been under the care of an engine keeper appointed each year by the corporation and paid a small salary. Two volunteer fire companies, under the control of the city, responded to fires with the "Victory" and "Maryland" engines, assisted by "ladder and axe" men and bucket men. Anyone not enrolled in a company became part of the bucket brigade.[137] But in February 1839, perhaps as a result of Henry Matthews's suit against city officials for the demolition of his house, the Independent Fire Company received its state charter as a legal body separate from the city government. Attorney Alexander Randall, another of John Randall's sons, headed the list of twenty-two incorporators. The act mentions "the engine of said company" but doesn't indicate whether this might be one of the city's engines. In 1847, the city formally "entrusted" its "Fire Apparatus" to the "Care and Keeping" of the fire company organized by Randall.[138]

City-sponsored or independent, fire companies were part of the social life of the city. As in the case of the local militia units, firemen met for training, and friendships grew from a shared objective. Fraternal organizations, such as the local chapter of the American branch of the International Order of Odd Fellows, officially established in this country in Baltimore in 1816, also attracted members. The temperance societies served a useful purpose, as did the Female Orphans' Society, organized by twelve women and incorporated by five of their husbands and friends in 1830.[139] For many Annapolitans, especially women and African Americans, church remained the center of their public social life. Sunday schools, class meetings, missionary and sewing societies gave women the opportunity to gather for charitable and religious endeavors.[140] As might be expected, public recreation during this period seems to have been water-oriented. Swimming at the Bath Springs in Acton Cove was popular, and the city built a raised walkway from the courthouse to the bathing site in 1837. Swimming in the harbor, however, was frowned upon, and fines were imposed on anyone who might "Bathe or Swim, or expose Themselves naked" on the Annapolis side of Spa Creek between Windmill Point and Acton's Cove before 8:00 p.m. Cold winters lured daredevil skaters onto the ice. In January 1835, two men skated the thirty miles from Baltimore to Annapolis and returned home after a congratulatory meal at the City Hotel. Later that month, when two other young men tried to repeat the feat, one drowned.[141]

As had been the case in Annapolis for more than a century, politics offered the most,

and usually the safest, excitement, whether in conventions of party faithful, street corner arguments, or electioneering. But the city's influence on state politics lessened as the power of Baltimore City increased. Maryland's reform law of 1837 removed Annapolis's right to two delegates in the General Assembly. The city's delegation was reduced to one in the election of 1838 and discontinued in 1840. No longer a separate political entity in the eyes of the state, Annapolis became part of Anne Arundel County in the new, popular elections for state senate and governor.[142] Worse yet, when the state's austerity program went into effect in the mid-1840s, the General Assembly met only every other year, cutting in half the income local businessmen counted on from legislators.[143] The city made its own government changes in 1843 by dropping the seven-member Common Council. Henceforth, the corporation would consist of the mayor, recorder, and five aldermen. Three election judges appointed by the corporation now supervised city elections, replacing the longstanding policy of having the officers of the corporation judge their own elections.[144]

On 4 July 1828, ninety-year-old Charles Carroll of Carrollton assisted in placing the cornerstone of the Baltimore and Ohio Railroad at the edge of Baltimore City. That same day on the rocky Potomac shoreline just outside of Georgetown, President John Quincy Adams doffed his coat to attack a tenacious root and lift the first shovelful of dirt for the Chesapeake and Ohio Canal. As their names make obvious, both the railroad and the canal were conceived with the same objective: to extend a trade route into the vast, rich country beyond the Allegheny Mountains. We know today that the railroad won the transportation sweepstakes, but in 1828 most bets were on the canal. Canals were a known entity, and organizations promoting the Potomac as a route into the back country had been around for more than half a century. Many Annapolitans remembered George Washington's visit in 1784 to secure Maryland's participation in the Potomac Company, and some no doubt had followed the activities of that company as it tried, with some success, to modify the great river for barge shipping. By the late 1820s, the 363-mile Erie Canal had opened the hinterlands of New York State to the Hudson, the Chesapeake and Delaware Canal neared completion, and Philadelphia was working on its main line of improvements west of the city. But a railroad? That was merely a dream based on a primitive steam locomotive and a few miles of track in England.[145]

Annapolis was going for the canal. Baltimore was hedging its bets, too, by looking for a way to connect the city with the C&O. When the city fathers of Annapolis heard that Dr. William Howard, a civil engineer from Baltimore, was exploring the head of the Severn for a possible canal route to that city from the Potomac, they directed Councilman James Murray to find some knowledgeable person to assist Howard with the survey — and report back to them.[146] There had to be a way for Annapolis to partake of whatever riches came along. And, indeed, legislation in 1829 created the Annapolis and Potomac Canal Company to build a "navigable canal" between Annapolis and the Chesapeake and Ohio Canal. This would be, the act said, a "work of great profit and advantage to the people of this state" and a benefit to users of the C&O by enabling them to avoid "the circuitous and difficult navigation of the Potomac river." The legislature directed the governor to contact the president of the United States immediately to see about having the Corps of Engineers survey the route.[147]

It was not until 1836 that such a survey was done, by a team of army engineers under the supervision of George W. Hughes. Hughes and his colleagues were paid by the state, and

his report is a celebration of every benefit that Maryland, and Annapolis, might ever hope for from the canal. The advantages of Annapolis, he said, "render her peculiarly adapted, as a terminus of the Chesapeake and Ohio Canal, to accommodate the immense business which it is believed that work will create." The city's harbor, so "easily defended," so ice free, "might conveniently afford shelter for all the shipping of the City of New York"! He looked at several possible canal routes from Georgetown to the Severn and preferred Spa Creek over College Creek as a terminus: "[it] furnishes the better water and forms a fine, safe and commodious basin for canal boats. The locks falling so near together in the immediate vicinity of Annapolis, will afford a great amount of water power for manufacturing purposes." Coal shipment by canal all the way to the Chesapeake, instead of just to Georgetown, would be of great advantage to the coal mines of Western Maryland and Pennsylvania. With the Annapolis canal linked to the C&O, Maryland could garner third place in the country's commerce and second place in tonnage, with connections to New York, Ohio, Missouri, and the Great Lakes. Thus, he crowed, "Maryland will truly become the *centre of the Union*; in the most intimate of all political connexions — that of commerce and profitable intercourse." It was all too good to be true, which the price tag quickly made clear. With an engineer's precision, Hughes tallied up the cost for the canal: $2,882,562.94.[148] The state had included $500,000 for the purchase of stock in the Annapolis Canal Company in its eight-million-dollar internal improvement bill of 1835 and had authorized the city to subscribe for 200 shares in the company, even if it had to borrow to do so.[149] But three million dollars? Not a chance!

During the summer of 1836, as George Hughes and his survey team tramped through the countryside, calculating elevations and stream flow, trains had been running for almost a year along the Washington Branch of the Baltimore and Ohio Railroad from its intersection with the main line at Relay to the nation's capital.[150] In March of 1837, just a month after Hughes delivered his report to the governor, the General Assembly passed legislation incorporating the Annapolis and Elk Ridge Railroad Company. Three of the six men named in the act were Annapolitans: Alexander Randall, Somerville Pinkney, and George Wells. The others were Amos A. Williams, a state-appointed director of the B&O, Anne Arundel County delegate Leonard Iglehart, and Elias Ellicott. The charter set the company's capital stock at $450,000 and authorized state participation if, and only if, the Annapolis and Potomac Canal Company released the state from its half-million-dollar obligation under the 1835 internal improvements act.[151] Given the relative cost of track versus canal and the proven success of the existing railroad, it probably didn't take long to scuttle the canal company. The city corporation, delighted with the railroad plan, subscribed $8,500 to the new company. At first, city officials thought to issue stock of their own to cover money borrowed from Farmers Bank, but after a few weeks of consideration, they scrapped that idea and used city taxes and debts due as collateral.[152]

Engineer George Hughes quickly transferred his allegiance to the railroad, for which he became chief engineer, presumably bringing his drawings with him. Work progressed slowly over the next three years on a route that crossed the county northwest from Annapolis roughly twenty miles to intersect with the B&O at a point east of Savage Mill and almost midway between Baltimore and Washington. There the terminus of the new road was called, with no imagination at all, Annapolis Junction.[153]

Pleased though they might be with the Annapolis and Elk Ridge Railroad, the citizens of Annapolis were not willing to have its trains run through the streets of their town. In April 1839, when railroad president Somerville Pinkney, who also happened to be an al-

derman, asked his colleagues in city government to approve a terminus at the dock, fellow alderman William Bryan protested, citing the danger from spark-shooting steam engines in a city where "houses are thickly built" and streets crowded with pedestrians as "likely to be destructive of property and certainly perilous to human life," especially for "laboring classes." Over the next five months, the issue was debated in public meetings and private conversations. Finally, in September, the corporation again considered the issue. Although 156 men had signed a petition approving a city route only for freight cars drawn by horses, city officers voted to open the city to steam trains, provided that they did not travel West and Church Streets, went no more than four miles an hour, and carried spark catchers on the locomotives.[154] Perhaps because of the public outcry, the line was never built and the railroad ended at a depot on the northwest corner of West Street and Calvert Street. Railroad officials tried again, in 1842, to extend the tracks to the dock, but it would be another sixty-six years before trains rumbled through the streets of downtown Annapolis.[155]

The first train of the Annapolis and Elk Ridge Railroad traveled from Annapolis to its junction with the Baltimore and Ohio's Washington Branch on December 25, 1840. Regular service began the next day with two trains departing Annapolis, the first at 5:30 a.m. and the second at 3:30 p.m., to intersect at Annapolis Junction with B&O trains leaving from Washington and Baltimore. Return trips to Annapolis were also timed to coincide with B&O trains. The trip to Baltimore took about two hours and cost $2.00: the somewhat longer trip to Washington cost $2.50.[156] And travel by train avoided the fifty-three closed farm gates that one traveler encountered on his thirty-six-mile, two-day journey from Annapolis to the District of Columbia by horse and carriage in 1848.[157]

The railroad assured Annapolis a place within the network of nineteenth-century transportation. Trains ran in almost any weather; no ice or windstorm or sandbar impeded their regularity. But it was the steamboat that saved the city. Not the boats that had been running between Baltimore and Annapolis and the Eastern Shore since the maiden voyage of the *Chesapeake* in 1813.[158] No, useful though the steamers were, with their three-hour runs to Baltimore several times a week, it was the effect of steam upon naval warfare that brought to Annapolis the fulfillment of its dream: the Naval Academy.[159]

The idea of a formal shore-based school to train young men as officers of the United States Navy was not new; John Paul Jones had recommended it in 1777, and over the next six or so decades a number of officers and secretaries of the navy had echoed his sentiments. The matter reached the U.S. Congress several times in the 1820s and '30s but never bore fruit. As with the naval depot-shipyard-arsenal issue, each time the possibility arose, Annapolis got its hopes up and lobbied the Maryland legislature, which dutifully sent resolutions to the federal government in favor of a Severn River location.[160] In 1839 the navy acknowledged the developing technology of the time by ordering three steam-powered warships, and, the same year, it consolidated its shore schools at the Philadelphia Naval Asylum. These actions, plus other matters of concern within the service, brought the issue of naval education to a head. Promising young men needed solid training in steam mechanics and modern warfare as well as in the duties and responsibilities of a naval officer. When George Bancroft was appointed secretary of the navy in March 1845, he moved swiftly to make the naval school a reality.[161]

Why Annapolis? There are several theories to explain Bancroft's choice of the city on the Severn for his new school. Certainly one factor was the presence of Fort Severn, by then an outdated army installation, on land already owned by the federal government. Another factor may well have been the recommendation of Captain Isaac Mayo, a member of the

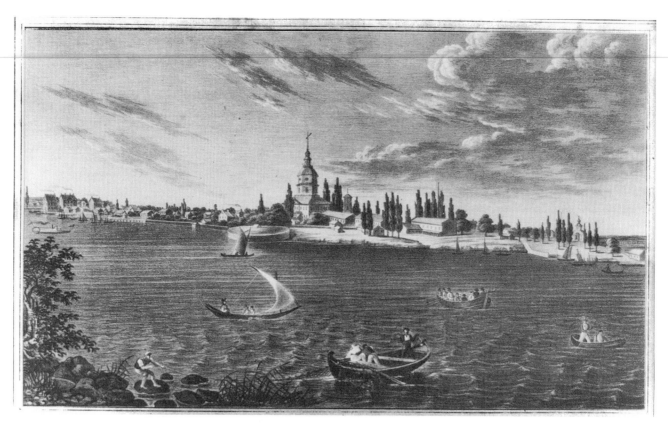

The round, enclosed structure that was Fort Severn seems to be tumbling into the water in this view of Annapolis from across the river, drawn in 1838 by Professor F. E. Zerlant. Steam and sailing vessels approach the city itself, to the left in the drawing. Courtesy of the Library of Congress.

Naval Board of Examiners in Philadelphia, to whom Bancroft turned for advice. Mayo knew Annapolis well. His family had lived in southern Anne Arundel County for generations, and Mayo's own home, Gresham, lay just a few miles from Annapolis on the other side of South River.[162] Or, perhaps all those years of lobbying finally paid off.

Bancroft, Secretary of War William Larned Marcy, and Commodore Lewis Warrington came to Annapolis in mid-July 1845 to inspect Fort Severn. Warrington, a navy representative on the Army Corps of Engineers team that had surveyed sites on the Chesapeake for forts and depots in 1817, was well acquainted with both the Annapolis harbor and the physical requirements of a navy installation.[163] Apparently the inspection went well, and a few weeks later, Secretary of War Marcy agreed to cede the fort to the navy. Bancroft immediately appointed Commander Franklin Buchanan superintendent of the school. Buchanan took command on 3 September 1845 and scheduled the opening day for 10 October.[164]

In 1845, Annapolis was still a small town on a narrow peninsula, with a gentle mix of eighteenth- and nineteenth-century structures. State librarian David Ridgely described the attributes of the town in its first history, published in 1841, admittedly to advance Annapolis as the site of a naval academy. Of the government buildings he noted — the State House, Treasury, Government House — none was new; nor was St. John's College, although the school was undergoing a renaissance under Principal Hector Humphreys, and a substantial brick dormitory and classroom building had been completed in 1837. The Ball Room, the City Hotel (formerly Mann's Tavern), and St. Anne's Church were all remnants of the eighteenth century. Nineteenth-century additions to the city included the county courthouse and City Hall, Farmers Bank, the theater on Duke of Gloucester Street, and Fort Severn. The fort, said Ridgely, was not only "perfectly healthy," but, viewed from the

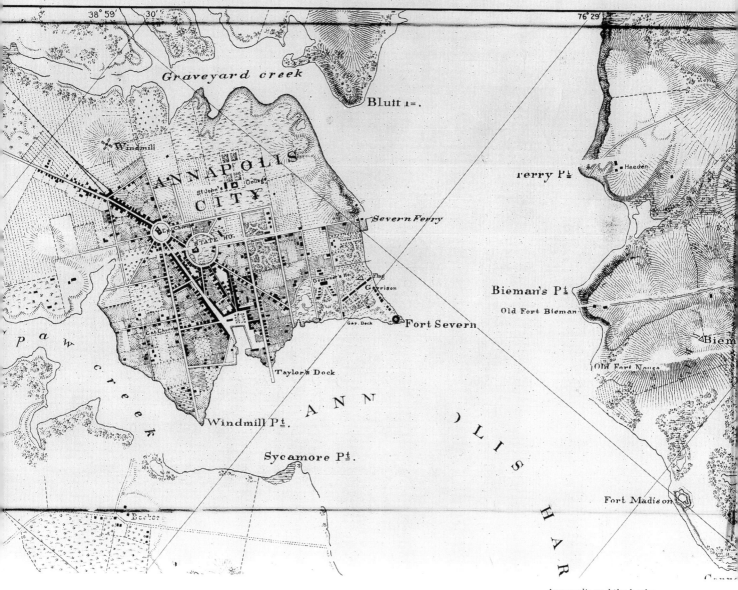

Annapolis and the harbor shoreline just before the advent of the naval school, as surveyed by U.S. Coast and Geodetic Survey engineers in 1844. A full chart of the harbor was issued two years later. Courtesy of the U.S. Naval Institute.

water, boasted "a romantic and picturesque landscape, ornamented by the dwellings, cottages, fort, trees and shrubbery." Notable among new buildings were three churches: St. Mary's Roman Catholic Church on Duke of Gloucester Street, the Methodist Church on State Circle, and the "African House of Worship" (Asbury Methodist Church) lately constructed on West Street "in the suburbs of the city."[165]

Yet the town retained an almost bucolic atmosphere. If Secretaries Bancroft and Marcy and Commodore Warrington strolled through Annapolis on that July day in 1845, they could not have overlooked the town's gardens and orchards. Near the fort were the stately mansions of Hanover Street — one of them the old Stewart house, then owned by Robert Welch of Ben, with its large vegetable garden tended by Welch's slave Luke Johnson, an exhorter at Asbury Church, who sold his extra produce at Market House and shared the proceeds with the Welches according to his own sense of fairness. Ogle Hall, with its shrubs

and stately trees, the walled garden of Paca House, the burning bush of Moses over the trellis of the old Lloyd home, Anne Pinkney's clematis and smoke tree in the garden of her home behind the State House — all would have been hard to miss. As would the bubbling spring "in the midst of King George Street" near its present intersection with East Street, where wooden footboards allowed the people of the neighborhood to cross the swampy marsh around it for their "daily supply of water."

Had the visitors ventured farther into town, they would have found more springs along the edges of both bordering creeks, and gardens everywhere, even amongst the clustered dwellings and shops of the Church and West Street business districts — Grafton Munroe's huge fig tree and colorful balsam pear vines on Church Street, the "tangled garden" behind the old Shaw house, the "great growth" of snowball bushes at 10 Francis Street, Peter Sausser's flower beds at West and Cathedral. In the residential sections of Charles and Market Streets, vegetable and flower gardens surrounded scattered homes. The cultivated area of Philip Clayton's yard at the corner of Market and Shipwright included his wife Mary's herb garden. Mary Brewer Clayton was well known in town for her healing salves and ointments. Down Shipwright Street, the extensive gardens of the Upton Scott mansion, then the home of Dennis Claude, featured two fifty-foot rows of fig trees as well as apricot, cherry, and English walnut trees and boxwood almost a century old.[166] Perhaps the natural beauty of the town, the scent of roses and clematis, had a part in the decision by these important visitors to make Annapolis the home of the new naval school.

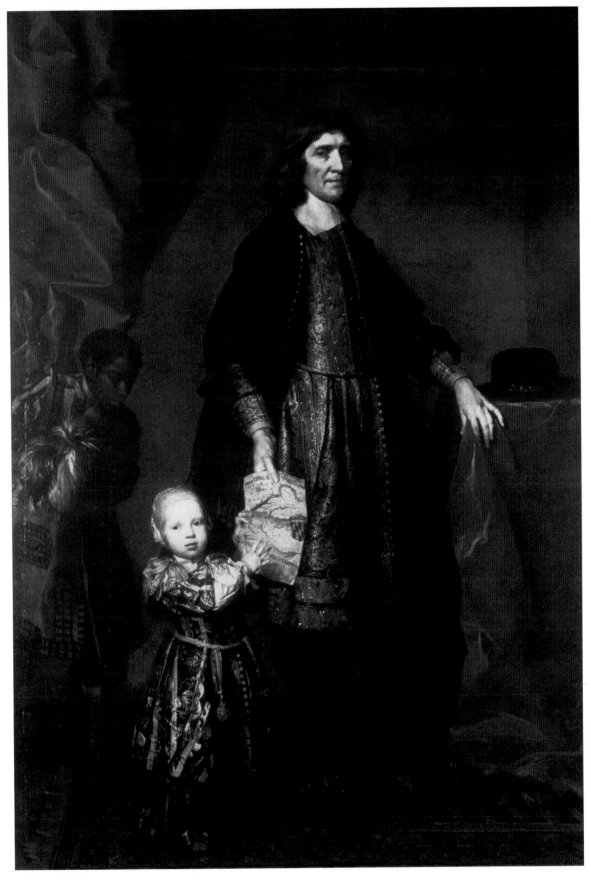

Cecilius Calvert, Second Lord Baltimore and first proprietor of Maryland, who hoped the religious nonconformists who settled Anne Arundel County would improve his status with Parliament. Photo courtesy of Enoch Pratt Free Library / State Library Resource Center, Baltimore.

Archaeologists found pieces of this Delft plate at a site near Whitehall Bay. The design appears to be the arms of the Lloyd family, early settlers on Broad Neck peninsula. Courtesy of the Anne Arundel County Lost Towns Project.

(opposite)
Charles Willson Peale's portrait of printer Anne Catharine Green, in 1769, may have been his first after returning to Annapolis from study in England. Arrayed in feminine satin and lace, Green holds a copy of the Maryland Gazette, *testimony to her status as a professional woman. Courtesy of the National Portrait Gallery, Smithsonian Institution.*

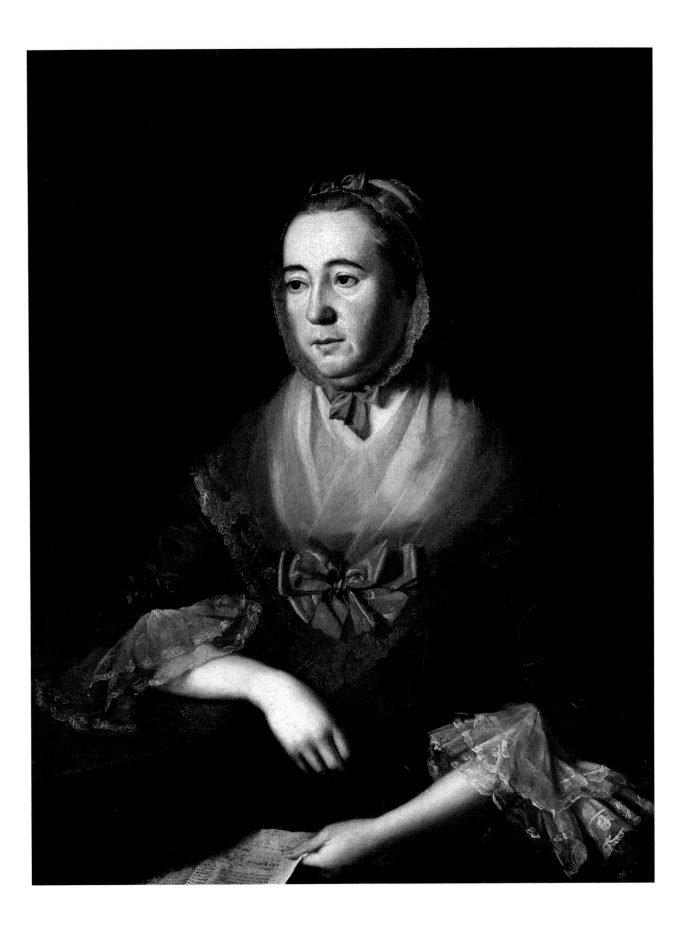

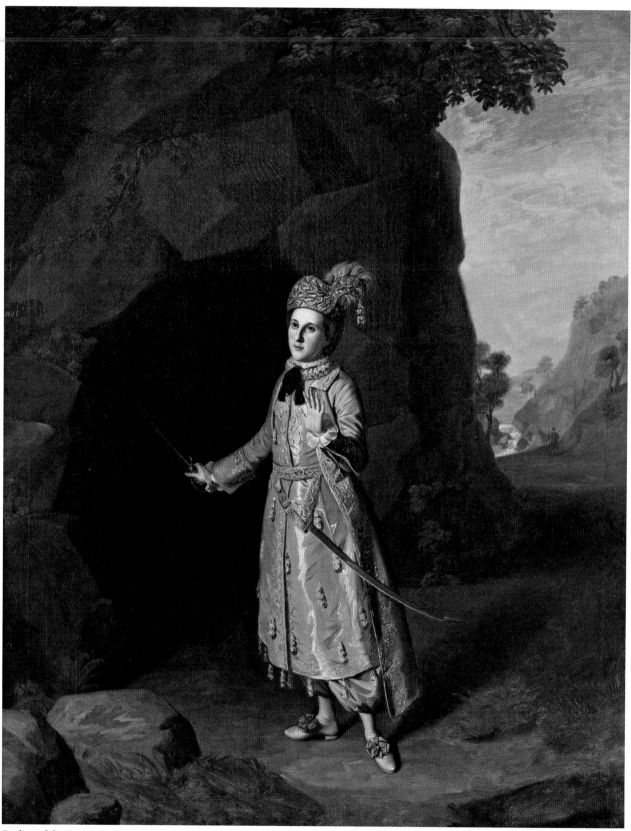

Darling of the American colonial theater, Nancy Hallam inspired poetry and a portrait by Charles Willson Peale when she appeared as Imogen in Shakespeare's Cymbeline *at the new Annapolis playhouse in September 1771. Courtesy of the Colonial Williamsburg Foundation.*

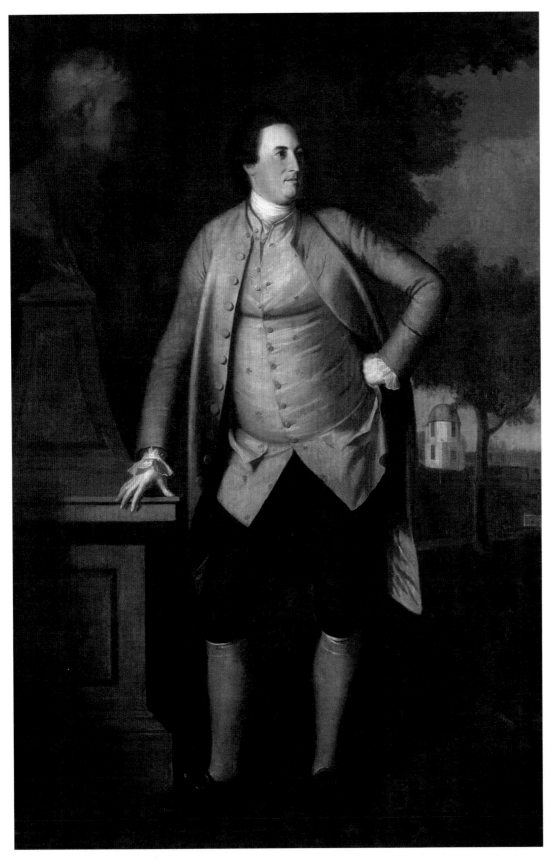

William Paca is pictured at his home on Prince George Street with his carefully planned garden and summer house in the background in this painting by Charles Willson Peale, c. 1772. Courtesy of the Maryland Historical Society.

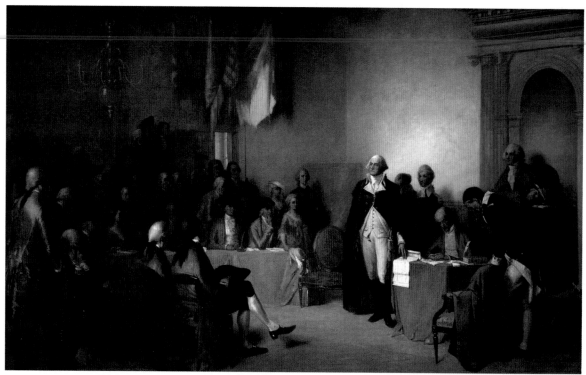

George Washington resigned as commander in chief of the Continental Army on 23 December 1783 in the Senate Chamber of Maryland's State House. In this painting, made more than half a century later, artist Edwin White depicted a number of people, such as Martha Washington, who did not actually witness the event. Courtesy of the Maryland State Archives, MSA SC 1545-1112.

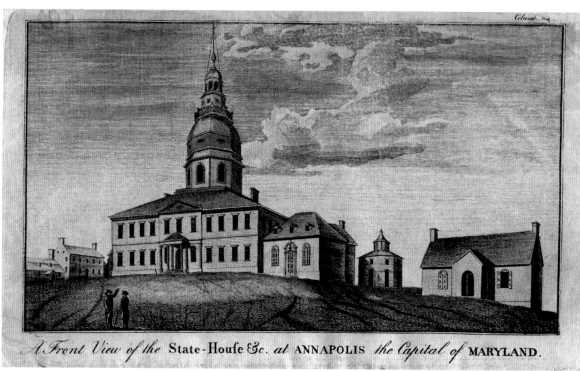

A Front View of the State-House &c. at ANNAPOLIS the Capital of MARYLAND.

Completed in 1788, the dome of Maryland's State House has commanded the Annapolis skyline ever since. This engraving by Charles Willson Peale, published in the Columbian Magazine in 1789, also shows the Council Chamber and Armory, the Public Necessary, and the Treasury Building within State Circle. Courtesy of the Maryland State Archives, MSA SC 194.

This watercolor view of Annapolis, painted in 1797 by Comte de Maulevier Colbert from Strawberry Hill, on the west side of College Creek, shows the city's major buildings from Windmill Point on the far left to St. Anne's Church on the right. Courtesy of the Maryland Historical Society.

The second St. Anne's Church dominates this watercolor by an unknown artist, painted about 1800 from an earlier view by Charles Cotton Milbourne. The former Bladen's Folly, which by that time was the main building of St. John's College (just to left of church), the State House, and Thomas Hyde's three-story "house of entertainment" (at right) are also shown. Courtesy of the I. N. Phelps Stokes Collection, Miriam and Ira D. Wallach Division of Art, Prints and Photographs, The New York Public Library, Astor, Lenox and Tilden Foundations.

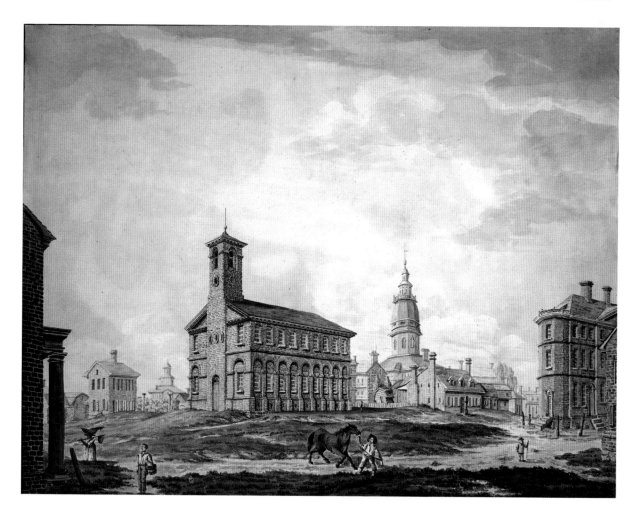

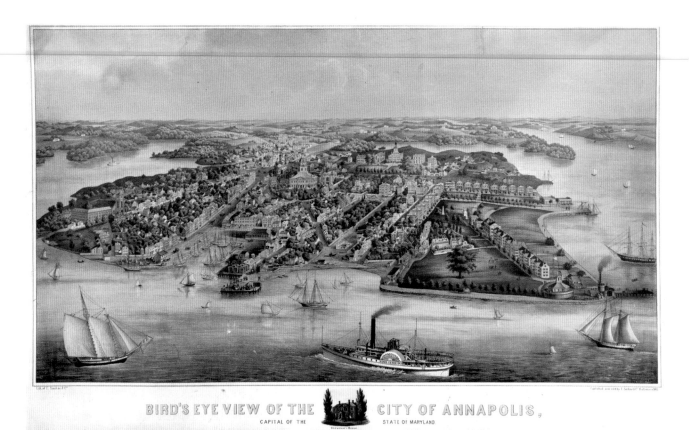

BIRD'S EYE VIEW OF THE CITY OF ANNAPOLIS,

CAPITAL OF THE STATE OF MARYLAND

Maryland's first official governors' residence, which was just outside the wall of the Naval Academy, is featured in the title line of this classic view of Annapolis by E. Sachse and Company, c. 1859. Sachse's artists speculated incorrectly about the steeple of St. Anne's Church, which had not yet been rebuilt after the disastrous Valentine's Day fire of 1858. Courtesy of the Maryland Historical Society.

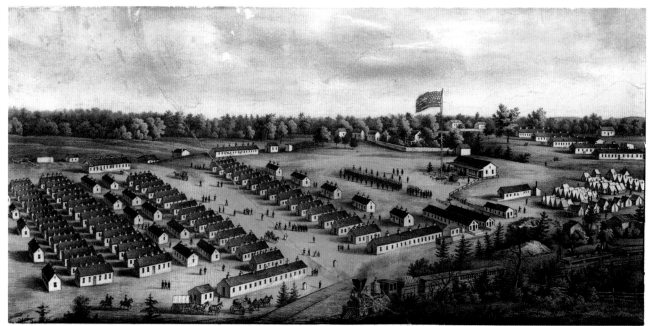

The third parole camp in the Annapolis area, built in 1863, was located south of the Annapolis and Elk Ridge Railroad line and east of today's Route 2. Each of the sixty barracks could accommodate 120 men, and every three barracks shared a cookhouse. The tents (at right) housed men for whom there was no room in the barracks; there were often more than 10,000 paroled soldiers in camp at one time. Courtesy of the Geography and Map Division, Library of Congress.

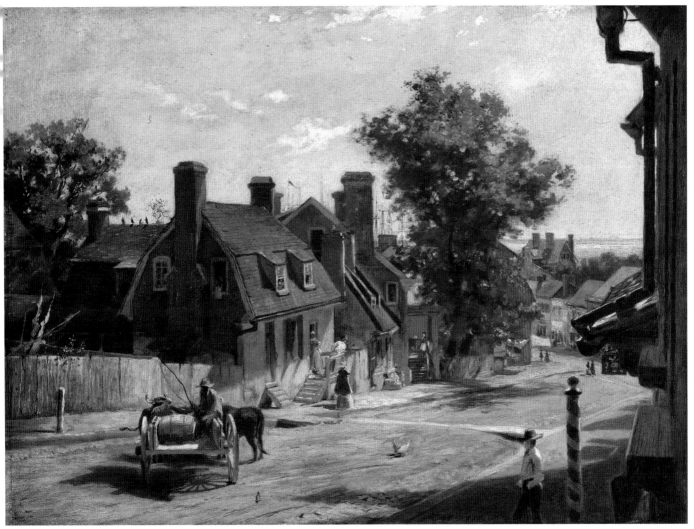

Attention given to Francis Blackwell Mayer's romanticized portrayals of the city's colonial history persuaded the state and city governments to see value in historic preservation in the late nineteenth century. This luminous painting of Francis Street dates from 1876, shortly after Mayer moved to Annapolis. Courtesy of The Metropolitan Museum of Art / Art Resource, N.Y.

THE YELLOW HOUSE.

A QUAINT OLD-FASHIONED GARDEN.

THE TANGLED GARDEN.

A FLAT-IRON CORNER.

SKETCHES IN ANNAPOLIS.—[See Page 722.]

The city's 1894 commemoration of the move of the capital of Maryland to Annapolis garnered national attention. These sketches of the John Shaw House (top left), the Judge John Brice House (top right), the Hammond-Harwood House (lower left), and the view from the bottom of Cornhill and Fleet Streets appeared in Harper's Bazaar *on 8 September 1894. Courtesy of the Maryland State Archives, MSA SC 4314-1-4.*

During its brief tenure on Compromise Street, c. 1874–1891, the Annapolis Canning Company packed oysters, fruit, and vegetables and celebrated its proximity to the Naval Academy. Courtesy of M. E. Warren Photography, LLC.

Excursions on *Emma Giles* gave Baltimoreans a pleasant break from the heat of city summers. The much-loved steamboat made regular runs to Annapolis and the South, West, and Rhode Rivers for more than forty years. This colorful advertisement for Bon Ton excursions features the *Emma Giles* and some of her popular landings. Courtesy of the Maryland Historical Society.

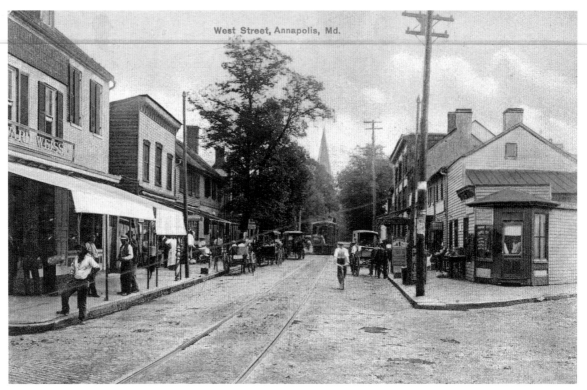

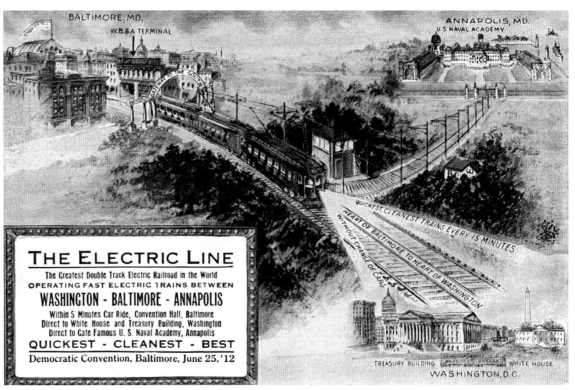

Horses, automobiles, and a bicycle compete with one of the small local trolleys in the first block of West Street, c. 1910. Courtesy of the Sands House Foundation.

This WB&A Railroad advertisement for its fast service to the 1912 Democratic Convention in Baltimore showed the intersection of the Annapolis track with the Washington–Baltimore line at Naval Academy Junction, near Odenton, about halfway between the two major cities. The more direct route to Annapolis from Baltimore came down the north shore of the Severn. Courtesy of Randall W. Bannister.

During the Tercentenary celebration in May 1949 many Annapolitans took advantage of the opportunity to cancel a special envelope and official stamp designed in honor of the event by local artist F. Townsend Morgan. Courtesy of the Sands House Foundation.

VIXI LIBER ET MORIAR

The Annapolis city flag was designed by Anna Dorsey Linder for the Peggy Stewart Chapter of the Daughters of the American Revolution at the request of Mayor Joseph Griscom, Jr. The central figure represents the royal crown and badge of Queen Anne, with its English rose and Scottish thistle, on the white banner of colonial Anne Arundel County. The City Council adopted the design in January 1965 but modified the colors a decade later to those shown here, for ease of reproduction. The motto translates as "I have lived free and will die so." Courtesy of the City of Annapolis.

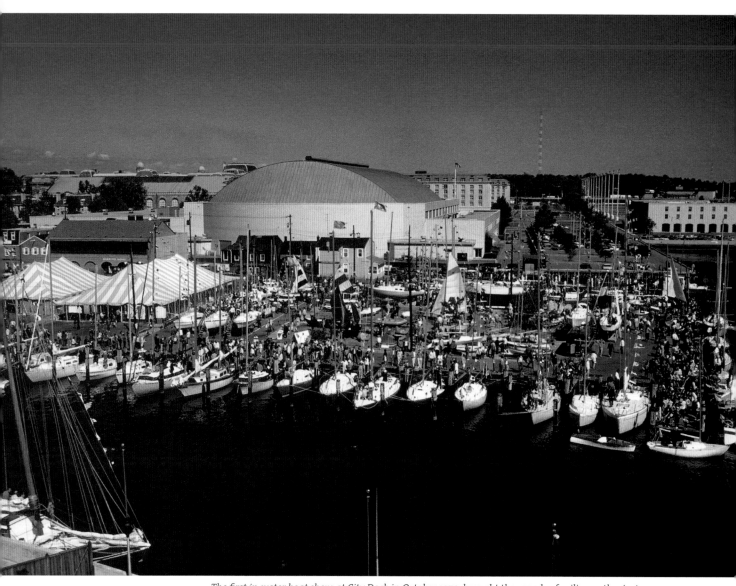

The first in-water boat show, at City Dock in October 1970, brought thousands of sailing enthusiasts to town. Some returned to make Annapolis their home. Courtesy of M. E. Warren Photography, LLC.

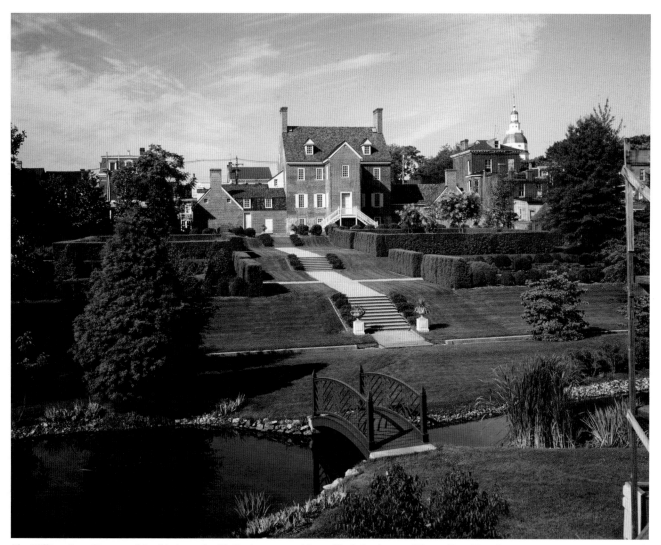

The William Paca House and Garden in 1976, with the terraces and formal beds in place and the replica of Paca's summer house under construction (right foreground). The stream flowed, as it did in Paca's time, although it no longer emptied into Governor's Pond, long since filled in and forgotten. Courtesy of M. E. Warren Photography, LLC.

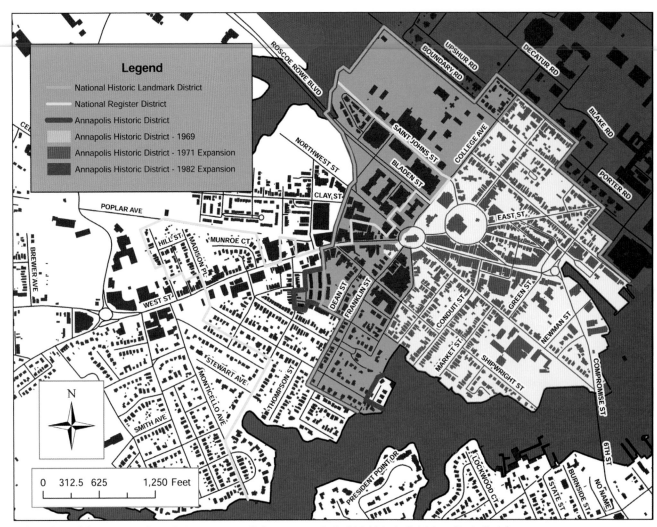

Legend

- National Historic Landmark District
- National Register District
- Annapolis Historic District
- Annapolis Historic District - 1969
- Annapolis Historic District - 1971 Expansion
- Annapolis Historic District - 1982 Expansion

N

0 312.5 625 1,250 Feet

Only with careful attention to boundaries can Annapolis homeowners find which historic district applies to their house. The National Historic Landmark District (1965), National Register District (various dates), and city historic district ordinance (various dates) are all somewhat different. Each district has its own benefits and requirements. Map, corrected to 2009, by Sean O'Neill, Land Use / GIS Planner, Annapolis Department of Planning and Zoning. Courtesy of the City of Annapolis.

A Military Town 1845 to 1870

When the United States Naval School opened at old Fort Severn on 10 October 1845, the city of Annapolis changed forever. Just as the move of the provincial capital to the shores of Spa Creek in 1695 had shaped the town's development for the previous century and a half, so the coming of the new Naval School would affect the life of Annapolis for the next 150 years, and beyond. At last, the two cornerstones of the city's economic foundation were in place, and given that one of them was backed by the state government and the other by the federal, city fathers felt confident of future stability.

Local residents followed the activities at the new school with great interest, welcoming the bustle and energy of those early days. The first superintendent, Commander Franklin Buchanan, was already well known in Annapolis. Scion of a prominent Baltimore City family, Buchanan had been married for ten years to Ann Catherine Lloyd, daughter of former governor and U.S. senator Edward Lloyd and granddaughter of Annapolis physician James Murray. While Buchanan was on sea duty, Nannie Buchanan and their children lived for part of the years from 1835 until at least 1841 in a house on Scott Street, just outside the wall of Fort Severn and only a few blocks from the Lloyd mansion on Maryland Avenue she had known as a child.[1]

Of Superintendent Buchanan's original seven-member faculty, four had a particular effect on Annapolis, setting the stage for years of similar interaction between the school and the town. Through their involvement in civic, social, cultural, and religious organizations, their marriages to local girls, and as progenitors of generations of city residents, Naval Academy faculty have significantly affected Annapolis history. Samuel L. Marcy, Professor Arsène Girault, and the Lockwood brothers, Henry and John, began this tradition.

Samuel Marcy, son of Secretary of War William Larned Marcy, came to Annapolis from the Philadelphia naval school as assistant instructor of mathematics under Professor William Chauvenet. He married Eliza M. Humphreys, daughter of St. John's College president Reverend Hector Humphreys, in 1852 and remained at the Naval Academy until the Civil War. He was killed in 1862 commanding Buchanan's old sloop-of-war, *Vincennes*, in the blockade of the Mississippi River. Samuel and Eliza's son, named William Larned Marcy after his grandfather, was a toddler when his father died. He grew up to become a professor at St. John's College, a city alderman, and the postmaster of Annapolis in the 1920s.[2]

French professor Arsène Napoléon Alexandre Girault was a naturalized citizen who had lived in the United States for almost twenty years.[3] He had served as an elder of a Presbyterian church in New Jersey and immediately joined Dr. John Ridout in establishing a Presbyterian congregation in Annapolis. Although local Presbyterians had met sporadically from the late 1780s and Dr. Ridout had long proposed the establishment of a church

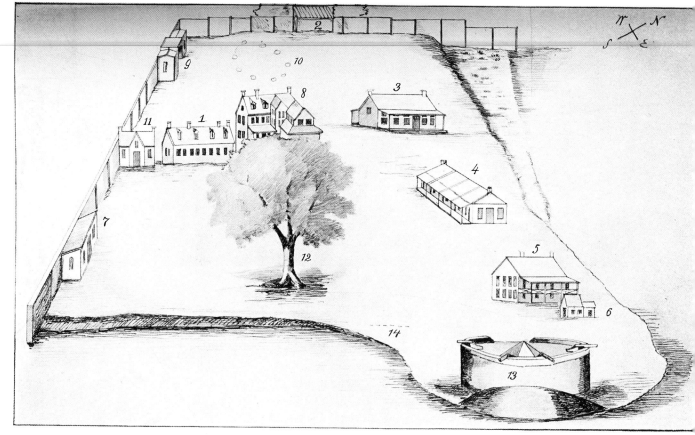

FORT SEVERN IN 1845 (FROM AN OLD MAP).

The numbers refer to the buildings, etc., as named after the Naval School was established.

1. Buchanan Row.	4. Apollo Row.	7. The Gas House.	10. Ring of Poplar Trees.	13. Fort Severn.
2. The Abbey.	5. Rowdy Row.	8. Superintendent's House.	11. Chaplain's House.	14. Site of Practice Battery
3. Mess- and Recitation-Rooms.	6. Brandywine Cottage.	9. Gate-House.	12. Old Mulberry Tree.	

The new Naval School at Fort Severn, in 1845, with its first academic and residential buildings in place. The superintendent's house had been the colonial home of Walter Dulany at Windmill Point. Courtesy of the Special Collections and Archives Department, Nimitz Library, U.S. Naval Academy.

in town, no formal, consistent meetings resulted until the arrival of Professor Girault. A minister from Washington, D.C., conducted the first service of the new congregation in the Assembly Rooms on 14 December 1845, with seventeen in attendance, among them a midshipman from Tennessee. Four months later, thirty men and women met to form a church. They promptly purchased the old Hallam Theatre on Duke of Gloucester Street, tore it down, and replaced it with a new wooden building set back from the street. The cornerstone of the new church was laid 25 July 1846 and the church was completed a year later, with dedication services 11 July 1847. Most of the basement was finished by the trustees of the Annapolis Primary School, and the girls' school met there for the next thirty years. Naval officers and employees of the Naval School, among them Superintendent Buchanan, contributed to the church's building fund, as did townspeople of other faiths.[4] Professor Girault left Annapolis with the academy for Newport, Rhode Island, in 1861 and retired from teaching after the war; but his son, Joseph Bonaparte Girault, remained in town and worked as a pay clerk at the academy for more than forty years.[5]

A graduate of West Point, Henry H. Lockwood had also taught at the Philadelphia naval school and moved to Annapolis in 1845 to instruct midshipmen in the physical sciences.

He saw active service in the Civil War as a brigadier general and commanded the Middle Department, which included Annapolis, from 5 December 1863 to 22 March 1864. After the war, he returned to the academy to head the Department of Natural and Experimental Philosophy until 1871. Lockwood bought a four-acre parcel west of Tabernacle Street (now College Avenue), which he developed in the early 1850s with small tenements. Known as Lockwoodville, it was incorporated into the academy in 1873. He also owned a farm on the east side of Spa Creek in what later became Eastport. Lockwood's daughter, Eliza Lockwood Sigsbee, continued the family's involvement in local affairs as an early advocate for a community hospital in Annapolis.[6]

Henry Lockwood's brother, naval surgeon John A. Lockwood, spent only a few years at the academy, as school physician and professor of chemistry, before returning to sea. However, his daughter Edith Anne, who married an academy graduate, class of 1867, was mother of Henry Francis Sturdy, an academy professor and long-time resident of the city, whose research and writing about Annapolis history helped shape the preservation movement of the twentieth century.[7]

Midshipmen also formed close associations with the town, many of them consecrated in matrimony. Among the first graduates to marry a local woman was James Iredell Waddell. Following training at sea, Waddell came to Annapolis to study for his lieutenant's exam, and fell in love with the daughter of merchant James Iglehart. Passed Midshipman Waddell and Anne Sellman Iglehart married in 1848, and she began the custom followed by so many other local navy wives: she stayed at home with her parents while her husband went to sea.[8] Lola Mackubin, descendant of five generations of an Annapolis family, married academy graduate John Taylor Wood in 1856 — and stayed home. Four years later, when Lieutenant Wood returned to the academy as assistant professor, they set up housekeeping together for the first time.[9] Wood's classmate Wilson McGunnegle and colleague Hunter Davidson married the daughters of a navy physician from Annapolis, who had himself married a local girl.[10]

The relationship between Naval School and town was best expressed in the employment offered local men. From paymaster to groundskeepers, librarian to classroom attendants, opportunities for civilian positions increased as the school grew. Watchmen were generally hired locally, and almost all of the school's laborers and waiters, clerks and stewards lived in town.[11] Richard Moale Chase, grandson of Jeremiah Townley Chase, served as secretary to academy superintendents from 1855 to 1901.[12] City Hotel barber Moses Lake, "a well-known and respected colored man," became in 1852 the first of a long succession of African-American barbers at the academy.[13] The slave Benjamin Boardley, who had built a small steam engine of scrap materials while a teenager, was allowed by his master to work as a laboratory attendant at the school. There he began a long career as designer and fabricator of scientific instruments and steam engines. Boardley was freed in 1859 upon payment of a thousand dollars raised by influential men who acknowledged his talents. He remained an employee of the academy through at least 1863 and later settled in Rhode Island.[14]

Other men moved to Annapolis expressly to work at the school. One of the first of these was Darius King, "a free colored man" and long-time employee at the naval school in Philadelphia, who came to Annapolis to run the midshipmen mess at the new school. Because of the 1832 restriction on the settlement of free negroes in Maryland, King needed an act of the General Assembly to bring his family to Annapolis. Two and a half years after his arrival, he received permission for his wife, Phebe, and their four children to join him.[15]

Early on, school superintendents contracted for renovations to the old fort and, between 1851 and 1854, constructed five brick dormitories, a laboratory and armory, recitation hall, chapel, and observatory.[16] Craftsmen and laborers, black men and white, learned quickly that Naval Academy jobs paid well, and positions there were coveted. When painter and glazier Jonathan Hutton took off for the California gold rush in the winter of 1850, Richard R. Conner and Westol M. Hohne applied for his job and submitted testimonials from prominent Annapolis men, some of whom signed for both.[17] In 1853, bricklayers at the academy earned $2.25 a day and carpenters $1.75, the same average wages paid workers in Washington, D.C.[18] There is evidence that master craftsmen at the academy were allowed to have apprentices and employees, whose wages the government reimbursed, thus further expanding the local work force.[19]

Annapolis businessmen and suppliers promptly submitted proposals for construction projects and, because they were local, could often make the low bids. Firms such as Iglehart and Company (hardware), Levi Phillips (sand), Iglehart and Caldwell (lumber), and Daniel M. Sprogle (bricks and lime) contracted to furnish their specialties.[20] Sprogle was once accused of overcharging, but after an investigation acquitted him, Superintendent Cornelius Stribling referred to their "acquaintance of three years standing" and complimented him for being "faithful honest & zealous" in his duties "as a master workman at the Academy."[21]

Town shopkeepers also benefited from the school. Not only did the newcomers buy from local merchants, but they paid promptly. Under a policy initiated by Superintendent Buchanan, students who did not settle their debts in town were reported to the Navy Department.[22] Midshipmen of that era ranged in age from thirteen to twenty-seven. The older students were men who had already served aboard ship and were returning to the classroom for a year to prepare for their lieutenant's examination. They tended to regard the town as a duty port and patronized the taverns, sometimes taking unauthorized, or "French," leave to do so. Drunkenness was a problem in the early years.[23] In 1858 the General Assembly prohibited the sale of intoxicating liquors to persons under twenty-one, but a specific ruling against sales to midshipmen, as well as students at St. John's, was not passed until 1865.[24] Prior to that time, midshipmen frequented city establishments on a regular basis. The Spirits Club met weekly at the Main Street tavern of Henry Matthews to enjoy oysters, terrapin, and whisky punch; and one night, spirited members removed the city's oil lamps from their posts. The Owls preferred William Rosenthal's saloon on Market Space. Other midshipmen gathered in their quarters for drink and revelry.[25] New regulations in 1850 prohibited rowdy clubs and confined mids to the yard unless given specific liberty. Even so, discipline continued to be a problem for successive superintendents, with alcohol often a factor in the disturbances.[26] Most egregious were the transgressions of Midshipman Henry McThorne in November 1853. Drunk and AWOL, McThorne walked into the Randall home on State Circle, went upstairs, removed his outer clothing, and fell asleep on the hall floor. When he was discovered, Alexander Randall, whom academy superintendent Louis M. Goldsborough described as "a gentleman of this place of the highest respectability, & with whom, or whose family, Mr. McThorne had no acquaintance," sent word of the intrusion to Commander Goldsborough. McThorne was removed from the Randall house, and from the academy.[27] Giving the story additional punch was the fact that Commander Goldsborough and Alexander Randall were brothers-in-law, married to daughters of former U.S. attorney general William Wirt. McThorne may have been found

by their formidable mother-in-law, the widowed Elizabeth Gamble Wirt, who was living with the Randall family.[28]

Although the midshipmen played pranks and occasionally drank to excess, local residents seemed to have taken no serious offense. In response to one complaint shortly after the school opened, Superintendent Buchanan assured Secretary of the Navy George Bancroft that "the citizens of Annapolis all spoke very highly of the conduct of the midshipmen."[29] The locals seem to have taken more interest in the opportunities for amusement that the new school offered them. Formal balls, the first held in January 1846, entertained distinguished guests from Washington and Baltimore as well as the "elite" of Annapolis. The Spirits Club presented the last theatrical performance in the Hallam Theatre.[30] Townspeople in general turned out to watch the parades, beginning with the solemn march through town of faculty and students before examinations in June 1846, and military drills on the school grounds under Henry Lockwood.[31] Writing in 1887, Elihu Riley summed up the opinion of the town: "The location of the Naval Academy at Annapolis has been of large advantage to the business of this place. The social benefits have been well appreciated by its people, and the constant succession of interesting events occurring at the Academy, has added to the enjoyment and culture of an already polished community."[32]

From the beginning the school made its mark on the town, and its effect on the physical environment was obvious to all. The state officially ceded its rights to the federally owned land at Fort Severn and Fort Madison in March of 1846, retaining concurrent jurisdiction with the United States only in the prosecution of certain civil and criminal offenses.[33] The following year, the school added to the seven acres of Fort Severn by purchasing twelve acres adjoining the fort to the west and bounded by Scott Street, Northeast Street (now

The ruins of Fort Madison angled toward the mouth of the Severn, and in the background rose the first lighthouse on Greenbury Point, built in 1849. Drawing by Naval Academy art professor Edward Seager, 1855. Courtesy of the U.S. Naval Academy Museum.

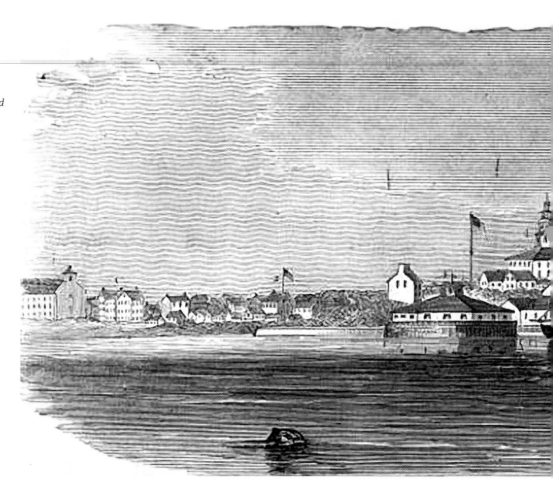

Maryland Avenue), and the Severn River. The first of many enlargements of the original fort, this was followed in 1853 by a much larger purchase, which carried the yard into the town as far as Hanover Street and west to Tabernacle Street (now College Avenue).[34]

It appears that the federal government's acquisition of this land met with the ready approval of the sellers. Of the four purchases in 1847, two granted the previous owners more than twice as much as their properties' assessed value in 1845 and one more than three times as much.[35] In 1853, when the school wanted to take in the two large blocks between Hanover and Scott Streets and land between Northeast Street and Tabernacle from Hanover to the river, thirteen property owners sold their lots and, sometimes, houses as well. Some of this was rental property, but a number of houses — those owned by Richard Parkinson, Benjamin Taylor, and the widows of Ninian Pinkney, Thomas Morgan, and James Bosley — had been family residences for years. Apparently the owners felt that the money involved was apt compensation for the loss of the family home. At least four sellers had purchased their properties after 1847, perhaps in anticipation of the school's desire for a larger campus. In those few cases where it is possible to compare purchase prices with the city's 1845 real property assessment or a previous purchase price, the federal government's payment was generous.[36]

The corporation of Annapolis contributed its title to the street beds of Scott and North-

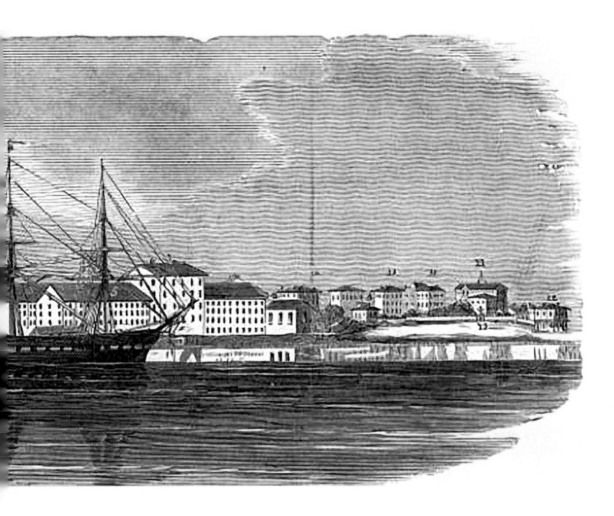

east Streets that fell within the school grounds and to the city wharf at the end of Northeast Street. In exchange, the federal government promised to extend Hanover and Tabernacle Streets to the water, pave them, and build a new public wharf at the end of Tabernacle.[37] Initiating a procedure that would be repeated again and again as the academy grew, academy engineers constructed a seawall from the new city wharf at the end of Tabernacle Street to Windmill Point and along the Spa Creek shoreline to the east end of Scott Street. Infill behind the seawalls added land for playing fields and parade grounds.[38] During the 1853 winter session of the General Assembly, even before the deeds for the second addition were executed, the State of Maryland ceded jurisdiction of the land bounded by Governor, Hanover, and Tabernacle Streets and the Severn to the United States of America to be used for "military or naval purposes." The Main Gate of the Naval School was at that time located at the northern corner of Governor and Scott Streets.[39]

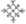

From the beginning, the Naval School attracted attention from visitors to Annapolis. When an overloaded steamboat unable to complete its planned excursion to St. Michaels landed its passengers in town on 5 July 1847, those who ambled over to the new school were well received, as were visitors to the State House. Elsewhere in town, rowdy and dissatisfied

passengers broke a window on Church (now Main) Street, got themselves thrown out of the City Hotel, and generally caused trouble. The day ended in a full-scale riot at the city wharf involving gunfire, hurled bricks and bottles, and a great deal of angry shouting. At least five locals were wounded before the vessel could be eased out of the harbor.[40] Fortunately this was an aberration in the city's growing role as a tourist destination, although unsavory characters continued to rouse the city's ire, and local "rowdies" were not blameless.[41] Several steamboat companies advertised excursions from Baltimore to "the beautiful city of Annapolis," where passengers could view "the State House and that delightful spot, the Naval School." Bands often played during the trip, hot dinners were served on board, and the trip home in the moonlight gave Baltimoreans one more reason to enjoy a steamboat ride. The Annapolis correspondent for the Baltimore *Sun* wrote in June 1858, "The hotels here at this neat, healthy and quiet place are all crowded with guests. Travelers come here from all parts of the country, and the Naval Academy is a great resort." Another hotel was being proposed, he said.[42]

The presence of a naval installation also brought visitors of national importance to Annapolis. The navy's steam frigate USS *Mississippi*, under the command of Commodore Matthew C. Perry, dropped anchor off the city in November 1852 preparatory to Perry's historic visit to Japan, which would garner for the United States the first glimpse of commerce with that closed society. Townspeople flocked to see President Millard Fillmore, who arrived by train on the morning of 8 November. "The citizens are all anxious to catch a look at the popular president," said the local correspondent of the Baltimore *Sun*.[43] With Fillmore was the new secretary of the navy, Baltimorean John Pendleton Kennedy. The dignitaries were met at the railroad depot by officers of *Mississippi* in full regalia. Superintendent Cornelius Stribling escorted them to the academy wharf, where they boarded a small steamer for the trip out to the frigate. The president and secretary spent the night on *Mississippi* and returned to Washington by train the next day. *Mississippi* lay off Annapolis until 18 November when she joined the steam frigate *Princeton*, which had been fitted out in Baltimore, and steamed down the Bay to Norfolk.[44] Leaving Annapolis with Perry was academy chaplain and professor George Jones, a "benevolent and public spirited" gentleman whose departure was viewed by the locals with regret.[45] After Commodore Perry's death in 1858 and in accordance with his wishes, his widow presented the academy with the bronze Japanese Bell that Perry had received as a gift from the regent of the Loo Choo Islands.[46]

By 1859, an anonymous author, almost certainly Owen Taylor, figured that there was enough tourist interest in Annapolis to support publication of a guidebook, the first, as the book says, "to act as a guide to strangers visiting the ancient city of Annapolis, on either business or pleasure." Included in the described attractions of this sixteen-page booklet are the Naval Academy, the State House, St. John's College, county and city government buildings, and Temperance Hall (above the Post Office at the corner of Northeast Street and State Circle, used for meetings of the Sons of Temperance). The only commercial establishments mentioned are the City Hotel and Farmers Bank. The guidebook lists five churches: Episcopal, Catholic, Methodist, Presbyterian, and the "African (Methodist)" church on West Street "in the suburbs of the city."[47] The first three of those congregations were, in 1859, embarked on major building projects.

The Episcopal church, St. Anne's, was being rebuilt following the disastrous Valentine's Day fire of 1858. Attributed to improper installation of a new furnace just two months

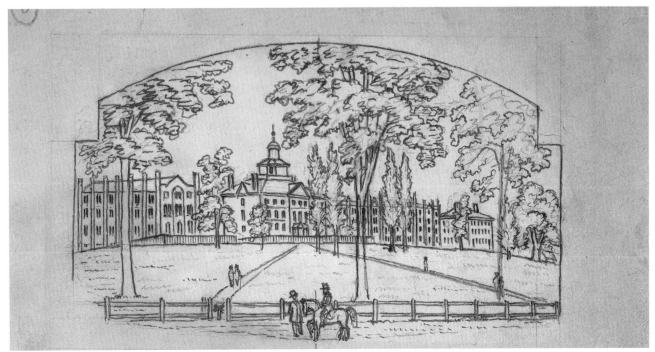

In the late 1850s, Annapolis's other college, St. John's, had three residence halls for students and faculty flanking its main building, now known as McDowell Hall. Begun more than a century earlier and left unfinished for years, the structure had been nicknamed Bladen's Folly. Drawing by John Warner Barber. Courtesy of the I. N. Phelps Stokes Collection, Miriam and Ira D. Wallach Division of Art, Prints and Photographs, The New York Public Library, Astor, Lenox and Tilden Foundations.

earlier, the fire severely damaged the structure. The pulpit and some of the furnishings were saved, and at first it was thought that the walls could be reused. When the south side crumbled, parishioners realized they would have to find the money for a new building. Only small sections of the walls and the lower stories of the tower from the second church could be used in this, the third church on the site. Reverend James R. Davenport, who had come to St. Anne's at the end of 1857, and vestrymen Alexander Randall and Judge William H. Tuck worked with New Jersey architect J. R. Condit to produce a Romanesque Revival building, and the vestry borrowed to fund construction. The new building was in use by mid-1859, but the steeple was not added until after the Civil War. George Wells donated a new bell to replace the one given by Queen Anne, which had been irreparably damaged in the fire. It wasn't until 1871, under rector William S. Southgate, that the loans were finally paid off. Bishop William R. Whittingham consecrated the new church in impressive ceremonies on 2 November 1871.[48]

A second Catholic church was also under construction in 1859. Granddaughters of Charles Carroll of Carrollton had given the Carroll property on both sides of lower Duke of Gloucester Street to three priests of the Congregation of the Most Holy Redeemer, known as Redemptorists, in 1852. The first St. Mary's Church, built thirty years earlier on land still owned by Mary Anne Caton Patterson, by then the Marchioness of Wellesley, was also transferred to the Redemptorists. The order intended to move its novitiate from Baltimore as well as attend to the spiritual needs of the city's Roman Catholics. The first group of Redemptorists arrived by steamboat on 16 March 1853, followed two weeks later by more priests, novices, and students. For the first time, Catholics of Annapolis could enjoy the benefits of being a parish.[49]

When the Redemptorists took over the Carroll complex at the end of Duke of Gloucester Street, tenants had occupied it for more than a quarter century; the buildings were in disrepair and the gardens overgrown. John Randall, brother of Alexander Randall, who

supervised the property for the Carrolls, had converted their chapel, on the top floor of the mansion, into a meeting place for the Annapolis Masonic Lodge. In the first years of their occupation, the priests and novitiates renovated the mansion to accommodate their needs, restored the gardens, and made improvements to the existing church.[50] Father Michael Mueller, who arrived in 1857 as superior and master of novices, felt that a new church would be better evidence of the Catholic presence in Annapolis. Told by his superior that permission would be granted only if he raised $2,000 in advance, Father Mueller appealed to the congregation and the leading citizens of the town, both Catholic and Protestant, and shortly secured the funds. The cornerstone was laid on 11 May 1858 in ceremonies performed by the Right Reverend John N. Neumann, C.Ss.R., then Bishop of Philadelphia (now Saint John Nepomucene Neumann). The novices and lay brothers did much of the work on the building, which is of Gothic Revival design drawn by architect Louis L. Long. The church was dedicated on 15 January 1860 in ceremonies probably enhanced by music from the large new organ given by Father Cornell, choir director. Four bells made by Andrew Meneely's Sons foundry of West Troy, New York, were hung in the tower. As with St. Anne's, the steeple came later, about 1876. Even while the church itself was under construction, a seventy-room college building, which served both as a novitiate and a rectory, was built on the east side of the church, parallel with Duke of Gloucester Street, with an extension back to the Carroll House. Again, lay brothers and novices turned their hands to the project, making their quarters livable in May 1860.[51]

The city's 275 Methodists who worshiped at the Salem Church on State Circle decided in 1858 to build a larger building on the same site. Their decision may have been prompted by a fire in the old church. The cornerstone of the new church was laid in June 1859 in ceremonies directed by the minister, Reverend John Thrush. The brick structure had a second-floor sanctuary with mahogany pews and trim and a balcony around three sides. A tall steeple and bell tower added to the impressive presentation. Services were held in the lower level fellowship hall until the entire building was completed in 1863. Bishop Matthew Simpson preached at the dedication on 29 November 1863.[52]

Worshipers at the First Presbyterian Church on Duke of Gloucester Street had as their minister in 1859 Reverend J. J. Graff. Those at Asbury M.E. Church on West Street were served by Reverend Henry Price, although the church and its Sunday Schools were still under supervision of Reverend Thrush, pastor of the Salem Methodist congregation. Not until 1864, with the organization of the Washington Conference at the Sharp Street Methodist Church in Baltimore, was Asbury able to have its own pastor authorized to administer the sacraments to his congregation.[53]

Not only were the churches flourishing, but the spirit of revival engendered by the academy encouraged local entrepreneurs to invest in businesses for the general good and specific needs. City pride prompted the mayor and aldermen to make a few much-needed civic improvements. Sanitation remained a subject of concern, and an 1848 bylaw directed that "rubbish, oyster shells, filth, dirt, shavings, stable manure," ashes, or refuse of any kind could be disposed of in the streets only on the first Monday, Tuesday, and Wednesday of each month.[54] Periodically the corporation ruled that "offensive refuse" such as soapsuds and fish brine were to be "emptied and scattered in the middle of the street" not dumped in the gutters.[55] A report to the City Council in August of 1854 noted that in one part of the city there were 53 hogs and 4 pigs, some of whose pens were "offensive," as well as two open privies.[56] Animals were still allowed to be unconfined outside the city; not until 1861 did an act passed by the General Assembly prohibit cattle, horses, sheep, or hogs from

roaming "at large" within two miles of the city borders.[57] In a move to beautify the city, the council directed the street commissioner in 1852 to plant trees in front of City Hall, the Assembly Room, and near the Market House. Trees at the market were apparently placed in "tree boxes," and both the boxes and the Market Square fence were whitewashed.[58] The Assembly Room trees must not have lived, because the council again ordered four shade trees planted in 1857.[59]

The most ambitious city activity in the 1850s was the construction of a new market house to replace the one built in 1784. Almost two years after a town meeting agreed to the proposal in the winter of 1854, the market house committee—Daniel T. Hyde, John T. Johnson, and Edward Hopkins—presented specifications and a drawing to the council. They proposed a new building, 120 feet long by 60 feet wide, with a cypress-shingled roof and an area for the city scales. Inside amenities included eight counters, 20 feet long and 3 feet wide, for butcher stands, each fully equipped for hanging slabs of meat.[60] A request for proposals was published in the *Annapolis Gazette* on 4 October 1855.[61] Contractor John M. Davis began work in the spring of 1857 and completed the building the following year at a cost of $4,462.50; the city had borrowed $3,000 from Farmers Bank. The roof was supported by two parallel rows of cast iron columns, a "rather sophisticated form of construction in 1857," according to twentieth-century architect James Wood Burch.[62]

Following a select committee report in 1854 that criticized the state buildings in Annapolis—"No State in the Union, at all comparable in importance to Maryland, has public buildings so inconvenient and unsuitable"—the state decided to spruce up its buildings on State House hill. Legislation in 1858 provided for bringing gas and steam heat into the State House and erecting a fire proof record office for the storage of state documents. Construction of an artesian well presumably allowed removal of the "Public temple," or privy, which the committee pointed out had been "complained of for years and is a disgrace to the State and an outrage to every feeling of refinement."[63]

Private enterprise stepped up during the 1850s to establish two marine railways, a savings institution, and the Annapolis Gas Light Company.[64] The last produced the most immediate benefit to the town. Under president Alexander Randall and directors Nicholas H. Green, Richard Swann, Joshua Brown, and William T. Iglehart, the gas company raised the required $23,000 through the sale of stock to individuals, the Redemptorists, and the city corporation, which bought the greatest number of shares for $5,000. All but possibly one of the thirty-five individual subscribers lived in Annapolis. Three women, Hester Ann Chase, Rebecca Stansbury, and Eliza H. Randall, were among the investors. The Annapolis gas works was built on three acres along the Severn River west of what is now Wagner Street, according to plans approved by a gas engineer from the Baltimore City gas works.[65] When the city's street lights came on during the evening of 7 January 1859, not only was there "a bright and beautiful light . . . at every point in the city" from the "large and comely lamps," but some of the buildings at St. John's College were lighted as well. The new Pinkney Hall "blazed with light—nearly one hundred burners being in full operation."[66] Hyperbole notwithstanding, not every point in the city was lighted immediately, and oil lamps remained in use for some time. Over the succeeding years, the city's street commissioner placed gas lights on public buildings and well-trodden streets. Householders in the Doctor Street (now Franklin Street) area described the perils of life in an unlighted city: "We the undersigned suffer Greatly dark nights for the want of a little light in our street for it is very dangerous for us in traveling such night. There is all ways more or less cattle laying on the side walks of the street and there is a row of posts planted along the bank fence and

we really cannot see them." They asked for a new gas lamp "at the corner of Mrs. Cowman's fence where they have been one [oil lamp] formerly planted and let us have a little light to guard us."[67] This 1859 plea may also have had something to do with the law two years later against roaming cattle.

Perhaps more important to the city in the long run was the accomplishment of the Annapolis Telegraph Company, whose original 61 stockholders registered themselves according to state law on 22 December 1860. Of the 2,100 five-dollar shares of capital stock, all but twenty were held locally in amounts of one to twenty shares. The city corporation and Annapolis grocer Magruder and Company each bought twenty shares, the Society of Redemptorists, two. Alexander Randall, Judge William H. Tuck, Thomas J. Wilson, and Alexander B. Hagner led the list of twelve twenty-share subscribers. Individual stockholders also included three professors at the Naval Academy and the president of St. John's College.[68] The *Annapolis Gazette* crowed on 6 December 1860: "WHO WILL BELIEVE IT? Nobody. And yet it is a fixed fact that we are to have a telegraph from Annapolis to the Junction. We actually saw the first coil of wire laid on last Saturday." The telegraph poles followed the Annapolis and Elk Ridge Railroad line from the depot on West Street to Annapolis Junction where it met the telegraph along the B&O line between Baltimore and Washington. As the *Gazette* predicted, work was obviously "pushed to completion with the utmost dispatch" by Joshua Brown, and by 28 February 1861, telegraph wires connected Annapolis to the rest of the civilized world.[69]

In June 1860, the eighth federal census showed a 50 percent increase in Annapolis residents during the previous decade. Of the 1860 total of 4,529 persons, 3,228 (71%) were white and 1,301 (29%) were black. Of the black residents 826 (64%) were free and 475 (36%) were enslaved. Residing at St. John's College were the president, 4 professors, and 27 boarding students. Also counted in the city's population were the 403 people living on the Naval Academy grounds, including administrators and professors and their families, 14 musicians, marines, sailors, 5 cooks (all free black men), and 272 midshipmen. Most of the other 27 men listed as naval officers, marines, or employees of the academy lived with their families outside the yard. Because only occupation is given and rarely the employer, it is difficult to assess fully the number of people living in town who were employed directly by the academy.[70]

Annapolis enjoyed that last spring and summer of peace. In late April Dan Rice's Great Show came to town for one thrilling day. With the only trained rhinoceros in America, a tightrope-walking elephant, "Comic Educated Mules," and brave, dashing equestriennes, Dan Rice's circus was wildly popular across the country. John Taylor Wood noted that Annapolis children and servants were "nearly crazy" with excitement. Dan Rice, a showman then at the top of his fame, drew crowds of spectators with his wit and humor, his songs and antics in the ring. Annapolis may have missed out on the celebrity, however, because Rice was not advertised for the Annapolis performances. He returned to the tent for shows in Washington later that month before taking his troupe south.[71]

Another spectacular attraction came up the Bay in early August and anchored for a week in the Annapolis Roads, off the mouth of the Severn. The London-built *Great Eastern*, a six-masted, sidewheel and screw propelled, iron-hulled steamship 689 feet long and "a quarter mile around her decks," was the largest vessel ever to sail the seas. Thousands of people rushed to Annapolis by train to see her, and a fleet of boats brought the curious down from Baltimore. The adventurous climbed aboard for a closer inspection of "the greatest marine wonder" of the age. Lieutenant Wood described the town as "very lively"

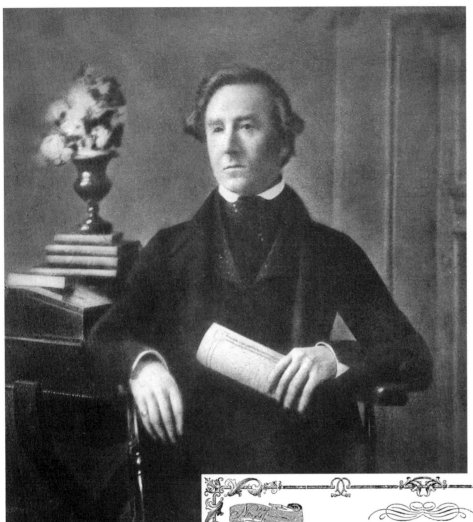

Prominent advocate for civic and industrial improvements in mid-nineteenth-century Annapolis, Alexander Randall involved himself in corporations to build the railroad, manufacture silk, install gas lighting, and bring safe drinking water to the city. Courtesy of Alice Randall (Mrs. John LeM. Randall).

Annapolis Telegraph Company,
ANNAPOLIS, MARYLAND.

This is to Certify, That *James Sands* titled to *One* Shares in the Capital Stock of the

ANNAPOLIS TELEGRAPH COMPANY,

of *Five Dollars* each, transferable only on the Books of said Company, personally, or by power of attorney.

Witness the Seal of the said Company, and the signature of its President and Secretary, this *First* day of *January* eighteen hundred and sixty *one*.

President.

REGISTERED BY Secretary.

Alexander Randall led the list of subscribers to the Annapolis Telegraph Company, making an investment of $100 for twenty shares. James Sands, number twenty-seven on the list, chose the more common purchase of one share. Courtesy of the Sands House Foundation.

A Brief Sketch of the Life of Alexander Randall

Alexander Randall's father, John Randall, left Virginia and the Jeffersonian vision of an agrarian America for Annapolis, where he and his son subscribed more closely to the Hamiltonian view of a commercial nation. Randall graduated from St. John's College in 1822, practiced law in Annapolis for more than fifty years, and served a term in Congress (1841–1843). There, his opposition to the "gag rule," which prevented consideration of petitions against slavery, suggested stands he would take later.

Randall was a delegate to the state's 1851 Constitutional Convention. During the Civil War, he was a strong supporter of the Union, and after the war a leading Republican. In 1864, when a new state constitution abolished slavery and reestablished the office of attorney general, Randall was elected to the office and served until 1867. He had a hand in the return of the Naval Academy to Annapolis from its Civil War home in Newport, Rhode Island.

Following a fire at the State House, Alexander Randall's powers of persuasion influenced the General Assembly to charter the Annapolis Water Company, in 1865. The company, which was ultimately acquired by the city, had the lasting benefit of providing a steady supply of pure water to the community. As president of the state's temperance society, Randall was less successful in a campaign against the consumption of beverages of a more stimulating nature.

Alexander Randall was involved in the life of Annapolis on many fronts: as president of the Farmers Bank from 1877 to 1881, as an advocate for public education, and as an active member of Saint Anne's Episcopal Church. He was responsible for the early residential development of Randall Court, the land surrounding the Bordley mansion, which had become his home in 1845. He was twice married, first to Catherine Wirt, daughter of a U.S. attorney general, and second to Elizabeth Blanchard, daughter of a rector of Saint Anne's. Of his fourteen children, son J. Wirt Randall followed in his father's footsteps as a prominent lawyer, banker, churchman, and political leader. Sons Blanchard, Burton, Henry, Daniel, and Wyatt distinguished themselves in business, medicine, architecture, law, and chemistry, respectively.

Alexander Randall died in 1881 at the age of seventy-eight. His remains lie in the family crypt in Saint Anne's Cemetery.

RICHARD E. ISRAEL
Alderman, Ward 1

with visitors. President James Buchanan and a large entourage came down from Washington on 9 August and had dinner aboard the ship, with many toasts and appropriate music by the ship's band.[72]

It was a hot summer, and young naval officers enjoyed sailing with their friends on the academy's schooner, *Rainbow*; picnics in Luce Creek were popular. Everyone thrilled at the partial eclipse of the sun on 18 July, the first in this area since 1806.[73] And in August academy personnel greeted with pleasure the arrival of USS *Constitution*, "Old Ironsides," which had been assigned as the school's practice ship.[74] But as summer progressed into fall, it was difficult to avoid anxious concern, as the four political parties debated the future of the country.[75] A local independent militia company drilled regularly.[76]

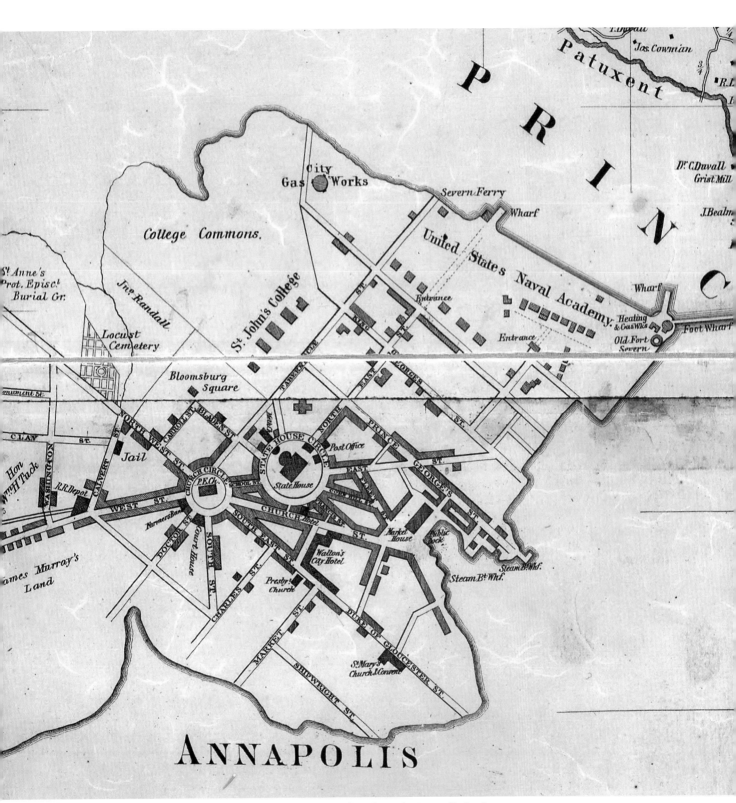

Simon J. Martenet's map of Annapolis in 1860 shows the expanded Naval Academy, the Annapolis Gas Company works, and the two burying grounds on Northwest Street. The City Hotel extended from Church Street (now Main) to Southeast Street (now Duke of Gloucester throughout). Detail from Martenet's Map of Anne Arundel County, Maryland. Courtesy of the Geography and Map Division, Library of Congress.

On 6 November 1860, 525 white men of Annapolis, age twenty-one and over, exercised their franchise in the most important presidential election of their lives. In Annapolis, as in the rest of Anne Arundel County and the state of Maryland, the contest was between John Bell, candidate of the Constitutional Union party, and John Breckinridge, nominee of the Southern wing of the Democratic party. For months prior to the election Baltimore and Annapolis newspapers promoted one or the other of these men — none seriously considered the other candidates, Stephen Douglas and Abraham Lincoln. Warned by the pro-Union editor of the *Annapolis Gazette* that a vote for Breckinridge was, in essence, a vote for the disunion of the country, by a slight majority (261 votes to 227), Annapolis voters selected presidential electors pledged to John Bell. Thirty-six men voted for Douglas and one man, only one, voted for Lincoln. Anne Arundel County's total vote, including Annapolis, also gave preference to Bell, although the second, fourth, and fifth districts gave substantial majorities to Breckinridge. In addition to the one Republican in Annapolis, two more men in the county voted for Lincoln. In the end, Maryland's eight electoral votes went to Breckinridge, who had won the state by a majority of some 400 votes out of roughly 39,000 cast, a victory the *Annapolis Gazette* attributed to "the myrmidons of power in Baltimore."[77]

It is not difficult to imagine the reactions of the city's residents when the papers announced that the man selected by only one of them was, in fact, going to be the next president of the United States. The other 99.8 percent of the voters, who had backed the losers, and presumably the vast majority of the townspeople in general, knew that there would be trouble ahead. The secession of South Carolina in December, followed by Mississippi, Florida, Alabama, and Georgia in early January 1861, compelled the people of Maryland to question their own state's choice for or against the Union. In Annapolis, as elsewhere in the state, men gathered in public meetings. Although only the news of the pro-Union ones made it into the *Annapolis Gazette*, it is safe to say that there were disunion meetings as well. Less public gatherings took place in taverns, homes, and on street corners. The most vocal supporters of the Union at a public meeting on 17 January included Dr. Dennis Claude, Colonel John Walton, Dr. Edward Jacob, and Alexander Randall. Randall's proposed resolutions against secession were adopted.[78] A formal gathering of the "workingmen of Annapolis" on the 31st was chaired by state commissioner of the Land Office, William L. W. Seabrook. Randall again called for preservation of the Union and was approved by "hearty response," as was Circuit Court judge Nicholas Brewer, with a similar text. Former Court of Appeals judge John Thomson Mason spoke in favor of secession and was jeered.[79] In the city election in April, voters elected as mayor John R. Magruder, a local merchant and lieutenant in the 22nd Regiment Maryland Militia, and as recorder Thomas J. Wilson, publisher of the *Annapolis Gazette*. At least two of the five aldermen, Dr. John Ridout and Dr. Dennis Claude, were, with Magruder and Wilson, strong Union supporters. Alderman Joshua Brown was superintendent of the Annapolis and Elk Ridge Railroad and, as events would show, not at all a staunch Unionist.[80]

There is no available record of what the black population of the city thought about secession, but they must have known it could not be in their best interest. Blacks knew no more of Lincoln than their white neighbors did, and during the presidential campaign, Lincoln had been very careful not to emphasize his attitudes toward slavery. The question in 1860 and 1861 was: Could states, or portions of states, remove themselves from the federal government?[81] But even if that were the only issue of dispute, secession and subsequent alliance with other slave-holding states would be of no benefit to blacks, slave or free.

Events moved swiftly once Fort Sumter fell to Southern fire on 13 April: on the 15th

Lincoln called for 75,000 volunteers to protect the nation's capital; Virginia seceded on the 17th; and on the 19th a Massachusetts volunteer regiment on their way to Washington fought with Southern sympathizers in the streets of Baltimore.[82] Alexander Randall's second wife, Elizabeth Blanchard Randall, was in Baltimore with the Randall children visiting her mother, and as soon as news of the tumult reached Annapolis, Randall rushed to rescue them. Finding the city "in a lawless condition" with "armed men rushing about," he arranged for them to go home in a special train that was going to Annapolis with a deputation to the Governor.[83] Reaching Annapolis Junction at ten that night, the Randalls "found that the rails on the Annapolis Road had been taken up to prevent the passage of troops from Annapolis to Washington and that we could not go down." They were obliged to spend the night with an acquaintance in the neighborhood and borrow his horse and carriage for the trip to Annapolis.[84]

Randall could not have been surprised that the tracks had been torn up. Once the rail lines south from Philadelphia were closed following the Baltimore riots, and probably even before, Anne Arundel residents surely realized that the best alternate route to Washington lay across Annapolis. After all, foreign emissaries arriving by ship had been landing there since there was a Washington. Why should the federal troops be any different? And, given the pro-secession sentiment in the county, the railroad was a logical target for sabotage.[85] The Naval Academy, a federal installation with weapons and ships, would also be a likely target. As early as the fall of Fort Sumter, Superintendent George Blake had begun making plans to save the academy and the school ship USS *Constitution* from capture by Southern sympathizers. Writing to Secretary of the Navy Gideon Welles on 15 April, he outlined his preparations and said that, should secessionists attack, he would order personnel under his command aboard *Constitution*, send her to either Philadelphia or New York, and destroy any munitions remaining on the academy's grounds.[86]

Meanwhile, Brigadier General Benjamin F. Butler and his Eighth Massachusetts Militia, who had left Boston on 18 April, were held up in Philadelphia with no direct rail access to Washington. Butler, a canny Massachusetts lawyer whose militia rank was a gubernatorial appointment but who was on the Board of Visitors of West Point, was not about to let this setback stop him from gaining his objective. Receiving permission from the president of the Philadelphia, Wilmington, and Baltimore Railroad, Butler decided to put his 700 troops aboard the railroad's ferryboat *Maryland* at Perryville, on the north shore of the Susquehanna River, and steam to Annapolis. The Eighth Massachusetts left Philadelphia by train in the late morning of 20 April, with cooked rations for three days and camping equipment, just in case. When they reached Perryville, the men loaded extra coal on the upper deck of the ferry and filled some empty whisky barrels with water for the voyage. *Maryland* reached the Severn about midnight on the 20th and anchored. Houses in town were lighted, and "mysterious rockets" crossed the northern sky over Baltimore.[87]

Superintendent Blake, convinced that Southern sympathizers intended destruction of his school and, worse, Old Ironsides, sent the schooner *Rainbow* out to reconnoiter the arriving strangers.[88] What a relief! Not only were these troops Union, but they were Massachusetts seamen ready to save his precious charge.[89]

The next morning, 21 April, Maryland governor Thomas H. Hicks sent a strong, but futile, message to "the Commander of the Volunteer Troops on board the steamer, Sir: I would most earnestly advise that you do not land your men at Annapolis. The excitement here is very great, and I think that you should take your men elsewhere."[90] While messages and officials were ferried back and forth between *Maryland* and the town and academy,

Superintendent Blake prevailed upon Butler to save USS *Constitution* first. The vulnerability of the venerable vessel to secessionist sharpshooters on banks across the Severn still worried the superintendent. Butler agreed, making much of the dual meaning of saving the "*Constitution.*" The ship had to be wrestled out of the mud and across the river's shoals before she could go anywhere, but between the knowledgeable work of Butler's Massachusetts fishermen, now militiamen, and the steamer *Maryland*, she soon stood proudly in the Roads "where her guns commanded everything and everybody." During the maneuver, *Maryland* ran aground, possibly through the complicity of her Southern-leaning pilot, leaving the rest of the Eighth Massachusetts stranded aboard her with little water or food.[91]

Very early in the morning of 22 April, Butler's Special Brigade Order No. 37 went out to his men, still on *Maryland*, still in the Severn. At 5 a.m. they were to be "paraded by company and be drilled in the manual of arms, especially in loading at will, firing by file, and in the use of the bayonet . . . such drill to continue until 7 o'clock." The weapons were loaded with live ammunition.[92] At dawn the steamer *Boston*, with the Seventh New York Regiment aboard, eased carefully into the harbor. *Boston* had left Philadelphia shortly after the Eight Massachusetts on the 20th and taken the longer, Delaware River route. Uncertain what they might find, the men of the Seventh cheered to see *Constitution* safely at anchor, flying the stars and stripes, but they were initially alarmed at the "glitter of bayonets" flashing from a large steamboat aground in the river. When they realized this fearsome sight was only their comrades practicing diligently, the New Yorkers turned to attempts to get *Maryland* off the bar.[93]

In Annapolis, Governor Hicks continued to protest the troops' landing to General Butler, Superintendent Blake, and even President Lincoln. In a stern message to Hicks, Secretary of State William Seward reminded him that, "President [Lincoln] cannot but remember that there has been a time in the history of our country, when a General of the American Union, with forces designed for the defense of its Capital, was not unwelcome anywhere in the State of Maryland, and certainly not at Annapolis, then as now, the Capital of that patriotic State, and then also one of the Capitals of the Union."[94] Whether or not the state would remain loyal to the Union at this point, however, was a question Hicks did not want to answer.

While his men were drilling on the *Maryland* with live ammunition, Butler came ashore at the academy to meet in person with the governor, Mayor Magruder, and other officials, almost certainly including Alderman Joshua Brown, superintendent of the local railroad. One of the reasons these officials gave for opposing the landing of Northern troops was the fact that the soldiers couldn't get out of Annapolis; the railroad company had taken up the tracks, which it was certainly empowered to do, since the tracks and equipment were the private property of the railroad. In fact, Brown warned, if Butler's "troops passed over the railroad the railroad should be destroyed."[95]

Butler figured he'd handle that problem when he came to it. More urgently, he needed to get the Eighth Massachusetts off *Maryland*, and with characteristic shrewdness, he had devised a strategy for doing so. As the general told Hicks, his men were "not Northern troops; they are a part of the whole militia of the United States, obeying a call of the President." And, casually, in a postscript, he added: "It occurs to me that our landing on the grounds at the Naval Academy would be entirely proper and in accordance with your excellency's wishes."[96] Hicks could make no rebuttal to that except: "I content myself with protesting against this movement, which, in view of the excited condition of the people of

The Seventh New York
Regiment of Volunteers
were the first federal army
troops to land at the Naval
Academy, on 22 April 1861.
This drawing appeared in
Frank Leslie's Illustrated
Newspaper. *Courtesy of
the Special Collections and
Archives Department,
Nimitz Library, U.S. Naval
Academy.*

this State, I cannot but consider an unwise step on the part of the Government. But I most earnestly urge upon you that there shall be no halt made by the troops in this city."[97] And so, the Naval Academy, which had been so long courted and so warmly welcomed by the townspeople, which had brought pride and employment back to the city, became the base of a federal army that would occupy and control the city for the next four and a half years.

Because *Maryland* was still aground in the river, the first troops to land at the academy were men of the Seventh New York aboard *Boston*, which went back later for the Eighth Massachusetts. The city appeared to these northerners as "a picturesque old place, sleepy enough, and astonished to find itself wide-awakened by a war." The "lovely green lawn" of the academy welcomed the men, and "all the scene was fresh and fair with April."[98] It was, said one Massachusetts soldier, "one of the most beautiful places in the world."[99]

Both units needed food as well as wagons to haul equipment and supplies to the railroad depot on West Street. Writing years after these events, from his father's notes, Peter Magruder, son of the 1861 mayor, said, "Butler experienced no serious difficulty in obtaining all the meat and provisions necessary to feed his troops" and had no trouble finding transport teams.[100] The *Annapolis Gazette* remarked, "Horses and wagons and provisions

have been sold to the strangers, at high prices, for cash."[101] By the end of the day of 22 April, with more Union troops expected and with the town's excitement at a fever pitch, Governor Hicks called for the legislature to meet in special session in Annapolis on the 26th "to deliberate and consider of the condition of the State, and take such measures as in their wisdom they may deem fit to maintain peace, order and security within our limits."[102]

General Butler's first order of business was getting the railroad in order so he could move troops to Washington. As soon as his men had landed at the academy, he sent companies out to take control of the track. As expected, they found sections on the line to Annapolis Junction torn up, and they quickly set about making repairs. At the station, the engine sat useless — sabotaged. One of the Seventh New York told what happened next: "Here appeared the *deus ex machina*, Charles Homans, Beverly Light Guard, Company E, Eighth Massachusetts Regiment. . . . He took a quiet squint at the engine — it was as helpless as a boned turkey — and he found 'Charles Homans, his mark,' written all over it. The old rattletrap was an old friend. Charles Homans had had a share in building it." The industrial North won this round easily, as Homans pulled engine-savvy helpers from the ranks and promptly restored the "frowsy machine" to working order.[103] During the night of the 23rd, "the locomotive with armed sentries posted on either side of the cow-catcher chugged back and forth along the repaired stretch to guard it."[104]

Predictably, Governor Hicks was furious and fired off a note to the general saying that his seizure of the railroad was impeding the legal assembly of the legislature, which could not travel to Annapolis without the railroad. But Butler, in pious response, asked how the legislators would have been able to use the road anyhow with the tracks torn up. Instead, he said, "I am endeavoring to save, and not to destroy; to obtain means of transportation, so I can vacate the capital prior to the sitting of the legislature, and not be under the painful necessity of occupying your beautiful city while the legislature is in session."[105] In a logical progression, the military also took control of the new telegraph wires, which so conveniently paralleled the rail line.[106]

Rumors abounded, and probably none was as persistent, or feared, as that of a slave rebellion. The word in town on the 23rd was "that negroes across the Severn were in a state of insurrection. Brigadier General Butler immediately offered to place his troops at the command of Governor Hicks to help to quell the insurrection, which offer the Governor courteously declined."[107] Butler also asked that Hicks "announce publicly that any portion of the forces under my command is at your excellency's disposal to act immediately for the preservation and quietness of the peace of this community."[108] The irony of this exchange is that Butler was, in his civilian life, a Democrat who had written a college essay denouncing "abolitionists for distributing incendiary publications" and exciting the rebellion of slaves, who had supported Jefferson Davis in the Charleston presidential nominating convention less than a year earlier as "a moderate southerner whom he regarded as a candidate most likely to heal the breach between the sections," and who had attended the second Democratic convention in Baltimore as a Breckinridge man.[109] He would have had no quarrel with any of the local Breckinridge fans in a tavern discussion in November 1860. Now, however, he had made the same decision that so many Annapolis Democrats had: the Union was more important than sectional concerns and must be preserved at all costs. But none of those men in April 1861 had any idea how great the costs would be.

The immediate cost to Annapolis was the loss of the academy. Superintendent Blake wrote Secretary of the Navy Welles on the 24th for formal permission to move the school to the quiet safety of Fort Adams, an army post in Newport, Rhode Island. Without wait-

ing for an answer, he sent the 150 or so midshipmen remaining under his care out to *Constitution*.[110] Already the school had seen the resignations of a number of officers (among them Lieutenants John Taylor Wood and Hunter Davidson) and students whose politics or personal allegiances prevented them from siding with the Union cause. Some twenty more midshipmen, who had resigned but not left town, solemnly watched their classmates leave the yard.[111] Towed by the steamship *R.R. Cuylar* and with two companies of Massachusetts infantry aboard to defend her, USS *Constitution* left the Severn River on 26 April for New York.[112] The steamer *Baltic* departed 6 May with officers, faculty, and band, their families, the library, and "as much academic apparatus as she could carry." Both ships arrived in Newport on 9 May.[113] "Poor Annapolis," wrote former Lieutenant Wood, "what will become of it, its pride & support have gone."[114]

The second loss was the General Assembly. The *Annapolis Gazette* of 25 April 1861 reported, "It seems to be the impression that Legislature will pass an ordinance of Secession. The feeling hereabout is almost unanimous on the subject." Former governor Thomas G. Pratt sent messages dated 24 April to the commander of Virginia forces at Alexandria (which were in turn sent to General Robert E. Lee). Northern troops had taken "forcible possession of the navy-yard and the depot and railroad," he said; 2,000 men had left for Washington on the 24th and 12,000 additional troops had arrived that day by steamer from New York. The "Northern forces intend to hold Annapolis as a military post, at which to land the troops, ammunition, and provisions for Washington. . . . It is thought the legislature will pass an ordinance of secession at once. The people are in arms, and determined to unite in the cause of the South."[115] Even President Lincoln thought that the legislators "not improbably will take action to arm the people of the State against the United States." Although he had considered having General Winfield Scott, then commander in chief of the U.S. Army, "arrest or disperse" the legislators, he realized that they had "a clearly legal right to assemble" and "we can not permanently prevent their action." However, should the General Assembly act against the federal government, Scott was "to adopt the most prompt and efficient means to counteract, even if necessary to the bombardment of their cities; and, in the extremest necessity, the suspension of the writ of *habeas corpus*."[116] On the 25th, Governor Hicks, fearing the outcome of a legislative meeting in Annapolis, changed the venue to Frederick.[117] There, after only two days of deliberation, the General Assembly defused the immediate secession crisis by voting that it had "no constitutional authority to take such action." The decision to secede from the Union would have to be the result of an elected convention, sometime in the future, perhaps.[118]

The formerly sleepy town of Annapolis was now very much wide awake, and its citizens, even those who supported the Union, were not happy with their situation. One New Yorker, marching out of town on 24 April, noticed, "the townspeople stare at us in a dismal silence." He attributed this to fear of appearing "loyal" in a city of Confederates.[119] But as the pro-Union *Annapolis Gazette* put it, "The people of Annapolis are highly indignant at the occupation of our city. But, we are powerless to oppose them. Yielding to the advice of the more prudent, our people have refrained from any open demonstration against the troops. . . . The excitement here is terrible. No man seems to know what should be done to avert the evil that has come upon us; and all admit that we are utterly powerless to offer any resistance."[120] Many Annapolis families reacted as they had in earlier wars: they escaped to the country. "In town, most of the best residents have left, shutting up their houses for the time," noted former Lieutenant Wood, who moved his own family from quarters at the academy to his brother-in-law's house at Strawberry Hill.[121] Alexander Randall took his

wife, children, and servants to a kinsman's farm up the Severn. James Sands sent his family across the Bay to Centreville; and, one friend wrote to James's eighteen-year-old daughter, Sue, on the 28th, "people are going every day and in every direction."[122] In contrast to the New Yorker's assumption, those who remained, especially if of Southern sympathies, quickly learned to be very careful what they said and to whom.[123]

Having been officially named commander of Annapolis by General Scott on 25 April, Brigadier General Butler continued to attend to the defenses of both the town and the railroad.[124] Scott transmitted to Butler the president's orders of the 24th concerning bombardment of cities and suspension of habeas corpus but urged that they be carried out "in a right spirit; that is, with moderation and firmness."[125] Butler was more concerned with protecting the town from attack by Confederate sympathizers. By 27 April he had stationed troops of the Sixth New York at Fort Madison and Fort Nonsense, the old fort on the heights overlooking the academy that had so worried Superintendent Blake. Signal rockets along the "interior road," presumably Generals Highway, prompted him to send out a detachment of two hundred men backed by a suitable number of boats to transport reinforcements up the river if necessary. The steamer *Maryland* and an iceboat donated by the city of Philadelphia, each with four guns, patrolled the Bay and entrance to the Severn River. As for the landward side of the town, Butler had had Professor Lockwood "mark out a line of intrenchment" across the narrowest point of the peninsula between Spa and College Creeks, and his troops had "thrown up embankments on Judge Brewer's farm on the line of the Annapolis railroad, about one-half mile from the city" to protect West Street and the railroad line. He intended to detail for the "permanent occupation" of the town 1,300 men from various Massachusetts and New York units. About 1,100 men were strung out along the railway from Annapolis to the Junction.[126] A former assistant professor of engineering at the academy laid out a rail line from the depot at the corner of West and Calvert Streets to the deep-water wharf at the academy, and the power and experience of the industrial North was demonstrated yet again when the volunteer militiamen quickly laid down track along Northwest, Carroll, Bladen, and Tabernacle Streets so that equipment and personnel could be moved smoothly through town.[127]

General Orders No. 12 of the War Department, dated 27 April 1861, set up "a new military department, to be called the Department of Annapolis, headquarters at that city" to "include the country for twenty miles on each side of the railroad from Annapolis to the city of Washington, as far as Bladensburg, Md. Brig. Gen. B. F. Butler, Massachusetts Volunteers, is assigned to the command." In the same orders, Fort Adams was "placed temporarily under the control of the Secretary of the Navy, for the purposes of the Naval Academy."[128]

After one week of occupation, young shop clerk Martin Revell wrote to his friends the Sands family in Centreville:

> I will have to be very laconic, for we are very busy now selling lumber, for or to the Garrison (no longer an Naval Academy here), they are building warehouses, stables, and quarters, down there. Annapolis is no longer the quiet little place of former days. Vehicles of every kind and description rattle throu our streets, our side walks are crowded with persons from all parts (of the North). I could not pretend to describe the once Naval School, vessels are continually landing, it looks like a business, camp fires are burning all over the yard, soldiers eating hear and there, there are about three thousand in the yard now, there is a report that there will be five thousand more on in a few days. The Rail Road from the Garrison to the Depot I hear is commenced,

sentinels keep guard from the Garrison to the Depot, they are stationed about ten yards a part, Oh! how very strange it seems to us here. The soldiers are still civil, but you might say military despotism reigns here.[129]

General Butler, on the other hand, felt the situation was so secure that he sent for his eldest daughter, who was at Georgetown Visitation School in Washington, and wrote to his wife, Sarah, still at home in Massachusetts, on the 28th: "*We have won.* I have a very excellent house here, well furnished, a good corps of servants, and am keeping house. Shall be here some months. . . . You had better come on. . . . Bring nothing but your table service of silver [and] summer clothes as the weather is warm."[130] Butler's "excellent house" was almost certainly within the academy walls, and his "good corps of servants," former academy employees from Annapolis. In a letter to Superintendent Blake on 24 April, Butler had stated his intention to let the academy's housing officer assign quarters to the troops and had promised to "most fully cooperate with him in the preservation of the public property."[131] Sarah Butler arrived in Annapolis the second week of May (without the silver) but remained only about ten days before sailing down the Bay to Fortress Monroe, Virginia, to join her husband, who had been reassigned by the high command following his abrupt seizure of Baltimore. She returned to their home in Lowell in early August.[132]

After the first shock, the city settled down quickly, and gradually most of the families who had left returned home.[133] The soldiers, said the *Annapolis Gazette*, were "well behaved and treat our citizens with every respect."[134] And those citizens who might have made trouble for the soldiers were keeping very quiet. "Secession in this neighborhood is dead, and we trust forever. . . . It is 'the thing' now to be a Union man," said the editors of the *Gazette*.[135] Or, as Martin Revell said, "It is, you might say, suicide to speak for the South here." Martin considered going "to some clime more congenial to my feelings, although the strongest ties that can bind me now are here, but those must be severed if possible."[136] Writing his own first-hand account of those days, many years later, state official William Seabrook maintained that a large majority of the people of Annapolis would have "adhered to the Union cause" even without the presence of federal troops.[137]

Possibly some of the change in attitude had as its cause the opportunity for city shopkeepers, merchants, and suppliers of services to benefit from the occupation. Martin Revell's employer was not the only businessman selling to the military. In fact, the *Philadelphia Inquirer* purported to have received a letter from "one of the oldest and most estimable citizens of Annapolis who suggests a plan by which the city of Baltimore can be made to feel the proper retribution for her unwillingness or inability, to control the lawless element of her population." Annapolis should become the "commercial emporium" of the state! "It is already the seat of a wealthy and refined population, which only needs an infusion of business men to inaugurate an era of commercial activity and consequent prosperity." After the ignominy of living in the shadow of Baltimore City since the Revolution, at least one man saw the opportunity for revenge. "Northern businessmen who within the last few weeks, have been compelled to pass through Annapolis, have declared that before many years it would rival Baltimore in the struggle for commercial supremacy," said the *Inquirer*.[138] Certainly that's the way things looked in early May when Lizzie Davis, who signed herself "of the Southern Confederacy," wrote from Annapolis to Sue Sands, "Susie, you would think we had changed places with the Baltimoreans. They say they are so quiet now, and we are nothing but bustle. You hear nothing but carts and see soldiers."[139]

Another factor in the quieting of Southern sentiment may have been rumors in late May

that the federal government intended to remove the academy permanently from Maryland. Mayor Magruder appointed a committee to "remonstrate with the proper authorities," but a resolution of removal made it to the House of Representatives in July before being tabled. The *Annapolis Gazette* confirmed that this threat was, in effect, blackmail: "We have high authority for saying that the Academy will *not* be removed from this place so long as Maryland remains loyal."[140]

In mid-May the army headquarters removed to Baltimore City, and Annapolis, while still a military depot, lost its position of importance to the general war effort. Eventually, command of the entire state came under the Middle Department, again with headquarters in Baltimore.[141] In addition to troops from other places assigned to Annapolis, the city had its own Union volunteer militia units, which after September 1861 drilled in the Assembly Rooms.[142]

Annapolis did not, of course, become a "commercial emporium" to rival Baltimore City, but its location and the facilities at the academy did make it an attractive port for the reception of troops, of battlefield casualties, and, later, of paroled Union soldiers. Elihu Riley marks 25 July 1861 as the arrival of "the vanguard of that great army of sick and wounded that was located in Annapolis during the civil war," but actually the first wounded came in on the 21st, the day the Union troops were routed at the First Battle of Bull Run. Fifty soldiers arrived by train that day, followed by more a few days later. These first patients were probably treated in the academy's hospital and the chapel, but as the numbers of wounded increased, most of the yard became a hospital.[143] Dorothea Dix, who had been commissioned superintendent of United States Army nurses in June, began her visits to the academy in August. An experienced observer of hospitals from her many years of advocacy for the mentally ill, Dix concerned herself not only with the nursing staff, but also with food service, sanitation, and the general well-being of the patients. She may have stayed with the Randall family, at least on early visits, and Alexander went with her to the academy. In October, his brother, Dr. Burton Randall, became the hospital's medical director.[144]

Although the vast majority of men brought to Annapolis were Union soldiers, in the early years of the war a few Confederates received care here as well. Eleven wounded Confederate prisoners arrived in late August 1861, following General Butler's invasion of Cape Hatteras, and the "secession" ladies sent them "all kinds of dainties." Hospital personnel ordered these shared with the Union sick, and the *Annapolis Gazette* remarked snidely that, although "the exertions of the rebel sympathizers [were] . . . commendable," they had not previously shown "even the least portion of benevolence towards the hundreds of Federal Soldiers" wounded and sick at the academy hospital "several weeks past." Union women as well had apparently not thought of this charity until that time, but with the encouragement of Catherine Brewer, wife of Judge Nicholas Brewer, they quickly remedied the situation. From then until the end of the war, local women provided special treats to the wounded and sick at the city's hospitals, independently and, later, through the U.S. Sanitary Commission. The patients especially welcomed fruits and flowers, and Elizabeth Randall was one of the women who shared the bounty of her garden and orchard.[145] William Seabrook's wife even brought a sixteen-year-old New York soldier into their home on Duke of Gloucester Street and nursed him back to health. He was killed at Gettysburg two years later.[146]

Throughout the late summer and fall of 1861, Annapolis continued to host emissaries on their way to the national capital and to receive wounded Union troops from points south.[147] The town was active, but not overwhelmed. In late October, however, Brigadier General Ambrose E. Burnside was ordered to "establish his headquarters" at Annapolis

In January 1862, twenty-five vessels waited in the Severn to embark more than 30,000 troops for an expedition to the North Carolina coast. The men, under command of Brigadier General Ambrose E. Burnside, camped on Naval Academy and St. John's College grounds and for miles along the rail line out of town. Harper's Weekly, 18 January 1862. Courtesy of the Maryland State Archives, MSA SC 1779-10-41.

and "assemble at that point the troops under his command" for an expedition to the North Carolina coast. With units arriving daily by train and ship, the population of Annapolis, which just a year before had been fewer than five thousand souls, suddenly swelled to six times that size.[148] General Burnside and government officials from Washington reviewed the troops in mid-November in the company of Governor Hicks, the governor of Massachusetts, and "a number of spectators."[149] Burnside's men were camped along the rail line, and passengers traveling at night found "the gentle slopes of the hills and the oak groves along the road ablaze with camp fires and illuminated tents." Volunteers from Massachusetts, Connecticut, Pennsylvania, and New York's famous D'Epineuil Zouaves, with their colorful uniforms and red fez headgear, cheered the trains as they passed.[150] In the harbor, vessels jockeyed for position. Sixteen transports, four schooners, and five floating batteries were in place by early January, waiting orders to load the expedition, and a new wharf was built at the academy to facilitate embarkation.[151] Following the participation of Burnside's officers and musicians in the inauguration ceremonies for Maryland governor Augustus Bradford on 8 January 1862, the expedition left for the South.[152]

With the influx of soldiers came disease. Townspeople especially feared smallpox. When several cases appeared in November 1861, the city's doctors went about the town giving vaccinations. As was customary, the city government agreed to pay for vaccinating the poor and authorized the mayor and city health officer Dr. Washington G. Tuck to do whatever was necessary to prevent the spread of the disease.[153] With the soldiers also came crime, much of it attributed to drunkenness. Although the provost marshal filled the guard house lock-up with drunken soldiers in mid-November 1861 and prohibited the sale of intoxicating liquors to the troops, the problem recurred time and time again throughout the war.[154] The abduction and rape of a local child in January 1862 was only the first in a long series of murders, beatings, and other crimes perpetrated against citizens of the Annapolis area.[155] And the roads — muddy in wet weather, dusty in dry — by the spring of 1862 were almost impassable. In his address to the city government in April 1862, newly elected mayor J. Wesley White lamented "that the conditions of our streets in many portions of the City, owing to the constant passage of heavily ladened waggons during an unusually soft and rainy season of some months duration, are such as to require the immediate attention." Although the city fathers had asked the federal government as early as June 1861 for assistance in repairing streets damaged in the war effort, no one seems to have paid attention. Street maintenance remained a problem, requiring city funds and, often, increasing city debt.[156] The federal government did agree to pay for repairs to streets disturbed by the laying of gas lines between the academy and St. John's College and repaired the county road leading into town, which had been "greatly damaged by the heavily laden government wagons."[157]

The city's practice of hiring only those "loyal to the Federal Government" was formalized by an order adopted by the corporation on 13 May 1862.[158] By late August, military authorities required an oath of allegiance from all persons leaving the city. Sue Sands complained in September, "We are now bound hand, foot and tongue we cannot go from one city to another without taking the oath of allegiance, and getting a pass from the Provost and every word we utter is caught up and repeated and called treason."[159] Arrest or detainment of people suspected of having Southern sympathies became more common, and often relatives turned to staunch Union men such as Dr. John Ridout or Alexander Randall to arrange for release or better treatment of the prisoner.[160]

Sue Sands described the city in April 1862 to her cousin: "There is no business doing here except by the loyal shopkeepers who get cheated by the Soldiers. There is but a few soldiers here now, not more than two regiments. One regiment is stationed at the once beautiful Naval School, which they have torn to pieces, there is not a sprigg of grass to be seen in the place, and the buildings which were once so handsome you would scarcely recognize, and the beautiful College Green is in the same condition."[161]

News stories in June of 1862 identified Annapolis as the site of the proposed federal Camp of Instruction, which would train volunteers and draftees in the basics of military drill and procedure. Some 50,000 men were expected, and even the *New York Journal* approved the selection of Annapolis for this "admirable" scheme. With its harbor, railroad, and proximity to Washington and Baltimore, "no better site," said the *Journal*, "could have been chosen."[162] Local entrepreneurs began building rental housing in town in anticipation of the influx.[163] Orders issued on 5 June established such a camp and assigned its commander, but the concept quickly morphed into a holding camp for a particular cohort of Union soldiers removed from active duty. At this point in the war, soldiers captured by the enemy were generally paroled — released on their honor that they would not fight again until some specified conditions were agreed to by the two armies. Union men who had

been paroled on the battlefield and furloughed until they could be formally exchanged were now ordered to Camps of Instruction at Annapolis, Camp Chase (near Columbus), Ohio, and Jefferson Barracks (at St. Louis), Missouri, to be held there until exchanges could be arranged and they could then be returned to their regiments or sent home. Parolees from regiments raised in New England and the Mid-Atlantic states were directed to report to Annapolis immediately or be listed as deserters.[164]

And so, after just over a year of war, the elements that would determine life in Annapolis for the next three years were in place. Each would assume greater or lesser importance according to events in the country at large, but the general pattern was set. Annapolis was a military post with its own guard and hospitals and a camp for paroled Union soldiers, and from time to time, it was a staging area for units preparing for the field. The town's two colleges, railroad, and telegraph line had been taken over by the military; its harbor was full of ships transporting men and matériel, and its streets were full of loaded wagons. Over the next three years, tens of thousands of men would pass through the town, many of them sick or wounded. No one spoke in those days of posttraumatic stress disorder, but it is certain that the majority of these men suffered not only the physical damage but also the mental strain of battle. Criminal activity in and out of the parole camps continued, and death was a constant, both for soldiers and for townspeople affected by disease or crime. A man who lived in town during these years said later, "Annapolis . . . had an excellent opportunity to perceive the demoralization and brutalization of war. Men who had evidently come from refined homes and been accustomed to modern comforts soon lost all sense of decency, and their vulgarity and coarseness were almost indescribable. . . . Murders became an almost everyday occurrence. . . . Human life was held in the greatest contempt and homicides ceased to attract attention."[165]

Town life was subsumed by the war. Not only did residents face daily the evidence of war in their own streets, but news from the front, news from other parts of the country, lists of the dead — all brought home to Annapolis the tragedy of a nation divided. For those whose hearts followed the Confederacy, whispered tales, smuggled letters, and the threat of arrest marked their days. For those whose sympathies lay with the federal government, the benefits of jobs and increased business revenue vied with worry about their own loved ones in the service. But no matter which side the locals favored, disease, noise, mud, confusion, and the ever-present strangers overwhelmed them all.

And there were strangers — officers and enlisted men of units stationed in and near the town, paroled soldiers, officers and crews of the transport vessels in the harbor, correspondents from Northern newspapers, foreigners arriving by ship, and all the numbers of civilian men and women who followed the troops for economic reasons. Relatives haunted the hospitals and the camps anxious for a moment with a father, brother, or son.[166] Representatives from the U.S. Sanitary Commission and the U.S. Christian Commission, civilian agencies formed to support the medical and spiritual welfare of the military, spent time in Annapolis.[167] Most of these strangers came from the North, and just as the New England delegates to Congress who stayed in Annapolis during the winter of 1783–84 complained of the town's indolence and fondness for parties, so their descendants almost eighty years later also viewed the town in less than charitable fashion. Early in the war, a Massachusetts soldier remarked, "Annapolis is the sleepiest town in the world. . . . I fell asleep yesterday after being here fifteen minutes. . . . Sleepiness pervades everything and overcomes everybody."[168] A correspondent for the *New York Commercial Advertiser*, didn't see this slower pace as all bad: "If history does not record the city of Annapolis among the oldest on this

The Brewers: A Family Divided by War

The division that the Civil War struck through many families in Annapolis is no better il-
lustrated than by the case of Judge Nicholas Brewer (1795–1864). A noted lawyer, Brewer
accepted an appointment to the bench of the District Court in 1837, serving until his death.
He was also a progressive farmer who pioneered the use of guano fertilizer in his orchards,
in what is now Presidents Hill, and dispensed apple cider and practical agricultural advice
to his neighbors.

Although Brewer was a staunch supporter of the Union, his family was deeply divided.
Four of his sons shared his Union sympathies, but three others joined the Confederate forces.
His son Isaac served with the Washington Artillery of New Orleans until killed in battle at
Rappahannock Station, Virginia, on 23 August 1862. Richard, an 1858 West Point graduate,
was mortally wounded at Piedmont, Virginia, on 25 June 1864. Charles, who served as a sur-
geon with the Confederate forces, survived the war, as did his younger brother John, a cap-
tain in the Grand Army of the Republic. Judge Brewer lost yet another family member to the
war when his wife, Catherine, died on 16 November 1862 from an illness probably contracted
while nursing Union troops hospitalized at the Naval Academy.

Letters from Isaac to his family chart the increasing alienation between North and South
as the war progressed. On 30 June 1861, three weeks before the actual outbreak of hostili-
ties at Bull Run, Isaac wrote, "It pains me to think that a family who has lived so united &
harmoniously together should now be divided, and yet I do not think that because we are
politically divided that we should cherish any hard feelings towards each other." But by 2
January 1862, Isaac admitted the painful breach within the family, beseeching his mother,
"Why should father be so bitter towards us when we are only following out the principles he
instilled into us?" Perhaps the death of Isaac and, later, of Richard helped Judge Brewer come
to terms with his surviving Rebel son, Charles. In a codicil to his will, three weeks before his
death on 16 October 1864, the judge made special provision to ensure that Charles received
an equal share of his estate.

A final testimony to the Brewers' conflict and reconciliation is the Annapolis National
Cemetery at the corner of West Street and Taylor Avenue. Judge Brewer leased the property
to the federal government between 1862 and 1865 for use as a cemetery for Civil War dead.
Today, veterans of both the Union and Confederate forces repose beneath the greensward
together, enemies no more.

MICHAEL P. PARKER
Professor of English, U.S. Naval Academy

continent, it should do so. I feel as though dropped back into the past fifty years, and I
confess the sensation is not disagreeable. . . . The quiet of the place is subduing after the
feverish excitement of New York."[169] But after two years, a Rhode Island soldier termed An-
napolis "a mean kind of A place the soldiers call it the no God town."[170]

Paroled Union troops began arriving in Annapolis in early July 1862 and were lodged on the St. John's College green. Within a month, there were more than five hundred parolees in town and two thousand by the end of August.[171] These were not happy men. They had left home and family and made their way to Annapolis assuming "that every necessary preparation had been made for the proper accommodations of all who should report to this camp." What they found was very different. Many were still recovering from wounds or sickness; all wanted either to be mustered out or exchanged immediately and sent back to their units.[172] Denied that, they fought amongst themselves, plundered orchards, threatened and even attacked locals, and caused general havoc in the town.[173] Judge Nicholas Brewer complained to the army surgeon general in late August that, although the men had finally been supplied with tents, they lacked proper clothing and bedding. Even the sick were "lying on the ground . . . as they have not even a tent hospital to keep the wounded together." Mrs. Brewer took them bandages and food, but she had no bedding to offer them.[174] In August, Sue Sands wrote, "The air is so foul and polluted that I can scarcely breathe it."[175] Finally, in September, the accumulated three thousand paroled men were moved out of town to a new camp where some measure of control could be administered.[176] They were virtual prisoners, men whose crime had been capture by the enemy and who now were forcibly detained by their own side. Their prison came to be known as Camp Parole.

At first, the parolees came to Annapolis from the battlefield, but in September of 1862, men began arriving from Southern prisons.[177] Although these early survivors of the notorious Confederate prisons were in better physical condition than those who arrived later in the war, they still needed special attention, and procedures were established for their treatment in Annapolis that would continue for the rest of the war. St. John's College had been essentially taken over by the government in July, the buildings modified for use as a hospital. Six hundred men could be accommodated in barracks and tents on the grounds.[178] When paroled prisoners arrived by steamer at the Naval Academy wharf, the sick were admitted to either the academy or St. John's hospitals and the rest of the men were taken to the St. John's College Green Barracks. There they were "marched to the river, made to throw away their old clothes and cleanse themselves" before being given new clothing and food. After a few days, they were sent out to Camp Parole.[179] Of course, this routine did not always work smoothly. Sometimes sick and debilitated prisoners were sent to the parole camp, and an army surgeon in the camp made an official complaint in November 1862 against the practice of hurrying men "out of the various hospitals in large numbers (and as the men say themselves 'just to get quit of us') to report to this camp."[180] At this time there were seven to eight thousand men living in tents at the camp, with sufficient clothing and food but without adequate heat or sanitary facilities, and with only a rudimentary guard.[181] Paroled men generally were separated from their units, and therefore from their accustomed officers and the friends and relatives with whom they had enlisted. They were anonymous souls hundreds of miles from the civilizing factors of family, regular employment, and the social institutions of their towns or cities. There were few curbs on their behavior.

Besides the paroled prisoners, the city housed the provost guard and additional troops assigned to guard the hospitals, the railroad, and the parole camp. Most of the guards lived in the College Green Barracks.[182] Other camps were situated outside the town from time to time as temporary staging areas.[183] With thousands of men in the area, especially the

paroled prisoners with little to occupy their time, and liquor available, albeit illegal, crime continued to be a problem in the town. One afternoon in November 1862, Sue Sands's mother was on the second floor of their home on Prince George Street dressing her two youngest children "when her room door opened and in walked a drunken soldier. She was very much frightened and ran down stairs locking the man in her room." A neighbor removed the man and no one was hurt. "It is the first time we have been disturbed by them," wrote Sue.[184] Later that month, Dr. Ridout noted, "A drunken parole soldier was shot down at Judge Mason's door a few days ago by a guard" after escaping from the guard room. Dr. Ridout felt that the paroled soldiers "are far worse than other soldiers."[185] A detachment of the camp guard patrolled the countryside within six miles of the camp "arresting marauders and stragglers."[186] But they were unable to stop the theft of horses, sheep, tobacco, turkeys, corn, apples, peaches, turnips, and small boats from nearby farms. Gangs of men on the loose damaged farm buildings and threatened owners, tenants, and servants. Samuel Duvall, keeper of the lower South River ferry, wrote Alexander Randall, "Three of them Striped them selves naked and surrounded a woman that was washing." Had Duvall not come by "they would have done all they wanted." His family could not sleep for fear.[187]

Even when the soldiers were relatively benign, their presence inhibited normal city life. Farmers bringing produce to town were harassed as they passed the camps. Orchards and woodlots were destroyed by soldiers stealing firewood; fields were trampled.[188] Anna Key Steele, who lived with her family on Tolly Point Farm at the end of the Annapolis Neck Peninsula, wrote of those days and her father's reaction: "[My father] died at the height of the Civil War, his end hastened by his anxiety for Mother and me, surrounded by encampments of Yankee troops. On one of the last days that we drove in to Annapolis, as we passed through the lines of tents and soldiers on either sides of the road they called after us 'there goes old secesh and his daughter.' I saw his nostrils flare and his color blaze and he said to me, 'We will not drive in again — we will go in by bateau.'" As a suspected Southern sympathizer whose brother was with Mosby's Rangers, Anna Steele once had her trunks searched when she boarded the steamboat to go to visit friends in West River, but no contraband was found. Henry Maynadier Steele, her father, died 29 March 1863.[189]

Following President Lincoln's call on 2 July 1862 for 300,000 men to enlist for three years and the appropriate act of Congress authorizing a draft, the enrollment of "all able-bodied" white male citizens between the ages of 18 and 45 years began in the Federal states, including Maryland. Upon completion of the enrollment, enough men to supply each county's quota would be drafted into the army. Andrew W. Chaney served as the enrollment officer for the Annapolis district. Of course, by this time, a number of local men had already enlisted in the Union army and were in the field.[190] Others, among them John Taylor Wood, with his wife Lola and their baby, had slipped quietly across the Potomac River.[191] Now, men who had not come to a decision about military service, on either side, faced the possibility that they might lose any choice in the matter. As Dr. Ridout wrote in late August, "Many of our young men from this region have gone off to Virginia within the last 10 days, in consequence of the draft which is soon to take place, preferring, if they must enter the army, to fight the Yankees, rather than their friends, as they call them. It is a sad delusion that so many Marylanders are labouring under."[192] Chaney completed enrollment in the city on 19 September with a list of 545 names, of whom 173 were considered eligible for

the draft, the others being exempted because of age, occupation, or some reason not noted. The divinity students at the Redemptorist seminary at St. Mary's were listed but exempted. Forty-eight men were noted as presently serving in the Union army or navy, and of these, two were either sick or dead, one had been discharged, and one had deserted. Beside the names of seventeen men Chaney entered the comment "Supposed to have gone South" or just "Gone South." At least six of those seventeen Confederates died before the end of the war.[193] Although Dr. Ridout's two enrolled sons were exempted, he was still critical of the draft, writing, "This draft was an injudicious move in the border States, and in Md at least has been badly managed." Many fit men were exempted, he complained, leaving others to carry their weight.[194]

As the fighting continued and the bureaucracy of war solidified, the Medical Department at Annapolis, comprising the Naval Academy and St. John's hospitals (named U.S. General Hospital, Division No. 1 and No. 2, respectively) and the hospital at Camp Parole, created its own small world. Dr. Thomas A. McParlin was appointed director of the department in the spring of 1863. An Annapolis native, son of West Street silversmith William McParlin, and a graduate of St. John's College, Dr. McParlin had been a surgeon in the U.S. Army for fourteen years.[195] Under him were the directors of the three regular hospitals. A fourth hospital, for treatment of men with contagious diseases, principally smallpox, was established in 1863 on Horn Point as an adjunct to the Division No. 1 hospital.[196] Dr. Bernard A. Vanderkieft, who took up his duties in Annapolis in June 1863, supervised the Division No. 1 and Horn Point hospitals.[197] Born in Holland, Vanderkieft was a veteran of the Royal Dutch Navy and the hospitals of the Crimean War. He immigrated to New York in September 1861 and immediately enlisted as assistant surgeon in the D'Epineuil Zouaves. His first posting was Annapolis, where the Zouaves joined other units preparing for Burnside's Expedition. When the Zouaves mustered out the following spring, Dr. Vanderkieft was made surgeon of another New York regiment and, eventually, of the hospital at Sharpsburg, Maryland, established following the Battle of Antietam. He was assigned to Annapolis in May 1863.[198]

Over the next two years, Dr. Vanderkieft encouraged the services of some thirty female nurses, who ministered to the sick by preparing nourishing foods, reading to patients and writing letters for them, and generally supplying "the place of mothers and sisters to these hundreds of sufferers." The hospital drew temporary cooks and caregivers from the ranks of convalescent patients, but the "lady" nurses oversaw the dietary kitchens and gave continuity to nursing procedures. Directing these nurses was Mrs. Adeline Tyler, an aunt of Elizabeth Randall's and former administrator of the Church Home and Hospital in Baltimore, who had nursed Union men wounded in the April 1861 riots. In the summer of 1864 when Tyler was forced by exhaustion to retire, Maria M. S. Hall, a young woman who had cared for wounded troops in Washington and Antietam, took her place.[199] Dr. Vanderkieft also initiated social and cultural events at the academy hospital complex, and a number of local residents attended the Vanderkieft Literary Association evenings, "entertainments," and services at the chapel, which had been returned to its original use by the hospital chaplain and the U.S. Christian Commission.[200]

Early on it became obvious that a cemetery for the remains of soldiers who died in Annapolis was going to be necessary. In the summer of 1862, the federal government leased land about a mile from the city, near the smallpox hospital, from Judge Nicholas Brewer. The cemetery was expanded to just over four acres in 1863 and 1865, and the United States

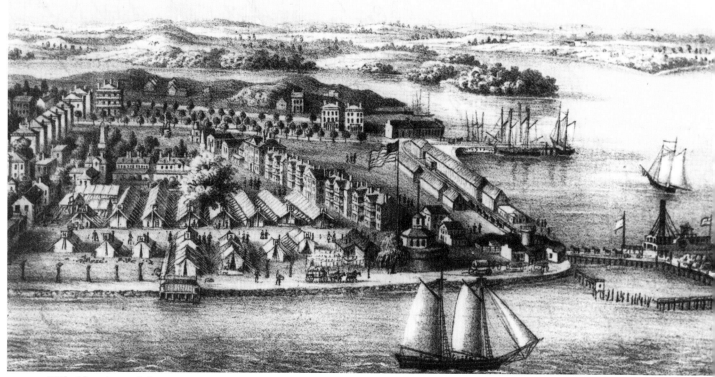

With sick and wounded soldiers arriving every week, the Naval Academy grounds soon became a huge hospital post. Surgeon Bernard A. Vanderkieft directed this hospital from June 1863 until the end of the war. Courtesy William Smith Ely Collection, Edward G. Miner Library, University of Rochester Medical Center, Rochester, N.Y.

received title to the entire cemetery from Brewer's heirs in 1871. Now known as the Annapolis National Cemetery and listed on the National Register of Historic Places, the cemetery contains the graves of about twenty-five hundred men and three female nurses who died in the Civil War from wounds received in battle, illness, accidents, or the violence that ended the lives of many parolees and guard troops in Annapolis. All but a few of the soldiers had served the Union. The six or eight Confederates died as prisoners of war, and the lone Russian sailor was shot in a local bar.[201]

The story of the Russian sailor illustrates the diversity of visitors to Annapolis during the war. Five vessels of the Russian navy had been sent to the United States in the fall of 1863 so that they could harass British shipping in the Atlantic should that country declare war on Russia over its domination of Poland. That war didn't occur, but the Russians stayed through the winter anyhow. Most of the time, they anchored in New York harbor, but from late January to early March 1864, they visited the Chesapeake. Two of the ships, the clipper *Almaz* and corvette *Varyag*, spent February in the Severn River. Their crews roamed around town, ate and drank in local establishments, and, occasionally, went off with "street women." A midshipman aboard *Almaz* named Nikolay Andreyevich Rimsky-Korsakov joined his colleagues on a sightseeing trip to Washington but said nothing particular about either that city or Annapolis. Nor, apparently, did he use his leisure time here to compose any of the music for which he later became famous.[202]

Just a few days into the visit, Nicholas Demidoff, a sailor aboard *Almaz*, got into a fight in a tavern near the academy wall and was shot dead by tavern keeper William T. League.

Perhaps language was to blame, perhaps there were other causes. The result remained a dead Russian whose body needed proper burial. Accordingly, the academy chapel became the scene of ceremonies on the morning of 6 February celebrated by a Greek Orthodox priest who traveled with the fleet. The two-hour public funeral in the Greek ritual was attended by American officers, patients at the hospitals, and local citizens as well as Russian officers and crew. Following the High Mass, the coffin was carried to the soldiers' cemetery in a long solemn procession of men from both countries marching slowly to dirges played by the Russian band. One American observer wrote, "Few of us have ever witnessed more impressive and touching services than those."[203]

There is no record of who made Seaman Demidoff's coffin; perhaps one of his countrymen took on the sad task, but Annapolis carpenters who turned to coffin making had no trouble finding work during the war. Daniel H. Caulk, a woodworker-undertaker whose funeral business on Fleet Street might have handled 100 to 150 burials a year before the war, expanded his operation as the numbers of dead increased. Soon after the war began he brought in a young carpenter named James S. Taylor to help with the business. All soldiers who died at the city's military hospitals were buried in coffins, whether they were embalmed and sent home or laid to rest in the local cemetery. Each draped with the

Miss Maria Hall, director of female nurses at the Division No. 1 hospital in 1864–1865, was popular with patients and staff. The anonymous photographer who took this photograph titled it, "Annapolis hospital, Miss Hall's Tent." Courtesy William Smith Ely Collection, Edward G. Miner Library, University of Rochester Medical Center, Rochester, N.Y.

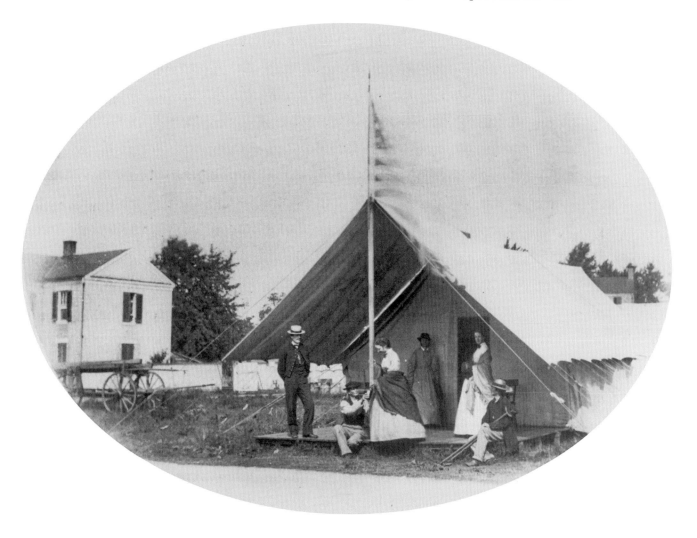

Carpenter James S. Taylor's coffin making during the Civil War led him to establish a funeral business in Annapolis that continues to this time. Courtesy of Robin Taylor.

American flag, ten or more coffins might lie in the chapel each day awaiting transport to their final destination.[204]

Military uses of its campus created a difficult situation for St. John's College. The army built new barracks on the campus early in 1863 to receive and process paroled Union prisoners, and as the numbers of sick and wounded increased, the college hospital took over McDowell Hall in October 1863. Professor William H. Thompson, who had tried to keep the school alive by continuing the preparatory department for the previous two years, was forced to find classroom space elsewhere. In February 1864, in response to his request, the city government gave Thompson permission to hold classes in City Hall rent free if he would accept four scholarship students from the local primary school.[205]

Following months of complaints from soldiers and civilians alike about the parole camp just outside of town, Commissary General of Prisoners Colonel William Hoffman sent his assistant, Captain H. M. Lazelle, out to investigate in March 1863. Captain Lazelle's report detailed the problems at the camp—lack of discipline; inadequate sanitary, provisioning, and medical facilities; and general poor condition—and recommended that the camp be moved. Expansion was not an option, Captain Lazelle wrote, because "the ground immediately outside the present camp is so covered with accumulations of rubbish and filth and the sites of old tents and huts." Besides, with the exception of wood for the camp, which was purchased in Annapolis at a cost of $5.25 a cord, supplies generally came from Baltimore by rail, and with six thousand men in residence, sixteen wagons were "constantly employed" hauling in supplies along roads that were in "extremely bad" condition. Relocating the camp to a place where it could be served directly by railroad would relieve the traffic and the damage to the roads of Annapolis, "so much complained of."[206] With apparent agreement on all sides, the federal government rented the 250-acre farm of Charles Sellman Welch, with a house and large brick barn, for $1,500 a year. Lieutenant Colonel George Sangster, commander of the parole camp, implemented plans drawn up according to specifications by Colonel Hoffman. By mid-May, Colonel Sangster reported that contracts had been made for the lumber. Men in the camp would construct sixty 120-man barracks, twenty kitchens, three storehouses and a six-building hospital. He expected the new camp to be ready in six weeks, after which all transportation would be "by the railroad, the camp being on the side of it."[207] In July 1863, the new Camp Parole was placed under the command of Colonel Adrian Root of the 94th

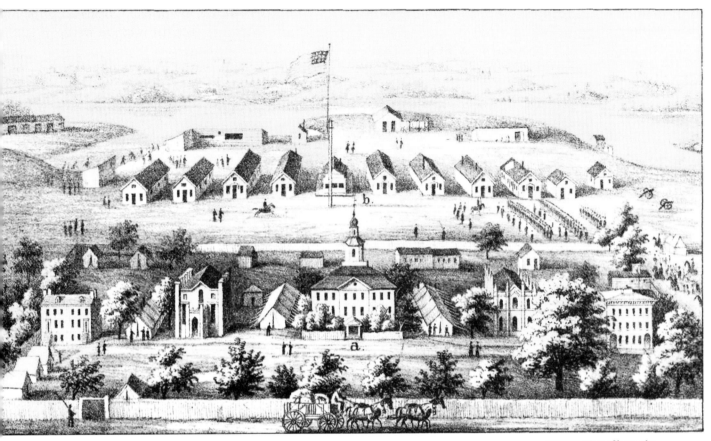

Construction of barracks on the back campus, tents between the college buildings, and conversion of the buildings themselves into hospital wards completely displaced St. John's students and faculty by late 1863. Courtesy of Edward C. Papenfuse, MSA SC 1477-388.

New York Volunteers, who remained in charge of the camp throughout the war and took over the additional command of the Post and District of Annapolis in April 1864.[208]

In the city, local residents were bent on improvements. The city contracted for grading the damaged streets and installing curbs and gutters, and property owners laid sidewalks.[209] "A number of energetic citizens" filled in the old Governor's Pond at the bottom of King George and Hanover Streets, reclaiming "several acres of swampy land . . . from waste" below Bridge Street, on which they built "small frame tenements."[210] In May 1863 the city fathers appropriated $500 to buy stock in the Steam Ferry Boat Company, which intended to raise $6,000 "to purchase a suitable steamboat to ply between here and North Severn." City merchants "contributed liberally," and on 8 September the small steamboat *Ready* initiated regular steam ferry service across the Severn River from the foot of Tabernacle Street.[211]

Just prior to the November 1863 general election, Major General Robert Schenck, commander of the Middle Department, which included all of Maryland, issued an order that provost marshals throughout the state should "support the Judges of Election . . . in requiring an oath of allegiance to the United States, as the test of citizenship of any one whose vote may be challenged on the ground that he is not loyal." General Schenck thoughtfully included the text of the required oath in his order. As might be expected, Governor Augustus Bradford protested vehemently this intrusion into the affairs of the state, whose election judges, he said, were perfectly capable of carrying out a proper election without military assistance. However, the significant majority vote for Union candidates, most of

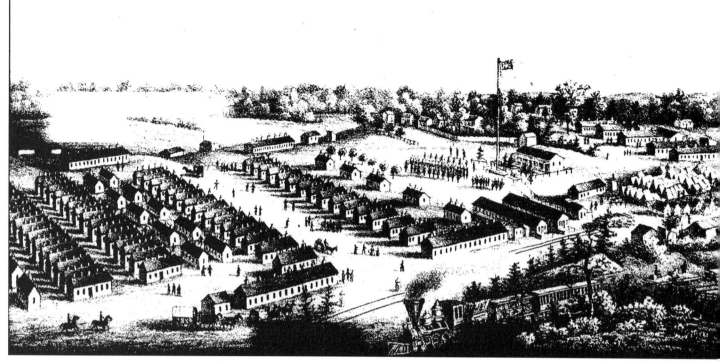

Soldiers at the third parole camp in the Annapolis area could purchase stationery depicting their virtual prison, which lay south of the Annapolis and Elk Ridge Railroad line and east of today's Maryland Route 2. Courtesy of the Dennis M. Gurtz Collection, MSA SC 5642-1-19.

whom favored a constitutional convention and the emancipation of slaves, may be credited to the presence of soldiers at polling places.[212]

In Annapolis, 462 men voted in the November 1863 general election, compared with 488 who had voted in the general election two years earlier. Two-thirds of the city's voters in 1863 selected Union ticket candidates for the legislature who were not supported by the rest of the county and who, as a result, did not win. Democrats William Tell Claude, Thomas S. Iglehart, and Eli J. Henkle received the majority of votes in county districts outside Annapolis. The same city-county split was true for candidates for state's attorney and clerk of the court. The vast majority of city voters turned away from local men James Revell and Nicholas H. Green, both Democrats, and voted for their Union rivals. Only because the rest of county voters selected them did Revell and Green win.[213] But their victory was marred by arrest. Revell and Green, along with candidate William Tell Claude, former governor Thomas G. Pratt, former state senator Thomas Franklin, former U.S. Senate clerk Joseph H. Nicholson, and seven other Annapolis men, including Sue Sands's friend (and later husband) Martin Revell, refused to take General Schenck's oath and were denied the right to cast their ballots. Not only did they refuse to take the oath of allegiance, these men, many of them attorneys, also determined to bring suit against the election judges for "refusing to receive their votes in accordance with the election laws of the State of Maryland." Captain Francis J. Keffer, of the 71st Pennsylvania Volunteers and provost marshal of the Annapolis district, who, the *Annapolis Gazette* commented, "obeys orders to the letter," turned their names over to the military commander of Annapolis with a query about

what he should do if the election judges were, in fact, arrested by county authorities. At the Circuit Court session on 12 November, the county grand jury, said by the *Annapolis Gazette* to be composed largely of "Secessionists and their Democratic allies," handed down "a number of indictments charging the Judges with official corruption." Union man Judge Nicholas Brewer promptly delivered a scathing rebuke to the errant jurors for what he considered a partisan action, and fearing a stay in Fort McHenry or banishment South, the jurors withdrew the indictments. Instead of a civilian arrest of election judges, the protesters themselves were arrested by the military. With the exception of Senator Franklin, who was granted an extended parole because of poor health, the men spent several days in Baltimore being examined by military authorities, who presented them their alternatives: "take the oath of allegiance or go South." Within a week, all had taken the oath and returned home except Pratt and Nicholson, who were placed under arrest and sent South via the Union army post at Fortress Monroe. Nicholson took the oath and was released two days later; Pratt refused the oath and remained at the fort for some time.[214]

Reports of a smallpox epidemic in Annapolis and a paucity of accommodations for the legislature prompted some to suspect that the winter 1864 meeting of the General Assembly might be held elsewhere, but the *Annapolis Gazette* assured readers, "Since the foundation of the Ancient City there has not been so many commodious and well kept boardinghouses within its limits as at the present time. The City Hotel, which has been recently much improved, will of itself more than accommodate comfortably every member of the Legislature."[215] The smallpox epidemic was not so easily dismissed. Dr. John Ridout confirmed the widespread fear: "The panic is so universal that almost everyone, old as well as young, is desirous of being vaccinated." Lack of both time and vaccine made it difficult for the city's physicians to inoculate everyone, but as usual the city corporation offered to pay for vaccinations for the poor and reopened the municipal smallpox hospital. Eight deaths had been recorded by mid-January, and the disease continued to threaten the city through the spring; but it was not as serious, Dr. Ridout thought, as the city's medical officer, Dr. Washington G. Tuck, proclaimed.[216]

Undaunted, the General Assembly went into session in the State House on 6 January 1864 and, as one of its first acts, passed legislation calling for a constitutional convention.[217] The Assembly also enacted legislation to provide bounties to men enlisting in the Union Army. Free men, black or white, who enlisted for three years were eligible for $300 from the state. Slaves who joined up received their freedom and $50 at enlistment and another $50 when honorably discharged. Slave owners who filed manumission papers for an enlisted slave received a bounty of $100.[218] Those owners loyal to the Union also were eligible for $300 from the federal government in compensation for each former slave. An advertisement by recruiting headquarters in Baltimore stated that free black men would receive $400 bounty.[219]

Although it is unclear if the promise of a state bounty made a difference to Annapolis slaves, it is certain that they and their free black neighbors flocked to enlist in regiments of the United States Colored Troops (USCT) in February 1864. The impetus for their enthusiasm was more likely the appearance in town around the 22nd of that month of a company of "negro soldiers," almost certainly belonging to the 30th Regiment USCT, on their way to Baltimore. Camped at the College Green Barracks, the soldiers mingled with townspeople and at one point a smart-looking group paraded through town. As the *Annapolis Gazette* put it, "the military spirit among the colored gentry became quite lively."[220] So lively that

between 22 and 27 February, seventy-five black men from Anne Arundel County enrolled. Most of them, fifty-seven, signed up with Company D of the 30th Regiment. During the same period thirteen joined Company C, four joined Company E, and two, Company F. These were not the first Anne Arundel County men to enlist in USCT companies, nor the last, but this was by far the greatest number from the county to join during a defined time period.[221] Among the men enrolling during this period were thirty-two slaves, of whom at least seventeen belonged to persons with property or residence in Annapolis. It is difficult to determine how many of the free men who enrolled lived in Annapolis, because their location is given only as "Ann Arundel Co," but many of their last names are those of long-time local families: Lane, Parker, Pindell, Brice, Boston, Johnson. Anne Arundel men made up almost the entire roster of noncommissioned officers in Company D, James Allen was First Sergeant, Marcellus Calvert, Philip H. Pindell, and John Chew, sergeants, Samuel Hall, Abram Hebron, and William Pointer, corporals. Sergeant Chew was almost certainly a resident of Annapolis as, until his enlistment, he was a slave of Circuit Court Judge William H. Tuck. Eight other men, all enrolled as privates, lived in or near the town as slaves of George Wells, as did the eight slaves, now soldiers, belonging to former governor Thomas G. Pratt, Dr. Washington Tuck, and five other Annapolis white families.[222]

The 30th and 39th Regiments USCT, both of which included men from Anne Arundel County and Annapolis, were attached to Brigadier General Edward Ferrero's Fourth Division of the Ninth Army Corps, under General Ambrose Burnside. The local men's first camp was almost literally in their own backyard.[223] Burnside had been ordered to bring the Ninth Army strength up to 50,000 men and rendezvous in Annapolis in March 1864. The Ninth Army camp adjoined Camp Parole, probably to the west, along the railroad.[224] The Maryland USCT units, "dressed in uniforms," were approved by an observer at the parole camp as "a fine-looking body of men, and I am glad to see them ready for the field."[225] Generals Burnside and Ulysses S. Grant reviewed the troops before the army shipped out for Virginia in late April.[226]

While the men in Camp Parole waited to be sent back to their regiments or discharged from the service, some availed themselves of the entertainments of the town. They explored Annapolis, "a miserable looking place," said one, and many climbed to the dome of the State House to see the "magnificent view of the city" and surrounding area.[227] Commercial establishments in town such as Mullavell's Bowling Saloon on West Street, with four "full-length alleys," liquor, wines, and cigars, catered to military clientele.[228] At least seven photographers offered the popular *cartes de visite*, which soldiers could send home to family and friends. For convenience of their subjects, J. L. Winner and Frank J. Quimby and Company set up studios at Camp Parole, and A. H. Messenger's gallery at the General Hospital Division 1, photographed men too sick to leave the academy yard.[229] For benefit of residents and visitors alike, Dr. Thomas O. Walton extracted teeth painlessly with nitrous oxide at his office on Conduit Street. A company of opticians from Washington opened a branch of their business on Main Street in April 1864, where they sold field glasses and compasses as well as "spectacles."[230] The circus returned to Annapolis for a week in the spring of 1864 under the management of the woman "formerly Mrs. Dan Rice," divorced and remarried, who campaigned her "Great National Circus" during the war.[231] And, as might be expected, there were houses of "ill fame" in town, at least two of them on West Street. Provost Marshall Keffer tried valiantly to shut down "these dens of iniquity," but it is unlikely he had much success.[232]

Soldiers in the camps amused themselves as best they could, writing letters home, cooking food, policing their barracks, gambling and drinking if that was their wont. From time to time they ventured out into the countryside for something other than the usual wood gathering. Farmer-soldiers from other parts of the country picked strawberries, cherries, and blackberries in season and explored nearby farms on land that they generally considered sandy and poor. "It appears a miracle from such land they should be able to raise enough for their own subsistence," said one Ohio man. Local residents, both black and white, did odd jobs at the camp — washing, cleaning, polishing shoes — and others visited daily with milk and butter for sale.[233] Reports of violence outside the parole camp lessened after the camp moved to its final location. Either the guards were more attentive, discipline improved, or the men were simply too tired and sick to cause trouble in the neighborhood.

Camp and town routines came to an abrupt halt early in July 1864, and for a few days city residents, military and civilian, were gripped with excitement as Confederate forces under Lieutenant General Jubal Early crossed the Potomac into Washington County and began to make their way east through Maryland. As had been the case in past wars, townspeople assumed that the state capital would be a target of the invading army and reacted with fear or, in the case of Southern sympathizers, with jubilant anticipation.[234]

Word of the danger came on 3 July to Colonel Root, commander of the Annapolis District, who was ordered on 6 July to send six companies of his guards by rail to Monocacy Junction, near Frederick, with three days' rations and a hundred rounds of ammunition each. The Ohio soldiers at Camp Parole who had so enjoyed the Anne Arundel County cherries were among those who left before dawn the next morning.[235] When wounded Union soldiers began straggling back into Baltimore and Howard Counties a few days later, the possibility of Confederate capture or demands for ransom, such as had been paid by the cities of Hagerstown and Frederick, threw Baltimore City into panic. Raising the anxiety were tales coming in of Confederate General Bradley T. Johnson's cavalry raids into Carroll and Baltimore Counties, where his Rebels, including the legendary Colonel Harry Gilmor, were destroying rail and telegraph lines. Former academy professor General Henry H. Lockwood was assigned command of Baltimore City's hastily assembled civilian force.[236]

According to the *Annapolis Gazette*, capital city residents did not sense any direct threat to their own safety until Sunday 10 July when reports arrived that Confederates had seized control of the railroad between Baltimore and Washington. Then the bell on City Hall summoned citizens to a town meeting that evening at which Henry H. Goldsborough, president of the Constitutional Convention then meeting in the city, and Dr. Washington G. Tuck called for volunteers to build entrenchments to protect the city from land invasion. A few "gentlemen" scouts left town to reconnoiter, a "heavy picket guard" patrolled the outskirts of town, and pretty much everyone else spent a sleepless Sunday night.[237] At the request of city officials, martial law was instituted on 11 July and Colonel Root was ordered by his superiors to "defend and protect the city at all hazards" and to compel the citizens to help.[238] Union men apparently volunteered for entrenchment duty with alacrity, but "the 'Secesh' held aloof, knowing that if the Confederates came here 'twould be for our benefit," and had to be arrested by the guards before agreeing to join the workers.[239] At the hospitals, recuperating wounded and sick who could "handle a spade or pickax" helped with the town entrenchments or with the Naval Academy's own defenses. Within hours "an entrenchment from two to three feet deep with a breastwork of sufficient height for ample

protection was erected" across the Annapolis peninsula.[240] Whether or not these earthworks were located on or near those supposedly constructed in the first days of the war under Brigadier General Butler is not mentioned in contemporary accounts. However, since the narrowest part of the peninsula would have remained the same, they may have been. The 1864 entrenchments extended one mile across the railroad tracks and West Street from the head of College Creek to Spa Creek, almost certainly at Old Woman Cove.[241] Children living in Presidents Hill in the 1920s played in the "trenches behind Jefferson Place" and Hill Street in 1920, and Peter Magruder, writing in 1945, said remnants could still be identified then.[242] There was no obvious sign of them in 2001, almost sixty years later.[243]

In town, businesses and schools were closed, and Alexander Randall noted in his diary that a force of about five hundred men was ready to defend the town.[244] The fortifications were manned by civilians and army personnel, who, it was asserted later, could have resisted "a cavalry attack of 5,000."[245] A gunboat was stationed off the city wharf; on the Severn, armed vessels patrolled and private craft assembled to carry off civilians "at the first appearance of the foe."[246] It was to one of these boats that Samuel W. Brooks, assistant to Governor Bradford, transferred the state's most important papers in the dead of night with the assistance of Mayor Solomon Phillips, who had a carting contract with the federal

Annapolis residents hastily built fortifications in July 1864 to secure their town against a rumored attack by Confederate troops under General Jubal Early. This view is almost certainly of the line of defense positioned between the head waters of College and Spa Creeks to prevent an invasion by land. Courtesy William Smith Ely Collection, Edward G. Miner Library, University of Rochester Medical Center, Rochester, N.Y.

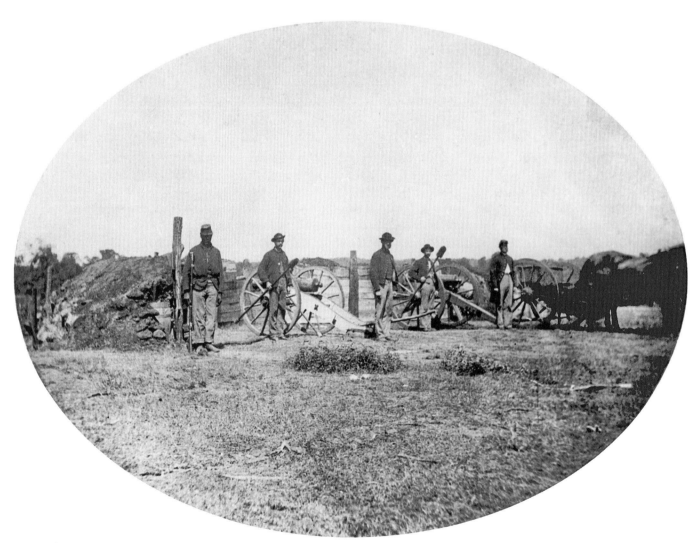

government. As soon as the papers were aboard, Brooks and the papers steamed off to the security of one of the government's armed transports, where they rested safely until the danger was past.[247]

Fearing the possibility of danger to hospital nurses from Confederate troops, authorities ordered the women to leave Annapolis. Some nurses obeyed, took a train west, and were stopped by Confederates north of Baltimore. The men commandeered the train and left the nurses on the tracks to be rescued the next day. At least one of the women never returned to Annapolis.[248]

After a few anxious days and nights, news of the Confederate retreat back across the Potomac reached town on the 14th of July, and both military personnel and civilians relaxed. The troops who had been manning the West Street fortifications paraded through town to the accompaniment of the Division No. 1 hospital band, and everyone went home. In its account of the excitement, the *Annapolis Gazette* added, "We cannot close this article without alluding to the alacrity and promptness with which the colored people came forward and rendered valuable service."[249] Defense of the town brooked no discrimination.

Once the excitement died down, Convention president Goldsborough and his colleagues went back to work on the new state constitution, which they completed in early September. As expected, the 1864 constitution freed all Maryland slaves as of 1 November 1864 and codified an oath of allegiance required of voters and officeholders that was similar to General Schenck's in the November 1863 election. Franchise was granted only to those white male United States citizens and state residents over twenty-one years of age who had not in any way, by word or deed, aided the Confederacy.[250]

The new constitution, submitted to Maryland voters on 12 and 13 October, failed by almost 2,000 votes until ballots from Maryland's Union soldiers in the field gave the document a 375-vote majority. Although the majority of Annapolis voters (252 to 134) had favored the creation of a new constitution in the April 1864 referendum, when the document was presented to them in October, they turned it down (218 to 161). There had never been any question about sentiments in the county as a whole: almost three-quarters of the county had voted against the convention in April, and more than 80 percent rejected the constitution in October.[251]

In the general election of November 1864, slightly fewer than half the 490 Annapolis voters chose the Republican ticket electors, thus casting their vote for a second term for President Abraham Lincoln. The rest of the county gave Lincoln only 12 percent of their vote — more than the pitiful two votes in the 1860 election, but certainly not a ringing endorsement.[252] Nonetheless, Lincoln supporters in Annapolis threw a huge parade through the city to celebrate the "growing list of Union victories and the re-election of Abraham Lincoln." As *The Crutch*, the newspaper published by Division 1 hospital personnel, commented on 19 November, "The inhabitants of the Ancient City probably never witnessed a display on so magnificent a scale since its incorporation and were, doubtless, (those patriotically and loyally inclined) jubilant and revivified; while to the unpatriotic and disloyal inclined, it must have caused chagrin." Men from the hospitals and Camp Parole marched from the entrenchments on the outskirts of the city to the Market Square, where there were speeches by Colonel Root and "a number of the city's most prominent citizens," capped by a fireworks display.[253]

The festive music of the November parade was an anomaly to local ears more accustomed to the dirges played by the Division 1 hospital band as it accompanied the dead to

Men arriving from prisons in Richmond were often so near death from starvation and exposure that no care could save them. This private from Company C, 8th Kentucky Volunteers, died on 4 May 1864, two days after admission to the Division No. 1 hospital on the grounds of the Naval Academy. Harper's Weekly 18 June 1864.

the federal cemetery on West Street. During the winter of 1864–65, these sad processions increased after thousands of men were released from Confederate prison camps that fall. Ten thousand desperately ill prisoners from Libby Prison and Andersonville arrived in Annapolis by steamboat in December, and forty to sixty at a time were carried to the cemetery under the drone of dirges and muffled drums.[254] There were 303 burials in National Cemetery that month, the most of any month during the war.[255] The prisoners brought with them tuberculosis, cholera, smallpox, and typhoid, threatening hospital personnel as well as other patients. Of the six lady nurses stricken by typhoid that winter, five died.[256]

President Abraham Lincoln visited Annapolis very briefly in February 1865 on his way to and from a peace conference with Confederate representatives on the steamboat *River Queen* off Fortress Monroe. In what seems to have been a spur of the moment decision, Lincoln arrived by special train at 1:00 p.m. 2 February, with only two aides, and walked from the depot on West Street to the academy dock, accompanied by Captain G. S. Blodgett, post quartermaster. There the president went aboard the fast steamer *Thomas Collyer* for the trip down the Bay. Ice in the mouth of the Severn and off Thomas Point slowed the vessel, but she reached her destination just before 10:30 that night, after what the lucky correspondent for the *New York Herald* who just happened to be on board said was "undoubtedly . . . the quickest trip on record from Annapolis to Fortress Monroe." Lincoln met immediately with his secretary of state, William H. Seward, and the three Southern negotiators aboard *River Queen*. Hours of discussion resulted in stalemate and the parties dispersed the next day. Lincoln made an overnight return to Annapolis on *River Queen* and took the train back to Washington. Apparently he did not retrace his walk through the town.[257] What effect the sight of that tall, thin, care-wrought man striding through the town had on local residents is not known.

The country's most famous nurse, Clara Barton, arrived in Annapolis later that spring with presidential authority to establish an office at Camp Parole to locate missing prisoners of war. She lodged in town for two months waiting for the War Department to authorize space for her at the camp and postage for mailings. Once at the camp, Barton found that there were few rosters of prisoners available and the men themselves were in such debilitated condition that she could obtain little information from them. She quickly gave up the effort, went back to Washington, and used her own funds to organize the Bureau of Records of Missing Men of the Armies of the United States.[258]

For some years residents of Annapolis had been concerned about their water supply. Drawn from shallow public wells throughout the city, with pumps at various street corners, the water tended to be brackish and its quantity inconsistent. Exacerbating local concern was the pervading fear of fire and, as the city grew, the increasing likelihood that wells would not provide enough water in an emergency. A nasty paper fire in the basement of the State House during the General Assembly session of 1864 focused the legislators' attention on the potential for serious damage to their capitol, and they quickly appropriated money for a large cistern on State Circle as a stopgap measure.[259]

City residents knew, however, that a state cistern would not have saved the buildings destroyed by a disastrous fire at the southern end of Main Street in February that year. Two frame houses and a three-story brick building called Noah's Ark, housing twelve families "of all colors and complexions," were destroyed and the adjoining store and residence of Nicholas Killman seriously damaged by a raging fire that, because of high winds, endangered the entire lower part of town. Legislators, soldiers, and the visiting Russian officers and seamen helped put out the fire, but residents were shaken, and the next month the city government agreed to spend $100 "to ascertain the feasibility of introducing a supply of water for the use of the city."[260] It is probable that the City Council was also mindful of the fact that plentiful city water would be an advantage in the city's continuing efforts to have the Naval Academy returned to Annapolis.[261]

Alexander Randall arranged for a survey by an army engineer, who determined that if the streams on Judge Nicholas Brewer's farm at the head of College Creek were used, the cost for dams, reservoir, pumps, pipes, and so forth might be just over $42,000. With the legislature's interest aroused and the possibility of obtaining state funding at hand, Randall urged the formation of a water company, and in July 1864 the city government gave its approval with a bylaw authorizing the purchase of capital stock.[262] The Annapolis Water Company was chartered as a private corporation by the state legislature in March 1865 to supply abundant "pure water" to Annapolis "and thereby also to prevent the destruction of public and private property by fire." The company could sell up to 2,000 shares of capital stock at $50 each, with the city authorized to subscribe for 200 shares and the state 400 shares. The governor was to contract with the company to have water supplied to state public buildings and grounds. The state's participation was predicated on $20,000 being raised from private stockholders.[263] The thirteen incorporating individuals included Alexander Randall, his nephew Alexander B. Hagner, Judge William H. Tuck, former mayor John R. Magruder, Dr. Bernard A. Vanderkieft of the Division No. 1 hospital, and two women: Hester Ann Chase, daughter of Jeremiah Townley Chase and the town's wealthiest woman, and Alexander Randall's sister Ann Voorhees, widow of Commodore Philip Voorhees.[264]

With $30,000 in capital from city and state and the requisite $20,000 raised from private citizens, the company hired engineer William R. Hutton, whose experience with the Washington, D.C., Water Works impressed them. Hutton quickly determined that Brewer's ice pond would not supply the 200,000 gallons a day that the company thought necessary to satisfy the present and future needs of the city and the Naval Academy. Edging farther and farther from the city center, he finally chose a mill seat at the head of South River as the most advantageous site. The company bought eighty-three acres of land in July 1865, ordered the pumps, and began laying pipe. Additional land atop a nearby hill was pur-

chased for a reservoir seventy-four feet higher than State House hill. Gravity would take the water to the city in an eight-inch reinforced-concrete pipe and distribute it through a system of smaller pipes. The directors of the company eschewed lead piping because in the past, they said, water run through lead pipes in the city "on some occasions proved injurious to health." The waterworks went into operation on 28 October 1866. In the first two months of service, the academy used more than 1.5 million gallons at a cost to them of less than $500.[265]

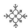

When news of General Robert E. Lee's surrender on Sunday 9 April 1865 reached the army camps in Annapolis, hundred-gun salutes rent the air and the city government immediately proclaimed a parade and illumination. On Wednesday the 12th, "jubilant" soldiers packed the streets to admire the public buildings, McDowell Hall, and many private homes that "were transfigured into fairy temples of light." Bands played and rockets shot into the night sky from the State House steps. The assassination of President Lincoln two days later immediately transformed celebrations to anguished grief. The City Council put on mourning badges, draped City Hall with black, and appealed for business closings and church services on the day of the funeral.[266]

Almost as quickly as the army had come, it left. Paroled prisoners were released from internment, and by the end of June the commander at Camp Parole was ready to auction horses, wagons and carts, and the barracks and other buildings. Within a month the soldiers were gone.[267] Patients at the Division 1 and 2 hospitals remained somewhat longer, with those still needing care finally transferred to hospitals in Baltimore. Furniture, bedding, equipment, and thirteen brass band instruments at the Division 2 hospital at St. John's College were auctioned on 24 July at what must have been a particularly gruesome event: among the goods advertised for sale was "a large quantity of clothing, the effects of deceased soldiers."[268] Although there had been hints that the academy might absorb the college, by the end of August control of St. John's had been "restored" to its Visitors and Governors, who met in early September to resurrect their school.[269]

Repairs to the Naval Academy buildings and grounds began as soon as possible and, with some 150 men on the job, were completed by the first of August, just in time for the arrival of ships from Newport loaded with the school's furniture and equipment. To reduce the chance that returning midshipmen might contract diseases lingering from the sick soldiers, the buildings used by the hospital had been repainted and repapered. Classes resumed for the more than five hundred midshipmen in October 1865.[270]

Although there had been talk of relocating the academy, Annapolis and the State of Maryland successfully defended their claim. Given the lament by a Newport correspondent to the Baltimore *Sun* that businessmen in the Rhode Island port expected to lose "a patronage of nearly $500,000 a year" and "fair maidens" would be robbed "of their accustomed moonlight ramble by the seaside, and prospective chances of matrimony," it is no wonder that the city fathers, and mothers, were delighted to have the academy back. If the school's return meant losing to the federal government more city land and even the state governor's mansion, that seemed a small price to pay.[271]

Rumors that the state would sell to the academy the colonial dwelling occupied by Maryland's governors since 1753 had been circulating through town since the spring of 1864, shortly before Congress acted to ensure the school's return to Annapolis. Dr. Ridout mentioned the deal to his son in March of that year: "The Senate Naval Comm'rs have re-

ported & ask for $25,000 to buy the Government House — It was the price at which it was offered by the state, I suppose to keep the school here, but surely only half its value."[272] With enabling legislation from the Maryland General Assembly, the building and its four-acre lot on the north side of Hanover Street were conveyed to the United States government in August 1866. Dr. Ridout was correct about the price paid. Two years later, the General Assembly authorized the expenditure of $100,000 for purchase of suitable ground in Annapolis and construction of a new official home for the governor. The committee appointed to handle the matter selected a lot between the State House and Tabernacle Street, razed the existing houses, and arranged for the erection of a typical mid-Victorian-style mansion, which ended up costing twice the budgeted amount.[273]

The academy's new superintendent, Rear Admiral David Dixon Porter, envisioned a "new era" for the school and promptly set about "a major program of acquisition and construction." Within three years, academy grounds expanded to include not only the former Government House, but also ten acres of the St. John's College green along College Creek and the sixty-seven-acre plantation, Strawberry Hill, on the opposite side of the creek. The construction from 1866 to 1869 of some dozen classrooms, auxiliary buildings, and residences, including the massive New Quarters to house the greatly increased brigade, gave employment to hundreds of Civil War veterans.[274]

On 28 October 1865 the officer of the day at the academy recorded that the "last of the soldiers" boarded a steamer at the academy wharf. Professor Bolander notes this as the end of the army's presence in Annapolis, but official military control did not cease until 31 January 1866. The war ended by presidential decree on 2 April 1866.[275]

Annapolis did not resume its prewar quiet when the soldiers left. The Union army's four years of residence had changed the town, and those changes would continue to affect the city for many years. Among the tangible effects of the war was a more densely populated urban center, created by the new buildings thrown up to house officers and others associated with the military. Construction continued after the war as city soldiers returned home; "several fine brick dwellings" were nearing completion by the fall of 1866.[276]

The city government joined the boom by rebuilding the Assembly Rooms, which had been badly damaged by the army during its occupation. From at least 1863, the provost marshal and his guard had occupied the building; and although the city had tried to charge them $500 a year rent and obtain assurance of compensation for damages, the Quartermaster's Department informed the council that the federal government "did not pay rent for public property used for public purpose for military authority."[277] At the conclusion of the war, the city filed a claim against the federal government for damages and sent Nicholas Brewer of John and Alexander Randall to Washington to collect it. The two emissaries brought home $6,218.20, for which they received a 10 percent commission, and the council immediately contracted for repairs.[278] What started as "repairs," however, ended up being "rebuilding" and cost the city more than $10,000, not including the new furniture. A second story doubled the space, and the City Council decided to make the new building City Hall as well as Assembly Rooms. Balls, concerts, and other public events and entertainments could take place in the elegant second floor hall, which had a stage and "ornamental work." Separate rooms were prepared for lectures and meetings and for the deliberations of the city government; the police office and watch house were lodged in the basement.[279] A dance given by the junior class of the academy on 9 January 1868 appears to have been the first use of the "handsomely furnished" ball room, and the local correspondent to the *Sun* wrote, "Ladies and other connections of the midshipmen were present from many

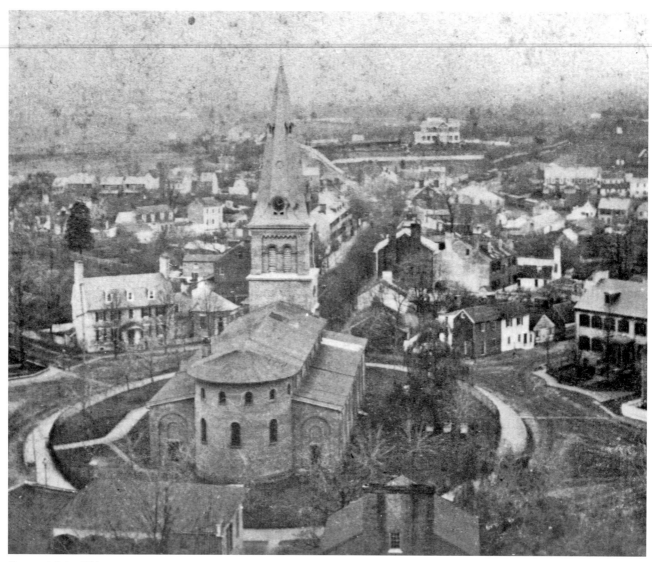

The exact date of this photograph is not known, although the year was probably 1866 or 1867. The exact time was 11:10 a.m., according to the city's new clock in St. Anne's new steeple. Judge William H. Tuck's impressive home looms in the distance, out West Street. Courtesy of the Maryland State Archives, MSA SC 1890-1733.

distant states."[280] The old City Hall and Engine House on Main Street was sold to William T. Iglehart in September 1868 for $2,515.[281]

There were a number of other changes in the city after the war. The city government made arrangements with the vestry of St. Anne's Church for a town clock to be placed in the new steeple, and contributed $50 to its purchase. In 1869, city employee Sammett Evans was paid $50 a year "for minding the town clock."[282] Baseball became a popular pastime for local men and boys who had seen northern soldiers play the game. The Annapolis Base Ball Club was organized in 1865. In 1867, the Junior Severn Club lost to the Peabody Club of Baltimore 33 to 13 in a game on the St. John's campus, but they served the winners dinner in the club's quarters.[283] In a mood of temperance, in 1866, the city's colleges joined with the mayor and aldermen in supporting legislation that prohibited sale of liquor to students at St. John's and to midshipmen, present or future, even if over twenty-one years of age. An amendment the next year extended the law to include seamen and marines.[284]

In 1862 a group of Annapolis African Americans formed the African Methodist Epis-

What appears to be a dusting of snow highlights the ruts in West Street after the war. From this angle St. Anne's steeple and the State House dome are almost in line, challenging the viewer to determine just where the photographer stood. Courtesy of the Maryland State Archives, MSA SC 1890-3214.

copal Union Bethel Church of Annapolis under the leadership of the Reverend John F. Lane. Allied with the historic A.M.E. movement in Philadelphia and Baltimore, this congregation stood separate from the predominantly white Salem Methodist Church on State Circle and the black Asbury Methodist Episcopal Church on West Street. Reverend Lane and his parishioners, including Marcellus Hall, William H. Dorsey, Robert Davis, Mary A. Johnson, and Mary Malone, met first at the Hall home on Duke of Gloucester Street. A year later, the congregation bought a lot on Franklin Street from the Smith family, heirs of Charity Folks, and built a small frame church they named Macedonia A.M.E. Church. The congregation was large enough by the early 1870s to consider construction of a more imposing meeting house. They moved Macedonia Church out to Parole, where it became a mission church, later Mt. Olive A.M.E. Church. The cornerstone of the new brick church on Franklin Street was laid on 27 September 1874 with ceremonies attended by A.M.E. dignitaries from Baltimore, members of local African-American charitable, fraternal, and military organizations, and a brass band and drum corps, which led a procession through

town prior to the services. The church was completed a year or so later and named Mt. Moriah.[285]

During the war a group of about one hundred white Methodists left the recently completed Salem Church to form their own congregation. Whether this split reflected the country's dilemma or was simply a reaction to the elaborate new building on State Circle, with its rented pews, is not clear. Most likely the schism resulted from "basic differences" that manifested themselves in the style of meeting house chosen by each congregation. Trustees of the new church bought a lot at the northeast corner of Maryland Avenue and Prince George Street and built the simple, one-story Wesley Chapel, which was dedicated on 8 July 1871. The two Methodist congregations became known as First Church and Wesley Chapel.[286]

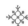

Aside from the emancipation of Maryland slaves in 1864, the most important effect of the Civil War era on the city's African-American population may have been the creation of schools for black children and adults. Although the state constitution of 1864 authorized a statewide system of public education, and legislation the following year directed county school commissioners to use a portion of the taxes paid by black property owners to establish schools for black children, the first black schools in Annapolis and Anne Arundel County were established by private effort with private money. With the permission of Secretary of War Edwin Stanton, the barracks at Camp Parole and St. John's College provided construction materials for several county African-American schools, built by volunteers in each neighborhood. Most of the teachers for these early schools were men and women from the North, usually white, who were hired and paid by charitable organizations such as the Baltimore Association for the Moral and Educational Improvement of the Colored People. While it did not actually build schools in Anne Arundel County, the federal Bureau of Refugees, Freedmen, and Abandoned Lands, commonly called the Freedman's Bureau, encouraged local participation in building and furnishing the schools and helped school trustees arrange for teachers. Freedman's Bureau agent Major William Vanderlip was based in Annapolis from 1865 until at least 1868, and his reports to his superiors give important clues to the development of the Annapolis schools.[287]

In Annapolis, the black school movement began in June 1865 with the approval by the city government of a request from Asbury Methodist Episcopal Church for permission to establish a free school for colored children.[288] In October of that year, Stanton School enrolled its first students.[289] Existing records do not make clear an association between Asbury's request and the organization of Stanton, but given the timing, the proximity of the two buildings, and the influence of Asbury's congregation in the black community, some connection is likely. Over the summer of 1865, as the army camps and hospitals in the city were being dismantled, African-American residents carted away enough lumber from the barracks on the St. John's College green to build a school.[290] The first trustees of the school, William Butler, Charles Shorter, and John Maynard, contracted to buy a lot on Washington Street from an heir of Nicholas Brewer, Sr., and it was on that lot that the frame sixty-by-seventy-foot school building was erected. The first year, 98 students attended Stanton School; in 1866, the number rose to 107. Stanton also offered a night school for students over sixteen, of whom there were 63 in 1868.[291] During the first years, at least, Stanton had both black and white teachers, but the trustees preferred black teachers and the Freedman's Bureau tried to accommodate them.[292]

Stanton School was not the only school for black children in the Annapolis area during the first postwar years, when outside financial support was available. Both Asbury and Macedonia Churches opened Sunday schools, which taught basic reading, writing, and arithmetic as well as religious subjects, and which, by 1866, served two hundred pupils. St. Mary's Catholic Parish ran a grammar school, known as "Colored School Number 2," from at least 1866. By 1871, the School Sisters of Notre Dame were teaching classes in a building on Chestnut (now Newman) Street.[293] In 1868 the Grand United Order of Galilean Fishermen, a secret African-American society organized in Baltimore in 1856, opened a private school for black children at 91 East Street that continued into the 1890s.[294] In Parole, the "Little Red School House" near Old Solomon's Island Road was probably another "barracks school" and served the children of the new Parole community until the mid-1870s.[295]

In the early years, students and teachers at black schools were abused verbally and sometimes physically by whites who feared the effects of an educated African-American population. In Annapolis, Daniel Hale Williams, who later became a world-renowned physician, was jeered and threatened by whites as he and his friend Hutchins Bishop walked to Stanton School from the Bishop home on Church Circle.[296] In June 1867, "a crazy white man" set a small fire at Stanton School, but Major Vanderlip reported that the white people had been "generally friendly to the school" and that the "prejudice" was "disappearing."[297]

Stanton School received teachers and funding from the Baltimore Association from 1865 until about 1870, but some local financial support was also necessary. By 1868 the trustees had amassed a considerable debt, including the $900 due for the school lot. Through subscriptions gathered at fundraising events, the lot debt was paid off by January 1869 and the title transferred to trustees William H. Butler, William Dorsey, William Bishop, Moses Lake, Charles Shorter, Charles Johnson, and Noble Watkins with the requirement that the land always be used as "the site of a school for the colored children of the City of Annapolis and its vicinity."[298] It must have been clear to the trustees that private donations, whether from organized charities or the pockets of local residents, could not be depended upon to sustain the school over the long haul. Apparently sensing the impending demise of the Baltimore Association and well aware of state laws mandating county support for black schools, William Bishop went before the county Board of Education in March 1869 with the request that they "appropriate funds for the operation of the Stanton School." And, in June, after four years of dragging their feet on the state's demand that taxes collected from black residents be used to fund black schools, the county Board of School Commissioners paid Stanton School $83 from the black taxpayers fund. The amount was insignificant; the precedent saved the school. By 1872, when support from out-of-town charities had ceased and the Freedman's Bureau people had gone home, only two black public schools remained open in Anne Arundel County. One of them was Stanton.[299]

The 1870 federal census shows a population increase in Annapolis of almost 30 percent over 1860 figures. Slightly fewer than one-quarter of the county's citizens lived in Annapolis. Most of this growth is attributable to the marked (43%) increase in the city's black population as former slaves left outlying plantations to live as free men and women in an urban environment that was more diverse and probably more welcoming than the county's. Employment opportunities for African-American men had broadened since 1860, with free men now working in crafts such as brickmaking and shoemaking and in commercial food service as butchers and cooks. (There were two men in town in 1870, one white, one black,

who gave their occupation as "French cook." The white cook was born in France, the black one in Maryland.) As in 1860, almost all of the town's barbers were black. Women of both races were restricted to occupations similar to those in 1860, with most of them still shown as boardinghouse keepers, domestics, housekeepers, or "at home." Whites accounted for 68 percent of the city's total population of 5,744, and blacks 32 percent. Almost 30 percent of the total were children between the ages of five and eighteen.

Of the 3,066 males counted in town, more than 660 (22%) resided on the grounds of the Naval Academy, St. John's College, and St. Mary's Seminary. Most of these men had been born in other states, and a number of the St. Mary's priests and seminarians were from Germany. Annapolis had a total foreign-born population of 506, more than half of the county's total of foreign-born men, women, and children.[300]

New to Annapolis in 1870 but not counted with the colleges were forty-four men born outside Maryland, ten of them blacks or mulattos, and most of them from New York or Pennsylvania. Of these forty-four, half had married in Anne Arundel County between 1862 and 1869, and at least nineteen had definitely served in the military during the war. Whether they had been stationed in Annapolis with the guard units or had recovered in one of the city's hospitals, these men found reasons to remain in town after the war. Among these forty-four who stayed — John Beall, Waldo Bigelow, Alfred Britton, William Finkle, Samuel Jickling, George Quaid, Matthew Strohm, for instance — were the progenitors of several generations of Annapolis families. Their presence helped to mask, at least statistically, the void left by the local men who did not return from the war, either because of death or because they, too, married and settled elsewhere.[301]

It seems that, in general, Annapolitans understood their commonality, no matter the divisions the war had imposed upon them. After several years' domination by Union party supporters, overreaction may have prompted city voters to elect Democratic candidates to all city offices in the first municipal election after ratification of the state's 1867 Constitution. The new constitution had deleted the loyalty oath required by the 1864 Constitution and returned suffrage to those who had sided with the Confederates. Among the newly elected city officers was Recorder Samuel Thomas McCullough, former Second Lieutenant, Second Maryland Infantry, CSA.[302] Southern sympathizers joined their Union colleagues in establishing new businesses in town.[303] Veterans who had fought for the South found employment in state government, and former Confederate naval officer Hunter Davidson was named the first commander of the State Oyster Police Force in 1868.[304]

According to Elihu Riley, Confederate and Union veterans in Annapolis "fraternized like brave men." His words almost certainly referred to the country's first local celebration of Decoration Day held jointly by Union and Confederate veterans. On 29 May 1886, men from both sides paraded together through Annapolis and, together, laid flowers on the graves of their fallen comrades.[305] And in this city they lay side by side in death. Of 118 Civil War veterans buried in St. Anne's, Cedar Bluff, and Locust Grove cemeteries, fifty-eight fought with the Confederacy and sixty with the Union.[306]

Great Expectations 1870 to 1908

For more than a decade after the Civil War, Annapolis struggled to grow accustomed to the cataclysm that had swept over it — the population increase, the freedom of all its black residents, the awareness of itself in the national consciousness and, conversely, its own citizens' awareness of the outside world. Much like a nesting mallard who fluffs her feathers out over her eggs, so the city fathers moved to accommodate these changes. And, like the mother duck, the city hoped its actions would result in new life and prosperity. To support and sustain that prosperity, the municipal government would need to come to grips with its responsibility for the nest itself, the infrastructure of the city. The challenges were almost overwhelming.

Amendments to the city charter passed by the General Assembly in the early 1870s codified the reality of development along outer West Street by extending the city limits to a line drawn from the head of College Creek to Old Woman Cove on Spa Creek, probably along the defensive embankments thrown up during the summer of 1864. At the same time that municipal control spread westward, it shrank to the north when the Naval Academy purchased four acres of Lockwoodville west of Tabernacle Street (now College Avenue). The city claimed jurisdiction over its harbor from the end of Duke of Gloucester Street to Sycamore Point at the east side of the mouth of Spa Creek and from there across the Severn in a narrow triangle to Fort Madison, but it ceded to the federal government the water around the academy for a hundred feet or more off the shoreline, thus setting the stage for more seaward expansion of the yard.[1]

Adoption of the Fifteenth Amendment to the U.S. Constitution in 1870 secured to the country's African-American men the right to vote, even in states, like Maryland, that did not ratify it.[2] The November 1870 congressional elections presented the first opportunity in fifty years for black men in Annapolis to exercise their franchise. To accommodate what they estimated to be 1,500 eligible voters in Annapolis, the City Council divided the city into three wards and assigned each a convenient polling place.[3] The First Ward extended from the Naval Academy to the city dock at Randall Street and west to State Circle and St. John's Street; the Second Ward took in the dock and the southeastern part of the city to South Street; the Third Ward encompassed the land from St. John's College to Church Circle and west of South Street.[4] Candidates of the new Republican party, officially formed in Maryland in 1867, took Anne Arundel County by a small majority with the support of newly registered black voters.[5] Black voters were an important component of the party in Annapolis. The large number of African Americans in the Third Ward (and later in the Fourth Ward) determined Republican success in city elections, and a modern historian notes that in Annapolis "the party seems to have been more responsive to blacks" and given them a "stronger voice in party affairs" than was the case elsewhere in Maryland.[6]

African-American men in Annapolis also could vote for city officers in the municipal

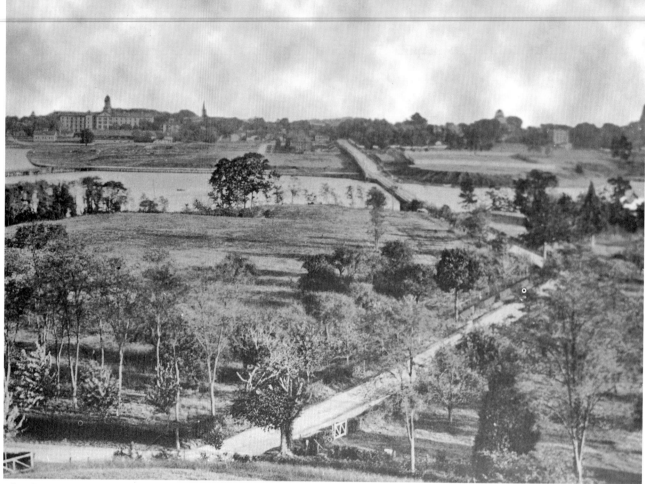

After the Civil War, Naval Academy superintendent David Dixon Porter built a large anchor-shaped naval hospital on Strawberry Hill at the end of King George Street, overlooking College Creek. Used only briefly, it became known as Porter's Folly and was torn down in 1907. This 1890 photograph taken from the hospital site shows the academy on the left, St. John's College to the right of the bridge, and the State House at far right. Photograph by Henry Schaefer. Courtesy of Historic Annapolis Foundation.

election the following April 1871. Poll books from this election are available for Wards 1 and 2, but only in Ward 2 did the election judges note the race of the voter. There, of the 320 men who registered, 79 were identified with a "C," meaning "colored." Perhaps it is not surprising that, from the position of their names on the roster, it appears blacks came to the polls in small groups. When the polls closed and the ballots were counted, Democratic candidates had won in Ward 2 by an average of ten votes each.[7] Their majority did not hold for the entire town, however, and Republicans, led by Mayor James Munroe, took control of the city government. Only City Counselor William H. Tuck and Alderman Dennis Claude Handy represented the Democrats. The contest was close in all wards, with just a handful of votes determining the winners (Counselor Tuck won by only a single vote citywide). Luther Colton, editor of the *Maryland Republican* and advocate of the Conservative Democrats, which he unabashedly labeled the "white man's party," attributed the Republican victory to African-American voters.[8]

Local Republican leaders obviously saw it that way, too, and in the next municipal election (1873), they added an African American, William H. Butler, to their slate of city candidates. Butler, a forty-three-year-old carpenter who lived next door to the City Council chambers on Duke of Gloucester Street, was a major landowner in the city, with $14,000

William H. Butler and His Contemporaries

William Henry Butler, Sr., the first African American to be elected an alderman of the city of Annapolis, in 1873, was born into slavery in Anne Arundel County. Emancipated at the age of twenty-one, he came to Annapolis about midcentury and was taken in and nurtured by a community of free black families. Butler's life in that community became closely interwoven with three families in particular, the Bishops, Prices, and Shorters. He married Sarah, niece of master carpenter Charles Shorter, builder of the first Asbury Methodist Church. Butler was said to be a quick study, and he became a successful businessman, with a large brick house on Duke of Gloucester Street.

Butler's friends the Price family trace their origins to former slave Smith Price, who married Nova Scotian Ann Shorter, sister of Charles. They lived just outside of the city gate in the second block of West Street. The Prices had a long association with the history of Methodism in Annapolis, and Smith Price donated land to establish the city's first African Methodist Episcopal Church in 1803.

The Bishop family, descended from British immigrant William and his enslaved wife Jane Ennis Bishop, made a considerable fortune during the nineteenth century carting, sweeping chimneys, and selling wood and coal. They lived in a handsome brick house on Church Circle at the corner of South Street. Dr. William Bishop, Jr., was one of the first physicians of the city's Emergency Hospital, the predecessor of today's Anne Arundel Medical Center.

The impact of these men, their extended families, and other free blacks within the nineteenth- and twentieth-century African-American community was profound. William H. Butler, Sr., and his contemporaries were not only influential in their own time; their legacy lived on well into the twentieth century in their children and their protégés: Wiley H. Bates, alderman, merchant, realtor, and philanthropist; James Albert Adams, alderman and undertaker; William Howard, attorney-at-law; and William H. Butler, Jr., alderman and school teacher. Each generation was measured by the accomplishments of those who had gone before them. Their influence is felt today.

JANICE HAYES-WILLIAMS
Historian

worth of real property in 1870. He had prospered during the Civil War and bought his imposing townhouse in 1863.[9] Butler garnered fewer votes than any other Republican aldermanic candidate, but in his party's landslide, he out polled even the leading Democratic challenger to win a seat on the City Council. William H. Butler was the first African American to gain elective office in Maryland.[10]

Republicans lost control of the city government in the 1875 election. With just over a thousand votes tallied, Democratic majorities ranged from 43 to 114 votes. It was, said the *Maryland Republican*, a "rebound against Republican misrule." Late in the day, when some Republicans in the Third Ward broke party ranks and cast their ballot for Democratic candidates, fighting broke out. The violence seems to have been more along party lines than racial ones, and both whites and African Americans were badly injured. A black teenager, who even the rabid Democrat Luther Colton admitted in his newspaper was innocent of participation, was shot and killed. Baltimore newspapers and the *New York Times* carried

reports of the fracas.[11] The next year, Democrats in power modified the city charter to add a sixth alderman and have two men elected by the residents of each ward. It took more than a decade for any one ward to gather enough Republicans to overwhelm the Democrats, but from 1887 to 1907, residents of the Third Ward consistently elected a Republican African American as one of their two aldermen.[12]

African Americans were exercising their freedom of expression in other ways as well. First on their agenda seemed to be the establishment of neighborhood churches to serve as a base for religious worship, education, and social activities. Asbury Methodist Episcopal Church and Mt. Moriah A.M.E. Church continued to serve black Methodist congregations. African-American Baptists bought land on Northwest Street, where they built Zion Baptist Colored Church in 1876.[13] Within a decade, Zion Church was sold to St. Anne's Parish to house their mission church, St. Philip's, which had evolved from a school for African-American girls begun by the ladies of St. Anne's in 1871. The Maryland Colored Baptist Congregation, possibly including the previous Zion Church members, bought a lot on Market Street from William H. Butler and built First Baptist Church in 1885.[14] Outside the then city limits, in the community that grew up on the site of the Civil War Camp Parole and continues to this day, African Americans bought land for Mt. Olive A.M.E. Church in 1873 and a year later moved the wooden Macedonia Church from Franklin Street.[15]

Black Annapolitans were not the only ones working toward a church of their own in this postwar decade. Twenty local German families organized a German-language Sunday School in 1874 with the assistance of a Lutheran circuit rider. Within a year, they had incorporated themselves as St. Martin's German Evangelical Lutheran Church and begun construction of a church on Francis Street.[16] Immigrants from the various Germanic states were not a new phenomenon in the city, but the advent of the Naval Academy band in 1853 increased their numbers. Most of the fourteen musicians living on the academy grounds in 1860 were natives of Germany or its associated states. After the Civil War, they and their later colleagues settled with their families in town, forming the nucleus of an active German-speaking population.[17] The 1870 census designated 506 Annapolis residents as born in a foreign country, and almost 30 percent of these foreigners were natives of Germanic states. Of seventy-six adult males who gave their birthplace as Germany, a third were skilled craftsmen: cabinetmakers, shoemakers, jewelers, tailors, carpenters. Another 20 percent made their living supplying food and beverages, with confectioners leading the list and bakers, butchers, brewers, and restaurateurs close behind. The eight German musicians living in town outnumbered the German merchants and storekeepers and the few who gave their occupations as fisherman or sailor. Of the rest, only five German men were grouped under the generic rubric "laborer"; the others have specific occupations, from math professor to barn keeper. A large number of these men headed young families, and usually their wives and children were listed as Maryland natives.[18]

It is impossible now to determine the religious affiliation of most of these German immigrants. Some, like Gottlieb Feldmeyer, were Methodists.[19] Others, such as the Himmelheber, Frank, Gessner, and Zimmermann families, became parishioners of St. Mary's, and at least one family, the Diefels, joined St. Anne's.[20] There were enough Lutherans, however, to sustain St. Martin's Church, where services were held in German until 1916.[21]

Reaching out to white residents around the dock and just outside the academy wall, St. Anne's built a mission chapel in the late 1870s at the corner of East and Prince George Streets which would be "hospitable to people in town who might not be at home in the assigned pews of the big church." In practice that meant free seating instead of pew space

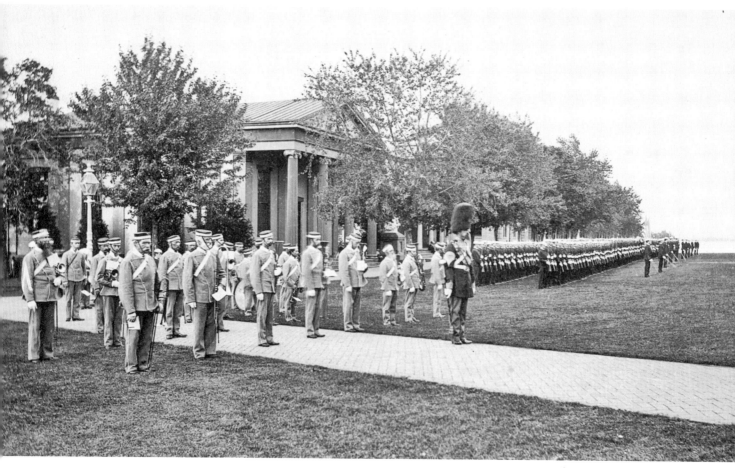

purchased from the vestry.[22] The Presbyterians followed the Episcopalians' example in 1889 with an African-American mission Sunday School "on the outskirts of the City" at West and Jefferson Streets.[23] Staffing the West End Chapel eventually became too much for the small downtown congregation, and the property was sold at the turn of the century for residences.[24]

Annapolis acquired its first platted suburb in 1868 when a group of local businessmen, chartered that year as the Mutual Building Association of Annapolis, subdivided a third of the peninsula across Spa Creek into small lots. Farm and woodlands for the previous two hundred years, the northern tip of the land between Spa and Back Creeks would now grow houses. The developers offered prospective homeowners the opportunity to finance a lot, or a lot and house, with a mortgage loan payable in affordable installments over a period of years.[25]

Surveyor John Duvall subdivided the Mutual Building Association's 101.25 acres into a grid of 256 lots in September 1868. Richard Swann's farm at the tip of Horn Point, recently the site of the hospital for contagious Union troops, was not included; and Swann, who ran the mess hall at the academy, continued to supply its tables with vegetables, fruit, and eggs.[26] Most of the two hundred acres on the south side of what was then First Street (now Sixth Street) had been sold to General Henry Lockwood in 1867, and Lockwood also

The Naval Academy bandsmen might be older than the midshipmen, and have mustaches, but they stood just as straight in this view, in 1877, with drum major Andrew Denver ("Old Denver") out in front in his impressive roped bearskin hat. Courtesy of the Special Collections and Archives Department, Nimitz Library, U.S. Naval Academy.

continued to farm.[27] Already in place along the subdivision's Spa Creek waterfront were a couple of houses and a marine railway. Wilhelm Heller, a recent German immigrant and one of the founders of St. Martin's Church, ran a marine railway on the southern curve of Sycamore Point for almost fifty years.[28]

To encourage development of their new village of Horn Point, the Mutual Building Association obtained permission from the state legislature in 1870 to build a toll bridge over Spa Creek. The wooden, fixed-span bridge crossed from the foot of Duke of Gloucester to Third Street (now Fourth); tolls were fixed at 5¢ for each foot passenger, horse, or mule and 3¢ per sheep, calf, or hog.[29] Although their lots were relatively small, most only a third of an acre, early residents kept chickens and livestock and tended large gardens.[30]

Not until the mid-1880s did lot sales in Horn Point take off, but once they did, the village developed steadily. Impetus for growth began with operation of the Annapolis Glass Company on Severn Avenue in 1886. Chartered in 1885 as a stock company to manufacture glass, china, and pottery, the Annapolis glassworks took advantage of a deposit of fine glass sand in the banks of the upper Severn, transported to the Spa Creek site by barge. Skilled glass blowers and other employees moved to Horn Point, and the company built a row of brick houses for them off Sixth Street (now First Street) often called Murphy's Row, for Charles J. Murphy, one of the company's founders. Other workmen boarded in private homes, sometimes paying for their accommodations with glass.[31]

Beginning with the Fourth of July 1887, summer excursionists from the city wended through the village on their way to the new, hugely popular resort at Bay Ridge on Tolly Point. The county, responding to pleas from Annapolitans who wanted to reach the fun on foot or in their own carriages, built bridges across Back Creek and Lake Ogleton and laid an oyster-shelled road along the shoreline. The Spa Creek bridge had to be repaired to handle the traffic. Bay Shore Drive was a boon to local livery stables and hack drivers, but the road needed repairs after every high tide or storm. It passed into history as soon as the resort closed in 1903.[32]

By 1890, the now-thriving village of Horn Point had a volunteer fire department (1886), a Baptist church (1889), a Methodist Sunday school (1887), an African Methodist Episcopal congregation (1890), and an elementary school for white children (1886), which met first in a home at the corner of First Street and Severn Avenue and a year later in a two-room schoolhouse on Third Street.[33] It also had an official name. According to Charles Murphy, the glassworks generated enough mail that he and others felt the need for a post office, so he went over to Washington and spoke with the assistant postmaster. When asked what the new postal destination should be called, Murphy chose the name of his native town in Maine: Eastport. The Eastport Post Office set up shop at "No. 7 Brick Row," one of Murphy's houses, in 1888.[34]

The Annapolis plate in George M. Hopkins's 1878 *Atlas of Anne Arundel County* shows clearly the link between employment and residential development in Annapolis. Older buildings still clustered near the colonial town center, along streets in the Church Street/West Street corridor and near the dock, but by 1878 there was dense development just outside the Naval Academy walls to the northwest and near the railroad on the west. Housing infill crept along the streets of the colonial mansion blocks on Maryland Avenue, King George and Prince George Streets, but the area remained bucolic.[35] There were other groupings of lots within the boundaries of the 1718 plat that lay, undeveloped, in the hands of a few individuals. Outside the old town, behind buildings facing West Street, land own-

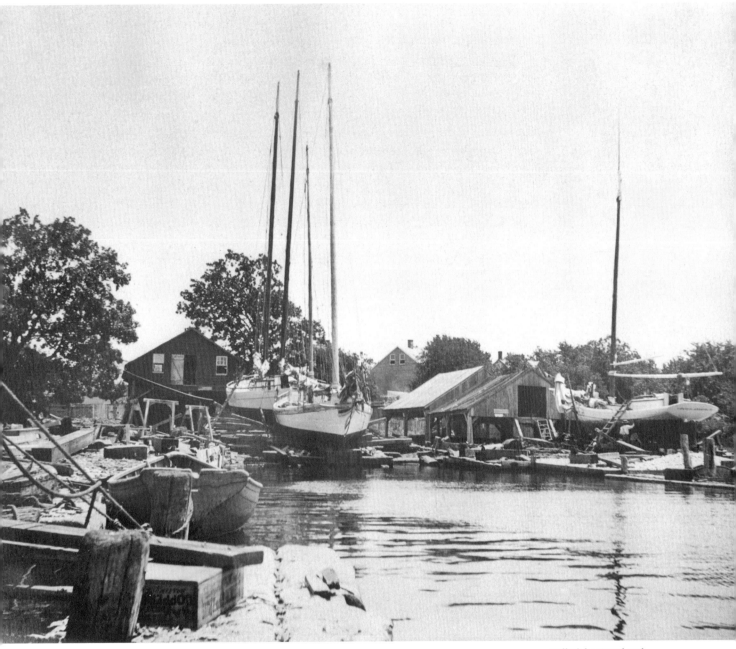

Heller's boatyard and marine railway on Sycamore Point, at the mouth of Spa Creek in Eastport, was one of the first to welcome yachtsmen exploring the Bay. Photograph by George Barrie, c. 1898. Courtesy of The Mariners' Museum, Newport News, Va.

ers such as Judge William Hallam Tuck, James Murray, and Nicholas Brewer retained control of property that would be essential for further expansion of the city.[36]

Much more informative than the 1860 Martenet map of Annapolis, the Hopkins map depicts in elaborate detail the town just prior to 1878. One of the most striking differences from 1860 is the number of oyster houses — fourteen — along the waterfront and even, in one case, in the water itself, presumably on a pile of discarded oyster shells. These "houses," where oysters were shucked and packed, either raw or steamed, for shipping as far west as California and east to Europe, testify to the importance of the oyster industry on the Bay in the decades after the Civil War.[37] In the nine seasons from 1875 to 1900 for which there

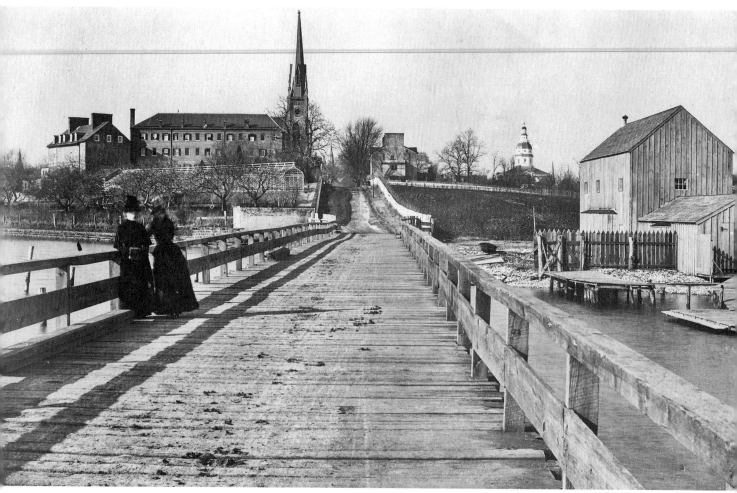

The first bridge over Spa Creek was a wooden span from the end of Duke of Gloucester Street to what is now Fourth Street in Eastport. The Severn Boat Club replaced an oyster packing house on the Annapolis side in the late 1880s. Courtesy of the Maryland State Archives, MSA SC 252-146.

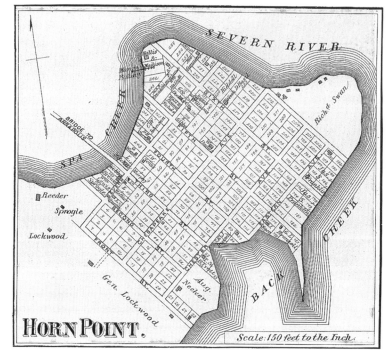

Slow to develop at first, the new village of Horn Point boasted fewer than thirty buildings in 1878. Inset from G. M. Hopkins's Atlas of Anne Arundel County. Courtesy of the Geography and Map Division, Library of Congress.

are statistics, Maryland tongers and dredgers harvested an average of more than nine million bushels of oysters annually, fifteen million in the all-time peak season of 1884–1885.[38] That year there were 350 shuckers working in Annapolis packing houses and making 15¢ for each gallon of shucked raw oysters.[39] Men, women, and children twelve and over, black and white, all found work in oyster houses doing jobs that were wet, dirty, seasonal, and not very well paid. But their lives were at least safe. The men and boys who worked the boats were "exposed to cold and hardship without restraint or protection of law," and every year some of them died.[40]

In spite of all his care and effort, George Hopkins's map was out of date as soon as it hit the streets; a building boom was under way, and the landscape was already changing. The *Maryland Republican* gleefully recorded the boom and attributed it to cheap, readily available building materials and labor.[41] More likely it was the increasing population's demand for houses coupled with newly platted lots on which to build them. When former state senator and prominent businessman George Wells defaulted on a mortgage secured by his Annapolis property in 1877, the court-appointed trustee, Alexander Randall, lobbied the city government to extend South Street to Cathedral Street and Conduit Street to Spa Creek so that Wells's land could be subdivided. The city complied.[42] The aldermen also approved a new street — Union Street — to link Conduit and Market and brought Cathedral up the hill to Conduit, providing easy access to the new development.[43] As with the extensions of Holland and Randall Streets, being opened during the same period across town, when the city cut streets through private property, it had to compensate the owners.[44] And sometimes, as had been the case with East Street earlier, that meant paying to move structures built unwittingly in a future street bed. Probably the most expensive house relocation involved a lovely eighteenth-century brick dwelling on Duke of Gloucester Street that encroached upon the street bed of the now-extended Conduit Street (see illustration on p. 214). Residents of the new neighborhood to the south complained that the house created a bottleneck at the intersection. It took ten years for the city to negotiate a deal with the two elderly sisters who lived there: if the city paid them a lifetime $500 annuity and took care of the necessary construction costs, it could move the easternmost side of the house out of the roadway and place it at the rear of the remaining structure. Conduit Street property owners paid an additional tax in 1899 to help cover the cost. The house still faces Duke of Gloucester today, but as a dwelling of three bays instead of five.[45]

Even with the inconveniently narrow intersection at Conduit Street and Duke of Gloucester, lot sales of the Wells property went well. Within a decade or so, new houses lined Charles, Conduit, Cathedral, and upper Market Streets. William H. Butler purchased several of the Market Street lots, and he and other African Americans, such as Harry Valentine, built houses that they rented to both white and black families.[46] Elihu Riley attributed the building boom to the "liberal spirit of the Workingman's Building and Loan Association," organized in May 1877, which made homeownership possible for those of modest income.[47] Excavations on the extension of Conduit Street revealed skeletons and coffins, possibly from an old, forgotten burial ground.[48]

Development was taking place on the other side of town as well. Former academy instructor and Confederate commander James Iredell Waddell returned with his wife to Annapolis in 1875 and acquired a corner of the Randall block at Prince George Street and College Avenue. Waddell, celebrated by Southerners for his aggressive pursuit of Union shipping in the Pacific Ocean as captain of the CSS *Shenandoah*, had spent a decade in England after the war. When he and Anne Iglehart Waddell came back to her native city,

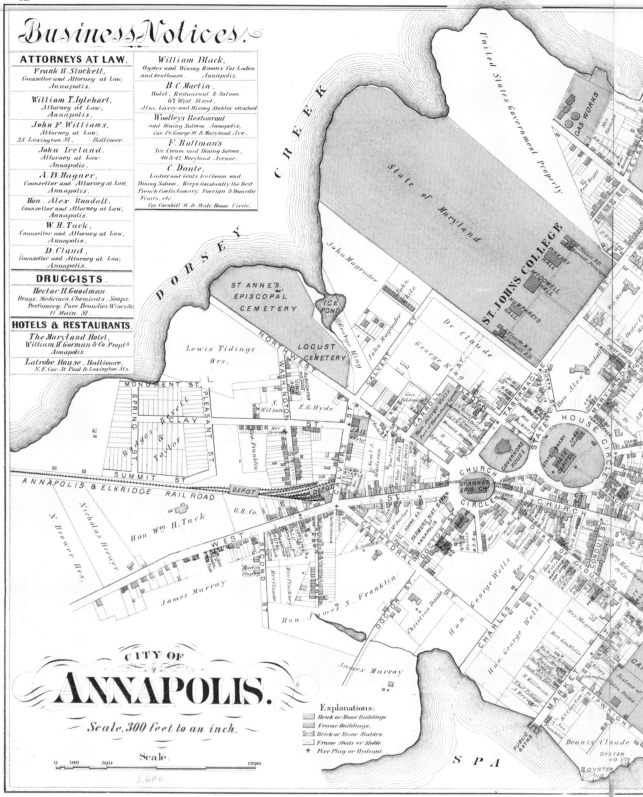

Business Notices.

ATTORNEYS AT LAW.

Frank H. Stockett,
Counsellor and Attorney at Law;
Annapolis.

William T. Iglehart,
Attorney at Law,
Annapolis.

John F. Williams,
Attorney at Law,
35 Lexington St. Baltimore.

John Ireland,
Attorney at Law,
Annapolis.

A. B. Hagner,
Counsellor and Attorney at Law,
Annapolis.

Hon. Alex. Randall,
Counsellor and Attorney at Law,
Annapolis.

W. H. Tuck,
Counsellor and Attorney at Law,
Annapolis.

D. Claud,
Counsellor and Attorney at Law,
Annapolis.

DRUGGISTS.

Hector H. Goodman,
Drugs, Medicines, Chemicals, Soaps,
Perfumery, Pure Brandies, Wines &c.
11 Main St.

HOTELS & RESTAURANTS.

The Maryland Hotel,
William H. Gorman & Co. Prop'ts
Annapolis.

Latrobe House, Baltimore,
N. E. Cor. St. Paul & Lexington Sts.

William Black,
Oyster and Dining Rooms for Ladies
and Gentlemen. Annapolis.

B. C. Martin,
Hotel, Restaurant & Saloon
67 West Street.
Also, Livery and Hiring Stables attached

Woolleys Restaurant
and Dining Saloon Annapolis.
Cor. Pr. George St & Maryland Ave.

F. Rullman's
Ice Cream and Dining Saloon,
40 & 42 Maryland Avenue.

C. Daute,
Ladies and Gents Ice Cream and
Dining Saloon. Keeps Constantly the Best
French Confectionery. Foreign & Domestic
Fruits, etc.
Cor. Cornhill St. & State House Circle.

CITY OF
ANNAPOLIS.

Scale, 300 feet to an inch.

Scale.

Explanations:
Brick or Stone Buildings.
Frame Buildings.
Brick or Stone Stables.
Frame Sheds or Stable.
+ Fire Plug or Hydrant.

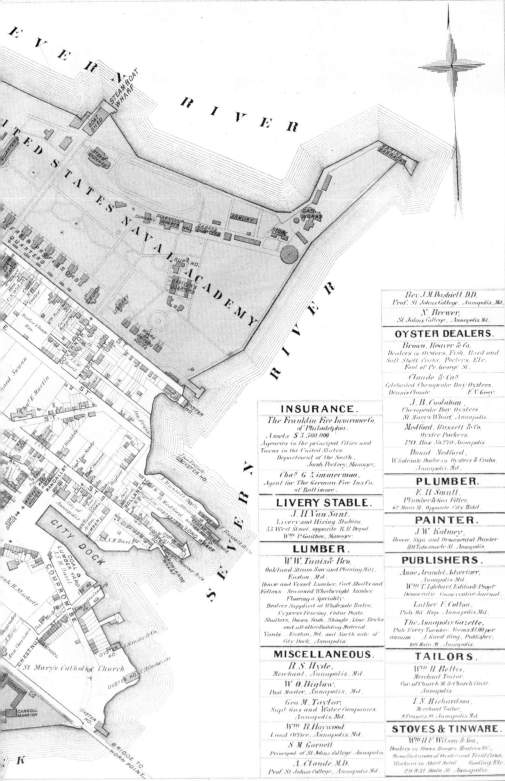

13

RIVER

STEAMBOAT WHARF

BOAT SHED

STEAM ENGINE HO.

UNITED STATES NAVAL ACADEMY

GUNNERY DEPART. HALL

CADETS QUARTERS

ARMORY

STORE

GAS WORKS

SUPT. HO.

OFFICERS QUARTERS

RIVER

RIVER

SEVERN

CITY DOCK

COMPROMISE

COAL YARD

LUMBER YARD

CHESTNUT

St. Mary's Catholic Church

OYSTER HO.

CARROLL MANSION

BRIDGE TO EASTPORT

Rev. J. M. Dashiell, D.D.,
Prof. St. Johns College, Annapolis, Md.

N. Brewer,
St. Johns College, Annapolis, Md.

OYSTER DEALERS.

Brown, Heaver & Co.
Dealers in Oysters, Fish, Hard and
Soft Shell Crabs, Peelers, Etc.
Foot of Pr. George St.

Claude & Co.
Celebrated Chesapeake Bay Oysters,
Dennis Claude. F. V. Gray.

J. B. Coolahan,
Chesapeake Bay Oysters
St Marys Wharf, Annapolis.

Medford, Russell & Co.
Oyster Packers.
P.O. Box No. 250, Annapolis.

Daniel Medford,
Wholesale Dealer in Oysters & Crabs,
Annapolis, Md.

PLUMBER.

E. H. Smull,
Plumber & Gas Fitter,
62 Main St. Opposite City Hotel.

PAINTER.

J. W. Kalmey,
House, Sign and Ornamental Painter
80 Tabernacle St. Annapolis.

PUBLISHERS.

Anne Arundel Advertiser,
Annapolis, Md.
Wm. T. Iglehart, Editor & Propr.
Democratic Conservative Journal.

Luther F. Colton,
Pub. Md. Rep. Annapolis, Md.

The Annapolis Gazette,
Pub. Every Tuesday. Terms $2.00 per
annum. J. Guest King, Publisher,
109 Main St., Annapolis.

TAILORS.

Wm. H. Bellis,
Merchant Tailor,
Cor. of Church St. & Church Circle,
Annapolis.

I. N. Richardson,
Merchant Tailor,
2 Francis St. Annapolis, Md.

STOVES & TINWARE.

Wm. H. F. Wilson & Son,
Dealers in Stoves, Ranges, Heaters &c.,
Manufacturers of Oyster and Fruit Cans,
Workers in Sheet Metal Roofing Etc.
29 & 31 Main St. Annapolis.

INSURANCE.

The Franklin Fire Insurance Co.
of Philadelphia.
Assets $3,500,000
Agencies in the principal Cities and
Towns in the United States.
Department of the South,
Jacob Peetrey, Manager.

Chas. G. Zimmerman,
Agent for The German Fire Ins. Co.
of Baltimore.

LIVERY STABLE.

J. H. Van Sant,
Livery and Hiring Stables,
55 West Street, opposite R. R. Depot
Wm. P. Gaither, Manager.

LUMBER.

W. W. Tuniss & Bro.
Oakland Steam Saw and Planing Mill,
Easton, Md.
House and Vessel Lumber, Cart Shafts and
Fellows. Seasoned Wheelwright Lumber.
Flooring a Specialty.
Dealers Supplied at Wholesale Rates.
Cypress Fencing, Cedar Posts,
Shutters, Doors, Sash, Shingle, Lime, Bricks
and all other Building Material
Yards. Easton, Md. and North side of
City Dock, Annapolis.

MISCELLANEOUS.

R. S. Hyde,
Merchant, Annapolis, Md.

W. O. Biglow,
Post Master, Annapolis, Md.

Geo. M. Taylor,
Supt. Gas and Water Companies,
Annapolis, Md.

Wm. H. Haywood,
Land Office, Annapolis, Md.

S. M. Garnett,
Principal of St Johns College, Annapolis.

A. Claude, M.D.
Prof. St Johns College, Annapolis, Md.

Entered according to Act of Congress in the year 1878 by G. M. Hopkins in the Office of the Librarian of Congress at Washington.

In 1878, lots were being platted in the upper Clay Street area, but much of the city and its adjoining farmland remained undeveloped. Oyster packing houses line the shore of Spa Creek and one even sits in the water. G. M. Hopkins, Atlas of Anne Arundel County, Maryland. *Courtesy of the Geography and Map Division, Library of Congress.*

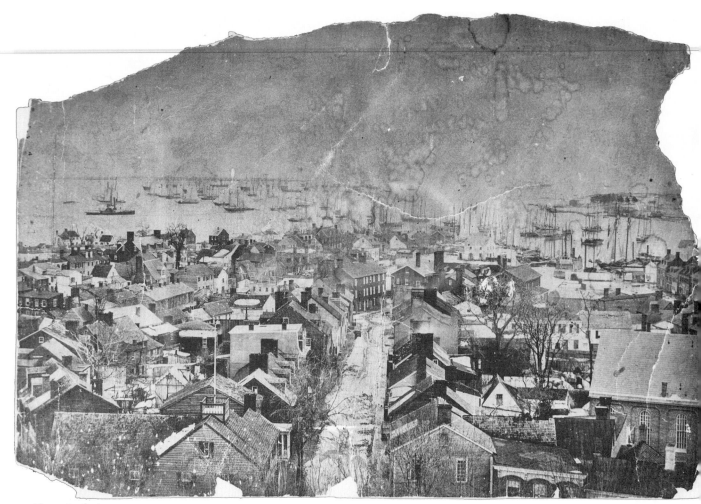

The oyster fleet crowded the harbor on this winter day, c. 1879, while commercial and residential buildings clustered around the dock in the most densely settled part of the city. Courtesy of the Maryland State Archives, MSA SC 985-277.

they brought with them plans for an impressive British-style Queen Anne home, which they built a few years later.[49] The Randalls themselves built a larger British Queen Anne–style duplex at the corner of State Circle and North Street.[50] Less grand were the fourteen tenements built by Joseph Basil at the lower end of King George Street just above its intersection with East Street.[51]

In the decade between 1870 and 1880 the city's population grew by more than 15 percent. In 1880, for the first time, the census was taken by ward, providing a look at the differences among the three divisions within the city. As might be expected, most of the workers in the seafood industry, the military, and general maritime pursuits lived in the First Ward, which had the largest number of households. The First Ward also had the largest number of foreign-born residents, amounting to just over half the city's total. The Third Ward on the other hand, had the fewest foreign born and the largest number of African Americans. A sizable number of Third Ward residents were farmers or gardeners. Employment in the Second Ward was more equally distributed among maritime, seafood, military, construction, crafts, and commerce. Across the city, construction, including building trades such as painting, plumbing, and cabinetmaking, was the third largest employment sector, following the seafood industry and the military.[52]

William M. Abbott clearly appreciated the potential of Annapolis in the mid-1880s. Abbott, a newspaper man from the Eastern Shore who had come to Annapolis fifteen years

before to work for the *Maryland Republican*, established the city's first daily newspaper in May 1884. The *Evening Capital*, he wrote, would be a "Family Paper," "independent in politics," covering the important events and issues in city, county, and state. "He who does not read a daily paper, is woefully behind the times, and if not already an old fogy will soon become one," editorialized Abbott.[53] For more than a century and a half, Annapolis had supported regular newspapers, but all of them, like the *Maryland Republican*, which was still being printed in 1884, were weeklies, occasionally published semiweekly during the legislative session. Although the daily Baltimore *Sun* included a column on Annapolis doings once or twice a week, it generally did not carry Annapolis advertising. The new *Evening Capital* would bring local news (and advertising) to local readers six days a week. There would be no old fogies in this town!

Oyster tongers routinely endured the harshest conditions on the Bay. These men were among more than a hundred working off Tolly Point one day in the winter of 1879. Frank Leslie's Illustrated Weekly, 8 February 1879. From the author's collection.

With a daily paper, Annapolitans could follow the details of city politics and society and weigh in on issues and controversies. One of the first problems addressed by editor Abbott was the poor quality of water flowing from Annapolis Water Company hydrants.[54] Although the private company had replaced its original sheet-iron and cement piping with cast-iron pipes five years earlier, heavy rains during the spring of 1884 made water from the forty city hydrants unpotable.[55] And many households relied on hydrants for drinking water. Cesspools and inadequate sewers had contaminated most of the private and public wells, and not every homeowner could afford to pipe city water inside his house.[56] For the benefit of the general public, the city had an artesian well dug at the city dock in 1887. At a depth of 201 feet, the water quantity was good, if not tasty, and the city ordered a convenient drinking cup, nickel- or porcelain-lined, to be placed at the well head.[57] Although the water company continued to make improvements to its system, the *Evening Capital* reported in 1896 that their product was "offensive and unfit for culinary use," citing as an example the eleven eels "taken from the water pipe at the foot of Hanover Street near the Marine barracks."[58] Complaints about the public water system continued into the new century, but so did outbreaks of typhoid from polluted wells. The City Council finally directed that all households connect to Annapolis Water Company mains by 1 January 1905. Landlords of rental houses could install a water source at some "central point" within one hundred feet of each dwelling in a tenement block and give tenants a "can" to carry water back to their house.[59]

Another sign of Annapolis's rise in status in the 1880s was the construction of a second railroad line from Baltimore City. When the Annapolis and Elk Ridge Railroad made its first run on Christmas day 1840, it seemed like a miracle — Baltimore in two hours instead of the better part of a day by horse or boat! But if fast was good, faster would be better, and in 1872, Mayor James Munroe bemoaned the fact that there was no "air line railroad" with a thirty-minute run to the big city.[60] Munroe got his wish fifteen years later on the morning of 9 March 1887, when the first train of the Annapolis and Baltimore Short Line Railroad

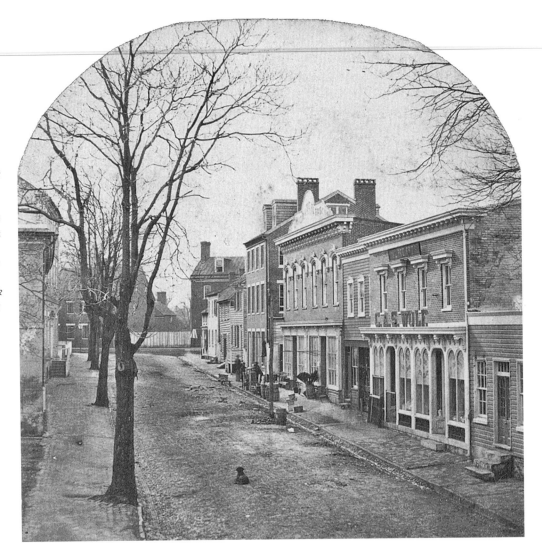

left Annapolis for Baltimore, a trip that would take only slightly more than half an hour.[61] The Short Line tracks ran from Camden Station in Baltimore straight down Broadneck Peninsula, crossed the Severn on a wooden trestle bridge, and came into town across College Creek to a new station on Bladen Street. From the beginning, the Short Line ran three round trips each weekday to Baltimore and advertised "Quick time, and no change of cars" — it truly was a short line.[62]

In fairness, Annapolis may not have been the only reason for the Short Line. The "Queen Resort of the Chesapeake" at Bay Ridge was drawing several thousand people each day during the summer, and for the first seven years most of those people came from Baltimore by Weems Line steamboats.[63] The opportunity for additional transportation was obvious, and James H. Vansant, developer of the resort and owner of an Annapolis livery stable, secured the backing of the Baltimore and Ohio Railroad to build a spur line to Bay Ridge.[64] The spur left the Annapolis and Elk Ridge track near the National Cemetery, crossed the headwaters of Spa Creek, and meandered through farmland down the peninsula. Locals kept tabs on the construction during the spring of 1886, and hundreds waved and cheered as the first steam engine pulled four freight cars over Spa Creek. "It was the opening of a

new era in the history of our city, and county," enthused the *Evening Capital*. Even as the Short Line's Irish and Italian workers labored on the Severn River trestle that July, the first train of the Bay Ridge and Annapolis Railroad reached the resort.[65] This was a welcome shot in the arm for the Annapolis and Elk Ridge Railroad, recently reorganized as the Annapolis, Washington, and Baltimore Railroad. Arrangements with the Baltimore and Potomac Railroad, whose line crossed the AW&B at Odenton, brought excursions from Wilmington and Philadelphia.[66] Not to be outdone, the new, competitive Short Line promoted a "Business Men's Special," which left Baltimore in the late afternoon for a pleasant summer evening at Bay Ridge, and offered a steamboat-rail option so that vacationers could choose leisurely travel one way and speed the other. With crowds routinely larger than the entire population of Annapolis, the resort needed the trains of both lines as well as the usual steamboats. For a little more than a year in 1890 and 1891, railroad ferries left Bay Ridge for Claiborne on the Eastern Shore. Train cars were detached from their engine at Bay Ridge and loaded aboard the ferry; when they reached Claiborne another engine waited to take cars, freight, and passengers across the shore as far as Ocean City. The 131-mile trip from Baltimore to the ocean took six hours.[67] The fast, convenient rail service also brought Eastern Shore passengers and freight to Annapolis and Baltimore.

The new rail lines in and out of the city sparked interest in new residential and commercial development, and debt and death opened opportunities for subdivision of large tracts of land on the outskirts of the city. Madison, Jefferson, and Hill Streets had been laid out in the 1870s as a result of an equity case dividing Judge Nicholas Brewer's orchards on West Street amongst his heirs. Now, in the mid-1880s, a few houses and small shops appeared on West Street between the imposing mansion of Judge William H. Tuck and the Bay Ridge railroad, and lots were sold on Madison Street — the first steps toward the neighborhood that would be called Presidents Hill.[68] Across West Street, similar litigation had parceled out the hundred acres once farmed by Lewis Duvall to the heirs of James Murray, and by 1890 they, too, were ready to cash in on the city's potential. While the Brewer heirs sold their apportioned lots themselves, the Murray heirs enlisted the aid of George T. Melvin. An attorney and newspaper owner from Denton, Melvin could be termed the city's first modern real estate developer. He laid out lots of about a tenth of an acre each from Shaw and West Streets east and south to Spa Creek, and named the new streets after the extended Murray family (Murray, Cheston, Steele) and other solid citizens such as St. Anne's rector, the Reverend William S. Southgate (who built the first house on his namesake street). Melvin planted trees to make the bare lots more attractive and advertised heavily in the local papers.[69] At the same time he was touting Murray Hill, Melvin was also developing West Annapolis, across College Creek, for the heirs of Luther Giddings.[70] In anticipation of the success of West Annapolis, Melvin had bought land on the other side of Weems Creek and built a bridge to it.[71] Perhaps because of the Panic of 1893, which slowed construction nationwide, or perhaps because Annapolis did not yet have the population to support this sudden plethora of residential development, none of the three subdivisions really took off until the first decades of the twentieth century.[72] George Melvin was a man ahead of his time, but undaunted. After losing his real estate clients through disappointment and his Weems Creek land and bridge through foreclosure, Melvin turned to other pursuits and became president of the new Annapolis Bank and Trust Company, president of the Annapolis and West River Steamboat Company, and owner of the Maryland Hotel.[73]

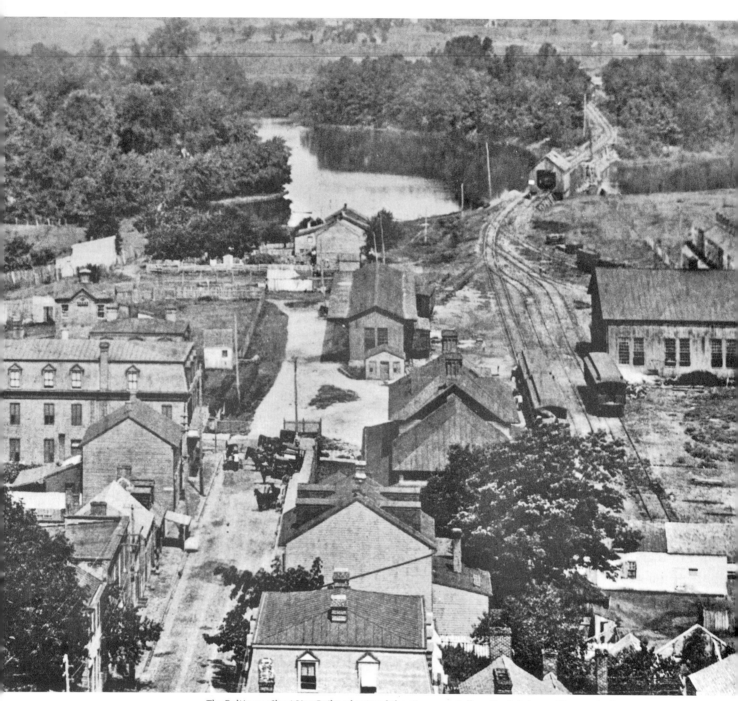

The Baltimore Short Line Railroad entered the city across College Creek, between the cemeteries, to the left, and St. John's College, to the right. The roof of the station, which faced Bladen Street, is visible under the foreground trees in this c. 1890 photograph by Henry Schaefer, a popular Annapolis photographer. Courtesy of the Maryland State Archives, MSA SC 985-261 (detail).

Billed as the "Queen Resort of the Chesapeake," Bay Ridge attracted thousands of summer vacationers, who traveled by steamboat, train, or Bay Shore Drive to enjoy the amusements of this Victorian playground. Courtesy of the Maryland Historical Society.

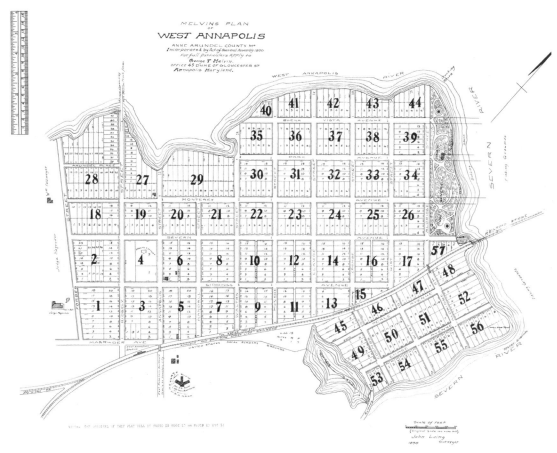

The plan of West Annapolis made for George T. Melvin in 1890 shows the anchor-shaped naval hospital Porter's Folly at lower left and tracks of the Short Line and Bay Ridge Railroads. Frederick Law Olmsted redesigned the section of the grid north of Claude Street (running northwest from between lots 11 and 13) in 1907 as Wardour. Courtesy of the Maryland State Archives, MSA S2323-1855.

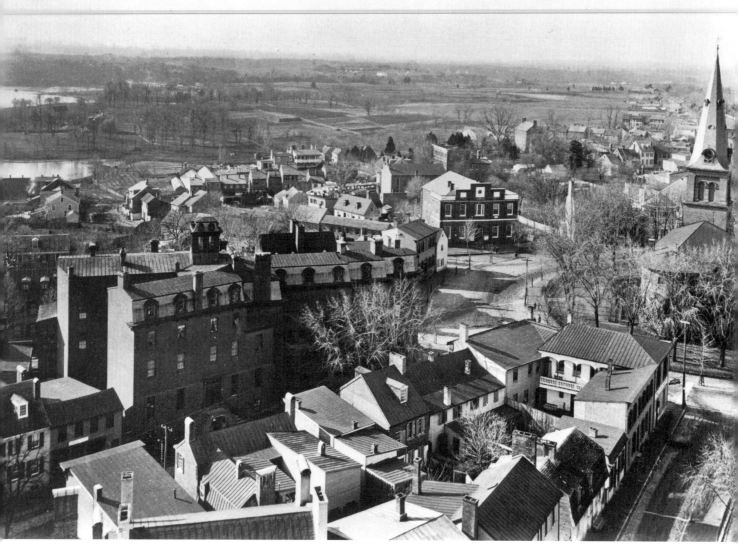

A c. 1890 view by Henry Schaefer from the State House shows Acton's Cove at the left middle ground and the land that Richard Acton surveyed in 1651 before its development two and a half centuries later as Murray Hill. Courtesy of the Maryland State Archives, MSA SC 985-264.

Just as city residents were getting used to their new railroad, innovations in the use of electricity brought them another opportunity to show how progressive their town was, or wanted to be. A few cities across the country were installing the incandescent street lamps invented by Thomas Edison in 1879 and marketed by his Edison Electrical Illuminating Company. In Baltimore a few savvy entrepreneurs began to apply electrical power to industry and street lighting in 1880, and Cumberland, in Western Maryland, electrified its street lights in 1884.[74] Not having a great deal of industry clamoring for electric motors, Annapolis was more interested in following Cumberland's lead. For thirty years most of the city's streets had been lit by gas lamps, with old-fashioned oil lamps in places where there were no gas lines.[75] In late 1886, the City Council began to investigate the reliability and cost of

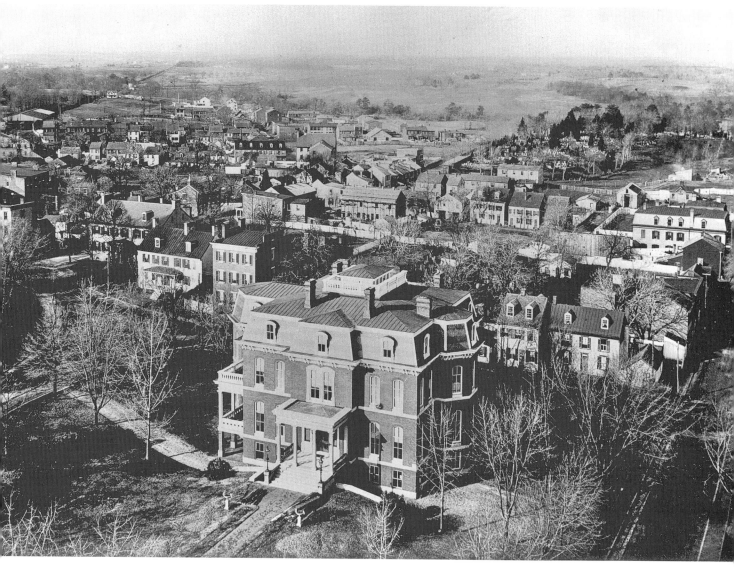

Another view by Henry Schaefer from the State House dome, c. 1890, this one looks west beyond the post–Civil War governor's mansion, across the land between West Street and College Creek, to the tombstones of the city cemeteries, in the right rear. Courtesy of the Maryland State Archives, MSA SC 985-263

incandescent street lights.[76] The council quickly received proposals from both incandescent and arc light companies as well as new cost figures from the old Annapolis Gas Light Company, whose officials saw their best customer eyeing the competition. At first, thrifty aldermen accepted the gas company's offer while they considered, briefly, having the city build its own plant to supply electricity for municipal use and sale to others.[77] But five businessmen, including locals Dr. George Wells and Elihu S. Riley, chartered the Annapolis Electric Light Company of Anne Arundel County in March 1888 and began to pressure the city government to go electric. Throughout the spring and summer of 1888 the debate seemed a constant issue in City Council meetings and in *Evening Capital* coverage (Abbott wholeheartedly supported electric lights). At this point not only were the new electric company and the old gas company squaring off at council meetings, but the Schuyler Electric Light Company, which was installing electric service in Hagerstown, joined the fray.[78]

In August 1888, the City Council awarded a two-year contract to the Annapolis Electric Light Company, which would provide electric lighting to streets, the Council Chamber, Assembly Rooms, fire department, and market at a cost of $3,500 per year. Hedging their bets on the future, the council decided on forty arc lights and forty-six incandescent street lights.[79] Construction of the new electric plant, next to the gas works on Hanover Street, began the winter of 1889. Plant equipment was in place by mid-March; and in May, the company put up the poles, wiring, and the lamps.[80]

Astonishment overwhelmed the town on 1 July 1889 when, suddenly, the electric lights came on. The lights "shone with a brightness and brilliancy that attracted general attention from our citizens," said William Abbot in atypical understatement. Residents on streets with arc lamps found that they could read or sew by the light coming through their front-room windows. Some industrious painter even painted a house by street light.[81] (But there must have been a run on heavy-weight curtain material for bedroom windows!) In addition to municipal buildings and the State House, most stores on Main Street immediately installed incandescent light fixtures.[82] Other commercial establishments quickly adopted the new technology, but many Annapolis residences still used gas lights well into the twentieth century.[83] Electric lighting proved to be less reliable and more expensive than gas, but people were so anxious to have the new streetlights placed in their neighborhoods that it is doubtful the city could have gone back to the old ways.[84]

Almost overnight a city that had prided itself on the trees along its sidewalks found that, despite their natural beauty, they obscured the new electric lights. Which would prevail? The lights, of course, and eventually the city ordered that tree limbs around the lights be trimmed back. It also didn't take long for residents to discover that "thousands of insects of all kinds are attracted by the electric light."[85] But the major change to the city's aspect was the overhead wires festooning almost every street, and when another technological marvel gained popularity in Annapolis, there were telephone wires as well.[86] Telephones had been used in Baltimore since 1877 and reached five other Maryland towns before the first Annapolis phones linked Government House and the state comptroller with the Baltimore office of the new Chesapeake and Potomac Telephone Company in 1884.[87] Ten years later C&P established a telephone exchange in Annapolis "at the request of a number of property holders" and gained permission from the city government to put up poles and wires. The city charged them a $2 annual tax on each pole.[88] Fortunately for the telephone company, most streets already had poles for electric service that could also handle telephone cables.

As had been the case earlier in the century, it took a disaster, or two, to focus the attention of Annapolitans on the need for effective fire fighting. The old Independent Fire Company had disbanded sometime before a fire on Cornhill Street in December 1879 consumed five houses and threatened the State House and other nearby buildings. Only the heroic efforts of Naval Academy midshipmen, marines, and officers, and their steam engines, prevented greater damage. Heeding the plea of the *Maryland Republican*, John L. Beall led local men in the formation of Rescue Hose Company No. 1.[89] But even with a willing fire company, the city still did not have the equipment or the trained personnel to fight a major fire. Just before dawn on 22 October 1883, fire broke out in Louis Clayton's grocery store at the south corner of Fleet Street and Market Space. Within minutes the four three-story brick attached buildings facing Market Space, built in 1772 by Charles Wallace and once occu-

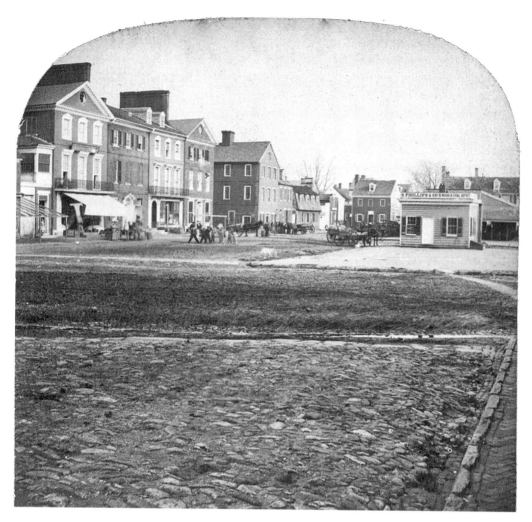

Just a year or so after W. M. Chase made this photograph, a disastrous fire swept through the buildings facing Market Space, from Fleet Street to Main, on 22 October 1883. Two people died in the blaze, which destroyed the four-part mercantile building on the left, built by Charles Wallace in 1772. Courtesy of the Robert N. Dennis Collection of Stereoscopic Views, Miriam and Ira D. Wallach Division of Art, Prints and Photographs, The New York Public Library, Astor, Lenox and Tilden Foundations.

pied by the colonial mercantile firm of Wallace, Davidson, Johnson, were in flames. The fire quickly spread to adjacent buildings along the block and up lower Main Street. Light from the blaze could be seen fifteen miles away. Two members of the Legg family, who lived above Clayton's store, perished. Again, only the presence of Naval Academy personnel and equipment saved the day. By the time a fire company from Baltimore City arrived on a special train later that morning in response to a frantic telegraph from Mayor Abram Claude, the fire was under control.[90]

This time, local residents were fed up. At a meeting on 31 October, they demanded an accounting of the city's fire apparatus. The report showed that of three hand engines, only one was "in good order," and of the hose, one section was "burst" and several hundred feet "unreliable." The rest of the equipment was in equally poor shape. Independent Fire Company No. 2 organized in March 1884, and by November the company and City Council had gathered money for a steam engine.[91] A city bylaw in January 1885 made the two companies "part of the City organization" and set up basic regulations and duties under direction of a city fire marshal to be elected annually by the City Council. The new steam engine would be under the control of a paid engineer, and a paid fireman would guard the engine house and equipment.[92] The city also bought a fire bell and installed it above the Assembly Rooms.[93] A second inventory of fire equipment in March 1885 showed 102

active members in the two fire companies and great improvement in both the condition and extent of the apparatus.[94] A third fire company, Water Witch Hook and Ladder, organized later that year.[95] Rescue Hose used a frame building at West and Washington Streets until a new brick engine house was built just up the street in 1908.[96] Independent No. 2 found accommodation in the City Hall–Assembly Rooms building, modified to house the engine in 1901, and the city built a frame firehouse for Water Witch on a lot on East Street it purchased for the purpose in 1884.[97] With a fire company in each ward, volunteers could reach their station easily, and response time to the fire diminished. Until the Independent Fire Company bought its own horses in 1903, the steam engine was pulled to fires by two roan ice-wagon horses belonging to John Flood, who owned the icehouse on the city dock. Evangeline White remembered that "at the first clang of the bell," their driver would race them to the firehouse, back them into the shafts of the engine while the engineer fired the boiler, and then "the engine plunged out of the firehouse with these two beautiful horses snorting and charging away, the smoke and sparks poring out the big stack of the engine."[98]

When the next major fire occurred, in 1902, all three fire companies fought the blaze, which destroyed Weigard's Confectionary on State Circle, St. Martin's Church on Francis Street, and several adjoining houses. The Naval Academy sent two hundred men for a bucket brigade, but the city fire companies worked well together and contained the conflagration.[99] Two years later, a division of city firemen took their steam engine to Baltimore City to help with the disastrous 7 February 1904 fire, and just ten days later they fought a battle of their own when a fire in Richard G. Chaney's livery stable ignited houses and shops along West Street and Colonial Avenue. The three fire companies again turned out in force, assisted by the Naval Academy's equipment, sailors, marines, and the entire second class of midshipmen. Students from St. John's helped homeowners and tenants to safety and manned one of the hoses. And what must have seemed like the entire population of the town, including Governor Edwin Warfield and his family, hastened to the scene to watch. Chaney's stable hands had led every horse from the building "at the first sign of fire" and turned them "loose on Murray Hill." In all, thirteen houses and two stables burned, several firefighters and observers were injured; three cats, a dog, and a mule lost their lives; and thirteen families were left with little more than the clothes on their backs.[100]

Just as fires attracted the curious to scenes of disaster, so hangings brought people out to witness tragedy, and sometimes to be the cause of it. Hangings were popular. "Vast crowds of both colors . . . swarmed on low roofs and fences" on 21 December 1877 to watch the hanging of county resident Henry Norfolk, said to be "the first white man ever hanged" in Annapolis. Tickets to the jail yard on Calvert Street were issued to 280 people, but about 350 crammed in to be up close when the convicted wife-murderer dropped through the trap door beneath the gallows.[101] This bloodthirsty behavior surged out of control when lynch mobs meted out their own version of "justice," fostered by the simmering racial hatred of the times. In June 1875, perhaps 150 white men from the Odenton area of the county came to Annapolis in the middle of the night, broke into the jail, and dragged John Sims from his cell. They said the African-American man had committed an "outrage" on a white woman who lived near them; the black community thought he had saved her from a runaway horse. The gang, some of whom were masked and some in blackface, took Sims about two miles up the railroad line and hanged him from an oak tree. A jury convened the next day by State's Attorney James Revell took testimony from witnesses and quickly determined that Sims "came to his death . . . at the hands of a mob to the jury unknown." The

neighborhood near Admiral Drive and West Street where the lynching occurred came to be called Simms Crossing.[102] Another group of vigilantes pulled Wright Smith, a black man, from the jail in October 1898, and when he ran, they shot him. The *Ledger*, an African-American newspaper published in Baltimore, did not excuse Smith's guilt in the death of a white woman but did accuse the mob of an equivalent crime: "True American citizenship rebels against the lynchings of criminals, because it is murder, pure and simple."[103] Henry Davis, who had been jailed for assault on an African-American woman in 1900, confessed to a similar crime against a white woman from Crownsville in 1906. Shortly before Christmas that year, a white mob hauled him out of the jail and attempted to hang him from a chestnut tree high above College Creek some two hundred yards up the WB&A railroad track. When the rope broke, they shot him. No one was convicted of the deaths of Sims or Smith or Davis.[104] Juries might decline to investigate fully, but some knew who the killers were. Hushed stories of men with torches passing through their neighborhood the night Henry Davis died persisted for years in the Presidents Hill community.[105]

The city's eleven churches and chapels promoted countless religious and social activities: Sunday services and schools, weekly prayer meetings and Bible study, missionary and religious societies, edifying lectures, and, in season, Christmas pageants, strawberry festivals, and Sunday school outings at Bay Ridge, Round Bay, or just across Spa Creek at Boucher's-on-the-Spa.[106] From the Maryland Chapter of the Sons of the American Revolution, formed in the State House in 1889, to the local lodge of the Benevolent Protective Order of Elks, founded in 1900, to the Knights of Jerusalem, the three fire departments, four Masonic lodges, Severn Boat Club, Isaac and Rebecca Lodge, Local Improvement Association, Capitol City Club, women's Civic League, or any of the other twenty-eight organizations listed in the 1897 city directory, there were ample choices for anyone — black or white, male or female — who wanted to participate in the social, fraternal, or civic life of the town.[107]

The Local Improvement Association, formed in 1884 by public-spirited townsmen, sought to upgrade the city's appearance by planting trees and encouraging other improvements. Probably their most lasting contribution was the large landscaped circle at the bottom of Main Street, which the association hoped would make Market Space more attractive. Unfortunately, the city controlled the circle and did not maintain the plantings. Within a decade, the Improvement Association's initiative was known as Dog Turd Circle.[108]

Sports were popular in turn-of-the-century Annapolis: baseball and football (not in the streets, please, without the mayor's permission); sailing and rowing, with crew races and the annual Severn Boat Club regatta from its frame clubhouse at the foot of Duke of Gloucester Street; roller skating at Dr. William Bishop's rink on Northwest Street; and the new craze, bicycling.[109] The Annapolis Cycle Club competed against riders from other towns and lobbied for a track near Annapolis. In the summer, local bikers thronged Bay Shore Drive to Bay Ridge, where the League of American Wheelmen sponsored races in the 1890s.[110] The popularity of this new mode of transportation in the city is clear from the regulations passed by the city government: no riding on sidewalks and alleys (June 1894), no riding at night without a bell and lighted lantern (July 1894), no riding faster than ten miles an hour, especially without at least one hand on the handlebars (July 1897). Each infraction, assuming the pedestrian police caught the culprit, netted the city a fine of one to ten dollars.[111]

And then, there was swimming, or "bathing," as the favorite summer pastime was usu-

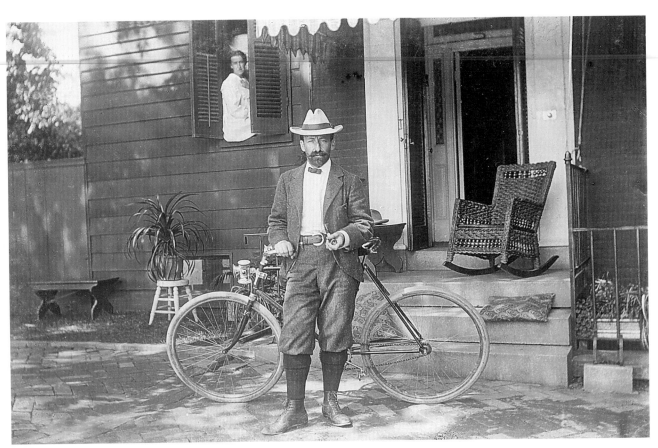

This law-abiding cyclist, almost certainly Peter H. Magruder, shows off his machine, equipped for night riding, in front of the Magruder home on Duke of Gloucester Street, in 1898. One of Peter's sisters watches from the window. Courtesy of Randall W. Bannister.

ally termed. By 1871, Annapolis was "fast becoming a favorite summer resort," and visitors at the City Hotel could enjoy hot and cold baths with fresh or salt water. Those who preferred more natural surroundings could patronize "the bathing places of the city," which included the bath house built at the bottom of Market Street by the Annapolis Bath Company shortly after the Civil War.[112] This structure had deteriorated by the late 1870s, however, and neighbors complained that men were "running around the house with their person exposed."[113] Jackson Brewer's slaughter house, just a block away at the foot of Conduit, probably deterred squeamish bathers. Brewer chortled to the *Maryland Republican* in 1877 that "he intends to give the bathers of the Spa bloody baths hereafter. He says fair exchange is no robbery."[114] Indecent exposure continued to trouble residents in this time of Victorian sensibilities, and eventually the city posted a policeman on the King George Street bridge over College Creek during the bathing season to prevent untoward displays.[115] But what about the health of swimmers in creeks notorious for the effects of sewer outflow? When the Eastport Bath House at the end of Spa Creek bridge opened in June 1895, its proprietors advertised separate bathing hours for gentlemen and ladies (men in early morning and evening, ladies from 8 a.m. to 3 p.m. only) and reported that the bathing area was "free from all sewerage and filth, in a strong tide."[116]

Local musical groups, amateur and professional — the Mandolin and Guitar Club, Annapolis Cornet Band, the Naval Academy Band, and Henry Schreyer's orchestra — played regularly. The city even built a bandstand in front of City Hall in 1890 for the cornet band's concerts. The academy band, under direction of Charles A. Zimmermann from 1887 to

View from the foot of Church (now Main) Street, c. 1876–1885, of what might be a parade heading up the street. The space in right foreground that became the City Circle park was graced only by a signal pole and a raised pad, possibly the flooring of the pre-1858 market house. Courtesy of Be-hold, Inc., Yonkers, N.Y.

1916, entertained the crowds at Bay Ridge while the midshipmen were off on summer cruise. Professor Schreyer's orchestra was a particular favorite at dances held in the Assembly Rooms by both whites and African Americans.[117]

Public events such as the dedication of Baron Dekalb's statue on State House hill in August 1886 and the Trades Display in April 1889 were holiday occasions attended by most of the town.[118] The Opera House, in the Masons' building at the southwest corner of Maryland Avenue and Prince George Street, opened in the winter of 1873, bringing professional theatre and vaudeville back to Annapolis after almost thirty years. Nationally known actors like Laura Keene, whose show opened the theater, packed the house. In 1885, the Bijou Opera Company mounted performances of Gilbert and Sullivan's new operetta, "The Mikado; or, the Town of Titipu," with tickets at less than a dollar and a Saturday matinee.[119] In 1902, the old City Hotel was modified and enlarged to become the Colonial Theatre, "a 20th Century Playhouse" with seating for more than a thousand in splendid style and 360 electric lights illuminating its elaborately frescoed walls and ceiling. Elihu Riley made the dedicatory speech on 18 May 1903 before the first night's performance of "The Holy City." None of the owners of the new building were local, and much of the conversion of the building from hotel to theater had been done by out-of-town firms.[120]

As had been true since its inception, the Naval Academy attracted people to a variety of activities, particularly plays and sporting contests.[121] And, because of its large number of local employees, probably everyone in town knew the school's academic schedule. When formal classes ended in late spring, midshipmen set off on the academy's ships for a training cruise, usually to foreign ports. Making sure the students came home safely were professional seamen, most of them stationed in Annapolis and familiar members of the community. In June 1896, the Ladies Auxiliary Association and the local Tawawa Literary Society gave a grand reception for the "Annapolis young men" who were leaving for the summer. In addition to speeches and music by the Mandolin and Guitar Club, James Howard, T. Arrington Thompson, William H. Butler, and Louis Chase argued that night's debate topic: "Resolved that the Negro has more right to complain than the Indian."[122] Thompson and Butler were African-American aldermen from the Third Ward; the Tawawa Society was almost certainly an outgrowth of the Tawawa Theological, Scientific, and Literary Association established in 1883 as an independent Chautauqua society at Wilberforce University, in Tawawa Springs, Ohio.[123]

Although today we might assume from later events and reminiscences that African Americans and whites in Annapolis led completely separate leisure lives, that may not be entirely true. At least one member of the traditionally black Masonic Universal Lodge No. 14 F. & A. M., which had been formed by Annapolis men stationed in Newport with the Naval Academy in 1864, was a white man: Alexander Hart. Hart, a New York–born Union Army vet, settled in Annapolis after the war and opened a tobacco store on Maryland Avenue.[124] Johnson's 1896–97 city directory does not differentiate by race its list of organizations, and only through other sources can they be linked, usually anecdotally, to blacks or whites. Evangeline White mentions a "young man's" music group called the Annapolis Mandolin Club and implies that it was white; a "Mandolin and Guitar Club" played at both the (African-American) Tawawa Society ladies' 1896 reception and the Opera House and sold its tickets at Feldmeyer's Drug Store.[125] The *Afro-American*'s Annapolis notes are equally ambivalent. What was the Capitol City Club that gave "a grand select ball" in 1896 attended by naval officers, who were, at that time, definitely white? The *Afro-American* reported the affair in glowing terms.[126] Would it have done so had the occasion been an all-white event? The white-owned *Evening Capital* marked the deaths of elderly black residents such as Edward Tasker, "a well-known and respected colored citizen," and Julia Bell, "much beloved by all the neighbors, both white and colored."[127] The *Negro Appeal* saluted the white mayor, Edwin Seidewitz, for selling more plants (104,000) to Baltimore City parks than any other Maryland florist.[128] Both white and black organizations scheduled affairs in the city Assembly Rooms, although for most of the postwar period, African-American events were held on the lower floor and white ones took place on the second floor.[129] As in most of the South, the barriers between races in Annapolis prior to Jim Crow legislation at the turn of the century were not always as high as they later became.[130]

There was no doubt, however, that schools for the children of white and African-American families would remain separate, be they public or private. The city's public white primary schools limped along into the late 1870s with little change until the Presbyterian Church decided in 1877 that it could no longer accommodate the girls' school in its basement.[131] Perhaps because the boys' school was not large enough to accommodate girls, too, the county school commissioners moved the two divisions down Green Street to the large, two-and-a-half-story brick house they bought from Frank Stockett in 1878.[132] The Stanton School continued as the city's public primary school for African-American children of both

sexes. Legislation in 1872 finally required the state to allocate money to one black school in each district, and teachers at Stanton began to be paid from state funds.[133] In the early 1880s, a training school supported by "ladies of Annapolis and the United States Naval School" taught young black girls "useful industry" so that they could "procure an honest living . . . [and] become useful members of society."[134]

As had been the case all along, families who could afford to have a nonworking child could often afford to pay for his, or her, tuition at a private school. Most of the private schools run by white women emphasized education for girls and very young boys. White boys and girls also could attend St. Mary's School, established by the School Sisters of Notre Dame in 1867 and not restricted to Catholics.[135]

Older boys usually attended St. John's College preparatory school. It took about a quarter-century for St. John's to recover after the Civil War. After the disappointment and strain of six presidents in twenty-one years, the college and its prep school rejoiced at the 1886 appointment of Thomas Fell, a well-traveled Englishman and popular professor of Greek and Latin, who served as president for the next thirty-seven years. Fell quickly doubled enrollment to 138 students, raised professors' salaries, and added courses to the prep school for students who wanted to pass the Naval Academy entrance exams. He also spruced up the physical plant and, most important, managed to combat the college's perennial poverty.[136] Whenever the state Board of Education chastised Anne Arundel County for its lack of a high school, the county school commissioners pointed to St. John's as perfectly adequate.[137] Girls finished at the Arundel School or went to Baltimore for high school. The Arundel School boasted in 1896 that its graduates would be admitted to the Women's College of Baltimore without examination.[138]

In addition to Stanton School, black children could attend the Galilean School on East Street, St. Philip's Parochial School, or the school begun by the School Sisters of Notre Dame in 1874 in a small wooden building on Chestnut (now Newman) Street.[139] The last, known as the St. Mary's "Colored School," considered itself a public school until 1885 and admitted black children of any religion at no charge. Financial difficulties were a continual threat for the school, and even after requiring a small tuition, its existence remained in doubt. African-American parents, most of them Protestant, paid the tuition and continued to send their children to the sisters. Two hundred ten youngsters attended in 1888, far more than the number of white children in the parish's other school. The "Colored School" moved to a new building, on Duke of Gloucester Street, in 1891. Five years later the school began receiving financial support from the Drexel family of Philadelphia, and with their help the new school was enlarged a few years later. Over the years a significant number of Annapolis African-American children received their elementary education from the sisters.[140] High school was another matter. If they could afford it, black families sent their teenagers to board at academies in Baltimore or Washington or other schools farther away. Annapolis students attended St. Paul's School in Lawrenceville, Virginia, and the prep schools of black colleges such as Bowie Normal School, Howard University, Morgan College, and Hampton Institute.[141]

After gubernatorial vetoes by Democratic governor Frank Brown in 1892 and 1894, Republican governor Lloyd Lowndes signed a bill in 1896 that guaranteed state funding for textbooks in all Maryland public schools. Enrollment "took a sudden jump."[142] The same legislative session also approved construction of a new public grammar school in Annapolis financed by bond issues of $12,000 by the county and $6,000 by the city.[143] Built on the Green Street property adjacent to the Stockett house, the new school removed chil-

dren from that "old dwelling house entirely unsuited for the purpose" and placed them in a three-story brick building designed from the start as a school, with large, airy classrooms and indoor plumbing.[144] Classes opened in the not-quite-finished school in September 1897 for 521 students, aged six to twenty-one, with William E. Smith as principal.[145] Smith, a stern and experienced teacher from New England, had added eighth, ninth, and tenth grades to the grammar school in 1896 to form a high school department, and the grammar and high school departments shared the wonderful new building. An eleventh grade, the accustomed last year of high school then, was added in 1897. It must have taken two years for the first high school class to complete eleventh grade, because the first graduation was held in June 1899. High school students returned to the Stockett house in 1900 following its renovation.[146] As principal of both the grammar and high schools, Smith may have imposed order and improved the curriculum, but local student Evangeline Kaiser didn't like him very much: "It was a fearful punishment to both teachers and pupils to have had him placed in full authority over us, a group of warm-hearted, friendly Southerners. Well, he whipped us into shape"—quite literally. She does credit Smith with "launch[ing] us upon our upward way to better and bigger schools" during his three-year tenure.[147]

As soon as classes started in the new school on Green Street, African-American residents asked the city to support a similar replacement of the old Stanton School. The City Council endorsed their petition, and the next General Assembly authorized construction and furnishing of a new "public free school building for colored children" on the land currently occupied by the old building on West Washington Street. As with the white school, two-thirds of the anticipated cost of $9,000 would be financed by the county, one-third

The new brick Stanton School on West Washington Street opened in 1899 as a "public free school for colored children" in grades one through eight. It replaced the wooden school built on the same location just after the Civil War. Evening Capital Historical and Industrial Edition, *May 1908. Courtesy of the Special Collections and Archives Department, Nimitz Library, U.S. Naval Academy.*

by the city. The building committee included three men involved in construction of the Green Street school and local black leaders Dr. William Bishop and William H. Butler, Jr.[148] Completed in December 1898 and opened the next year, the new brick two-story Stanton School remained a grammar school with only eight grades. Although a citizens' committee continued to press school commissioners for a school that would "correspond in every particular" with the white high school, it would be more than thirty years before the county built a high school for African-American children.[149]

Not only did the requests for a black county high school fall on deaf ears, but in 1904 the state withdrew its support of African-American schools, throwing funding back solely on the taxes paid by black property holders in each county. Predictably, the school year for black children in Anne Arundel County immediately shrank, from ten months to two and a half.[150] Over the succeeding years, as the length of the Stanton school year fluctuated but always remained shorter than the white term, black groups appealed for parity, without success. By 1906, state Department of Education statistics showed 800 students at Annapolis white schools with an annual apportionment of $14.25 per student; Stanton had an enrollment of only 384 and received $3.91 per student. Teacher pay was equally disproportionate.[151]

As educational opportunities at city schools diverged by race, the only aspect of the curriculum that seems to have crossed the color line was the Sloyd system of manual arts education, instituted about 1904 and based on a Swedish program that combined progressive training in wood and metal crafts and needlework as a way to improve hand-eye coordination and focus the mind while preparing children for both practical employment and further education.[152] Although the system was used in both Green Street and Stanton Schools, by the time African-American children reached the third grade, about half their time was "devoted to industrial work — the boys being taught manual training, carpentry, and blacksmithing and the girls cooking, sewing, and general housework."[153] Not at all what the Swedish educators had in mind.

Meanwhile, the county school commissioners tore down the Stockett house and built a new high school for white children on the site. Because this was to be a countywide school, the city escaped responsibility for any part of the projected $20,000 cost of the building and the new heating plant that would serve both it and the grammar school next door.[154] The Annapolis High School opened in September 1907 with only two floors finished; the entire building was completed in 1908. Centrally controlled electric lights, fireproofing, nine "commodious class rooms," and metal ceilings "painted in beautiful pastel shades" reflected the latest in school design. The ground floor housed the benches and equipment of the Sloyd system; the *Evening Capital* praised the mechanical drawing facilities: "few colleges are better equipped than the local High School in this department."[155]

The notoriously difficult examination for admittance to the Naval Academy bred a particular single-purpose school that flourished in Annapolis for many years. In addition to the preparatory school at St. John's College, several academy alumni offered classes and tutoring designed to get their students successfully through the entrance exam. The longest lived and best known was the U.S. Naval Preparatory School run by Robert L. Werntz, USNA Class of 1884. Begun about 1891, Werntz's school taught almost a hundred young men annually in classrooms located in the Masons Opera House building on Maryland Avenue.[156] Other local prep schools included the Perry Preparatory School, J. A. Perry, USNA Class of 1893, principal, and the Wilmer-Chew school under Joseph R. Wilmer,

who graduated from St. John's College in 1874 and the Naval Academy in 1878, and John L. Chew, St. John's Class of 1885.[157] The young men attending these crash courses usually boarded at homes in town, providing steady income for local women and excitement for their daughters.[158]

All the while that developer George Melvin and editor William Abbott were chivvying townspeople to increase business and move forward, others in Annapolis were beginning to see advantages in remembering the town's colonial glory. In October 1874 the City Council directed a committee to arrange celebratory events commemorating the centennial anniversary of the burning of the *Peggy Stewart*. Not everyone jumped on the bandwagon, and the parade and illumination reflected a distinct lack of interest. Better attended were the reenactment of the ship's burning at the city dock and the "centennial tea" in the State House, which raised $400 to establish a hospital in town.[159]

Although the *Peggy Stewart* celebration was not a rousing success, the possibility that fame and money might be gained from history simmered in the town's collective consciousness. J. Guest King, who had purchased the *Annapolis Gazette* in 1868, was one of the first local businessmen to exercise the advantage of antiquity. In 1871, King suddenly added a hundred years to the volume number of the paper, giving it a beginning date of 1746. A few years later, he removed any doubt about his intent by resurrecting the name *Maryland Gazette*.[160] Elihu S. Riley's *The Ancient City*, printed in 1887, updated the *Annals of Annapolis*, written by his great-uncle David Ridgely forty-six years earlier, and placed a modern, if chauvinistic, history in the hands of city residents. A publication by the Anne Arundel County Historical Society in 1888 joined *The Ancient City* in promoting the city's history and lauding recent progress.[161]

In the face of developing municipal pride, it must have been a serious blow to locals when a rather nasty article titled "The Finished City" appeared in the popular, and national, *Frank Leslie's Monthly* in March 1888. "The present aspect of Annapolis gives little idea of the prosperity it once enjoyed," wrote author Walter McCann, who was definitely not an Annapolitan. He attributes the sobriquet to the city's inhabitants, who, "with a certain regretful fondness," admit that the city has "no future."[162] *Evening Capital* editor Abbott took the criticism to heart and responded with an editorial suggesting that the city expand itself beyond its limited peninsula to create a "township," which would include Germantown, Eastport, even Bay Ridge, thus "ridding ourselves of the bad reputation we have of a 'finished city,' 'a mile-square town,' etc."[163] But architect Henry Randall, son of Alexander, offered a different interpretation. With a native's perspective on the city's built environment, he applauded the "exquisite workmanship binding the hurrying business life of today with the old-fashioned peace and cultivation of Colonial Maryland." The city may be "finished" in the sense of modern progress, but it retained special values of its own, he argued.[164]

As the years passed, there were other opportunities to remember the past. St. John's marked its one hundredth anniversary in 1889 with a three-day event that drew alumni and attention to the school.[165] Just a few years later, Annapolis celebrated its own genesis, the decision that gave life and a new name to the tiny village on the Severn River: the move of Maryland's capital from St. Mary's City to Ann Arundell Towne in 1695. Except that Annapolis, in conjunction with the state legislature, chose to have the two-hundredth anniversary celebration in 1894. Elihu Riley, editor of the lavish *Memorial Volume: Celebration of Two Hundredth Anniversary of the Removal of the Capital of Maryland from St. Mary's to Annapolis, March 5, 1894*, related their convoluted reasoning, which had to do with the change to the Gregorian calendar almost a century and a half before. In their attempt to translate accurately the dates of the Old Style calendar to the New Style, planners of the two hundredth celebration seem to have lost a year. Riley, who was city counselor in 1894 and a city delegate to the planning committee, got the dates right in *The Ancient City*. Why he let the committee select 5 March 1894 instead of some more appropriate day in 1895 for the commemoration is a mystery.[166]

No matter what the date, the celebration combined parades and music with serious speeches and topped off the day with the usual grand ball in the Assembly Rooms. Under bright and sunny skies, the first parade of the day featured officials of the state and town riding in polished carriages, followed by students from St. John's and the city's public schools and members of the fire departments and local civic and fraternal organizations. Setting the beat were the Naval Academy Band, the Colored Drum Corps of Annapolis, and the Latchford Drum Corps of Baltimore County. So much bunting was hung on businesses and private homes that merchants ran out and had to send to Baltimore for more. Horses and dogs sported brightly colored ribbons, and the parade marshals wore black suits, black derby hats, white gloves, and orange and black sashes. The parade was marred for African Americans by someone's unfortunate decision to make Alderman William H. Butler, Jr., ride in a carriage separate from his white Third Ward colleague. Later in the day, ceremonies at the Opera House and the House of Delegates chamber preceded a second, "masked," parade and an old-fashioned illumination. The timing of the latter coincided with an electrical outage, and several serious collisions between horse and man during the relative darkness demonstrated how reliant the townspeople had become on well-lighted streets.[167]

Summing up the day in a congratulatory editorial, William Abbott wrote, "Whatever may be said of Annapolis as the slow, sleepy city, etc., whatever her citizens undertake to do they do it with credit. While the town has not made the rapid strides that some of her sister towns and cities have, there has been a sure and steady growth both in business and population. At the same time it has not lost any of its historical interest, its culture and refinement."[168] It was not finished at all.

Probably the most important outcome of this emphasis on history was the legislature's decision to scrap the "renovations" made to the Old Senate Chamber during a major remodeling of the State House in 1878. In an attempt to modernize the room, architect George A. Frederick had torn out the gallery, removed the architectural features of walls and windows, and replaced the furniture. Complaints over the years had resulted only in the appointment in 1892 of a committee to study the issue. Following the celebrations in 1894, the Senate returned to the question and directed architect J. Appleton Wilson and artist Frank B. Mayer to make recommendations for proper restoration of the room to its appearance at the time of Washington's resignation in 1783. Appleton and Mayer immediately made a detailed study and submitted their report, but work on the chamber was postponed until the State House annex, with its new chambers for the House and Senate, was almost complete in 1905.[169] This decision to restore the Old Senate Chamber was viewed by a later architectural historian as "the first manifestation of a preservation ethic" in Annapolis.[170]

After the county finally, in 1887, completed a bridge across the Severn River, upstream of College Creek, the Naval Academy moved to acquire the former ferry landing and the rest of Lockwoodville between Hanover Street and the Severn and along King George Street west of Wagner Street. The resulting condemnation proceedings involved about sixteen residential properties, the gasworks and electric plant, an oyster house, and the street beds of Severn Street and the western end of Hanover.[171]

The city redrew its boundaries to reflect the academy's purchases while extending its own jurisdiction to include all of College and Spa Creeks and the waters of the harbor from Fort Madison to Tolly Point.[172] But as the city was officially acknowledging the loss of taxable property valued by the court at more than $70,000, it already was resigned to giving up several blocks between King George and Hanover to the east as well.[173] To understand why, it is necessary to backtrack a few years.

In the mid-1890s, after thirty years of benign congressional neglect, the Naval Academy's buildings were declared a "disgrace" by the school's Board of Visitors and a subsequent naval committee of the House and Senate.[174] Perhaps convinced by naval scholar Alfred Thayer Mahan's argument, detailed in his book *The Influence of Sea Power upon History* (1890), that the security and future power of the United States depended upon its naval forces, both the visitors and the congressional committee recommended a complete reconstruction of the yard. Robert Means Thompson, an academy alumnus and member of the Board of Visitors, contracted with New York architect Ernest Flagg to design a completely new physical plant, one that would reflect the importance of the navy and the education of its officers.[175] Excitement in Annapolis deflated when Representative William Emerson Barrett of Massachusetts called for the new academy to be built at some other, healthier, port — preferably in his home state — without the "squalor and filth" of Annapolis.[176] The General Assembly fired off an angry protest to Congress defending the city and threatening

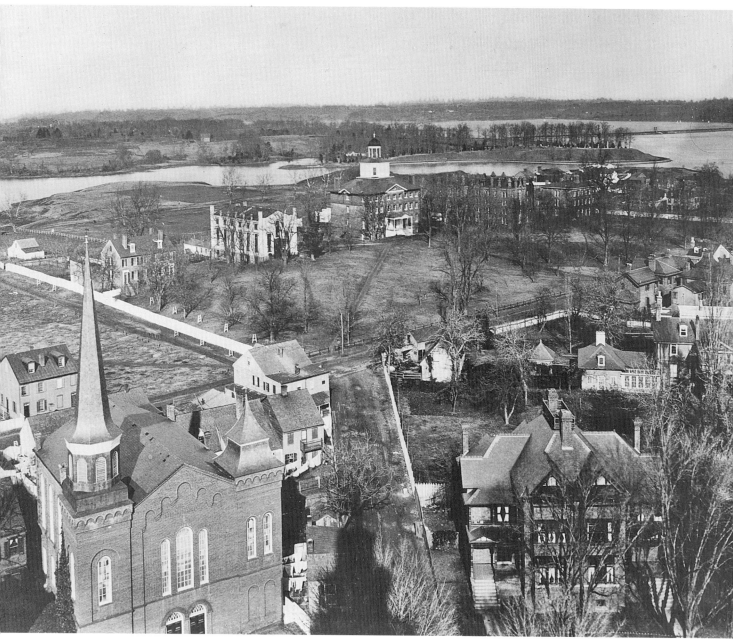

In this photograph taken from the dome of the State House c. 1890, the new Severn River Bridge, built in 1887, is visible in the background on the right. St. John's College is at center. The colonial Bordley-Randall House, right middle ground, in Randall Court lost some of its view after construction of the Queen Anne–style duplex in the foreground. Calvary Methodist Church is in the left foreground. Courtesy of the Maryland State Archives, MSA SC 252-106.

that, since Maryland had given the federal government "valuable property" for the academy (its governor's house, for instance), removal would be a "breach of good faith to the State."[177] But the city government knew just what it was that Barrett was referring to.

Just outside the academy's wall, between Hanover and King George Streets and from Governor Street to Spa Creek, lay a racially mixed neighborhood of commercial and residential properties, most built on the fill dirt that had obliterated Governor's Pond. As had

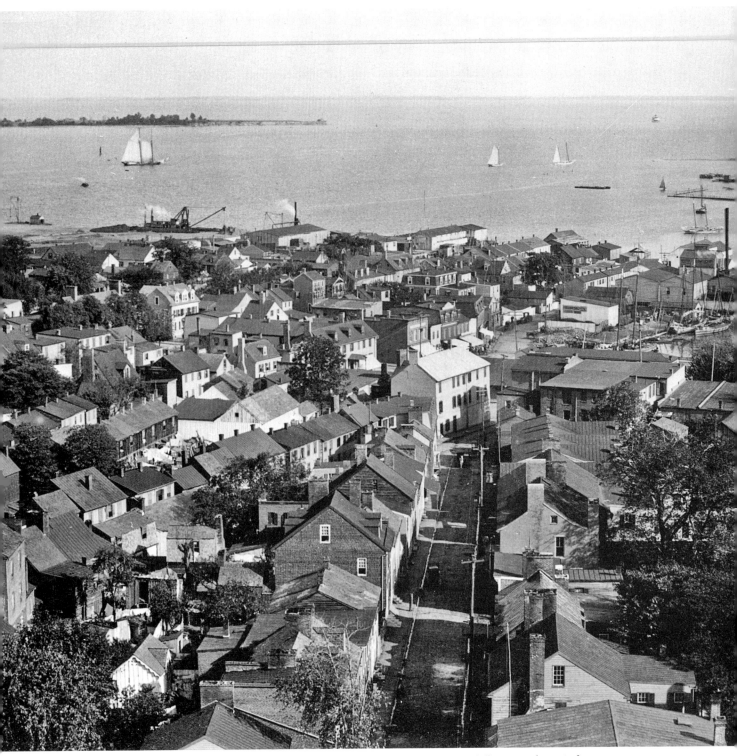

Looking east from the State House dome about 1905 down Cornhill Street to the part of town known as Hell Point, between the city dock and the expanded Naval Academy. Heavy equipment just offshore was probably putting in the seawall for the recently created Farragut Field within the academy. Courtesy of the Maryland State Archives, MSA SC 1890-4735.

been the case with Lockwoodville, many of the tenements in this area housed employees of the academy: laborers, food service workers, laundresses, domestics, as well as skilled craftsmen, musicians, a school teacher, and several shop owners.[178] There were also a large oyster-packing house and adjacent shucking shanties. The academy's building and grounds officer complained mightily about the area's "rum shops, and other houses of questionable character," but he saved his greatest scorn for the oyster workers, whose "loud, boisterous, and very unsavory" language was audible inside the yard. Worse, "there are always oyster shells piled up and spread about on this property, containing more or less meat attached, in a state of decomposition, creating a very unpleasant odor, which is wafted by the prevailing wind into the Cadet and Officer's Quarters."[179] The City Council knew this, and they admitted that Barrett's criticism might be "partially" true. The solution? Have the academy take over the offending property. In fact, city officers felt that "under present conditions" (the potential loss of the school), the academy should not have to pay for it; the state should acquire the land and just give it to them.[180] Before the legislature could react to this, Congress itself picked up the ball and directed the academy's Board of Visitors to estimate the cost of acquisition. After the board's visit in June 1896, the municipal surveyor and tax collector prepared a report with maps and figures, which Maryland senator Arthur P. Gorman presented to his colleagues in the spring of 1898. The city's suggested purchase price, 25 percent more than the 1898 assessment and including the cost of paving certain streets with Belgian blocks, came to just under $93,000, and Gorman included that amount in an amendment to the naval appropriation for 1899. The federal government took title to the land, just under eleven acres, in 1902.[181]

Even as the appropriation for Flagg's first two buildings was being approved by Congress in the spring of 1898, Admiral George Dewey and Captain William Sampson were proving Mahan's theory in both the Pacific and the Atlantic.[182] The brief Spanish-American War guaranteed the future of the Naval Academy. It also livened up the city of Annapolis that summer, not only with returning naval heroes, but by the presence of some ninety-four Spanish naval officers and sailors who had been captured in the Battle of Santiago. Admiral Don Pascual Cervera y Topete and his men were given suitable housing at the academy and permission to go about town. St. Mary's priests ministered to their spiritual needs, and Annapolis society was charmed by their courteous dignity. Spanish lessons were popular with local girls, but Clarence White, then a clerk at Ridout Brothers store on Main Street, remembered the heavy Spanish gold he took in from sales of civilian clothing to the men. Admiral Cervera and his men left in September.[183] The Spanish cruiser *Reina Mercedes*, raised from the floor of Santiago harbor by the U.S. Navy after the battle, served as a station ship at the academy from 1912 until 1957.[184]

Admiral Don Pascual Cervera y Topete and some of his officers, captives taken in the Spanish-American War, enjoy a summer afternoon on the back porch of the Magruder home on Duke of Gloucester Street, 1898. Mrs. Magruder and her two daughters have pride of place next to the admiral. Courtesy of Randall W. Bannister.

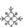

Once the spigot of federal spending opened for the Naval Academy, state and private money augmented the flow, and for a while it seemed that the stream of construction projects would never end. Annapolis almost drowned in workmen, noise, and dust, to surface a decade later irrevocably altered.

Between 1899 and 1909, more than twenty-five major buildings rose on the Annapolis peninsula. The city finally got its first real post office; St. John's College reveled in a new library, dorm, and gymnasium; the State of Maryland deepened its commitment to its capital with an addition to the State House and a Court of Appeals building. And the Naval Academy? By 1908, only the two gatehouses at the Maryland Avenue entrance remained from the old complex; the rest of the buildings conformed with Flagg's monumental plan.[185] The building boom prompted private investors to erect a massive addition to William Paca's colonial mansion and open a premier hotel, which they named Carvel Hall in honor of Richard Carvel, hero of Winston Churchill's popular 1899 novel of the same name.[186] The city's white Baptists, who had been traveling to First Baptist Church in Eastport for services, benefited from congregant G. E. Merrill's job on the construction of the new academy and erected a church of their own on College Avenue with, legend says, broken stones discarded in the building of Bancroft Hall.[187]

All of this construction produced the inevitable accidents, and, although there were several physicians in town, the closest hospitals were an agonizing train trip away in Baltimore or Washington. In February 1902, Mayor Charles A. DuBois and a group of local women chartered the Annapolis Emergency Hospital Association, with ten women, including the wives of the academy superintendent and chaplain, as the first board of managers. With funding by the state, county, and city and with contributions from civic, fraternal, and academy organizations, a construction company, churches, and individuals, the association bought Edwin Seidewitz's house on Cathedral Street and outfitted it as a cottage hospital. The ladies secured a medical staff of ten city and county physicians, including the town's leading African-American doctor, Dr. William Bishop, and retained the services of consultants from Johns Hopkins Hospital and Medical School. The Emergency Hospital opened in July 1902 with one nurse-superintendent and a student nurse; their first patient was a stone cutter injured while working on the Court of Appeals building. Over the next seven years, the hospital became increasingly important to the people of the city, and in 1909 a new building, designed for the purpose, was begun at the corner of Franklin and Cathedral Streets.[188]

Residential construction also prospered during this first decade of the twentieth century, and the developments of Murray Hill and Presidents Hill soon echoed with their own sounds of hammers and saws. In-town lots became prized locations for substantial homes, particularly in the blocks between the State House and the academy. The Third Ward, along the Clay Street corridor and Northwest Street, filled with small homes and tenements as residents of the areas formerly just outside the academy wall had to move to new housing. By 1908, the streetscape of the inner city had taken on much of its modern appearance. Outside the city, the suburbs of West Annapolis and Eastport attracted workers and their families, and a new steel bridge to Eastport replaced the rickety original in 1907.[189] Some African Americans bought building lots in Germantown and Parole as insurance against further academy expansion into the town. They weren't going to be caught again.[190] And, indeed, in 1908 rumors surfaced that academy officials hoped to extend the

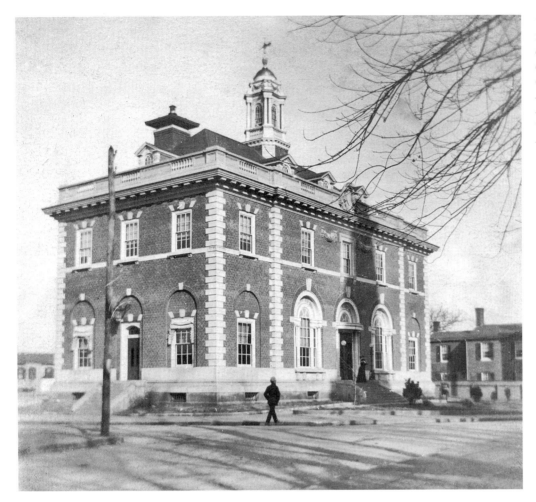

yard out to King George Street in a straight line from creek to creek. The *Evening Capital* questioned: "When forced out of their homes, where will these people go?"[191] But the rumors were just that—this time.

Gottlieb's Department Store on Main Street was the city's most impressive turn-of-the-century mercantile establishment. Built in 1899 by Leon Gottlieb, the store had plate-glass windows to display wax mannequins dressed in the latest styles and an "electric railway cash system" that whooshed money between the shop floor and the office on a mezzanine in the back.[192]

Leon Gottlieb had come to Annapolis from Russia as a young man in the 1880s and was naturalized in 1894.[193] He was one of perhaps ten Jewish merchants in the town in 1900, most of them also from Eastern Europe or Russia, who had fled the pogroms in their native countries with the hope of a better life in America. Although a few Jews had lived briefly in Annapolis since the 1700s and a small number of German Jews had arrived in the mid-1800s, it wasn't until the late nineteenth century that there were enough Jewish families to create a community in which they could practice their faith and strengthen each other socially and economically. Most of these immigrants were craftsmen—tailors, shoemakers—or retail merchants selling liquor, clothing, dry goods, and furniture. They tended to settle along Market Space and inner West Street, where their multigenerational families lived over first-floor shops. Keeping kosher was not easy in a Christian city, nor

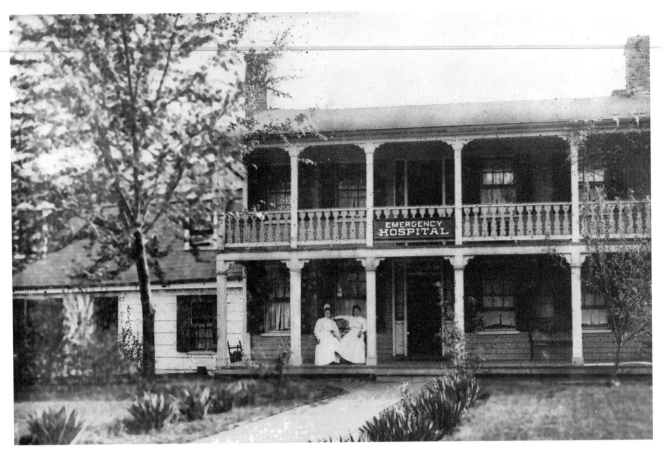

Nurses relax on the porch of the Emergency Hospital on Cathedral Street, which opened in 1902 in the former home of a local florist. Colonial physician Richard Tootell once lived on that property, and his house may have been incorporated into the one shown here. Courtesy of the Maryland State Archives, MSA SC 985-1-166.

was learning English, nor was following Jewish Sabbath laws in a place where the principal market day was Saturday.[194] But these families worked hard, supported each other, and, as Evangeline White wrote, "proved to be a great asset to our town."[195] When, in 1896, there were enough men for the traditional minyan, they formed the Annapolis Hebrew Association and held services at Moses Goodman's home on Bladen Street. The city's influx of workmen after 1900 offered more opportunity for merchants and drew additional Jews to town. Jewish women formed a ladies auxiliary, the "Sisterhood," in 1905 to arrange social events and, when needed, matchmaking and to take care of the poor and needy in a Jewish community that then numbered more than thirty families, or about 150 people. The following year, nine men chartered the congregation as Kenesseth Yishroal (Assembly of Israel), later modified to Kneseth Israel. Services continued in private homes — above Max Kotzin's shoe store on Market Space, for instance — until 1910, when a building at 183 Duke of Gloucester Street was purchased for the first synagogue.[196] Louis Baer, one of the founders of Kenesseth Yishroal, was elected to the City Council from the Third Ward in 1903 and 1905.[197] Charles and Edward Weiss supported the establishment of Annapolis Bank and Trust Company in 1900 with the understanding that Jews would have access to loans.[198] Jewish merchants advertised heavily in the *Evening Capital* and the *Negro Appeal*, and their stores were well patronized.[199]

With double-digit increases in population in 1880, 1890, and 1900, and with the numbers of workmen attracted by construction after 1899, the city relied upon its police force to keep order, especially at night when "drinking saloons and other disreputable places" contributed "materially to the riotous and disorderly element" of the population.[200] The

town constable system had given way to an organized police force in the years following the Civil War; the first chief of police, Thomas Basil, was appointed in 1867. The chief and his officers were selected for two-year terms by the City Council and thus were subject to the vagaries of patronage politics, a fact that was decried by outgoing mayor John DeP. Douw in 1909.[201] Frequent turnover in the positions of chief and officers was routine until Charles H. Oberry was appointed in 1907 to what became an eighteen-year tenure. The changes in personnel may not have been entirely political, because the officer's job posed its own challenges. Each policeman was required to outfit himself in the proper uniform, specified in 1897 as a "dark blue single breasted frock coat, with policeman's buttons . . . dark blue vest and pantaloons . . . dark blue overcoat, with same buttons in winter," and both winter and summer helmets. He could not drink or even appear in bars when on duty unless on police business, could not smoke in public, could not engage in political discussions, and could not leave the city without permission.[202] Although the force asked the city in 1881 to supply them with revolving pistols and a one-arm restraint called a nipper, the only weapon mentioned in 1890 regulations was a baton, to be used only in self-defense or to secure a prisoner. Policemen were obliged to be courteous and to know their beats and the laws they upheld. Most of them worked at night, with only the chief and, after 1907, one officer on duty during the day — unless the dogcatcher needed protection, or ballot boxes needed guarding in an election, or there was a parade. The numbers of officers increased from three in the early 1870s to four by 1875, to five in 1890, and six three years later. In 1897, a "round officer" was added to oversee the beat police at night.[203] The station house occupied part of the ground floor of City Hall, and in 1894 four steel cells replaced the old ones.[204] In addition to solving crimes, policemen were responsible for enforcing the social laws of the late 1890s and early 1900s against swearing and disorderly conduct, throwing refuse in the streets that would injure horses, "barking and catching" (soliciting customers into stores or stables), and loitering and drinking at the city's fish market.[205]

Built at the head of City Dock in 1890, the city fish market contained stalls for vendors of fresh seafood, which could be unloaded directly from boats behind the building. At either end of the market were cook shops selling prepared foods. Whatever part of the fish wasn't sold — scales, tails, heads, innards — went out the back of the stalls into the water, where it rotted and stank.[206] The fish market was only one of several causes of noxious smells during this period. Responding to complaints, the City Council prohibited the rendering of tallow (1892) and of all beef and sheep fat between May and November (1900).[207] The council also got a handle on the garbage situation. Garbage removal by a private contractor cost the city $100 in 1888 but had increased to $1,515 in 1900 — 26 percent of street costs for that year. In 1901, Mayor Charles A. DuBois reported that appropriations for removing garbage and cleaning the streets had increased that year because the newly paved streets required "more labor to keep them clean, and the greater accumulation of garbage on account of the increase of population, the number of workmen, etc., required upon the new buildings in course of erection."[208] The Independent Fire Company took on the collection of garbage in 1903 in order to raise funds to buy Fire Department horses.[209] Garbage was burned at the town dump, near the head of College Creek, until complaints of the "sickening smell" of grease and burning crab shells forced the council to find a site outside of town for summer dumping.[210] Until 1906, refuse was placed in barrels to be collected by the garbage carts, but in that year a city ordinance directed householders and storekeepers to place rubbish in metal cans or wooden boxes, with covers and handles, by 8:00 a.m. for removal daily May through October and thrice weekly in the winter.[211] Paving continued both downtown

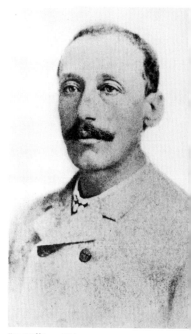

Dr. William Bishop, a graduate of Howard University College of Medicine, was a prominent physician and Annapolis resident of African-American descent. He was a member of the first medical staff of the new hospital until his death in 1904. Courtesy of the Maryland State Archives, MSA SC 783-1-1.

and in newer residential areas, but the most significant improvement in the city at the turn of the century was the installation of a new sewer system, completed for most of the old city in 1900.[212]

All these improvements cost money, and the city went deep into debt to pay for them. In 1870 the city owed just under $20,000 on loans from Farmers Bank and privately held bonds. Legislation authorized the council to issue additional bonds to pay its debts in 1878 and 1894.[213] Three years later, the city's responsibility for a third of the cost of the Green Street grammar school and debts accumulated from street paving and sewers necessitated further borrowing, and the city proposed a $30,000 bond issue to the voters. Regardless of council support and encouragement from editor Abbott of the *Evening Capital*, voters turned it down. Abbot attributed the defeat to apathy — only 836 out of an estimated 2,000 voters cast ballots — and a negative stance by "the colored vote," who, he said, "were influenced by a certain element" opposed to the issue. Some people felt that only taxpayers should vote on bond issues, as denial of this source of revenue forced the government to raise the annual tax rate.[214] Mayor Richard H. Green and the council solved this problem in 1898 by making an end run around the voters and obtaining authorization from the General Assembly to issue the bonds without a ballot.[215] But the push to make the city's infrastructure worthy of the investments being made and contemplated by the federal and state governments raised again the need for capitalization. In 1900 the city still owed $21,000 on past debts and the estimated cost of the desired improvements was $100,000, so the legislature approved a $121,000 bond bill. Having learned their lesson in the last bond ballot, the city invited taxpayers to comment on the proposed improvements. They also opened the election to "duly registered voters and taxpayers," without regard to gender or race. This meant that, for the first time, Annapolis's property-owning women were encouraged to vote. Although the enabling legislation required that voters unable to write be assisted in preparing their ballots, the city ignored this and "five hundred illiterates were virtually disenfranchised," leaving about 1,300 eligible voters. The 1900 bond bill passed with a 441-vote majority out of the 703 ballots cast.[216] A $25,000-bond bill designated for street improvements, mainly in residential areas, received voter approval in 1906, although the *Evening Capital* noted that "there can be no question that most of the vote against the ordinance was from the colored population." Leading members of that community favored the bill, reported the paper, but others voted nay because they believed it would increase rents.[217]

When yet another bond issue passed the legislature in 1908, even editor Abbott expressed concern about the City Council's tendency to borrow. The new bonds would fund improvements to the Assembly Rooms ($10,000) and paving in Murray Hill, Presidents Hill, and the Third Ward ($30,000), but there was the possibility that repayment would raise the city's property tax rate over the $1 per $100 limit specified in the charter. Mayor Gordon Claude defended the bonds as necessary for street improvements that would increase home construction, thus raising the tax base. City officials opened the polls to any taxpayer regardless of age, gender, or race, but the bill was defeated solidly in a light turnout. A few women "of both colors" participated in the election, and, said the *Evening Capital* approvingly, "it is believed that with two or three exceptions the total feminine vote . . . was against the issues. The women seem to be firm against higher taxes."[218]

Some of those women may have had more than taxes on their minds. Just a year before, a group of women had battled with the City Council over the proposed introduction of a railway through residential streets of Annapolis. Such an action would be illegal without

(opposite)
President Theodore Roosevelt addressed the crowd at commemoration ceremonies for John Paul Jones in the new Dahlgren Hall on 24 April 1906. The casket bearing the deceased naval hero stands just below the podium. Almost seven years elapsed before Jones was laid to rest in the Naval Academy Chapel. Courtesy of the Maryland State Archives, MSA SC 182-1610.

the consent of taxpayers whose property bordered the roadway, they maintained. State Librarian Anne Burton Jeffers, Hester Harwood, and two other women took their case to the Circuit Court, where Judge John G. Rogers dismissed the complaint with a curt note that he was "too busy" to file an extended opinion. The women filed an appeal in the Court of Appeals. They lost.[219] Anne Jeffers threatened that if the trains ran, "she would never live in her [King George Street] house again, and she never did." Hester Harwood remained in the Hammond-Harwood House, with the trains rumbling along side it, until her death in 1924.[220]

For slightly more than a quarter-century, trains did run through the streets of Annapolis. After years of flirting with the idea of trains through town, and a couple of aborted agreements with other rail lines, the City Council gave a twenty-five-year franchise to the Washington, Baltimore, and Annapolis company in June 1907.[221] Construction of trackage through town began in October, and the WB&A relocated its terminal from the old wooden station on West Street to a new, smaller brick station at the corner of West and Calvert.[222] When asked his opinion of the proposed trolley system, George T. Melvin, former developer and now president of the Annapolis Bank and Trust Company, gave his enthusiastic approval. "Of itself this will bring many desirable people here either as sightseers or as permanent residents and will open for Annapolis a new era which can not prove otherwise than stimulating not alone to trade and industry but to social and home life."[223] Anne Burton Jeffers and her friends did not agree, and eventually, most of the rest of the town didn't either.

Beginning in April 1908 trolleys and interurban trains of the Washington, Baltimore, and Annapolis Electric Railway traveled down West Street, around Church Circle, down Main Street and across Market Space to Randall Street, up Randall to King George and down College Avenue back to Church Circle and West Street.[224] The city's first trains ran on a new system of single-phase alternating current from high-voltage overhead wires. The large interurban passenger trains traveled the loop through town, stopping at the Naval Academy and the governor's mansion as well as the West Street station. Trains left Annapolis hourly for Baltimore from 5:30 a.m. to 8:30 p.m., with a last train at 10:30 p.m. The Baltimore to Annapolis trains began at 6:45 a.m. and ran each hour until 9:45 p.m. The last train left Baltimore just before midnight. Passengers bound to Washington transferred to the WB&A's Baltimore-Washington interurban route at Naval Academy Junction. The trip to Baltimore took an hour; to Washington, fifteen minutes more. In between the big-city runs, little local streetcars made their circuit around town every fifteen minutes. The inner-city fare was a nickel, three cents for children — the equivalent of an amusement park ride in every child's backyard.[225] Suddenly Annapolis was all trains, all the time. During the first five months of service, a monthly average of 31,000 adults and 1,400 children traveled the tracks of Annapolis. Not until September did the novelty wear off, at least for adults. The city garnered more than $1,100 in franchise taxes in the first six months.[226]

The WB&A experiment with alternating current quickly proved a poor choice, and in 1910 the company converted to the more commonly used direct current. One of the streetcars was modified for the new power, and the line was extended briefly to Parole; but after a couple of accidents with the heavier interurban passenger and freight trains, streetcar service closed in 1914. The interurban trains continued to make the circuit through town on their regular schedule.[227] Evangeline White remembered life in town with the big trains: "Buildings all along the line trembled and shook, pictures were always jarred to crooked positions on the walls, and in every instance the noise of squeaking rails and air-

The first train to run through downtown, shown here on Church Circle, arrived on 25 March 1908 filled with celebrities for ceremonies opening the WB&A Electric Line. Regular service began on 3 April with trains circling the town hourly during the day on the intercity route to Baltimore and Washington. Courtesy of the Maryland State Archives, MSA SC 1890-2496.

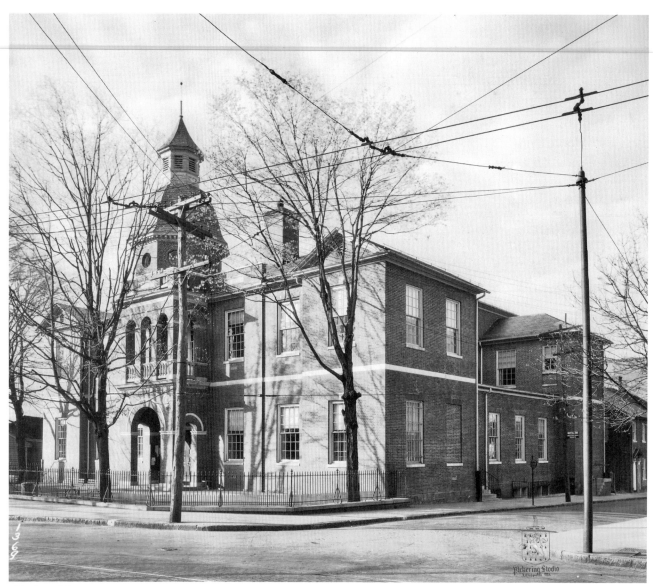

This view of the Anne Arundel County Courthouse, which had been renovated and enlarged in 1892, shows the additional wiring required by the new electric interurban trains that began running in 1908. Courtesy of the Maryland State Archives, MSA SC 1804-2-53.

compressed brakes added to the din and unhappiness of our people."[228] Anne Jeffers had warned them.

The Annapolis Short Line Railroad, now owned by the Maryland Electric Railway Company, also electrified its line in 1908, offering forty-five-minute travel to and from Annapolis and Camden Station in Baltimore every half-hour during the day.[229] As had been the case since its inception, the Short Line's comparatively quick travel time and night-time freight service made it a popular alternative to the WB&A. Businessmen in Annapolis could order goods from Baltimore in the afternoon and expect shipment the next morning; iced cars brought perishables safely and speedily to local stores.[230] The Short Line's experiment with alternating electricity lasted until 1913, when the railroad was converted to 1200-volt direct current. The two railroad lines merged in 1921 under the WB&A name.[231]

Once they saw their city firmly linked to the national hubris of the new century, Annapolis residents could acknowledge with pride the beginnings of their "ancient city." The new construction, electric rail service, increased population, and bustling commercial climate had removed the "finished city" stigma of earlier years. Now, they believed, Annapolis would move into the mainstream of twentieth-century America with confidence in its continued prosperity. It was time to throw a party. And what better occasion to celebrate than the bicentennial of the city charter? After all, Annapolis was one of the oldest cities in the nation and, because industry had passed it by, it had a number of colonial buildings still around. Now that they didn't have to be embarrassed about their lack of progress, Annapolitans were ready to capitalize on it.[232]

Spearheaded by Mayor Gordon H. Claude, a mass meeting in the new House of Delegates chamber of the enlarged State House in November 1907 revved up the excitement and allowed attorney J. Wirt Randall to give everyone the historical background.[233] Committees of the Annapolis Charter Bicentennial Association planned events for the "Bicentennial Big Boom:" speeches, parades, music, and the dedication of an elaborate Toleration Monument to be placed in the circle park near the market. They decided on a three-day celebration, from Saturday 21 November to Monday 23 November, and invited the entire state and just about every public official they could think of to participate.[234]

The Toleration Monument seems to have been the idea of J. Wirt Randall, who recommended a public fountain and whose committee contracted with Baltimore architects Wyatt and Nolting and sculptor Hans Schuler for the design. The City Council paid for digging an artesian well under the monument from which pipes would carry water to a "seven foot granite drinking basin for horses."[235]

Local businesses, organizations, and individuals contributed funding for the event and the railroad companies offered special trains at reduced fares so that people from miles around could attend.[236] The *Evening Capital* published the huge, aptly named *Historical and Industrial Edition*, with photographs and biographies of most of the major businessmen in town and glowing descriptions of their establishments.[237]

Annapolis "never exhibited a more festive appearance," as the birthday events began on Saturday 21 November with speeches at the State House. Dr. Bernard C. Steiner, eminent Maryland historian and librarian of the Enoch Pratt Free Library, gave the keynote address, and Governor Austin Crothers promised to build a "wide and ample boulevard" to the city from Baltimore. Football games — Navy versus Virginia Polytechnic Institute at the academy, and St. John's against Johns Hopkins University at Baltimore — drew crowds of spectators, while other visitors roamed the town and visited a special contingent of warships anchored at the mouth of the Severn. (Decisive victories by both local teams added to the celebratory spirit of the day: St. John's blasted Hopkins 11 to 4; the academy overwhelmed VPI 14 to 5.)[238] Sunday's program featured religious observations in each of the city's churches and an afternoon service at St. Anne's with the Reverend J. Nevitt Steele of Trinity Parish in New York City preaching. Descendant of an old Annapolis family, Reverend Steele was the president of the Maryland Society of New York.[239] Locals must have been especially gratified by a full-page spread in Sunday's Baltimore *Sun*, which summed up their city's new attitude: "A new and progressive spirit is animating [Annapolis] people. While realizing that an interesting historical past is a good heritage and one of which to

Sculptor Hans Schuler produced this design for a public drinking fountain at the foot of Main Street to commemorate the first settlement of Annapolis. Fed by an artesian well and featuring figures representing the religions of 1650: Roman Catholic, Puritan, and Church of England, the structure would be topped with a large lighted globe. The well was dug and water piped to a nearby hexagonal granite trough for horses but the fountain itself remained a dream. Courtesy of Michael P. Parker.

be proud, it is also realized that this is an age of achievement and that the future of the City of Anne is in the hands of her citizens." The paper noted that $1 million of the city's $4 million taxable base had been added in the previous ten years.[240]

Monday, 23 November, was "the greatest day in the history of Annapolis," exulted the *Evening Capital*, and the streets "were so densely packed that passage was nearly impossible." Thousands of Marylanders and former city residents joined locals at morning ceremonies dedicating the cornerstone of the new fountain and watched as more than a thousand school children, followed by city officials, paraded from Green Street around Church Circle to Prince George Street before ending at Market Space and the fountain location. Even kindergartners marched in time to the Naval Academy band, and all wore black and gold sashes.

In the afternoon another parade of more than 3,000 men "eclipsed anything that has been seen in Annapolis in many years." Eight hundred midshipmen in blue contrasted with two hundred St. John's cadets in gray as they, Annapolis fire departments, and men of the Fourth and Fifth Regiments of the Maryland National Guard stepped out to the music of three bands and the cheers of onlookers. Another parade in the evening featured civic and fraternal organizations, confetti, and "the omnipresent feather tickler" offered for sale by street vendors. The *Sun* noted, "Staid and dignified matrons forgot their dignity and elderly men even took a hand in the general good time." Above them draped strings of "varicolored electric lights," the modern equivalent of the candle or gaslight illuminations of centuries past. The day ended with the ritual ball and supper at the "handsomely decorated" Assembly Rooms, given by the Junior Order United American Mechanics.[241] It was, all in all, a most glorious event.

In contrast to the torpor that followed the Revolutionary War, Annapolis rose from the turmoil and distress of the Civil War with new energy and anticipation, ready to grasp the technological advances of the period. Increased municipal responsibility, industrious newcomers, and attention from federal and state governments benefited local businesses and encouraged a sense of well-being. During this period, Annapolis took on much of its twentieth-century appearance, with construction of the new Naval Academy and state buildings, residential infill and development downtown, and the new suburbs outside the city. Improvements in social and political opportunity suggested that at some time, still to come, all citizens might play an equal role in the life of their town. Their postwar expectations largely fulfilled, residents could look forward with confidence to the third century of their chartered city.

Promise Denied 1908 to 1940

To be sure, 1908 was a momentous year in the life of Annapolis, a year of satisfaction and celebration — for its white citizens. For the city's African Americans, 1908 marked the arrival of local Jim Crow legislation that destroyed for years any hope that they might share equally in the benefits and prosperity of their town.

During the first decade of the twentieth century, Maryland succumbed to the tide of racial discrimination that was sweeping the South. This was a period of intense party politics, and after four years of a Republican governor (Lloyd Lowndes, 1896 to 1900) and the growth of Republican influence throughout the state, Maryland's Democrats saw codified subjection of the African-American voter as their way to regain political power. As their successful 1903 platform put it, the Democratic Party intended that the "political destinies of Maryland should be shaped and controlled by the white people of the State."[1] The General Assembly of 1904 passed an amendment to the state constitution that made proof of understanding of that document a suffrage requirement for any male who could not vote before 1 January 1869 and his male descendants.[2] Thus the term "grandfather clause": if your grandfather couldn't vote before passage of the Fifteenth Amendment, you might not be able to vote either. The same Assembly passed similar charter amendments for the cities of Frederick, Snow Hill, and Crisfield.[3]

The state constitutional amendment failed ratification in 1905 by 60 percent of the vote (68% in Anne Arundel County). Undeterred, the 1908 Assembly passed another, similar amendment, but this time allowing men to escape the grandfather clause if they or their wives owned $500 worth of property.[4] Applying this concept to Annapolis, Anne Arundel County delegate A. Theodore Brady introduced into the House in March 1908 a bill to change the voting qualifications in the city's charter. The bill passed the House unanimously and was sent to the Senate, where, shepherded by county senator James A. Brashears, it was approved by fifteen of the twenty-three senators voting.[5] Signed into law by Governor Austin L. Crothers on 8 April 1908, this amendment to the city's charter extended the right to vote in municipal elections to males twenty-one years and over who had lived in the city for one year and who met at least one of three qualifications: (1) owned $500 worth of assessed property in the city, (2) were naturalized citizens or the sons of naturalized citizens, (3) were entitled to vote in Maryland or any other state before 1 January 1868 or were the lawful descendants of men who were entitled to vote on that date.[6] Since the city's municipal franchise in 1868 linked to the 1867 state constitution, which gave suffrage only to white males, the city's new grandfather clause effectively disfranchised African-American residents who did not own assessed real or personal property valued at $500.[7] According to the *Afro-American Ledger*, fewer than 100 of 800 previously qualified "colored" voters could meet the new property requirement.[8] Among the fortunate were incum-

bent African-American alderman J. Albert Adams, with property on the tax rolls valued at almost $7,500, and Wiley H. Bates, with property worth well over $6,000.[9]

Registration under the new law took place in June 1909, just in time for the next municipal election in July. Charles E. Myers, Clarence M. Jones, and A. Claude Kalmey served as registrars for Ward 3.[10] Among the men denied registration by Myers and Kalmey, but not, apparently, by Jones, were John B. Anderson, Robert Brown, and William H. Howard. All met legal age and residence requirements, but none of the three had property on the city's assessment rolls, and none of them qualified under the grandfather clause. Anderson was a Civil War veteran of both the U.S. Colored Troops and the U.S. Navy, who could have voted in 1868 had he been white. Brown, a whitewasher, held that his father could have voted in 1868 but for his color. Howard, an attorney admitted to the Anne Arundel County bar in 1901, argued that his grandfather could have voted in 1868 had he not been black.[11]

Given that few, if any, African Americans voted in the city election on 12 July, it is not surprising that Ward 3 lost its black, Republican alderman. Instead, registrar Charles E. Myers, a Democrat, took his seat.[12] Black voters were not disfranchised under state law, and when the state grandfather-clause amendment came up for ratification in the general election of November 1909, Republican leaders made sure their people knew how to vote it down. The county passed the amendment by only 182 votes out of 4,430 cast, and the *Evening Capital* reported, "The negro vote has been schooled and drilled almost nightly . . . and piled up its mass of ballots against the measure." The amendment lost statewide by 54 percent of the vote.[13] The General Assembly passed a third disfranchising amendment in 1910, but in November 1911 it was rejected by 64 percent of the voters (74% in Anne Arundel), who confirmed their disgust by also electing a Republican governor.[14]

One of the most vehement opponents of the state disfranchising amendments was attorney and reform leader Charles Jerome Bonaparte of Baltimore. Grandson of Jerome Bonaparte, King of Westphalia, and Betsy Patterson of Baltimore, and grandnephew of the Emperor Napoleon, Bonaparte took time from his positions as secretary of the navy and, later, U.S. attorney general in the Theodore Roosevelt administration to return to Maryland and lobby against the General Assembly's attempts to circumvent the national constitution.[15] When Republican activists decided to take the Annapolis charter amendment to court, Bonaparte was a logical standard bearer. In 1910, he joined local attorney J. Wirt Randall, president of Farmers National Bank and former delegate and state senator, and Baltimore lawyers Edgar H. Gans and Edwin G. Baetjer as counsel for Anderson, Brown, and Howard in their suits against the registrars Myers and Kalmey. The cases were heard in the U.S. Circuit Court for the District of Maryland in October 1910, with Annapolis city counselor Ridgely P. Melvin and Baltimore attorneys William L. Rawls and William L. Marbury as counsel for the defendants. The plaintiffs won with the argument that the Annapolis charter amendment was antithetical to the Fifteenth Amendment to the Constitution of the United States.[16]

Showing typical Democratic persistence on this issue, Counselor Melvin and his colleagues appealed to the U.S. Supreme Court. Representing Anderson, Brown, and Howard in Washington were Daniel R. Randall, who replaced his deceased half brother, Edgar H. Gans, and the young Morris Soper, who later spent forty years of his sixty-year legal career as a respected judge on state or federal benches.[17] The Supreme Court heard arguments in the Annapolis case in November 1913 at the same time that it considered similar disfranchising legislation by the state of Oklahoma. Both appeals were struck down on 21

June 1915. The Fifteenth Amendment took precedent over state and municipal law; the grandfather clause was unconstitutional.[18]

In Annapolis the immediate result of the high court's decision was the registration of black voters and subsequent reelection of J. Albert Adams to the City Council in July 1915.[19] But race relations already had been irreparably damaged as patterns of discrimination in the city hardened under public legislation and private prejudice. Maryland laws in 1904 and 1908 required steamboat owners to provide separate sleeping, dining, and rest room facilities for black travelers.[20] The new electric interurban trains and trolleys in Annapolis were legally integrated for exactly ten days in April 1908 before the legislature passed a law requiring separate cars for "colored" passengers in five counties, including Anne Arundel.[21] Deed covenants in Spa View Heights and on the Redemptorist property across from St. Mary's Church prohibited the sale of property to blacks.[22]

Over time, entertainment venues, eating establishments, and public drinking fountains and rest rooms became segregated. Educator and author Philip L. Brown detailed African-American life in *The Other Annapolis, 1900–1950*. He noted that, although black households continued to be scattered throughout the old city, as the years went on, separation by race increased. Some African Americans accused local real estate agents of changing the policy of intermixed neighborhoods that had existed for centuries. "They seemed to practice a system of preventing 'coloreds' from buying properties in areas not already inhabited by 'coloreds,'" wrote one. As the Clay Street corridor developed in the first decades of the new century, many black families moved to what Brown termed the "Harlem of Annapolis."[23]

Although divided by race, citizens of the city could come together in times of crisis or general concern. One of these was the cause célèbre of John Snowden, a black man convicted of murdering a pregnant white woman named Lottie May Brandon at her home on Second Street (now Lafayette Avenue) in August 1917. Snowden steadfastly maintained his innocence during his trial in 1918, an appeal by his attorney, A. Theodore Brady, and the last-minute attempts to commute his death sentence. Those pleading with Governor Emerson C. Harrington for clemency included at least seventy prominent white businessmen and civic leaders. Within the white community, Snowden's cause was also championed by Ella Rush Murray, wife of one of the Murray heirs of Acton, whose cook's daughters had given initial evidence against him. Mrs. Murray hired a female attorney from New York, recommended to her by Charles J. Bonaparte, to investigate the case.

In a formal statement made the day before his death, Snowden reaffirmed his innocence. Reprieve efforts by black and white Annapolitans came to naught, and John Snowden was hanged in the yard of the Calvert Street jail on the morning of 28 February 1919. Fearing trouble, Governor Harrington had posted National Guard troops throughout the city, but there was no rioting, no disturbance in the town, just the prayers and hymns that accompanied Snowden to the gallows. Three days after Snowden's death, the *Evening Capital* printed a letter from an anonymous man confessing to the murder.[24]

J. Albert Adams, by turns blacksmith, funeral director, liquor dealer, and alderman, owned property on the west side of College Creek and entertained notable African Americans at his summer home there. Evening Capital Historical and Industrial Edition, May 1908. Courtesy of the Special Collections and Archives Department, Nimitz Library, U.S. Naval Academy.

Harlem in Annapolis

Annapolis's old Fourth Ward was technically a political creation. In reality, it was far more. The ward was the heart of black Annapolis, pulsing with energy and life through the early 1900s, the Roaring Twenties, the Depression. Three generations of African Americans created a close-knit community where everybody knew everybody. No one locked their doors and neighbors gathered regularly on front porches along Clay Street. Many in the ward were homeowners.

Churches were the community's soul, a source of solace and aid in hard times. And times were hard. Poverty was a fact of many lives. But people made the most of what they had. Being part of a family and a community gave them the dignity, self-respect, and independence the world outside did not. Achievements at the Stanton School were a source of pride, a key to success.

Entrepreneurial spirit thrived in dozens of black-owned businesses. Most necessities were within walking distance. The doctor's office, pharmacy, midwife, undertaker, barber shops, hair dressers, dry cleaners, tailor shop, two supermarkets, Susie's Tea Room, Happy Brooks's Luncheonette — all are gone now, replaced by government buildings and a parking garage.

The Fourth Ward was also a crossroads of African-American culture that extended far beyond city boundaries. During the first half of the twentieth century, the ward enjoyed a cultural heyday that led black educator and historian Philip Brown to call it Annapolis's Harlem.

By the 1920s, the ward had Anne Arundel County's only black movie house. Sam and Lena Eisenstein's Star Theater was one of several Jewish businesses serving the community. Nighttime crowds kept the Waltz Dream Ballroom and other night spots jumping. They enjoyed local and national talent that most other blues and jazz lovers traveled to Washington, Philadelphia, or New York to hear. Before her debut at New York's Apollo Theater, Pearl Bailey was belting out songs at Eudie Legum's Washington Hotel. And at the Wright Hotel, Duke Ellington, the Harlem Dictators, Ella Fitzgerald, Sy Oliver, and the Van Dykes performed with style in the Harlem of Annapolis.

ANN D. JENSEN
Annapolis author

As construction of the new Naval Academy buildings in Annapolis wound down toward the end of the century's first decade, the navy began building a research laboratory on ten acres of Greenbury Point, across the Severn. Research and development were not new activities on the river. Early experiments with steam engines took place at Annapolis shortly after the Civil War, and the Naval Experimental Battery had tested ordnance from the site of Fort Madison from 1872 until 1892, when it moved its window-rattling guns to the less populous Potomac River, at Indian Head. USS *Holland*, the navy's first successful experimental submarine, operated in the Chesapeake while based at Annapolis from

1900 to mid-1905.[25] The U.S. Naval Engineering Experiment Station (known locally as the experimental station) opened on Greenbury Point in August 1908. Its mission was applied "research and development, evaluation and testing" of materials and equipment used aboard naval vessels. The lab also presented an opportunity for midshipmen and postgraduate naval engineers to gain experience in a laboratory setting. Early work at the lab included the testing of machinery, fuels, lubricants, and metals. By 1913 the lab employed about sixty people—mechanical engineers, chemists, draftsmen, machinists, metal workers, assistants, and clerical staff—under the supervision of three naval officers. Because their work resulted in critical improvements to the fleet, the lab's responsibilities and personnel increased over the years, bringing both skilled and semi-skilled jobs to the Annapolis area.[26]

Three years after the Engineering Experiment Station got under way, local residents gaped as small, flimsy biplanes buzzed their town, now the home of the navy's first Naval Air Station. When initial flight tests elsewhere in 1910 and 1911 proved to navy officials that aviation could become an important complement to the fleet, the government ordered one plane from the Wright brothers and two from Glenn Curtiss, one of the latter a hydroplane. Three recent graduates of the Naval Academy were tapped as the service's first aviators; Lieutenant John Rodgers went to Ohio to learn on the Wright plane, and Lieutenants Theodore Ellyson and John Towers trained at Curtiss fields in California and New York. In the fall of 1911, the three men, their planes, and the enlisted men who had been schooled as the navy's first airplane mechanics arrived at the new aerodrome on Greenbury Point. The proximity of the Experiment Station, which could test airplane parts and perform aeronautical experiments, was a big factor in the navy's selection of the Severn River location. During the summer of 1911, workers had dodged stray bullets from the mids' rifle range across Carr's Creek as they cleared trees and bushes from about sixty acres of land and built a huge wooden hangar for the three planes. Test flights from the Greenbury Point field ranged up and down the Bay, with aviators trying out radio communications and setting records for air time and altitude. Buckets of burning gasoline in rowboats anchored along the flight path lighted night landings. Design and testing of a compressed-air catapult to launch a plane from the deck of a ship was one of a plethora of aviation firsts accomplished at the Naval Air Station, Annapolis. In the end, the facility's success was its undoing. The aerodrome soon merited expansion, and, after the harsh winter of 1911–1912 forced a temporary move to sunny San Diego, the navy felt that an all-weather location would best serve its needs. In the fall of 1913 the operation relocated to Pensacola, Florida.[27]

A second local naval experiment, short-lived in Annapolis but a success elsewhere, was the academy's dairy farm. When a serious outbreak of typhoid fever hospitalized twenty-nine midshipmen in the fall of 1910, the secretary of the navy ordered an investigation of the academy's food suppliers and food service personnel. The report of the examining board, dated 5 January 1911, identified milk supplied to the academy as a probable source of the infection and recommended that "the Naval Academy should own and control a suitable herd of cows and dairy." The principal source of the academy's milk at that time was the 95-cow dairy of C. E. Remsen on Greenbury Point.[28] The academy's commissary officer, Samuel Bryan, immediately began looking into dairy management and within ten months had established a model dairy with 120 cows on land formerly occupied by the "Porter's Folly" hospital. Gastrointestinal disorders amongst midshipmen dropped dramatically. The dairy's success demanded a larger operation, and in 1914 it moved to a new facility at Gambrills. Milk was transported to the academy daily by WB&A trains.[29]

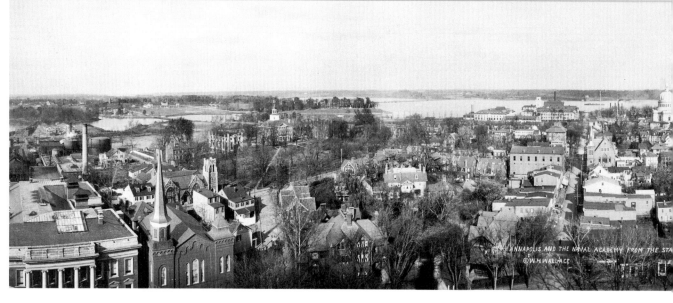

ANNAPOLIS AND THE NAVAL ACADEMY FROM THE STA
©W.H.WALLACE

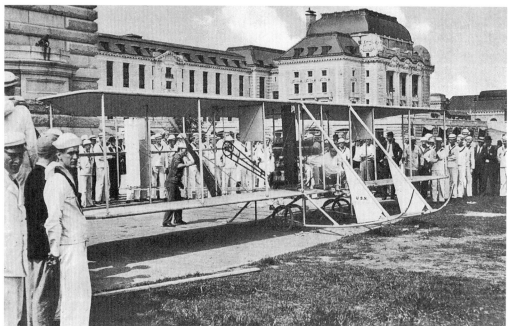

Lt. John Rodgers, USN, made the first flight over Annapolis on 7 September 1911 from Farragut Field at the Naval Academy. He is shown here, seated in the Wright biplane behind the new Bancroft Hall. Courtesy of Randall W. Bannister.

Finally, in 1913, entered an academy-based facility that would remain, at least for another thirty-eight years. The Naval Postgraduate School was not a new concept; for years the navy had offered additional education to academy graduates, sometimes at the academy. Now, however, all courses were combined under the direction of Commander John Halligan, Jr., whose faculty would prepare sea-hardened officers for advanced engineering courses at leading universities. The school took over the 1903 Marine Barracks, near the academy hospital, which were later named in honor of Halligan.[30]

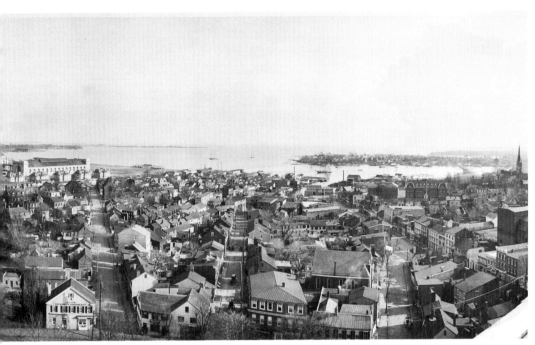

By the time W. H. Wallace made this photograph, in 1911, construction of the new Naval Academy buildings designed by architect Ernest Flagg was essentially complete. The elaborate dome of the new academy chapel rivaled the State House dome (from which this shot was taken) on the city skyline. Courtesy of the Library of Congress.

Annapolis was generally pleased with the navy's increased presence, except for one aspect: because of the navy, Prohibition came to Annapolis almost two years ahead of the rest of the country. Not that temperance was a new concept in town. The temperance movement of the nineteenth century had attracted many local advocates, especially among Methodists and Baptists. But the sale and consumption of alcoholic beverages remained a firm component of Annapolis life. In 1913, for instance, the city issued thirty-five liquor licenses to saloons (9), restaurants (14), hotels (9), and lodges (3). With a population of around 9,000 people, this meant one licensed retailer of spirituous liquors for every 260 people, or one for every 57 of the estimated 2,000 voters.[31] And it appears that about two-thirds of those voters appreciated the opportunity to imbibe. When the state allowed a "local option" vote on Prohibition in the November 1916 general election, Annapolis men voted 1,075 to 611 to keep the town wet; Prohibition lost in every ward. The most vehement proponents of a dry city seem to have been women, who were, of course, not allowed to vote. On the day before the 1916 election, pro-dry white women, dressed in white and wearing white caps, marched through Annapolis carrying banners "embellished with sharp phrases and other things, setting forth their cause." In a separate event, African-American women, children, and Boy Scouts "made a fine showing" as they paraded, the young girls on horseback and small children in "a large automobile truck," with floats and flags, singing all the way. After the parades, participants gathered at an open-air rally in front of Asbury Methodist Church, where "the white and colored folks of the city mingled together in the course of the evening's demonstration."[32]

In a startling use of electricity, blinking street lights broadcast results of the 1916 election throughout the area. Residents of Annapolis, Germantown, Eastport, and West Annapolis had only to look out their windows, and remember the code printed in the *Evening Capital*, to see who would be the next president and whether or not they could raise a glass to celebrate. Woodrow Wilson won the vote and was, presumably, toasted appropriately.[33]

Other sections of the country continued to fight for Prohibition, and in December 1917

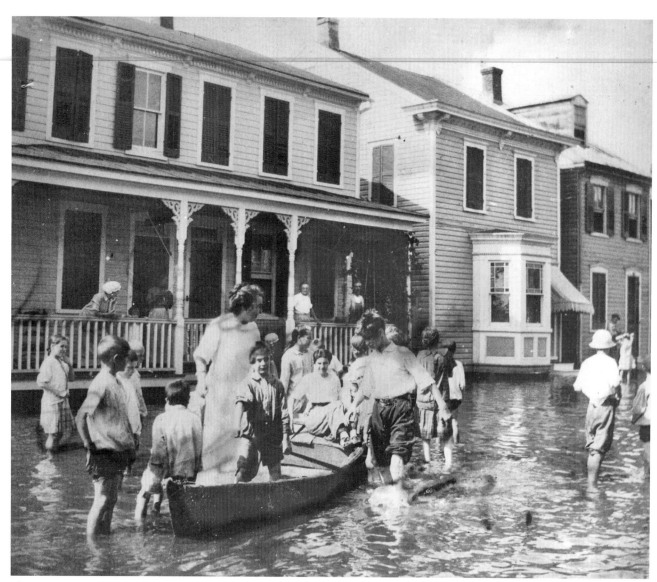

The worst storm in memory hit Annapolis on 3 August 1915. Exceptionally high tides floated bodies in the cemetery and flooded the dock area. These intrepid seamen are on lower Prince George Street. Courtesy of the Maryland State Archives, MSA SC 2140-1-303.

Congress sent the Eighteenth Amendment to the states for ratification. Maryland's General Assembly not only ratified the national amendment but also considered a bill of its own that would have the same result.[34] The House voted down the statewide bill on 6 March 1918, but in a matter of hours Secretary of the Navy Josephus Daniels, invoking "war-time regulations," ordered saloons in the state's capital city "closed for the duration of the war." His action apparently surprised Naval Academy officials as much as it did the townspeople; Superintendent Admiral Edward W. Eberle denied having made any complaints.[35]

Daniels's decree extended to saloons, hotels, restaurants, and private clubs within a five-mile radius of the city; no liquor could be brought into town, not even for household use. That Annapolis was one of eight cities with permanent naval installations affected by the secretary's order was cold comfort to local officials, who bemoaned the loss of $10,000 in annual liquor licenses. The president of the county commissioners predicted, "Hundreds of men working in Annapolis now on the big government contracts . . . will vacate their boarding houses here and move to Baltimore." A sign on one local saloon read, "Don't ask

me what I'm going to do; what the hell are *you* going to do?"[36] The town went dry at 4 p.m. Saturday 16 March 1918, "in a thoroughly dignified manner," said the *Evening Capital.* Charles Weiss, prominent saloon owner and dealer in spirits, left for an extended stay with his daughter in New York.[37]

Although the navy secretary's edict extended only until the end of the war, by that time the Eighteenth Amendment was the law of the land. Its enforcement legislation, the National Prohibition (Volstead) Act, went into effect 1 February 1920.[38] After passage of the Volstead Act, the Annapolitan Club adjusted its membership rules to welcome naval officers to the clubhouse on Franklin Street, where they could enjoy the popular mint juleps prepared by chief steward Joseph Duvall, son of the academy superintendent's coachman.[39] When the Twenty-first Amendment came up for ratification in Maryland, on 12 September 1933, Annapolis voters gave it a whopping 83 percent majority. The county followed suit, with every district going for repeal.[40]

Those "big government contracts" mentioned by the county commissioner in March 1918 resulted mainly from America's entrance into The Great War in April 1917. Although the Naval Academy graduated its 1917, 1918, and 1919 classes early, it dramatically increased plebe enrollment during the war years, and construction began on two new wings that would enable Bancroft Hall to accommodate 2,200 midshipmen. At the same time, a total of 2,000 reserve naval officers lived in temporary barracks as they rotated through the yard for refresher courses before going to sea.[41] Across the Severn, where the flight school had been, the navy built a radio transmitter facility, one of several along the East Coast designed to maintain communication with Europe even if the enemy cut undersea cables. Four 500-foot towers were erected in 1918 to support a square antenna 1,600 feet in length. The 500-kilowatt transmitters went into service in September 1918. Skilled ironworkers came to town for an hourly wage of 75¢; one of them, twenty-one-year-old Tommy Mullaney from New York, died after falling 300 feet to the ground. His fiancée, student nurse Lillian Simmons, collapsed in grief when Tommy's fellow workers carried his broken body into the Emergency Hospital.[42] In addition to jobs at the Annapolis naval complex, local men found employment an easy train ride away at Camp George G. Meade, which opened near Odenton in 1917 to process recruits, or at Saunders Range, the marksmanship training camp near Glen Burnie.[43]

Anne Arundel County counted more than 2,300 men in military service during the war. Although two-thirds of them were attached to the army and a few were marines, the county's navy contingent (768) was second in number only to Baltimore City and County, both of which had populations far in excess of Anne Arundel's. Not surprisingly, most of the county's naval force, both white and black, were career men: officers, pharmacy or commissary mates, marines, and sailors attached to the academy.[44] Just over a thousand county men joined the regular army, either voluntarily or through the draft; most of the remaining five hundred or so soldiers were members of the National Guard. Men of Annapolis in Company M and the Machine Gun Company of the First Regiment, Maryland National Guard, were mustered into federal service in the summer of 1917 and attached to the 115th Infantry, in the 29th Division of General John J. Pershing's American Expeditionary Forces in Europe. After training at Camp McClellan, Alabama, the guardsmen went overseas in June 1918. They spent two months in the trenches near the Alsace-Swiss border before being ordered to the Argonne sector of the Western Front where they faced a well-entrenched line of Ger-

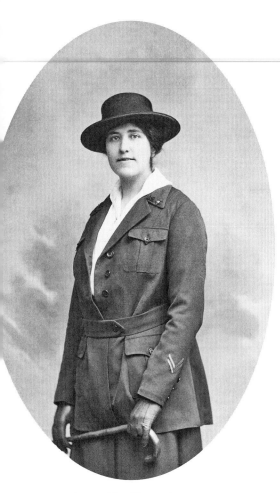

Annapolitan Margaret Wohlgemuth, U.S. Army Nurse Corps, was stationed in France for almost two years. She returned to her position as superintendent of nurses at the Emergency Hospital in 1919. Courtesy of Peg Burroughs.

man machine guns. Writing home from a captured German dugout during the Meuse-Argonne offensive of October 1918, the 115th's commander, Colonel Milton A. Reckord, said, "We have been through all the hell I ever expect to see."[45] Infantry private first class Jacob Pindell got married soon after he returned home to Anne Arundel County in 1919. When their first child was born, in January 1921, the new parents named their son France America, because, explained that son, "my father went to France and came back to America and they were so happy he wasn't killed in the war."[46]

Of the sixty-nine Anne Arundel County servicemen who lost their lives in the war, thirty of them had given their home address upon enlistment as Annapolis or its suburbs. They were the sons of a butcher, a baker, a waterman, farmers, Orphans Court judges, a state senator, a tailor, a Confederate Civil War veteran. Almost 75 percent of them died of disease, most often pneumonia, a complication of the Spanish influenza pandemic, which was more fatal to Allied servicemen in 1918 than were the Germans. Six guardsmen from Annapolis, serving under Colonel Reckord, died in action in the ravaged Meuse-Argonne sector in October 1918.[47]

In September 1918, local physicians J. Oliver Purvis, Walton Hopkins, and Frances Weitzman volunteered for the army medical corps. Drs. Purvis and Weitzman served briefly in the states, but Dr. Hopkins spent six months at a base hospital in France. Nurses Margaret Wohlgemuth and Mary Sedlacek joined the Army Nurse Corps and left in May 1917 for France, where they worked in American hospitals for almost two years.[48]

Men, women, and children at home did all they could for the war effort. Red Cross committees made dressings, sewed hospital garments, knit sweaters, scarves, belly bands, and socks, and collected linens for hospitals in France and clothes for Belgian refugees. The War Camp Community Service organized dances and other recreational activities for servicemen at the new Bladen Street Armory. The Woman's Land Army encouraged victory gardens; children at Green Street grammar school cut gun wadding and collected bottles for recycling. Boy Scouts and city committees of the county's Liberty Loan Committee sold war bonds — "Liberty Loans" — and *Evening Capital* headlines routinely urged residents to buy bonds and, in October 1918, to "Give the Hun the Final Blow."[49]

St. John's College, which had offered a military program for more than thirty years, was designated a unit of the Student Army Training Corps (SATC), and young men from across the country came to Annapolis for officer training at the school.[50] Many households rented rooms to service personnel, construction workers, and their families. By early 1919 the town was so full the *Evening Capital* begged people to take in boarders. "There is today such a demand for rooms or even 'a' room as Annapolis has never experienced — not even in the days when the 'new Naval Academy' was being built."[51]

In September 1918 there came into this mix of students and townspeople and military men, each with his or her own personal fear and anxiety over the war, a new cause for worry: the killer influenza. Brought to the East Coast that month by soldiers returning from Europe, the disease followed them home to cities large and small across the nation. During September and October almost 11,000 people died in Philadelphia, 4,500 in Pittsburgh, 3,100 in Washington, D.C. Experts estimate the death toll in the U.S. at more than half a million, perhaps 100 million worldwide. Overall, the influenza "killed more humans

than any other disease in a period of similar duration in the history of the world."[52]

In Annapolis the academy seems to have been struck first. By 21 September there were thirty-three midshipmen in the Naval Hospital with the flu and academy officials had put the yard under quarantine.[53] On 2 October, 288 children at the grammar school were infected and sick teachers couldn't find substitutes; the next day, city health officer Dr. William S. Welch closed city schools. Lines at Green's Drug Store stretched down Main Street as people waited an hour and a half for their prescriptions. "Such a thing was never known in Annapolis before," said the *Evening Capital*, "the town is full of sickness." The Emergency Hospital prohibited visitors. People died. For days the newspaper printed columns of the names of the sick. "Everybody was down with it," remembered Jack Flood, who as a child had watched the funeral procession for nineteen-year-old seaman Joe Daniels from his house next door on Market Street.[54] "People were absolutely frightened to death; it was so sudden," said Tom Worthington, whose mother had been sick with influenza but recovered.[55]

Movie theaters, pool rooms, and other public venues were closed on 7 October, and county schools two days later. Now the newspaper carried obituaries: a wife, a mother, local servicemen at Camp Meade (2), navy men who lived in town (3), SATC men, nurses at the Naval and Emergency Hospitals (2). Often these obituaries mentioned, in seeming denial, the former health of the victim — a "strong, husky young fellow," a boy "strong and robust" — because this was a disease that preyed upon not just the very old and the very young, as was usual with influenza, but upon "the strongest members, the most robust members of our society."[56]

On two Sundays in mid-October no bells rang; the town's churches were closed. The pastor of Mt. Moriah asked his congregation to pray at home.[57] Yet, on one of those Sundays, in the midst of sickness and death, indefatigable Liberty Loan Committee women and Patriotic League girls canvassed the city for war bond subscriptions, ringing every door bell. At least one of them ended up in bed with the flu.[58] The "mere handful" of physicians still in town were seeing as many as a hundred patients a day, and Drs. James J. Murphy, Joseph C. Joyce, and John Russell of Eastport all came down with the illness.[59] William Oliver Stevens, then a professor at the academy, wrote that Annapolis was "literally, a stricken city." He walked up East Street past the "heap of new coffins piled up on the sidewalk and in the street itself," probably waiting for use by James Taylor and Sons, whose funeral business was then on Fleet Street.[60] In the night quiet, residents of the second block of West Street could hear the thump, thump of hammers as carpenters nailed up coffins for Ellen Parker's undertaking establishment across the street. Two of the city's funeral establishments, Taylor's and B. L. Hopping, prepared 130 bodies for burial in October and shipped thirty-nine of them to "nearly every state in the Union." One local church had forty-five funerals that month.[61]

A total of 1,800 naval personnel and dependents, including more than half the 2,118 midshipmen, had been treated at the Naval Hospital by mid-October, but only twenty-eight died. At the end of the month, Dr. Welch tallied 151 people in Annapolis, Eastport, Germantown, West Annapolis, and the academy dead of the influenza itself or the pneumonia that so often followed it — ten times the normal death rate. The *Evening Capital* predicted that "when the record for the year 1918 is recorded in the history of Annapolis, there will be written on its pages the gruesome account of deaths for one month, which are unparalleled in the annals of this community."[62] It has been done.

Just as people were beginning to recover from the influenza onslaught, news from

France trickled in and nine Annapolis families received the dreaded letters telling them that while they were fighting for their own lives here, their sons and brothers and husbands had lost theirs over there.[63] And then, suddenly, the war was over.

News of the armistice agreement reached Annapolis on 7 November 1918, and everyone who could make a noise did so. Whistles blew, sirens shrieked, church and fire company bells rang and rang. "Men, women, and children shouted themselves hoarse, laughed and wept for joy." Schools, which had reopened on the 4th, closed again as townspeople gathered their loved ones around them in celebration.[64] On the following Monday, 11 November, the State Department announced the signing of the armistice, and Mayor James F. Strange called for an impromptu parade that evening to honor the "Dawn of Peace." All Annapolis turned out: cadets and SATC men from St. John's College and marines and sailors from the academy marched to music by the academy band accompanied by school children and a host of women's organizations. A hundred automobiles, decorated with bunting and lanterns and filled with happy people, joined the procession. At the end, everyone gathered on State House hill to listen to speeches and sing together — "Maryland, My Maryland" and "Home Sweet Home" and the "Star-Spangled Banner."[65]

In the years following the Great War, local veterans organized Annapolis branches of the Veterans of Foreign Wars, American Legion, and Fleet Reserve Association. American Legion Post 7 honors Guy Carleton Parlett, 2nd Lt., U.S. Army, who succumbed to pneumonia at Fort McClellan in April 1918; Post 141 honors William Cook and Wardell Pinkney, both sailors from Annapolis who died at sea in 1919.[66]

Unlike the Civil War, the First World War seems to have had no real effect on the postwar population of Annapolis. The 1920 federal census showed little change in the number of city residents from 1910, even though the town's boundaries had been extended in 1914 to include the whole peninsula, from the heads of College and Spa Creeks along Taylor Avenue (then known as Division Street). Most of the newly incorporated land beyond Murray Hill was still farmland. The first section of Spa View Heights, west of what is now Monticello Avenue, was advertised in 1910, but the new lots still awaited their houses.[67]

The biggest change during the previous decade had taken place at the Naval Academy, where the numbers of midshipmen and other personnel had increased eightfold. By 1920 almost a quarter of the city's official population lived within the academy's walls. To service this behemoth, roughly one out of every four workers outside those walls, in the city proper, was employed directly by the U.S. Navy or the Naval Academy. About 10 percent of these people were naval personnel; the others were civilians, both white and African American, hired by the academy as instructors, clerks, stenographers, carpenters, painters, laundresses, bandsmen, janitors, barbers, cooks, messmen, laborers.[68] But the census figures do not tell the complete story. The livelihoods of hundreds of the city's other three thousand or so workers depended on the navy payroll to support their stores, tailor shops, restaurants, hotels, boarding houses, laundries. Service workers, most of them African American, found jobs as cooks, maids, chauffeurs, gardeners, and laborers in the private homes of naval officers or others employed directly or indirectly by the academy. Visitors drawn to the academy by family, business, or curiosity increased the navy's economic importance to the town. Annapolis was a navy town.

The foreign-born population of the town in 1920 continued to number more than four

hundred souls, largely because of emigrants from Italy and Greece who settled here during the first decades of the twentieth century. The first Italian immigrants of modern times came to town in the mid-1890s as Naval Academy bandsmen, and then a few years later stonecutters arrived to work on the new Naval Academy. Some brought their families with them, others sent for relatives when they could or provided the connections that attracted friends from the home country. Eventually, Italians made up a third of the academy band. Families with names like Florestano, Maggio, Schifanelli, Ciccarone, and Rosati became part of the local scene. In addition to musicians, Italian men thrived in Annapolis as builders, barbers, cobblers, and tailors. By the 1920s local shoppers could buy Italian pasta and cheeses along with their vegetables from Italian grocers. Italians assimilated into the congregation of St. Mary's Church, and most encouraged their children to speak only English.[69]

Greek immigrants came in force a little later, and most followed the example of the Cardes and Samaras brothers, whose confectionaries and restaurants were popular in the early days of the century. In 1910, the Cardes family owned two restaurants, the Academy Dining Rooms on Main Street and a confectionary and ice cream plant on West Street. The Samaras brothers ran another Main Street eatery, the Maryland Restaurant. As was the case with Italian immigrants, Annapolis Greeks worked hard to bring their extended families over from the old country. Most went into the food service business. By the late 1930s, there were at least fifteen Greek-owned restaurants in Annapolis and its immediate suburbs. Occasionally during these years a Greek Orthodox priest came to Annapolis for services, which were held on Saturdays at St. Anne's Church. For the most part, however, Greeks traveled to Baltimore to worship until the congregation built its own church, Saints Constantine and Helen Greek Orthodox Church, on Constitution Avenue in 1949. In 1938 Greek women of Annapolis formed a chapter of the Greek Orthodox Church's philanthropic society, Philoptochos, to run a Greek school and care for the needy in their community.[70]

Established churches in Annapolis underwent changes during the first quarter of the new century. St. Anne's gave up its mission church on Prince George Street, reportedly because the population they had intended to serve had been displaced by Naval Academy expansion. The growing Kneseth Israel congregation purchased the building in 1918 and modified it for their use. The new synagogue was dedicated three years later in elaborate ceremonies attended by local clergy and visiting rabbis and cantors.[71] The city's white Methodist congregations rearranged themselves during the same period. Led by Elihu S. Riley, a group of Methodists allied themselves with the Southern branch of the church and, in 1914, built a frame church they named Trinity Methodist on West Street at Amos Garrett Boulevard. Not long after that, the two downtown Methodist churches, First Church on State Circle and the Wesley Chapel congregation, which had dedicated its own impressive brick building on Maryland Avenue and Prince George Street in 1902, began to explore the possibility of reuniting. In 1921, the congregations agreed to join as one church, to be called Calvary, and to worship in the State Circle building. To accommodate the new membership of almost eight hundred, that 1859 building needed to be enlarged. Henry Powell Hopkins, an architect and member of the church, drew up plans for an education wing and designed a new facade for the old church that was more in keeping with the historic character of the city. The renovated church opened on 30 March 1924.[72]

In addition to the older congregations, local residents who were adherents to the

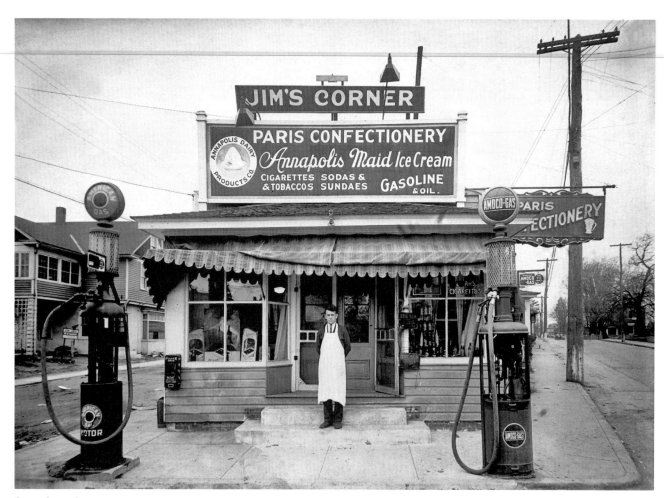

James Speros Leanos stood outside his first store, at the junction of Spa Road and West Street, for this photograph, taken about 1924. Jim's Corner later moved across West Street, where it remained until closing in 1999. Courtesy of Elizabeth Leanos Alexopulos.

teachings of Mary Baker Eddy organized themselves into the Christian Science Society of Annapolis in 1914. Fifteen years later, they associated formally with the First Church of Christ, Scientist and in 1937 dedicated a building at the corner of College Avenue and Bladen Street as a church.[73]

For the first time, in 1920, census officials cared how many women of voting age there were in the country, because ratification of the Nineteenth Amendment, formally accomplished in August of that year, gave every woman aged twenty-one and over the right to vote.[74] In Annapolis, female property owners of both races had been voting in city bond elections since 1900, and in 1908 the *Evening Capital* admitted that they "seemed to have little difficulty in voting after a simple explanation had been given."[75] Local suffragettes had been active in Annapolis since at least 1916 as members of the Just Government League of Anne Arundel County. Numbered among league members were civic leader Maggie Boone Moss and Emma Abbot Gage, an editor of the *Evening Capital*. Academy professor William Oliver Stevens considered the group the only bright spot of culture in a town that he likened to an intellectual desert.[76] When the city's National Guard units left town for training in Alabama in July 1917, members of the Just Government League thoughtfully handed out stamped postcards for the men to mail home when they reached camp. Clever ladies that

they were, each card also carried the league's message: "Women Ask A Voice In Their Own Government."[77]

Annapolis women exercised their new franchise in the presidential election of 1920, and it appears they did so with enthusiasm. Compared to the national election of 1916, when more men cast ballots on Prohibition (1,687) than for president (1,539), the city vote for president in 1920 totaled 3,125, an increase of 85 percent over the larger 1916 figure. And the winners in 1920 were Republicans, indicating that women did not follow the dictates of the city's Democratic machine.[78] Five years later, city Republicans proposed the first woman candidate for alderman. Amy Ogle, wife of lawyer Maurice Ogle and daughter of Charles E. Werntz of the Werntz Preparatory School, ran on the Republican slate with her uncle Robert L. Werntz, a candidate for city counselor. Both lost. It would be another half-century before Annapolis elected a woman alderman.[79] On the other hand, in 1921 the City Council chose Emma Abbott Gage as city clerk. Gage, writer and editor for her father's newspaper for twenty-five years, was the first woman in either the city or the county to "receive such an appointment."[80]

Those hundred automobiles cruising down Main Street in the 1918 victory parade were the tip of the iceberg that has been sinking the city for the past century. The first automobile chugged into town early in the century (no one really knows who was at the wheel), and it wasn't long before the national craze took over the streets of Annapolis. The 1910 city directory listed only one person, A. H. Wilson, selling auto parts, a sideline to his harness and bicycle supply business. Fourteen years later, the 1924 directory included dozens of businesses engaged in automobile sales, service, and supplies, as well as gas stations (3), wreckers, and even "auto funerals" (Taylor's).[81] Independent Company No. 2 raised enough money to buy an "Automobile Fire Engine" in 1911, and the City Council authorized employment of a "mechanician" at $60 a month to drive it.[82] In vexed hyperbole, the author of a 1929 article in the Baltimore *Sunday Sun Magazine* deplored Annapolis's "seventy-nine gas tanks and filling stations, one on every corner and several in between, flaming in their garish gorgeousness."[83]

Tradition has it that Zack Merriken was the first in town to offer taxi service. Selina Curry and a friend saved their pennies so each could pay Merriken 10¢ for a taxi adventure out to Three Mile Oak and back.[84] Ever alert to potential income as well as the safety of residents, the City Council decreed a twelve-mile-an-hour speed limit in town and required a license to drive within city limits — with fines for noncompliance. Nonetheless, accidents became common; and soon, busy thoroughfares such as West Street were "off-limits to the children of the neighborhood."[85] On the other hand, heavy traffic downtown blew trash neatly into gutters, making work easier for street sweepers.[86] The first traffic light was installed at the corner of Main and Conduit Streets in 1931.[87] The city's first commuter by automobile may have been navy captain Joseph Mason Reeves, who rented the Wells house on Charles Street in 1918 and announced that he intended to "motor" between Annapolis and his job at the Navy Department in Washington.[88]

With the automobile came increased demand for paved roads. Baltimore and Annapolis Boulevard, down the Severn's north shore, was completed in 1915, and the new Severn River Bridge in 1924 brought traffic across the river in appropriate style. Delayed by war, the National Defense Highway, between Annapolis and Washington, was dedicated on 16 July

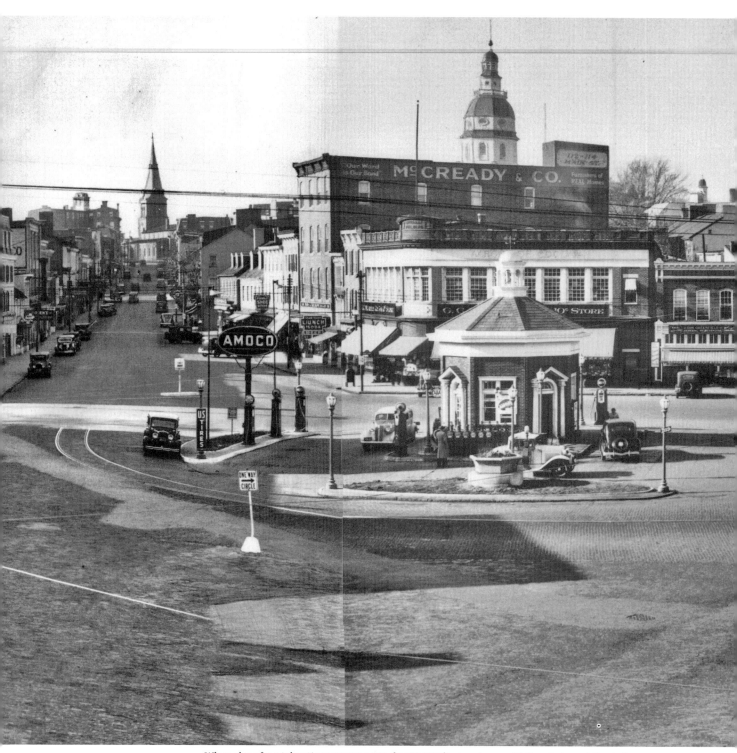

When plans for a toleration monument in the City Circle came to naught, the city leased the circle, in 1929, to the American Oil Company, which built the Lord Baltimore Filling Station and public rest rooms, segregated by gender and race. The 1908 horse trough remained—as a planter. Courtesy of the Maryland State Archives, MSA SC 1885-1-834 (detail).

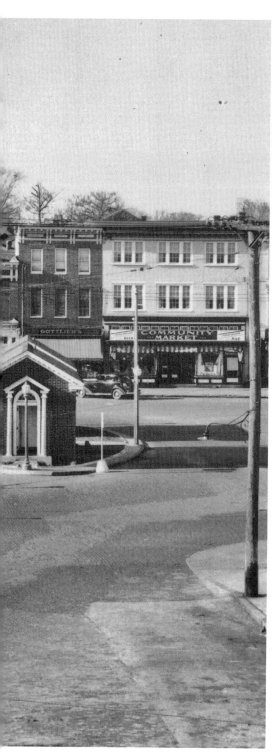

1927, by which time it was already obsolete.[89]

Ferry service from Annapolis to the Eastern Shore was not a new concept; for centuries sailing vessels and, later, steamboats had carried passengers and freight between the two shores on scheduled trips. But it was not until the state guaranteed financial assistance through the State Roads Commission that a reliable, reasonably inexpensive system emerged, due in large measure to the popularity of motorized vehicles. Beginning in June 1919, ferries departed from a wharf at the end of King George Street for the twenty-three-mile trip to Claiborne, which took at least an hour and a half. Initially the ferry made two round trips a day, costing $2 for each vehicle, 50¢ for a passenger on foot. In a congratulatory editorial, the *Evening Capital* predicted that the new ferry service would put Annapolis "on the line of a great through traffic" between the two shores and benefit local merchants. Governor Emerson C. Harrington, taking a broader view, saw the ferries bringing trucks of produce to Baltimore, instead of Philadelphia, and connecting Baltimore and Washington tourists with the delights of Ocean City.[90]

Over the years, ferries *Gov. Albert C. Ritchie*, *John M. Dennis*, *Harry W. Nice*, and *Herbert R. O'Conor* joined the fleet, each with greater size and capacity than the one before. In 1930 the company moved the eastern terminus to Matapeake, on Kent Island, cutting the journey's distance to under nine miles and the average time to less than forty minutes, which allowed six round trips a day all year round. By 1939 ferries made twenty round trips a day in the summer and fourteen in the winter, carrying well over half a million passengers and almost two hundred thousand cars and trucks that year. With ferries a fact of life, the state took over the company in 1941 and constructed a new western terminus at Sandy Point.[91] Merchants in Annapolis considered this "a great loss to the city" because travelers often had strolled around town and had a bite to eat at nearby restaurants while they waited for the ferry.[92]

Smaller boats presented opportunity to Charles Chance, owner of a boatyard in Eastport. Chance saw a market in the yachts that came into the Annapolis harbor and anchored out in the creek because there were no docking facilities for them. Heller's boatyard on

Crowds turned out for ceremonies opening the grand new Severn River Bridge on 14 June 1924. Festive activities included a pageant, boat and swimming races, and an evening picnic and dance. Courtesy of the Maryland State Archives, MSA SC 1477-5596.

Sycamore Point had for years accommodated what few visiting sailors there were, but Chance believed that modern yachtsmen needed, and would pay for, the opportunity to tie up in a yacht basin designed for the purpose. In the late 1920s, Chance bought most of the waterfront along Compromise Street from the old Severn Boat Club at the foot of Duke of Gloucester Street to the city dock. The Great Depression killed his dream, but Chance should be credited with development of the first Spa Creek marina.[93]

During the 1920s, Annapolis moved further into the mainstream of American life. Not only did immigrants, the growing presence of academy personnel from other parts of the country, and participation in the war give locals a taste of the world, but technological wonders of the age had their own effect. Movies, for instance. The first movie theater opened in 1908 on Market Space, to be followed quickly by at least three others in the First Ward (Lyric on Market Space, Magnet on Main Street, and Victoria on Maryland Avenue) and two in the

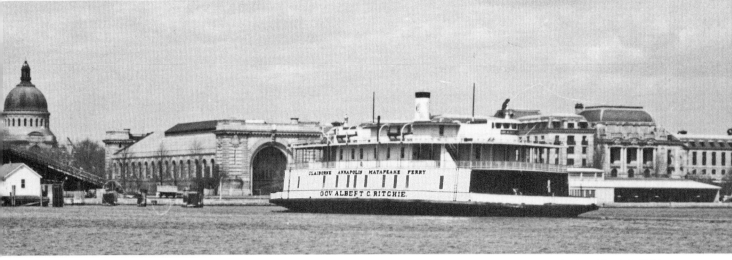

The Gov. Albert C. Ritchie approaches the ferry slip at the end of King George Street c. 1938 in this photograph by Naval Academy professor Charles Clinton Bramble. Courtesy of Beatrice Backer Simpson.

Third Ward (on West Washington and Clay Streets), echoing the racial segregation of the period. There were even a couple of summer "airdomes" under tents. Most of these early theaters were nickelodeons showing silent films spiced up with live music and vaudeville acts.[94] The only ones that lasted for any period were the Clay Street theater (to 1930) and the Magnet on Main Street (to 1922). The Colonial Theater, on Conduit Street, refashioned itself as a premier movie house in 1911, although it continued to present "clean vaudeville" censored by the management. *Birth of a Nation* played at the Colonial in 1916.[95] Less than three years later, on 17 January 1919, a heart-stopping fire destroyed the theater and several businesses on Main Street. The businesses were rebuilt, but the theater was not.[96]

The Republic Theater on Main Street and the Star Theater on Calvert were "modern" movie theaters, built for the purpose in 1915 and 1921 respectively. And in 1920, Annapolis got its only "movie palace," the elaborate 920-seat theater on State Circle designed by Henry Powell Hopkins. With the Colonial gone, the Circle Theater was the city's only building equipped for stage productions. Annapolis High School held graduation ceremonies there in the 1920s.[97]

Local residents not only saw movies in theaters, they could watch them in production. A few scenes of the silent thriller *The Hero of Submarine D-2* (1916) were filmed at the Naval Academy, and when Ramon Novarro starred in the *The Midshipman* (1925), locations in Annapolis were featured as well. Two of the first sound motion pictures — *Annapolis* (1928), starring John Mack Brown, and *Salute* (1929), directed by John Ford — were shot on location in the academy and Annapolis. Their success led to five more midshipman movies in the next decade, with stars such as Dick Powell, Van Heflin, Robert Young, and James Stewart donning crisp navy uniforms or scruffy football jerseys to thrill audiences across the country.[98] Small wonder that to many Americans "Annapolis" came to mean the Naval Academy, not the city.[99]

Not only did the academy, and sometimes Annapolis itself, figure in first-run movies, but novels featuring midshipman life or the colonial town appeared throughout the early decades of the century. Lieutenant Commander Edward L. Beach's five books set at the academy, culminating with *Ralph Osborn — Midshipman at Annapolis* (1909), H. Irving Hancock's four-volume series *Dave Darrin at Annapolis* (1910 to 1913), and George Bruce's *Navy Blue and Gold* (1936) all featured attractive young men engaged in heroic acts against dreadful odds. "Typically for boys' books of the time . . . good character and honorable and

When Charles Chance purchased land along Compromise Street from the Redemptorists in 1929 for a marina, he also bought Oyster Island, which had been created from the debris of a nineteenth-century oyster-packing business. Centered on the island was this hut, used in the 1920s as a meeting place by the Knights of Columbus. Courtesy of the St. Mary's Parish Archives, Annapolis.

courageous behavior always win in the end."[100] Boys across America devoured these books and dreamed about the navy life. Other novels of the period brought tales of the ancient city to children and adults. *Impostor: A Tale of Old Annapolis* (1910) by John Reed Scott, *Peggy of Old Annapolis* (1930) by Daniel Hawthorne, and Augusta Huiell Seaman's mystery novel *The Brass Keys of Kenwick* (1931) were all popular then, if virtually unknown today.[101]

Contact with the outside world was not so attractive when it aggravated racial and ethnic tensions in town. The Knights of the Ku Klux Klan came to Annapolis in 1922, with their message of "Pure [Protestant] Americanism," and welcomed new members in ceremonies featuring their ubiquitous fiery cross. One night in late October that year two thousand white-robed, torch-bearing men from as far away as Atlanta marched through town to the amazement of "hundreds of residents" who had never before seen the like. After the march, the men enjoyed an oyster roast and ham supper at Horn Point beach, in Eastport.[102] Klan activity continued through the decade and into the early 1930s, although it seems to have received little encouragement from civic leaders and none at all from the *Evening Capital*. When one candidate for alderman in 1927 was rumored to be a Klansman, his opponent vehemently denied spreading such "slurs." Yet, night-time assemblies of sheet-draped men burned huge crosses to demonstrate the Klan's opposition to Jews, Catholics, African Americans — anyone not like them — and other townspeople watched with fear.[103]

As Annapolis became more and more segregated in the early years of the century, Parole emerged as the city's largest African-American suburb. The subdivision of lots along Parole Street in 1907 encouraged new houses, and the laying of sidewalks along West Street in 1914 made it possible for residents to walk safely to jobs in the city or the academy.[104] In 1924 money from the Julius Rosenwald Fund, the local black community, and the county financed construction of the two-room Camp Parole Elementary School on Hicks Avenue. James Hicks's subdivision in 1928 opened lots on Bunche, Holeclaw, Dorsey, and Carver Streets around the school, with a lot set aside for its Parent Teacher Association.[105]

Churches continued to be an important part of African-American life, and Parole soon contained four. When the old Macedonia Church was condemned in 1909, the congregation moved across West Street to a hilltop site on Hicks Avenue and built Mt. Olive African Methodist Episcopal Church.[106] Shortly after the formation of the King's Apostles Holiness Church of God in 1910, a group of worshipers in Annapolis joined the movement. Just over a decade later, they bought land in Parole and built a church.[107] The Asbury Methodist Mission, organized by Reverend J. J. Cecil in 1925, met first in an old canning factory. Six years later, the congregation bought property nearby, moved an old school house to the lot, and furnished it as a house of worship.[108] In 1919 Second Baptist Church moved from downtown to a site in the Simms Crossing neighborhood on Poplar Avenue just west of Germantown.[109] With an elementary school and churches as the centers of family life, Parole developed into a strong, close-knit community that would take care of its own.[110]

Annapolis's other suburbs also grew during the first decades of the new century. Closest to the city were Neuva-Villa Park on Spa Road, which was platted in 1924, and Germantown. African Americans settled in the Neuva-Villa subdivision, where houses soon

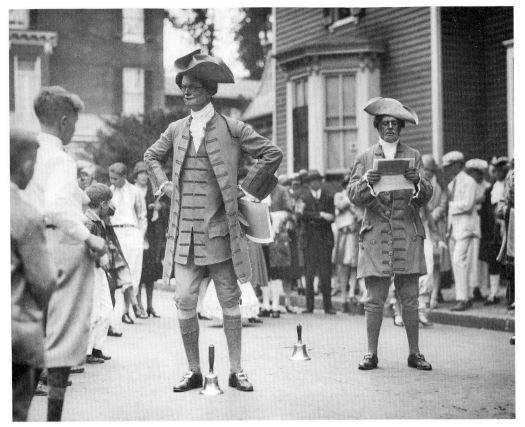

Spurred by St. John's College, the city celebrated its colonial heritage on 15 May 1928 with reenactments, house tours, a parade, Maypole dances, and a ball at the State House. Photograph by Rudolph A. Torovsky. Courtesy of the Maryland State Archives, MSA SC 3571.

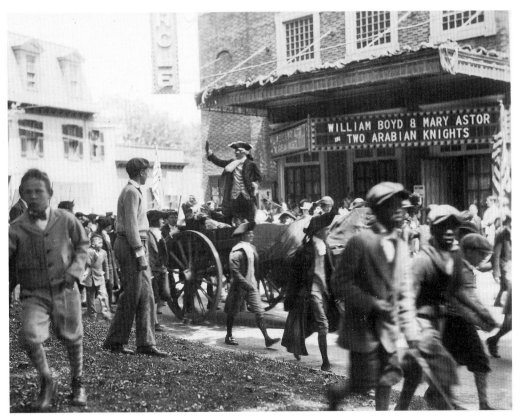

Young boys marched along with costumed adults as the Colonial Day parade passed the Circle Theater. Boys and men both wore knee pants. Photograph by Rudolph A. Torovsky. Courtesy of the Maryland State Archives, MSA SC 3571.

Preservation Pioneers: St. John's and the CRCA

In the 1920s and '30s, Annapolis's early history and architecture became the subjects of increased interest and advocacy. Although hampered by the Great Depression and World War II, the city's preservation pioneers accomplished more than is generally known and laid a foundation upon which later preservationists successfully built.

St. John's College bought the James Brice and Hammond-Harwood Houses in the mid-1920s as part of a campaign to restore four eighteenth-century properties. The college hired R. T. H. Halsey, known for his work on the American Wing of the Metropolitan Museum of Art, to conduct classes on architecture and decorative arts in the Hammond-Harwood House. Furnished with antiques, the house was opened as the Colonial Museum of St. John's College between 1928 and 1932. St. John's housed staff in the Brice House but was unable to follow through on plans to buy the Pinkney-Callahan and Peggy Stewart houses.

The college sponsored Colonial Day on 15 May 1928 to celebrate Annapolis's early history. Residents and visitors toured old homes and thronged to outdoor pageants featuring dramatic portrayals of historic events. President and Mrs. Calvin Coolidge attended a costumed reenactment of Washington's resignation of military command. They declined to don colonial garb themselves. The day closed with a dinner and ball in the State House. Plans to make Colonial Day an annual event did not succeed.

Local artist Mary Craven Johnson, inspired by a talk about the Williamsburg reconstruction project, initiated the Company for the Restoration of Colonial Annapolis in 1935. The company's directors admired Colonial Williamsburg's accomplishments, welcomed its practical advice, and envied its Rockefeller money; but they wanted to preserve Annapolis, not remake it in the museum-city mold.

Despite sparse resources, the CRCA took meaningful steps toward preserving the city's colonial history and architecture. The group commissioned a map of pre-1812 buildings and submitted early Annapolis photographs to the Historic American Buildings Survey, the first nationwide canvass of historic structures. Although CRCA attempts to prevent the demolition of the Maccubbin House on Main Street failed, the resulting public awareness about threats to Annapolis's old buildings benefited efforts to move the Reverdy Johnson House from Northwest Street to St. John's campus. Three decades before passage of the present Historic District Ordinance, the CRCA commented on plans for the C&P Telephone Company offices built on the original Reverdy Johnson site and weighed in on the location and design of the James Senate Office Building on College Avenue. The company established an office in the Hammond-Harwood House in 1936 and conducted limited tours but was unable to expand operation of the house museum. The CRCA's relationship with the Federated Garden Clubs of Maryland helped create the Hammond-Harwood House Association, in 1938, which assured stewardship of the architectural masterpiece.

The Company for the Restoration of Colonial Annapolis was active until 1939 then lapsed into dormancy through World War II. After a brief revival in 1947, it again became inactive and was legally dissolved in 1954. The CRCA's last $455 was donated to the two-year-old Historic Annapolis, Inc. Its sole surviving officer, long-time Carvel Hall owner Albert H. MacCarthy, brought his experience to the new preservation group's first board.

GLENN E. CAMPBELL
Senior Historian, Historic Annapolis Foundation

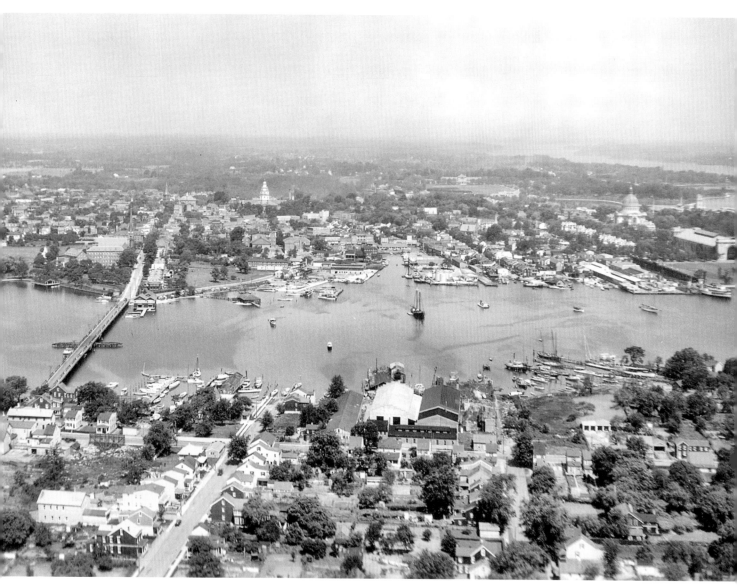

Small boatyards and marine railways dotted the Eastport shoreline in the first decades of the twentieth century. The largest was Chance Marine Construction Company, located between the present Second and Third Streets, which produced sub chasers for the U.S. Navy in World War I. Courtesy of the Maryland State Archives, MSA SC 252-44.

appeared along Smithville and South Villa Streets.[111] Germantown was the name given to the farms and scattered homes along both sides of West Street beyond the National Cemetery. As the large tracts were platted into lots, blocks of houses changed the landscape along both the main road into town and the railroad track, the latter with its convenient Glen Avenue station. The county consolidated several nearby elementary schools into a four-room frame building at the corner of West and Russell Streets in 1918 and named it Germantown Elementary School. The school was enlarged to nine rooms by 1933.[112]

In West Annapolis, the Giddings sisters finally settled a dispute that had clouded titles there, and the subdivision quickly became popular. Determined to replace the original grid layout for the river-end of the peninsula with a more natural design, Elizabeth Giddings contracted with Olmsted Brothers Landscape Architects, of Brookline, Massachusetts, to create a plan that would place large irregularly shaped building sites on winding roads. The resulting neighborhood was called Wardour. Stations on the Short Line Railroad at Wardour and West Annapolis gave residents convenient access to both Annapolis and points

north to Baltimore.[113] Residents chartered an improvement association and volunteer fire company in 1911 and immediately built a fire station. At about this time an elementary school was constructed on Annapolis Street. West Annapolis Methodists met there before building their church next door in 1915.[114]

Across Spa Creek, the village of Eastport, oldest and largest of the city's suburbs, was by 1920 a small town with a thriving maritime industry, elementary schools for both white and African-American children, electric street lights, and enough clout with the legislature to elect its own road commissioners.[115] Chesapeake Avenue, to the south of the original town, was subdivided in 1908, and additional lots opened on the western side of an extended Severn Avenue in 1918 and 1919.[116] Wilhelm Heller's boatyard was joined by Chance Marine Construction Company on Severn Avenue (1913) and Sarles Boat and Engine Shop farther up Spa Creek (1924), both of which also built and repaired yachts and work boats. McNasby's Seafood Company on Back Creek was one of the largest in the area, employing thirty-two shuckers in day and night shifts (at $28 a week) and shipping 2,000 gallons of packed oysters a week in 1918.[117] Stores and shops along Fourth Street catered to Eastport residents. St. Luke's Chapel, a mission church of St. Anne's at Chesapeake Avenue and Second Street, grew under the watchful eye of legendary vicar, the Reverend James L. Smiley.[118]

Along the southern border of the city, at the head of Spa Creek and along the old Bay Ridge and Annapolis rail line, lay more than thirty acres of densely wooded land owned by Washington philanthropist and diplomat Truxtun Beale. Beale offered it to the city for a public park in 1930. When the council demurred, Beale conveyed the property to the Truxtun Park Commission, formed by members of several local civic organizations.[119] The land remained undeveloped for more than a quarter-century.

Postwar expectations, burgeoning suburbs, and a town full of naval officers and college professors — and their families — pressured the local schools to measure up. Annapolis High School's physical plant, once thought so splendid, could not accommodate enrollment increases, especially after the state mandated school attendance to age sixteen in 1916. By 1926, with six hundred students in a building that, even with an addition, could handle maybe four hundred, the school went on staggered sessions. Principal Louise Linthicum had instituted an academic curriculum in the early 1920s, but the science labs were inadequate and discipline problems undermined serious study.[120]

Bad as the situation was at Annapolis High, it paled beside conditions at Stanton School. There, a high school program had been added in 1917 to an already overcrowded structure, forcing some children into a nearby rented annex.[121] Taking matters into their own hands, Stanton parents decided on a location for a new high school and by 1928 had paid $1,000 toward the purchase price of $2,500 for a block of twenty-nine lots in the Neuva-Villa subdivision, with a pleasant aspect above the headwaters of Spa Creek.[122] Purchase of an adjacent seven acres, for which they had already paid $1,300 of the $5,000 asking price, was approved by the school board in 1930.[123]

Under pressure from both the black and white communities, the legislature passed a law in April 1929 authorizing a million-dollar bond issue to fund construction of four county high schools and make improvements to several existing elementary schools under the direction of the special Board of Education Building Commission. The school board intended to allocate $400,000 to Annapolis High, $200,000 to a new Glen Burnie High

School, and $50,000 each to an Annapolis "colored school" and a high school in south county. Germantown Elementary was earmarked for a $10,000 addition.[124]

Thanks to regular practice drills, when fire struck the Green Street high school around noon on 11 February 1930, all 650 students escaped safely; but the obvious danger, as well as damage to the building, only underscored the need for a new school. County voters approved the bond-issue referendum in November 1930.[125]

It seemed that every white person in town got into the battle over the location of the new Annapolis High School. Committees of the PTA and the school board prepared detailed analyses of several sites, students and businessmen wrote letters, and public meetings held during the winter of 1931 went on for hours. Even St. John's College got involved when its farm, north of Germantown, came up for consideration. Any school built there, said college officials, would have to be of an appropriate colonial design "worthy of the traditions of Annapolis . . . and its splendid future" and approved by the college's authority on preservation, Dr. R. T. H. Halsey. The final decision came after the selected architects, Buckler and Fenhagen of Baltimore, and an expert in school siting from Johns Hopkins University tramped around the options with state school officials in March 1931. Their choice? Farmland owned by the McGuckian family just south and west of Spa View Heights near Spa Road. It had enough acreage for playing fields, a "fine elevation" for the building, "proper exposure for classroom lighting," and "splendid drainage."[126] Although some Annapolis High parents complained about the proximity of the McGuckian site to the "colored settlement" on Spa Road, in the end its advantages prevailed. The same advantages, in exquisite irony, that the Stanton parents had seen already. The two schools would be no more than a few hundred yards apart.[127]

The Annapolis High site was within the city limits, but the City Council waived the $700 building permit fee for the county, and the construction contract for just under $280,000 was awarded in November 1931. Groundbreaking ceremonies took place on 20 January 1932 before a thousand people, including the entire high school student body, who walked over from Green Street.[128]

By this time, construction of the "Annapolis Colored High School," on a $50,000 contract, was "about finished."[129] The actual cost of the school came to almost $60,000, of which $3,600 was a contribution from the Julius Rosenwald Fund. Two-storied, of brick with wood-framed roof and floors, the school had eight classrooms and a two-story auditorium with east-facing windows.[130] It "compares favorably," said the *Evening Capital*, "with Negro schools in Salisbury and other counties of the state." At the dedication on 27 November 1932, the school was named for Wiley H. Bates, who had contributed the largest amount, $500, toward the purchase of the land and whose name had been proposed by the new school's PTA.[131] Bates was the only high school in the county for African-American teenagers, but not until 1938 did the Board of Education agree to provide transportation for students outside the Annapolis area. When a new Germantown Elementary School was built on Locust Avenue in 1939, the old wooden school at West and Russell Streets was cut into sections and moved on greased skids five hundred feet to the Bates campus. There, its eight classrooms accommodated high school students and, later, upper-grade students from the overcrowded Stanton School.[132]

Annapolis High School opened for public inspection the second week of September 1932 (more than 4,000 took the tour), and classes began on the 15th for about 850 students, some of them transfers from private schools in Baltimore and Washington. Not all of the school furniture had arrived, but the cafeteria was in business, serving "sandwiches,

pie and cake for five cents each, and [a] cold plate lunch for fifteen." The school contained eighteen classrooms, four science classrooms equipped with the "most modern" and "best" laboratory equipment, large rooms for commercial and vocational training, music, and home economics, a library, cafeteria, boys' and girls' gymnasiums, and a thousand-seat auditorium.[133]

One of the side benefits of the new Annapolis High School and the development of Spa View Heights was the attention paid to the city's noxious dump on the site of the once-delightful Maybury's Spa. After twenty years of stashing garbage in the marsh at the head of Spa Creek — now within smelling distance of their glorious new school — the City Council finally made good on its talk about an "odorless" incinerator and built a $42,000 facility in 1934.[134] But by the mid-1930s, Annapolis, like the rest of the country, was in the throes of the Great Depression, and the incinerator probably wouldn't have been built if the construction company, Pittsburgh Des Moines Steel, hadn't agreed to buy the $50,000-worth of bonds the city issued to pay for it.[135]

Although its citizens went through difficult times, Annapolis weathered the Great Depression without the bread lines and wholesale poverty of other, industrialized cities, because the city had the cushion of federal employment: the North Severn labs, the Postgraduate School, and, most important, the two thousand or so midshipmen who had to be fed, clothed, cleaned up after, barbered, and taught. As the *Evening Capital* put it in December 1931, "Probably due to the presence of the Naval reservation here, charity workers state that Annapolis and vicinity does not have as many idle men as many communities."[136] Thirty-nine Annapolis businesses advertised in the 1935 *Lucky Bag*, the Naval Academy's yearbook. From insurance agents to pharmacists, automobile dealers to jewelers, photographers to opticians, locals courted midshipman customers. Tea rooms and restaurants catered to mids and their parents and drags (dates); hotels competed for those same parents and drags as well as for other people attached to the academy and the Post Graduate School. Prep schools advertising in 1935 included not only the Werntz School, but also Severn School, in Severna Park, and the Annapolis Preparatory School, taught by academy graduates Lieutenant Commander Schamyl Cochran and Lieutenant, j.g., Arthur W. Bryan. Twelve tailors outdid themselves to attract custom from naval officers of all stripes. The majority were local — William H. Bellis and Company had been making naval uniforms in Annapolis for almost a century — but at least five were associated with larger operations in Philadelphia, Norfolk, or Washington, D.C. Most of the twelve had shops conveniently located on Maryland Avenue.[137]

However, at the start of the Depression decade, there already had been academy jobs lost in the African-American community. The navy had brought Filipino enlisted men to the academy to work in the Mess Hall during the 1920s, replacing black civilian messmen. Although blacks still worked as cooks and kitchen help, by the end of the decade, they had lost the coveted jobs of mess attendant and steward.[138] Filipino messmen lived aboard the steel-hulled barracks ship USS *Cumberland*, moored in Santee Basin, but whenever they could visit in town, they did so. And some fell in love with local women and married them. These wives could be African American or white — race was not a major concern for their husbands. But the offspring born to these unions did present a problem for color-conscious Annapolis. Which segregated school would these children attend? Which movie theater? Which drinking fountain or rest room could they use? Alexander Eucare, son of a Filipino

father and Scots mother, said that, eventually, the mothers' race determined on which side of the line the children would stand.[139] The number of Filipino men was not overwhelming — there were about 130 living at the academy and in town in 1930 — but as their families grew, so did the discrimination against them. In 1934, the City Council supported a bill in the General Assembly that would prohibit all interracial marriages. Annapolis's African-American alderman Charles Oliver was especially concerned that "Filipinos not be allowed to marry negroes."[140] The statewide legislation, passed in 1935, prohibited marriages between members of the "Malay" race and both whites and African Americans.[141] When Filipino enlisted men were ordered back to active duty in 1933, civilian African Americans returned to the academy as messmen, but only briefly. Ignoring protests from the city leaders, both black and white, the navy decided a year later to place black enlisted men in those jobs. The local men were out, no matter who replaced them, and no one was happy.[142]

Early on, established local charities such as the Red Cross and the Christ Child Society, as well as church and civic organizations, PTAs, and the Naval Academy, joined with the new Community Welfare Association (CWA) to provide clothing and food to the needy. During 1931 the CWA distributed clothing, food, and more than $4,300, the last going mainly for medical and housing costs. The Christian Science Church and Naval Academy Band Welfare Association were among a number of groups that supported the Truxtun Park Commission's tree-cutting initiative during the winter of 1932. More than ninety men, both white and black, made 28¢ an hour — the same wage paid laborers working on the high school — cutting firewood that could be given away or sold to support the program.[143]

As times worsened, the city cast around for money to pay its debts, but when the council offered a $50,000 bond issue in 1933, no one stepped up. The bonds were finally sold to a Baltimore investment firm almost a year later.[144] Market House tenants had trouble paying their rents.[145] The repeal of Prohibition and the city's ability to again license vendors of spirits probably had a lot to do with the city government's solvency during the remaining years of the Great Depression.[146]

Responding to Governor Albert Ritchie's initiative, the Community Chest for Annapolis and Anne Arundel County organized in October 1932 to accept private and public funds. Its first drive collected a third of its $30,000 goal in the first month and the money was distributed throughout the county before Christmas.[147] In Annapolis, a hundred St. John's College students offered to do anything, "even sweep chimneys," to earn enough money to stay in school.[148] Sixty local merchants encouraged patronage with a "popularity" contest in 1933 in which shoppers could vote for the young lady of their choice when they made cash purchases or paid a bill. More than 130 girls from Annapolis and the county entered the contest to vie for trips to Bermuda and cash prizes. The *Evening Capital* ran almost daily vote totals.[149]

A troubling rumor that the Naval Academy would lay off civilians rumbled through the town in the fall of 1932. Confirmation came in the spring of 1933; a third of the sixty-one professors and instructors would be fired and about ninety laborers and building attendants would be laid off at the end of the school year. Civic organizations met at Carvel Hall to protest the Navy Department's order, and a delegation went to Washington to present Maryland Senator Millard Tydings with their proposal for keeping civilian professors on the payroll at reduced salaries by rotating teaching duties among them. The secretary of the navy turned this down "because of the urgent necessity for economy." Federal salaries had been cut 15 percent and the academy's budget slashed.[150]

This diagram of the portion of the Naval Academy yard between Spa and College Creeks shows the squared boundary of the academy's land in 1845 superimposed upon the wavy shoreline of the creeks and the Severn River in 1808. Broken lines, hatched areas, and italics refer to former structures and uses, including the round Fort Severn. Courtesy of Randall W. Bannister, used with the permission of the U.S. Naval Institute.

Business in town on 4 March 1933 came to a complete standstill as people listened on the radio to the inauguration of President Franklin Delano Roosevelt. Columbia Broadcasting System covered the event and "put on a wonderful show." In 1930 almost half the homes in Annapolis had a radio set, as did most stores and private clubs.[151] Everyone wondered what the new president would do about the economy. A former assistant secretary of the navy, Roosevelt's effect on the academy and the town was positive. Within a few years, construction — and jobs — returned to the yard with additions to Bancroft Hall and the chapel, classrooms, a museum, housing, and other improvements.[152] New Deal money came to Annapolis to pave streets and sidewalks, clear snow, lay water lines, renovate the City Council chambers (1934), build a state Hall of Records (1935), staff the Green Street playground (1937), rebuild Stanton and West Annapolis Schools (1939), replace Germantown School (1939), and replace city slums with low-rent public housing (College Creek Terrace, 1940).[153]

The Great Depression in Annapolis can be summed up in the memories of those who lived through it: Emily Peake's account of her fifth-grade classmate who stood outside the Republic Theater night after night selling magazine subscriptions and his mother's homemade fudge; Tom Worthington's refusal ever again to eat turnips, winter staple of his Depression diet; Jack Flood's memory of young men who'd had to leave college and were glad to make $10 a week in the A&P store on Dock Street. The Bay still nourished abundant seafood, and truck farmers in the county brought their produce to the market house or peddled vegetables and fruits from wagons through residential areas. And most homes had enough backyard to grow vegetables or keep a chicken or two. People may not have had enough to eat or adequate heat or clothing, but they got through it.[154]

For entertainment, Annapolitans continued to enjoy fire department carnivals, held

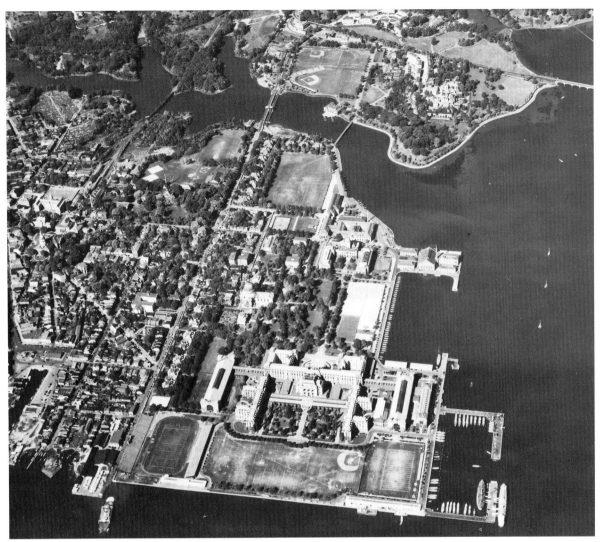

The manicured parade grounds and playing fields of the academy stand in stark contrast to the density of downtown in this 1939 photograph. Farragut Field is center foreground and Thompson Stadium is to the left of it, adjoining the ferry terminal and the Hell Point neighborhood. Courtesy of the Special Collections and Archives Department, Nimitz Library, U.S. Naval Academy.

each summer at the city dock or on streets and vacant lots near the stations. Eastport had its carnival on the grounds of the elementary school on Fifth Street. West Annapolis's carnival set up in an open field near the junction of Taylor Avenue and Annapolis Street.[155] But baseball was king of the season, and rivalries between communities and teams drew spectators by the hundreds. Annapolis men played at the "beautiful ball park," with dugouts and two covered grandstands, on the south side of West Street between Germantown and Parole. African-American teams and white teams alternated practice evenings and game days. Eastport's ball park, on Feldmeyer's farm near Boucher Avenue, was home to the Eastport Bonecrushers, named, it was said, for the horse bones in their field, not the injuries from their sport.[156]

During the school year, the city's two colleges offered a variety of sporting events, free to young and old. Football at the academy's Thompson Stadium, near the Spa Creek waterfront, was especially popular. From high in the bleachers, sports enthusiasts could follow the game and still keep an eye on sailboat races in the Severn. St. John's College also played football, but it was in lacrosse that the school excelled. Under coach William "Dinty" Moore, St. John's won the national lacrosse title in 1930 and 1931. The undefeated 1931 team went

on to win an international competition against a Canadian championship team later that year.[157]

As it turned out, those glorious games were the pinnacle of the college's participation in interscholastic sports. Only a few years later, Stringfellow Barr and Scott Buchanan gave the quasi-military school a complete about face by initiating a curriculum similar to one then being taught at the University of Chicago. Guided by tutors, students read and discussed the "Great Books" of Western civilization. Viewing fraternities and intercollegiate sports as disruptive of the intense scholarly atmosphere they were creating, Barr and Buchanan abolished them, substituting intramural sports open to all. The New Program took a while to catch on, but when it did, the school gained national attention and enrollment shot up.[158]

During her second deployment at the Naval Academy, the legendary yacht America *had her own pier in Dewey Basin, where she could be admired by people who revered her days of sailing glory. About to be restored at the start of World War II, she was destroyed in the Palm Sunday 1942 snowstorm when a shed collapsed on her at a local boatyard. Courtesy of The Mariners' Museum, Newport News, Va.*

Politics in the City Council was especially fractious during the early Great Depression years under Republican Mayor Walter E. Quenstedt. Counselor Roscoe C. Rowe and Fourth Ward aldermen Charles A. Oliver and Charles L. Spriggs were also Republicans, allied against the six Democratic aldermen from Wards 1, 2, and 3.[159] One of the bones of contention was the Annapolis Water Company. Since 1867 this private company had supplied water to the city from its reservoirs four miles west of town, laid and maintained water lines, and absorbed complaints about water quality and quantity. When the state decided to sell its stock in the company in 1911, the city corporation bought the shares, and, the next year, obtained the rest of the outstanding stock from other owners. Laws in 1912 authorized a bond issue for the purchase and amended the company charter to make the mayor an ex officio director.[160] At this point, the company's two reservoirs, still fed by streams at the head of South River, together held seven million gallons of water, pumped through nine miles of pipes at a maximum rate of about four million gallons a day.[161] Over the years, additional legislation gave the City Council a lock on three of the five directorships (1918) and eventually all of them (1931). Beginning in 1912, the company operated as a public utility under President George T. Melvin, who held that post until his death in 1920, and the city government took responsibility for bond issues to enlarge and improve the water supply. In 1928 the company erected a standpipe for water storage in the Presidents Hill section, on the highest point in town, where once Civil War defenses had guarded the city from Confederate attack.[162]

The most important waterworks improvement during this period was the construction of a filtration system in 1931. Speakers during dedication ceremonies 23 May 1931 credited Melvin with spearheading the city's acquisition of the company and lauded him as "pioneer" of the filtration movement. The city celebrated this municipal success with a marathon of runners and the usual parade.[163] But later that summer, when Republican council members followed Mayor Quenstedt's lead and refused to submit to the 1931 law giving control of the company to whichever party won the city election, relationships between the two political parties soured. Only another law, in 1933, confirming that all five directors

Oysters, here being unloaded at the city dock c. 1930, fed many an Annapolis family during the Great Depression. Photograph by Carl S. Thomas, Sr., from the collection of Mr. and Mrs. J. Oliver Thomas. Courtesy of the Maryland State Archives, MSA SC 2258-1-18.

must be members of the municipal corporation (with at least one member from the minority party), and the reelection of the argumentative Mayor Quenstedt eased the situation.[164] Even with all the dissension over company governance, water quality must have improved, because West Annapolis petitioned for inclusion in the city system instead of the county's Sanitary District. Water lines were finally laid in West Annapolis in 1938, after the Works Progress Administration agreed to cover most of the cost.[165]

Another issue before the City Council in the early 1930s did not raise the same level of acrimony, perhaps because aldermen could unite against what they perceived as a common enemy — the Washington, Baltimore and Annapolis Railway. Agreeing with the sentiments of Anne Jeffers and her supporters a generation before, many locals could not wait until the rail line's franchise expired on 30 June 1932 and the trains left city streets. Interurban trains from Annapolis to the big city were fine, but in town they were noisy, they shook buildings, and they impeded automobile traffic. The railroad took its trains off Main Street, Market Space, and Randall Street in October 1928 so the city could do some repaving, and people got used to their absence. But as a result, instead of making a smooth loop through town, the incoming trains had to turn left at West Street and Church Circle and go against automobile traffic around the circle to reach College Avenue. Townspeople complained about the danger, and with the automobile's popularity increasing, in any competition between the railroad and car owners, the railroad was bound to lose.[166]

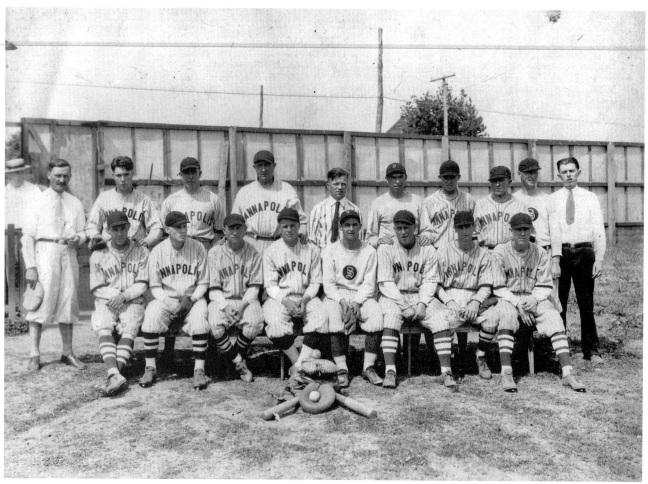

For decades the Annapolis baseball teams, African American and white, practiced and played home games at the fenced ball field on West Street near Chinquapin Round Road. Courtesy of C. W. Cadle, Jr.

THE ANNAPOLITAN DRIVING ASSOCIATION
WILL GIVE THEIR FOURTH

MATINEE RACE

LABOR DAY, SEPT. 5, 1932
BEGINNING 1.30 P. M.

Camp Parole Race Track
CAMP PAROLE, MD.

PONY RACE, PACE, TROT AND ROAD RACING

WASHINGTON HORSES:---Prince Carroll, owned by Maggie Foot Carroll; Uno, owned by Mr. Audrick; Direct Guy, owned by R. L. Parham; Robert M., owned by W. B. Boyd; Silver Bill, owned by Tommy Alton.
ANNAPOLIS HORSES:---Warren McCylo, owned by Charles Bowie; Colonel Boco, Jr., owned by Joseph Carroll; Acy Todd, owned by Joseph Carroll; Queen Bengin, the world's famous trotter, owned by Tommy Alton; Echo Boy, owned by Joseph Henson. MULE RACE 3.15. COLT RACE---Prince Carroll, Peter Direct, Echo Boy, Pluto Guy.

Come and enjoy a day of pleasure and sport. The association will spare no expense to make this a great attraction. Refreshments served on the grounds.

ADMISSION: Adults, 35c. **Children Under 12, 20c.**

COMMITTEE:---Joseph Carroll, Pres.; Chas. Bowie, Treas.; R. L. Parham, Vice-Pres.; Capt. Strother, Gen. Mgr.; J. C. Smith, Sec.; Samuel Gray, Judge.

ART PRESS ANNAPOLIS

Harness racing at the oval track on land between present-day Route 2 and Riva Road was popular in the first half of the twentieth century. These Labor Day races were sponsored by local African-American horsemen and drew competitors from Washington, D.C., as well as Annapolis. Courtesy of the Maryland State Archives, MSA SC 2028.

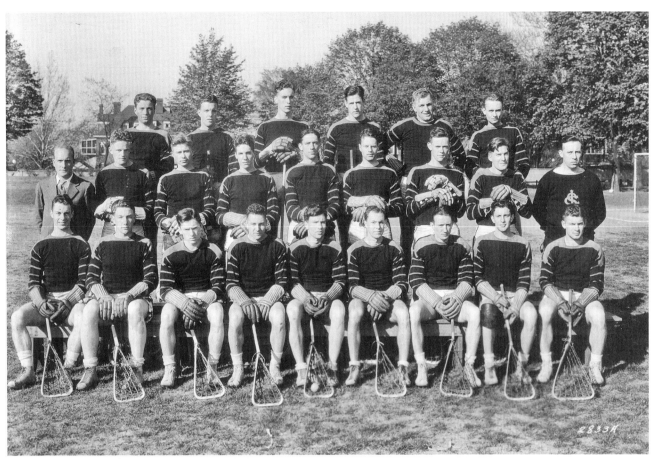

St. John's College lacrosse team, 1932, in their black and orange uniforms. Legendary coach William "Dinty" Moore stands at the right end of the second row. Courtesy of the St. John's College Library Archives

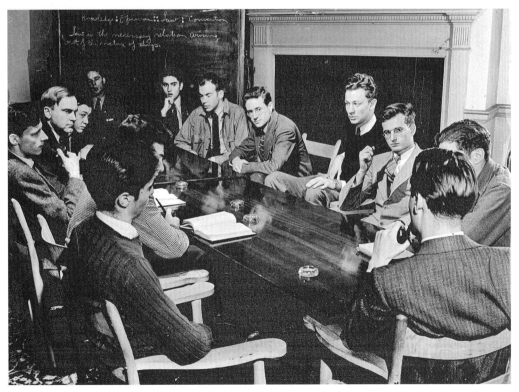

In 1937 the quasi-military St. John's College made the dramatic switch to a curriculum based on discussion of a particular set of Great Books. Students and tutors met to question and learn together in seminars, such as this one in 1940. Courtesy of the St. John's College Library Archives.

More than a year before the railroad's franchise was due to expire, petitions against renewal began arriving at City Hall, and with little discussion, the council voted unanimously to get the trains and tracks and wires off the streets as soon as possible. But by June 1932 the WB&A was in receivership and fighting for its life; the Annapolis situation was only one of its many problems. For the next three years, trains continued to rumble through city streets while the company battled Annapolis and other cities in one court after another. Was the railroad subject to state and local property taxes? Could it condemn a right of way received by franchise? It was all nasty—and expensive. Finally, in May 1935 foreclosure mooted the questions, and the railroad's property was sold at the door of the Anne Arundel County Courthouse in Annapolis on 14 June 1935. The Short Line was separated out and sold to the newly formed Baltimore and Annapolis Railroad Company, which continued to operate the north shore line to Baltimore. Trains on the south shore line ceased on 20 August 1935, and for the first time in almost one hundred years, the tracks out of Annapolis along West Street and General's Highway were quiet. In town, the council noted cheerfully that the problems of traffic congestion and parking had been solved with the demise of the trains.[167]

The typhoid outbreak at the Naval Academy in 1910, the one that resulted in the academy's running its own dairy farm, was also the catalyst for the Annapolis government's most ambitious public works project—the sewage treatment plant—and, eventually, for annexation of the city's closest suburbs. In late December 1910, as thirty patients lay sick with typhoid fever in the academy's new hospital overlooking the Severn, some observant soul noticed that tongers were pulling up oysters from the river bottom at the point where the hospital's sewer line flowed into the river. When this news reached academy superintendent Captain John M. Bowyer, he notified Dr. Marshall L. Price, secretary of the Maryland State Department of Health in Baltimore, who immediately forbade further oystering in that area. The next day, Dr. Price and a team of investigators went to the site on the State Fishery schooner *May Brown*. Oysters they collected off Hospital Point were "covered with a shiny layer of partly decomposed sewage" and tested positive for intestinal bacteria even though, noted Dr. Price, the effluent from the hospital had been disinfected before discharge. Health Department scientists found no evidence of typhoid bacillus in the samples taken. Still, cautioned Price in a report to Governor Austin L. Crothers, the situation warranted further study of the state's oyster beds "not alone for the protection of life and health, but for the protection of the oyster industry."[168]

Governor Crothers was well aware that Maryland's oyster industry was critical to the state's economy. Although the harvest had dropped markedly from its peak in the 1880s, in 1904 Maryland was the country's third largest oyster producer, with a catch of almost 4.5 million bushels valued at just under $2.5 million. Crothers also must have understood the secretary's concern for the health of all those who ate the popular bivalve, which was shipped all over the country from Maryland packing houses. Federal Department of Agriculture chemist George W. Stiles, Jr., stated, "From a public health point of view, the most serious menace to the shellfish industry to-day [1910] is the promiscuous discharge of sewage into natural bodies of water."[169] And by 1911 the linkage of sewage (and oysters) to outbreaks of typhoid fever was also well-known, if not fully understood, by a general public who had been conditioned to suspicion by the sensationalized Typhoid Mary story just a few years earlier. Across America, cities were beginning to disinfect municipal water sup-

plies and build sewage disposal systems.[170] In Annapolis, the first patient treated in the newly built Emergency Hospital in December 1910 had typhoid fever. Over the next eight months, the disease spread over the town as it had periodically for centuries; the hospital's death rate for 1911 was unusually high. Prior to the development of antibiotics, the general mortality rate for typhoid fever was 10 percent (after antibiotics, it dropped to 1%).[171]

Meanwhile, taking chemist Stiles seriously, the United States Department of Agriculture made a survey of Chesapeake Bay oyster beds and determined that the Severn River was "badly polluted" — so polluted that any oyster taken from the river would have to be "transplanted in non-polluted waters before offering for shipment" or the state would suffer liability under federal law. It was time for the legislature to act, which it did during the 1914 session with acts directing the state Board of Public Works and the City of Annapolis to cooperate with the federal government to construct a sewage treatment plant for the city and authorizing the city to issue $50,000 in bonds to pay for it.[172] The state's act may have produced some preliminary surveys, but nothing concrete emerged. The war intervened.

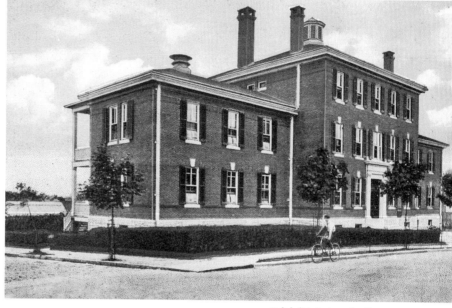

It didn't take long for the first Emergency Hospital on Cathedral Street to prove its worth, and a replacement building designed for the purpose opened in 1910. The first admission to the new hospital was a typhoid fever patient. To help staff the hospital, the board of managers opened a training school for nurses in 1911. Courtesy of Beverly Davis Valcovic.

In 1920, the legislature tried a new approach by instructing the governor to appoint a three-member commission to discuss the issue with Naval Academy representatives and draw up plans for a system that would deal with the sewage on the Annapolis peninsula "either by a disposal plant or by carrying it into the Chesapeake Bay."[173] This commission was surprisingly effective. At no cost to the public, its members prepared a plan to connect "interceptor" lines to the existing city and academy sewer lines and carry the discharge across Spa Creek, Eastport, and Back Creek to a treatment plant that would filter and disinfect the waste before it was piped far out into the river. They couldn't quite figure out how to separate storm water from sewage, but otherwise the plan made sense. The commission estimated the cost of the project, with a capacity of 2.5 million gallons a day, at $400,000.[174]

For reasons unclear today, this promising plan lay dormant for nine years until, at the urging of Anne Arundel County senator Ridgely P. Melvin, the General Assembly established the Annapolis Metropolitan Sewerage District in 1931 and charged it with the design, construction, and maintenance of a sewage treatment system that would encompass the drainage districts of Back, Spa, and College Creeks and "those parts of the drainage areas of Weems Creek and the Severn River, in which are located the communities of Annapolis, Eastport, Germantown, West Annapolis, the U.S. Naval Academy and other federal properties." (The boundary was extended to Parole Street in 1933 for a total area of five and a half square miles.) Financing would be shared between county and city, with the commission empowered to issue tax-free bonds of an amount up to 5 percent of the assessable base of the district. This law had teeth: rights of condemnation and contract, requirements for annual audits and reports, and salaries for the five commission members and their staff.[175]

Could it be coincidence that legislators at the same session chastised the "Battle Creek, Michigan, Breakfast Food Company" for its "libelous, untruthful and poisonous propaganda" against the safety and wholesomeness of oysters as a food source?[176]

Relying on the 1922 plan augmented by the extended area outlined in the 1931 law, the Annapolis Metropolitan Sewerage Commission (AMSC) began its surveys and contracted for land on the south side of Back Creek for the plant.[177] Things went well until residents of Eastport balked. The plant would smell, they said, and property values would sink. The commission arranged for Abel Wolman to speak in Eastport. Wolman, chief engineer with the State Department of Health, was lead author of a recent study that identified the cause of a thirty-seven-case typhoid outbreak in Eastport in 1928 as private wells contaminated from privies and cesspools after high water. His description of the plant and its importance to their own families seems to have quieted concerns.[178]

But this was the Great Depression, and although initial AMSC bond offerings sold better than those for the incinerator, money was tight. Plus, the inevitable squabbling between city and county delayed progress. On the positive side, the engineers figured out how to separate out storm water and sewage, so the system's capacity would not be strained by fresh water.[179] As with so many other Annapolis projects during the 1930s, the federal Public Works Administration saved the day by purchasing almost $400,000 worth of commission bonds in 1934.[180] Streets were dug up for pipes through the months of 1934 and 1935, and in the bitterly cold winter of 1936 divers laid sewer lines under twelve inches of ice on Spa Creek.[181]

The sewage treatment plant went into operation in early September 1936, and the academy began sending waste through its lines a few months later. By January, 1.3 million gallons were being treated daily. There were a few glitches, but water at the city dock began to clear, and AMSC engineer Robert L. Burwell predicted that people could swim safely "in the entire creek within two years."[182] And what of all those children who had grown up swimming in polluted waters? At least one of them believed that the immunity conveyed by close association with all that bacteria was beneficial. "When I went to Korea in 1949," said Dennis Claude, "I was the only one who didn't get sick."[183]

Concomitant with the sewage issue was the issue of the city's annexation of its adjoining suburbs. Then, as now, the city government never met an affluent suburb it didn't want to annex. The idea of absorbing residential and commercial development adjacent to the city limits was not new. However, the areas previously incorporated into the city — West Street, Murray Hill, Spa View Heights, Presidents Hill — had always been within the city's "precincts" and control. Residents affected already received mail at the city post office and considered themselves part of Annapolis.

Mayor James F. Strange first voiced the idea of annexing three communities outside the city's traditional boundaries — Eastport, Germantown, and West Annapolis — in 1918; and his successor, John J. Levy (mayor 1919 to 1921), set up a commission to study the matter. There was enough interest within Eastport and Germantown to get legislative approval for a special annexation election in June 1920; but when push came to shove, taxpayers (men and women) in both communities voted no, by an unequivocal 416 to 36.[184]

Perhaps because the mayor and aldermen didn't want to go back to the General Assembly for every annexation possibility, certainly not when the results were as embarrassing as in 1920, they asked for, and got, a law enabling the municipal government to schedule a special election whenever 20 percent of the property owners of a nearby area petitioned for annexation. The issue arose off and on over the next decade, with no particular action.[185]

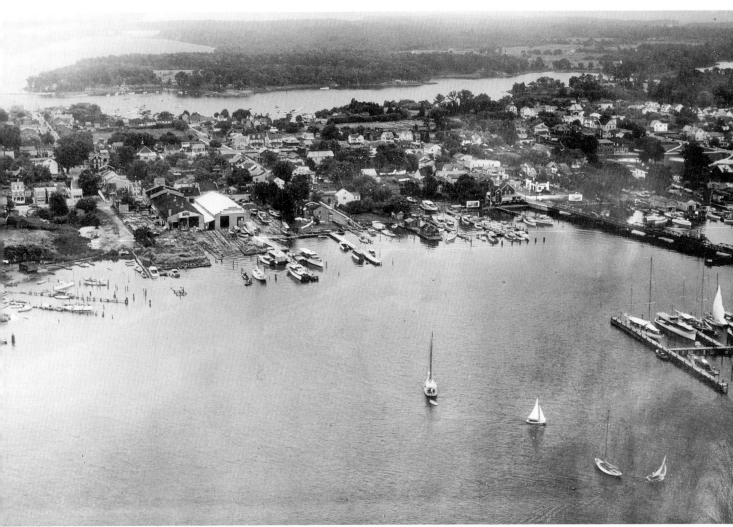

In 1933, with the endorsement of the Chamber of Commerce, the president of the Home-wood Improvement Association asked for another chance. Annexation of the Homewood-Germantown area would give the city an additional six hundred acres, five hundred homes, and about 2,500 people. The council decided to see if the rest of the AMSC district favored annexation before scheduling an election. Within a few weeks, 85 percent of West Annapolis voters were said to have signed petitions, but their improvement association was against annexation. Eastport remained opposed. In the end, petitions were not presented and elections were not held.[186] Annapolis mayors saw the logic of bringing into the city fold (and its assessment books) the entire area embraced by the AMSC. The suburbs saw higher taxes and loss of their village autonomy. For the rest of the 1930s, city and suburban residents continued to discuss the issue without resolution. Some of the outlying communities had public water, through either the city or the county's sanitary commission, their own stores, service businesses, and local firefighters, not to mention sewerage from the AMSC.[187] Their citizens questioned why they should become part of the city. Most thought they would resist as long as possible.

Residents of Eastport were not at all sure they wanted the new sewage treatment plant to be built on the other side of Back Creek (background), until they learned that their contaminated wells had caused a typhoid outbreak. Waterway pollution was also a serious health matter, but by the late 1930s, when this photograph was taken, the water in Spa Creek (foreground) had begun to clear. Courtesy of the Maryland State Archives, MSA SC 2140-228.

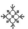

The Anne Arundel County Public Library was born in a small room on the second floor of City Hall on 8 January 1921. Midwifed by Naval Academy and St. John's College professors, Presbyterian minister Dr. S. E. Persons, and several ladies, the fledgling library received encouragement from the City Council and local religious and civic organizations. It opened with about two thousand donated books, mostly fiction, and a volunteer staff who admitted patrons on Tuesday and Thursday afternoons and Saturday mornings. Anyone who paid the 10¢ fee for a library card could borrow books. As with the hospital, the Annapolis community regarded their first public library with pride and a sense of responsibility: they used it, they volunteered at it, they contributed money and books to it. The city government appointed a library commission (headed for many years by academy professor Horace J. Fenton) to oversee its operation, and in September 1921 the commission hired the first librarian, Eliza Gracie Suydam, at a salary of $25 a month. Reportedly, Suydam was the quintessential old maid librarian, who whipped out her cane to admonish noisemakers. She doesn't seem to have inhibited the library's use; by 1923, circulation averaged a hundred books a day. Over the next few years, the commission evolved into a more formal organization and finally into the Public Library Association of Annapolis and Anne Arundel County, incorporated in 1936. When the city renovated the City Council chambers in 1934, the library moved to the old high school building on Green Street; but the board wanted a permanent home for its collection, which had increased fivefold.[188]

For several years there had been rumors that the old Reynolds Tavern on Church Circle would be demolished to build a gas station. Influential members of the library association began negotiations to make the colonial tavern a public library. City and county governments increased their annual library appropriations, and Farmers National Bank, which owned the building, agreed to the sale. Academy professor Henry F. Sturdy, Ward 3 alderman Elmer M. Jackson, Jr., and businessman F. Marion Lazenby were among those who secured dormant funds from the old Annapolis Female Orphan Society to purchase the tavern.[189] Volunteers helped the library staff move about 14,000 books to the new "convenient" location; a building committee made necessary renovations; and a library friend donated "a pretty rag rug" to the reading room. The new library opened on 17 February 1936, with afternoon hours during week days and morning hours on Saturday.[190] The following year, Esther K. King, graduate of Columbia University Library School, took over as librarian, a position she held for the next thirty-four years. Although ostensibly the new library could be used by anyone, the board opened a branch for African Americans at College Creek Terrace on Clay Street in 1940. The branch was supported for many years by the Library Guild, which

Originally colonial hatter William Reynolds's home and business, often a meeting place for the City Council, later a banker's residence, and, after 1936, a public library, Reynolds Tavern, on Church Circle, was accustomed to being at the center of city life. Photograph by E. H. Pickering, June 1936 , for the Historic American Building Survey. Courtesy of the Library of Congress.

raised money for books and sponsored concerts and lectures by black authors. When the branch closed in 1950, librarian Eloise Richardson became children's librarian at Church Circle.[191]

While the library association was rescuing Reynolds Tavern, another group formed with the objective of saving the rest of the city's eighteenth-century treasures. Influenced by the example of Williamsburg, whose restoration and reconstruction had been glowingly described to the Naval Academy Women's Club by Vernon Geddy, vice president of Rockefeller's restoration effort, in January 1934, club member Mary Craven Johnson called upon Naval Academy, St. John's, and city officials to join her in an effort to bring similar benefits to Annapolis.[192] Following a great deal of discussion and an organizational meeting at the home of St. John's College president Amos W. W. Woodcock in December 1935, Johnson and her husband, academy professor Captain T. Woolsey Johnson, sat down with city counselor William J. McWilliams to draw up bylaws for the Company for the Restoration of Colonial Annapolis (CRCA).[193] A few days later, three hundred "enthusiastic citizens" attended a "very nice" dinner at Carvel Hall hotel to elect directors of the organization and hear Annapolis repeatedly described as the "Athens of America." Comparisons of Annapolis with Williamsburg abounded. Baltimore attorney George Forbes noted that he had once "suggested that Andrew Carnegie buy the entire city and restore it to its colonial appearance." As Carnegie apparently had no such interest and Rockefeller was already engaged, the only hope for Annapolis now, he said, was "if each rich man would take a house to restore" or maybe the state . . . [194]

The CRCA set up an office in a wing of Hammond-Harwood House and began giving tours of the city. With encouragement from the CRCA, local photographer E. H. Pickering took pictures of the town, and Arthur Trader, chief clerk of the state Land Office, drew a map with what he believed to be the shoreline and major buildings of pre-Revolutionary Annapolis. *Evening Capital* editor Elmer M. Jackson, Jr., quickly wrote his version of the history of the town, which he dedicated to the CRCA.[195] William Oliver Stevens wrote a better history, even though focused largely on the Naval Academy, with a foreword by Peter H. Magruder, secretary of the CRCA.[196]

The next year, Rear Admiral David F. Sellers, Naval Academy superintendent and president of the CRCA, brought Kenneth Chorley up from Williamsburg to give the group a reality check. Chorley was president of Colonial Williamsburg and had been involved in Rockefeller's activities there from the beginning. His remarks were, surprisingly, not repeated in the *Evening Capital*. Counselor McWilliams attended the long meeting and noted in his diary, "A gent by the name of Chorley from Williamsburg made some very interesting and pointed remarks. And very practical and coldblooded he was too." Perhaps this experienced and business-minded preservationist gave the CRCA much the same advice he offered to the nascent Historic Charleston Foundation in 1945. Set up an "independent nongovernmental organization which could set its own agenda without ties to any existing organization or city politics," he told the South Carolina group.[197] Another Annapolis preservation organization would take this to heart at another time.

The acerbic McWilliams, whose city position gave him membership in the new organization, privately labeled the effort "Pink Tea stuff," but for a brief period in the years before the Second World War, CRCA activities focused attention on the city's colonial history and attempted to preserve it.[198] The CRCA influenced the C&P Telephone Company's decision to move an eighteenth-century house on Northwest Street to the St. John's College campus, talked about beautifying the waterfront, and lobbied for brick sidewalks instead

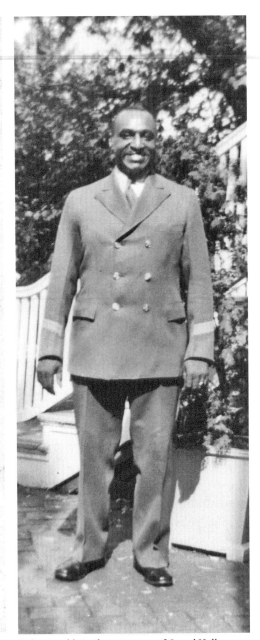

Marcellus Hall, long-time employee at Carvel Hall, wrote a tour book in 1937, which he autographed as "ye old Bell Captain." The book's focus on the academy was understandable, since the families and drags of midshipmen often stayed at Carvel Hall, and the author knew them all. Courtesy of Beatrice Martin Buchheister.

Indispensable to the managers of Carvel Hall, bell captain Marcellus Hall ran what was essentially an apprentice program for local young black men, training and supervising them before he either took them on as career employees or sent them off to other futures. Courtesy of the Maryland State Archives, MSA SC 2140-1-13.

of concrete, sometimes successfully. When they were unable to save the eighteenth-century Maccubbin-Thompson house at 193 Main Street, CRCA members contracted with an architect to make measured drawings before it was destroyed, and they placed artifacts saved from the house in Main Street store windows.[199] Perhaps the group would have gone on to greater accomplishments had not the war changed everyone's priorities.

During the 1937 session of the General Assembly, Anne Arundel County senator Ridgely P. Melvin introduced a $1 million bond bill to fund construction of a massive state office building in Annapolis. Governor Harry W. Nice, having just completed his transformation of Government House, agreed that sprucing up the state's presence in the capital was a good idea and signed the bill. Folks in Baltimore City, where most of the state government's employees worked and lived, were not pleased. They threatened to call for a referendum. Annapolis countered with resolutions to boycott Baltimore stores, cancel advertisements in the chauvinistic Baltimore *Sun*, and levy fines on trucks bringing in goods from the misguided city.[200] And so began a series of confrontations that lasted more than a year and led the governor to remark, "The office building we had looked upon as a pleasant dream is turning out to be a nightmare." Baltimore interests aside, he had enough to worry about with the people of Annapolis. When a rumor surfaced that the state Board of Public Works had chosen Randall Court as the location for the building, thus destroying the venerable Bordley-Randall House, a tumultuous meeting of citizens on 12 October 1937 ruled that one out. The Board of Public Works finally chose the least contentious site: College Avenue, across from Government House, between Bladen Street and the Post Office.[201]

Supportive of local pride in the city's colonial heritage, architects Henry Powell Hopkins and Laurence Hall Fowler based their building concept on the grand old homes of Annapolis. "The building itself, in general design and character, is a combination of the spirit of all the houses in Annapolis — the Chase Home, the Hammond-Harwood House, and the Brice House," wrote Hopkins, "on a much magnified scale." State workers moved into the completed structure in December 1939. Contrary to the fears of Baltimore employees, most of the departments housed in the new building were already located in Annapolis. Eighteen months after the move, a Baltimore *Sun* reporter found that of 169 people working in the new building, only thirty-three were employed by departments formerly located in Baltimore. "Practically all of them now commute daily between Baltimore and Annapolis by automobile."[202]

Their commute was eased by the new dual-lane highway between the two cities. Begun in 1934 and finished four years later, the highway was one of three modern roadways out of Baltimore built during the 1930s. And as these presumably reluctant state employees cruised along the last stretch of that wonderful, wide concrete highway leading to the Severn River, they could enjoy the beautiful old trees shading the median. On other road projects contractors just cleared the whole right of way first off and then planted saplings later when the road was finished. But Annapolitan William Tell Claude, who worked for the State Roads Commission in the late 1930s, "hated to see a tree cut down." "Claude pleaded with his superiors for a change of policy that would preserve all possible foliage as the new highways unfolded. Since then, every tree that can be saved is spared."[203] Both the new state office building and the new Governor Albert C. Ritchie Highway were dedicated on 27 April 1940 with a parade and "colorful all-day celebration."[204]

A change to the city charter in 1937 lengthened the terms of office for mayor and aldermen from two years to four. In the election that July, Democratic incumbent mayor Louis N. Phipps ran against the city's first woman mayoral candidate. Mildred Morrison Clements, wife of academy mathematics professor Guy R. Clements, had long been active in the Better Government League and in local and state PTAs. Although a native of Pennsylvania, Clements had lived in Annapolis for more than twenty years; she was a founding member of the Book Lovers Club, begun in 1921.[205] In 1930 Clements led the fight that prevented three gasoline storage tanks, with a total capacity of more than 140,000 gallons, from being constructed on Compromise Street less than a hundred yards from the Green Street schools. The City Council had approved the oil company's request, but in the face of opposition from the county school board, the Annapolis, West Annapolis, and Germantown PTAs, and more than 1,400 petition-signing citizens, they were forced to reconsider. By odd coincidence, similar gas tanks exploded at a Gulf Refining Company plant on the Delaware River near Philadelphia in the middle of the controversy, thus proving the opposition's point.[206]

Drafted at the last minute as Republican mayoral candidate in 1937, Clements presented a list of sixteen questions for Phipps to answer. Most dealt with his fiscal responsibility and personal gain from city contracts. They were refuted publicly by Counselor McWilliams, who acknowledged that, while he had not always agreed with the mayor, he believed him to be the best candidate. (McWilliams did not run for reelection as city counselor.) Although the Democratic *Evening Capital* said "there was practically no comment around the polls about the man vs. woman issue which was given so much publicity nationally," Clements garnered only 30 percent of the vote.[207] Perhaps these words written by Eleanor Roosevelt nine years earlier are relevant: "[Party bosses] will ask women to run for office now and then, sometimes because they think it politic and wise to show women how generous they are, but more often because they realize in advance their ticket cannot win in the district selected. Therefore they will put up a woman, knowing it will injure the party less to have a woman defeated, and then they can always say it was her sex that defeated her. Where victory is certain, very rarely can you get a woman nominated."[208] Also on the ballot of the July 1937 municipal election was repeal of the "blue laws" that prohibited movies and dances on Sundays. Voters approved that by a two-to-one majority.[209]

The Annapolis Civitan Club investigated housing conditions in the city in the mid-1930s and produced a report that spurred city officials to make an informal study of their own. What both groups found was that a large number of residential structures were uninhabitable. What to do? Fortunately, Congress passed the United States Housing Act (also known as the Wagner-Stegall Bill) in 1937, authorizing grants and extremely low interest loans to local governments that wanted to build low-rent housing. During its 1937 session, Maryland's General Assembly passed legislation enabling state and municipal agencies to take advantage of the federal program. And in June of that year, the City Council established the Annapolis Housing Authority (AHA), with five commissioners, chaired by former mayor John deP. Douw.[210]

One of the first acts of the AHA was another study of the housing situation. They found that of the city's 2,761 residential units, more than 38 percent were substandard, with substandard defined as a dwelling unit lacking two or more of the following: bathroom, hot

The Career of Louis N. Phipps

One of the most colorful characters in Annapolis politics in the twentieth century was Louis N. Phipps (1896–1984). Born in Tracy's Landing, near the southern end of Anne Arundel County, Phipps moved to Annapolis after World War I to enter the booming automobile business. He launched Phipps Buick on Cathedral Street in 1923. With his eye on a political career, Phipps ran for Third Ward alderman and was elected in 1927. A thoroughgoing populist, he used his ties with the city's blue-collar workers, many of whom shared his South County roots, to challenge the entrenched Democratic bosses. He reshaped existing organizations, from the Third Ward Democratic Club to the local Ku Klux Klan, into cogs in his own emerging political machine.

Phipps was elected mayor of Annapolis in 1935 and reelected in 1937 by a wide margin. An efficient though controversial administrator, he relied on back-room contacts and his network of supporters to further his agenda. He believed in "progress" and successfully solicited federal funds to realize his vision of a modern Annapolis, paving over the last cobblestone streets, securing a new state office building for the city, and establishing the Annapolis Housing Authority. In 1936 Phipps was one of the original founders of the Maryland Municipal League.

In 1938 he won a seat in the state Senate and attempted to serve as both senator and mayor simultaneously. Public outcry and state law forced him to relinquish his seat in City Hall. After a stint in the army during World War II, Phipps resumed his senatorial career. He exercised powerful influence on the suburban development that transformed Anne Arundel County during the postwar years.

Opposed by an attractive young Republican candidate, Joe Alton, in the 1962 election, Phipps withdrew from the senate race at the last minute and ran instead for county clerk, a position he won handily. But the time for Louis Phipps's kind of politics had run its course. He was defeated for reelection in 1966 by the reform candidate, Marjorie Holt, of Severna Park, who later served as congresswoman for the Fourth District.

During the final eighteen years of his life, "Uncle Louis" remained a familiar presence in Annapolis, weighing in on issues of the day and delighting waiters and children throughout the city with his signature silver-dollar tips.

MICHAEL P. PARKER
Professor of English
U.S. Naval Academy

water, running water, central heat, any heat, electric lights, refrigeration, interior flush toilet, bath or shower. Living in those substandard homes were more than 86 percent of the town's 938 African-American families, about 12 percent of 1,759 white families, and almost all of the fifteen Filipino and/or Chinese families. Clearly something had to be done.[211]

Figuring that the most important need was getting black families out of the slums, the Housing Authority bought seven acres of land on Clay Street, tore down the seventeen substandard dwellings there, and built the first low-rent housing project in Maryland. Designed by Annapolis architect Earle S. Harder, the 108 fire-proof units were constructed

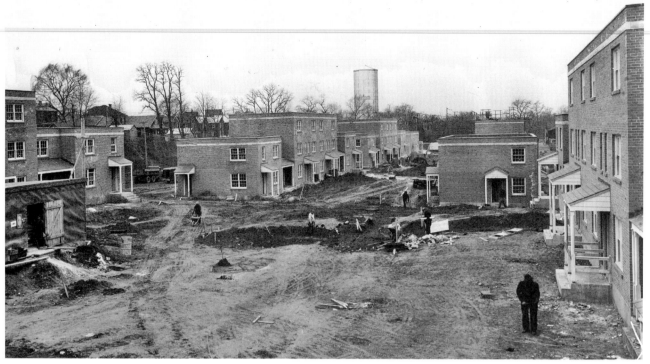

of brick and steel, their exteriors in keeping with the city's colonial appearance. Each had a full bathroom, modern kitchen, living-dining room combination and one to three bedrooms. Believing that the new tenants would want furniture that looked as fresh as their apartments, the AHA arranged with vocational instructors at Bates High School to have boys in carpentry shop repair and refinish discarded furniture for the tenants. Metal work classes fabricated medicine chests, trays, and other useful items from scrap metal. Bates girls made curtains to complement interior colors chosen by Harder.[212]

When more than two hundred families signed up for apartments in what was named College Creek Terrace, AHA and city officials were delighted. Units rented for $17.25 (one bedroom) to $18.50 (three bedrooms) a month to families whose income fell within specific limits ($969 per year for two people; $1,128 for six or more, for instance). Rental rates included heat, hot and cold water, and electricity. (The cost for slum housing in town was estimated at $23 to $26.50 a month, including utilities — when there were any.) Everyone — the governor, the mayor, the pastors of Asbury and Mt. Moriah, local physicians (black and white), and public health officials — was happy with the new housing. And because this complex was centrally located, tenants would remain in a downtown African-American neighborhood, near jobs and family.[213]

From Jim Crow legislation and the 1908 grandfather clause to the inequality of Bates High School to the construction of low-rent housing, which by fact, if not by law, would house African Americans in a location separate from most white development, the four decades before the Second World War saw Annapolis's black citizens pushed further and further away from mainstream city life. What happened in Annapolis merely echoed policies and attitudes of other cities, especially those in the South. In the next half-century, all of them, including Annapolis, would be held to account.

A Threatened City 1940 to 1960

The Great Depression ended in Annapolis, as in the rest of the United States, with the build up to World War II. When early news of the war in Europe reached Annapolis, residents of the city and the Naval Academy anticipated U.S. involvement. What they could not have known was the effect that war would have on their town. As with the Civil War, a lifetime before, the flow of military men would inundate the city, and this time, many would come with young families in need of housing and support. In this war, there would be no question of loyalty: military or civilian, employed directly in the war effort or volunteer, the people of the town would do what they could for their country. And, as with that earlier war, some of the temporary residents would choose to settle permanently in Annapolis. Their expectations would be the catalyst for the city's next transformation.

Following the fall of France in the spring of 1940, Congress authorized creation of a "two-ocean navy," and the academy geared up to supply the additional officers necessary for an expanded fleet. The school's four-year program was shortened to three years, and more plebes were admitted. Post Graduate School enrollment swelled. In February 1941, 696 graduates of civilian colleges arrived for the first four-month course leading to reserve commissions as ensigns. By the end of the war, the academy would have prepared more than 4,300 midshipmen and 3,300 reserve ensigns.[1]

Over in Eastport, the new Annapolis Yacht Yard was crafting sleek cabin cruisers for the commercial market and repairing vessels for wealthy yacht owners. Chris Nelson and Erik Almen had bought the old Chance Marine Construction yard on Spa Creek in 1937 from the Reconstruction Finance Corporation, which had taken title to the yard after financial troubles forced its closure in the early years of the Depression. Aware of the British navy's interest in motor torpedo boats, called PT (patrol torpedo) boats in the United States, Nelson decided that his yard could build their Vosper-designed seventy-foot version. By the time Nelson had traveled to England, secured rights to the Vosper plans, and was ready to negotiate a contract with the Royal Navy, Congress had passed the Lend-Lease Act, giving President Franklin Roosevelt authority to purchase American goods and military equipment for our European allies. As a result, Annapolis Yacht Yard built 128 Vosper PTs for the British and Russian navies under contract with the U.S. government. The yard also built two 110-foot submarine chasers for the U.S. Navy, the next generation of the subchasers that had been produced in the same yard a quarter-century earlier by Charlie Chance.[2]

From the spring of 1941 until the end of the war, Eastport rang with the mallets and saws of more than five hundred men building boats in two eight-hour shifts. A night shift of women workers secured the wooden planking laid up during the day. New buildings expanded the yard's capacity, almost covering the four acres bounded by Severn Avenue,

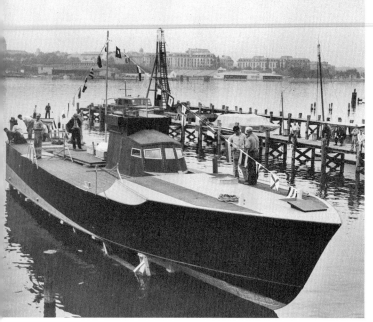

In the spring of 1942, Annapolis Yacht Yard launched its first Vosper-designed motor torpedo boat built for the British navy. The hull was double-planked mahogany over laminated oak; the power was three 1350-horsepower Packard engines. Courtesy of Lynette Almen Engelke.

First and Fourth Streets, and Spa Creek and housing not only boat sheds but machine, welding, and other shops.

Late in the war, the yard constructed seventy PT boats in kit form for the Russian navy. Detailed plans and instructions were translated into Russian with the help of officers attached to their embassy. Three Annapolis Yacht Yard men spent nine months in Leningrad directing assembly of the kit boats. AYY employees were proud of their vessels and some of them painted their names and the date somewhere inside before the boats were released.[3]

Across the Severn, the Engineering Experiment Station's chemical, mechanical, metallurgical, welding, and internal combustion labs enlarged their facilities and personnel rolls to solve specific problems for both the fleet and the navy's airplanes. From 1942 until his death in 1945, Dr. Robert H. Goddard worked at the station with a small team of scientists to develop liquid-propellant jet-assisted take off (JATO) rockets to shorten the distance required to launch heavy planes.[4]

The naval (high-power) radio station on Greenbury Point doubled its number of radio operators to fifty, increased its enlisted personnel, and added transmitters and acreage. "One of the most powerful transmitters in the world," the 500-kilowatt station sent scheduled messages to ships and naval shore installations as far away as Guam. Security was tight and armed marine guards patrolled the perimeter.[5]

With hundreds of navy personnel and civilian defense workers streaming into town, the question of where they would live became critical. Naval officers with family in the area simply settled in for the duration. Those without local ties moved into the new Perry Circle apartments, built in 1939 on the site of Porter's Folly, across from Gate 8, or the less-attractive Quonset huts arranged at the western end of King George Street in what was called "Homoja Village." Two wings of Bancroft Hall were constructed in 1941 for midshipmen and reserve candidates.[6]

Passage of the National Defense Act (June 1940), which provided federal funds for defense worker housing, prompted Annapolis Housing Authority chairman William F. Stromeyer to initiate condemnation proceedings for a little more than five acres of St. John's College land, to build 134 housing units. At the same time, rumors suggested that the Naval Academy was interested in acquiring the entire college as part of its prewar expansion. Advocates for the college gained the attention of President Roosevelt, who declared that only the navy, not the Housing Authority, could take the college, and then only if it was essential for national defense. Both Stromeyer and the navy backed down.[7]

Instead, the Housing Authority built fifty-one apartments in a six-building brick complex on the south side of St. John's Street. Designed by local architect Earle Harder, who had been responsible for College Creek Terrace, the new "Bloomsbury Square" was completed in just six months at a cost of $250,000. Mayor William U. McCready, owner of a Main Street furniture store, furnished a demonstration apartment, and most of the units were rented to senior navy enlisted men before the project opened on 1 December 1941.[8] Other navy men and their families found rooms or tiny apartments for rent in private homes.[9]

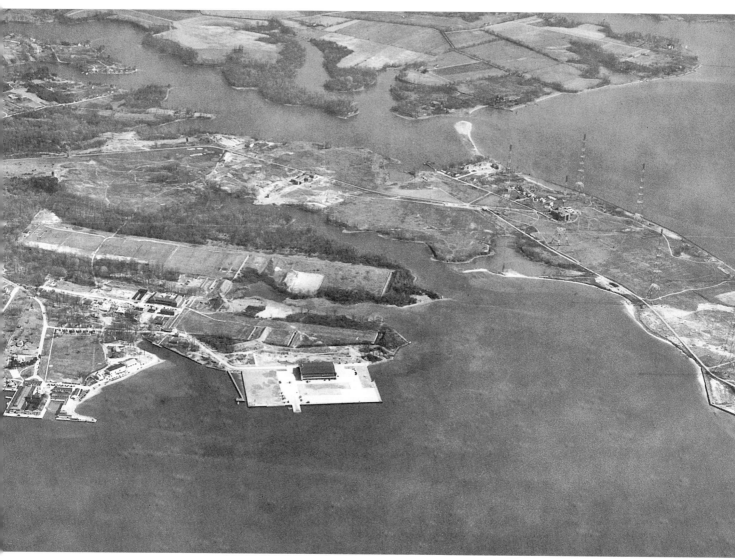

Housing for civilian workers was another story. Chris Nelson complained in October 1941 that he needed to hire 100 to 150 men at Annapolis Yacht Yard, "but they won't stay in Annapolis because there's no place to live." The following month, the federal Office for Emergency Management announced that fifty "trailer-homes," each accommodating a family of four, would be built for AYY workers. The Farm Security Administration completed fifty trailers on Jackson and President Streets in February 1943, and later that year, another fifty units of prefabricated federal emergency housing — "cardboard houses" many called them — were built on a nearby farm. In the winter of 1945, the Eastport Manor subdivision added twenty-two brick duplexes in the President Street area.[10] For many families, the housing solution was a summer cottage in one of the waterfront communities near Annapolis. Cottage owners, trapped in Washington or Baltimore by jobs and gas rationing, installed heat (kerosene burners were popular) and maybe some insulation in their vacation homes and rented them as year-around residences. Navy wives often remained there with the children when their husbands shipped overseas.[11]

The U.S. Navy complex on the north shore of the Severn, shown here in 1942, included the Engineering Experiment Station, a seaplane base, and a powerful low-frequency radio station with tower-supported antennas on Greenbury Point. Courtesy of the Special Collections and Archives Department, Nimitz Library, U.S. Naval Academy.

One hundred Quonset huts, called Homoja Village, housed military families during and after the war. Courtesy of the Special Collections and Archives Department, Nimitz Library, U.S. Naval Academy.

Where civilian defense workers, or anyone else, would *not* live was the neighborhood called Hell Point, which lay on the water side of Randall Street. A close-knit community of African Americans, Filipinos, and whites employed at the academy or in the seafood industry, Hell Point had long enjoyed a well-deserved reputation for toughness and pride. Much of the original Hell Point had been taken by the academy at the turn of the century, but more than a hundred families still lived between Randall, Prince George, and King George Streets in 1941. Roughly a third of their homes were owner occupied; most of the others, titled to absentee landlords, were two-story frame dwellings without running water, electricity, or central heat. Also within the two-block area were commercial establishments: lunchrooms, a saloon, Senator Louis Phipps's gas station, oil tanks, the old steamboat landing and ferry wharf, and the yard and warehouses of the Johnson Lumber Company.[12]

There appears to have been little outcry from the city at large when, in October 1941, it realized that the academy had acquired, by purchase or condemnation, every property in Hell Point save a dozen houses on Randall and Prince George Streets. Residents were ordered to vacate their homes on 15 December. With housing in town hard to come by and no money received yet for their sales, even the more affluent Hell Pointers felt abandoned. Alderman Jesse Fisher, whose house at 11 Randall Street was one of those taken, said he would understand if his property "was to be used for national defense purposes . . . but to take my home and other homes for a drill ground and playing field, on such short notice, is outrageous." What struck many Annapolitans later was that after the navy demolished the buildings, the land lay empty throughout the war. Halsey Field House, located on the site today, was completed in 1957.[13]

For those who had lived through World War I, the activity in town was all terribly familiar — giving blood, making bandages, selling war bonds, collecting scrap metal, entertaining servicemen stationed nearby. But this war carried the threat of enemy bombing or sabotage right here at home, and this time radio broadcasts brought the war, live and ugly, into living rooms all over town. News of the attack on Pearl Harbor on 7 December 1941 and the declaration of war the next day was followed immediately by reports of air raids in New York. "War news worse than we thought," wrote one listener.[14] Families installed dark green window shades for the blackouts that began a few weeks later, and daytime air raid sirens sent schoolchildren into hallways, where they crouched giggling at the excitement. Wearing hard hats and arm bands, volunteer air raid wardens patrolled the city's streets at night checking that all was dark, and quiet.[15]

After years of uncertain employment during the Depression, jobs in Annapolis were now easy to come by. Women found themselves in demand as replacements for men off at war: the Eastport Fire Department took on women for desk jobs; the Experiment Station and Naval Hospital welcomed members of the Women's Reserve; and the Naval Academy recruited black women for laundry work and other jobs formerly held by enlisted men, thus enabling them to get Civil Service pensions.[16] Local families had more income than before, but rationing and shortages limited their ability to spend it. Wartime food scarcity

followed depression privation. "Some kids were hungry for a long time," remembered Tom Worthington, who lived through both.[17] At Bates High School, students raised chickens on five acres next to the school and sold them — 1,500 in 1942 alone. The school mule, Jack, plowed a fifteen-acre plot nearby where the boys grew vegetables under the direction of agriculture teacher James Whittington. Girls in Home Economics classes canned the produce for use in the school cafeteria.[18]

Navy wives volunteered along with everyone else, but mostly they "coped with their little children, and waited, and prayed."[19] There is no way now to tell how many local men and women actually served in the military. Only the names of those who died appear on the official Gold Star Roll. According to that record, of the men who listed their next of kin — wives or parents (or in one case grandparents) — as residing in Annapolis, West Annapolis, or Eastport, eighty-seven lost their lives during the war. Of these, fifty were naval personnel or marines, thirty-six army or army air force men, and one was in the merchant marine. Forty-seven were killed in action, more than half of them in the Pacific; three died at Normandy. Twenty-three had attended the Naval Academy. At least three sets of first cousins were killed. The local men were sons of mayors (2), physicians, naval officers, World War I veterans, a plumber, an electrician, a bandsman. More than half the dead left wives in Annapolis, and in at least eighteen cases, neither the serviceman nor his

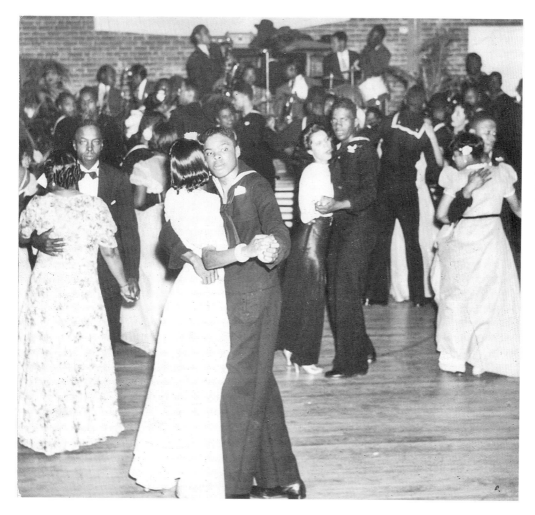

The Girls' Service Organization of the Annapolis USO arranged dances, like this one at the Bladen Street Armory in May 1942, for sailors on the USS Cumberland at the Naval Academy or soldiers stationed at Fort Meade. Courtesy of the Afro-American Newspapers Archives and Research Center.

wife had local connections — the war had brought them here, and, as so often happened, the wife chose to remain at their last posting when her husband went to sea.[20] What the Gold Star Roll does not reveal are those men and women who had relatives and friends in Annapolis but whose legal survivors lived elsewhere. Sometimes their names showed up in *Evening Capital* obituaries; other times their loss was borne without public recognition.[21]

Unconfirmed news that the Germans had capitulated reached Annapolis on 5 May 1945, but the city "remained calm" until President Harry S Truman made the official announcement at 9:00 a.m. on the 8th, at which point the town echoed with bells and sirens, businesses closed, and "church doors were opened wide." "There was rejoicing," the *Evening Capital* reported, "but there was little gaiety."[22] Too many men were still fighting in the Pacific. Not until President Truman announced the Japanese surrender on 14 August did residents allow themselves to celebrate with enthusiasm. "The city went wild," according to the *Evening Capital*. "Old residents state that nothing to equal the demonstration had ever been seen in the ancient streets in all its history." Their horns honking, cars full of cheering passengers strewing confetti and shredded paper paraded "bumper to bumper" through town dragging tin cans. At the academy, 2,000 midshipmen, let loose in the yard, snake-danced and yelled and beat the Japanese bell for hours. The next day, so many people waited in line for non-rationed gas that filling stations ran out.[23] The city's official parade took place on 4 September, with what must have been every military band, war-volunteer group, fire engine, and military unit in town in the line of march. Fort Meade sent a detachment of equipment and personnel, and the veterans of past wars rode in decorated automobiles. American flags flew from homes and stores, and hundreds of people lined the streets to watch and cheer. As the marchers paraded through the Fourth Ward, the city's black community peppered their applause with shouts of encouragement for Naval Academy plebe Wesley Brown, the only African-American midshipman in the ranks. "Annapolis loves a parade!" enthused the *Evening Capital*.[24] The Greater Eastport Civic Association dedicated the city's first permanent memorial to "those who served in the defense of our country," at Sixth Street and Severn Avenue, on 30 May 1951.[25]

Threats to the St. John's College campus bracketed the war, with the second, in the summer and fall of 1945, being the more serious. Quiet reports had been circulating for months, and in June 1945, when the House Naval Affairs Committee "tentatively approved" acquisition of the college as a component of the planned postwar expansion of the Naval Academy, the town's businessmen, newspaper, and mayor publicly applauded the move. "Come on in and take more — take all you want to," was the invitation attributed to Mayor William U. McCready. What he and the Chamber of Commerce and a good many others feared was that the academy — called "the very bone and sinew of Annapolis" by the *Evening Capital* — would leave town if denied the college's land.[26] St. John's officials, aware early on of the navy's interest, had prepared a position statement in April that seemed to agree to the takeover if it was "in the national interest," reflecting the stipulation of federal need in the previous, 1940, attempt. However, Dean Scott Buchanan soon came to see the issue as the government's exercise of eminent domain over a liberal arts college and dug in his heels against it. At stake was the thirty-two-acre college campus with a venerable history and the college's New Program, unique in the United States, versus an estimated 70 percent of the city's income. At stake as well were the three residential blocks between Hanover and King

George Streets and the end of King George Street west of College Avenue, which also figured into the navy's expansion plans.[27]

The college was not without supporters. St. John's alumni rose up against the navy takeover and against any thought of moving their college somewhere else, a possibility that President Stringfellow Barr and Dean Buchanan were considering. Dr. Thomas Parran, chairman of the St. John's Board of Visitors and Governors who also happened to be surgeon general of the U.S. Public Health Service, tried to intercede between the government and the school. Metropolitan newspapers came out in favor of St. John's, with *The Washington Post* suggesting that a second naval school be established on the West Coast. And a group of a hundred Annapolis women, led by Nancy Walton Rigg, met with Governor Herbert R. O'Conor in an unsuccessful attempt to enlist his support for the college. Passing the buck, the governor arranged for a few of them to meet with Vice Admiral Ben Moreell, of the Bureau of Yards and Docks.[28]

Arrayed against the college were the local Chamber of Commerce's Committee for the Retention of the Academy, which claimed the backing of ten thousand people (including, they said, the entire General Assembly), federal employees at the academy and elsewhere, and members of the Rotary, Civitan, and Knights of Columbus organizations. Eighty percent of the residents of the Annapolis area "urged retention and expansion" of the academy, said the committee. Maryland's U.S. senator Millard E. Tydings and Anne Arundel congressman Lansdale G. Sasscer were strong proponents of the navy's presence in Annapolis.[29]

As Congress and the navy discussed the future of the academy in Washington, midshipmen and academy officials in Annapolis set about celebrating their school's hundredth birthday. Events began on 7 October 1945, just days after the Senate Military Affairs Committee heard testimony on the navy's acquisition of St. John's. A memorial service, parades, dinners, a centennial ball, and a squadron of navy planes forming "100" over Thompson Stadium were followed by football and the dedication of Ogle Hall as the Alumni House. The fact that probably everyone recognized the irony of these events — the next centennial might be in California — made them all the more touching.[30]

As it turned out, Congress, the secretary of the navy, and a blue-ribbon board of naval officers and civilians decided that acquisition of St. John's was not essential for the academy's programs, nor would it be necessary to open a second school in California. The formal decision, announced in the spring of 1946, would keep the academy a four-year school in Annapolis and supplement its officer corps with Reserve Officer Training in selected colleges and universities. Joseph D. Lazenby, chairman of the Committee for the Retention, and Clarence E. Tyler, past president of the Chamber of Commerce, wrote a concilia-

Young women who dated midshipmen were known as drags. Here two drags, dressed for a formal hop, greeted their escorts on the back porch of the Bordley-Randall House, c. 1942. Photograph by John Phillips. Courtesy of the Maryland State Archives MSA SC 2140-420.

Church attendance was mandatory for midshipmen for more than fifty years, and congregations such as that of the College Avenue Baptist Church, shown here on 30 April 1944, welcomed the young men into their church families and, often, into their homes. Compulsory church attendance ended for Naval Academy students in January 1973. Courtesy of the Special Collections and Archives Department, Nimitz Library, U.S. Naval Academy.

tory letter to Barr, apologizing for any "acrimonious statements" made during the affair and offering "the friendship" of the Chamber.[31] But it was too late for Barr and Buchanan. Both men left Annapolis within the year, planning to start a new liberal arts university in another location far from the influence of the navy.[32] St. John's College and its New Program continued. Returning veterans boosted postwar enrollment figures, and in 1949 the school welcomed a new president, Dr. Richard D. Weigle, who would devote himself for the next thirty years to the college's financial and institutional security.[33]

After the war, burgeoning suburbs eclipsed Annapolis. In 1940, for the first time in more than two hundred years, a few more people lived in the county's Second District, surrounding Annapolis, than in the city itself. During the next decade, the Second District's population grew by more than 80 percent while the city's increased only slightly, with the result that in 1950, suburban residents outnumbered city dwellers by almost two and a half to one.[34] Even before the end of the war, developers began filing subdivision plats for vacant parcels around Annapolis, and when construction materials became available, houses went up quickly. Much of the new building took place on the Eastport peninsula, at first replacing the temporary, wartime housing in the President Street area and then expanding along Bay Ridge and Tyler Avenues. Almost all of these houses were simple one-story, two- or three-bedroom cottages built on small lots to a standard design that met the requirements for Federal Housing Administration loans: Colony Hills, for example, or Victor Haven, and, later, Primrose Acres.[35] In 1950, the population of the unincorporated village of Eastport was 4,594, only slightly less than Easton, more than the towns of Chestertown and Crisfield, and just under half that of its neighbor across Spa Creek.[36] Bowing to need (a 1946 survey counted 16,800 cars traveling the Spa Creek bridge in sixteen hours), the old swing-draw bridge to Fourth Street was replaced in 1947 by a modern concrete and steel structure seventeen feet above mean low water at its hydraulic draw. The new bridge spanned the creek from Compromise to Sixth Streets, taking traffic away from the Fourth Street shopping district, which suffered a predictable loss of business. Market Street resident Emily Peake remembered that the construction disturbed rats "big as cats," which ran up Duke of Gloucester Street to the little store at the corner of Market Street, where they destroyed all the packaged goods and terrorized the owner.[37]

Subdivisions in the Parole area — on Gilmer Street and Rosewood west of Dominoe Road, for instance — were spurred by a new county road (now Forest Drive) linking Solomon's Island Road with Chinquapin Round Road.[38] Nearer to the city, but still outside its boundary, were Admiral Heights, built on farm land near Weems Creek (1947), and Carroll Hynson's Capital Hill Manor on the east side of Spa Road (1948).[39] All of these offered affordable housing for the families of those working in Annapolis after the war, as well as local veterans looking to take advantage of federal loans and move to the suburbs. But until these developments were built out, housing remained tight and people continued to live in those "winterized" summer cottages.[40]

Postwar federal grants affected Annapolis in another, potentially more important way by funding a high-speed highway that would replace the old Route 50 and completely bypass the city. When the state highway commission announced a new four-lane bridge across the Severn River in 1944, it was only a matter of time before that bridge and the new Revell Highway to the Sandy Point ferry became part of the new U.S. Route 50 corridor between Ocean City, Maryland, and Washington. Four years later, plans for the Washington-Annapolis "expressway" were in place, and in 1949 the first contract was awarded, for the segment from Annapolis to Route 301.[41] Construction began two years later, with sections of the highway being opened as they were completed. Governor Theodore R. McKeldin dedicated the still unfinished road as the John Hanson Highway in 1957, and in November 1961, Governor J. Millard Tawes cut the ribbon on "the final link," near Cheverly. Building the twenty-six and a half miles of dual-lane, limited-access, high-speed highway through bucolic farms and forests had cost more than $33 million. Federal government employees

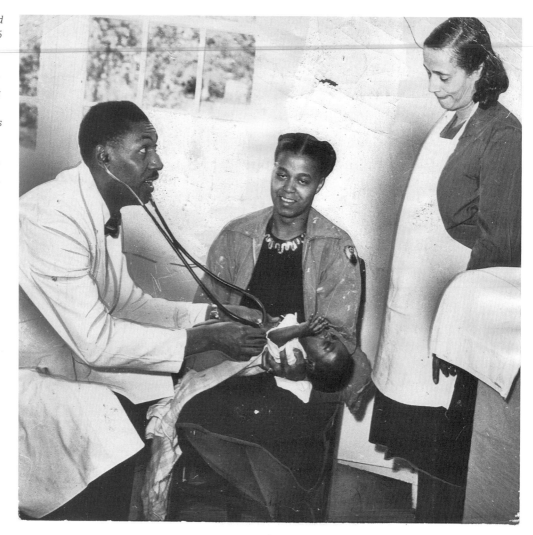

Parole residents established a health care center in 1936 to house medical treatment facilities for their community; a decade later they began a purpose-built structure at Drew and Parole Streets. Here, Dr. Aris T. Allen examines Allen F. Harris, age three months, under the watchful eyes of his mother and nurse Myrtle Jackson at the brand new Parole Health Center building, June 1949. Courtesy of the Afro-American Newspapers Archives and Research Center.

who lived in Annapolis were invited to the ribbon cutting. "We are fond of Annapolis and we want to stay there," said one worker, who noted that his commute had just been reduced by ten minutes each way.[42]

As the people of Annapolis, and the nation, cemented their love affair with the automobile, passenger service on the Washington, Baltimore and Annapolis Railroad ended with the last train to the Bladen Street station on 5 February 1950. The railroad company put buses on the Baltimore to Annapolis route and maintained this service until September 1983. By 1959 the bus terminal had moved to West Street, on the site of the 1870 train station, which had been demolished and replaced in 1923 by the Annapolis Dairy. Here, the B&A shared facilities with the Greyhound Bus Company, formerly housed in a garage on Carvel Hall property on King George Street. Ticket agents and the Terminal Restaurant took over the old dairy building.[43]

Even as contracts were let for the highway to Washington, construction was already under way on the long-discussed bridge across the Chesapeake. Governor William Preston Lane, Jr., championed the bridge from his first days in office in 1947, and it received approval, and funding, from the legislature that year. Arching across the Bay for just over four miles between Sandy Point and Kent Island, the bridge was heralded as the "largest

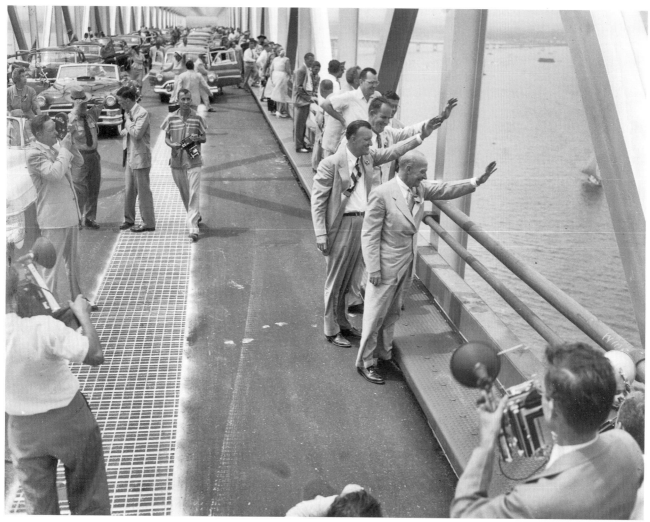

On opening day of the Chesapeake Bay Bridge, 30 July 1952, former governor William Preston Lane, Jr., (at front) for whom the bridge was named, current governor Theodore R. McKeldin, and Delaware governor Elbert N. Carvel waved to boaters on the water more than 180 feet below the center span. Courtesy of the Maryland State Archives, MSA SC 2117-246.

continuous entirely over-water steel structure in the world," its length almost eight miles including the approaches. The highest point on the roadway over the main channel to Baltimore cleared mean high water at 186.5 feet.[44] Suspension cables were spun on the bridge at night, creating a burst of daylight in the dark sky that amazed watchers on the shore. Dedication ceremonies, at which the bridge was named after Governor Lane, took place on 30 July 1952. At that point, travel time from Manhattan to Washington via the recently completed New Jersey Turnpike and Delaware Memorial Bridge shrank from seven to four and a half hours.[45] Completion of John Hanson Highway nine years later made the trip even shorter.

While they watched construction progress outside city limits, Annapolitans discussed how at least some of these travelers might be routed into town. The State Roads Commission first offered to link its new highway to downtown Annapolis with a road across Weems and College Creeks that would merge with Clay and Northwest Streets, destroying some 120 homes and decimating the Fourth Ward business district. Opposition from residents in the area and newly elected mayor Roscoe C. Rowe resulted in Rowe Boulevard, the appropriately named western extension of Bladen Street, which opened in November 1954.[46]

ROGERS
INN

Annapolis, Maryland

★

For Tourists

Standard Rates

★

Three Baths, Showers
Free Parking, Garages

★

ON ROUTE 50

Five Minutes From
the Naval Academy

MRS. GEORGE L. ROGERS, Hostess

1202 WEST STREET TELEPHONE 2721

Finding themselves no longer on the route to anywhere after U.S. Route 50 left town in the early 1950s, Annapolis business owners, like Mrs. George Rogers, feared the end of their livelihood. Courtesy of Beverly Davis Valcovic.

One of the attractions of Annapolis that drew new residents in general and young physicians in particular was the city's hospital. A change in the Annapolis Emergency Hospital association bylaws in 1942 set term limits on the board of managers, effectively ending the "Lady Board," which had operated the hospital since its founding forty years earlier. The ladies generally had reelected themselves until they resigned on their own or died. Now, with term limits, membership could expand. At its 1945 annual meeting the association elected three male board members. One of them, investment banker John Baldwin Rich, immediately took control and began preparing the hospital, both staff and physical plant, for a future that most felt would bring more patients and improved medicine. Which it did. In 1949, the hospital's name was changed to Anne Arundel General Hospital, reflecting both its service area and the breadth of its specialties. By the early 1950s, the practice of bringing in physicians from Baltimore hospitals as chiefs of service ceased with the appointment of local chiefs for pediatrics (Dr. Philip Briscoe, 1948) and medicine (Dr. Frank M. Shipley, 1952). Local chiefs for obstetrics (Dr. Samuel Borssuck), gynecology (Dr. Stuart Christhilf), and surgery (Dr. Jess Wilkins) followed quickly. Patient admissions of just under 2,400 in 1941 rose to more than 4,000 in 1951. Reflecting the national baby boom, the 366 births of 1941 were surpassed by 719 babies born ten years later. With new testing procedures and a hospital-based laboratory under full-time pathologist Dr. Manning W. Alden, lab tests skyrocketed from 408 in 1941 to more than 31,000 in 1951. A few women remained on the hospital board, but more worked for the hospital through the Women's Auxiliary, established in 1944. Auxiliary members sewed sheets and baby clothing and raised money by sponsoring community concerts and selling used clothing and accessories at the popular Clothes Box.[47]

Following the death of Dr. William Bishop in 1904, the hospital's governing board no longer accepted African-American physicians to the staff. During the years when only white physicians could treat hospital patients of any race, African Americans under the care of black physicians often chose black hospitals in Washington or Baltimore when hospitalization was required. African-American physician Dr. Theodore H. Johnson maintained

a well-equipped medical clinic and maternity ward on Northwest Street. The maternity ward was especially important to his community, because for the first fifty-three years of its existence, the Annapolis hospital did not admit African-American women for maternity care. Howard University–trained physician Aris T. Allen, who established a family practice in Annapolis in 1945, recounted stories of his midnight flights to Howard University's Freedmans' Hospital with a mother in labor in the back seat of his car.[48] The black community learned well the incalculable sorrow when a delivery gone wrong caused damage to a mother or child only because their skin color denied them proper care.

Fundraising for a new wing for Anne Arundel General Hospital began in June 1949 at a kick-off dinner at the home of Tom and Ronnie Carr in Ferry Farms. Less than a month later, the drive had raised $500,000 from individuals, businesses, and civic organizations, two-thirds of them outside the city limits. Additional funding came from the Summerfield Baldwin, Jr., Foundation, the federal government, and county bonds. Construction began with a groundbreaking ceremony in November 1952. The Baldwin wing, with a host of modern facilities, was completed in May 1955 and named to memorialize its major donor. Three years later, the hospital achieved two major milestones: the hiring of its first professional hospital administrator, Lyman C. Whittaker, and its first full accreditation from the Joint Commission on the Accreditation of Hospitals.[49]

New labor and delivery rooms and an improved nursery suite in the Baldwin wing allowed the hospital to open its doors to African-American maternity patients and still maintain racial separation for those who desired it. Staff privileges were given to African-American doctor Raymond L. Richardson in 1954. He was followed quickly by Dr. Johnson and both Dr. Aris T. Allen and his wife, Dr. Faye Allen, who had received her medical degree from Howard in 1950 and joined her husband in practice. Segregation by race in staff facilities ended in the late 1950s and throughout the hospital a few years later.[50]

For more than two decades Annapolis had listened to radio programs produced by big-city stations and sponsored by big-city advertisers. Only after the war did Annapolis get its own station and then, suddenly, it had not one but three. First on the air, in December 1946, was WASL, at 810 kilocycles, which had its studio and tower on Silopanna Road. WASL played standard music of the day and produced children's talent shows and plays to attract local listeners. The station was more successful in a later incarnation as WYRE, "The Voice of the Bay."[51]

Just weeks later, on 10 January 1947, WANN began broadcasting at 1190 kc. Owner Morris Blum, who had been a marine radio operator before and during the war, chose Annapolis on a whim for his postwar venture. With studios on the second floor of the bank building at the top of Main Street and a tower on Bay Ridge Road, WANN soon became a popular place on the dial, as Blum featured rhythm and blues, rock, and gospel music from dawn to dusk. WANN disk jockey Charles W. "Hoppy" Adams was Annapolis's first radio personality.[52]

The third local station to reach the Annapolis radio audience had been in the works for almost eight years before its first broadcast. While WASL and WANN were AM stations limited to daylight hours, WNAV received FCC permits for both AM and FM and for nighttime programming. Conflicts with another Maryland station delayed its AM broadcasting until 1949, but the FM side of the band went on air 15 January 1948. WNAV built its tower

in what was then a remote spot off Admiral Drive but had its first studios in Carvel Hall. Nighttime licensing allowed the station to broadcast Naval Academy basketball games and pick up affiliation with the national Mutual Broadcasting Network.[53]

Postwar Annapolis saw an increase in the number of boats used for pleasure. Large yachts stopped in the Severn on their way up and down the Intracoastal Waterway, and smaller sail and power boats darted around the creeks and river. At the end of the Depression, a group of local businessmen turned the old Severn Boat Club into the Annapolis Yacht Club and built a large wooden clubhouse on pilings at the end of Compromise Street. AYC members also bought Charlie Chance's nascent marina from the Reconstruction Finance Corporation and formed the Yacht Basin Company.[54] With more than a hundred slips and a gas dock, the Yacht Basin attracted yachtsmen, both transient and local. Annapolis Yacht Club had sponsored sailing races and summer and fall regattas for small one-design boats and large sailing yachts before the war; the prestigious ocean race from New London finished in Annapolis in 1939.[55] After the war, racing continued on an even larger scale. A spring series was added in 1946, and two years later the club organized a junior fleet to teach youngsters to sail. From New York to Virginia as well as the Chesapeake, sailors and their classic wooden boats came to Annapolis to compete and socialize.[56] The Naval Academy sailing program begun in the late 1930s gained strength after the war under superintendent Rear Admiral James L. Holloway,

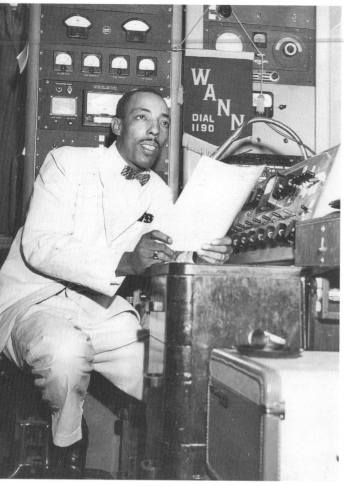

By 1959, Charles W. "Hoppy" Adams handled station promotion and sales in addition to his jobs as announcer and disk jockey. WANN studios were on Church Circle at the time, and the transmitter was on Bay Ridge Avenue. Courtesy of the Afro-American Newspapers Archives and Research Center.

Jr., who brought in the commodore of the New York Yacht Club to help organize the Naval Academy Sailing Squadron. Legendary sailing yachts donated to the academy — especially *Vamarie* and *Highland Light* — raced with midshipman crews against local boats in regattas and long distance races and became much beloved.[57]

Annapolis paused in the spring of 1949 to commemorate the three hundredth anniversary of European settlement on the Severn River. Billed as a celebration by both the city and Anne Arundel County, festivities covered an entire week, 22 to 27 May, and included activities focused on the region's importance to education (as a resource in teaching colonial history) and recreation ("as the leading yachting center of the eastern seaboard"). There were the predictable parades (two on land, one on water), anniversary exhibits (all over town and the Naval Academy), speeches (many), concerts (several: band and choral, student and adult, African American and white), open houses, sailing races, a fly-over (104th Fighter Squadron), naval vessels on display (four), the Princess Anne's Ball (in the gym at St. John's College), and an afternoon visit by First Lady Bess Truman. Elmer M. Jackson, Jr., general manager of the *Evening Capital* and *Maryland Gazette*, chaired the Annapolis Tercentenary Commission, Inc., assisted by forty commission members representing local civic groups, city, county, and state governments, St. John's College, and the Naval Academy.[58]

This Annapolis Yacht Club building witnessed the postwar boom in yacht racing, junior fleet instruction, and marina development along Compromise Street until it was replaced in 1963. Courtesy of the Maryland State Archives, MSA SC 252-73.

Master shipwright John Trumpy and his two sons bought Annapolis Yacht Yard in 1947 and continued building their classic power yachts, employing many of the men who had worked for AYY during the war. They launched the Rumak III in 1955. Courtesy of M. E. Warren Photography LLC, MSA SC 1890-30,273.

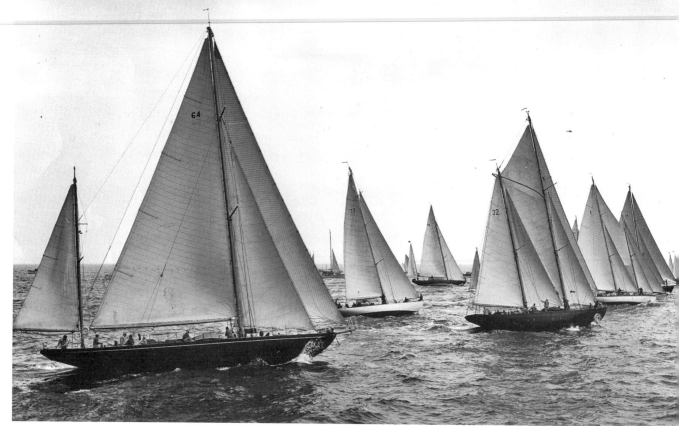

Naval Academy yachts Royono *(64),* Vamarie *(32), and* Highland Light *(34) at the Class A start of the Newport–Annapolis Race, 1951. The course was reversed in 1957 to become the Annapolis–Newport Race. For many years, these demanding offshore contests alternated years with a race to Bermuda. Courtesy of the U.S. Naval Institute.*

(right)
Arnie Gay, crouched on the pier, began his Annapolis career running this boatyard on Severn Avenue and winning every sailing race he could, which was most of them. Courtesy of Julia Gay.

Arnold C. Gay

Many hands made Annapolis today's sailing capital, but the city's rise to sailing fame began when a New Englander, Arnold Channing Gay, steered his wooden schooner *Delilah* into Spa Creek in 1946. The reputed father of Annapolis's modern sailing industry arrived with just $1.47 in his pocket. He found a waterfront of dilapidated, rat-infested piers, but he recognized the city's potential as a world-class sailing center.

Within just a few years, as owner of boatyards on both sides of Spa Creek, Arnie Gay was proposing new docks on the creek, to "benefit local business," advocating an Annapolis to Bermuda race to attract people with "money in their pockets," and, in general, promoting yachting as important to the city's economic health. He encouraged marine hardware and service businesses and rival boatyards, believing that the more active the city's marine industry, the better for all. To hammer the point home, Gay gave local merchants tangible evidence of the maritime industry's value by paying his Eastport yacht yard employees in two-dollar bills. When the Naval Academy expanded its grounds along the creek, Gay helped persuade them to put in stone seawalls instead of steel bulkheads to keep the wave action down. Then he lobbied the city to place fixed moorings in the harbor.

Arnie Gay never lost his passion for sailing. He taught midshipmen offshore racing techniques, ably demonstrating them in 1978 when he won the Bermuda race in *Babe*, one of the last wooden racing yachts. A fierce competitor who won many trophies, he also took pride in being the best on-board cook.

Commodore of the Annapolis Yacht Club in the late 1960s, Gay was also active in civic affairs, chairing the Committee for a Clean and Beautiful Annapolis, serving as president of the Annapolis Chamber of Commerce, and volunteering for countless committees. Although instrumental in encouraging the Whitbread Around-the-World Race to come to Annapolis for the first time in 1998, he did not live to see the event. Arnie Gay died in January 1994, at the age of seventy-four.

ELLEN MOYER
Mayor of Annapolis, 2001–2009

Serving as executive director of the commission was Sarah Corbin Robert, wife of academy professor Henry M. Robert, Jr., and daughter-in-law of the originator of *Robert's Rules of Order*, the essential tome on parliamentary debate.[59]

What made the Tercentenary celebration exceptional was the pageant: *Song of the Severn*, an original script written by Alan J. Levitt, with choreography by Adolphe Robicheau and a special song, "Roll on River," composed by Naval Academy Band clarinetist Martin DeMey (lyrics by Levitt) and sung throughout the performances by baritone Robert Jachens. Levitt and Robicheau participated courtesy of the Domar Celebration Service, professional event producers of New Hampshire, which the commission hired when they realized they had an $18,000 budget to work with — $10,000 from the state, $5,000 from the city, and $3,000 from the county. Levitt, "a young director of wide experience in both the American Theater and in staging European camp shows during World War II," came to Annapolis in February, and in three months wrote and produced a pageant with a cast of 853 costumed locals, 30 horses, and a half-sized replica of an 1853 locomotive and coaches loaned by the B&O Railroad. A two-hundred-foot stage, with two levels and ramps, was built on the

Annapolis High School athletic field. Experienced announcers from WANN dubbed the spoken parts under direction of station manager Tom Carr, an electronic organ supplied the music, and recorded sound effects provided excitement.[60]

It would have been a wonderful week if only the weather had cooperated. Instead, driving rain, cold, fog, mist, and high winds chilled spectators, postponed or canceled events, ruined costumes, and generally made everyone miserable. Of six attempted performances of the three-hour pageant only two were completed; rain shorted out electrical connections and flooded the organ.[61] More than a thousand ticket holders were turned away one night. By popular request, Levitt and the Domar costumes returned for a four-day reprise in June. This time the weather was fine.[62]

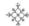

The Tercentenary celebration might be seen as the last hurrah of the old Annapolis it saluted — the one-peninsula city squeezed between two creeks — because precisely one year later voters in the surrounding suburbs agreed to a dramatic extension of the city limits. Or some of them did.

Although annexation had been rejected by suburban communities in the 1930s, city officials never gave up on their desire to bring the entire Metropolitan Sewerage District under municipal control. The issue was discussed at a town meeting in 1940 at which Mayor George Haley said he thought "annexation was inevitable." The following year the City Council authorized a $2,300 study of city government and annexation by the Public

Administration Service of Chicago, which led to another town meeting on the subject in November 1941.[63] After a wartime hiatus, annexation proponents pushed through the 1945 session of the General Assembly laws that prepared the way for yet another election and for the extension of water and sewerage to the annexed areas that did not yet have them. The city even passed a new milk ordinance canceling its support for local dairies, because people in the suburbs were said to favor milk from Western Maryland Dairy.[64] But even with pro-annexation support from the Chamber of Commerce, Citizens Group Association, and other organizations, the election on 4 June 1945 drew only a third of the registered voters of Eastport, Germantown-Homewood, West Annapolis, and Wardour to the polls. Sixty percent of them voted no. A "disappointed" Mayor William U. McCready said he hoped suburban residents would "see their error and in the very near future rectify it."[65]

Errors were indeed recognized, at least by the measure's proponents, and they handled the next annexation attempt differently. The 1941 Public Administration Service report had criticized the city's "'cumbersome' . . . committee system of government" and recommended that the charter be changed to enable "more efficient municipal operation" before annexing the suburban communities. This recommendation was ignored in 1945. It returned to the table four years later and was included in legislation creating the Annapolis Annexation Charter Commission, a body of nine members: four from the city, four from the communities outside the city, and one from an area removed from both. These nine volunteers would address the entire issue of annexation, hold a special annexation election, and, should annexation go through, would "examine and study the present Charter of the City of Annapolis to determine if the said Charter needs revision." Recommendations for revision would be reported to the General Assembly at its 1951 session.[66]

Mayor Roscoe C. Rowe appointed one city commissioner from each ward: Noah A. Hillman, Captain Charles C. Slayton, USN (Ret.), Sarah Corbin Robert, and Dr. Aris T. Allen. (D. Claude Handy was added to the commission following Capt. Slayton's death in March 1950.) The Anne Arundel County Commissioners chose Winson G. Gott, Jr., of Eastport, Melvin Schlossman of Homewood, William Martin of Fairfax, and Clarence E. Johnson of Cedar Park to represent the suburban communities on the Annexation Commission. As required in the enabling legislation, these eight members elected a ninth commissioner and chair, retired tax consultant John Lansdale, of Cumberstone in the county's First District.[67] By April of 1950, the commission had decided on the boundaries of the new Greater Annapolis. This time, instead of a selective list of communities to be incorporated into the city, the annexed land was described in metes and bounds extending from Edgewood Road on the east along a line approximating today's Forest Drive to the "Annapolis-Edgewater State Road" (Old Solomons Island Road) on the west and then to Admiral Drive and Weems Creek on the north.[68]

City income for the year ending 30 June 1949 was $131,991 from property taxes and $217,092 from other sources, such as fines, fees, licenses, and parking meters. City expenditures that year exceeded income by $1,500. Annapolis could not afford to lose money through annexation. Bond issues would be necessary to pay for extending sewer and water lines to the annexed neighborhoods, but officials felt sure that the new property tax revenues would more than cover the debt without pushing the tax rate above the one-dollar-per-hundred limit. Everyone hoped that other costs—such as upgrading the more than thirty-five miles of annexed roads, many of them gravel—could also be paid for by the increased tax base. However, money was not the primary reason so many businessmen and government officials supported annexation. A larger city, they believed, would receive

TABLE 8.1 Results of Annexation Election, 23 May 1950

Ward and Poll Location	5th Eastport School		6th Colony Hills		7th Bates High School		8th West Annapolis School		Totals
Estimated population	2,580		2,340		2,050		2,470		9,440
Registered voters	1,365	53%	848	36%	1,026	50%	1,249	51%	4,488
									48% of est. pop.
Number who voted	566	42%	388	46%	427	42%	618	50%	1,999
									45% of reg. voters
For annexation	198	35%	209	54%	342	80%	307	50%	1,056
									53% of votes
Against annexation	368	65%	179	46%	85	20%	311	50%	943
									47% of votes

Source: Evening Capital, 23, 23 (extra edition), 24, 29 May 1950.

"the respectful attention of any elected body" and become again "a dominant force — as it has been in the past — in the affairs of Maryland." Only with more land well served by essential utilities could the city grow. For residents of the targeted communities, especially Parole and West Annapolis, and the concerned city and county health officer, Dr. William A. French, the principal benefit of annexation would be the installation of much needed sewers.[69]

Just under 2,000 registered voters in the suburban arc went to the polls on 23 May 1950; 113 of them made annexation a reality. Voters in the Homewood and West Annapolis neighborhoods were almost equally divided on the issue; old Eastport remained significantly opposed; the newer subdivisions near the base of the Eastport peninsula gave annexation a slight majority. The overwhelming support of residents in Fairfax and Parole tipped the scale.[70]

Two aldermen for each of the four new wards were elected on 23 May: three Democrats, three Republicans, and two Independents. The Independents, prohibited from stating party allegiance because of their employment at the Naval Academy, were philosophically Democrats. The aldermen-elect met informally with the existing council for the next six months to help plan for changes such as the extension of water and sewerage to their constituents, an enlarged city police force, and cooperation amongst fire departments. There was a brief dispute over exactly when annexation would become official. Given the need to make some financial adjustments between the county and city as well as to solve some other problems, 1 January 1951 was selected. On that day, the assessable tax base of Annapolis doubled from just over $11 million to $22.5 million; city boundaries expanded from three-quarters of a square mile to more than five and a half square miles; and the population rose from 10,000 to almost 20,000, making Annapolis the fourth largest city in the state. Membership on the City Council doubled as the eight new aldermen were sworn in. In his lengthy speech to a capacity crowd in the City Council Chambers, Mayor Rowe

welcomed the people of the new Annapolis and called upon all residents of the city to join together and "let the other part of Maryland know that nowhere are there better citizens than in this community."[71]

For all his brave words, Mayor Rowe's smiles that day must have carried an edge of panic. How was his "cumbersome" city government going to provide municipal services tomorrow to a population twice the size of yesterday's? In spite of all the persuasive efforts of Rowe and his reform-minded colleagues, the charter revision component of the commission's work had not been a success. As authorized, and following the recommendations of the 1941 Public Administration Service reports, the Annexation Commission had

Residents of Germantown-Homewood (foreground), Admiral Heights (background), and Simm's Crossing, at the headwaters of Weems Creek (top left), became Annapolitans on 1 January 1951. Courtesy of M. E. Warren Photography LLC, MSA SC 1890-30,230B.

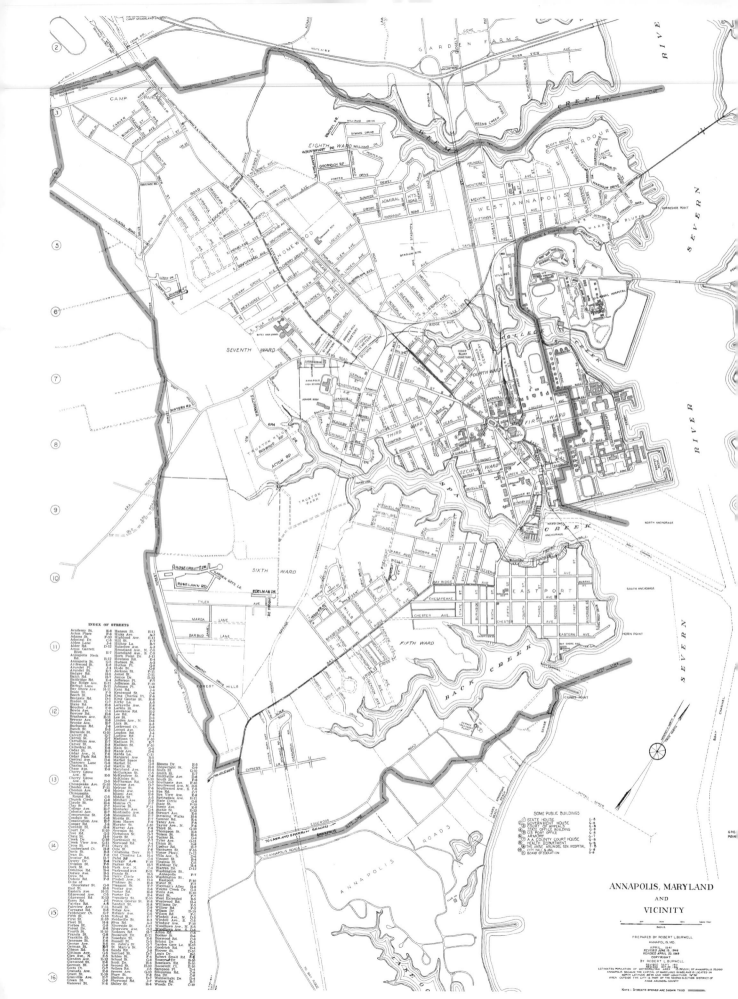

ANNAPOLIS, MARYLAND
AND
VICINITY

PREPARED BY ROBERT L. BURWELL
ANNAPOLIS, MD.
APRIL, 1941
REVISED JUNE 15, 1946
REVISED APRIL 20, 1949
COPYRIGHT
BY ROBERT L. BURWELL
SEPT., 1941

ESTIMATED POPULATION OF METROPOLITAN AREA 25,000
ANNAPOLIS BECAME THE CAPITAL OF MARYLAND IN 1695 AND IS LOCATED IN
NORTH LATITUDE 38°59' AND WEST LONGITUDE 76°30'
THE AREA OUTSIDE THE CITY IS PART OF THE SECOND ELECTION DISTRICT OF
ANNE ARUNDEL COUNTY

NOTE: STREETS OPENED ARE SHOWN THUS

SOME PUBLIC BUILDINGS

1 STATE HOUSE
2 GOVERNMENT HOUSE
3 COURT OF APPEALS
4 STATE OFFICE BUILDING
5 U.S. POST OFFICE
6 ARMORY
7 A.A. COUNTY COURT HOUSE
8 THE ANNE ARUNDEL GEN HOSPITAL
9 CITY HALL & JAIL
10 BOARD OF EDUCATION

SCALE

looked carefully at the existing charter — and scrapped it. Instead, they proposed a modern charter giving Annapolis a government headed by a chief executive officer — a "strong mayor" — who voted only to break ties in the council, had veto power over legislation, appointed department heads with council approval and fired them without it. Instead of the old committee system, the proposed charter established departments of finance, public works, and public safety, each with a full-time professional administrator, and brought employees into a merit system. It was a revolutionary and courageous attempt to pull the city government into line with current thinking on big city management and remove it as much as possible from the vagaries of politics. And there was not a chance it would go through, because state senator Louis N. Phipps did not like it.[72]

The "affable" Senator Phipps, former alderman (1927–1929), former mayor (1935–1939), former state senator (1939–1943), and state senator again as of the election of 1950, was publicly acknowledged as the leader of the city's Democratic Party when the four aldermanic candidates he supported won City Council primary elections in June 1949. Three of them prevailed in the July general election. There was talk that Phipps people actually backed the successful Republican Roscoe C. Rowe against the non-Phipps Democrat William U. McCready, who was seeking a third term as mayor.[73] Five of Senator Phipps's "friends," including his brother-in-law, Arthur G. Ellington, were elected aldermen of the new wards in May 1950, giving his faction eight out of seventeen votes on the council. Senator Phipps approved of annexation, but he did not approve of any extensive revision of the city charter, which he believed "would serve for many years to come as is."[74]

In the end, all the public council meetings, private caucuses, letters to the editor, amendments, and compromises came to naught. The Annexation Commission submitted its revised charter to the General Assembly during the 1951 session as required. The charter bill was referred to the Anne Arundel County delegation, headed by Senator Phipps. Only Delegate Orlando Ridout IV dared to vote in favor of bringing the bill to the House floor. The charter revision died.[75]

That session of the Assembly did pass acts to recognize the new boundaries of the city, reduce the number of aldermen per ward to one each, and change the city's election dates. It also authorized the city to borrow $2.5 million for water and sewer improvements, and to allow the city to acquire land and construct off-street parking facilities.[76] The Senate also passed Senator Phipps's "pet legislative 'baby'" — a bill to construct a multimillion-dollar state office building in Annapolis.[77] It was hard for city politicians to argue with a man who was bringing them a larger state presence (and more state employees), especially when the Post Graduate School at the Naval Academy was moving out. Phipps was, said one Naval Academy official, "sincerely though utterly unreasonably devoted to holding for Annapolis what she has and getting more."[78]

Rumors had been around for decades that the Naval Post Graduate School would leave Annapolis. The gossip became reality when federal legislation in 1947 established the U.S. Naval School, General Line, on the three-hundred-acre grounds of the Del Monte Hotel in Monterey, California. Subsequent orders directed that all naval postgraduate schools relocate there by 1953. During the winter of 1951, the Annapolis Chamber of Commerce made a last-ditch stand to keep the postgraduate engineering school and laboratories in Annapolis, or at least to delay their move. An *Evening Capital* editorial in mid-March admitted, "It isn't often that this newspaper differs with the wishes of the Navy," but in this case the paper's vice president and general manager, Elmer M. Jackson, Jr., was chair of the Naval Affairs Committee of the Chamber and determined to do whatever was necessary

(opposite)
In one day the area of Annapolis increased from less than three-quarters of a square mile to more than five and a half square miles, with a population that made it suddenly the fourth largest city in Maryland. City boundaries in 1951 were essentially the same as on this 1957 map. Courtesy of the Bureau of Engineering and Construction, Department of Public Works, City of Annapolis.

to retain the school. It was "reckless spending" to build new buildings in California when there was land in Annapolis, editorialized the paper, which considered the Homoja huts "better looking" than some other navy housing in the area.[79] Appeals went out to state and federal representatives, and a contentious Chamber delegation called upon the school's superintendent, Rear Admiral E. E. Herrmann. Herrmann showed the men around the school and the labs at North Severn. In the course of the day, they made a special visit to the half-Homoja hut–quarters of a PG School student, his wife, and three children — quarters so cramped you "could shower and cook at the same time." Statistics on the negligible effect of the school on the town — only a third lived in town and most used the commissary and did their "big shopping" in Baltimore or Washington — helped convince the delegation that, maybe, the navy was making the right move. Phipps was particularly surprised by the living quarters, "Gosh," he said, "I always thought these people each had a whole hut."[80] The Chamber of Commerce and *Evening Capital* withdrew their opposition.

Student and faculty families were not the only people heading for the West Coast when the school left town at the end of the fall term. Also traveling to California were civilian employees, most of them African-American men, who ended up rooming together in Monterey. Their families remained in Annapolis.[81]

Although the City Council had discussed their responsibility to provide recreational facilities for city residents before the war, it wasn't until the expectations of returning veterans and their young families pushed the issue that city-sponsored recreation became a reality. The movement began when veteran athletes formed the Annapolis Athletic Association in 1946 to encourage football and other team sports. Three years later, city officials leased to AAA the old city dump behind the incinerator on Spa Road, with the agreement that they would develop ball fields for the use of any organized athletic group in the city, "without regard to race, color or creed." Work by municipal employees and AAA resulted in a football field, christened in 1954 in memory of two recently deceased AAA members. Weems-Whelan Memorial Field honors Lieutenant Commander George Thackery Weems, USN, killed during a test flight in 1951, and Joseph Francis Whelan, a World War II marine who enlisted in the Air Force after the war and died in a plane crash in 1948.[82]

Joining the AAA in pressing the city for attention to sports were the Greater Annapolis Recreation Association, representing almost forty civic organizations, and the Annapolis Recreation Committee, established to run the USO building on St. Mary's Street when it came under city control in 1948.[83] In 1953 the General Assembly passed legislation creating a five-member volunteer Board of Recreation and Parks for the City of Annapolis, to "establish, maintain, operate and control parks, athletic and recreational facilities and activities" for the people of the city. The board and the Park Fund tax for maintenance and support of these facilities required approval at the next city election, the first for the "new," much larger Annapolis. Although recreation was second on the list of popular issues prior to the May 1953 balloting, fewer than half the voters actually marked the referendum ballot, and the measure passed by a very slim margin, with the highest number of favorable votes coming from the Fourth and Seventh Wards. Perhaps it was no surprise that the referendum failed in three of the four new suburban wards, the ones that had been ambivalent about annexation three years earlier. Recreation was fine; tax increases weren't, even at only 5¢ per $100 of assessed value. The tax rate in 1953 was $1.39: $1.00 for general revenue, $.34 for the Annapolis Metropolitan Sewerage Commission, and $.05 for parks.

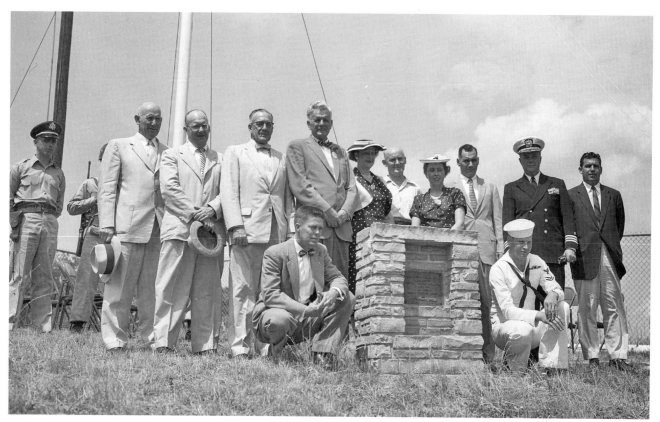

With park income now assured, the city accepted title to Truxtun Park in 1955 and over the next few years built a pier, boat ramp, and the first picnic pavilion, and hired a superintendent of recreation and parks to oversee city-sponsored recreational activities.[84]

The same young postwar families who lobbied the city for parks and playgrounds also wanted improvements in the city's public schools, except that the city government had no control over the public schools within its boundaries. School employees, curricula, and policies were a function of the Anne Arundel County Board of Education. City residents could, and did, serve on the board, but they carried no more weight in deliberations than other members. And in the years after World War II the county school board faced challenges more substantial than just those posed by the Annapolis schools. The population of Anne Arundel County grew by about 75 percent during the war years and simply boomed in the 1950s; by 1960, there were three times as many people in the county as there had been before the war. This startling, sudden increase put enormous stress on the school system. The state mandate in 1945 to return to the twelve-year program, which had been cut to eleven years during the Depression, further stretched capacity. School construction, even financed by bond issues totaling $16 million over the next decade, could not keep pace with enrollment.[85]

In Annapolis, a 1947 fire severely damaged the Green Street elementary school, and $330,000 of the board's first $7 million bond issue in 1949 went to renovations and enlargement of the building, making it "as fireproof and modern as funds would permit." The board used another $2 million of this money to make major improvements to Wiley H. Bates High School, still the only high school in the county for African-American children. Completed in 1950, the new Bates was "the largest, most modern high school in the

More than five years of attention by the city and the Annapolis Athletic Association transformed the one-time city dump behind the old incinerator on Spa Road into a playing field dedicated, in 1954, to the memory of George Thackery Weems and Joseph Francis Whelan, members of the AAA killed on military duty in 1951 and 1948, respectively. Courtesy M. E. Warren Photography, LLC, MSA SC 1890-30,563.

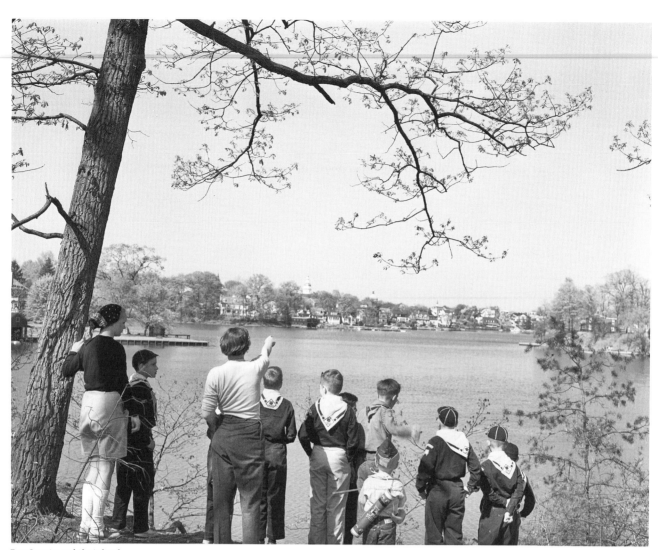

Boy Scouts and their leaders look out over Spa Creek from Truxtun Park, c. 1957. Truxtun Beale, diplomat and philanthropist, had tried to give more than thirty-two acres at the head of the creek to the city for a public park in 1931. The municipal government refused the offer, and the land remained undeveloped and in the hands of a private commission for a quarter-century until the city took title to it in 1955. Courtesy M. E. Warren Photography, LLC, MSA SC 1890-30,797A.

county," with forty-five classrooms, a theater, seven-hundred-seat cafeteria, and vocational wing with a full range of industrial arts shop facilities. State and county education officials and six African-American ministers from across Anne Arundel participated in dedication ceremonies held on 22 October 1950 in the new gymnasium. The new organ, played by teacher Mrs. Bernice Hayes, and the student band and chorus contributed appropriate celebratory music. It was a splendid occasion.[86]

When Annapolis High School could no longer accommodate the new eighth grade, six hundred white seventh and eighth grade students moved into the old high school building on Green Street, then used by the board as its headquarters. By the time the new Annapolis Junior High School was completed on Chase Street in 1953, the Green Street building was overcrowded and classes had spilled over into the old USO building on St. Mary's Street.[87]

Elementary schools in the newly annexed areas of the city also benefited from the bond issues. The white school on Fifth Street in Eastport received renovations and a wing on its Chesapeake Avenue side in 1951. In Parole the old Rosenwald school was replaced by a modern brick building on ten acres off Chinquapin Round Road. The new Parole Elementary opened in 1953 with twelve classrooms, a cafeteria-auditorium, multipurpose room,

offices, and a teachers' lounge. By December 1955,the new Eastport and Parole schools, as well as every other school in the city, were over capacity. Stanton and West Annapolis were on half sessions.[88] With the exception of Annapolis Elementary, all schools within the city drew students from outside municipal boundaries. Summer communities that were now year-round, expanded pre- and postwar housing, and new subdivisions, such as Hillsmere (1952), Rolling Knolls (1952), and Tyler Heights (1955), continued to attract new residents to the Annapolis peninsula.[89] For more than a generation after World War II, there were overcrowded schools in and around Annapolis.[90]

The U.S. Supreme Court's 1954 ruling in *Brown v. Board of Education* that segregated schools were "inherently unequal" and its order the following year that schools should be integrated "with all deliberate speed" were received by the Anne Arundel County Board of Education with resignation but little enthusiasm. Annapolis residents on the board in May 1955 were its president, Mildred M. Clements, the PTA activist who had once run for mayor, and African-American physician Dr. Aris T. Allen. David S. Jenkins, superintendent of schools since 1946, understood well the circumstances of black education in the county — it had been the subject of his 1942 master's thesis. At a time when emotions ran high across this country, it would be up to Jenkins and the board to bring integration to their county's school children, safely and peacefully. Their job was not made easier by the fact that racial statistics of Anne Arundel schools varied markedly from one end of the county to the other. White children made up more than 95 percent of the school population in north county; in the southern part of the county the majority of school children were black.[91] Annapolis fell somewhere in the middle.

The board promptly did what any bureaucracy does when faced with a crisis: it appointed a commission to study the situation and advise them — in this case as to how desegregation could best be implemented. The board also hoped that the racially integrated commission would discuss its deliberations and recommendations with county parents and take some responsibility for unpopular decisions. Annapolis-area commission members were African-American alderman T. Norwood Brown, Annapolis businessman Paul Whitmore, and William E. Brown, a retired Naval Academy employee and PTA leader in the black community.[92] The commission's report nine months later, in March 1956, confirmed what the board already knew: the county's main problem was overcrowded schools. Elementary integration would be reasonably simple, said the commission, because these schools would continue to draw from their neighborhoods and their present student body would not change dramatically. Integrating the junior high and high schools would be more difficult, especially given the prospect of moving Bates junior and senior students into the county's already over-capacity white secondary schools. As immediate goals, the commission recommended removing any racial designation from school names and giving every child the right to attend the school nearest to his or her home or to request "admittance to another school through the Board of Education." The commission urged that "a substantial start" in desegregation should begin that fall. They also wanted those substandard school buildings improved or replaced.[93]

Deciding that "desegregation at all levels" was "not feasible at this time," the board announced that the first three grades of all county public elementary schools would "operate on a non-segregated basis" beginning in September 1956. Children in those grades could *choose* to attend the school nearest their home regardless of its traditional racial composition. Additional grades would be desegregated each year "as the program expands." The board anticipated that by 1963 students in all grades would go to the nearest school

TABLE 8.2 High School Graduates Going to College, 1955 and 1956

	Annapolis High	Bates High
1955 Graduates	183	158
Entered college	55	46
Percentage	30	29
1956 Graduates	206	180
Entered college	60	41
Percentage	29	23

Source: Anne Arundel County Board of Education (Minutes) 1955/06/29–1957/04/03 [MSA CM1391-8]. These statistics were compiled during the board's consideration of the need for a county community college.

or request a waiver allowing them to attend another school of their choice.[94] This "freedom of choice" policy, in which no school was specifically — or technically — segregated, mirrored the policies adopted by the school boards of other counties in the state, all of whom believed that by eliminating the dual-school system, they were complying with the Supreme Court directives.[95]

Even in a racially mixed community like Eastport, very few African-American children left the familiar all-black Third Street school to attend the formerly all-white Eastport Elementary School on Fifth Street. Third Street school parents railed against the poor conditions and the use of an unsuitable annex to ease overcrowding; Fifth Street parents agitated for an addition to the present building and a new school near Tyler Avenue. When Third Street parents threatened to keep their children out of school altogether unless they got a new school, the board decided to fully integrate the Fifth Street school. Overcrowding there had been alleviated by the construction of Tyler Heights Elementary. Third Street first and second graders began the 1962–1963 school year at Fifth Street; the rest moved into the enlarged school in January 1963. This was not what most black parents had hoped for, and they were not happy to be forced out of their old school. Fifth Street assistant principal Elaine Hollidayoake remembered that combining the schools went smoothly because principal Jeanette Russell "didn't do anything different" and the board assigned well-respected African-American teachers, such as Marita Carroll, to the school. The school's new black male teacher received more attention because he was a male teacher than because he was African American. Perhaps more important to the success of Eastport desegregation was the fact that the neighborhood had always been racially mixed. Some black and white children had played together on the streets, and most were familiar with persons of the other race.[96]

By 1964 all of the city's white public elementary schools had at least a couple of African-American students in their classrooms, and a few had African-American teachers. But there is no record of a white student choosing to attend a black school. Because the Parole and Clay Street neighborhoods were segregated, Parole Elementary and the new Adams Park Elementary, opened in 1958 to replace Stanton School, remained segregated *de facto*, as did Bates. During his six-year term as the only African American on the school board,

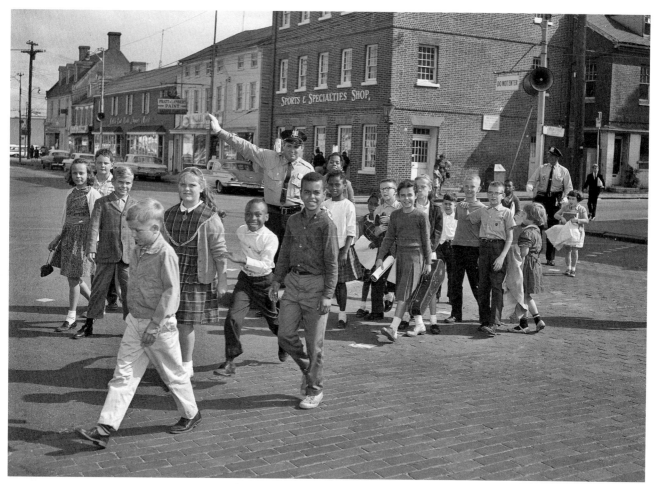

School's out! Annapolis Elementary School students cross Main Street at the foot of Green Street under the watchful eyes of city policemen, c. 1962. Photograph by Stu Whelan. Courtesy of the Maryland State Archives, MSA SC 2181-1-178b.

Dr. Allen represented blacks in the county who wanted faster integration, but he believed in the "good intentions" of the board and went along with the "slower and more conservative approach."[97]

In contrast to the delaying policy of the county, St. Mary's Catholic schools integrated across the grades in September 1957. For almost a century, St. Mary's Roman Catholic Church had maintained separate elementary schools for black and white children. In 1949, African-American Catholics had built a new church, with an elementary school, in the Clay Street section of town. St. Augustine's Church on Bates Street opened with the school in its basement already in use. Over the next eight years, as many as eighty-four black children in the first eight grades, Catholic or not, were taught by two School Sisters of Notre Dame, who lived with other nuns in the convent on Shipwright Street. After the elementary students moved to St. Mary's Duke of Gloucester Street school in 1957, Bates Junior High students used St. Augustine's for five or six years as an annex to the Stanton School building.[98]

St. Mary's High School, opened in 1946 and housed in a new building on Duke of Gloucester Street a year later, accepted non-Catholic students as well as the children of the parish.[99] The school began accepting African-American students in the fall of 1954.[100]

A few black students were attending the city's two colleges at the time of the *Brown* decision in 1954. The Naval Academy had been officially open to African-American students

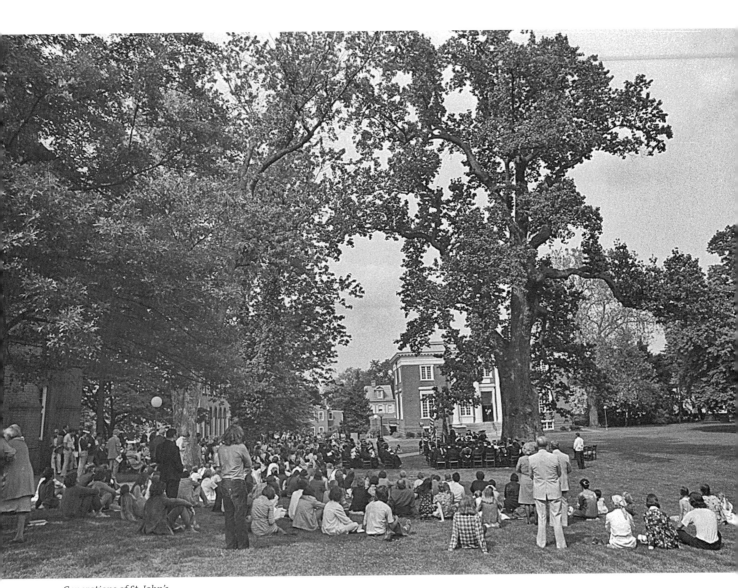

Generations of St. John's graduates received their diplomas in ceremonies under this stately tulip poplar, thought to date from about 1600. Traditionally the meeting place of men plotting opposition to the British crown, it became known as the Liberty Tree. The tree was removed in October 1999 after being irreparably damaged in hurricane Floyd. Photograph by Tom Darden. Courtesy of the Maryland State Archives, MSA SC 1907-b3-b7-8.

since 1872, but the first to graduate was Wesley A. Brown, Class of 1949. Brown was the sixth African-American man accepted into the academy; three had become midshipmen during the 1870s and two more in the 1930s. All of them, including Midshipman Brown, suffered racially charged harassment and all except Brown left the academy within fifteen months. The black community of Annapolis suffered along with them. Messmen forced to watch abuse with impotent fury could do little in the dining room, but they and others opened their homes to black midshipmen and did what they could to help these young men survive.[101]

Brown's hard-won success did not start a landslide; in 1965 there were but five black midshipmen. The 1966 appointment of chemist Dr. Samuel P. Massie, Jr., as the first African-American full-time professor at any of the country's military academies, signaled the academy's interest in attracting high-caliber students and faculty, no matter their race. Recruitment programs aimed at minorities and a required "comprehensive human-relations course" enabled the academy to graduate more significant numbers of black officers by the 1970s.[102]

St. John's College admitted its first African-American student, Martin Dyer, in 1948 at the urging of both the faculty and students. Fifty-six years later, Dyer remembered feeling like "a totally unwelcome stranger" in segregated Annapolis, but the welcome he felt on campus "made all the difference in the world." Dyer was followed by a handful of other black students through the 1950s, some recruited from segregated Baltimore high schools by St. John's students who were veterans of the Korean War's racially integrated military units and refused to tolerate a policy of injustice in their college.[103] Their sentiments were shared by the school's new president, Dr. Richard D. Weigle. Shortly after his inauguration, St. John's took the logical next step and decided to admit women in the fall of 1951. Weigle brought Barbara Leonard from Smith College to serve as assistant dean, live on campus, and be the school's first female tutor.[104] Although the Naval Academy named its first female instructor in 1972, women were not admitted as midshipmen until 1976.[105]

During the 1950s and early 1960s, as the public school system tried to cope with school construction, desegregation, the academic pressures laid upon it by the Soviet Union's launch of Sputnik in 1957, and increasing demands for expanded foreign language courses, more parents began to consider private schools for their children's education. By 1960, private schools accounted for about 17 percent of county enrollment. In Annapolis, the Catholic schools of St. Mary's, which primarily served families of the parish, and the Holladay School, a private grade school run by Miss Helen Woodward on Southgate Avenue, were longstanding city institutions. Responding to new demands, several private kindergartens and elementary schools opened in the 1950s, including Kneseth Israel, West Tutorial, Naval Academy Primary (1953), and the Annapolis Children's Kindergarten. St. Paul's Lutheran Church–Missouri Synod, which dated from 1954, established a parochial school two years later in its new building on Rowe Boulevard. And in 1958, a group of parents connected with St. John's College founded Key School as a nonsectarian elementary school that would encourage intellectual curiosity and independent thinking. Located first in Eastport, the school moved in 1961 to the manor house property in Hillsmere.[106]

No matter where they went to school, in the first years of the 1950s students again crouched in hallways or under desks — "duck and cover" — as air raid sirens once again brought war into the classrooms, this time with the threat of a nuclear attack. The Board of Education handed out booklets detailing procedures to be followed should a bomb drop nearby, and on 14 May 1952 three hundred people participated in a fifteen-minute citywide air raid drill, which simulated an air attack and detonation of a bomb in Murray Hill. Residents were encouraged to take refuge in the city's four official shelters — the Courthouse, State House, Court of Appeals, and the tunnel between the latter two — but only a few did. The Naval Academy did not modify its schedule during the Korean conflict, but midshipmen and locals associated with the navy paid close attention to the battles half a world away. Across the Severn, the Engineering Experiment Station employed more than a thousand civilians in technical and support positions, and two of them were named to Radiological Services in the county's Civil Defense organization. The federal government's official casualty list for the Korean War tabulates deceased military personnel by county. Nineteen men from Anne Arundel, all serving in the army, were missing or lost their lives in action or after capture.[107]

After the Korean conflict, expansion of Naval Academy facilities renewed with construction of the field house on the Hell Point property acquired fifteen years earlier. Com-

The U.S. Naval Academy after World War II

In October 1945, less than two months after the end of World War II, the U.S. Naval Academy celebrated its centennial and accepted the challenge of preparing the next generation of men to lead the U.S. Navy and Marine Corps into the new Cold War world. Graduates faced the crises of the Berlin blockade, the Korean War, and Middle Eastern turmoil. Hovering around four thousand, the academy's student body underwent a number of dramatic changes over the next thirty years. In 1949, Ensign Wesley Brown became the first African-American graduate. Other minorities joined the brigade and, in 1976, the first women were admitted to the academy. Notable graduates since the war include President Jimmy Carter and numerous military, political, and business leaders. Among academy graduates who became astronauts, Alan B. Sheppard was the first American in space in 1961.

The school's curriculum kept up with rapidly changing times and technological advances, such as jet aircraft, nuclear ships, and rocket-launched weapons. Electives were introduced in 1959 and, ten years later, the entire program was reorganized, enabling midshipmen to choose majors in engineering, math, science, the humanities, or management.

By the mid-1950s, a building program was under way that would add a field house, a new mess hall, and fifty-three acres of landfill along the seawall for athletic fields. At the same time, the non-profit Naval Academy Athletic Association built the Navy and Marine Corps Memorial Stadium on Taylor Avenue. Though some thought the field house and stadium detracted from the city's historic setting, the facilities were a boon to the local economy. Navy sports events and celebrity players, such as Heisman Trophy winners Joe Bellino (USNA '60) and Roger Staubach (USNA '65), bolstered school pride and brought alumni and other visitors to town, benefiting local hotels, restaurants, and shops.

Within the yard, Bancroft Hall was enlarged and four new buildings were constructed along the Severn River. Nimitz Library was joined by Chauvenet, Michelson, and Rickover Halls, containing modern classrooms, laboratories, and other facilities for the study of math, science, engineering and weapons.

From its creation, the Naval Academy has been one of Annapolis's chief employers, and a mutually beneficial relationship has existed between the school, its students, staff, and faculty and city businesses and residents. Many midshipmen have found a home-away-from-home and opportunities for meaningful community involvement. Residents have often reaped financial benefits from boarding young women visiting the academy or from renting out their homes during the school's graduation week.

Many postwar academy alumni retired in Annapolis, where they and their spouses became active in community organizations and activities. Preservationist Anne St. Clair Wright, daughter, wife, and mother of academy alumni, and others drawn to the town because of the academy had an important impact on what Annapolis became in the post–World War II era.

JAMES W. CHEEVERS
Associate Director and Senior Curator
U.S. Naval Academy Museum

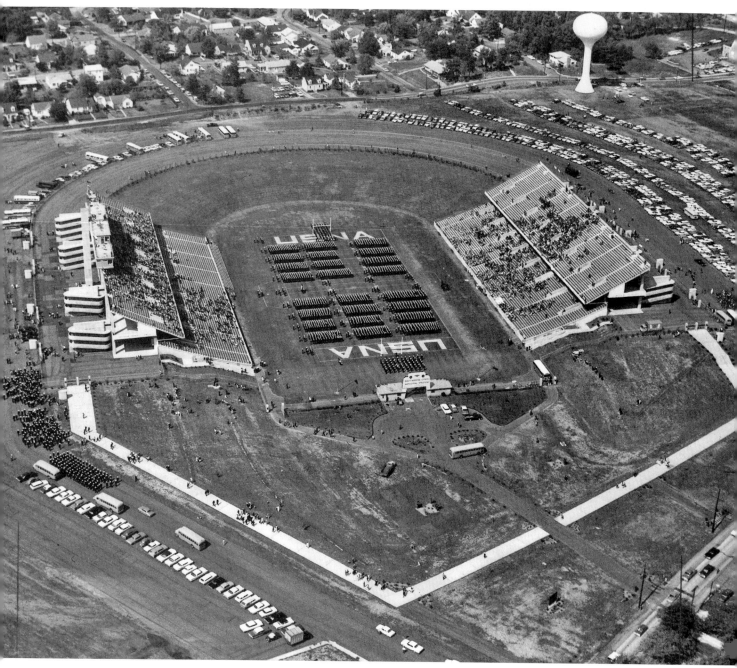

pleted in 1957 and named for Admiral William F. "Bull" Halsey, Jr., the 158,000-square-foot field house shadowed the city waterfront, its green copper roof a new landmark for sailors. Further expansion into the harbor and the Severn by landfill gave the midshipmen more playing fields, but the filling in of most of Santee Basin meant the death of *Reina Mercedes*, "which was sold for scrap after forty-five years at the Academy." The academy's building program of the late 1950s also resulted in two additional Bancroft Hall wings and new classroom and auditorium buildings.[108] During this period, the Naval Academy Athletic Association finally achieved its goal of a modern football stadium on the outskirts of the city. Built on land bought for the purpose before World War II, the Navy–Marine

Built on a leveled hill between College Creek and the new community of Admiral Heights, the Navy–Marine Corps Memorial Stadium thrilled midshipmen and fans alike with a state-of-the-art football field. Photograph by Stu Whelan, c. 1963. Courtesy of Betty (Mrs. J. Stuart) Whelan and the Special Collections and Archives Department, Nimitz Library, U.S. Naval Academy.

Corps Memorial Stadium was dedicated in September 1959. The new stadium, funded entirely by private money, boasted seating for almost 30,000 fans and ample parking for their vehicles. Academy football players and coaches celebrated their new playing fields by turning in five winning seasons between 1959 and 1965 and five consecutive victories over Army.[109]

Article 15 of the aborted 1951 revised municipal charter asserted the city's "power to plan and zone the city with the general purpose of guiding and accomplishing a coordinated, adjusted, and harmonious development of the city." The article provided for a five-member planning and zoning commission to draw up a master plan for land use and development and recommend zoning ordinances to govern the subdivision of land, establish zoning districts, and regulate building. Three commission members would be mayoral appointees, to be joined by an alderman and the city engineer.[110] Determined to implement as many of the charter revisions as he could get away with, Mayor Rowe backed an ordinance in June of 1951 that authorized a zoning commission similar to the one created in the lost Article 15. Members of the commission were Alderman Clarence A. Remaley, an insurance agent who lived in West Annapolis, city engineer Joseph M. Axelrod, and Rowe's appointments: Commander Edward P. Wilson, USN (Ret.) of Spa View Heights, stationery store owner Murray Davis of Presidents Hill, and Norman DeWind of Parole. To assist them in development of a master plan, the city hired Jefferson C. Grinnalds, a zoning engineer from Baltimore, who had written that city's first zoning ordinance in 1921 and had worked on federal and state planning legislation in the 1920s and '30s.[111]

The concept that government had the right to determine appropriate land use and place certain restrictions on building within its jurisdiction was not new in Maryland. Nor was it new in Anne Arundel County, which had accepted some fairly limited zoning regulations in the 1940s and was, in 1951, addressing the critical need for its own master plan. But the Annapolis City Council had never before involved itself directly in this arena. Citizens approached the Zoning Commission's new master plan with either eager approval or outright criticism; few were unmoved. The *Evening Capital* revealed the plan prior to a series of public hearings in November 1951 in which the commission and Grinnalds tried to explain each ward's particular zoning districts and the uses permitted therein. District designations included maritime, industrial, personal services, educational and cultural, retail business, and so forth and provided for three levels of density in residential development. Residents in the newly annexed areas generally preferred whatever old zoning they'd had under the county, which they didn't always get in the new plan, and thus tended to be less than enthusiastic. In Wards 1 through 4, the "old city," two issues received the most attention: a public safety provision limiting the construction or renovation of frame buildings in the central part of downtown and, most outrageous of all, the creation of a Colonial Preservation Committee, which would review construction plans for all structures built before 1800 or standing within one hundred feet of a pre-1800 structure. If the committee did not approve the proposed renovation, addition, or demolition, no building permit would be issued. Appeals would go immediately to the courts, not to the City Council. At the public hearings, you could almost hear the gasps of outrage as these points were explained. A couple of local lawyers scoffed at such an intrusion into personal ownership; clearly it was illegal! But a few brave souls, among them several retired naval officers and

county zoning commissioner and architect Archibald C. Rogers, spoke in favor of preserving the city's colonial heritage.[112]

On 11 January 1952, Roscoe C. Rowe, retired naval officer, attorney, and mayor of Annapolis, succumbed to a heart attack following back surgery at Bethesda Naval Medical Center. The council's impetus for municipal modernization died with him. Alderman Robert H. Campbell served as acting mayor until Arthur G. Ellington was elected on 15 January to succeed Rowe.[113]

After the public hearings on its master plan, the Zoning Commission made a few minor adjustments and added a new section prohibiting the sale of liquor within three hundred feet of a school or church. Then the plan went to the City Council, where it was referred to the Bylaws and Ordinance Committee — which deleted the entire preservation section. At the final public hearing before the council vote, the new mayor explained his disapproval of the preservation initiative as too intrusive on the rights of property owners. Better, he said, to find "a financial angel to buy Colonial properties for preservation." But many in the audience had heard that wish before and knew it had no more validity in 1952 than it had had in the 1930s. Academy professor Henry F. Sturdy cautioned against "plucking the golden goose to death," and Dr. Douglas Huntley Gordon, who had been president of St. John's College for a short time in the 1930s, admonished the council to "think of the people as a whole" not just about property owners. But it was to no avail. Attorney Carroll Albaugh reflected the majority opinion and drew intended laughter when he suggested that the preservation committee might require that he "wear a wig" if he wanted "to change a brick" of the house he'd recently bought on Hanover Street.[114]

But this time, Professor Sturdy and his cohorts would not be silenced. They began checking into how other cities had dealt with preservation issues; the historic districts created by Charleston and Alexandria looked especially appropriate. And they called a "Historic Annapolis rally" at St. John's College. Some 250 people packed McDowell Hall on 7 April 1952 to discuss preservation and its effect on tourism and the city's economy. Everyone knew that once the Bay Bridge and the expressway to Washington were completed, Annapolis would lie just off a major north-south route — it could offer travelers something special or it could die. Much was made of Virginia's supposed $400 million a year from tourism compared with Maryland's $80 million. A steering committee was named to set up a new organization; Sturdy suggested it be called Historic Annapolis. And it was.[115]

Members of the steering committee included professors Sturdy and Walter B. Norris; J. Pierre Bernard, president of Annapolis Bank and Trust; Morris L. Radoff, state archivist; Joseph D. Lazenby; Sarah Corbin Robert; and St. Clair Wright. Wright was chair of the ordinance committee, which immediately crafted another preservation ordinance, this one modeled on the Charleston plan, with a delineated historic district and board of review. Exterior changes visible by the public to any pre-1800 building in that district would be presented to the board of review, but this time, its approval was not required for a building permit. The hope of the committee was that "cooperation . . . rather than compulsion" would make the ordinance effective. Mayor Ellington had made it clear that any preservation legislation "with teeth" would not pass the council.[116]

A second mass meeting at the end of April elected officers and a twenty-member board of directors for Historic Annapolis, Inc. Marine Major Charles E. Emery, an enthusiastic and published photographer, became president of the organization. Directors included steering committee members Bernard, Radoff, Wright, Sturdy, and Lazenby. The last two,

Charles Carroll, Barrister, House on its way from the corner of Main and Conduit Streets to St. John's College campus, October 1955. Historic Annapolis, Inc., raised money for the move, its first preservation coup. Courtesy of the Maryland State Archives, MSA SC 1890-497.

along with fellow directors Albert H. MacCarthy and Orlando Ridout IV, had been members of the now "dormant" Company for the Restoration of Colonial Annapolis. In 1954, a majority of the members of the CRCA voted to give Historic Annapolis, Inc., the roughly $500 remaining in its treasury and dissolve their organization.[117]

The City Council passed the revised comprehensive zoning ordinance on 14 May 1952 at a meeting interrupted only briefly by that evening's air raid drill. Before passage, the restriction on frame construction in the center city had been made slightly less onerous and the alcohol sale prohibition removed entirely in favor of another ordinance limiting the number of liquor licenses to the current ninety-three. Historic Annapolis's preservation ordinance made it through two readings and was held over for the June meeting. Finally, on 9 June 1952, Annapolis passed its first historic district legislation by a vote of eight to six.[118] As a statement of wishful thinking, the new ordinance was fine; as an effective zoning tool, it was useless. It would be seventeen years before the City Council passed a historic district ordinance "with teeth."[119]

During discussions of the preservation ordinance, people mentioned the ancient, empty, and threatened Charles Carroll, Barrister, House at the corner of Conduit and Main Streets, whose owner wanted to replace it with a structure more suited to its premier business location. Built in the mid-1720s by Dr. Charles Carroll and modified around 1740, the house retained its colonial fabric and appeal.[120] Saving this house, by moving it to the St. John's College campus, became the first major accomplishment of Historic Annapolis, Inc. It was a move that demonstrated clearly the force and determination of the organization. It also highlighted a strength that would serve the group well in future battles. Chair of the fundraising efforts for Historic Annapolis was Admiral Harry W. Hill, USN (Ret.), whose 1938 book on the silver service designed for USS *Maryland* included careful research on colonial Annapolis houses. Admiral Hill and other retired naval officers made Annapolis their home port of choice. By the late 1950s, it was said that "more admirals retire to Annapolis than to any other place in the country" — forty in 1957, along with fifty captains and many from assorted lower grades. Not all were former Naval Academy superintendents, as Hill was, but most were graduates of the academy who found friends and activities to their liking in this navy town.[121] From their ranks came faithful supporters of Historic Annapolis, Inc.

In its first decade, Historic Annapolis concentrated on researching the city's oldest structures, developing tours and training guides, giving lectures, and publicizing the city as a locale worthy of attention and preservation — and all the while, trying to keep itself alive financially. Relying on membership fees and a few corporate contributions, Historic Annapolis had little choice but to become an all-volunteer organization. Of the many city or suburban residents who became involved, hundreds were women who found volunteering for Historic Annapolis a rewarding and educational experience. Chief among them was St. Clair Wright, who dominated Historic Annapolis and the preservation movement in Annapolis for more than thirty years.[122]

Early on Historic Annapolis persuaded the C&P Telephone Company to use "COlonial" for its Annapolis exchange — 263 was originally expressed as "Colonial 3" — so locals had to say the word every time they told someone their phone number. Conferences sponsored by Historic Annapolis brought preservation and planning experts from up and down the East Coast to Annapolis for discussions centered on how cities could make the best economic use of their history by reconciling urban renewal with preservation. The conferences were open to the public and learning took place on both sides of the podium.[123]

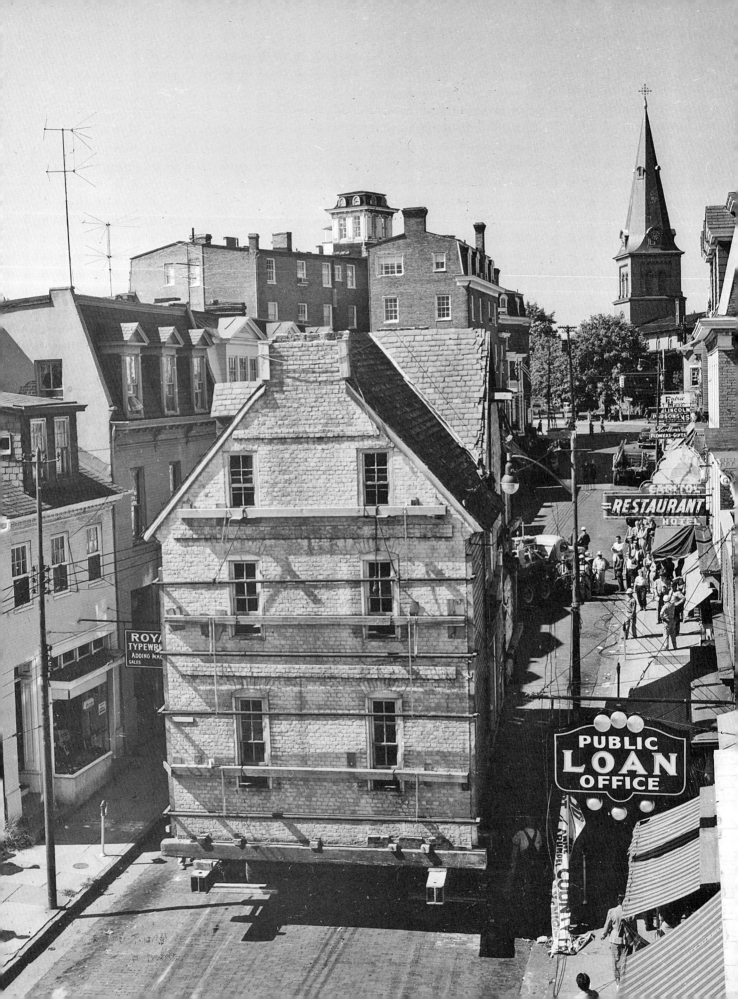

The first serious test of preservation's clout came in 1962 when, again, the Naval Academy decided that its continued existence in Annapolis depended on acquisition of town territory. Announcement of a naval advisory commission's recommendation in *The Washington Post* in early March came as a surprise to city preservationists but not to the mayor and officers of the Chamber of Commerce and county trade council—the business faction. The naval commission proposed a $68.4 million renovation and enlargement of the academy's physical plant, including a glass-walled science building designed by Edward Durell Stone of New York and a "plaza-style entrance," both of which would lie in the remaining three city blocks between King George and Hanover Streets. The navy also figured to take in the ten properties on Prince George and Randall Streets left out of the 1941 absorption.[124] The advisory commission, headed by the well-known Admiral Ben Moreell (by then retired), had been charged with creating a master plan for urgent academy enlargement. In their eyes, the twenty-seven acres comprising the three blocks were an obvious solution to the problem of where to place classrooms and laboratories necessary to the school's recently modernized curriculum. To Annapolis residents, whose consciousness of their city's historic value had been raised by the educational activities of Historic Annapolis, what was obvious was that these three blocks contained some very important houses: the Peggy Stewart House, once owned by Anthony Stewart of "tea party" fame, for instance. For Jim and Elaine Underwood, new owners of the Tilton House at 9 Maryland Avenue, Admiral Moreell's plan would deprive them of the colonial home they had moved from Washington to enjoy. Jim Underwood formed the Citizens Action Committee to oppose the plan, saying that if the navy were successful, "no intelligent prospective homeowner will ever buy a piece of property along the Navy wall again. Property is bound to depreciate and slums will follow."[125] But the academy's $30.5 million payroll, and the continuing belief by many townspeople that without the navy the city would sink, set up the tug of war between preservationists and businessmen that has been repeated time and time again. If they cooperated, the Underwoods and the other ninety owners of the threatened residential properties would know, said the *Evening Capital*, which favored the Moreell plan, that they had given "unselfish cooperation in this enterprise so vital to the nation." After all, the historic houses would be relocated and reused, not destroyed. And besides, opined an editorial, the ultramodern Stone-designed building would "enhance Hammond Harwood and Chase Lloyd houses, calling greater attention to their charm."[126]

A raucous standing room only crowd packed Mahan Hall for a town meeting on 27 March 1962. As Alton ("Red") Waldron remembered it, "People started to try to find out how it all came about. It turned out that it all came about because the Naval Academy had set up a committee to look over the situation and decide what to do. Then somebody asked, 'How many Annapolis residents were on the committee?' The answer came back, 'Zero.' Well, that pretty well did it. As I remember, the place was not a mob, but they were really mad."[127] And "they" went to the top. There are any number of stories about how President John F. Kennedy got involved, but the best one is probably photographer Marion Warren's. Warren had been invited to join Maryland Representative Richard E. Lankford in presenting a Warren photograph to the president. "Well," said Warren years later, "Mrs. Wright heard about this and she loaded me up with a bunch of stuff, pamphlets and letters and gifts for the President, about Historic Annapolis and how the navy wanted to take those three blocks." He felt a little silly, going in there with "about fifteen pieces of this stuff," he said, but he knew he'd likely see the president only once, and he'd run into Wright every

day. It was easier to do what she wanted. The president "skimmed through it, and he asked a few questions." Warren was impressed: "He obviously really cared."[128]

Whether it was Warren's sacrificial moment, or St. Clair Wright's letters to naval officers across the country, or Robert and Jane Campbell's petitions with thousands of names, or presidential advice from Arthur Schlesinger, or some other, unsung hero, the result was the same: the navy's attempt to encroach further into the city was stopped, apparently permanently. "Many prominent people in this community, including most especially naval retired officers, opposed this expansion and stood firm on the side of Historic Annapolis," said Jack Ladd Carr. "It was the most heroic thing [Historic Annapolis] ever did."[129] And it made the organization the acknowledged advocate for the city's historic properties.

While some Annapolitans worked for preservation of the city's most valued old structures, others tried to get rid of the not-so-popular old houses, the ones that lacked running water, flush toilets, adequate heat, or other basic necessities. As with preservation, this was a movement that harkened back to the 1930s, but which had accomplished little. Preserving a historic structure and celebrating its role in the city's past was a positive step; slum clearance was nothing but trouble, and to this day remains a blight on black-white relations in this city.[130]

In the late 1940s civic groups decried the large number of substandard homes, most of which were occupied by African Americans. Their surveys and studies confirmed the extent of the problem, but did little to address it. The Reverend David H. Croll of St. Philip's Episcopal Church inspired the new Annapolis chapter of Frontiers International, a service organization of African-American businessmen and professionals, to reach out to the white community to form the biracial Citizens' Planning and Housing Association. The group intended to encourage volunteers to repair existing houses and to secure private funding for more affordable housing. With a distinguished membership of men and women, African Americans and whites, Christians and Jews, the CPHA no doubt did its best, but Dr. Aris T. Allen said later, "Nothing tangible came out of it."[131]

When the substandard dwelling issue came up in the 1949 city election campaign, most aldermanic candidates voiced their preference for more federal public housing. But there were two significant deterrents to federally funded housing: projects took a long time to reach fruition, and income limits restricted their units to only the poorest families. In Annapolis the need was right here, right now. Fifty-three families had been displaced during the 1940s, some by the new county buildings on South and Cathedral Streets. Even though the Annapolis Housing Authority completed sixty units at Obery Court, off Clay Street, in 1952 and eighty-four units at Eastport Terrace the next year, they would not be adequate to house all the qualifying families who were forced to move by public construction projects in the early 1950s: from the Dock area and Gott's Court to make way for parking lots, from Northwest and Calvert Streets to accommodate the new access road from Route 50, from Northwest and Carroll Streets to allow construction of the new state office building. Of Carroll Street, Charles Haste said, "It was one of the prettiest, shortest streets that you ever saw. It was between Northwest Street and Bladen Street. Those houses were built to have as many as four and five bedrooms. They were really beautiful. Some of our most famous doctors put their offices either on Northwest Street or on Carroll Street. Dr. Allen got his start on Carroll Street. He had . . . three, four rooms upstairs that

was converted to an office."[132] The people forced to move out of all these areas were almost universally African Americans.

The new $3 million state building (Senator Phipps's 1951 "baby") in the block bounded by Calvert, Carroll, Bladen, and Northwest Streets, was dedicated in 1958 and heralded an increased state presence in Annapolis. After just over a hundred years of biennial sessions, the General Assembly returned to annual meetings in 1950, with a "budget session" held for a month in even years in addition to the regular three-month sessions in odd-numbered years. Annual seventy-day sessions began in 1966 and were extended to ninety days in 1971. To comply with national and state reapportionment legislation in the 1960s, the General Assembly enlarged both of its houses, and as the bureaucracy grew, so did the number of state jobs and the demand for more office space in the capital.[133]

Many believed that state building projects had the added advantage of removing old substandard housing. Slum clearance by bulldozer, whether for government construction or commercial expansion, was popular with city planners across the country as a way of keeping tax revenues up and retaining workers and businesses in the downtown core. Overcrowded, often dilapidated housing in neighborhoods without open space or playgrounds, but with commercial activities and congestion, was considered by many well-meaning social progressives as undesirable. Better to move people to new, clean, modern housing units with playgrounds and quiet, away from the bustle of the inner city.[134]

The percentage of substandard housing in the city increased from forty in 1952 to sixty-five a decade later. Planners surveying the city in the early 1960s said that the city was aware of the situation, but "confusion exists as to the proper course of action in combating this blight." Aside from authorizing a hundred-unit public housing project in 1959, the first to be built on the outskirts of the city — Annapolis Gardens, occupied in 1961 — the council had no solution.[135]

Thus, at end of the 1950s, Annapolis balanced between promise and obscurity. On one hand the city's annexation of adjacent communities assured room for expansion of housing, businesses, and municipal control, not to mention tax base. New city boundaries enclosed a substantial population of energetic postwar newcomers, willing to work for improvements in medical care, recreation, housing, and education. With their enthusiastic participation, the preservation movement achieved its first successes. On the other hand, municipal government languished under the domination of a few entrenched, old-time politicians, abetted by the editor of the local newspaper. Wary of accepting professional advice in city planning or organization and bound to continued reliance on the Naval Academy and state government for economic stability, these men seemed unable to accept that unless they changed their attitude, the world would, quite literally, pass them by. The city could grasp the challenges of the postwar era, broaden its economic base, respond to the needs of all its citizens, or it could sink further into small-town bickering and decline. It had happened a century and a half before — would it happen again?

The City Preserved 1960 to 1975

The 1960s in Annapolis, as in the rest of the country, roiled with emotions often in conflict — anger, enthusiasm, fear, resolve, exuberance. Nationally, it was the era of civil rights, school integration, the Vietnam War, legislative reapportionment, urban renewal. Locally it was all of these and more, much more. For it was during this decade that Annapolis finally decided on its future, and took steps to get there. As had been the case in the seventh decade of the previous three centuries — the first port act in the 1660s, the golden age of the 1760s, the Civil War of the 1860s — the 1960s proved pivotal to the city's development.

Plans, conferences, committees, meetings — all were ubiquitous in 1960s Annapolis; and outside experts, state officials, and locals with agendas of their own all had a hand in shaping the city's decisions. Important, too, were federal laws and federal dollars. During the '60s, the Annapolis government gave up a good bit of its self-determination. On some matters it had no choice: federal legislation on issues such as civil rights, desegregation, and reapportionment trumped local laws and policies. But in other cases, the city submitted itself to federal regulations voluntarily, in the hope of financing solutions to its most persistent problem — decent housing for all its people — and realization of its new passion, preservation of its historic structures. And, as had been the case in those pivotal years of the previous centuries, the population of the city grew and attitudes and desires changed.

At the end of the 1950s, Annapolis had three commercial marinas: the Annapolis Yacht Basin on Compromise Street, Arnie Gay's yard at the end of Shipwright Street, and Smitty's at the Back Creek end of Sixth Street in Eastport. A young veteran living in Eastport named Jerry Wood had a couple of small wooden sailboats at Smitty's that he rented out to people who answered the ad he'd placed in the *Washington Post*. When Wood found that most of these folks couldn't sail, "he started doing lessons," remembered his associate Rick Franke. "Then it occurred to him that if we're going to do this, we may as well organize it." The Annapolis Sailing School opened in 1959, and by 1963 Wood was producing a school boat he called the Rainbow. A twenty-four-foot keeled Sparkman and Stephens sloop, the Rainbow was probably the second model of sailboat designed, as Franke says, "from the ground up to be built in fiberglass."[1]

The popularity of small sailboat racing brought the recently formed Severn Sailing Association (SSA) from Round Bay to Sycamore Point in 1957 and gave those Washington sailors another reason to come to Annapolis. SSA ran regattas, a spring series, Wednesday night racing, and a junior instruction program from their new dredged and bulkheaded facility at the end of First Street. The first national small-boat sailing championship races on the Chesapeake, the Adam's Cup, were held by SSA in the fall of 1960.[2] Across Spa Creek, the intrepid sailors of Annapolis Yacht Club initiated seasonal Wednesday night races in

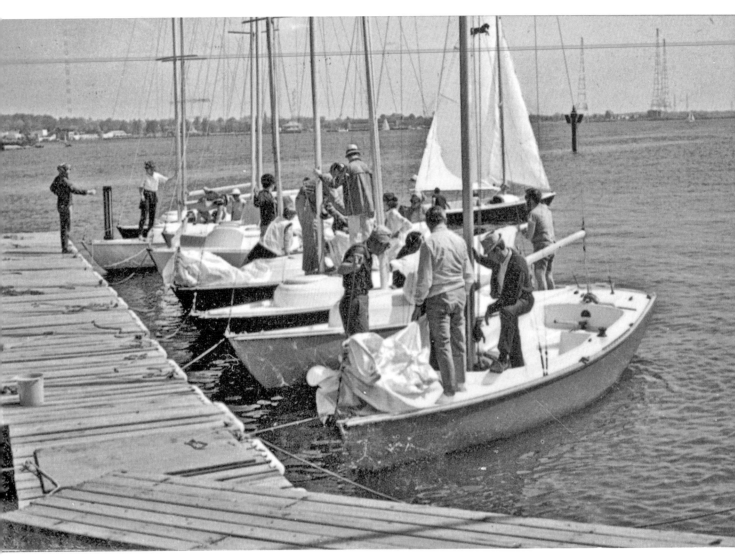

Novice sailors learning the ropes on Rainbow sloops at the Annapolis Sailing School's piers at the mouth of Back Creek, c. 1973. Courtesy of Emily H. Peake.

1959 and during the winter of 1962–1963 started an annual frost-bite series, in Rainbows rented from Jerry Wood. Their old clubhouse, with its badly slanted dance floor, gave way to a new structure on more secure pilings in 1963. The club also hosted the Annapolis chapter of the U.S. Power Squadron, many members of which docked their motor cruisers at the adjoining Yacht Basin.[3] African-American boaters, most of them from Washington, founded the Seafarers Yacht Club in 1960; seven years later they bought the old Third Street Elementary School and renovated it as their clubhouse.[4]

Boating in the '60s was enormously popular. Fiberglass and other synthetic materials opened yachting to people who had not wanted to invest the time or money required to maintain wooden boats. With boats made of fiberglass and Dacron or nylon sails, it was "easy for people who did not live in Annapolis to have a boat." New fiberglass one-design sailboats revolutionized yachting, bringing both cruising and competitive sailing within reach for hundreds of willing Bay skippers. Arnie Gay showed off an Alberg 30 in his yard in 1964, and within months ten local sailors had put in their orders for the Canadian-built boats and organized themselves for "joint cruising and keen one-design racing." Soon there were more Albergs on the Bay than anywhere else in the country.[5]

Leisure time, good salaries, and quick access along the new Washington-Annapolis Expressway (Route 50) made a weekend in Annapolis, or even a day on the Bay, an easy vacation for workers in the expanding federal bureaucracy.[6] And by the early 1960s, Anne Arundel County itself had industries bringing people to the area. Westinghouse Electric Corporation had located its Air Arm Division near the new Friendship International Airport in 1951 and, pleased with the area's amenities, including its recreational opportunities, had expanded. In 1965 the company was about to embark on a "multi-million dollar ocean research and engineering facility" near the Chesapeake Bay Bridge. Of 13,000 Westinghouse employees in central Maryland, some 5,200 lived in Anne Arundel County.[7] The city of Annapolis had welcomed the two hundred employees of Farm Bureau Insurance Company's regional office who arrived in 1952 and settled into their new brick building on Chinquapin Round Road. Hoping for more such businesses, the city rezoned the grid between Chinquapin and Legion Avenues from residential to industrial.[8]

Both the county and the city perked up when word came in 1964 that Aeronautical Radio, Inc., was interested in moving its operation from Montgomery County to Annapolis. Groundbreaking for the $1 million ARINC facility at the new Annapolis Science Center on Riva Road took place in February 1965. Described as a company that "specializes in electronic, mechanical and structural reliability and systems effectiveness and serves NASA, the military agencies and others," ARINC's reported $2.5 million payroll and three hundred workers would be an asset to any jurisdiction. When the company and its neighboring businesses demanded water and sewerage, which the city could easily supply, the mayor and aldermen decided to annex the entire 330-acre Parole area and rip that tax-rich emerging edge city from county coffers. Nasty words were spoken in the halls of both governments. When the county hastily built a sewage treatment plant on Truman Parkway, the city backed off and the edge city continued its growth under county control.[9]

If the lure of the water became compelling, sailors found they could enjoy it all the time from a new garden apartment in Eastport and drive that D.C. commute in the other direction. Americana Apartments (1960) and Severn House (1964) lay along the western shore of Back Creek; Admiral Farragut (1963) and Harbour House (1964) were not far from Spa Creek. A few years later the condominium craze brought townhouses to the head of Back Creek off Bay Ridge Avenue. The name — Georgetown East — reveals the developers' marketing strategy.[10] Upping the ante in 1968 was Tecumseh, the first waterfront high-rise condominium on Spa Creek. Multistory Tecumseh townhouses, backed to Severn Avenue, embraced a private marina in their midst — a unique (for Annapolis) combination of housing for people and boats. This was the first Annapolis project of Paul M. Pearson II, a polo-playing Washington entrepreneur who saw Annapolis first as a cash cow and later as a treasure. When townhouse owners complained about Herbie Sadler's noisy boatyard and crab shack at the end of Third Street next door, Sadler told them, "I was here first." Tecumseh put up a fence. It was the beginning of a new era in Eastport.[11]

It is impossible to sort out just how much of the city's population growth between 1950 and 1960 (133%) was made up of new residents and not the long-time residents of the land annexed in 1951, but a significant portion of the 29 percent population increase from 1960 to 1970 was more clearly the result of in-migration. The large number of housing units constructed during the decade testify to that conclusion.

Annapolis residents of the 1960s, slightly older, with slightly fewer young children and significantly larger incomes than their 1950s counterparts, stimulated a new interest in the arts. For much the same reasons that theater had been so successful in Annapolis two

centuries earlier — leisure time, disposable income, education — the performing and visual arts flourished during the 1960s. Organizations established during those years laid the groundwork for succeeding decades of artistic expression.

The Colonial Players preceded the 1960s renaissance. Formed just before the Tercentenary celebration in 1949 — hence their name — the Players' first performance, in June of that year, in the former USO building on St. Mary's Street, began a tradition of exceptional amateur theater in Annapolis that continues to this day. The town's two colleges contributed actors, directors, and backstage workers (many of whom had professional theater experience) to the local talent pool. In the mid-1950s, Colonial Players created a 110-seat theater in an abandoned garage on East Street and learned to play in the round. Loyal supporters applauded when the theater was renovated and enlarged ten years later to accommodate more ambitious productions. With the backing of the Players, the Children's Theater of Annapolis opened in 1958 to attract young actors and audiences.[12]

In 1961, Kenneth Page, band and music teacher at Annapolis High School, gathered other music teachers and some Naval Academy bandsmen into a community orchestra that met in the basement of Trinity Methodist Church on West Street. For its first concert, held in 1962 in St. John's College's new Francis Scott Key Memorial Hall, the orchestra was joined by local singers under the direction of Jean Ressler, director of First Presbyterian Church choir. The two groups formed the Annapolis Symphony Choral Society and performed at an annual concert series in Annapolis High School's auditorium beginning with the 1963–64 season. Recognizing that the musicians needed someone to handle logistics, fifty volunteers met in October 1964 and organized Friends of the Annapolis Symphony Orchestra (FASO). Players and singers parted ways in 1967 to become the Annapolis Symphony Orchestra and the Annapolis Choral Society, respectively. When Ken Page died two years later, FASO was instrumental in bringing nationally known pianist Leon Fleisher in as conductor. Suffering from dystonia in his right hand, Fleisher had turned to conducting, and in 1970 he agreed to hone his new skills on the Annapolis orchestra. Under Fleisher, remembered violist Lorraine Wycherley Shaw, the ASO changed from a "small community orchestra to a professional orchestra," and a number of local musicians were cut when he instituted auditions. The Choral Society did not endure, but some of its singers joined the Annapolis Chorale, established in 1973 under direction of James A. Dale, organist and assistant director of music at the Naval Academy.[13]

Beth Whaley, then president of Colonial Players, went to that first concert of the Annapolis orchestra and choral society in 1962 and thought, "if the two of them can do that, why can't we get all the arts together?" Acting on that thought, at intermission she "broached it to some people in the lobby: 'What do you think?' 'Sure, why shouldn't we?' So it was as simple as that." Whaley gathered a steering committee, plans were made, lots of people got involved, and in March 1963 the first Annapolis Fine Arts Festival brought art, music, drama, and poetry to the St. John's College campus for two exciting days. "The town was a little dull in those days," said Whaley. Crowds turned out, delighted to see the richness and variety of arts in Annapolis. The festival "was a way to encourage all of the arts" — inspiring participants and attracting the public's attention to them.[14]

After two years at St. John's, Annapolis Fine Arts Festival board member Joan Baldwin suggested moving the event to the city dock. With cooperation from the city, the Naval Academy, and hundreds of volunteers, the Fine Arts Festival in June 1965 featured not only Annapolis-area performers and artists but national stars Van Cliburn and Count Basie. The first such gathering to utilize the city dock, the festival changed the way residents

Paul Whitmore, Beth Whaley, and Michael Jasperson in the Colonial Players' production of The Rainmaker, *September 1959, at the theater on East Street. Courtesy of Colonial Players, Inc.*

and visitors viewed the downtown waterfront. Now it was an entertainment venue, and Annapolis itself was part of the fun. Over the next decade the festival brought color and excitement to the city dock. The children's "Discovery Tent," where youngsters could play and paint and explore their own artistic talents, the performances by groups from around the area, art exhibits, and big name entertainment made the event a local must-see and a major tourist attraction. "One of our stated goals, right from the very beginning at St. John's, was to work for a cultural center for Annapolis," said Whaley, and in 1979, long after the festival had moved from the dock and died out, its remaining resources helped turn the 1932 Annapolis High School into Maryland Hall for the Creative Arts.[15]

Focusing attention on community talent resulted in just what festival organizers had hoped for: more artistic events and more enthusiastic audiences. Forty-two area artists joined together to form the Maryland Federation of Art in 1963, and five years later opened their first gallery in a loft off State Circle.[16] Dancer Grace Clark, who had taught locally for a number of years, founded the Annapolis Civic Ballet in 1966.[17] And that same year, the Summer Garden Theatre — Joan Baldwin, Tony Maggio, Al Tyler, and a cast of volunteers — presented *Brigadoon* in the parking area behind the by-then-defunct Carvel Hall. The following year the theater leased the old Shaw blacksmith shop on Compromise Street — cobwebs, mud, pigeons, and all — and began a summer tradition.[18]

Participation in the arts in Annapolis, whether as performer or support crew, made natives proud of their town and helped new residents feel at home, make friends, and become part of the community. In those days when many women did not work out of the home, volunteering in the arts gave mothers, young and older, a rewarding outlet for their creativity and talents.[19] Many of these volunteering women also applied their talents to historic preservation and progressive politics, becoming a critical force in the public life of the city.[20]

There were people in town during those years who realized that the new highway to Washington, a four-thousand-home Levittown planned for Benjamin Ogle's farm near Bowie in Prince George's County, a shopping center on the old harness racing oval near Parole, and the increasing numbers of new residents on the Annapolis Neck would change Annapolis whether or not it was prepared, or willing. The 1952 city zoning code, "like the majority of those throughout the nation, was designed around the concept of land restriction rather than permitted uses." It was not a comprehensive plan that managed growth in a sensible or pleasing way — hence the conferences, plans, proposals of the 1960s.[21] Historic Annapolis, Inc., brought national experts in city planning to a Roundtable Conference on Historic Preservation in Modern City Planning in June 1960, where some two hundred attendees heard men like Robert D. Calkins, president of the Brookings Institution, praise their city as a unique "example of the commercial life of the eighteenth century" worthy of protection.[22]

The Committee for Annapolis, a group of businessmen and -women intent upon "rejuvenating the civic and economic life and the physical fabric of the city," contracted with the similarly business-oriented Greater Baltimore Committee (GBC) to examine the city's potential and problems and come up with a master plan for revitalization. Neither committee opposed historic preservation if it resulted in economic benefit. The GBC's first report in 1960 acknowledged the city's "rich cultural and historic heritage" and suggested ways to work new development around it, including a regional shopping district on West

Street and a series of highways, such as a "Spa Road Bypass" from the old Severn River Bridge to Forest Drive, to divert traffic away from downtown.[23]

To be fair, the City Council was not totally oblivious to the future. It passed a few more of the modernizations contained in the dismissed 1951 charter, bringing the Metropolitan Sewerage Commission under complete municipal control, for example, and establishing a civil service system for city employees. It also set up a permanent, five-member Planning and Zoning Commission, the first members of which were Alderman J. Roger Fredland, Reverend Leroy Bowman, Jacob L. Crane, William J. Martin, and Bertram E. Spriggs, with city engineer Joseph Axelrod sitting ex officio. Not only was instituting the commission a sensible decision for the time, it was also one of the prerequisites for obtaining funding from the federal Urban Renewal Administration, and federal funding looked very attractive.[24] The Planning and Zoning Commission quickly cooperated with the Committee for Annapolis to fund the second phase of the Greater Baltimore Committee's master plan, which was adopted by the City Council in April 1962. Again, this document acknowledged that the city was "more aware now of its historic heritage than at any other time in its more recent past," but it did not suggest how that heritage might be sustained.[25] Jack Ladd Carr, who was hired as the city's first professional planner, explained the situation years later: "There was a lot of hostility to planning in the community, and there was also a lot of hostility to historic preservation in the community." Implementation of the comprehensive plan put Carr in the middle between Historic Annapolis and the business-oriented Committee for Annapolis.[26] The latter group, intent upon redevelopment of the aging, sagging retail and housing conditions on the west side of Church Circle, presented its first Town Center Plan in May 1962. The new shopping district, to be called St. Anne's Mall, would "minimize public expenditures by emphasizing private enterprise," asserted the committee's executive director, Ronald Paape.[27]

Even more than parking downtown, local shoppers wanted a "full-service department store." At least that was what two-thirds of the people surveyed told the Greater Baltimore Committee's planners as they worked on the 1962 comprehensive plan.[28] Is it any wonder that the new Parole Plaza shopping center drew buyers away from downtown, offering a large Sears store, a Britts Department Store, and, better yet for those Washington transplants, the familiar Woodward and Lothrop, which arrived in 1964? By 1965, Parole had twenty-five stores and services and "acres of free parking."[29] It was a tough act for city merchants to follow.

While Annapolis dithered over its perceived dilemma between preservation and business factions, the politics of planning and preservation gained momentum in other places, eventually forcing the city's hand. Maryland voters approved a referendum giving urban renewal powers to cities and counties (1960), the General Assembly created the Maryland Historical Trust (1961), and in Washington, D.C., Jackie Kennedy persuaded her husband to halt an Eisenhower-era plan to bulldoze the nineteenth-century townhouses of Lafayette Square for a federal high-rise office block (1962). Securing the assistance of architect John Carl Warnecke, who cleverly placed ten-story office buildings behind the townhouse facades and preserved the quiet elegance of "President's Park," Jackie Kennedy "kicked off the modern historical preservation movement in the United States."[30] Historic Annapolis advocates might have argued with that statement, but not with the effect the Kennedys had on Annapolis preservation. Nor would they have argued with the influence of Warnecke, because it was he who assured the Naval Academy that it could have the new buildings it needed so badly without taking the city's "Three Ancient Blocks." The navy selected his

Anne St. Clair Wright, a founder and long-time president of Historic Annapolis, Inc. Courtesy of Historic Annapolis Foundation.

firm, John Carl Warnecke and Associates, in 1963 to design Nimitz Library and Chauvenet, Michelson, and Rickover Halls.[31]

Two proposals surfaced in 1964 from planners focusing on the city dock. One proposal was made for the city by the Corinthian Conservation Company, whose vice president was former Historic Annapolis executive director Robert J. Kerr II. Historic Annapolis and the Annapolis Waterfront Businessmen's Association contracted for the other plan by third-year architecture students at Ohio University. Both efforts suggested multistory residential and commercial structures facing the water along what is now known as Ego Alley.[32] In no time at all, at least one aspect of those plans became reality when Hospitality House, Inc., leased land from the Yacht Basin Company and announced its intent to build a seventy-five-foot-high hotel between Compromise Street and the harbor. Thus began the great hotel controversy that pitted Historic Annapolis and such ad hoc residents' organizations as the Annapolis Waterfront Association against the business interests of the city, principally the editor of the *Evening Capital*, most of the City Council, and merchants who saw the prospect of conventioneers and tourists as their solution to Parole Plaza. From May 1964 until shortly before the hotel's opening in December 1967, court cases, ill-conceived legislation, design changes, and verbal sparring disturbed the town. It seems unlikely that anyone reading the newspaper or talking to his neighbor could have avoided taking a stand, and at one point more than 1,400 citizens petitioned the City Council against an ordinance that would allow hotels of this size on the waterfront.[33]

Preservationists and other tall-building opponents were shocked by the City Council's passage in December 1964 of a forty-five-foot height restriction for the historic district that blatantly exempted any permit then under appeal or in the courts (such as the hotel) and allowed further exemptions "for the public good." St. Clair Wright, president of Historic Annapolis, Inc., was not averse to going over the council's collective head, and it seems fair to say that she was behind a good bit of what went on over the next few months.[34] Historic Annapolis brought in the illustrious John Carl Warnecke to present a formal report on the importance to Annapolis of "creative conservation," which, he said, would bring economic success to the town. Warnecke advocated a comprehensive plan "with teeth" for the historic district, which provided for urban renewal, a revolving fund for land acquisition, and a quasi-public development corporation that would manage the revolving fund, obtain federal grants and private contributions, and offer financial assistance to people who wanted to make "proper restoration" of their properties. "Any town can build motels and modern offices," he said, "but the combined amenities of Annapolis are unique."[35]

Wright's hand was also evident in legislation passed by the General Assembly in April 1965 establishing the Maryland Commission on the Capital City. The General Assembly felt "it should take part in a concerted effort . . . in preserving the colonial and historic features of Annapolis, and at the same time planning for its orderly growth and development." The eleven-member body included the president of the Senate, speaker of the House, director

Anne St. Clair Wright

Although a Virginia native, St. Clair Wright (1910–1993) was a navy daughter and navy wife whose ties to Annapolis dated from her family's first move to the city in 1912. Eventually, Wright and her husband, Captain J. M. P. Wright, settled permanently in Annapolis, where she became one of the founding members of Historic Annapolis, Inc., in 1952. For nearly forty years, Wright was the preeminent preservation leader in Annapolis, serving Historic Annapolis in a variety of roles, always as a volunteer.

Trained as an artist, with a B.F.A. from the Maryland Institute of Fine Arts, Wright added her appreciation of design and aesthetics to more traditional preservation concerns of architectural integrity and historical significance. She invoked several core principles during her years in Annapolis: She believed that preservation should be based on sound scholarship that drew upon a variety of disciplines for guidance. She believed that new construction should respect its older neighbors but should employ contemporary design elements, not mimic past styles. And she believed that modest buildings contribute to the overall streetscape, even if they are not of individual architectural or historic significance.

St. Clair Wright was adept at marketing particular projects as well as preservation in general. An old building on Main Street took on luster when identified as the birthplace of a Maryland patriot. Possible associations with the Revolutionary War brought Bicentennial funding to restore three waterfront-area buildings. As local preservationists began to compile a record of accomplishment, Wright developed a presentation she called "The Incredible Change," using before and after pictures to remind her audiences of how preservation had transformed the city's appearance and helped revitalize its economy. She warned of the consequences of failing to act, using glue and construction paper to create "scare" photos with mockups of the oversized buildings that could be built along the waterfront under then-current zoning rules. Using a mixture of persuasive charm and detailed arguments, she frequently won the support of local and state officials for her projects. But Wright was not afraid to fight if necessary. Some battles, such as the dispute over the downtown hospital parking garage, created serious rifts within the community.

Recognition of St. Clair Wright's leadership of one of the nation's oldest preservation organizations included awards from the National Trust for Historic Preservation and the Maryland Historical Trust, citations from the State of Maryland and the House of Delegates, and an honorary doctorate of public service from the University of Maryland.

JEAN B. RUSSO
Associate General Editor, Archives of Maryland Online
Maryland State Archives

of state planning, Anne Arundel County senator, superintendent of the academy, Anne Arundel County executive, mayor of Annapolis, and four members appointed by the governor. This most distinguished group looked over the shoulders of the City Council, although the law stated that the commission could not "require or compel" compliance with its recommendations.[36] The General Assembly's interest in Annapolis was no surprise given the

1964 decision of Governor J. Millard Tawes to expand the state presence in its capital city. An Eastern Shoreman, Tawes saw no need to place additional power in the hands of Baltimore City, and he had been a general supporter of historic preservation. Besides, the state was committed to construction of another multimillion-dollar building on Northwest Street for the state income tax division. Protecting that investment made good sense.[37]

The tipping point for Annapolis was the election of thirty-year-old, one-term alderman Roger W. "Pip" Moyer as mayor in May 1965. Moyer, a fifth-generation Eastporter who taught English and coached basketball at St. Mary's High School, credited St. Clair Wright with helping him understand the importance of preservation to his town. His council votes against the hotel won him the election, he said. It didn't hurt that Moyer was an exceptionally bright politician with standing in both African-American and white communities. His political mentor was Joseph Alton, recently elected county executive under Anne Arundel County's new charter form of government, and the two of them shared a progressive attitude toward legislation and human relations. They also shared a respect for St. Clair Wright. "When I took office [as mayor] in 1965, there were thirteen empty stores and two abandoned gas stations on Main Street," Moyer said later, adding that Wright told him what to do to fix that and he did it. "St. Clair would keep our stationery in her office, Joe's [Alton] and mine. She would write letters on our behalf and we'd just go over and sign them when she called us."[38]

The venerable but by then somewhat seedy Carvel Hall closed its doors for the last time in July 1965, heating up the pro-hotel cry for accommodations downtown. That same week Secretary of Interior Stewart L. Udall appeared at the semiannual meeting of Historic Annapolis, Inc., to present the city with a plaque and certificate designating the Colonial Annapolis Historic District a National Historic Landmark. Udall urged the city to pass a zoning ordinance "with teeth" (everyone seems to have used this expression), to protect its architectural scale and waterfront views. He also supported Historic Annapolis's plan to preserve Paca House, the historic structure enveloped by Carvel Hall.[39]

Concern over the loss of Carvel Hall's two hundred hotel rooms, fear that removing the property from tax rolls would raise taxes on others, and a general suspicion of saving old houses caused some early opposition to Historic Annapolis's plan to restore William Paca's fine old house.[40] But most city residents probably would have agreed that restoration of a house built and occupied by a signer of the Declaration of Independence would be a national coup for Annapolis. And most people who knew the inside story credited the building's salvation to Wright's ability to put together financial deals. Historic Annapolis bought Paca House and the Prince George Street side of the property (old Stoddert lot 93) for $125,000 and raised the same amount to fund preliminary renovations. The State of Maryland bought the garden on the King George Street side (old Stoddert lot 104) for $305,000, as authorized by the General Assembly and Board of Public Works. Historic Annapolis agreed to restore the gardens under the supervision of the Maryland Historical Trust.[41]

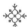

Deals were made — Historic Annapolis did not object to a height exemption for the fifty-six-foot Arundel Center building, for instance. Fights were lost —140 Main Street and the Compromise Street hotel, although the latter when finished was very a different structure from its original design. But following Mayor Pip Moyer's election, preservationists began to sense that perhaps, soon, the tide might run in their favor. When the Clean and Beautiful Annapolis Committee, formed in the summer of 1965, lobbied for removal of overhanging

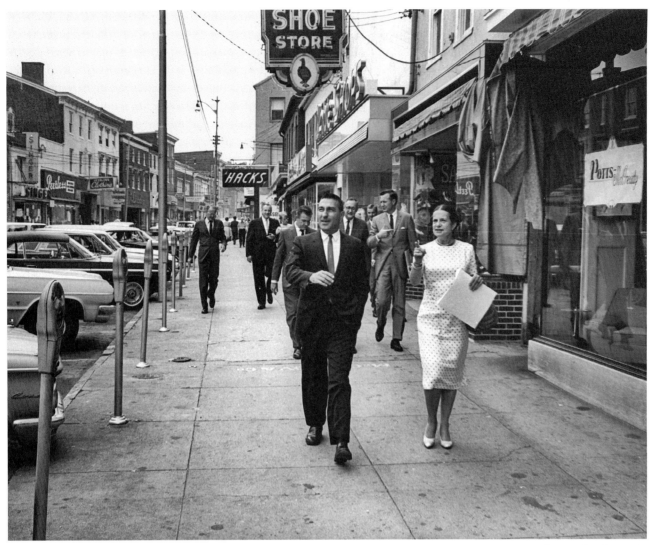

signs in the historic district, the City Council passed an ordinance to that effect in February 1966. Even though the sign legislation came with a six-year grace period, the eventual result was a downtown cleared of the familiar neon colors, the blinking lights, the massive wood and metal protrusions from colonial facades. It was a major victory for the preservationist camp.[42]

Moyer admitted that it was hard for him to get the necessary five votes on the council during his first term, and the movement toward a historic district ordinance "with teeth"—the objective of all those Historic Annapolis–educated volunteers—swelled and ebbed.[43] Initially not one but two historic district ordinances were introduced to the City Council in March 1965. One, offered by alderman and mayoral candidate Eugene Lerner, provided for a five-person commission that would determine which historic structures in the city deserved preservation and then rule on any building permits that would change them. Under the Lerner plan, commission members would have specific qualifications: an architect, a realtor, the city engineer, and two persons with preservation backgrounds. The other plan, authored by alderman Noah Hillman, applied architectural review to an entire historic district—the 1952 ordinance with permit control. In order to keep discus-

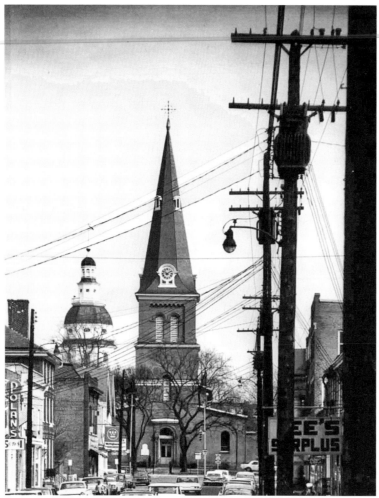

At the request of St. Clair Wright, photographer Marion Warren designed this view of upper West Street to assist Historic Annapolis in persuading the public and the city government that wires should be placed underground. Also well displayed are the projecting signs they persuaded the city to ban from the historic district. Courtesy of Historic Annapolis Foundation.

sion out of the upcoming election, both men agreed to defer council action until after May, but Lerner lost his bid for mayor and left the council.[44]

The next fall, Hillman reintroduced his ordinance, revised to incorporate Lerner's idea for a commission with qualifications, this time requiring an architect, realtor, building contractor, alderman, and someone selected by Historic Annapolis. Hillman's ordinance passed on first reading the following February 1966. The Maryland Commission on the Capital City (MCCC), no doubt meaning well, sought to put a little pressure on the council by having Senate President William S. James, a member of the MCCC, introduce before the legislature, then in session, a scenic easements bill that would give the state control over property within a 3,600-foot perimeter of the State House. The bill would be withheld, wrote MCCC chairman Kent Mullikin to the city in March, if the council passed an "adequate protective ordinance" and maintained "strict administration" of the height limits. City "cooperation," he wrote, would "certainly encourage the State, County and Federal Government in their expanding programs for our Capital City." Senator James could not have more effectively stopped passage of the ordinance had he shredded it. Aldermen did not appreciate state oversight.[45]

The next time the Hillman bill saw the light of a council meeting was September 1966, at which time alderman Arthur G. Ellington introduced an amendment putting it up for referendum in the next city election — two and a half years away! Ellington justified his action by saying, "This has been one of the most controversial ordinances that has ever come through the council the people should have the right to decide." Alderman Louis Hyatt agreed, saying, the "majority of people in Annapolis do not support this measure." The vote on Ellington's amendment was four against and three for, with the African-American aldermen from Wards 4 and 7 abstaining. A shocked and obviously furious Moyer, who had found out about the amendment only minutes before the meeting, accused Ellington of "letting his personal feelings toward one or two people in this city affect you." The alderman's opinion of St. Clair Wright and Historic Annapolis was no secret.[46]

Public outcry against this delaying tactic pushed the ordinance back on the council's agenda in March 1967, when, in response to a petition from 650 residents of Wards 1 and 2, Hillman asked for an immediate special referendum election. Ellington opposed it. Angry words were spoken by both sides. Moyer said the $10,000 cost made a special election a bad idea. Stalemate. Finally, a couple of days later, Alderman T. Norwood Brown (R-Ward 7), obviously tired of the bickering, came up with the answer: drop Wards 3 (Ellington's

ward) and 4 from the historic district and let the ordinance go through without referendum. This modification allowed Ellington to back down gracefully from what had become an embarrassing argument.[47] The Hillman ordinance, much revised but still with teeth, passed on 8 May 1967, with only Alderman Charles G. Bernstein (D-Ward 2) still holding out for referendum (Ellington's acquiescence was part of the deal). The ordinance changed the name of the implementing board to the Historic District Commission and set the district boundaries as running east of South Street and College Avenue to the Naval Academy. (See map of historic districts at end of color illustrations gallery.) Appeals of the commission's rulings would be made to the council and then to the courts.[48] Members of the first Historic District Commission, appointed in June, were Alderman Brown; John G. Rouse, Jr., an attorney who had chaired the old Board of Review; Joan duPont, the Historic Annapolis representative; George Phillips, owner of the Harbour House Restaurant on the city dock; and clothing store owner Melvin B. Schlossman, who had once headed the Committee for Annapolis.[49]

For about two months things went smoothly. Then Donald Taylor applied to demolish a house on Market Street so he could enlarge the parking lot behind his funeral home on Duke of Gloucester. The Historic District Commission (HDC) turned him down on the grounds that the parking lot was not in keeping with the residential character of Market Street. Taylor appealed to the City Council and won, but Harvey Poe, who lived in the eighteenth-century landmark across Market Street from the threatened house, took the case to the Circuit Court.[50] Poe, an attorney who had come to Annapolis just after World War II to teach at St. John's, had been involved in city politics, as a concerned citizen, for some years and was an early mentor of Pip Moyer. Believing the ordinance to be unconstitutional because appeals went from the quasi-judicial HDC to the City Council instead of to a judicial body, Poe hoped that his requested injunction "would slow the process, prevent Taylor from immediately demolishing the house, and, perhaps, give us time to pass a better-drawn ordinance."[51] In the end, Poe lost one and won one; both the house and the ordinance went down. That fall, Judge E. Mackall Childs ruled that, for a number of reasons — "flaws, vague passages, and departures from other United States legal documents" — the ordinance was "unconstitutional and void."[52] Hillman said later that he was not surprised by the decision; the ordinance had been "watered down" until it was a "far cry" from his original.[53]

Back at square one, Moyer turned to his long-range planning group, the Old Town Task Force, members of which were among his most trusted advisors: Wright, Poe, Rouse, Hillman, Alderman Howard H. Dignen (D-Ward 5) and John T. Chambers, Jr. (R-Ward 7), Pearson, city planner Jesse Nalle, and Henrietta Fiedler, owner of a Main Street children's store. The task force had hired consultant Robert Lamb Hart, formerly a partner in John Carl Warnecke and Associates, and in May 1967 published yet another city planning guide.[54] After discussions with Hart, Pearson, and Wright, Poe and attorney John A. Blondell drafted a new historic district ordinance without the flaws ascertained by Poe and cited by Childs.[55] The result went, as required, to the council's Bylaws and Ordinance Committee — Ellington, Hyatt, and Chambers — in February 1968. When the new ordinance emerged, it carried with it a referendum clause.[56]

It's impossible now to know just what would have happened to the historic district ordinance if the referendum election had been held in the spring of 1968 when the bill was debated in the council chamber. Certainly, supporters turned out for hearings, but preservationists "feared a public referendum" because they were not sure people outside the

district's boundaries cared "if the historic section of the city was preserved or not." Many voters saw "Hysteric Annapolis" as just a bunch of new-resident do-gooders trying, "to protect everything that was constructed two hundred years ago," as Alderman Hyatt put it. "Junk was built then, too," he said. Historic preservation was a fairly new concept in the 1960s and not necessarily seen as progressive.[57] The ordinance might well have failed, and Annapolis would have followed a very different track.

But in the summer of 1968 the City Council voted to tear down the Market House. This was not the first time in its hundred years that the old market had been threatened. Most recently, in 1959, the council had given some thought to razing it for parking, but wiser heads had prevailed and the Market House had escaped. Although Market Space and the city dock received attention from planners throughout the 1960s, the hotel and the use of the area as an entertainment venue focused public opinion on the desirability of an open dock area with wide visibility. It just needed some "facelifting." The council approved acquisition of property along Compromise Street toward the hotel for parking, and State Senator Edward Hall arranged for $100,000 in state and federal financing for dock area improvements.[58] When the council considered renewal of the Standard Oil Company lease to the city circle, city planner Jesse Nalle reminded them that it was their decision "whether, for the rest of history, there's a gas station in the middle of our historic downtown. . . . I think you should do the right thing." As Nalle said later, "The motion to renew the lease failed by one vote. I consider that my major contribution to Annapolis."[59] Nalle prepared a new plan for traffic, parking, and landscaping around the circle and Market House.

Pushing the effort to demolish the market was the *Evening Capital*'s editor, Elmer M. Jackson, Jr., who declared that the Market House "was a 'shabby building with flaps' when he first came to Annapolis as a freshman at St. John's College in 1923 . . . 'and it has not improved.'"[60] His oft-repeated opinion, plus the fact that renovations might cost as much as $250,000, persuaded many residents and most of the council that the market's location would be better used for parking — "well landscaped," of course. Alderman Ellington didn't care about the landscaping. "I'm not worried what it looks like. We need parking," he said.[61] In August 1968, the council cast its vote, 6–2, to tear the market down.[62]

Again a preservation issue pushed townspeople to angry words, threats, and, for the standard bearers — Jackson and St. Clair Wright — vitriolic insults and rumors of personal gain. And again, the courts became involved. Wright had claimed since the 1959 uproar that the Market House was built on land deeded to the city with a reversion clause. At first, city attorney Malcolm Smith pooh-poohed this, but when three descendants of the 1784 grantors filed suit in the Circuit Court in December 1968, he recommended that the city hold off demolition until a ruling could be issued.[63] And there the issue remained, in limbo, for another seven months.

Late in 1968, Talbot Speer, the Baltimorean who had owned the *Evening Capital* since the 1920s, announced he was selling the press. The new owner, a Washington diplomat named Philip Merrill, removed Jackson from the paper's staff and took personal control of editorial policy.[64] Three days before the 1969 City Council election and historic district referendum vote, the *Evening Capital* ran an editorial urging "all those who value the city's colonial heritage, who object to high rise buildings in the historic district and who want to see Annapolis prosper to vote FOR the historic district ordinance."[65] It also probably didn't hurt that Mayor Moyer's reelection campaign had promised "political backing and some financial help" to council candidates who agreed to support the ordinance referendum.[66]

At the dawn of a new era of representative government, Annapolis voters chose their city's future. Heralding the end of the traditional ward system, with its traditional ward bosses, this election marked the beginning of decennial ward redistricting, occasioned by the Supreme Court's reapportionment decision of 1962. Reregistration of city voters in 1966 showed that more than two-thirds of them lived in the suburban wards represented by only half of the eight aldermen.[67] Two years later, the electorate served by the same four aldermen had grown to 70 percent of the city total. The council had no choice but to make at least a rudimentary attempt at equalizing ward population. It did this by combining Wards 1 and 2 into a new Ward 2 and lopping off sections of Wards 3 and 8 to add voters to Ward 4. Because the resulting eight council votes (seven aldermen and the mayor) was asking for deadlock, the council named the entire city Ward 1 and had its alderman elected citywide. Ward 4 remained predominantly African-American; Ward 7 was divided almost equally by race.[68]

Two familiar names were not on the ballot in this election; Aldermen Ellington and Bernstein had decided to retire. Both had served on the City Council since 1941, Bernstein as alderman, Ellington as alderman and, from 1952 to 1961, as mayor. New faces on the council as a result of this contest were St. John's assistant dean, Robert L. Spaeth, who took Ellington's Ward 3 seat, and local photographer J. Stuart Whelan, Jr., who won a close at-large aldermanic race over African-American Harvey Ennis. Democratic incumbent Pip Moyer won more than 60 percent of the mayoral votes, which did not follow party lines.[69]

The May 1969 municipal election stands as probably the most important in modern Annapolis history. Passage of the first historic district ordinance "with teeth" set the city on a new course, although fewer than a quarter of the city's voters actually cast a ballot on this important question. Perhaps the preservationists were right and nobody really cared, or perhaps the electorate, who had weathered almost a year of Market House crisis and more than four years of historic district controversy, were simply tired of it. No matter. The majority of those who did vote voted "For," and the ordinance carried each ward and won overall by a two-to-one majority.[70] One of the earliest in Maryland, the city's historic district ordinance would protect more than 1,500 historic structures, maintain the "traditional scale of downtown," benefit the municipal tax base, and ensure Annapolis as a "livable environment" with great tourism potential.[71]

At a special meeting in July 1969, the new council unanimously approved a motion brought by Alderman Stuart Whelan, chair of the the Market House, Harbor, and Docks Committee, that would rescind the previous council's decision to demolish Market House and would direct his committee to make recommendations for a "positive action program to make the market into a real asset." With the future of the building resolved, the Circuit Court case was dismissed in August. The City Council authorized necessary renovations, and a refurbished Market House reopened in August 1972 to "brisk trade" for the stall holders offering cheese, seafood, bakery goods, coffee and tea, deli items, and produce, with poultry and meat sellers still to come.[72]

What made the 1960s so remarkable in Annapolis was that at the same time the city welcomed new residents, gloried in the arts, shored up its municipal structure, and settled the future of its historic district, it also desegregated its public places and schools and began the urban renewal process that would forever change the blocks west of Church Circle.

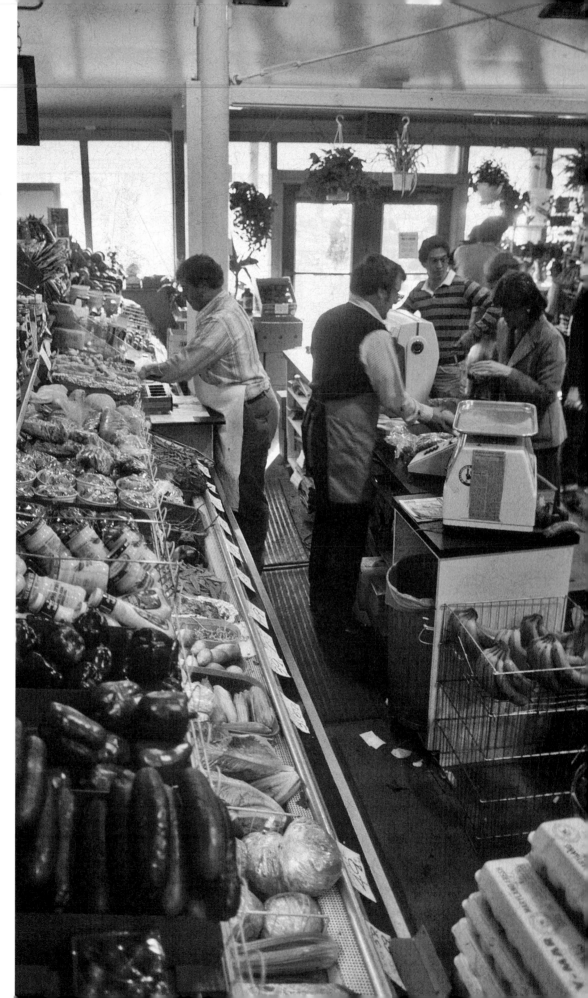

Downtown residents, boaters, and tourists appreciated the large variety of fruits and vegetables sold at Kaufmann's stall inside the renovated Market House. Courtesy of M. E. Warren Photography, LLC.

TABLE 9.1 Results of Municipal General Election, 20 May 1969

Ward	2nd	3rd	4th	5th	6th	7th	8th	Totals	Averages
Registered Voters	1,498	1,281	939	2,393	2,286	1,931	2,211	12,539	
Percent who voted	43	37	46	47	45	43	46		44
Mayoral Election									
Roger W. Moyer	527	459	398	758	572	770	636	4,120[1]	
Percent for Moyer	63	57	78	59	45	70	53		61
Jean H. Losure	324	332	98	501	676	307	553	2,791	
Historic District Ordinance (HDO)									
for HDO	383	312	73	323	292	230	388	2,001	
Percent who voted	58	53	18	40	46	34	48		42
Percent in favor	78	72	79	64	50	62	67		67

Sources: Annapolis Board of Supervisors of Elections (Election Returns) 1949–1969 [MSA M101-1], 1969 folder, "Statement of Canvas, 20 May 1969, Ward Summary"; "Voters Registration, 17 March 1969."

[1] The official tally for Moyer was calculated as 4,118 with the figures given here. His percentage of the vote does not change with corrected calculation.

Annapolis was still two cities: one of them predominately white, the other predominantly African American; by the end of the decade, the two were simultaneously more integrated and more apart.

The civil rights movement in Annapolis focused on integration of restaurants and public schools. Thelma Sparks, supervisor of mathematics for the county Board of Education, knew when she went to lunch with her white colleagues from the board's office in the old Green Street high school building that they had to choose a downtown restaurant that would serve her. In 1960, only a few did.[73] The Little Campus Inn had been integrated in 1954 by St. John's student Everett Wilson, and Read's Drug Store on Main Street decided in the late 1950s to serve African Americans at their lunch counter; but most other restaurants would simply ignore a black customer, even one seated with white friends. As Charles Haste explained later, "If you went into a store that had no seats, you were almost treated like anybody else. We had a market downtown; anybody could go in there, any color could go in there. You could stand next to this one, you could stand next to that one, because there were no seats. It was one of the most ridiculous things. Anybody could go to the oyster house because they had no seats. You could go into any grocery store. You could go into any clothes store because they had no seats."[74] But you might not be able to try on clothes in the store, which is why African-American Annapolitans shopped in Baltimore or Washington whenever they could.[75]

Organized protests began in November 1960 with a rally at First Baptist Church on West Washington Street and the decision to picket the Terminal Restaurant on West Street, where African Americans who worked in Washington could not buy a cup of coffee while they waited for the bus. Coordinating the demonstrations were the Anne Arundel County chapter of the National Association for the Advancement of Colored People (NAACP) and

the Annapolis branch of the Congress of Racial Equality (CORE). The former, founded in 1944, had long been active in the black community; its president from 1959 to 1962 was physician Theodore H. Johnson, Jr. The chair of the local CORE organization was Bowie State College professor J. Alexander Wiseman.[76]

In 1960, on the day after Thanksgiving, five local African Americans: dentist Samuel Callahan, teachers Marita Carroll and Ethel Thompson, Lacey McKinney, and bail bondsman William Johnson, sat down inside the Terminal Restaurant and waited to be served. Marita Carroll remembered: "The gentleman who was working told us that he could not serve us. He could give us something to take out. We told him that we had just missed our bus and we wanted something to eat, and we would not leave until we were served. So then he had no other choice but to call the police. They came in and took off their caps and took a copy of their trespassing act out, read it to us, and asked us if we were going to leave. We said, 'No.' So then they had no other choice but to arrest us." Johnson posted bond for everyone and they were released.[77]

After two days of picketing along West Street, the Terminal Restaurant changed its policy. Shortly thereafter, the owner of the Little Tavern just down the street announced quietly that he, too, would welcome African Americans inside, and several other city restaurateurs reconsidered their discrimination against black customers. Picketing with local African Americans were some students from St. John's College and a few white residents of the city.[78]

The following fall, Annapolis became a stop on the "Freedom Ride" highway, as attempts by civil rights activists, mostly students, to integrate restaurants along Route 40 spilled over into Baltimore and Annapolis. Hundreds of young people — black and white, men and women — from northern colleges demonstrated in Maryland over four weekends in November and December 1961; more than sixty-nine were arrested for trespass. Forty-one of those arrests were made in Annapolis, where police were less lenient than in Baltimore, and roughly a quarter of those charged here spent more than a week in the old jail on Calvert Street. Three white women were so bored they painted their cell, and one twenty-two-year-old man, veteran of forty days in a Mississippi jail the previous spring, went on a five-day hunger strike. On the first two Saturdays, demonstrators were pretty exclusively outsiders, but during the Thanksgiving holiday Annapolis residents joined picketers outside Government House, and on the final Saturday, 2 December, most of the nine adults and seven juveniles arrested in sit-ins at four city restaurants were from the Annapolis area, at least two of them St. John's College students.[79]

The worst confrontation took place that last Saturday, at Henkel's Steak House on the corner of West and Cathedral Streets, where Milton L. Henkel turned a garden hose on demonstrators, including African-American teachers Marita Carroll and Bill Reed, who were staging a sit-in at his restaurant. Carroll remembered: "It was miserable. When we left there, we went right down to Dr. Johnson's office, and he gave all of us shots so that we wouldn't catch colds. . . . I had on this tweed suit, little fur collar, and regardless of how many times I had that suit pressed, cleaned, pressed, it was always wrinkled." Carroll said later that being soaked with water was better than the alternative: Henkel had waved a shotgun at them earlier and threatened that no one would leave there alive. One of the leaders of the sit-in, a Johns Hopkins University graduate student, hit Henkel, who in turn beat him with the hose nozzle and then sprayed five local policemen.[80]

All of the five wet policemen outside Henkel's Steak House that afternoon were white. The Annapolis Police Department had hired two African Americans in 1960, Andrew

Turner and George Leverette, but they were not welcomed warmly and soon resigned. Norman Randall joined two years later, the first black to make the force a career. At first allowed to patrol only on foot and only in Ward 4, African-American policemen suffered insults from both races, yet they were especially valuable to the city as a bridge between the police and the black community during this contentious decade.[81]

Well aware that the city's segregated public facilities were at odds with its status as a tourist attraction, and concerned about the "unfavorable publicity" Annapolis had received, the City Council backed statewide public accommodations legislation with a resolution to the General Assembly in February 1962.[82] The assembly debated such legislation in the 1962 short session and again in a special one-day session called for that express purpose in March 1962, but it was not until the following year that Maryland made a serious attempt to countervail the Jim Crow laws of the early 1900s. The Public Accommodations Act of 1963 prohibited discrimination on the basis of race, creed, color, or national origin at any public establishment, except bars and taverns, in Baltimore City and twelve of the state's twenty-three counties (although Carroll County's participation required a referendum). Until a last-minute amendment, Anne Arundel County was included in the list of counties to which the law did not apply.[83]

The state public accommodations law, the 1963 March on Washington, and the federal Civil Rights Act of 1964 energized the black community, especially those working for full integration of the county schools. Reverend Warner R. Traynham, who had succeeded David Croll as rector of St. Philip's Episcopal Church, was then the president of the county branch of the NAACP. He and Dr. Wiseman of CORE bombarded the school board with requests for speedier desegregation. They were supported by the state Commission on Interracial Problems and Relations and the county grand jury, which determined in October 1964 that Bates High School was "grossly overcrowded" and that there was "excessive transportation of many Negro pupils."[84] The school board accepted the spirit of the criticism and ruled that in September 1965 students entering grades 7, 8, and 9 in all areas of the county except those served by Annapolis and Southern High Schools would be denied the "choice" option; they would have to attend whatever school was closest to their home. Only when new secondary schools were completed in the city and south county would this apply to the rest of the junior high and high school pupils; the board suggested 1969 as a target date.[85]

This was not acceptable to county civil rights groups, who formed the Joint Civil Rights Committee on Education and named Walter Blasingame chairman. A native of Georgia, Blasingame had participated in sit-ins and demonstrations as a college student in Virginia and was not afraid to speak his mind. The Joint Civil Rights Committee objected not only to the board's lack of progress in student integration but also to the facts that school staffs were not being integrated appropriately and that, between 1962 and 1965, only eight promotions to supervisory or administrative positions had gone to African-American teachers. Deciding that they had little chance of success with the county school board, the committee appealed directly to the United States Office of Education, which ruled in January 1966 that the Anne Arundel County school system must be fully desegregated — students, teachers, staff — by September 1966. At their regular meeting in March of that year, the school board instructed superintendent David S. Jenkins "to implement the provisions of this directive."[86]

In Annapolis the all-black Bates High School closed in June 1966 to reopen that fall as an integrated "middle high school" with all area 9th graders and the 10th graders who

lived outside the city.[87] Although Philip L. Brown, who was vice principal before and after the transition, said that there were "no incidents that could be labeled racial in nature," the presence of white children in the venerable black school was difficult for both races. For two years, the school lost its name and was called Annapolis Middle High School before becoming Wiley H. Bates Junior High School in 1968. Even more difficult was the transfer of the city's black teenagers from Bates Junior-Senior High to Annapolis High, where they numbered less than a third of the student body. Except in sports, leadership roles that had been a given at Bates were not accessible to most African Americans at Annapolis. There was little preparation for integrating the two schools and no orientation for either students or faculty. Black students suffered prejudice and treatment that they considered unfair and unequal.[88] Perhaps most affected that first year were the black members of the Class of 1967, who had spent the previous five years at Bates looking forward to the same graduation ceremonies their siblings and parents had enjoyed: walking across the stage in the Bates gymnasium packed with relatives and friends, singing the Bates song, wearing the Bates purple and gold. Instead, they completed their high school education in the three-building complex on Constitution Avenue and Chase Street and walked across the stage of Maryland Hall.[89] Who could expect them to sing?

For activists, the next step was ensuring that each elementary school had a suitable mix of black and white children. Making school assignments on the basis of geography — the school closest to the student's home — had not produced the complete desegregation required by federal authorities. The city schools most geographically segregated were Parole, which remained predominately black, and Germantown, which remained predominately white. Redrawing boundaries became almost an annual event as neighborhood demographics changed and new schools opened. Some children seemed to play "musical schools," and busing became a fact of life.[90]

Just as radio had brought the agony of the London blitz into homes all over America — Edward R. Murrow's voice as familiar as your next-door neighbor's — so television made national news a national pastime — Walter Cronkite's face recognizable to the entire country. There were one million television sets in use in Maryland in 1960, one for roughly every three people in the state. In May 1963, those televisions broadcast news of riots in Cambridge, on the Eastern Shore, after sit-ins in that city turned violent. In August it was not only the marchers in Washington who listened spellbound to Martin Luther King's dream; anyone of any color could experience it, just one step removed, on network news that night. And, less than three months later, Annapolitans, like the rest of the country, found themselves glued to the television for the four days of live coverage following the assassination of President John F. Kennedy. Over the next five years, as demonstrations and violence escalated — culminating in H. Rap Brown's "Burn, Baby, Burn" speech, again in Cambridge, in July 1967 — the nation's racial stress level rose. It is no wonder, then, that after King was assassinated, on Thursday 4 April 1968, riots broke out in cities across America — some of them very close to home.[91]

If one thing could be said to have saved Annapolis from the fires that burned that weekend in Baltimore and Washington, it would be sports, most specifically basketball: the teammates who played it — with camaraderie and mutual respect — and the spectators who followed it and admired the local stars. In the 1950s and '60s, the Annapolis Falcons, a basketball team of former high school and college standouts in their mid to late twenties,

played integrated league games all over Maryland and won most of them. Everyone associated with the team was African American except Roger "Pip" Moyer, who played from 1957 to 1965, Dick Callahan, and occasionally Norman Finkle. In April 1968 Moyer was mayor of Annapolis and Callahan was assistant supervisor of the city's Department of Recreation and Parks.[92]

For the first few days after King's death, Annapolis was quiet, as the mayor and black leaders worked behind the scenes to maintain calm. Students at Annapolis High School held a memorial service; city and county officials eulogized King and ordered flags lowered to half mast; city police commissioner Ridgely Gaither complimented citizens on their restraint; Governor Spiro T. Agnew banned the sale of liquor in Anne Arundel County. Two small fire bombs, a few broken windows, and a couple of trash-can fires marred the peace on Saturday, but the city kept its cool until Sunday, when rumors that black militant Stokely Carmichael—the man who after King's death had called for "executions in the streets"—was somewhere in Annapolis sent excited young African Americans into the streets. Mayor Moyer brought in Special Deputy Sheriff George Phelps and his well-trained security officers, all of them African Americans, who were used to handling crowds at Carrs Beach, and had local black policemen keep an eye on suspected gang leaders. Moyer also turned to his childhood friend Joseph "Zastrow" Simms, a popular African American who had grown up on Clay Street but was then confined to the Maryland Penitentiary in Baltimore. Simms remembered: "I got a call to come to the warden's office, and it's Pip. I said, 'Pip, don't worry. One thing about Annapolis, the people there love that city and they're not going to destroy it.'" Simms suggested key people for the mayor to talk to, "people who knew about Pip and his athletic exploits and [who] knew of his friendship with me." Moyer immediately began procedures to get Simms out of jail and back into the Fourth Ward.[93]

For the next three days, the mayor walked the city, from Eastport to Parole, making contact with black leaders and kids on the street, listening to complaints, counseling calm. At one point he found himself on West Street facing a group of young teenagers who were beating on cans and "raising hell," looking for trouble. Someone had called the police and suddenly behind him there were members of the county's new tactical force, armed and ready. One of the officers yelled, "Get out of the way, mayor, we'll take care of them," and Moyer heard a shotgun shell slip into place. As Moyer said later, "These kids weren't dangerous, they were just loud, and I wasn't afraid of them. I was more afraid that someone would get shot." Moyer took the kids to the Terminal Restaurant, bought them coffee and sodas, and arranged an impromptu record hop at St. Augustine's Hall on Washington Street. The following night, Monday, as fires continued to burn in big cities only an hour away, more than eight hundred of Annapolis's black teenagers returned to St. Augustine's to dance to the Van Dykes, a popular R&B band, and listen to the mayor plead with them to come to him with their problems.[94]

With the help of black leaders such as Roland Brown, George Phelps, J. Alexander Wiseman, and Marita Carroll, black ministers such as Reverend Leroy Bowman, Reverend Rufus Abernathy, respected local figures such as the Falcons stars and Simms (who got that early release), and a mayor who was comfortable in the black community, Annapolis remained free of the violence experienced in other cities across the country. Simms was right: "Annapolis people didn't want to destroy their town, and they didn't. The real heroes," he reflected years later, "were the people of Annapolis."[95]

The outcome of almost a week of tension in town was positive. High school students and young adults, white and black, organized themselves as People's Right in Democratic

Equality (PRIDE) and petitioned the City Council for better recreational facilities. The council listened and agreed to support conversion of the Stanton School, then a storage facility, into a center for activities that would attract older teenagers. Initial funding for the Stanton Center came from WANN owner Morris Blum and his well-known DJ, Charles W. "Hoppy" Adams, and the Board of Education turned the building over to the city.[96] Simms became the first director of the Stanton Community Center, which was in use by September 1969. An indoor basketball court, added to the building in 1974, testified to the continuing importance of that sport in the life of the city.[97]

Carl Snowden, who has been active in Annapolis affairs for decades, believes that 1968 was a "milestone" in the racial attitude of Annapolis. The students of the late 1960s were less willing than their predecessors to swallow racial inequities, less able to forgive injustice, real or perceived.[98] Snowden himself was a leader in a February 1970 riot at Annapolis High School, the culmination of several weeks (some would say years) of open anger from African-American students who wanted a greater presence in school activities, more black teachers, and classes in black studies. Some two hundred students "rampaged" through the school during the morning of 12 February, breaking windows and creating general havoc. Police arrested four black students, two girls and two boys, on a variety of charges, including assault and battery, and the school suspended forty-one others. Walter Cronkite led that night's CBS Evening News with film of the event.[99]

Demonstrations in Annapolis during the 1960s were not always directed at racial inequality. Another major national concern during these years was the war in Vietnam. As had been the case with the Korean conflict, the Naval Academy did not make any drastic changes in schedule or curriculum in response to increased United States involvement in Vietnam in 1965, but through special speakers and demonstrations the administration and faculty tried to prepare midshipmen for what they could expect in the war zone.[100] St. John's College faculty and students tended to lean against the war, and some of them formed Tutors and Students for Peace. Along with the local Committee to End the War in Vietnam and Citizens for Peace, they demonstrated in Annapolis and Washington during the late 1960s.[101] Looking back on that period forty years later, some Annapolitans felt that antiwar sentiment during the Vietnam era lessened the influence of the academy on the city. Certainly the increase in the civilian population and tourism also had their effects, but local young people during the 1960s seemed less inclined than the generations before them to view the academy as an attractive venue for sports or social activities.[102]

One hundred twenty-two Naval Academy graduates died in action in Vietnam.[103] At least one of them was a local man: Lieutenant Commander Wilmer Paul Cook, whose plane, "The City of Annapolis," was shot down over North Vietnam in December 1967. Of the sixteen other deceased servicemen who gave their hometown address as Annapolis, almost half were marines, the rest divided almost equally amongst the navy, army, and air force. Five were officers, who died at an average age of thirty-one. The twelve dead enlisted men had lived an average of just over twenty-one years. Thirteen of the seventeen died in hostile action or as a result of wounds received in such action. Much like Annapolis dead in other wars of that century, these men were the sons of military veterans, Naval Academy employees, a navy bandsman, a barber, a grocer. Some were fathers themselves; some never had that opportunity. There is no available tabulation of the local men who served in Vietnam and survived.[104]

For decades there had been no doubt that some of the housing in Annapolis was simply unfit for human habitation. There was also no doubt, at least in the minds of planners and the City Council, that parts of downtown, with struggling businesses and increasing crime rates, needed rejuvenation. When Maryland voters approved the 1960 referendum extending urban renewal powers to cities, Annapolis immediately petitioned the General Assembly for state approval to carry out urban renewal projects with federal money. Legislation granting this took effect in June of 1961, and the City Council began the process that would allow the city actually to obtain federal funding — a long and drawn-out series of hoops to be jumped through.[105] In March 1963, the City Council created a seven-member Annapolis Urban Renewal Authority (AURA) to "carry out urban renewal projects," including "clearance, redevelopment, and rehabilitation of slum areas or blighted areas." AURA had extraordinary powers. The only things it couldn't do were initiate a project, issue bonds, or levy taxes; any other action concerning urban renewal fell into the agency's bailiwick. Among the early members of the authority were Yacht Basin president Henry Ortland, Jr., chair; automobile dealer Meyer W. Gilden, vice-chair and treasurer; alderman Noah A. Hillman; dentist Victor S. Leocha; builder Russell Meade; banker George Velenovsky, and Bowie State professor J. Alexander Wiseman. Bennett Crain, Jr., served as the authority's legal counsel.[106]

Identified as blighted in the early 1960s were both sides of West Street from Church Circle to College Creek and Colonial Avenue, the Pinkney–Fleet–lower Cornhill area, Cathedral Street from Franklin to Conduit, and Hanover Street and part of College Avenue outside the academy wall. Of these, the West Street corridor garnered the most concern.[107] Gone now were most of the businesses that had made the Fourth Ward a mecca for African-American entertainers and homeowners. Wright's Hotel on Calvert Street burned in 1950; the Star Theater shut its doors before 1959; the Washington Hotel was abandoned. Second and third generation descendants of the Jewish merchants who had served the black community had moved to other professions and closed family retail businesses; those merchants who remained no longer lived above the store. Black-owned shops, taverns, restaurants, and professional offices remained, but vacant buildings dotted Clay, Calvert, and Washington Streets. Crime in the area increased.[108]

With initial funding from the city, AURA hired a consulting firm to develop an application to federal authorities for roughly $200,000 in grant money to study "Urban Renewal Area One," the West Street corridor. The first map of the targeted area, released in March 1964, assumed the name Town Center Project, suggested by the Committee for Annapolis in 1962, and extended that plan's boundaries to cover the blocks bounded by Northwest, Washington, Lafayette, Dean, and Franklin Streets. Subsequent planning studies would determine which structures should be razed, which rehabilitated, and suggest possibilities for reuse as retail stores, offices, and hotels, as well as housing. Redevelopment within the area, to be performed by private companies, would comply with urban renewal guidelines.[109] Authorities assured residents of the area that anyone "displaced under this plan would have to be provided with 'safe and sanitary' substitute dwellings." African-American aldermen Roscoe J. Parker (R-Ward 4) and T. Norwood Brown (R-Ward 7) approved the plan but voiced their concern that "people not be displaced helter skelter throughout the county."[110]

Actual construction of the Town Center Urban Renewal Project did not begin until 1970, but the expectation of that construction, and of the demolition that would precede it, created a climate of impermanence throughout the designated area. As the maps made clear, planners considered almost every building in this part of town deficient in some way. It was hard to escape the conclusion that the neighborhood had failed and its residents would be better off somewhere else. With this atmosphere permeating government thinking, it is perhaps understandable, although unfortunate, that Anne Arundel County executive Joseph W. Alton, Jr., decided to follow through on a long-desired relocation of the county jail and replace it with county offices in order "to renew the Calvert St. area with a complex of government and community facilities."[111] This is the same revitalization concept that had prompted selection of the block between Calvert and Carroll Streets for the 1958 state office building and would color state acquisition of properties along Bladen Street in the late 1960s.[112]

The first section of the Arundel Center, on Calvert Street south of the jail, opened late in 1966, and a number of county offices moved from the Court House to the "spankin' new" building.[113] It proved so popular that as soon as the new county Detention Center on Jennifer Road was completed the following spring, county officials demolished the old jail and began negotiating for properties on the corner of Calvert and Northwest Streets in order to enlarge their office space. Although the county leased part of the Gott's Court parking lot from the city, parking for employees in the new building remained a problem, so the county began to buy land across Calvert Street for a garage. By 1969, half of the businesses and buildings along the perimeter of the block bounded by Calvert, Washington, and Clay Streets that had been there ten years earlier were gone, and there was a large hole in the middle of the block.[114] The county was "moving ahead of the Urban Renewal plan, thereby avoiding any Federal control over the area."[115] AURA chair, Henry Ortland, Jr., who had been pleased that "some of our work has been done for us" by the Arundel Center construction in 1966, must have been overjoyed when the federal Department of Housing and Urban Development credited the county's entire cost of the garage, estimated at more than $2 million, toward the city's one-quarter share of the urban renewal funding when it was calculated four years later.[116]

While the county steamed ahead, AURA preparations lay dead in the water. For reasons not clear today, the city lost its HUD certification in 1964. Mayor Roger Moyer considered recertification a priority of his new administration in 1965 and pushed city officials to make it happen. Following his announcement of their success early the next year, Moyer appointed Marita Carroll and Marian Satterthwaite as new members to the authority, and the council approved boundary changes that pushed the district farther into the Clay Street neighborhood.[117] T. Norwood Brown (R-Ward 7) resigned his seat as alderman to become the community relations officer for AURA. One of his jobs was advisor to the Project Area Committee, which was formed with people who lived in the Town Center neighborhood. The committee was intended as a liaison between AURA and the residents and business owners affected by the project. Minutes of the committee meetings indicate that, not unreasonably, its members' greatest concern was affordable housing for the displaced families and relocation of existing businesses. Project planners assured them that the application to HUD could not go through without a "satisfactory plan" for relocation housing and that the Annapolis Housing Authority would be developing more units for this purpose. As for neighborhood businesses, "an area would be reserved for their relocation" in the Clay Street corridor.[118]

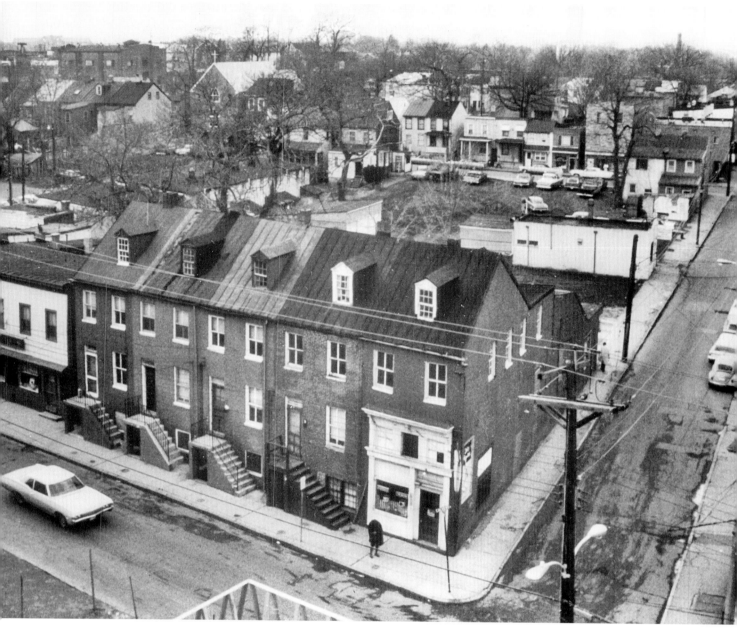

Few Project Area Committee members or citizens who would be directly affected by the Town Center plan showed up at City Hall on 29 January 1970 when AURA submitted its final plan to the public. But others in attendance voiced loudly their questions about housing. No public housing was included in the thirty-acre project area, although the mixed-income, subsidized "garden-type" apartments suggested for the Larkin Street acreage could include public housing units. Housing for sale or rent to moderate-income families and higher-priced units for "young working professionals" were planned for other parts of the project. By the numbers, the plan offered enough housing units to accommodate the number of people being displaced; by the cost of those units, the plan offered area residents little. Dr. Wiseman, then chair of AURA, responded to complaints that African Americans were being driven out of the Fourth Ward by saying, "HUD did not want to see

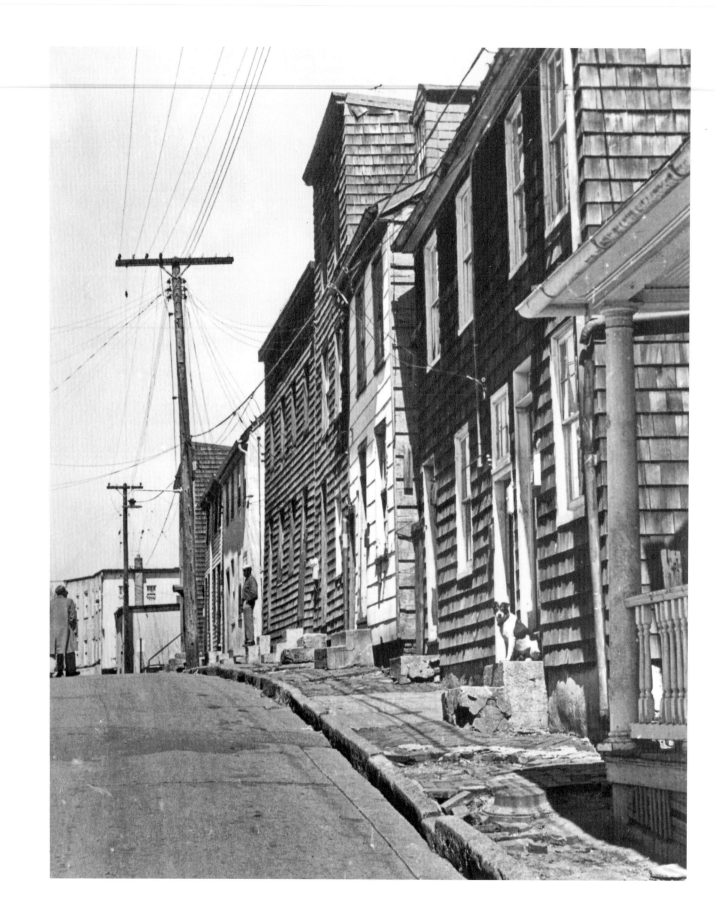

public housing in the project area for fear of 'Ghettoizing' it into an all-black neighborhood." A mix of housing, he felt, would be better for the ward. The Project Area Committee voted in favor of the Town Center plan at its February meeting. The paperwork went off to HUD's Philadelphia office in March.[119] Mayor Moyer later credited AURA member Marion Satterthwaite's expertise with HUD regulations as the reason for that department's approval of the Town Center plan in a record-setting six months. "The HUD people said it was the best application they'd ever seen," he said.[120]

During the 1960s, while the AURA board and staff jumped through hoops on the Town Center project, the city government worked with other federally funded programs to improve housing conditions in areas outside the Fourth Ward. It appears that this effort was not as successful as had been hoped: for instance, the Neighborhood Improvement Program, authorized in 1967 as a "fix-up campaign" to improve substandard housing in other parts of the city, spent only about half of its HUD grant and brought fewer than half its targeted units into compliance with the city's building code.[121]

The city's progress in providing the housing for families relocated from the Town Center project area and from other substandard housing in the city picked up in the late 1960s as the need became urgent. As a quick solution, the Annapolis Housing Authority took over the private, four-year-old, 273-unit Harbour House apartment complex in Eastport, with its pool and recreation center, in 1968. Some of the elderly residents who qualified financially remained, but the rest of the apartments were available for AHA clients.[122] Robinwood, a 149-unit townhouse development, and Newtowne Twenty, with 78 units, were built in 1970 and 1971 on land annexed from the county on the south side of Forest Drive. Bowman Court, with 50 units, joined Annapolis Gardens in 1974. In addition to AHA projects, private developers built low-cost housing under "almost the full range of federal programs," and these communities tended to be in the same areas as the AHA communities: Newtowne Nineteen (c. 1969) near Annapolis Gardens on Admiral Drive; Newtowne Twenty-two (1970), Bywater Estates, Sections 1 (1971) and 2 (1972), and Annapolis Woods (1971) punctuated Forest Drive between Chinquapin Round Road and Hillsmere. Most of the Forest Drive developments sat on land annexed from the county for the purpose. The publicly assisted, privately managed housing added up to about 578 rental units and 308 subsidized sale units by 1972. And even though the city's housing study that year noted that Annapolis had "one of the highest proportions of publicly assisted housing in the nation," it was not going to be enough. One reason was that Anne Arundel County had no public housing at the time, and people who needed help paying the rent simply moved to Annapolis. Another reason, stated the 1972 study, was that privately owned low-cost housing in Annapolis had been "diminished by a combination of public and private renewal and middle-class preferences for older housing that formerly served low income families."[123] By 1974, the AHA controlled a total of 950 units and was building the 156-unit Glenwood Highrise for senior and disabled tenants.[124]

Most of that older housing, renewed with public and private money and now attractive to more affluent residents, was in the new historic district. Annapolis reversed the usual inner-city "filtering," in which older homes with fewer amenities become available to moderate- or lower-income families as the previous owners move up to something newer and more luxurious. Here, said the 1972 housing study, the value of housing had risen 97 percent during the 1960s, and was expected to "continue to increase as low cost units are removed and the remaining stock appreciates in value." During that same period, more than 450 housing units in the old city were replaced by offices, shops, the hospital, other

(opposite)
Some Larkin Street houses had no running hot water inside and toilets in a shed in the back yard. Most used kerosene stoves for heat. Hazel G. Snowden wrote of life on Larkin Street in her book Missy "Joy and Pain" *(1998). Courtesy of the Maryland State Archives, MSA SC 2140-401.*

construction, or parking lots. Housing in the Pinkney–Fleet–lower Cornhill Street area was especially dreadful and especially obvious to tourists and legislators.[125] St. Clair Wright, then cochair of the Anne Arundel County Committee of the Maryland Historical Trust, and Pringle Symonds of Historic Annapolis, Inc., made efforts to obtain financial backing from either the Trust or HUD that would enable owners of these buildings to rehabilitate the structures. There was even discussion amongst AURA, Historic Annapolis, and the city about applying for an official urban renewal project, similar to the Town Center project, for the Pinkney-Fleet area. The expressed objective of all these efforts was to maintain the racial and economic mix of the neighborhood while improving the living conditions. Any new construction would, of course, be "consistent in design" with its historic neighbors.[126]

What happened in the end was that "market forces" — which is to say money or maybe even too much money — outpaced attempts to keep poor residents, most of whom were African American, in their Pinkney–Fleet–lower Cornhill Street houses. The 1972 study had warned that the household profile in this district, as in the Town Center area, "would be dictated more by economics than by housing needs." And it was.[127] When a new, restoration-minded corporation bought a row of houses on Pinkney Street, tenant Edith Kirby figured that was the end of her life downtown. Her granddaughter agreed. "We're all going to go, and we won't be able to return," she said. "What they have here won't be available for poor people."[128] A few members of Historic Annapolis created the private Nicholson Corporation to purchase historic properties quickly and quietly for resale to people who would renovate them appropriately, and some of those properties were in the Pinkney-Fleet area.[129] But, as Mrs. Kirby had understood, the residents after renovation were rarely, if ever, the people who had lived there before.[130]

Historic Annapolis obtained state and federal funding to restore two structures on Pinkney Street as part of its Bicentennial Buildings program, in preparation for the anniversary of the American Revolution celebration. Both the barracks at 43 Pinkney and the Tobacco Prise House at 4 Pinkney, later named the Waterfront Warehouse, were post-Revolutionary buildings, but their improved appearance helped spruce up the street, making it more attractive to private investors.[131]

When federal laws governing the procedures for distributing money to states and municipalities changed and Community Development Block Grants supplanted the old urban renewal funding programs in the mid-1970s, the city's Department of Community Development became the primary applicant for HUD funding. The Annapolis Urban Renewal Authority wrapped up its independent relationship with HUD and succumbed to city oversight. By 1979, the Town Center project had relocated 33 businesses and 237 families, according to an article in the *Washington Post*. It closed out in the following year.[132]

Was urban renewal in Annapolis a success? The answer depends on who is giving it. The people most involved in the administration of the Town Center project believed that the repair and improvement of the West Street infrastructure — the new water and sewer pipes, sidewalks, underground wires, repaved streets, trees — benefited the entire city. Patricia Barland, who worked with AURA in the late 1970s, said that not everyone in the project area needed to move to public housing. Some area homeowners used urban renewal funds to rehabilitate their houses, others took compensation and moving expenses and built new homes on the outskirts of town. Some businesses didn't want to stay, others tried to and couldn't make it. Urban renewal money paid for acquisition and demolition of dilapidated structures, but most of the new construction was privately financed and owners had to make a profit.[133] Urban renewal's greatest value, said Norwood Brown, was to the

city's poorest residents who lived in structures where "you could see light coming through the ceiling. People had space heaters in the middle of the floor. I remember thinking, 'Lord let me get these people out of here before they die in a fire.' We moved these people into modern homes with central heat, hot and cold running water, and inside toilets."[134]

There were other people, however, who cited urban renewal as the reason for a whole catalog of social ills, from political disenfranchisement to crime to racial discrimination and alienation. Their complaints centered on five points: (1) Residents and business owners in the Town Center were promised that after reconstruction they would be returned to the area and they were not. (2) Urban renewal moved poor inner-city blacks into public housing that was already almost exclusively African American, thus exacerbating *de facto* segregation. (3) Much of the city's public and subsidized housing was built on the outskirts of town. (4) Relocation of blacks away from the Fourth Ward was a deliberate ploy to disperse African-American votes and lessen their political power. (5) Demolition of homes and decline of small businesses contributed to the increased crime rate and urban decay along West Street.[135]

There is no doubt that most of the people relocated to low- or moderate-income housing ended up on Admiral or Forest Drives "isolated from other residential areas, from needed community facilities and services, and from former friends and acquaintances." Without cars, residents had to rely on taxis or the private Arundel Bus Company's three old blue-and-white school buses for transportation to stores, work, and church. Urban renewal and city officials denied that this was a deliberate attempt to remove African Americans from their political base in the Fourth Ward, reiterating Wiseman's assertion that HUD regulations required that blacks be moved away from all-black neighborhoods. Former mayor Roger Moyer said HUD believed that to do otherwise would be "reestablishing the ghetto."[136] The fact remains that only one black alderman was elected between 1973 and 1985, instead of the usual two. That this change was as much the result of redistricting and white population increases on the periphery of the city as it was the relocation of Fourth Ward African Americans was not mentioned by complainants. In fact, when ward lines were redrawn in 1971 to comply with federal "one-man, one-vote" requirements, planners attempted to distribute the populations so that the "present tradition" of two black aldermen would be maintained.[137]

Thus, urban renewal resulted in two tragedies: one the break-up of the downtown African-American communities, the other the assumption among blacks that that break-up had been done to them deliberately. Jack Ladd Carr, who as city planner had been involved in the early stages of urban renewal, said that promises were made to the black community: they "thought that they were going to get what they wanted, and it didn't take long for them to see that they were going to get shafted. . . . What we did in Annapolis was decant the black population that was here and create ghettos in the outlying areas. . . . We broke up a viable community. We didn't know that until it was gone."[138] Joseph "Zastrow" Simms, who was raised on Clay Street, said, "By urban renewal [blacks] were able to move into a different area somewhat away from their roots, but into better houses. I wouldn't say it made a better home."[139] Joe O'Connor, a long-time HUD official familiar with the Town Center relocation, summed it up: "That's the story of urban renewal, not just in Annapolis, but everywhere." The bitterness would last a long time.[140]

The first U.S. Sailboat Show, in October 1970, punctuated the city's emergence from the 1960s with an exclamation point of masts. Innovative idea of Annapolis Sailing School owner Jerry Wood and his partner Peter J. Carroll, the show featured boats in the water at the outer edges of City Dock and tents with more boats and marine equipment in the center. At that time, boat shows were traditionally winter events, held in a big-city convention hall or armory; a fall show, with boats in the water where they belonged, was revolutionary. Many people in town thought Wood and Carroll would lose their shirts on this one, and besides, why should the city rent its prime dock area to some private company? But the state office of tourism and folks at the Department of Natural Resources liked the idea and backed it with grant money and in-kind assistance. Naysaying merchants changed their minds on the first day of the show when they realized that "by three o'clock in the afternoon, all of the downtown restaurants had run out of food" and people were buying lunch fixings at the A&P on Dock Street.[141]

What was also unusual about this boat show was the presence of a large number of European boatbuilders who saw this as their opportunity to sell to the U.S. market. Boats arrived from Sweden, Finland, and the U.K., and their support personnel charmed American sailors. When all the money was counted and vendors, governments, and local merchants pronounced themselves happy, Wood and Carroll knew they had a hit. A year later, the city agreed to rent the dock for a total of ten days so that the U.S. Powerboat Show could follow the sailboat show in October 1972. By allowing buyers to order in the fall and pick up their new boats in the spring, the Annapolis boat shows affected the entire boating industry. By bringing thousands of boat lovers to Annapolis each year, the shows changed the town.[142]

During the 1960s, the population of the city and its immediate suburbs increased by almost 30 percent; most of the new residents had migrated to the area, most of them were white. Waterfront housing around the Eastport peninsula attracted retirees and upper-income renters, but new apartments and townhouses between Bay Ridge Avenue and Spa Road, priced to fit a broad budget range, were particularly popular. By 1970, the Eastport bridge was carrying some two thousand vehicles a day, and commuters and sailors tried to out shout each other in the perennial battle over whose traffic backups were worse. The Coast Guard had restricted rush-hour bridge openings in 1966, but six years later the number of boat slips up-creek from the bridge had more than doubled (from 100 to 220) and would triple (to 347) when pier plans on the books were approved. The decibel level of complaining boaters reached new heights. Their ire was matched by that of the four thousand new residents across the creek who suffered "intolerable delays" from bridge openings. The City Council, caught in the middle, pleaded with state and federal officials for scheduled bridge openings around the clock in the summer months.[143] To give some relief to the Eastport commuters, the council extended Hilltop Lane from its terminus at Admiral Farragut Apartments, just east of Spa Road, to Tyler Avenue and widened Tyler in the process, to create an attractive alternative to the beleaguered bridge. Of course, once the road was open, townhouse developments such as Saltair (1973) just added more cars.[144]

The early 1970s were marked by the City Council's attempts to bring the municipal organization into the modern era. With three times as many residents as in 1950, traffic was not the only challenge facing Annapolis officials; police and fire services, governmental structure, and infrastructure maintenance and improvement were all concerns of the

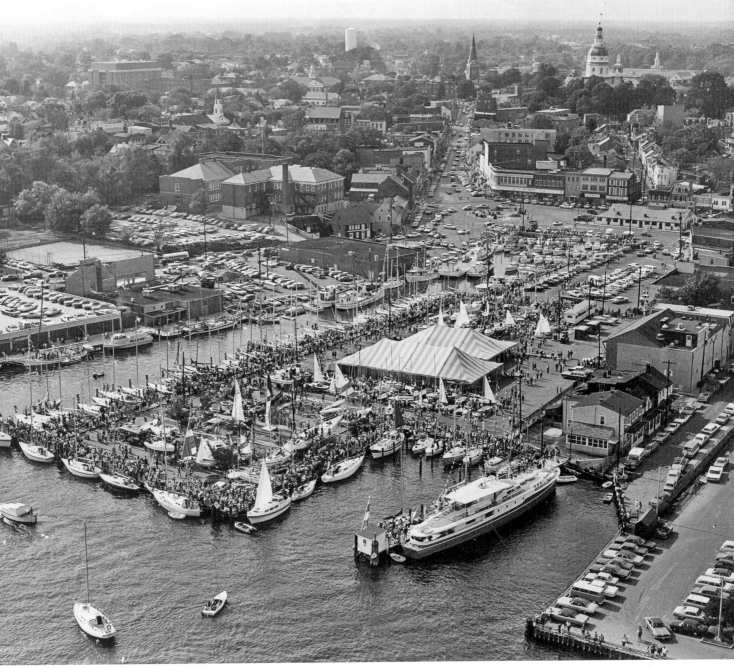

period. The result in most cases was not only increased professionalism but also relocation outside the old city.

The Annapolis Police Department grew from fifty officers in 1960 to seventy-three in 1971, all of them still operating out of a few rooms in City Hall. After considerable council debate, Mayor Roger Moyer had appointed Lieutenant General Ridgely Gaither, USA (Ret.) as police commissioner in 1966. Gaither had been commander of the Second Army, and his supporters hoped his experience with military police would prove useful. During the tenure of Gaither and Anthony W. Howes, police chief from 1961 until 1973, the city built a stand-alone police station with modern radio and telephone systems, monitored

Parking was at a premium when the first Annapolis Boat Show, October 1970, brought sailors to town to see, and buy, sailboats shown in their natural habitat. The governor's yacht, Maryland Lady, *provides scale in the foreground. Courtesy of Rick Franke.*

holding cells, and bullet-resistant windows. Located on Taylor Avenue on the piece of land known for centuries as the Small-pox Lot, the new facility opened in 1972. Since the mid-1950s, female civilian school crossing guards had been attached to the police organization, and during the 1960s, the department had hired a civilian clerical staff of three, all of them women and one of them, Gloria Matthews, African American. The city's first sworn full-time female police officer, Barbara Hopkins, joined the force in 1973.[145]

Two charter amendments in 1974, during the term of Chief Bernard Kalnoske, changed the organization of the police department by eliminating the commissioner position and making a professionally qualified, experienced chief responsible for the department's activities and personnel. Police officers were brought into a "civil service based merit system," with required testing for hiring and promotions. In 1975, the force numbered ninety-four sworn officers, including parking enforcement personnel first hired in 1973.[146]

As Annapolis grew in size and population, its legendary volunteer firefighters could not cope with the increased demands on their time and equipment. By the 1960s most volunteers did not work near their stations, and even if they did, employers were often unwilling to allow the men time off for calls. In 1958, 150 active volunteers and 23 paid firefighters staffed the city's five stations, which, since annexation, included the Eastport and West Annapolis companies as well as the three traditional city units. A decade later, those numbers had changed to 72 active volunteers and 45 career firefighters, and over the succeeding years, the balance continued to shift away from volunteer participation. Volunteers who found they could not balance a full-time job, a long commute, and family life with middle of the night fire calls dropped out. But during the late 1960s and early 1970s at least two dozen volunteers decided to switch jobs and signed on as career firefighters with the city department.[147] A casualty of the shift away from a volunteer firefighting force was the loss of the ward-based fire stations, which for so many years had been a social and political center as well as fire department.[148] Neighborhood boys who had sat around the station of an evening, listening to stories told by veteran firemen, had to find another place to hang out.

The Eastport company moved in 1961 to a modern station near the junction of Bay Ridge and Chesapeake Avenues, where it could more easily reach the new population centers. A decade later West Annapolis Fire and Improvement Company relocated to a site adjoining the Detention Center, outside of the city limits. Again, the reason for the move was improved access to the burgeoning suburbs, but neither the station's old neighborhood nor the City Council was pleased with this decision, and they initiated litigation to keep the station within the city. In 1971 the circuit court upheld an agreement the West Annapolis organization had signed with the city at the time of annexation, in which the company reserved the option to leave if it so desired, which it did.[149]

Fire losses in the 1950s and early 1960s lowered the city's fire insurance rating to pretty much rock bottom, and the rating bureau told Mayor Joseph Griscom that if the city did not comply with its recommendations for improvement, insurance companies would add a surcharge to already high policy costs. This threat convinced the council to reorganize the fire department. Their first step was to hire Charles H. Steele as the city's first full-time, professional fire chief, in 1964. That year, the department handled 294 fire calls and 561 ambulance runs. It was also the year the city lost its first firefighter in the line of duty. Sixteen-year-old John Schwallenberg, Rescue Hose Company volunteer, died of smoke inhalation while fighting a warehouse fire on Virginia Avenue. His tragic death underscored the dangers faced by firefighters. Synthetic materials, multistory buildings, and more complex

construction added to the traditional perils, making firefighting an increasingly hazardous occupation.[150]

In addition to instituting training programs for city firefighters, Chief Steele worked closely with Police Chief Kalnoske and the heads of public works and planning and zoning on arson cases, proper water distribution to fire hydrants, and building code enforcement, especially in the new multifamily buildings. The city's ratings went up and the cost of insurance went down. Central to the reorganization plan was the consolidation of manpower at fire stations located away from the traffic problems of the center city.[151] In 1972, Steele presented the City Council with plans for a new 12,000 square foot facility on Forest Drive that would accommodate two pumper trucks, a ladder truck, rescue vehicle, and ambulance. The building opened in 1973, the first station in Annapolis to be manned entirely by career firefighters.[152]

Roger Moyer had wounded the legendary Phipps political machine with his election as mayor in 1965.[153] His reelection, with 60 percent of the vote, in 1969 and the retirement of old-guard aldermen Bernstein and Ellington, put Moyer in a position to initiate some changes in the municipal structure. The following year the council created the Department of Public Works and made it responsible for all city land and buildings; the city water system, sanitary sewer system, and disposal plant; public wharves; construction of public roads, mains, and sewer lines; garbage collection and disposal; and all city-owned motor vehicles and equipment. The director of public works, deputy director, and the city

This major fire, on 1 June 1970, was the first of two that severely damaged the colonial Middleton Tavern and would have justified its demolition. Instead, the owners chose to restore the building, a testament to the commercial benefits of history. Courtesy of C. W. Cadle, Jr., Annapolis Fire Department.

engineer were required to be professional engineers.[154] One of the first jobs facing the new department was coordination with the county on a new sewage treatment plant to be built across Edgewood Road from the city's original plant. The jointly owned facility, built with additional funding from state and federal agencies, was designed to treat ten million gallons of wastewater a day and would be operated and maintained by the county. It went online in 1976.[155]

Another significant modification in municipal government structure was the council's formal recognition in 1972 that the office of mayor was a full-time position and that the incumbent should be properly compensated. The first mayor to enjoy the $18,000 a year salary was John C. Apostol, the thirty-four-year-old Republican elected mayor in 1973.[156]

Following the 1970 census, an ad hoc commission appointed by the council divided the city's 30,000 people equally into eight wards "free of any favoritism whether of race or political parties."[157] Concerned that this plan would deny African Americans the two aldermanic seats that had been customary for almost half a century, Alderman Robert L. Spaeth proposed new boundaries giving one ward an 85 percent black population and another 50 percent. The other six wards ranged from 35 to 4 percent black. As Spaeth explained, his plan wouldn't "'guarantee' the election of two black aldermen . . . but would provide the 'potential' for their election." African-American alderman John T. Chambers pronounced himself satisfied with this effort, as did president Samuel Gilmer and the directors of the county NAACP chapter.[158]

In the city election of May 1973, the primarily black Ward 3 (Parole area) returned Chambers to the council, but African-American candidate William Richardson, running as a Republican from the new fifty-fifty Ward 4, lost to Democrat James R. Stilwell, a white retired admiral.[159] It is doubtful that redistricting had anything to do with a unique new

alderman: Barbara Neustadt, the first woman to serve on the City Council in all its 265 years. Neustadt ran unabashedly "as a woman, a housewife, and a mother" and said she had received permission from her husband, a Naval Academy professor, to do so. A dedicated community volunteer and immediate past president of the American Association of University Women, Neustadt had worked on Capitol Hill and was no stranger to the nuances of government.[160]

In addition to new police and fire stations, City Dock and Market House renovations, and road work in the early 1970s, the city also attacked its perennial parking problem by agreeing to turn the 140-car Gorman Street parking lot behind City Hall into a four-deck, 400-car parking garage. The lot dated to the early 1950s, when the city had acquired most of the interior of the block bounded by Main, Conduit, Duke of Gloucester, and Green Streets. Construction of the garage required purchase of several other properties behind the encircling buildings, as well as the Little Tavern at 135 Main Street, which was demolished to provide an entrance to the garage. Originally intended for 500 cars, the garage design was modified by architects and planners, hired by Historic Annapolis, who verified St. Clair Wright's contention that a smaller structure would be both adequate to the need and cost effective. Contrasting the city's effort with the county garage on Calvert Street, former mayor Roger Moyer said, "We have a very functional parking garage and you don't even know it's there."[161] John Carl Warnecke would have been proud.

An unfortunate combination of parking and personality posed the first serious challenge to the city's 1969 Historic District Ordinance. When the congregation of Mt. Moriah A.M.E. Church decided to build a new church out of town, where it would be more convenient to members leaving the Ward 4 urban renewal project for the suburbs, the county bought the old church for parking and potential expansion of the Courthouse. At the time of the purchase (1970), Franklin Street was not within the Historic District, but new boundaries drawn the following year placed the church under the purview of the Historic District Commission.[162] County Executive Joseph W. Alton, Jr., made it clear he intended to demolish the structure. Surely the Historic District Ordinance did not apply to the county government! But the city held that the county *was* subject to the ordinance, just as the city was, and if the HDC denied the demolition application, as happened, then the county could not tear down the church. In testimony to its historic importance, Mt. Moriah earned a place on the National Register of Historic Places in 1973.[163] The county executive was "very, very angry," recalled then-HDC chair Pringle Symonds. "There was a rumor Joe Alton might try to demolish it in the middle of the night on Halloween, so we had shifts of people sitting in a car" near the church to keep watch.[164] Teacher Lulu Hardesty, who lived next door and supported the preservation effort, kept an eye out for trouble.[165] With the support of the Historic District Commission, Historic Annapolis (St. Clair Wright, president), the Maryland Historical Trust, and the state Commission on Negro History and Culture (Carroll Greene, president), the city took the matter to the courts. In January 1974, the Court of Appeals ruled that Anne Arundel County "is subject to the application of the Historic District Ordinance, sections 22-226 through 22-236, inclusive, of the code of the City of Annapolis."[166]

Of five church congregations to forsake the inner city in the early 1970s, Mt. Moriah's Franklin Street church was the only one not subsequently demolished by a government building program. The enlarged state complex swallowed College Avenue Baptist, which moved to Forest Drive and became Heritage Baptist Church in 1972, and Calvary Methodist, whose congregation accepted state land across College Creek and built a new church,

Rubble in this photograph, taken by Clifton Revell Moss from the State House steps in April 1973, resulted from the demolition of Calvary United Methodist Church, which was to the right, and the Court of Appeals building, shown here with only its shell remaining. Lawyers Mall and the Legislative Services Building now stand on the site. Courtesy of the Sands House Foundation.

also dedicated in 1972.[167] Anne Arundel County bought St. Philip's Episcopal Church building on Northwest Street to enlarge the Arundel Center; the congregation bought land on Bestgate Road where they built a church and rectory.[168] The Annapolis Urban Renewal Authority demolished the Larkin Street building of Second Baptist Church and financed the congregation's new church on Poplar Avenue in the Simms Crossing neighborhood.[169]

These churches, along with Kneseth Israel and St. Martin's Evangelical Lutheran, both of which moved out to the intersection of Hilltop Lane and Spa Road in 1963, seemed pleased with their increased accessibility to suburban parishioners, available parking, and room to expand their activities, especially in early childhood and elementary education.[170] Other, newer congregations chose the fringes of the city or adjacent county for their houses of worship: Unitarian Universalist Church of Annapolis, off Bestgate Road (1969); Evangelical Presbyterian Church, Ridgely Avenue (1971) (also the first location of the Annapolis Christian School [1971]); Holy Temple Cathedral Church of God, Dorsey Avenue (1973).[171]

Not only churches left downtown. The county library system joined the exodus with its new Annapolis Area Library, which opened on outer West Street in November 1965. This was the first purpose-built library in the county — soundproof, fireproof, air-conditioned, with modern lighting and lots of parking. Library Board of Trustees president Elmer M. Jackson, Jr., was particularly proud of the "teletype machine that connects with Enoch Pratt Library in Baltimore so that information needed by school children and others, not available here, can be obtained in a matter of minutes." Reynolds Tavern continued as library headquarters until the system moved to Truman Parkway in 1976, where it joined the county Department of Public Works and Department of Health in the new Government Park.[172]

Some long-time downtown businesses fled in the face of higher rents and less parking; others just closed. Against the pleas of the City Council and downtown customers, the A&P Food Store on Dock Street shut its doors in the spring of 1972 after thirty-four years in that location, leaving the old city without a chain grocery store.[173] Patron preference for the Plaza Theater in Parole (1966) and Eastport Cinema (1973) led the Capital Theater on West Street to give up its run in 1974; the building was modified for professional offices.[174] Most devastating of all was the demise of John Trumpy and Sons boatyard. Following delivery of his last wooden power yacht, a 65-foot luxury craft named *Sirus*, in March 1973, John Trumpy decided to close the five-and-a-half-acre yard, citing difficulties in getting good workmen. But others held that Trumpy's was the "victim of plastic technology, the cost of craftsmanship, and the high-rise condominium building boom."[175] With the Tecumseh on one side of him and another multistory condo being built on Sycamore Point, Trumpy applied to the City Council for a zoning change that would allow him to build a 156-unit complex on his property as well. The council declined and Trumpy sold out. The

yard's equipment went on the auction block in July 1974. It was, said one watcher, "the end of the era of custom-built, wholly wooden yachts in America."[176]

Another landmark was destroyed when the state made good on its intent to "increase the governmental importance of Annapolis." The master plan, by the Philadelphia firm of Wallace, McHarg, Roberts, and Todd, created a formal, landscaped corridor into the city, with the sight line ending at the State House. State buildings clustered at the Taylor Avenue–Rowe Boulevard intersection and on both sides of a Bladen Street mall would serve as focal points along the way. In the outer cluster would be new buildings for the Department of Natural Resources, Courts of Appeal, and Annapolis State Police Barracks, a visitors' center, and rapid transit terminal; the inner cluster, adjacent to State Circle and College Avenue, would include a House of Delegates office building, other offices, a heating plant, and parking garage.[177] Wallace, McHarg advocated modifying the 1903 Court of Appeals building for offices, but the state-selected lead architect for the project, Lawrence P. Sangston (who said the marble interior of the court building reminded him of "public toilets" and the Tiffany glass dome wasn't Tiffany's), decided to replace the Beaux Arts building with one that would "be as near to Georgian architecture as we can make it today."[178] Protests by local citizens' groups, the City Council, county council, Historic Annapolis, a prominent architecture critic, and the National Trust for Historic Preservation could not persuade the state architects that Annapolis thrived on a variety of architectural styles. There was a brief, vain hope that the state was subject to the Historic District Ordinance, but when that died, the building was lost and the only thing locals could save were some furnishings and slabs of marble sold by the contractor before demolition. The state did hold on to the marble columns and the Tiffany skylight.[179] By 1975, the state's Annapolis complex totaled more than two million square feet of space in sixteen buildings, including the new Tawes State Office Building (Department of Natural Resources), Courts of Appeal, State Police Barracks, Thomas Hunter Lowe House of Delegates Office Building, Central Services Building, and Legislative Services Building (scheduled for completion in spring 1976). State employees working in Annapolis numbered approximately 2,800 compared to 1,100 in 1967.[180]

So, what else, besides government office buildings, moved into the "new" Annapolis? Mostly tourist attractions: restaurants, taverns, shops, and a wax museum, the last replacing the Dock Street A&P. For many old-timers the end of the Annapolis they knew came with the conversion of LaRosa's Italian Restaurant, later Novelli's, to Fran O'Brien's Anthony House (1973), or the sale of Sam Lorea's Tavern to Pauvre Papillion (1974), or the Downtown Tavern's transformation into McGarvey's (1974).[181] In each case, a blue-collar establishment with loyal local clientele was transformed into a popular singles bar attracting Washington professionals tired of Georgetown and Old Town Alexandria. Of the fourteen businesses new to the city in 1974 and early 1975, seven were bars and restaurants. Joining dining spots like Middleton Tavern and Harbour House on the city dock were the new Treaty of Paris Restaurant in the renovated Maryland Inn and the upscale Auberge de France and Le Crêpe Normande on Main Street. Annapolis was becoming a happening place. Guitar legend Charlie Byrd alternated gigs with national jazz greats at the Maryland Inn's King of France Tavern. Guided walking tours visited Hammond-Harwood House, Chase-Lloyd House, and the new gardens behind the William Paca House, where interior restoration kept the house itself closed except for special occasions. Antique shops on Maryland Avenue drew collectors; small boutiques on Main Street sold handmade crafts and toys; and new and used bookstores delighted browsers. Guests who wanted overnight

Paul "Sid" Cohen parked his souvenir truck at the city dock on weekends so tourists could buy a memento of their visit to Annapolis. Of the businesses facing Dock Street, only Donatelli's had installed a colonial facade when Tom Darden took this photograph in 1973. Courtesy of the Maryland State Archives, MSA SC 1907-b5-b4-45.

accommodations other than the ubiquitous motels on Route 50 could stay at Paul Pearson's eighteenth-century Maryland Inn or the new, modern Hilton Hotel on the waterfront. With a pleasant morning stroll down to the city dock, visitors and residents alike could buy fresh vegetables from county farmers outside Market House in summer or watch skipjacks leave for nearby oyster beds in the fall.[182]

For a town that ten years earlier had worried about empty stores on its main streets, this was all a bit much. On one hand, the city's economy looked good. Rents for downtown office and retail space were up; employment in the four levels of government, source of almost half the jobs in the region, was expected to increase; assessments on recently restored old buildings raised city property tax income to new levels. Locals enjoyed good jazz and arts festivals and relaxing on the refurbished City Dock as much as any tourist; but many Annapolitans, both old and new, worried that their city might now be too successful. Mayor Apostol attributed his election in 1973 to his advocacy for limited growth: "We probably have more tourists than we know what to do with," he said. "A lot of the people don't want to grow anymore."[183]

Earth Day in 1970 focused attention on pollution of the waterways around Annapolis that creek watchers had complained about for a decade or more. The principal reason for the Truxtun Park swimming pool in 1967 had been the fact that the Department of Recreation and Parks could no longer let children in the summer camp program swim in Spa Creek.[184] The City Council established a nine-member Annapolis Environmental Commission in 1972 and hired the Chesapeake Bay Foundation to study pollution source points in Spa Creek. The council also forbade swimming and water skiing near the city dock. Environmental awareness was partly responsible for moratoriums in 1974 on permit approval for large planned unit developments and pier and bulkhead construction.[185]

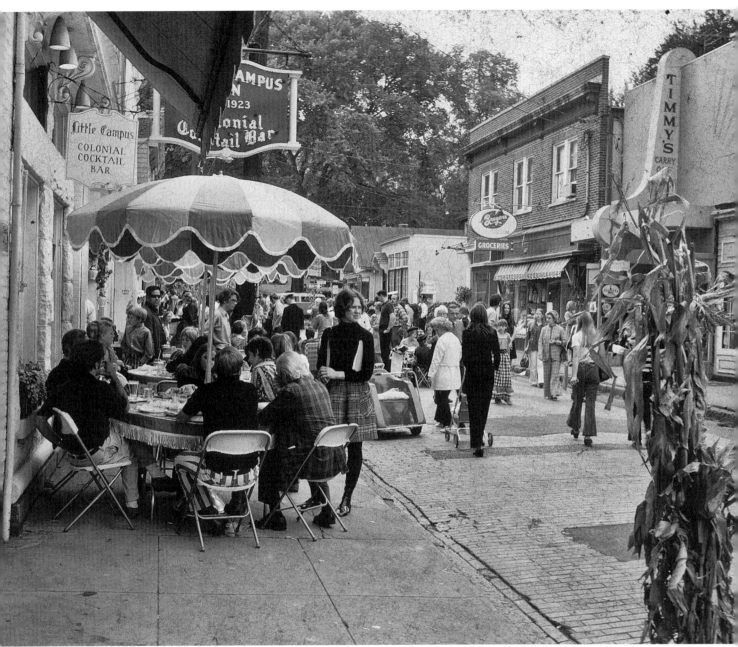

Maryland Avenue maintained its residential character long after West and Main, the two other commercial streets, had lost their over-the-shop housing. Local business owners sponsored this fall street fair, c. 1972. Courtesy of M. E. Warren Photography, LLC.

Other concerns of the mid-1970s were overcrowded elementary schools, inadequate police protection, road capacity, and public access to the waterfront. The Planning and Zoning Commission stated clearly the city's ambivalence in its 1975 Comprehensive Plan. The "concerns and values" of residents and officials "have shifted perceptibly," they wrote, and while in the 1960s the push had been "for economic development . . . the policy of capturing all possible commercial and office development may sacrifice unique qualities of the city and treasured values of the residents for tax dollars." The City Council adopted this latest comprehensive plan, replacing the much different 1965 one, in December 1974.[186]

Thus, the people of Annapolis welcomed the approach of the bicentennial of the American Revolution with some ambivalence. They could celebrate their chosen city's colonial

Children and adults enjoyed cruising about the Annapolis harbor aboard the Harbor Queen. *Photograph by Tom Darden, c. 1973. Courtesy of the Maryland State Archives, MSA SC 1907-b3-b5-21.*

Annapolis harbor in the summer of 1976. Tents at Susan Campbell Park on the renovated City Dock probably sheltered the annual Maryland Clam Festival, held in August. Courtesy of the Special Collections and Archives Department, Nimitz Library, U.S. Naval Academy.

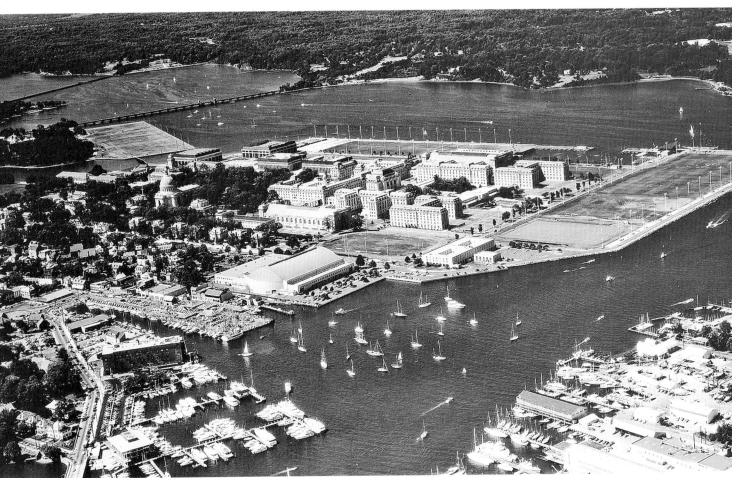

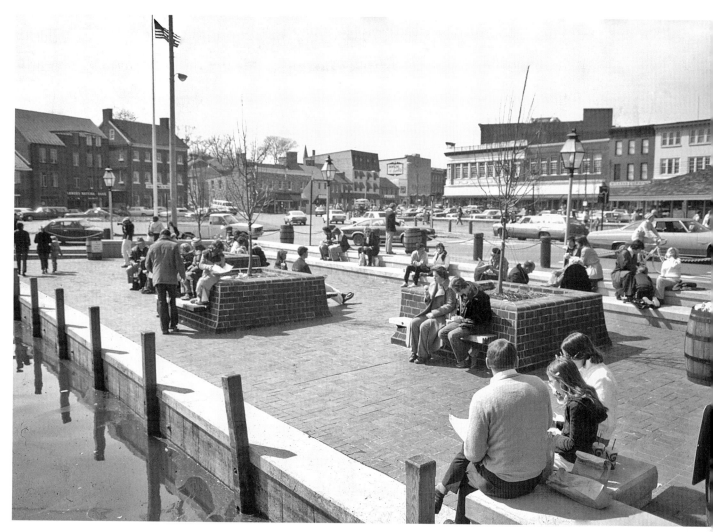

An Annapolis custom begins—lunch at the newly renovated city dock on a sunny spring day in the late 1970s. Courtesy of M. E. Warren Photography, LLC.

past with honest pride in its renewed vigor, but beneath the surface there lurked apprehensions about the future. Could their popular, restored downtown remain viable if it cast its lot with tourism and gentrification, or would it lose its variety, its identity as a municipality, and become a "virtual yuppie theme park"?[187] One fact remained unquestioned: Annapolis residents, new and old, loved their waterfront, loved their State House, loved their view down Main Street — loved their city on the Severn.

Epilogue

"Where shall we spend the rest of our lives?" In the mid-1990s a couple living in California with three young children asked themselves that question and began looking. Because both had graduate degrees in business and felt comfortable with the techniques of factual analysis, they set up a spreadsheet with their criteria for the ideal place to live: an attractive, small town on navigable water with good schools, high-quality medical facilities, a college or university, and a successful business environment. They preferred to be on the East Coast within easy reach of airports and a large city. Using all the comparative data she could find, the wife started making lists.

Because Annapolis popped up in first or second place on most of those lists, the couple decided to make an exploratory weekend visit. Standing in line at a popular local seafood restaurant on Saturday night, they got into a conversation with the people around them and someone said, "Come on over for coffee tomorrow and we'll show you around." It was, said the wife years later, a "bingo moment." The spreadsheet may have brought them here, but it was the welcoming friendliness, the sense of place, the personality of the town that made their decision easy — Annapolis![1]

For another couple, the move from El Salvador was an economic necessity. No matter how hard and long they worked, there was little opportunity beyond subsistence farming in their native country; and with no money to send their children to school, the next generation would surely endure the same hard life. In Annapolis family members already in the city would help them find housing and jobs. Yes, they might have to live crammed into one or two rooms and work long hours for little money, but the children could go to public school and learn what their parents had not. Here, in Annapolis, the husband could do landscaping or work in a boatyard. The wife could baby-sit or care for the elderly. Both could work in restaurant kitchens. Surely, in time, their lives would be better; their children would have hope.[2]

For more than 350 years, men and women have been drawn to the city on the Severn by its location, its culture, or its economic possibilities. Whether nonconforming Protestants, despairing Englishmen, eighteenth-century craftswomen, Union army vets, Greek cooks, retired naval officers, twenty-first century MBAs, or impoverished Hispanics, all came determined to find a better life in a new environment. Especially in the early centuries, not every immigrant to Annapolis came willingly. For some a slave ship was reality and choice not an option; for others the alternative was imprisonment or death. But once here, and once freed, those who remained did so for much the same reasons as those who came deliberately.

Not every immigrant succeeded, not every immigrant stayed, but those who did put their own stamp on the town. And one of those stamps is a sense of potential, a culture of acceptance. Annapolis has traditionally welcomed newcomers. Whether it is because the city's ancient role as seaport has always attracted temporary residents or because the natural turnover at its colleges and naval establishments regularly churns up the population, the city does not display the xenophobia, the entrenched social hierarchy, of many other small Southern towns. Long-time residents have almost always made room for new

blood. New arrivals have been accepted for their skills and willingness to work, for their knowledge and application of experience to the needs of the city. Throughout the history of Annapolis, its newcomers have come to hold positions of importance in the life of the town. From Edward Lloyd I and William Paca to Jonas Green and William Abbott, from Wiley Bates and Aris Allen to Beth Whaley and Anne St. Clair Wright, immigrants have directed their abilities to the benefit of the city.

As the city moves into the twenty-first century, today's new residents will influence tomorrow's city. Over time they, too, will become "old" residents ready to welcome the next influx of immigrants. Annapolitans, old and new, are here because they want to be. Like those who came before them, they have chosen Annapolis as their hometown, to enjoy with pride today, to cherish with resolve for the future.

Acknowledgments

Although this is not a book by committee, it is a book by community — a community composed of historians, both amateur and professional, who have given generously of their scholarship and insight, with the determination that this book should be the best possible history of Annapolis; of my family, friends, and neighbors, whose encouragement has sustained me through the decade; and of those who consider themselves Annapolitans, no matter where their actual residence, who have shared their memories, knowledge, artifacts, and opinions of their hometown.

Chief among the professional historians who have offered assistance as I researched this book is Dr. Edward C. Papenfuse, archivist of the State of Maryland and commissioner of land patents, whose knowledge of the history of Annapolis is based on a career of intensive scholarship. He has enlightened and advised my work in local history for more than forty years, and his contributions to this book have been invaluable. Closest to the progress of the manuscript was Dr. Jean B. Russo, for more than twenty-five years historian with Historic Annapolis Foundation, who shared her extensive research files on city infrastructure, officeholders, interesting tidbits, and other useful material. Jean read an early draft of each chapter, giving it the benefit of her familiarity with facts and sources as well as her editorial acuity. Dr. Gregory A. Stiverson, a scholar well known in Annapolis for his oversight of historical events and organizations, also read early drafts and offered critical advice that clarified my thoughts and presentation.

Members of the Annapolis History Consortium have followed this book from its inception, offering information and encouragement without stint. You will see them credited in the notes for published and manuscript sources, formal and informal interviews, research assistance, and personal communications beyond count. I need to give special appreciation to a few, hoping the rest will understand that space constraints preclude naming everyone: Robert Worden, administrator of the consortium list, which has grown over the years to more than one hundred names, and gracious contributor of fact and advice; Emily Peake, faithful source for specifics of Annapolis people and places in the nineteenth and early twentieth centuries; Janice Hayes-Williams, my guide to the city's African-American population; Michael Parker, who has informed my research with his own work on city topics and people; Glenn E. Campbell, senior historian at Historic Annapolis Foundation, whose research into twentieth-century preservation attempts rivals his work on colonial topics; James W. Cheevers, whose knowledge of the United States Naval Academy is at the same time both broad and incredibly minute; naval historian John F. Wing, who offered fascinating tidbits from his recent work in colonial port records; and Richard E. Israel, whose legal mind illuminated murky laws and whose stories highlighted people of past times. These experts are among the authors of sidebars featuring notable people and topics. I am grateful to them all, as I am to Anthony D. Lindauer, land historian and expert in early Annapolis, who graciously shared his groundbreaking finds, and to scholar C. Ashley Ellefson, expert in Maryland's early legal history, who kindly discussed with me his thoughts on the city charter, and to Shirley V. Baltz, whose collections at the Maryland State Archives are the result of her many years of careful research.

Funding for the "Annapolis History Bibliography" and subsequent "Annapolis History Chronology," with which I began the book project in 1999 and 2000, came from the Historic Preservation Commission of the City of Annapolis and from a Millennium Grant of the Maryland Commission for the Celebration of 2000, designated by the steering committee of the nascent Annapolis, London Town, South County Heritage Area and administered by the Annapolis and Anne Arundel County Conference and Visitors Bureau. Recognition of the contributors to the bibliography appears in the acknowledgments of that work. Both the bibliography and the chronology will be available electronically in the future.

The book itself received major funding from the Maryland Historical Trust through grants to the City of Annapolis, the Annapolis, London Town, South County Heritage Area, now termed the Four Rivers Heritage Area, and the Annapolis Maritime Museum. Throughout the project, Nicole Diehlmann, chief of the Maryland Historical Trust Office of Planning and Museum Programs, and Marcia Miller, administrator of Research and Survey in MHT's Office of Research, Survey, and Registration, have represented the Trust in oversight of the progress and direction of the manuscript. Joining them in guiding the project were Donna Hole, now retired chief of historic preservation for the city, Donna Ware, former historic sites surveyor for Anne Arundel County and now executive director of Historic London Town House and Gardens, Karen Engelke and Donna Dudley, successive executive directors of the heritage area, and Heather Ersts, former curator of the Annapolis Maritime Museum. I am indebted to all of these women, whose encouragement, good advice, and commitment to the project have been of inestimable value. My appreciation is due also to Orlando Ridout V, chief of the Office of Research, Survey, and Registration at the MHT, to Peggy Wall, former president and CEO of the Annapolis and Anne Arundel County Conference and Visitors Bureau, to Patricia Barland, chair, and the rest of the Executive Committee of the Four Rivers Heritage Area, and to Jeff Holland, executive director, and the Board of Directors of the Annapolis Maritime Museum for their support of the project.

Among those who gave me formal interviews were Richard Callahan, Richard Franke, Edward Hartman, Al Luckenbach, Roger "Pip" Moyer, the late France America Pindell, Norman Randall, Joseph "Zastrow" Simms, and Alice Wright. I did informal interviews routinely by telephone and email, over coffee, or while standing in the aisle of the grocery store, with old friends and acquaintances and with knowledgeable people from every section of the city. Isabel Shipley Cunningham, David S. Hanner, Fred Hecklinger, David Hildebrand, Madeleine Hughes, Bill Mueller, Matthew Palus, Albert Johnson, Rock Toews, Tom Worthington, and many others gave their time and, often, the products of their own research to this project. All of them have a stake in this book, and I want to acknowledge their help.

I am indebted to Historic Annapolis Foundation for giving me access to interviews conducted in 2002 and 2003 by Matthew Palus under a grant from the Maryland Historical Trust. I want to extend appreciation also to the subjects of those interviews who have allowed me to quote them. I also appreciate the generosity of the Annapolis Maritime Museum board, who allowed me to use materials prepared for the museum by C. Jane Cox and members of the county's Lost Towns Project.

An investigation of Annapolis records must begin at the Maryland State Archives, which holds original records dating from the seventeenth century. Dr. Papenfuse and his staff, whether in administration, archiving, conservation, records management, or information technology, have been unfailingly helpful. A decade of archivists and archival assistants

under the Search Room direction, successively, of Patricia Melville, R. J. Rockefeller, and Michael McCormick is too long a list to recount, but the fact that they have almost always greeted me with a smile indicates their professional attitude toward the challenging patron. Assistance from MSA research staff, especially Jen Hafner, Emily Oland Squires, and Alexander Lourie, has been important to the book. The archives maintains one of the country's premier online sites for historical resources, a boon to researchers anywhere at any time. I am thankful for it.

Another important repository of records useful for Annapolis history is the Maryland State Law Library, which includes rare books, federal documents, a complete set of Maryland laws, and a fine collection of pamphlets in addition to more general historical and legal texts. Former state librarian Michael Miller and current library director Steven P. Anderson manage a knowledgeable and accommodating staff. Again, over a decade of research, I have been helped by too many pleasant librarians to list; I hope they each know my appreciation is heartfelt.

Annapolis is fortunate to be a small city with two important colleges. The U.S. Naval Academy boasts a first rank academic library, and I appreciate the privilege of its stacks and microfilm collection. The Nimitz Library Special Collection and Archives contains materials essential to local history as well as to naval and academy history. The current archivist, Jennifer Bryan, has been happy to share her knowledge and collections, as was her predecessor, the late Gary Lavally. While more specialized, the St. John's College Library holds interesting sources not readily available elsewhere. The Anne Arundel County Public Library is a treasure of both collection and staff. At the West Street branch, the Maryland Gold Star Collection includes valuable books long out of print, the perennial delight of local historians. Materials not on the county system's shelves can be ordered through a statewide network of public and private libraries and even libraries farther afield. Librarians at the Annapolis and Eastport branches have fielded every request I've made over the years, no matter how arcane.

For more recent details of city government, demographics, housing, preservation, infrastructure, and other topics, the City of Annapolis departments of Planning and Zoning, Historic Preservation, and Public Works were important sources of information. Theresa Wellman, Jackie Rouse, and Virginia Burke were among those who opened their files to me. Former historic preservation chiefs Donna Hole and Patricia Blick answered questions graciously and provided written materials. Engineers Sam Brice and Paul Lackey, waterworks assistant superintendent James Bolitho, transportation director Danielle Matland, Recreation and Parks former director Richard Callahan, and current director LeeAnn Plumer responded to my queries with patience and interest. Former mayors Ellen Moyer and Dean Johnson and various aldermen and -women have been strong supporters of the project.

Nearby, in Baltimore, the manuscript collection, library, and exhibits of the Maryland Historical Society all revealed important information. Librarian Francis O'Neill is himself a valued resource for materials on specific topics. Enoch Pratt Free Library's Maryland Department contains not only a wonderful collection of books and periodicals but also vertical files of clippings to illuminate long-forgotten persons, places, and events. At other times I consulted the collections of the Museum of Industry, Baltimore Museum of Art, Maryland Geological Survey, and the Sheridan Libraries at the Johns Hopkins University.

In the Washington area I received welcome assistance from the staffs of the National Archives branches downtown, at College Park, and at Suitland, the Library of Congress,

the National Agricultural Library in Beltsville, the Naval Historical Center, and, most important, the University of Maryland Hornbake Library's Marylandia Department.

Readers of citations will find references to people as far away as Nova Scotia who answered questions or sent published materials for project files. I appreciate their willingness to reflect on their particular area's role in Annapolis history.

Friends and colleagues who took on specific research tasks include Patricia Holland, who gathered and inventoried sources for the bibliography; Constance Neale, who abstracted city ordinances and then read reels of microfilmed school board minutes to prepare a chronology of public education in the county; Carolyn Bialousz, whose technical skills include the ability to read my handwriting; Lynne MacAdam, who aimed her research skills at specific targets and then developed and worked with the illustration inventory; David Haight, a new resident of the city, who didn't let unfamiliar local resources stop him from tracking answers to obscure questions; Rhea Clagett, who did her best to keep me on task; and Joel Fauson, Esq., formerly of Patton Boggs, whose careful legal counsel guided difficult decisions. I appreciate each contribution to the project.

The tragic consequence of taking so long to finish this project is that some of the people who helped it along did not live to hold a book in their hands. I want to acknowledge with regret for their loss Jack Kelbaugh, who sent me folders of clippings he knew I would want; Stephen Patrick of the City of Bowie Museums, whose delight in the Belair Mansion and its history was contagious; Peg Wallace, of the Annapolis Maritime Museum, who loaned me valuable materials and recounted her experiences as a real estate agent in Annapolis in the 1970s. Stanley L. Quick shared his research on the naval history of the War of 1812, and Marion Warren told me his best stories in an interview I taped shortly before his final illness. My interview with Beth Whaley, actor and arts advocate, gave me a first-hand look at the development of performing, musical, and visual arts organizations we take for granted today. Jack Ladd Carr's memories of Annapolis in the 1960s and 1970s were especially important to my understanding of urban renewal. Each time I saw him, he told me to hurry up and finish this book. I am so sorry it took too long for him and so many others.

I am fortunate to count among my friends thoughtful editors such as Carol Patterson and Ann Jensen. Carol was the first reader of each chapter, and her excitement as the story developed pushed me onward. No one should have to read a manuscript of this length more than once; Carol read the whole thing three times, and parts of it more, and remained enthusiastic. Ann applied her ability to a later draft, as did Ann Hofstra Grogg, and their critiques yielded comments valid and practical that directed my revisions.

Over the years, the manuscript has been reviewed in whole or in part by any number of people. Among them were all of the scholars and editors named above joined by Shirley Baltz, Rhea Clagett, Ann Cobb, Dick Cobb, Donna Dudley, William S. Dudley, Heather Ersts, Donald Farrell, Donna Hole, Al Luckenbach, Will Mumford, Noel Patterson, Elizabeth Stewart, and Mame Warren. Marcia Miller and Orlando Ridout V, of the Maryland Historical Trust, made invaluable catches and criticisms on my final manuscript. Whether expert or interested general reader, their comments have made this a better book, and I appreciate their time and thoughtful consideration.

When I began collecting images to illustrate the book, I turned to large repositories such as the Maryland State Archives, the Maryland Historical Society, the Special Collections and Archives at Nimitz Library at the USNA, the Mariners' Museum in Newport News, Virginia, and other institutions. Their staffs were universally helpful, but I must mention particularly my debt to Rob Schoeberlein and Maria Day at the state archives, who pa-

tiently coordinated my requests from Special Collections and the Maryland Commission on Artistic Properties. Images from private collections allow this book to reflect the city as a whole. Among the individuals who loaned me their photographs or drawings were Elizabeth Leanos Alexopulos, Randall W. Bannister, Barbara Britton Baxter, Samuel McL. Brice, Beatrice Martin Buchheister, Peg Burroughs, Charles W. Cadle, Jr., Lynette Almen Engelke, Michael Fitzpatrick, Julia Gay, Jonathan William Green, Holly Hammer Hagelin, Patrick Hornberger, Kenneth Kimble, Al Luckenbach, William J. McWilliams, Jr., Willard Mumford, Edward C. Papenfuse, Michael Parker, Emily Holland Peake, Alice M. Randall, Beatrice Backer Simpson, Eric Smith, Lemuel K. Taylor IV, Robin Taylor, Beverly Davis Valcovic, Donna Ware, Betty Whalen, Dick Whaley, the late Donald Williams, William Wilson, John Wing, and Robert Worden. I just wish that every wonderful image could be in the book. Glenn Campbell, Jean Russo, and Jennifer Orrigo at Historic Annapolis Foundation; Alice Wright of the Community Health Center at Parole; Lisa Mason-Chaney of the Hammond-Harwood House; Janis Jorgensen of the U.S. Naval Institute; Ann Jensen and Kelley Bond of the Sands House Foundation; and Cara Sabolcik of St. John's College found images that would enhance the book. Mame Warren and Joanie Surette generously allowed me to use a great many original photographs by Marion Warren as well as his copies of historic images. Any Annapolis book with illustrations must include Warren's work, and I want to thank Mame and Joanie for this privilege. Tony Lindauer generously allowed me to use his maps to illustrate colonial land use on the Annapolis peninsula, Peg Udall kindly contributed her graphic ability and advice, and Rhea Claggett and Mame worked with me to identify the most appropriate illustrations from the almost seven hundred in the inventory. For the technical work of preparing images from individuals and helping me collate all the art for the book, I relied on Richard Speaks of Annapolis Prepress, whose skill and patience made this part of the process a pleasure. With unflappable grace Rick and his colleague Ann Sarber found solutions to tricky last minute problems. At each stage of the project, Jim Martin and his associates at FreeState Press printed chapters or manuscript with unfailing cheerfulness and expertise. I am deeply indebted to Lynne MacAdam, who not only created tables of statistics but also applied her expertise and patience to proofreading copy and, finally, to compiling the index.

I am grateful to my daughter Penney McWilliams Koeppen for scientific assistance and to my son Garrett McWilliams for technical advice. To them both, as to the rest of my family and my dear and faithful friends, I extend my sincere appreciation for their love and patience and optimistic support during the years of this project.

At the Johns Hopkins University Press, editor Robert J. Brugger offered guidance and encouragement, and designer Richard Hendel made this a beautiful book. My thanks to them both.

Readers and editors have done their best to avert errors of fact and message. I bear final responsibility for what I have written.

Appendix 1 Census Tables

TABLE 1. Population of Annapolis, 1800 to 1840

Census	1800	1810	1820	1830[1]	1840
Total Annapolis population	**2,213**	**2,188**	**2,292**	**2,623**	**2,792**
White	1,294	1,296	1,374	1,587	1,707
Black	919	892	917	1,036	1,085
Black population					
Free	273	328	391	458	586
Slave	646	564	526	578	499
Number of households	288	289	327	363	399
White heads of household	246	231	255	263	298
Free black heads of household	40	57	71	93	98
Slave heads of household	2	1	0	7	3
Total AA Co. population	**22,623**	**26,668**	**27,165**	**28,295**	**29,532**
Total Md. population	**341,548**	**380,546**	**407,350**	**447,040**	**470,019**

Sources: Jean Russo, analysis of 1800–1820 Annapolis census schedules; author's analysis of 1830–1840 Annapolis census schedules; Maryland Office of Planning, *Census 2000* (brochure, 2000).

[1] Figures for this year include residents of Fort Severn.

TABLE 2. Population of Annapolis, 1850 to 1870

Census	1850[1]	1860[2]	1870
Total Annapolis population	**3,011**	**4,529**	**5,744**
White	1,826	3,228	3,882
Black	1,185	1,301	1,862
Black population			
Free	533	826	1,862
Slave	652	475	
Number of households	455		
White heads of household	336		
Free black and slave heads of household	119		
Total AA Co. population[3]	**32,393**	**23,900**	**24,457**
Total Md. population	**583,034**	**687,049**	**780,894**

Sources: Author's analysis of 1850 Annapolis population schedule; *Population of the United States in 1860* (Washington, D.C.: Government Printing Office, 1864) 1: 214; *Statistics of the Population of the United States . . . Ninth Census* (Washington, D.C.: Government Printing Office, 1872) 1: 163, 645; Maryland Office of Planning, *Census 2000* (brochure, 2000).

[1] The 1850 census schedules are unreliable. The slave list includes 43 manumitted slaves and 3 fugitives no longer in the state. Owners of at least 70 slaves almost certainly lived outside the city.

[2] The figures for 1860 include midshipmen and others living on the grounds of the USNA; 1850 and 1870 figures do not include the academy.

[3] Howard County was broken out of Anne Arundel by the Maryland Constitution of 1851.

TABLE 3. Population of Annapolis, 1870 to 1900

Census	1870	1880	1890	1900
Total Annapolis population	**5,744**	**6,642**	**7,604**	**8,525**[1]
White	3,882	4,096	4,685	5,512
Black	1,862	2,546	2,914	3,002
Chinese			2	
Japanese			2	11[2]
"Civilized Indian"			1	
Native born	5,238	6,235	7,142	8,047
Foreign born	506	407	462	478
Percentage foreign born	9	6	6	6
Males	3,066		3,907	4,450
Females	2,678		3,697	4,075
Ward 1			3,060	3,580
Ward 2			1,989	2,369
Ward 3			2,555	2,453
AA Co. population	**24,457**	**28,526**	**34,094**	**39,620**[1]
White	12,725	14,649	19,580	24,236
Black	11,732	13,877	14,509	15,367
Native born	23,562	27,696	31,169	35,748
Foreign born	895	830	2,925	3,872
Percentage foreign born	4	3	9	10
Total Md. population	**780,894**	**934,943**	**1,042,390**	**1,190,050**

Sources: Statistics of the Population of the United States . . . Ninth Census (Washington, D.C.: Government Printing Office, 1872) 1: 163, 312, 629, 645; *Statistics of the Population of the United States at the Tenth Census* (Washington, D.C.: Government Printing Office, 1883), 64, 419, 450, 513; *Report on the Population of the United States at the Eleventh Census* (Washington, D.C.: Government Printing Office, 1895) 1: 176, 415, 460, 767, 799; *Twelfth Census of the United States, Census Bulletin* 28, Washington, D.C., 3 Jan. 1901, 1–3; *Twelfth Census of the United States, Census Bulletin* 78, Washington, D.C., 30 July 1901, 5, 7.

[1] These figures are as calculated. *Census Bulletin* 28 shows Anne Arundel County population as 40,018 and Annapolis as 8,402. However, the more detailed figures given in *Bulletin* 78 add up to the totals shown here.
[2] This figure is a composite of persons designated as "colored" but not "Negro"; no racial specifics are given in the source.

TABLE 4. Population of Annapolis, 1910 to 1940

Census	1910	1920	1930	1940
Total Annapolis population	**8,609**	**11,214**	**12,531**	**13,069**
Within city bounds[1]	8,262	8,518	9,803	9,812
On USNA grounds[1]	347	2,696	2,728	3,257
White	5,408	8,252	9,125	9,206
Black	3,184	2,954	3,218	3,792
Other races	17	8	188	71
Native born (white)	4,951	7,819	8,648	8,774
Foreign born (white)	457	433	477	432
Males	4,308	6,635	7,231	7,536
Females	4,301	4,579	5,300	5,533
Ward 1[1]	2,173	5,035	4,916	5,153
Ward 2	2,431	2,260	2,403	2,484
Ward 3	4,005	2,174	3,160	3,396
Ward 4		1,745	2,052	2,036
AA Co. population	**39,553**	**43,408**	**55,167**	**68,375**
White	25,396	29,986	40,040	50,524
Black	14,136	13,411	14,927	17,763
Other races	21	11	200	88
District 2[2]	5,437	6,489	8,885	13,168
White			6,057	9,123
Black			2,828	4,036
Total Md. population	**1,295,346**	**1,449,661**	**1,631,526**	**1,821,244**

Sources: Thirteenth Census of the United States, Taken in the Year 1910, vol. 2, Population 1910 (Washington, D.C.: Government Printing Office, 1913), 824, 830, 849; Annapolis Planning Department, *Comprehensive Plan* (1985), figure A-2; *Fourteenth Census of the United States, State Compendium, Maryland* (Washington, D.C.: Government Printing Office, 1924), 7, 8, 11, 14–15, 21–22, 25; *Fifteenth Census of the United States 1930,* (Washington, D.C.: Government Printing Office, 1931), vol. 1 485–486, 488, 491, vol. 3, part 1 (1932), 1059, 1066; *Sixteenth Census of the United States 1940,* (Washington, D.C.: Government Printing Office, 1942), vol. 1, 463–465, 468, vol. 2, part 3 (1943), 536, 555, 565 (corrected as per *Census of Population 1950,* vol. 2, part 20).

[1] Total population figures for Annapolis for 1910–1940 included personnel at the U.S. Naval Academy as part of Ward 1, although the academy is outside city boundaries. Separate figures for residents of the city and the USNA were given in the Annapolis Planning Department's *Comprehensive Plan* (1985), figure A-2.

[2] District 2 lay outside the boundary of Annapolis (which was District 6) and included the peninsula between the Severn and South Rivers west to Route 3 and south along the Patuxent River to Governor's Bridge.

TABLE 5. Population of Annapolis, 1940 to 1980

Census	1940	1950[1]	1960[2]	1970	1980
Total Annapolis population	**13,069**		**28,006**	**35,582**	**37,107**
Within city bounds	9,812	10,047	23,385	30,095	31,740
On USNA grounds	3,257		4,621	5,487	5,367
White	9,206	6,400	15,963	20,925	20,021
Black	3,792	3,629	7,316	8,871	11,250
Other races	71	18	47	54	97
Asian and Pacific Islanders			58	245	372
Spanish origin (any race)			232	345	413
Males	7,536	4,805	11,130	14,052	14,666
Females	5,533	5,242	12,255	16,043	17,074
Ward 1[1]	5,153	1,868			
Ward 2	2,484	2,271			
Ward 3	3,396	3,250			
Ward 4	2,036	2,658			
Total AA Co. population	**68,375**	**117,392**	**206,634**	**297,539**	**370,775**
District 2	13,168	24,212			
Total Maryland population	**1,821,244**	**2,343,001**	**3,100,689**	**3,922,399**	**4,216,975**

Sources: Sixteenth Census of the United States: 1940, Population, vol. 2, part 3 (Washington, D.C.: Government Printing Office, 1943), 536, 555, 565 (corrected as per *Census of Population: 1950,* vol. 2, part 20); Annapolis Planning Department, *Comprehensive Plan* (1985), figure A-2; *Census of Population: 1950,* vol. 2, part 20 (Washington, D.C.: Government Printing Office, 1952), 9, 12, 19–20, 39, 41; Alexander D. Speer, "Annapolis City Demographics," 1960–2020 (Anne Arundel County Department of Planning and Code Enforcement, 1996); Maryland Office of Planning, *Census 2000* (brochure, 2000); *Evening Capital,* 23 May 1950.

[1] The federal 1950 census summaries did not give the population of the U.S. Naval Academy, and all categories apply only to city residents. For the following years, data taken from Speer's "Annapolis City Demographics" also do not include the USNA population.

[2] On 1 January 1951, the city annexed 4.8 square miles of adjoining county land with almost 10,000 residents. The city population in 1960 reflected this annexation as well as natural increase and in-migration.

TABLE 6. Population of Annapolis, 1980 to 2000

Census	1980	1990	2000
Total Annapolis population	**37,107**	**38,633**	**40,102**
Within city bounds[1]	31,740	33,187	35,838
On USNA grounds	5,367	5,446	4,264
White	20,021	21,552	22,457
African American	11,250	10,964	11,267
Asian and Pacific Islanders	372	445	661
Other races	97	226	856
Two or more races			597
Spanish origin (any race)	413	483	2,301
Males	14,666	15,417	16,975
Females	17,074	17,770	18,863
Total AA Co. population	**370,775**	**427,239**	**489,656**
Total Md. population	**4,216,975**	**4,780,753**	**5,296,486**

Sources: Alexander D. Speer, "Annapolis City Demographics," 1960–2020 (Anne Arundel County Department of Planning and Code Enforcement, 1996); "Census 2000, Summary Files 1 & 3, Demographic, Social, Economic, and Housing Characteristics" (City of Annapolis Department of Planning and Zoning); Maryland Office of Planning, *Census 2000* (brochure, 2000).

[1] Except for the USNA population and the total Annapolis population, all figures apply only to residents within the city boundaries and do not include data from the Naval Academy.

Appendix 2 Cemeteries in and around Annapolis

St. Anne's Cemetery, Northwest Street

When St. Anne's churchyard became overcrowded in 1790, Elizabeth Bordley gave land at the foot of Northwest Street to the people of Annapolis for a new burying ground. For many years it was called the City Cemetery. In the mid-nineteenth century, Judge Nicholas Brewer platted land east of St. Anne's Cemetery as a public burying ground called Locust Grove. At the end of the century, several local businessmen developed a new cemetery across Northwest Street, which they named Cedar Bluff. Both Locust Grove and Cedar Bluff have been incorporated into St. Anne's Cemetery.

St. Mary's Cemetery, Spa Road and West Street

Four parcels of land, acquired by the Redemptorists between 1858 and 1901, compose the almost four-acre burying ground for parishioners of St. Mary's Catholic Church. A part of the property had once been a garden and orchard owned by the same Judge Brewer who established Locust Grove.

Annapolis National Cemetery, West Street and Taylor Avenue

Beginning in 1862, the federal government leased a series of parcels of land from Judge Nicholas Brewer to be used as a burying ground for military personnel who died in Annapolis Civil War hospitals and parole camps. Totaling just over four acres, the land was deeded to the United States in 1871. More than 2,500 of the almost 3,000 graves date from the Civil War. The vast majority of the dead were Union soldiers and sailors, but the interments also included a few Confederates, three nurses from local military hospitals, and one Russian seaman who was killed in town. The cemetery is administered by the U.S. Department of Veterans Affairs.

John Wesley Annapolis Neck Cemetery, Old Annapolis Neck Road

This cemetery dates from sometime after the construction of the first John Wesley United Methodist Church near this site in 1879. The burial ground remained in place after the present church, on the corner of Bay Ridge and Forest Hills Avenues, was built in 1934.

Brewer Hill Cemetery, West Street

In 1884, eleven men of Mt. Moriah A.M.E Church incorporated the People's Brewer Hill Cemetery and contracted to buy four and a half acres of land from Nicholas Brewer III, son of Judge Brewer. Burials in the cemetery dated from even earlier than 1884. Earlier uses of the land in and around Brewer Hill Cemetery and the adjacent National Cemetery included a Revolutionary War military hospital, the county poorhouse, and small pox hospitals erected during outbreaks of the disease in the eighteenth and nineteenth centuries. Patients or paupers who died were often buried close by.

Asbury-Evergreen Cemetery, South Villa Avenue

Nine trustees from Asbury Methodist Episcopal Church bought two small parcels of land for a burial ground for members of their denomination in August 1884. This cemetery is sometimes called Old Sage Bottom for its location near the headwaters of Spa Creek.

Salem Cemetery, Annapolis Neck Road and Spa Road

This tiny cemetery is the last remnant of the Salem Methodist Episcopal Chapel. The cemetery is sometimes used today by descendants of families who lived in the Harness Creek and Aberdeen Creek area and attended the old chapel.

Fowler United Methodist Church Cemetery,
816 Bestgate Road

Located behind the Fowler Church, this traditional African-American cemetery dates from shortly after the establishment of the congregation in 1871.

Luther A. Palmer Memorial Cemetery, West Street and
Riva Road

The few graves that remain in the triangle of this intersection date from 1897 and were connected with the Edwards Chapel United Methodist Church, which once stood nearby. When commercial development changed the neighborhood, the congregation sold the church property and, in 1983, built St. Andrew's United Methodist Church in Gingerville.

Luce Creek Cemetery, Ridgely Avenue and Bestgate
Road

Located on property now owned by the Evangelical Presbyterian Church, this cemetery is also known as the Wellsview Methodist Episcopal Church Cemetery. A marker memorializes persons buried in unmarked graves from 1895.

Congregation Kneseth Israel Cemetery, Defense
Highway (Md. Route 450)

Dedicated in 1932, this is the only Jewish cemetery in the area. Because Jewish law forbids the casual disposal of any book containing God's name, there is a special section for the burial of prayer books.

St. Demetrios Greek Orthodox Cemetery, Riva Road

This cemetery dates from 1950 and in the early years was also known as St. James Cemetery. The only Greek Orthodox cemetery in Anne Arundel County, it is under the care of Ss. Constantine and Helen Greek Orthodox Church, which is located farther down Riva Road.

Hillcrest Memorial Gardens, Forest Drive

Established in 1952 as a nonsectarian burying ground, this twenty-three-acre, modern cemetery relieved pressure on the older cemeteries. It contains a chapel mausoleum, columbarium, and a special Jewish Garden. A pet cemetery adjoins the grounds.

Bestgate Memorial Park and Chapel, 814 Bestgate Road

Known also as Annapolis Memorial Gardens and, before that, as Pinelawn Cemetery, this large burial ground dates from the early 1960s and seems to have been associated for most of its existence with a funeral home or chapel.

EMILY HOLLAND PEAKE
Historian, St. Anne's Cemetery

Notes

Abbreviations

AA BE	Anne Arundel County Board of Education
AA CCT	Anne Arundel County Circuit Court
AA CT	Anne Arundel County Court
AALR	Anne Arundel County Court Land Records
AN MA	Annapolis Mayor and Aldermen
AN MAC	Annapolis Mayor, Aldermen, and Councilmen
AN MCT	Annapolis Mayor's Court
AOMOL	*Archives of Maryland Online*, an online publication series of the Maryland State Archives, http://aomol.net/html/index.html, cited by volume and page.
BDML	*A Biographical Dictionary of the Maryland Legislature, 1635–1789*, by Edward C. Papenfuse, Alan F. Day, David W. Jordan, and Gregory A. Stiverson, 2 vols. (Baltimore: Johns Hopkins University Press, 1979, 1985).
book files	Research files for this book, deposited in Maryland State Archives Special Collections
CHAN CT	Chancery Court
f.	folio
HAF	Historic Annapolis Foundation
L.	Liber
Laws of Maryland	These are available in printed volumes and online through the *Archives of Maryland Online* at http://aomol.net/html/index.html
LD OFF	Land Office
"Lot Histories"	Edward C. Papenfuse and Jane W. McWilliams, "Appendix F: Lot Histories and Maps," final report, "Southern Urban Society After the Revolution: Annapolis, Maryland, 1782–1784," National Endowment for the Humanities Grant H 69-0-178 [MSA SC 829-B1]
MA	William Hand Browne et al., eds., *Archives of Maryland*, 72 vols. (Baltimore: Maryland Historical Society, 1883–1972)
MHM	*Maryland Historical Magazine*
MSA	Maryland State Archives
MSA SC	Maryland State Archives Special Collections
MHS	Maryland Historical Society, Baltimore
NARA RG	National Archives and Records Administration, Record Group
UMD	University of Maryland

Chapter 1. Out of the Wilderness, a Town, 1649 to 1708

1. Donald W. Pritchard and Jerry R. Schubel, "Human Influences on the Physical Characteristics of the Chesapeake Bay," in Philip D. Curtin, Grace S. Brush, and George W. Fisher, eds., *Discovering the Chesapeake: The History of an Ecosystem* (Baltimore: Johns Hopkins University Press, 2001), 60–70; Carville V. Earle, *The Evolution of a Tidewater Settlement System: All Hallow's Parish, Maryland 1650-1783* (Chicago: Department of Geography Research Paper No. 170, University of Chicago, 1975), 19–23, 30–33; Anthony D. Lindauer, *From Paths to Plats: The Development of Annapolis, 1651 to 1718* (Annapolis: Studies in Local History, Maryland State Archives and Maryland Historical Trust, 1997), 4–5; John Smith, *General History of Virginia*, vol. 1, chap. 5, quoted in J. Thomas Scharf, *History of Maryland* (1879; reprint, Hatboro, Pa.: Tradition Press, 1967) 1: 7; Daniel Higman, "Ah, Wilderness! Part I, Vegetation of the Presettlement Forest," *Anne Arundel*

County History Notes 37 (July 2006): 6–9; Timothy Silver, "A Useful Arcadia: European Colonists as Biotic Factors in Chesapeake Forests," in Curtin et al., *Discovering the Chesapeake*, 151–152. Lindauer (p. 5) notes specific trees mentioned in early boundary surveys of present-day Annapolis: "red and white oaks, mulberry trees, pines, poplars, chestnuts and cedars."

2. Robert J. Brugger, *Maryland, A Middle Temperament, 1634–1980* (Baltimore: Johns Hopkins University Press and Maryland Historical Society, 1988), 3; Suzanne Ellery Green Chapelle, Jean H. Baker, Dean R. Esslinger, Whitman H. Ridgway, Jean B. Russo, Constance B. Schulz, and Gregory A. Stiverson, *Maryland, A History of Its People* (Baltimore: Johns Hopkins University Press, 1986), 9; Silver, "A Useful Arcadia," 153; David W. Steadman, "A Long-Term History of Terrestrial Birds and Mammals in the Chesapeake-Susquehanna Watershed," in Curtin et al., *Discovering the Chesapeake*, 101; Michael G. Kammen, ed., "Maryland in 1699: A Letter from the Reverend Hugh Jones," *Journal of Southern History* 29 (1963): 369.

3. Donna M. Ware, *Anne Arundel's Legacy* (Annapolis: Anne Arundel County, 1990), 127–129; Al Luckenbach, interview, 1 Dec. 2005, personal communication, 25 Apr. 2006; Henry Miller, "Living along the 'Great Shellfish Bay,'" in Curtin et al., *Discovering the Chesapeake*, 113–117.

4. Brugger, *Maryland, A Middle Temperament*, 10; Luckenbach, interview; Chapelle et al., *Maryland, A History of Its People*, 11–12; Edward C. Papenfuse and Joseph M. Coale III, *The Maryland State Archives Atlas of Historical Maps of Maryland, 1608–1908* (Baltimore: Johns Hopkins University Press, 2003), 1–3.

5. Scharf, *History of Maryland* 1: 24–51; Brugger, *Maryland, A Middle Temperament*, 3–5; Aubrey C. Land, *Colonial Maryland, A History* (Millwood, N.Y.: KTO Press, 1981), 4–5; John D. Krugler, *English and Catholic: The Lords Baltimore in the Seventeenth Century* (Baltimore: Johns Hopkins University Press, 2004), 6–10, 71–72, 104–108.

6. *The Charter of Maryland, June 20, 1632* (Annapolis: Maryland Hall of Records Commission, Department of General Services, 1982), with introduction by Edward C. Papenfuse.

7. Timothy B. Riordan, *The Plundering Time: Maryland and the English Civil War, 1645–1646* (Baltimore: Johns Hopkins University Press, 2008), 3–6; Krugler, *English and Catholic*, 6–7, 119–133. Quotation from Krugler, 6–7.

8. Al Luckenbach, *Providence 1649: The History and Archaeology of Anne Arundel County, Maryland's First European Settlement* (Annapolis: Studies in Local History, Maryland State Archives and Maryland Historical Trust, 1995), 2–3.

9. *BDML* 1: 190 (Leonard Calvert), 1: 373 (Thomas Greene), 2: 788 (William Stone); *MA* 3: 201–209; James Horn, *Adapting to a New World, English Society in the Seventeenth-Century Chesapeake* (Chapel Hill: University of North Carolina Press for the Institute of Early American History and Culture, Williamsburg, Va., 1994), 56; *Encyclopedia Britannica*, 15th ed., 3:

244–246; Clayton Colman Hall, *Narratives of Early Maryland, 1633–1684* (New York: Charles Scribner's Sons, 1910); Leonard Strong, "Babylon's Fall in Maryland" (1655), in Hall, *Narratives*, 235–236.

10. *MA* 1: 244–247; Brugger, *Maryland, A Middle Temperament*, 20–21. Quotations from *MA* 1: 244–245.

11. *MA* 3: 223–228, 231–237. In 1651, Cecelius Calvert reduced the amount of land for each person transported back to fifty acres (*MA* 1: 327–331). Although he did not give it as a reason, by that time some of the new settlers had begun to agitate against his government. Calvert quote from *MA* 3: 231. For details on Maryland's colonial land grant system, see Elisabeth Hartsook and Gust Skordas, *Land Office and Prerogative Court Records of Colonial Maryland* (Annapolis: Maryland Hall of Records Commission, 1946 [*AOMOL* 415]); or John Kilty, *The Land-Holder's Assistant and Land-Office Guide* (Baltimore: G. Dobbin & Murphy, 1808 [*AOMOL* 73]).

12. Horn, *Adapting to a New World*, 382–392, 167 (map).

13. Sargent Bush, Jr., ed., *The Correspondence of John Cotton* (Chapel Hill: University of North Carolina Press for Omohundro Institute of Early American History and Culture, Williamsburg, Va., 2001), 11–13.

14. Alice Granbery Walter, *Lower Norfolk County, Virginia Court Records, Book "B," 1646–1651/2,* (reprint, Baltimore: Genealogical Publishing for Clearfield Company, 1994, 1995), 113, 115; Horn, *Adapting to a New World*, 392; Riordan, *The Plundering Time*, 11, 17, 20, 294–295.

15. Donna Valley Russell, *First Families of Anne Arundel County, Maryland, 1649–1658*, 2 vols. (New Market, Md.: Catoctin Press, 1999, 2002).

16. *MA* 1: 369–371; Strong, "Babylon's Fall in Maryland," in Hall, *Narratives*, 235. Quotation from Strong.

17. Quotation from Brugger, *Maryland, A Middle Temperament*, 22.

18. Earle, *Evolution of a Tidewater Settlement System*, 24–25. Quotation on 25. Oronoco tobacco was a coarser variety with a stronger flavor than the sweet-scented tobacco grown in just a few specific areas of Virginia. While oronoco generally sold in England for less than sweet-scented, it was popular in Europe (Arthur Pierce Middleton, *Tobacco Coast, A Maritime History of the Chesapeake Bay in the Colonial Era* [Newport News, Va.: Mariners' Museum, 1953], 97–98).

19. See also Alan Taylor, *American Colonies* (New York: Viking Penguin, 2001), 130, 165; Nancy T. Baker, "Annapolis, Maryland, 1695–1730," *MHM* 81 (1986): 191; Lorena S. Walsh, "The Chesapeake Slave Trade: Regional Patterns, African Origins, and Some Implications," *William and Mary Quarterly*, 3rd ser., 58, no. 1 (Jan. 2001): 146; John Hammond, "Leah and Rachel, or, the Two Fruitful Sisters Virginia and Maryland," in Hall, *Narratives*, 304. Quotation from Hammond.

20. Lois Green Carr, Russell R. Menard, Lorena S. Walsh, *Robert Cole's World: Agriculture and Society in Early Maryland*

(Chapel Hill: University of North Carolina Press for the Institute of Early American History and Culture, 1991), 18.

21. Russell, *First Families*, 2: xxii–xxiii. Statistics are based on author's analysis of Russell's biographies and Tony Lindauer, "Early Plantations of Anne Arundel County" (typescript, 2006, in book files).

22. Chapelle et al., *Maryland, A History of Its People*, 14, 21.

23. Providence is the principal topic of the following: B. Bernard Browne, "The Battle of the Severn, Its Antecedents and Consequences, 1651–1655," *MHM* 14 (1919): 154–171; David A. Gadsby, "17th Century Providence and the Politics of Settlement; Religion, Power, and Place in Early Maryland" (unpublished typescript, 2004; see also David A. Gadsby and Esther Doyle Read, "Providence, MD: Archaeology of a Puritan/Quaker Settlement near the Severn River," National Register of Historic Places Multiple Property Submission, 2005); Luckenbach, *Providence*; James E. Moss, *Providence: Ye Lost Towne at Severn in Maryland* (Washington D.C., privately printed, distributed by the Maryland Historical Society, 1976); Karina Paape, "From Nansemond to Providence: The Quest for Piety and Profit in the Seventeenth-Century Chesapeake" (M.A. thesis, UMD, 1997); Daniel R. Randall, "Puritan Colony in Maryland," *Johns Hopkins University Studies in Historical and Political Science*, vol. 4, collected in *Municipal and Land Tenure*, ed. Herbert B. Adams (Baltimore: Johns Hopkins Press, 1886); Daniel Richard Randall, "The Puritan Colony at Annapolis, Maryland" (Ph.D. diss., Johns Hopkins University, 1887); Russell, *First Families*. Most of these sources draw on the same primary materials, as does this account. We do not always agree on the interpretation of those materials.

24. *MA* 1: 292; Luckenbach, *Providence*, 1; Sebastian Ferris Streeter, *The Susquehannocks in Their Connections with the Colonies of Maryland, Delaware, and Pennsylvania, and with the Iroquois, and other aboriginal Tribes in Six Periods* (manuscript, 1857, MHS MS 1056), 208; *AOMOL* 41:319; LD OFF (Patent Record), L. 5, [MSA S11-8], 626; B. Everett Beavin to Maryland Historical Society, letter (not dated, but stamped as received 2 May 1946) giving coordinates for sites on Greenbury Point (I am indebted to Tony Lindauer for this source).

25. Tony Lindauer, tract map of Providence 2006 (unpublished); Luckenbach, *Providence 1649*, 1–6; LD OFF (Patent Record), L. Q, [MSA S11-6], fs. 385, 386; Russell, *First Families*, 1: 8, 91, 94, 96, 103, 107, 115; *BDML* 1: 129 (Bennett); Gadsby, "17th Century Providence," 6–10. "Mutual securerity" quote from (Patents) Q, f. 386; "hamlet" quote from Luckenbach, *Providence*, 5. Town Creek is known today as Carr's Creek. The references to a town, and the town lands taken up, may reflect the old use of those terms simply as a division of land (*The Compact Edition of the Oxford English Dictionary*, 1971), as Michael P. Parker suggests (personal communication, 6 Aug. 2007), or they may have been in response to a demand made by Lord Baltimore. Cecilius Calvert's instructions to the first wave of colonists in 1633

directed them to establish a town where "all the Planters" would live in adjoining houses on streets. It would have been logical for him to require the same of this second wave of colonists only a decade and a half later, especially since town creation remained for more than half a century a topic of continued exhortation by the Calverts and, later, the crown. At the present time, however, the town land system in seventeenth-century Anne Arundel County is not fully understood, and there are no extant instructions from Lord Baltimore to support this theory. (See Cecilius Calvert, "Instructions to the Colonists by Lord Baltimore, 1633," in Hall, *Narratives*, 21–22.)

26. Lorena Walsh, "Land Use, Settlement Patterns, and the Impact of European Agriculture, 1620–1820," in Curtin et al., eds., *Discovering the Chesapeake*, 220–222; Gadsby, "17th Century Providence," 34.

27. Lindauer, "Early Plantations," 1–5.

28. Lindauer, *From Paths to Plats*, 3–5; Russell, *First Families*, 1: 1, 60, 121; Tony Lindauer, personal communication, 3 Jan. 2006. The rest of Hall's 200-acre grant was a 180-acre parcel on Rhode River. Hall died in 1655; his son, Christopher, patented his father's 180-acre parcel in 1670 (Russell, *First Families*, 1: 60–61; AALR, L. WH 4, f. 306).

29. *BDML*, 1: 20.

30. *MA* 1: 292; Edward Bennett Mathews, *The Counties of Maryland, Their Origin, Boundaries, and Election Districts* (Baltimore: Maryland Geological Survey Reports, 1906; online at *AOMOL* 630: 421), *BDML* 1: 186 (Cecilius Calvert).

31. *MA* 3: 196, 223, 235, 257–258.

32. Hartsook and Skordas, *Land Office and Prerogative Court Records*, p. 3.

33. Edward C. Papenfuse, *"Doing Good to posterity"*: *The Move of the Capital of Maryland from St. Mary's City to Ann Arundell Towne, Now Called Annapolis* (Annapolis: Studies in Local History, Maryland State Archives and Maryland Historical Trust, 1995), 12–13.

34. *MA* 3: 264–265; *BDML* 1: 129 (Bennett), 221 (Claiborne). "Reduce" quoted from *MA* 3: 265.

35. *MA* 3: ix, 271–272, 275–276, Donnell M. Owings, *His Lordship's Patronage, Offices of Profit in Colonial Maryland* (Baltimore: Maryland Historical Society, 1953) and *AOMOL* 662:105. For Lord Baltimore's argument against this maneuver by Bennett and Claiborne, see "Lord Baltimore's Case, Concerning the Province of Maryland . . . And Certaine Reasons of State, why the Parliament should not impeach the same" (London, 1653), in Hall, *Narratives*, 167–179; Clayton Colman Hall, "Introduction" to "Virginia and Maryland, or the Lord Baltimore's Printed Case Uncased and Answered, 1655," in Hall, *Narratives*, 183–186. Quotations from *MA* 3: 275.

36. *MA* 3: 276–277. Quotation from 276.

37. *MA* 3: 277–278; Russell Shorto, *The Island at the Center of the World* (New York: Doubleday, 2004), 182. All quotations of the treaty from *MA* 3.

38. Moss, *Providence: Ye Lost Towne*, 249–270. Legend has identified the treaty site as the present front campus of St. John's College, under the huge tulip poplar tree that reigned there until it was irreparably damaged in Hurricane Floyd in September 1999 and taken down a month later ("The History of the Liberty Tree," St. John's College Web site [www.sjca.edu/asp/main.aspx?page=6820, accessed 4/11/06]). Given that in 1652 the tree stood in a forest on Thomas Todd's land and was much smaller, its selection for treaty honors is highly unlikely. B. Everett Beavin made this point in a 1946 letter to the Maryland Historical Society.

39. "Virginia and Maryland," in Hall, *Narratives*, 218–228; *MA* 3: 311–312. Quotation from *Narratives*, 218–219.

40. "Virginia and Maryland," in Hall, *Narratives*, 225–226. Quotation from 225.

41. *MA* 3: 311–313; *BDML* 1: 21, 2: 791 (Strong), 877 (Wells). Quotation from *MA* 3: 313.

42. *MA* 1: 339–347; Brugger, *Maryland, A Middle Temperament*, 21.

43. Hammond, "Leah and Rachel," in Hall, *Narratives*, 305; John Hammond, "Hammond versus Heamans," *MHM* 4 (1909): 248–249. Quotation from "Hammond versus Heamans," 249.

44. Hall, "Introduction" to "Virginia and Maryland," in Hall, *Narratives*, 183–186; Paape, "From Nansemond to Providence," 78–79.

45. John Langford, "Refutation of Babylon's Fall" (1655), in Hall, *Narratives*, 254–275; Hammond, "Hammond versus Heamans," 236–251; Hammond, "Leah and Rachel," in Hall, *Narratives*, 281–308; Strong, "Babylon's Fall in Maryland," in Hall, *Narratives*, 235–246 (also printed in *MHM* 3 [1908], 228); Roger Heamans, "Heamans' Narrative" (London, 24 July 1655) in *MHM* 4 (1909), 140–153.

46. Battle cry quotations from Strong's account in Hall, *Narratives*, 244. My account of the battle is based on a careful reading of the primary sources noted above.

47. Langford, "Refutation of Babylon's Fall," in Hall, *Narratives*, 260–267; Hammond, "Hammond versus Heamans," 236–251; Hammond, "Leah and Rachel," in Hall, *Narratives*, 304–308; Virlinda Stone to Lord Baltimore, included in Langford's "Refutation," in Hall, *Narratives*, 266; *BDML* 1: 304 (Eltonhead), 422 (Hatton). Quotation from Virlinda Stone.

48. *MA* 1: 363–364; *BDML* 2: 574 (Marsh).

49. Moss (*Providence*, 347) counted 225 men under Stone, 17 of whom were killed and 32 wounded. He believed that Fuller led 175 men, of whom 2 died on the field and at least 4 were wounded (one being Thomas Marsh, who died in 1657).

50. See for instance, Moss, *Providence*, iii–iv (map), 336–339; Ethan Allen, *Historical Notes of St. Ann's Parish in Anne Arundel County, Maryland, Extending from 1649 to 1857* (Baltimore: J. P. Des Forges, 1857), 17–18; Browne, "Battle of the Severn," 169–171; Randall, " Puritan Colony in Maryland," 37; Paape, "From Nansemond to Providence," 78; Gadsby, "17th Century Providence," 14. Browne, who wrote with a Puritan bias, does not mention the executions.

51. *MA* 3: 304; Moss, *Providence*, 329; Browne, "Battle of the Severn," 171.

52. Robert and Mary Burle to "Ministers of Jesus Christ in N England," undated letter in Bush, *Correspondence of John Cotton*, 58, 489–496.

53. The quoted phrase is used by Kenneth L. Carroll, "America's First Quakers — Where, When, and by Whom?" *Quaker History* 85 (1996): 55.

54. Michael Graham, "Meetinghouse and Chapel, Religion and Community in Seventeenth-Century Maryland," in Lois Green Carr, Philip D. Morgan, and Jean B. Russo, eds. *Colonial Chesapeake Society* (Chapel Hill: University of North Carolina Press for the Institute of Early American History and Culture, Williamsburg, Va., 1988), 274; Lois Green Carr and David W. Jordan, *Maryland's Revolution of Government, 1689-1692* (Ithaca, N.Y.: Cornell University Press, 1974), 64.

55. Robert Clarkson to Elizabeth Harris, letter, 1657 (probably 1657/58), in J. Reaney Kelly, *Quakers in the Founding of Anne Arundel County, Maryland* (Baltimore: Maryland Historical Society, 1963), 16. In 1665, Clarkson received a patent for the 300-acre tract "Horne Neck," a peninsula that lay between Todd's (Spa) Creek and Beasley's (Back) Creek and later became the subdivision named Eastport (Patents, L. 8 [MSA S11-11], f. 404; Jane McWilliams, "Eastport Notes," typescript, 1993, in book files).

56. *MA* 3: 324–331; Hall, *Narratives*, 181–308 (encompassing the pamphlets by Hammond, Strong, Langford, and others cited above).

57. *MA* 3: 332–339.

58. *MA* 3: 339–342; *MA* 1: 369–371; Brugger, *Maryland, A Middle Temperament*, 21. Both quotations are from *MA* 1: 370. Calvert left punishment for the deaths at Severn up to Cromwell and his council (*MA* 3: 333). Of the six opposition delegates at Patuxent, four were already or would become Quakers (Kelly, *Quakers in the Founding*, 18–28). At least one historian believes that the religious beliefs of the Providence leadership, radical even to Cromwell's government, were responsible for the return of the province to Calvert control (Paape, "From Nansemond to Providence," 68–70). I am grateful for an email discussion with Ashley and Beverly Ellefson, 11 to 14 Jan. 2006, regarding the Calvert restoration.

59. Al Luckenbach, interview by author, 1 Dec. 2005; Earle, *Evolution of a Tidewater Settlement System*, 5; John W. Reps, *Tidewater Towns: City Planning in Colonial Virginia and Maryland* (Williamsburg, Va.: Colonial Williamsburg Foundation, 1972), 1, 13.

60. *AOMOL* 5: 31.

61. Ibid.; *BDML* 1: 25, 187 (Charles Calvert).

62. Lindauer, *From Paths to Plats*, 4–5.

63. *AOMOL* 5: 47.

64. Ibid.: 92.

65. Lindauer, *From Paths to Plats*, 5; Reps, *Tidewater Towns*, 92–95; Papenfuse and Coale, *Atlas of Historic Maps*, 16–19. Herrman quotations from maps in Papenfuse and Coale, 19. A search for "Arundelton" and variations in all *AOMOL* volumes 13 February 2006 turned up no use of the word in provincial records online at the Maryland State Archives.

66. Lindauer, *From Paths to Plats*, 5– 8; Russell, *First Families*, 1, 121–123; Baker, "Annapolis, Maryland," 191–192. Baker believes that the Todds built boats on the site throughout their occupation of it, but she cites no documentary evidence of this.

67. John F. Wing, *"Bound by God . . . for Merryland": The Voyage of the* Constant Friendship, *1671–1672* (Annapolis: Studies in Local History, Maryland State Archives and Maryland Historical Trust, 1999), 1, 11–14. *Constant Friendship* came into the creek at 2 a.m., probably with a southerly wind. Modern mariner Fred Hecklinger agrees with Wing that no skipper of a square-rigged, ocean-going ship could sail so calmly into Spa Creek at night, even in moonlight, and never with a southerly wind (Frederick E. Hecklinger, personal communication, 13 Feb. 2006).

68. "From the Journal of George Fox, 1672, 1673" in Hall, *Narratives*, 392–393, 399; Kelly, *Quakers in the Founding*, 2, 49–51. Kelly places the meeting house at Arundelton, but it was on the northern side of the river. By this time the largest Quaker meetings took place on West River, not the Severn. Fox's words from Hall, *Narratives*, 399.

69. Frederick E. Hecklinger, personal communication, 14 Feb. 2006.

70. Lindauer, *From Paths to Plats*, 4, 8–9; *AOMOL* 17: 19. Proctor quotation from *AOMOL* 17: 19.

71. *AOMOL* 7: 521, 609–619; Reps, *Tidewater Towns*, 94–96. Ridge quotation from *AOMOL* 7: 521; port name from *AOMOL* 7: 609.

72. *AOMOL* 7: Preface 5, 521; *BDML* 1: 29, 182 (Burgess), 187 (Cecilius Calvert); Reps, *Tidewater Towns*, 117.

73. *AOMOL* 7: 609–619.

74. Reps, *Tidewater Towns*, 96–99; *AOMOL* 5: 502; 19: 7, 49, 75, 110; 20: 181. A search in the *AOMOL* for "Proctor's Landing," "Proctor's land at Severn," or any instance of Robert Proctor's name in connection with the town on Acton's Cove turned up no evidence of this appellation in the provincial records online other than the 1683 town act.

75. *BDML* 1: 274 (Dorsey); Lindauer, *From Paths to Plats*, 6, 13; Tony Lindauer, personal communication, 22 Mar. 2006.

76. *AOMOL* 7: 609–619.

77. Lindauer, *From Paths to Plats*, 9–12; Baker, "Annapolis, Maryland," 192–193; AN MAC (Land Papers), 1684 [MSA M74-1].

78. AN MAC (Land Papers), 1684 [MSA M74-1]; Papenfuse, *"Doing Good,"* 26, fn. 30; Patricia Guida, Tony Lindauer, Edward C. Papenfuse, and Rouse Todd, discussion and exhibits at symposium, "From Paths to Plats: Annapolis before 1718," Maryland State Archives, 9 May 1990 [MSA SC 2255] (Jane McWilliams, "Special Report," *The Archivists' Bulldog*, 21 May 1990).

79. Baker, "Annapolis, Maryland," 192; Lindauer, *From Paths to Plats*, 4, 6, 12; AALR, L. IB#2, f. 157.

80. John Wing, personal communication, 16 Feb. 2006; *AOMOL* 5: 500–502.

81. Elizabeth A. Aiello and John L. Seidel, "Three Hundred Years in Annapolis: Phase III Archaeological Investigations of the Anne Arundel County Courthouse Site (18AP63), Annapolis, Maryland," 2 vols. (report prepared for Spills Candela/Warnecke by Archaeology in Annapolis, HAF, and Department of Anthropology, UMD, College Park, 1995), 1: 230–233, 257; Tony Lindauer, personal communication, 26 June 2010.

82. Papenfuse, *"Doing Good,"* 13; Lindauer, *From Paths to Plats*, 20. Dorsey's forty-foot brick house sat on the northwest side of the hill where the State House was later built. The house burned down about 1713 (ibid.). Elihu S. Riley (*The Ancient City: A History of Annapolis, in Maryland, 1649-1887* [Annapolis: Record Printing Office, 1887; reprint, 1977(?)], 302) named the house at 83 (now 211) Prince George Street as Dorsey's brick house and the residence of Governor Francis Nicholson. This assertion was properly debunked by Harry W. Hill in *Maryland's Colonial Charm Portrayed in Silver* (Baltimore: privately printed, 1938), 67–69, 264–266.

83. *BDML* 1: 129 (Bennett), 182 (Burle), 290 (Durand), 333 (Fuller); 2: 534 (Lloyd), 593 (Meares); Russell, *First Families*; Kelly, *Quakers in the Founding*, 56–72 and passim; Brugger, *Maryland, A Middle Temperament*, 30.

84. Chapelle et al., *Maryland, A History of Its People*, 28; Land, *Colonial Maryland*, 87; Brugger, *Maryland, A Middle Temperament*, 38–39; Edward Gregg, *Queen Anne* (London: Routledge & Kegan Paul, 1980), 63–64. The Glorious Revolution and its effect on Maryland are covered fully in Carr and Jordan, *Maryland's Revolution*. Queen Mary was the daughter of James II by his first wife and had been confirmed in the Church of England prior to her marriage to William in 1677 (Gregg, *Queen Anne*, 16–17). (I am indebted to David Fogle for suggesting this source.)

85. Carr and Jordan, *Maryland's Revolution*, 32–48, 222; *BDML* 1: 187 (Charles Calvert).

86. Carr and Jordan, *Maryland's Revolution*, 113.

87. *BDML* 1: 441 (Hill); Jane W. McWilliams, "Richard Hill," *American National Biography* (1999); *MA* 8: 185, 196; Carr and Jordan, *Maryland's Revolution*, 114. Quotation from *MA* 8: 185.

88. *BDML* 1: 31; Carr and Jordan, *Maryland's Revolution*, 62–67, 106.

89. *MA* 8: 122, 181–182, 184–185, 191, 197–198, 208–209, 212–214, 229; Carr and Jordan, *Maryland's Revolution*, 114–115; McWilliams, "Richard Hill." Quotation from *MA* 8: 185.

90. Carr and Jordan, *Maryland's Revolution*, 202–203, 221–231; Land, *Colonial Maryland*, 90–91; Chapelle et al., *Maryland, A History of Its People*, 28.

91. Land, *Colonial Maryland*, 91–92.

92. *BDML* 1: 32; *AOMOL* 75 (Bacon's *Laws of Maryland*): xxx; *Laws of Maryland*, 1692, chap. 2 (*AOMOL* 13: 425); Carr and Jordan, *Maryland's Revolution*, 212–213.

93. *AOMOL* 20: 83; Dorothy Louise Noble, "Life of Francis Nicholson" (Ph.D. diss., Columbia University, 1958), 9–22; *BDML* 2: 613 (Nicholson). Nicholson is sometimes given the appellation "Sir" (Kevin R. Hardwick, "Sir Francis Nicholson" *Oxford Dictionary of National Biography* [online version, copyrighted 2004–2007 by Oxford University Press, last accessed 8/27/07]; and Aiello and Seidel, "Three Hundred Years in Annapolis," 9, for instance), but an exhaustive search of English records by both Dr. Noble and the Lancaster Herald of Arms turned up no evidence for Nicholson's knighthood (P. L. Gwynn-Jones to Jane Hatcher, 9 Sept. 1994, letter filed with the copy of Noble's dissertation owned by Ann Jensen, 2006). I am indebted to Ann Jensen for use of Noble's dissertation and letters.

94. *AOMOL* 19: 110–113.

95. *AOMOL* 19: 71–78, 110–113; 38: 23–25; Papenfuse, "Doing Good," 8–12.

96. *BDML* 1: 33, 126 (Beard), 274 (Dorsey), 441 (Hill); Lindauer, *From Paths to Plats*, 3, 7, 12–15. Robert Proctor died sometime between September 1694 (AALR, L. IH#1, f. 266) and the spring of 1695.

97. Papenfuse, "Doing Good," 12–13, 26 fn. 40. Robert Proctor was in bad health by May 1694, when he assigned all his property to his wife, Rachel, and gave her power of attorney (*AOMOL* 38: 346). The provincial government paid Rachel for use of her inn (Papenfuse, "Doing Good," 13).

98. *BDML* 2: 802 (Taylard); Anne Elizabeth Yentsch, *A Chesapeake Family and Their Slaves* (New York: Cambridge University Press, 1994), 36–39. Taylard's house sat on a street of Beard's (about 33 feet wide) that later became known as the "southeast line" and caused no end of trouble when James Stoddert did not allow for it in his 1718 survey (Lindauer, personal communications, 22 and 23 Feb. 2006). See Lindauer's plat of Beard's survey, printed in this chapter. See also AALR, L. WT#2, f. 514.

99. Lindauer, *From Paths to Plats*, 17–18. Freeman's ordinary extended from Beard's High Street (now Duke of Gloucester Street) back into what became Main Street, just above Ridout Alley (Lindauer, *From Paths to Plats*, 17). Penny quote from CHAN CT (Records), L. 2, [MSA S517-4], f. 613, as quoted in Lindauer, *From Paths to Plats*, 17; quote regarding Freeman's house from Lindauer, *From Paths to Plats*, 18. For the distinction among ordinaries, taverns, and inns, see Rod Colfield, "Where Did All the Taverns Go? Exploring English Adaptation to the Chesapeake through Drinking Establishments," conference paper presented at The Early Chesapeake: Reflecting and Projecting, 19–21 Nov. 2009, Solomons, Md.

100. *AOMOL* 19: 110–113; Reps, *Tidewater Towns*, 118–128; Papenfuse, "Doing Good," 14; Lindauer, *From Paths to Plats*, 13; *AOMOL* 30: 144, 36: 498. Quotations from Reps, 124. Although Bloomsbury Square would have balanced the design, that land was not included in the town's original one hundred acres. In 1695 it was owned by Edward Dorsey. Charles Carroll and William Bladen subdivided the square in the early eighteenth century. Stoddert surveyed the outline of Bloomsbury Square in 1718 as lying within the city (Tony Lindauer, personal communication, 23 Feb. 2006).

101. Gregg, *Queen Anne*, 34–35, 120–121.

102. Papenfuse, "Doing Good," 13; *AOMOL* 19: 122–124, 128–136; "Journall of the House of Assembly" 1695, 1070–1078 (MSA SC M3191, available as Early State Records Online at *AOMOL* Web site); Carl N. Everstine, *The General Assembly of Maryland, 1634–1776* (Charlottesville, Va.: Michie Company, 1980) 164. Beard quotation from *AOMOL* 19: 122.

103. *AOMOL* 19: 208–209; Morris L. Radoff, *The County Courthouses and Records of Maryland. Part One: The Courthouses* (Annapolis: Hall of Records Commission, Publication No. 12, 1960, online at *AOMOL*: 545), 9. Quotation from *AOMOL* 19: 209. Naming the city after Princess Anne, sister of the queen and heir apparent to the throne, was an obvious choice, but historian Edward Papenfuse believes that the name also tactfully recognized Lord Baltimore's deceased mother, Anne Arundel (Papenfuse, "Doing Good," 14).

104. *AOMOL* 19: 187–189, 208–211. Quotation from 211.

105. Ibid., 150, 159–161, 189. Post quotation from *AOMOL* 19: 150.

106. Morris L. Radoff, *Buildings of the State of Maryland at Annapolis* (Annapolis: Hall of Records Commission, 1954), 3; *BDML* 1: 438 (Herrman).

107. *AOMOL* 19: 498–504. All quotations are from this act. The Great Seal with royal arms replaced Lord Baltimore's seal during the royal period (Donnell M. Owings, *His Lordship's Patronage; Officers of Profit in Colonial Maryland* [Baltimore: Maryland Historical Society, 1953, available online at *AOMOL* 662], 123).

108. Lindauer, *From Paths to Plats*, 14–15.

109. Ibid., 16; Radoff, *Buildings of the State*, 32; Radoff, *County Courthouses*, 11; *AOMOL* 19: 340–342. Pillory quotation from Radoff, *County Courthouses*; gates quote from *AOMOL* 19: 341.

110. *AOMOL* 22: 113.

111. Radoff, *Buildings of the State*, 3–9; Papenfuse, "Doing Good," 14; Lindauer, *From Paths to Plats*, 18; Provincial Court (Land Records), L. WRC #1 [MSA S552-8], fs. 740, 815; *AOMOL* 19: 194, 594–595; Radoff, *County Courthouses*, 13 [*AOMOL* 545].

112. Ford K. Brown, *The Annapolitan Library at St. John's College* (Annapolis: Board of Visitors and Governors of St. John's College [1931?]), 1–5, 10–15; Barrett L. McKown, ed., *The Annapolis and Anne Arundel County Public Library: A History* (Annapolis: Public Library Association of Annapolis and Anne Arundel County, 1987), 9; Charlotte Fletcher, "St. John's 'for

ever,'" *St. John's Review* 40: (1990–91): 8–10; Bernard C. Steiner, "Rev. Thomas Bray and his American Libraries," *American Historical Review* 2 (1896): 65–67, 73 (available online at Dinsmore Documentation [www.dinsdoc.com/steiner-1.htm], accessed 6/27/10).(I am indebted to Dorothy Callahan for this source.) The four hundred or so extant volumes of Bray's library are now housed at the Maryland State Archives (MSA SC 3585).

113. *AOMOL* 19: 420–426; Radoff, *Buildings of the State*, 23–24; Fletcher, "St. John's 'for ever,'" 2–8. Both quotations from *AOMOL* 19: 421.

114. Radoff, *Buildings of the State*, 24–27; Fletcher, "St. John's 'for ever,'" 2, 8–10. Arithmetic quote from Fletcher, 2, quoting Rev. Thomas Bray.

115. Radoff, *Buildings of the State*, 48–50. "Splendid" on 50.

116. *AOMOL* 19: 316, 498–504; 20: 453; 30: 144–145; 36: 498–500. The Kentish House was torn down in 1874 to build St. Martin's Lutheran Church; "Lot Histories", Parcel 13 Sect. I (16–28 Francis St.); Lillian Kipp, "St. Martin's (Francis Street) Remembered" (1998), 12–13. Quotation from *AOMOL* 36: 499.

117. Noble, "Life of Francis Nicholson", 23; William K. Paynter, *St. Anne's Annapolis, History and Times*, (Annapolis: St. Anne's Parish, 1980), 11; Radoff, *Buildings of the State*, 17–18.

118. George F. Frick, James L. Reveal, C. Rose Broome, and Melvin L. Brown, "Botanical Explorations and Discoveries in Colonial Maryland, 1688–1753," *Huntia* 7 (1987): 6–43; Kammen, "Maryland in 1699," 362–372. Quotation from Jones letter as transcribed in Kammen, 371–372.

119. *AOMOL* 19: 498–504, 38: 95–97. Road marks quoted from 38: 96.

120. Kammen, "Maryland in 1699," 368. Jones adds, "our miles are not soe longe as in England, yet they are measured miles." To travel one hundred of "our miles" in one day on horseback would suggest that Jones's miles were very short, however "measured."

121. *AOMOL* 22: 421; *BDML* 1: 34, 244 (Crauford); Lindauer, *From Paths to Plats*, 19. Quotation from *AOMOL* 22: 421.

122. *AOMOL* 22: 356, 454; *BDML* 1: 136–137 (Blackiston).

123. Charles B. Clark, "The Career of John Seymour, Governor of Maryland, 1704–1709," *MHM* 48 (1953): 142. Clark was referring to Seymour's salary, but Blackiston's was the same.

124. Radoff, *Buildings of the State*, 17–19; *AOMOL* 22: 556, 580; Nelson Waite Rightmyer, *Maryland's Established Church* (Baltimore: Church Historical Society for the Diocese of Maryland, 1956), 36–47; Paynter, *St. Anne's Annapolis*, 11–12. Beginning with the Assembly of 1650–1651, the legislature met as two houses. Men elected as representatives of the people sat as the Lower House. Men of particular status or loyalty to the proprietary government, who had been summoned to former assemblies by "special writ" from the governor, sat as the Upper House. In practice, members of the council, who had been appointed or confirmed to that position by the proprietor or, during the royal period, by the king, composed the Upper House (Land, *Colonial*

Maryland, 36–38; *BDML* 1: 20. and biographical profiles of Upper House members contained in vols. 1 and 2).

125. *AOMOL* 26: 178; Paynter, *St. Anne's Annapolis*, 113; Lawrence C. Wroth, *A History of Printing in Colonial Maryland, 1686–1776* (Baltimore: Typothetae of Baltimore, 1922), 165. Pieces of the King William communion service are still in use at St. Anne's (Richard E. Israel, personal communication, 5 Mar. 2006).

126. *BDML* 1: 33–34; "Lot Histories," Parcel 10, Sects. I, II; AALR, Ls. IB#2, f. 498 and WT#2, f. 327; Provincial Court (Land Records), L. TL#2 [MSA S552-9], fs. 688, 716; AA CT (Judgment Records), L. TB#1 [MSA C91-2], fs. 7–11 (March Court, 1705).

127. Edward C. Papenfuse, *In Pursuit of Profit: The Annapolis Merchants in the Era of the American Revolution, 1763–1805* (Baltimore: Johns Hopkins University Press, 1975), 14.

128. *AOMOL* 20: 554, 573; 22: 556, for instance; Papenfuse, *In Pursuit of Profit*, 6.

129. John Wing, personal communications, 6 and 8 Sept. 2005.

130. *BDML* 1: 136 (Bladen), 147 (Bordley); Rightmyer, *Maryland's Established Church*, 162–163; Ronald Hoffman, *Princes of Ireland, Planters of Maryland: A Carroll Saga, 1500–1782* (Chapel Hill: University of North Carolina Press for Omohundro Institute of Early American History and Culture, Williamsburg, Va., 2000), 61–72. Penny quote from CHAN CT (Records), L. 2 [MSA S517-4], f. 613, as quoted in Lindauer, *From Paths to Plats*, 17.

131. *BDML* 1: 165 (Brice), 345 (Garrett); Robert Harry McIntire, *Annapolis, Maryland Families*, 2 vols. (Baltimore: Gateway Press, 1980, 1989) 1: 86–87, 2: 69–70; Baker, "Annapolis, Maryland," 193–195.

132. Everstine, *The General Assembly, 1634–1776*, 165–166. Engine quote from 166.

133. Radoff, *Buildings of the State*, 10–11; Radoff, *County Courthouses*, 13–14; Lindauer, *From Paths to Plats*, 14; Charles B. Clark, "The Career of John Seymour, Governor of Maryland, 1704–1709," *MHM* 48 (1953): 134–146, 158. Seymour statement from *MA* 26, p. 390, as quoted in Radoff, *Buildings*, 11. Richard Clarke was the son of Rachel Beard by her first husband (Lindauer, *From Paths to Plats*, 14; *BDML* 1: 136).

134. Radoff, *County Courthouses*, 13–14; Radoff, *Buildings of the State*, 10–11; Lindauer, *From Paths to Plats*, 20–21; *AOMOL* 26: 391.

135. Rosemary B. Dodd and Patricia M. Bausell, eds., *Abstracts of Land Records, Anne Arundel County, Maryland* (Pasadena, Md.: Anne Arundel Genealogical Society, [no date]) 1: v.

136. *BDML* 1: 126 (Beard), 274 (Dorsey), 441 (Hill); Radoff, *Buildings of the State*, 42. Dorsey had disposed of his Annapolis property and was a Baltimore County resident at the time of his death (*BDML* 1: 274).

137. Lindauer, *From Paths to Plats*, 14; Aiello and Seidel,

"Three Hundred Years in Annapolis" 1: 22. For delegates, Jane McWilliams, "Councilors and Delegates from Annapolis and Anne Arundel County, 1692 to 1715" (typescript, 2005, in book files).

138. *BDML* 1: 273 (Dockwra); Papenfuse, *In Pursuit of Profit*, 9; Baker, "Annapolis, Maryland," 194–195.

139. *AOMOL* 26: 636.

140. *AOMOL* 27: 78, 159. Seymour's words on 78.

141. Baker, "Annapolis, Maryland," 195–196; Tony Lindauer, personal communication, 22 Jan. 2006.

142. C. Ashley Ellefson, "Governor John Seymour and the Charters of Annapolis" (2008, available online at the Maryland State Archives Web site as *AOMOL* 749), part 3, p. 1, *AOMOL* 25: 249; CHAN CT (Records), L. 2 [MSA S517-4], fs. 590–594. Images and transcripts of the two Annapolis charters and other documents relating to them are also online at *AOMOL* 749 as an appendix to Dr. Ellefson's paper.

143. *AOMOL* 51: 567–570, 384–390; 19: 498–504.

144. CHAN CT (Records), L. 2 [MSA S517-4], fs. 590–594; Alexander Pulling, *A Practical Treatise on the Laws, Customs, and Regulations of the City and Port of London, as settled by Charter, Usage, By-law, or Statute* (London: V. & R. Stevens and G. S. Norton, 1842), xiii–xvii, 16, 37, 404–405 [accessed online 10/14/05 at the Maryland State Law Library through that library's subscription to Thomson Gale, *The Making of Modern Law* (Gale, 2005)]. All quotations from the August 1708 charter as recorded in the Chancery Court record cited. I have used both my own transcription and the one by Beverly Ellefson at *AOMOL* 749. St. Mary's City's representation in the legislature ended with the royal assembly of 1704–1707 (*BDML* 1:37)

145. CHAN CT (Records), L. 2 [MSA S517-4], fs. 590–594; *BDML* 2: 899 (Willson); Tony Lindauer, "Annapolis People," unpublished electronic file, 2005; *AOMOL* 27: 213. For Evan Jones, see also Jane W. McWilliams, "The Early History and Development of Lot 96, 1695 to 1744," (report prepared for the City of Annapolis, 1997), which identifies Jones as an innkeeper from at least 1703 to 1708 and town watchman in 1704; he was an alderman from 1708 until his death in 1722. Jones was called a bookseller by Ford K. Brown (*The Annapolitan Library*, 6).

146. *BDML* 1: 136 (Bladen), 472 (Hunt); Ellefson, "Governor John Seymour," part 3, p. 2. Quotation from Ellefson.

147. *AOMOL* 27: 209–216.

148. Ibid., 191–192; Ellefson, "Governor John Seymour," part 3, pp. 3–6. Seymour's words quoted from *AOMOL* 27: 191; House quote from *AOMOL* 27: 192.

149. *AOMOL* 27: 220–221; Ellefson, "Governor John Seymour," part 3, p. 5.

150. *AOMOL* 19: 208–209.

151. Ellefson, "Governor John Seymour," part 3, p. 7.

152. CHAN CT (Records), L. 2 [MSA S517-4], pp. 595–596. This document is available online as an appendix to Ellefson,

"Governor John Seymour," (*AOMOL* 749). Dr. Ellefson believes that these former apprentices also had to have a visible estate of twenty pounds sterling (Ellefson, "Governor John Seymour," part 3, p. 7, for instance).

153. Ellefson, "Governor John Seymour," part 3, pp. 7–9; "Second charter of Annapolis from Historic Annapolis parchment," transcription by Jean Russo of the 22 Nov. 1708 charter belonging to HAF and deposited in Maryland State Archives Special Collections [MSA SC 5793]. This version of the charter, along with the official version in CHAN CT (Records), L. 2 [MSA S517-4], pp. 596–602, is online in the appendix to Ellefson's paper at *AOMOL* 749.

154. Ellefson, "Governor John Seymour," part 3, pp. 7–8; *AOMOL* 27: 250, 256, 270–273, 299, 358–360.

155. Papenfuse, *"Doing Good,"* 20; C. Ashley Ellefson, *Fortune's Orphan: The Troubled Career of Thomas Macnemara in Maryland, 1703-1719* (Cortland, N.Y.: Bevson Printing, 2009), 741; C. Ashley Ellefson and Beverly Ellefson, personal communication to author, 9 Mar. 2006; Ebenezer Cook, *The Sot-Weed Factor: Or, a Voyage to Maryland. A Satyre* (1708; reprint, Baltimore: Brantz Mayer, 1865, Shea's Early Southern Tracts No. II). Quotation re lawyer from Ellefson, *Fortune's Orphan*, 741. The bare-breeched lawyer was Thomas Macnemara, unpopular with Seymour even before he spoke against the August charter. Ellefson notes that Macnemara's punishment appears to have been unique in colonial Maryland (Ellefson, "Governor John Seymour," part 3, p. 3).

Chapter 2. A Chartered City, 1708 to 1764

1. Edward C. Papenfuse, *In Pursuit of Profit: The Annapolis Merchants in the Era of the American Revolution, 1763-1805* (Baltimore: Johns Hopkins University Press, 1975), 9, 14.

2. The November 1708 Charter of the City of Annapolis as recorded in CHAN CT (Records) L. 2, pt. 2 [MSA S517-3], f. 424; M[orris] L. Radoff, "Early Annapolis Records," *MHM* 35: 74–76; AN MAC (Proceedings) 1720–1722 [MSA M47-1] L. B; AN MCT (Minutes) 1720–1722 [MSA M44-1], L. B. Most of the single volume Liber B, which contains a few proceedings of the municipal corporation and minutes of the Mayor's Court, comprises documents relating to city land recorded in the Mayor's Court.

3. *BDML* 1: 147 (Bordley); Rosemary B. Dodd and Patricia M. Bausell, eds., *Abstracts of Land Records, Anne Arundel County, Maryland* (Pasadena, Md.: Anne Arundel Genealogical Society, [no date]) 2: 9, 69.

4. *AOMOL* 19: 110. See also Anthony D. Lindauer, *From Paths to Plats: The Development of Annapolis, 1651 to 1718* (Annapolis: Studies in Local History, Maryland State Archives and Maryland Historical Trust, 1997). Quotation from *AOMOL* 19: 110.

5. Lindauer, *From Paths to Plats*, 20–21; AALR, L. IB 2, fs. 117, 120, 123, 171.

6. *BDML* 1: 147 (Bordley). The commissary general headed

the provincewide probate court (Donnell M. Owings, *His Lordship's Patronage; Officers of Profit in Colonial Maryland* (Baltimore: Maryland Historical Society, 1953, available online at *AOMOL* 662: 39).

7. Sarah Jane Rose, Legislative History Project, Civil Office file, Anne Arundel County folder, MSA SC 4556; Dodd and Bausell, eds., *Abstracts of Land Records, Anne Arundel County, Maryland* 1: 128, 130, 131, 132, 135, 139 (Larkin enlarged his father's 450-acre tract, Larkins Hills, to 855 acres by a resurvey in 1706 and patent in 1718 [LD OFF (Patent Records), L. FF 7 [MSA S11-49], f. 166 and L. CE [MSA S11-61], f. 12]); AALR, L. IB 2, f. 526 and L. CW, f. 36; Marcia M. Miller and Orlando Ridout V, eds., *Architecture in Annapolis: A Field Guide* (Newark, Del.: Vernacular Architecture Forum, and Crownsville, Md.: Maryland Historical Trust Press, 1998), 120; City Officers spreadsheet 1720 to 1730 in book files. Colonial county courts performed administrative as well as judicial duties. Justices were more likely to be "substantial" citizens than professional lawyers. (Aubrey C. Land, *Colonial Maryland, A History* [Millwood, N.Y.: KTO Press, 1981], 110–111, 227. Quote from 227.)

8. LD OFF (Patent Record), L. FF 7 [MSA S11-49], f. 221.

9. Henry Hill, "The Case of Henry Hill In Relation to his Claim of Part of Todd's Harbour, and the Angle; partly in, and partly near the City of Annapolis," MHS Rare Broadside 12.

10. *AOMOL* 27: 534–535; *AOMOL* 19: 498; Henry Hill, "Remarks on Some few Paragraphs of 1 Case lately Publish'd, Entitled, The Case of Messieurs Bordley and Larkin, to the Land lying within and out of the City of Annapolis," MHS Rare Broadside 13.

11. *AOMOL* 33: 227, 234, 243; *Laws of Maryland*, 1718, chap. 19, Bacon's *Laws of Maryland* in *AOMOL* 75; *BDML* 1: 101 (Addison), 447 (Holland); *BDML* 2: 574 (Mariartee), 782 (Stoddert), 861 (Warfield).

12. *AOMOL* 33: 292–293.

13. LD OFF (Patent Records), L. RY 1 [MSA S11-60], f. 537; *AOMOL* 33: 394, 397, 404–405, 437–438; Todd quotations from *AOMOL* 33: 438.

14. Carroll T. Bond, *Proceedings of the Maryland Court of Appeals, 1695–1729* (Washington, D.C.: American Historical Association, 1933, online at *AOMOL* 77), xxvi; Aubrey C. Land, *The Dulanys of Maryland* (Baltimore: Johns Hopkins Press, 1955, 1968), 17–18, for instance; Hill, "Remarks" (this is the only extant reference to Bordley and Larkin's own publication); CHAN CT (Records), L. 6 [MSA S517-9], f. 353; AN MCT (Land Records) L. B [MSA M41-1], fs. 131–133; CHAN CT (Papers, Exhibits), 1718 James Stoddert, Resurvey of Annapolis [MSA S528-267], f. 114; *Laws of Maryland*, 1720, chap. 10. Quotation describing Bordley is from Bond. Quotation re lack of building supplies from the 1720 law cited.

15. *AOMOL* 33: 594; 34: 87, 226, 230, 233, 700; AALR, L. SY 1, f. 68. "Publick" from *AOMOL* 33: 594.

16. Jane W. McWilliams, "The Early History of the Bordley-Randall House," prepared for the City of Annapolis Department of Planning and Zoning, 1997; Prerogative Court (Wills), L. 19 [MSA S538-27], f. 99; John Humphreys, "Text of the funeral for Thomas Bordley, preached at St Anne's Annapolis," Bordley Papers, Maryland Historical Society MS 64, box 2. "Stone" quotation from Humphrey's sermon; "Beautiful Hill" quotation from the will. The records do not specify whether it was a kidney or gall stone that plagued Bordley.

17. *AOMOL* 36: 18, 20, 67, 198, 204, 397. "Commonage" quote from *AOMOL* 36: 18. Deferral quotes from *AOMOL* 36: 397.

18. AN MCT (Land Records), L. B [MSA M41-1], fs. 136, 141, 143, 144, 146, 156, 168, 169, 171, 178, 184, 186; AALR, L. SY 1, fs. 142, 177, 183, 209, 211, 236, L. RD 1, fs. 146, 152, 182, 185, L. IH & TI 1, fs. 83, 115, 117; *BDML* 2: 487 (Jennings); *Laws of Maryland*, 1725, Chap. 7; Prerogative Court (Wills), L. 20 [MSA S538-29], f. 274. "Commonly called" from law cited. Although legislation in 1725 confirmed that transactions filed in the Mayor's Court were as legal as those recorded in provincial or Anne Arundel County courts (*Laws of Maryland*, 1725, chap. 8), some purchasers recorded their deeds in both city and county records.

19. The Maryland State Archives, for instance, counts six versions of Stoddert's map in its holdings [MSA SC 1427-1, -2, -3, -4, -5, -6,-446, -455, -488, -501]; CHAN CT (Papers, Exhibits) 1718, James Stoddert, Resurvey of Annapolis [MSA S528-267]; Nancy T. Baker, "Land Development in Annapolis, Maryland, 1670–1776," in Lorena S. Walsh, Nancy T. Baker, Lois Green Carr, Jean B. Russo, P. M. G. Harris, "Annapolis and Anne Arundel County, Maryland: A Study of Urban Development in a Tobacco Economy, 1649–1776," National Endowment for the Humanities Grant RS-20199-81-1955 [MSA SC 4396], 6–11. This report is hereinafter cited in the whole as Walsh et al., "A Study in Urban Development." More on leases in the colonial period is in the analysis in book files of leased lots from "Lot Histories."

20. Maryland State Papers (Black Books 3) [MSA S987-4], items 21, 25, 27; Franklin Robinson, Jr., "Faith and Tobacco," draft mss. (2006), 153 (I am indebted to Jean Russo for this source.); *AOMOL* 33: 262; *Laws of Maryland*, 1718, chap. 8; CHAN CT (Papers, Exhibits) 1718 James Stoddert, Resurvey of Annapolis [MSA S0528-267]; Morris L. Radoff, *Buildings of the State of Maryland at Annapolis* (Annapolis: Hall of Records Commission, 1954), 32–35.

21. *Laws of Maryland*, 1954, chap. 53, ratified at general election 1954 (*Constitution Revision Study Documents* [1968], 587, 594).

22. Papenfuse, *In Pursuit of Profit*, 6; Suzanne Ellery Green Chapelle, Jean H. Baker, Dean R. Esslinger, Whitman H. Ridgway, Jean B. Russo, Constance B. Schulz, and Gregory A. Stiverson, *Maryland, A History of Its People* (Baltimore: Johns Hopkins University Press, 1986), 30–31; *BDML* 1: 186 (Calvert).

23. Owings, *His Lordship's Patronage*, 1–3, 102–104; Charles

Albro Barker, *The Background of the Revolution in Maryland* (New Haven: Yale University Press, 1940; reprint, n.p.: Archon Books, 1967), 122–126, 174–177, 382–383. "Court" and "country" quotations from Barker, 174.

24. Papenfuse, *In Pursuit of Profit*, 6, 10–12; Owings, *His Lordship's Patronage*, 104; *AOMOL* 38: 165, 406, 407; 34: 265; 36: 63, 38, 449. Quotation from Papenfuse, 6.

25. Papenfuse, *In Pursuit of Profit*, 10, 13; Nancy T. Baker, "Annapolis, Maryland 1695–1730," *MHM* 81 (1986): 201. Dockwra sat in the Lower House from Annapolis (*BDML* 1: 273). Tanyard owners Stewart, William Roberts, and Thomas Hyde served as councilmen and aldermen (see City Officers analysis in book files).

26. AN MCT (Minutes), L. B, [MSA M44-1]; AN MAC (Proceedings), L. B [MSA M47-1], fs. 11–13, 35, 50–51. Course called "race" in MSA M44-1, 51.

27. *AOMOL* 30: 372–374; Ronald Hoffman, *Princes of Ireland, Planters of Maryland: A Carroll Saga, 1500–1782* (Chapel Hill: University of North Carolina Press for Omohundro Institute of Early American History and Culture, Williamsburg, Va., 2000), 78, 83–84; *Maryland Gazette*, 10 Dec. 1728.

28. David K. Hildebrand, "Musical Life in and around Annapolis, Maryland, 1649–1776" (Ph.D. diss., Catholic University of America, 1992), 69–70; *BDML* 1: 245 (Cumming).

29. See for instance AN MCT (Land Records) L. B [MSA M41-1], fs. 141, 171. Scott Street was incorporated into the naval school grounds in 1853 (Jack Sweetman, *The U.S. Naval Academy: An Illustrated History*, 2nd ed., rev. by Thomas J. Cutler [Annapolis: Naval Institute Press, 1995], 45).

30. Hildebrand, "Musical Life in and around Annapolis," 194; Baker, "Annapolis, Maryland": 206; Radoff, *Buildings of the State*, 57–60; *Laws of Maryland*, 1728, chap. 9; Ginger Doyel, *Gone to Market: The Annapolis Market House, 1698–2005* (Annapolis: City of Annapolis, 2005), 11. Quotation from the *Maryland Gazette* 20 Oct. 1730 quoted in Doyel, 11. Radoff (p. 58) says buyers were alerted to market openings by the town drummer; Hildebrand says that at least c. 1717 the signal was the ringing of the church bell.

31. Alan F. Day, "A Social Study of Lawyers in Maryland 1660–1775" (Ph.D. diss., Johns Hopkins University, 1976), 921–925; AN MCT (Minutes) 1720–1722 [MSA M44-1], 40, 99; Aubrey C. Land, *The Dulanys of Maryland* (Baltimore: Johns Hopkins Press, 1968; originally published by MHS, 1955), 49. Legislative committees met at Lloyd's house, once Freeman's ordinary (*AOMOL* 27: 390). Also, see *BDML* for the careers of these men and see "Lot Histories," for the use of these lots.

32. *BDML* 1: 188 (Calvert); Stephen E. Patrick, "'I would not begrudge to give a few pounds more': Elite Consumer Choices in the Chesapeake, 1720–1785: The Calvert House Ceramic Assemblage," (M.A. thesis, College of William and Mary, 1990), 22, 29, 39, 48; Anne Elizabeth Yentsch, *A Chesapeake Family and Their Slaves* (New York: Cambridge University Press, 1994), 13,

41. Archaeological evidence found during an investigation of this property in the 1980s placed the Calverts' house over the one built by William Taylard, mentioned in Chapter 1. "Cousin" from Bernard C. Steiner, "Benedict Leonard Calvert, Esq., Governor of the Province of Maryland, 1727–1731," *MHM* 3: 296.

33. *BDML* 1: 185 (B. L. Calvert); Steiner, "Benedict Leonard Calvert, Esq.," 191–227, 283–342, passim (Steiner collected letters to, from, and about Benedict Leonard dated from 1718 until 1732); *AOMOL* 36: xi–xii, 25: 609; "Calvert Memorabilia," *MHM* 11 (1916): 282–284. Sister's quote from letter 30 June 1728 in Steiner, 321; Ben's nickname from family letters in Steiner, 335.

34. "Calvert Memorabilia," 282–284. Quotation is from Benedict's letter to Thomas Hearne 18 Mar. 1729, 282.

35. *BDML* 1: 189 (E. H. Calvert); Steiner, "Benedict Leonard Calvert, Esq.," 329; "Calvert Memorabilia," 285; Yentsch, *A Chesapeake Family*, 62–63. Ned's nickname from Steiner, 194, 227.

36. "Calvert Memorabilia," 283; Yentsch, *A Chesapeake Family*, 46–50, 107–110, 189; Patrick, "Elite Consumer Choice in the Chesapeake," 25–26; *Maryland Gazette*, 4 Mar. 1729; *BDML* 2: 618 (Ogle); Steiner, "Benedict Leonard Calvert, Esq.," 329, 338–339. But, regarding the bricking of the house, see n. 106 below for the 1764 fire and the contemporary description of Governor Benedict Leonard Calvert's former residence as "built of Wood" (*Maryland Gazette*, 1 Nov. 1764).

37. Carl N. Everstine, *The General Assembly of Maryland, 1634–1776* (Charlottesville, Va.: Michie Company, 1980), 230; *AOMOL* 30: 144; Charlotte Fletcher, "An Endowed King William's School Plans to Become a College," *MHM* 80 (1985): 157–166; "Calvert Memorabilia," 282; Steiner, "Benedict Leonard Calvert, Esq.," 341; *BDML* 1: 186 (B. L. Calvert); *AOMOL* 50: 491. Benedict's words from "Calvert Memorabilia," 282; quote from will from Steiner, 341.

38. *Pennsylvania Gazette*, 30 Nov. 1732; Arthur Pierce Middleton, *Tobacco Coast, A Maritime History of the Chesapeake Bay in the Colonial Era* (Newport News, Va.: Mariners' Museum, 1953), 45; David M. Ludlum, *Early American Winters, 1604–1820* (Boston: American Meteorological Society, 1966), 47; *Maryland Gazette*, 9 Feb. 1733.

39. *Maryland Gazette*, 16 Mar., 13 Apr. 1733; *AOMOL* 28: 45–46, 49–50; Barker, *Background of the Revolution*, 129–137. Quotation from *Maryland Gazette*, 16 Mar.

40. *BDML* 1: 47, 184 (B. Calvert).

41. Radoff, *Buildings of the State*, 77; CHAN CT (Records), L. 6 [MSA S517-9], f. 239; Joseph Chandler Morton, "Stephen Bordley of Colonial Annapolis" (Ph.D. diss., University of Maryland, 1964), 32, 58–61; Stephen Bordley to Rev. William Bordley, 8 Jan. 1734/35, Bordley Letterbook, 1727–1735 MS 81, MHS. Stephen Bordley's words are from his letter to Rev. Bordley, who did not follow Stephen's instructions.

42. Lindauer, *From Paths to Plats*, 20–23; Maryland Survey Papers (Resurvey Plats) Proprietor v. Jennings [MSA S64-3]; CHAN CT (Records), L. 6 [MSA S517-9], fs. 239–414; "Propri-

etary vs. Jennings," in Thomas Harris, Jr., and John McHenry, *Maryland Reports*, 4 vols. (New York: I. Riley, 1809–1818), 1: 61–98.

43. CHAN CT (Records), L. 6 [MSA 517-9], fs. 239, 258–259, 414; AALR, L. RD 2, f. 240; AN MCT (Land Records) L. B [MSA M41-1], fs. 195–206; Historic Annapolis, Inc., "Three Ancient Blocks of Annapolis" (1963), 10–11.

44. Ebenezer Cooke, "Sotweed Redivisus; or, the Planters Looking-Glass" (Annapolis: William Parks for the author, 1730; reprinted in *Early Maryland Poetry* [Baltimore: Maryland Historical Society, Fund Publication No. 36, 1900]).

45. Papenfuse, *In Pursuit of Profit*, 14; Lorena S. Walsh, "Town and County Population Growth," table 2, in Walsh et al., "A Study in Urban Development"; Baker, "Annapolis, Maryland," 201; Jean Russo, "The 1755 Census of Maryland, Anne Arundel County," analysis of the census figures from *Gentleman's Magazine* reproduced in Edward C. Papenfuse and Joseph M. Coale III, *The Maryland State Archives Atlas of Historical Maps of Maryland, 1608-1908* (Baltimore: Johns Hopkins University Press, 2003), 51. Papenfuse and Walsh give different figures for the population of Annapolis in 1710 (393 v. 326) and 1730 (776 v. 678), but they agree that there were roughly twice as many residents in 1730 as in 1710. Walsh estimates a total 1710 population in Anne Arundel County of 4,778, of whom 1,528 were slaves, and a 1775 population of 17,906, with 7,679 slaves (Walsh, op. cit., table 1).

46. Lorena S. Walsh, "The Chesapeake Slave Trade: Regional Patterns, African Origins, and Some Implications," *William and Mary Quarterly*, 3rd ser., 58, no. 1 (Jan. 2001): 148, 153–154, 158–159; Jean B. Russo, "Blacks in Colonial Annapolis," (unpublished paper for HAF, 2002). Groupings of rock crystals, small stones, pins, and other bits and pieces puzzled archaeologists investigating the basement rooms of the Charles Carroll House in the early 1990s. Anthropologist Mark Leone, director of the Archaeology in Annapolis program, and his colleagues believe these might be caches of "spirit materials" placed carefully by household slaves who lived and worked in these basement rooms after 1810, which is the date on a coin in the cache. If Leone is correct in his assumptions, these small, anonymous items may reflect a secret African persistence in Annapolis (Mark P. Leone, *The Archaeology of Liberty in an American Capital: Excavations in Annapolis* (Berkeley: University of California Press, 2005), xi, 200–244; Patricia Samford, "The Archaeology of African-American Slavery and Material Culture," *William and Mary Quarterly*, 3rd ser., 53, no. 1 (1996): 104–109.

47. Russo, "Blacks in Colonial Annapolis"; Yentsch, *A Chesapeake Family*, 171–189; Margaret Law Callcott, "The Eighteenth-Century Calvert Residence in Annapolis," *Riversdale Historical Society Newsletter*, Winter 1999 (www.ci.riverdale-park.md.us/History/riversdaletter/winter 1999 .html, accessed 4/2/04); Walsh, "Town and County Population Growth," 2–7, table 2; Nancy T. Baker, "The Manufacture of Ship Chandlery in An-

napolis, Maryland, 1735–1770," (unpublished paper prepared for Historic Annapolis, Inc., n.d.), 21; Marcia Myrl Miller, "The Chase-Lloyd House" (M.A. thesis, George Washington University, 1993), 127–128; *Maryland Gazette*, 13 May 1746; AN MAC (Bylaws and Ordinances) 1768–1791 [MSA M54-1], 12, 58, for instance. Yentsch quotes from *A Chesapeake Family*, 188. The Calvert figures are not an anomaly; the Anne Arundel County inventory analysis for urban households 1700 to 1770 shows a ratio of 2.38 children (birth to age 15) to women aged 16 to 50 (Walsh, "Town and County Population," table 1, p. 1).

48. Herbert S. Klein, Stanley L. Engerman, Robin Haines, and Ralph Shlomowitz, "Transoceanic Mortality: The Slave Trade in Comparative Perspective," *William and Mary Quarterly*, 3rd ser., 63 (Jan. 2001): 93–118 (I am indebted to Jean Russo for this source); Shirley V. Baltz, *The Quays of the City: An Account of the Bustling Eighteenth Century Port of Annapolis* (Annapolis: Liberty Tree, 1975), 26; Middleton, *Tobacco Coast*, 140; Land, *The Dulanys of Maryland*, 105–106; Shirley V. Baltz, *Belair from the Beginning*, (Bowie, Md.: City of Bowie Museums, 2005), 27; Russo, "Blacks in Colonial Annapolis"; *Maryland Gazette*, 6 Mar. 1751, 2 Nov. 1769, for instance. Quotation from *Gazette*, 2 Nov.

49. Walsh, "Town and County Population," 4, 9, table 1; Russo, "Blacks in Colonial Annapolis."

50. Russo, "Blacks in Colonial Annapolis"; Alan Taylor, *American Colonies* (New York: Viking Penguin, 2001), 315.

51. Middleton, *Tobacco Coast*, 145– 148; William Eddis, *Letters from America*, ed. Aubrey C. Land (Cambridge: Belknap Press of Harvard University Press, 1969), 38–39; Robert J. Brugger, *Maryland, A Middle Temperament, 1634–1980* (Baltimore: Johns Hopkins University Press and Maryland Historical Society, 1988), 16.

52. Land, *Dulanys of Maryland*, 3; Day, "A Social Study of Lawyers," 109–110, 921–926; *BDML* 1: 245 (Cumming), 284 (Dulany). An exhaustive study of the controversial Macnemara was made by C. Ashley Ellefson ("Thomas Macnemara and the Historians," unpublished paper, 2008).

53. A. Roger Ekirch, *Bound for America: The Transportation of British Convicts to the Colonies, 1718-1775* (Oxford: Clarendon Press, 1987), 17–19; Middleton, *Tobacco Coast*, 148–156; Eddis, *Letters from America*, 36–38; Brugger, *Maryland, A Middle Temperament*, 85–88.

54. Brugger, *Maryland, A Middle Temperament*, 87; Heather Ersts Venters, "Cooking up the Dough: Annapolis Women and Their Businesses, 1745–1755" (M.A. thesis, George Mason University, 1995), 6–7; *Maryland Gazette*, 24 Feb. 1728, 22 Apr. 1746, 13 May 1746, 7 Oct. 1747, 21 May 1752, 2 Nov. 1769, 6 Sept. 1770, for instance; AN MCT (Minutes) 1765-1767 [MSA M44-3], 85; AN MAC (Bylaws and Ordinances) 1768–1791 [MSA M54-1], 12, 17, 58. As soon as she was free, Crowder advertised herself as a quilter, putting her in competition with her former mistress (Venters, 7).

55. Janice Hayes-Williams, "Our Legacy," *The Capital*, 2 and 9 Feb. 2006; AA CT (Judgment Record) 1757/03–1760/06 (indicates Mar. 1757–June 1760) [MSA C91-23], 320, 386, 389, 1760/08–1762/11 [MSA C91-24], fs. 38, 166, 432, 433, 1767/08–1768/08 [MSA C92-30], 214, 1772/08–1773/08 [MSA C91-34], 152, for instance. I am indebted to Janice Hayes-Williams and Jean Russo for these court sources.

56. Jean B. Russo, J. Elliott Russo, and Catherine Cardno, "'Born of the Body of a White Woman': Interracial Bastardy in Colonial Maryland," paper presented at the Twelfth Annual Conference of the Omohundro Institute for Early American History and Culture, Quebec, June 2006. Additional research must be done on interracial children in Annapolis and Anne Arundel County before specific conclusions can be drawn for those jurisdictions.

57. Baker, "Annapolis, Maryland," 201; Bacon's *Laws of Maryland* (*AOMOL* 75); *AOMOL* 543: 10, 10b, 136; Day, "A Social Study of Lawyers," iv, 143–144, 146; Miller, "The Chase-Lloyd House," 117, 122–124; Walsh, "Town and County Population," 3, 7; Baker, "Land Development," 6; Jean B. Russo, "'The Fewnesse of Handicraftsmen:' Artisan Adaptation and Innovation in the Colonial Chesapeake," in Robert Olwell and Alan Tully, eds., *Cultures and Identities in Colonial British America* (Baltimore: Johns Hopkins University Press, 2006), 188; Taylor, *American Colonies*, 316; Lillian B. Miller, ed., *The Selected Papers of Charles Willson Peale and His Family* (New Haven: Yale University Press for the National Portrait Gallery, Smithsonian Institution, 1983) 1: xlix–l; Mark B. Letzer and Jean B. Russo, *The Diary of William Faris* (Baltimore: Maryland Historical Society, 2003), 42–43; AN MCT (Minutes) 1765–1767 [MSA M44-3], passim; AN MAC (Bylaws and Ordinances) 1768–1791 [MSA M54-1], 12, 58. Quote from Letzer and Russo, 43.

58. Karen Mauer Green, *The Maryland Gazette, 1727–1761: Genealogical and Historical Abstracts* (Galveston, Tex.: Frontier Press, 1990), 1–13; Maryland State Archives, *Maryland Gazette* Collection, 1728–1734 [MSA SC 2853]; Lawrence C. Wroth, *A History of Printing in Colonial Maryland, 1686–1776* (Baltimore: Typothetae of Baltimore, 1922), *AOMOL* 435: 59–70, 75–94; Maryland State Archives, *Maryland Gazette* Collections, 1745–1839 [MSA SC 2731, 3403, 3428, 3447]; *Maryland Gazette*, 9 Sept. 1773, passim; David C. Skaggs, "Editorial Policies of the *Maryland Gazette*, 1765–1783," *MHM* 59 (1964): 341–349. Owned by the State Law Library, the leather-bound volumes of the Greens' newspaper reside today in the controlled environment of the Maryland State Archives. Microfilm of the paper is readily available, and the Maryland State Archives has scanned most of its collection onto *AOMOL*.

59. *Maryland Gazette*, 1727–1765, passim; Naval Office Shipping Lists, Port of Annapolis, 1748–59 [MSA S204], transcribed and edited by John Wing (hereinafter cited as Wing, NOSL); Vaughan W. Brown, *Shipping in the Port of Annapolis, 1748–1775*

(Annapolis: U.S. Naval Institute, 1965), 12–13; Middleton, *Tobacco Coast*, 237.

60. Owings, *His Lordship's Patronage*, 63–67, 95–101; Brown, *Shipping in the Port of Annapolis*, 10–12; *BDML* 2: 801 (Tasker, Jr.).

61. *Oxford English Dictionary* (1971); Baltz, *The Quays of the City*, 10–11, 17–19, 34–38, and passim; "Lot Histories," Parcels 15 and 16, 39; Baker, "Manufacture of Ship Chandlery," 12–16, 64–66, 70.

62. *Maryland Gazette*, 15 Mar., 27 Sept. 1753, 13 Mar., 1, 8 May 1766; AN MAC (Proceedings) 1757-1765 [MSA M47-2], 35; Baltz, *The Quays of the City*, 22, Middleton, *Tobacco Coast*, 35–37. Worm quote from *Maryland Gazette*, 8 May 1766.

63. Baker, "Manufacture of Ship Chandlery," 12–16, 63; Jason D. Moser, "Colonial Marine Trades and Shipbuilding in Anne Arundel County, Maryland," in C. Jane Cox, ed., *Anne Arundel County's Lost Towns Archaeology Project Research Reports* (prepared for the Annapolis Maritime Museum, 2005, and used with the generous permission of the museum), 11–12, 22, 26, 33, and passim; Baker, "Annapolis, Maryland," 202; Middleton, *Tobacco Coast*, 41; Letzer and Russo, *The Diary of William Faris*, 66.

64. Baltz, *The Quays of the City*, passim; Jason D. Moser, "Ropewalks in the Eighteenth Century: The Structure of an Early Chesapeake Industry," in Stanley South, ed., *Volumes in Historical Archaeology*, vol. 39 (Columbia: Institute of Archaeology and Anthropology, University of South Carolina, 1998), 24, 62–69, 84; Moser, "Colonial Marine Trades," 23–26, 31; *Laws of Maryland*, 1753, chap. 24; *Maryland Gazette*, 15 Apr. 1729, 19 July 1734, 31 May 1749, for instance; Wing, NOSL; Miller and Ridout, *Architecture in Annapolis*, 154; Baker, "Manufacture of Ship Chandlery," 28–36, 39; Middleton, *Tobacco Coast*, 236, 261; *Maryland Gazette*, 27 July 1748, 28 Apr. 1763, 15 and 22 Aug. 1765. The *Maryland Gazette* carried graphic descriptions of the toadstool deaths.

65. *Laws of Maryland*, 1719, chap. 5.

66. *Laws of Maryland*, 1723, chap. 26; *Maryland Gazette*, 22 Dec. 1730; Baker, "Manufacture of Ship Chandlery," 8–9, 53; Baltz, *The Quays of the City*, 17–20; Moser, "Colonial Marine Trades," 31, 62; *Laws of Maryland*, 1753, chap. 24; LD OFF (Patent Records) L. Y&S 8 [MSA S11-94], f. 374; Miller and Ridout, *Architecture in Annapolis*, 105. Ship launch quotation from *Gazette*; Ship Carpenter's Lot description from *Laws of Maryland* 1753, chap. 24.

67. Papenfuse, *In Pursuit of Profit*, 11; *AOMOL* 50: 65, 224–225; LD OFF (Patent Records) L. BY&GS 3 [MSA S11-86], f. 62; "Lot Histories," Parcel 39, Sect. III; Joy Gary, "Patrick Creagh of Annapolis," *MHM* 48 (1953): 313–314; Analysis of "Vessels known to have been built in Annapolis from 1730 to 1763," in book files; Middleton, *Tobacco Coast*, 261; Baker, "Manufacture of Ship Chandlery," 45, 49–50, 55; Russo, "Fewnesse of Handicraftsmen," 192; *Maryland Gazette*, 16 Aug. 1753, 1 Aug. 1754,

10 Oct. 1754. The city eventually challenged Creagh's patent (AN MAC [Proceedings] 1757–1765 [MSA M47-2], 132–134). Description of *Hanbury* from *Maryland Gazette*, 1 Aug. 1754.

68. Middleton, *Tobacco Coast*, 239, 264 (Middleton gives the tonnage as 400 based on a contemporary document; the ship's certificate says 300 tons). See "Abstracts of Commission Book 82, 1733–1773," *MHM* 26 (1931): 259; Moser, "Colonial Marine Trades," 58. Description of Roberts from Moser, 58.

69. *Maryland Gazette*, 4 Aug. 1763.

70. Rebecca Key, "A Notice of Some of the First Buildings with Notes of Some of the Early Residents," *MHM* 14 (1919): 260; CHAN CT (Records), L. 134 [MSA S517-151], f. 721. The intersection of Church Circle and Northwest Street is now the location of the main Annapolis post office.

71. Analysis of "Vessels known to have been built in Annapolis from 1730 to 1763," in book files; Rufus Rockwell Wilson, ed., *Burnaby's Travels through North America* (New York: A. Wessells Co., 1904, reprint of 3rd ed., 1798), 82; Victor Hugo Paltsits, ed., *Journal of Benjamin Mifflin, the Record of a Tour from Phila to Delaware and Maryland, July 26 to August 14, 1762* (New York: New York Public Library, 1935), 12.

72. Analysis of "Vessels known to have been built in Annapolis from 1730 to 1763," in book files; Wing, NOSL; John Wing, personal communication, 27 Oct. 2006.

73. Wing, NOSL; Moser, "Colonial Marine Trades," 55, 64; Gary, "Patrick Creagh," 321; *BDML* 1: 245 (Cumming); *Maryland Gazette*, 2 Oct. 1755, 22 Jan. 1756, 7 Mar. 1765, for instance for Bryce; "Lot Histories," Parcel 6, Sect. IV.

74. *Laws of Maryland*, 1736, chap. 6; "Lot Histories," Parcel 39, Sect. I; Radoff, *Buildings of the State*, 36–38; Gary, "Patrick Creagh," 314; Baltz, *The Quays of the City*, 12–13; *AOMOL* 44: 535–536. This prison was on the northeast corner of Prince George Street and what is now Randall Street, but Randall Street was not cut through until 1831 (see "Lot Histories" cited above), AN MAC (Bylaws and Ordinances) 1826–1843 [MSA M54-4], chap. 120, p. 46).

75. Radoff, *Buildings of the State*, 43–44, 66–68; Gary, "Patrick Creagh," 319–320; Miller and Ridout, *Architecture in Annapolis*, 165–166.

76. *Laws of Maryland*, 1742, chap. 24; Radoff, *Buildings of the State*, 43, 77–78; "The Journal of William Black, 1744," *Pennsylvania Magazine of History and Biography* 1 (1877): 128; Gary, "Patrick Creagh," 314–315. "Four Acres" and "Dwelling House" quotes from the law; "fine House" and "Beautiful Spot" from Black, 128.

77. *AOMOL* 42: 508–512, 520–521; Morton, "Stephen Bordley," 118–120. Bordley's quotation from *AOMOL* 42: 508; Bladen's from ibid., 520.

78. *BDML* 1: 135 (Bladen); "Journal of William Black," 126; *AOMOL* 42, 515–516, 541, 551; Land, *The Dulanys of Maryland*, 157–161. Description of Bladen and his entertainment from

Black, 126. Simon Duff has often been credited with designing Bladen's vision of the governor's house. Rebecca Key said he came from Scotland with the plans in 1744 (Key, "A Notice of Some of the First Buildings," *MHM* 14 [1919]: 261–263). However, Joy Gary refutes that claim in detail. She believes that Patrick Creagh should receive more credit for the building (Gary, "Patrick Creagh," 316–319).

79. *AOMOL* 42: 557.

80. *AOMOL* 44: 524–526; Gary, "Patrick Creagh," 316.

81. Provincial Court (Land Records), L. EI 8 [MSA S552-17], f. 276; Radoff, *Buildings of the State*, 71–77, plate 13; *BDML* 1: 53.

82. Anne Arundel County (Wills), L. JG 1 [MSA C153-5], f. 107; Rev. William S. Southgate, "The Cemetery," *Evening Capital*, 9 May 1887. I am indebted to Emily Peake for this source. Elizabeth does not mention the land in her will, and no deed transferring the property to the vestry has been found.

83. Wilson, *Burnaby's Travels*, 81; Paltsits, *Journal of Benjamin Mifflin*, 11; "Journal of an Officer [Lord Adam Gordon] Who Travelled in America and the West Indies in 1764 and 1765," in Newton D. Mereness, *Travels in the American Colonies* (New York: Antiquarian Press, 1961), 408; Thomas Jefferson to John Page, 25 May 1766, in Julian P. Boyd, ed., *The Papers of Thomas Jefferson* (Princeton: Princeton University Press, 1950) 1: 20; Baltz, *Belair at the Beginning*, 23–24. All quotations from visitors' sources as noted in text.

84. *AOMOL* 46: 643, 668. Legislature's words from *AOMOL* 46: 668.

85. Wilson, ed., *Burnaby's Travels*, 81; "Journal of Gov. Thomas Pownall," *Pennsylvania Magazine of History and Biography* 18 (1894): 217–218; Paltsits, *Journal of Benjamin Mifflin*, 12–14; "Journal of an Officer Who Travelled in America," 408. Quotes re public buildings from Burnaby, 81 (poor, indifferent), Mifflin, 13 (antiquated); Pownall quote from his journal, 218; irregular quote from Gordon, the officer, 408.

86. "Lot Histories," maps, passim; *Maryland Gazette*, 19 Feb. 1752, 13 Mar. 1766; Baltz, *Belair from the Beginning*, 12–13; *Laws of Maryland*, 1768, chap. 21; Carroll quote from *Gazette*.

87. "Lot Histories," Parcel 39, map; *Maryland Gazette*, 9 Feb. 1733, 14 July 1747, 20 Jan. 1750, for instance; Baltz, *The Quays of the City*, 9–10; *AOMOL* 46: 387; *Maryland Gazette*, 16 June 1752, 1 Nov. 1759; *AOMOL* 50: 65, 224–225, 510; Wilson, *Burnaby's Travels*, 82. Arms order in 1749 from *AOMOL* 46, 387. The 1750 order was for 15 four-pounders, but both Burnaby and Mifflin (Paltsits, *Journal of Benjamin Mifflin*, 13) describe them as six-pounders.

88. J. Thomas Scharf, *History of Maryland*, 3 vols. (1879; reprint, Hatboro, Pa.: Tradition Press, 1967), 1: 470–472; *Maryland Gazette*, 6, 13 Nov. 1755. Alarming accounts in newspaper for 6 Nov., other quotations from 13 Nov. paper.

89. Chapelle et al., *Maryland, A History of Its People*, 3;

Maryland Gazette, 3, 17 Apr., 6, 13, 20 Nov. 1755; Hoffman, *Princes of Ireland*, 273–276; *BDML* 2: 727 (Sharpe).

90. *Maryland Gazette*, 3, 10, 17 Apr. 1755; James W. Cheevers, e-mails to author, 14, 15 Nov. 2007; Scarf, *History of Maryland* 1: 452–454. I am indebted to Mr. Cheevers for pointing out the importance of HMS *Centurion*.

91. Basil Sollers, "The Acadians (French Neutrals) Transported to Maryland," *MHM* 100 (2005): 230–234; Gregory A. Wood, *A Guide to the Acadians in Maryland in the Eighteenth and Nineteenth Centuries* (Baltimore: Gateway Press, 1995), 4–12; Scharf, *History of Maryland*, 1: 473–479; *Maryland Gazette*, 20 Nov. 1755. Quotation from *Gazette*.

92. AN MCT (Minutes) 1753–1757 [MSA M44-2], 75; *Maryland Gazette*, 4, 11 Dec. 1755; Sollers, "The Acadians," 235–237; Hoffman, *Princes of Ireland*, 277; Gregory A. Wood, *The French Presence in Maryland 1524–1800* (Baltimore: Gateway Press, 1978), 186–188; Key, "A Notice of Some of the First Buildings," 260; Robert L. Worden, *Saint Mary's Church in Annapolis, Maryland, A Sesquicentennial History, 1853–2003* (Annapolis: St. Mary's Parish, 2003), 12–13. Dulany quote from Sollers, 236.

93. Sollers, "The Acadians," 240–241; Hoffman, *Princes of Ireland*, 274–276; *Pennsylvania Gazette*, 16 May 1757; Provincial Papers (Land Office Miscellany) [MSA S50-103], "A List of Lands held by reputed Papists in A Arundel County." "Papist" quote from Provincial Papers.

94. *AOMOL* 55: xl–xli, 212, 279, 285–286, 299–300; *AOMOL* 9: 121; Jack L. Summers and Rene Chartrand, "History and Uniform of the 60th (Royal American) Regiment of Foot, 1755–1760," online at www.militaryheritage.com/60thregt./htm (accessed 5/8/10). Sharpe's quote from *AOMOL* 9: 121.

95. Annapolis Corporation to Governor Horatio Sharpe, 22 Dec. 1757 (original owned by Henry E. Huntington Library and Art Gallery, copy in Baltz Collection, [MSA SC 5224], box 3, folder 9); *AOMOL* 9: 113–115. Corporation quotations from letter to Sharpe; Sharpe quotations from *AOMOL* 9: 114.

96. *Dictionary of National Biography* (Haldimand); *Dictionary of Canadian Biography* (Haldimand) (www.biographi.ca [accessed 3/8/10]); Summers and Chartrand, "History and Uniform of the 60th (Royal American) Regiment"; *Maryland Gazette*, 6, 20 Nov. 1755, 28 Apr., 1 Dec. 1757.

97. *Maryland Gazette*, 23 Mar. 1758; *AOMOL* 9: 166–167; Baltz, *Belair from the Beginning*, 32. I am indebted to Katherine Clagett for the translation of Col. Haldimand's letter in *AOMOL* 9: 166–167; *Maryland Gazette*, 23 Mar. 1758. Haldimand's letter quoted from Clagett's translation of *AOMOL* 9: 167.

98. Papenfuse, *In Pursuit of Profit*, 14; "French and Indian War," *MHM* 9 (1914): 262; *BDML* 1: 397 (Hammond); *Maryland Gazette*, 8 May 1760; Jane W. McWilliams, "Acton Hall Chronology," prepared for the City of Annapolis Department of Planning and Zoning, 1997; *AOMOL* 9: 114.

99. "French and Indian War," *MHM* 9 (1914): 260–262; Anthony D. Lindauer, "Annapolis People" (electronic file, 2005);

Jean B. Russo, "City Officers, 1720–1989," prepared for HAF, 1990. Analysis of Annapolitans who submitted bills for quartering troops is in book files.

100. *Maryland Gazette* 20 Jan., 10 Mar. 1757, for instance; Elihu S. Riley, *The Ancient City: A History of Annapolis, in Maryland, 1649–1887* (Annapolis: Record Printing Office, 1887; reprint, 1977[?]), 119; Everstine, *The General Assembly of Maryland, 1634–1776*, 355; "Journal of William Black," 127; Elaine G. Breslaw, "From Edinburgh to Annapolis: Dr. Alexander Hamilton's Colonial Maryland Medical Practice," *MHM* 96 (2001): 411; St. Anne's Parish Register 1: 219; AN MAC (Proceedings) 1757-1765 [MSA M47-2]. 1. Quotation from *Maryland Gazette*, 20 Jan. 1757.

101. *Maryland Gazette*, 16 Jan. 1752, 30 Oct. 1759, 19 June 1766, 4 May 1769, 16 July 1772, for instance; *Maryland Gazette*, 24 Jan. to 5 Sept., 1765, passim [almost every issue during that period contains some mention of the disease]; *Maryland Gazette*, 10 Jan. 1765; David M. Ludlum, *Early American Winters, 1604–1820* (Boston: American Meteorological Society, 1966), 61; *Maryland Gazette*, 14 Mar. 1765.

102. *Maryland Gazette*, 14 Mar. 1765. *Inoculation*, also called variolation, placed pus or serum taken from a person suffering from smallpox under the skin of the uninfected subject to cause a mild case of the disease that would thereafter grant immunity. *Vaccination* for smallpox inoculated the subject with the cowpox virus, which also granted immunity to smallpox. Edward Jenner, an English physician, is credited with developing the vaccination procedure for smallpox in 1796. Stefan Riedal, "Edward Jenner and the History of Smallpox and Vaccination," *Baylor University Medical Center Proceedings* 18 (Jan. 2005): 21–25 (online through www.pubmedcentral.nih.gov, last accessed 9/28/07).

103. *Maryland Gazette*, 21 Mar., 11 Apr., 16 May, 18 July 1765; Breslaw, "From Edinburgh to Annapolis," 410–412; *BDML* 1: 147 (Bordley), 165 (Brice), 267 (Denton). Breslaw says there was a smallpox hospital in Annapolis in 1750, but there is no evidence of this in her source. A special house may have been used to sequester the ill in the 1765 epidemic. The *Maryland Gazette* of 29 Aug. 1765, reporting the recovery of the last victim, said, "she is to be removed away, and on Saturday the House will be clean'd with Burnt Tar, and White-wash'd." Research has not located this building.

104. *AOMOL* 34: 146, 148, 162–163, 228–229, 239–240; *AOMOL* 35: 166; *Maryland Gazette*, 13 May 1746, 7 Feb. 1754; Baltz, *The Quays of the City*, 34; AN MAC (Proceedings) 1757-1765 [MSA M47-2]; 43–44; AN MCT (Minutes) 1765-1767 [MSA M44-3], 32, 61, 69–71, 74, 117, 119, 193, 194; AN MAC (Bylaws and Ordinances) 1768-1791 [MSA M54-1], 4.

105. *Maryland Gazette*, 24 May 1745, 25 Apr. 1754, 8 May 1755; AN MAC (Proceedings) 1757-1765 [MSA M47-2], 5, 132–134. "Thick built" quotation from *Gazette*, 25 Apr. 1754; description of engine from 8 May 1755.

106. *Maryland Gazette*, 1 Nov. 1764. Yentsch believes Calvert's house was brick "from 1730" and explains this wooden house as another building on the property (Yentsch, *A Chesapeake Family*, 189.)

107. Baltz, *The Quays of the City*, 40; *Maryland Gazette*, 13 May 1746, 1 Mar. 1753, 10 June 1762; AN MAC (Bylaws and Ordinances) 1768–1791 [MSA M54-1], 18; AN MAC (Proceedings) 1757–1765 [MSA M47-2]. 4; AN MAC (Bylaws and Ordinances) 1768–1791 [MSA M54-1], 9; Baker, "Annapolis, Maryland 1695–1730," *MHM* 81 (1986): 206. The 1753 bylaw quote is from *Maryland Gazette*; fierce dog quote from AN MAC (Bylaws and Ordinances) 1768–1791 [MSA M54-1], 18.

108. AN MAC (Proceedings) 1757–1765 [MSA M47-2], 43–44; AN MCT (Minutes) 1765–1767 [MSA M44-3], 33, 58, 59, 69, 117, 193; (AN MAC (Bylaws and Ordinances) 1768–1791 [MSA M54-1], 19, 23, 31; AN MAC (Bylaws and Ordinances) 1826–1843 [MSA M54-4], 35, 52, 93; Annapolis Mayor and Aldermen (Proceedings) 1858–1861, 1862–1863 [M49-7], 11 Nov. 1862; AN MA (Bylaws and Ordinances) 1881-1897 [MSA M51-3], 153, for instance; AN MAC (Bylaws and Ordinances) 1768–1791 [MSA M54-1], 18. The term "blowing meat" is explained in *The Manufacturer and Builder* 6 (Dec. 1874): 283 available online through the Cornell University "Making of America" at http://digital.library.cornell.edu/manu0006-12 (last accessed 9/28/07).

109. *Laws of Maryland*, 1751, chap. 21; Doyel, *Gone to Market*, 14–15; Radoff, *Buildings of the State*, 59–60, 111–112, 113.

110. *Laws of Maryland*, 1718, chap. 8; *Laws of Maryland*, 1742, chap. 22; *Laws of Maryland*, 1747, chap. 24; William K. Paynter, *St. Anne's Annapolis, History and Times* (Annapolis: St. Anne's Parish, 1980), 114; "Lot Histories," Parcel 5; Miller and Ridout, *Architecture in Annapolis*, 129–130. "Little use" quotation from *Laws of Maryland*, 1751, chap. 21; "three Lives" quote from *Laws of Maryland*, 1747, chap. 24.

111. "Lot Histories," Parcels 5, 6; *Maryland Gazette* 26 Aug., 2 Sept. 1762, 28 Apr. 1763; Joseph Towne Wheeler, "Booksellers and Circulating Libraries in Colonial Maryland," *MHM* 34 (1939): 113; Key, "A Notice of Some of the First Buildings," 269; Letzer and Russo, *The Diary of William Faris*, 18, 20, 89; *BDML* 2: 670 (Quynn). "Wits and the literary" quote from Key.

112. Paltsits, ed., *Journal of Benjamin Mifflin*, 11–12; Baker, "Annapolis, Maryland 1695–1730," 198; Francis Barnum Culver, *Blooded Horses of Colonial Days* (Baltimore: self-published, 1922), 26, 31; *Maryland Gazette*, 29 Sept. 1749, 26 Mar. 1752, 10 Sept. 1754, 23 Apr. 1761; Jane McWilliams, "From the *Maryland Gazette*," *Evening Capital* 25 Sept. 1971; John Eisenberg, "Off to the Races," *Smithsonian Magazine*, Aug. 2004 (http://www.smithsonianmagazine.com/history-archaeology/races.html, accessed 5/8/10). Gate description from Paltsits, 11–12; girls' race quoted from *Maryland Gazette*, 10 Sept. 1754.

113. Jean Russo, personal communications with author 27, 28 Sept. 2006; *Maryland Gazette*, 30 Sept. 1747, 28 Apr. 1763, 21 Feb. 1765, 2 Nov. 1769; Baltz, *Belair from the Beginning*, 19, 30,

38; Eisenberg, "Off to the Races"; *BDML* 2: 906 (Woodward); Culver, *Blooded Horses of Colonial Days*, 27–28, 33, 86.

114. Jane McWilliams, *"The Progress of Refinement": A History of Theatre in Annapolis* (Annapolis: Colonial Players of Annapolis, 1976), 1–2; Miller, "Chase-Lloyd House," 129; Hildebrand, "Musical Life in and around Annapolis," 36, 43, 112.

115. McWilliams, *"The Progress of Refinement,"* 2–3; Julia Cherry Spruill, *Women's Life and Work in the Southern Colonies* (1938; reprint New York: W. W. Norton, 1972), 260–261; *Maryland Gazette*, 8 May 1760. Mrs. Douglass's description from George O. Seilhamer, *History of the American Theatre before the Revolution* (Philadelphia: Globe Printing House, 1888), 221.

116. Hildebrand, "Musical Life in and around Annapolis," 127–130; Elaine G. Breslaw, ed., *Records of the Tuesday Club of Annapolis, 1745–56* (Urbana: University of Illinois Press, 1988), xiii–xxviii; *Maryland Gazette*, 10 May 1749; Robert R. Hare, "Electro Vitrifrico in Annapolis: Mr. Franklin Visits the Tuesday Club," *MHM* 58 (1963): 62–66; Robert Micklus, ed., *The History of the Ancient and Honorable Tuesday Club* (Chapel Hill: University of North Carolina Press for Institute of Early American History and Culture, Williamsburg, Va., 1990), xv–xxxiv; John Barry Talley, *Secular Music in Colonial Annapolis: The Tuesday Club, 1745–56* (Urbana: University of Illinois Press, 1988). Quotations from *Maryland Gazette*.

117. Micklus, *History of the Tuesday Club*, xvii; Hildebrand, "Musical Life in and around Annapolis," 69–70; letter from J. O. Belt, Jr., Annapolis, to Samuel Galloway, London, 17 Jan. 1749, in Galloway, Maxcy, Markoe Papers Cont. #1 Doc. 8086, Library of Congress, copy in Baltz Collection, [MSA SC 5224-2-6]; Edward T. Schultz, *History of Freemasonry in Maryland* (Baltimore: J. H. Medairy & Co., 1884), 1: 22–25; Baltz, *The Quays of the City*, 12.

118. Gregory A. Stiverson and Phebe R. Jacobsen, *William Paca, A Biography* (Baltimore: Maryland Historical Society, 1976), 37. Quotations from title page of Forensic Club minutes on 37.

119. Nancy T. Baker, "Some Notes on Taverns in Annapolis, Maryland, During the Colonial Period," (unpublished paper prepared for Historic Annapolis, Inc., 1981), 5; "Journal of William Black," 130.

120. Hildebrand, "Musical Life in and around Annapolis," 47–62, 89–91, 221–228; Paynter, *St. Anne's Annapolis*, 16; "Journal of William Black, 1744," 127; *Maryland Gazette*, 21 Feb. 1754, 6 Nov. 1755, 21 May 1760, 26 Apr. 1764. "English" guitar quote from Hildebrand, 57.

121. *Maryland Gazette*, 14 July 1747, 22 Feb. 1753; *Maryland Gazette*, 21 Feb. 1754; Riley, *"The Ancient City,"* 136; *Maryland Gazette*, 12 June 1766. Quotations from the newspapers cited for those years.

122. *Maryland Gazette*, 29 Sept. 1747, 29 Sept. 1749, 17 Feb. 1753, 10 Sept. 1754, 30 Oct. 1759, 10 June 1762, 19 May 1763, for

instance; Hildebrand, "Musical Life in and around Annapolis," 16, 89–91, 94–102.

123. Radoff, *Buildings of the State*, 48–51; *AOMOL* 44: 78–79, 50: 65, 58: 122–123, 59: 146–147; *Maryland Gazette*, 14 July 1747, 1 Nov. 1759, 29 Jan. 1761; Key, "A Notice of Some of the First Buildings," 264–265. Quotation from Key, 265.

124. *Maryland Gazette*, 28 Apr. 1763, 24 May, 15 Aug. 1764 (supplement); AALR, L. BB 3, f. 521, L. IB&JB 1, f. 29; Eddis, *Letters from America*, 20–21; Kann Partners, "Annapolis City Hall Historic Structure Report," prepared for the City of Annapolis, 12 Aug. 2009, section 1: 11–17. Lottery quotation from *Maryland Gazette*, 28 Apr. 1763; land use quotation from BB 3, f. 521; Eddis's words from *Letters*, 20–21. The ballroom site is now the location of City Hall. A portion of the original ballroom structure remains as part of the present nineteenth-century municipal building (Kann Partners, op. cit.).

125. Carolyn J. Weekley, "Portrait Painting in Eighteenth-Century Annapolis," *Antiques*, Jan. 1977, 345; Smithsonian Institution Research Information Systems (SIRIS) (online at www.siris.si.edu [last accessed 5/8/10]); National Portrait Gallery, Portrait Search (online at npgportraits.si.edu [last accessed 1/15/08]).

126. Weekley, "Portrait Painting in Eighteenth-Century Annapolis," 345–348, 352; *Maryland Gazette*, 15 Mar. 1753.

127. Weekley, "Portrait Painting in Eighteenth-Century Annapolis," 346–347, 349; Richard Keith Doud, "John Hesselius: His Life and Work," (M.A. thesis, University of Delaware, 1963), viii, 5–22, 116; *BDML* 2: 906 (Woodward). Hesselius's subjects included Horatio Sharpe, Thomas Johnson, Anthony Stewart, and Eleanor, Elizabeth, and Charles, the children of Benedict Calvert (Smithsonian Institution Research Information Systems [SIRIS] [online at siris-artinventories.si.edu], last accessed 4/29/10).

128. Anne Arundel Inventory File, Walsh et al., "A Study in Urban Development."

129. Key, "A Notice of Some of the First Buildings," 259, 263–264; James Haw, Francis F. Beirne, Rosamond R. Beirne, and R. Samuel Jett, *Stormy Patriot: The Life of Samuel Chase* (Baltimore: Maryland Historical Society, 1980), 14–15. Quotations from Key, 264. Rebecca Key may have been recalling a story of this event told by her father, John Campbell, who was a beneficiary of the Jennings-Chase effort.

130. Annapolis Corporation Officers, 1708–1730, and Annapolis Corporation Officers, 1745–1767, in book files; *BDML*, vols. 1 and 2; Owings, *His Lordship's Patronage*; and Paynter, *St. Anne's Annapolis*.

131. Neil Strawser, "Samuel Chase and the Annapolis Paper War," *MHM* 57 (1962): 181–182.

132. Ibid., 182–183; *BDML* 1: 184 (B. Calvert), 2: 854 (Wallace); *Maryland Gazette*, passim for other common councilmen; "Annapolis Corporation Officers, 1745 to 1767," in book files.

133. Haw et al., *Stormy Patriot*, 15–16; *BDML* 2: 670

(Quynn); Strawser, "Samuel Chase and the Annapolis Paper War," 183–184; Barker, *Background of the Revolution*, 332; Letterbook of Dr. Alexander Hamilton, 1739 to 1744, MHS Dulany Papers MS 1265, quoted in Baltz Collection, [MSA SC 5224] box 4, folder 16; *Maryland Gazette*, 19 Apr. 1749 mentioned in Baker, "Some Notes on Taverns in Annapolis," 6; Miller, *Papers of Charles Willson Peale*, 37–38; *BDML* 2: 773 (Steuart); *Maryland Gazette*, 29 Nov. 1764. "Cudgelling" quote from Hamilton's letterbook; Peale's words from Barker. George Steuart was appointed to the governor's council in 1769. Elections at this time were held "vive voce," or by oral vote (Richard E. Israel, personal communication, 2 Sept. 2007).

134. *Maryland Gazette*, 14 Feb. 1765; *BDML* 1: 146 (Bordley), 184 (Calvert); Strawser, "Samuel Chase and the Annapolis Paper War," 184–185; Papenfuse, *In Pursuit of Profit*, 80, 144; Key, "A Notice of Some of the First Buildings," 259. Strawser identifies Harris as a grocer, but Papenfuse correctly counts him as a blacksmith.

135. *Maryland Gazette*, 11, 18 Apr. and passim to 22 Aug. 1765; Paul H. Giddens, "Maryland and the Stamp Act Controversy," *MHM* 27 (1932): 79–83; Barker, *Background of the Revolution*, 297–299; Haw et al., *Stormy Patriot*, 17–18. "Droop" quote from *Maryland Gazette*, 18 Apr. 1765.

136. Giddens, "Maryland and the Stamp Act," 83–84; *Maryland Gazette*, 29 Aug. 1765. All quotes from the newspaper account of the event.

137. *Maryland Gazette*, 5 Sept. 1765; *AOMOL* 14: 221–226; "Lot Histories," Parcel 12, Sect. III; *AOMOL* 61: lvi, 119, 184, 189–191; Haw et al., *Stormy Patriot*, 18. Description of event from newspaper; Sharpe's words from *AOMOL* 14: 221; damage quote from *AOMOL* 61: 189. Years later, with his business ruined and his presence unwelcome in Maryland, the sad, discouraged Zachariah Hood begged support from the Lords of the Treasury from his new home in the West Indies ("Resistance to Stamp Act," *MHM* 4 [1909]: 138–139).

138. *AOMOL* 14: 226–227; Giddens, "Maryland and the Stamp Act," 90–91; Land, *The Dulanys of Maryland*, 260–261. Hat's sign from *AOMOL* 14: 226.

139. *AOMOL* 14: 221; Giddens, "Maryland and the Stamp Act," 86–90; Ronald Hoffman, *A Spirit of Dissension: Economics, Politics, and the Revolution in Maryland* (Baltimore: Johns Hopkins University Press, 1973), 50–54; Land, *The Dulanys of Maryland*, 262–267; "Considerations on the Propriety of Imposing Taxes in the British Colonies, For the Purpose of Raising a Revenue, by Act of Parliament," *MHM* 6 (1911): 376–406, *MHM* 7 (1912): 26–58. "Lively," "powerful" from Land, 262; Dulany's argument from Land, 265.

140. *Maryland Gazette*, 10, 17, 23, 31 Oct., 10 Dec. 1765, 30 Jan., 20 Feb., 6 Mar., 3 and 10 Apr. 1766; Giddens, "Maryland and the Stamp Act," 92–95; Barker, *Background of the Revolution*, 308–311; Haw et al., *Stormy Patriot*, 19–21; Hoffman, *Princes of Ireland*, 283. Quotation re *Hawke* from *Maryland*

Gazette, 30 Jan. 1766; Carrollton's words from Hoffman; repeal reaction from *Maryland Gazette*, 10 Apr. 1766.

141. Giddens, "Maryland and the Stamp Act," 96; Chase letter to Messrs Walter Dulany, M. Macnemara, Geo. Steuart, John Brice, U. Scott, dated 16 July 1766 and printed as a handbill (bound between the years 1766 and 1767 in the original volume of the *Maryland Gazette* for those years at the Maryland State Archives MSA SC 2731; it is not included in the microfilm or online versions of the paper). Chase's words from handbill 16 July 1766.

142. *Maryland Gazette*, 13 Mar. 1766; Strawser, "Samuel Chase and the Annapolis Paper War," 181–182, 188–189. "Civic protest" quote from Strawser, 182; all other quotations from "Remonstrance" in *Maryland Gazette*, 13 Mar.

143. *Maryland Gazette*, 20, 27 Mar., 1, 8, 22 May, 19 June 1766; Strawser, "Samuel Chase and the Annapolis Paper War," 190–191; Haw et al., *Stormy Patriot*, 22–24; Chase handbill (see n. 141) 16 July 1766. Insults to Chase from *Maryland Gazette*, 19 June. Chase's words from his handbill. Under Chase's name on the last page is written, "This was NOT Printed by JGreen."

144. Strawser, "Samuel Chase and the Annapolis Paper War," 191–194; Haw et al., *Stormy Patriot*, 24; City Officer database in book files; AN MAC (Bylaws and Ordinances) 1768–1791 [MSA M54-1], 1–31, for instance. Chase's property qualifications for common councilman were challenged by the Mayor's Court, but their decision that he was ineligible was ignored by the voters (Strawser, 193). Jonas Green advertised his publication of the city's charter and bylaws in 1751, but no copy is known to exist (Wroth, *History of Printing in Colonial Maryland*, 199).

Chapter 3. Annapolis and the Nation, 1764 to 1790

1. For use of "golden age," see, for instance, Harrison Rhodes, "Annapolis and Annapolitans," *Harpers Magazine* 138 (Apr. 1919); William Oliver Stevens, *Annapolis, Anne Arundel's Town* (New York: Dodd, Mead, 1937), 92; Aubrey Land in the introduction to William Eddis, *Letters from America*, ed. Aubrey C. Land (Cambridge: Belknap Press of Harvard University Press, 1969), xxiv; George B. Tatum, "Great Houses from the Golden Age of Annapolis," *Antiques* 111 (1977), 174–185; Marcia Myrl Miller, "The Chase-Lloyd House" (M.A. thesis, George Washington University, 1993), 13n; Peter B. Potter, Jr., *Public Archaeology in Annapolis: A Critical Approach to History in Maryland's Ancient City* (Washington, D.C.: Smithsonian Institution Press, 1994), 74; Mark B. Letzer and Jean B. Russo, *The Diary of William Faris* (Baltimore: Maryland Historical Society, 2003), 3.

2. Eddis, *Letters from America*, xii, 13, 20. "Polished society" and "modern edifices" quotations from 13; "handsome women" from 20.

3. Jonathan Boucher, *Reminiscences of an American Loyalist, 1738-1789* (1925; reprint, Port Washington, N.Y.: Kennikat Press, 1967), 65.

4. Edward C. Papenfuse, *In Pursuit of Profit: The Annapolis*

Merchants in the Era of the American Revolution, 1763-1805 (Baltimore: Johns Hopkins University Press, 1975), 16–34; Jean Russo, "Economy of Anne Arundel County," in Lorena S. Walsh, Nancy T. Baker, Lois Green Carr, Jean B. Russo, M. G. Harris, "Annapolis and Anne Arundel County, Maryland: A Study of Urban Development in a Tobacco Economy, 1649–1776," National Endowment for the Humanities Grant RS-20199-81-1955 [MSA SC 4396], 29, 34 (hereinafter, whole work cited as Walsh et al., "A Study in Urban Development"); Lorena S. Walsh, "Annapolis as a Center of Production and Consumption," in Walsh et al., "A Study in Urban Development," 10–11.

5. Marcia M. Miller and Orlando Ridout V, eds., *Architecture in Annapolis: A Field Guide* (Newark, Del.: Vernacular Architecture Forum, and Crownsville, Md.: Maryland Historical Trust, 1998), 147–149; Donnell M. Owings, *His Lordship's Patronage: Officers of Profit in Colonial Maryland* (Baltimore: Maryland Historical Society, 1953) and online at *AOMOL* 662: 86, 176, 185; Robert Harry McIntire, *Annapolis, Maryland, Families*, 2 vols. (Baltimore: Gateway Press, 1980, 1989), 1: 625; Donna M. Ware, *Anne Arundel's Legacy* (Annapolis: Anne Arundel County, 1990), 73–74.

6. *BDML* 1: 164 (James Brice), 165 (John Brice), 197 (Carrollton), 214 (Chase), 395 (Hammond), 2: 632 (Paca), 691 (Ridout); Miller and Ridout, *Architecture in Annapolis*, 40–43, 131.

7. *BDML* 1: 164 (James Brice), 165 (John Brice), 197 (Carrollton), 214 (Chase), 395 (Hammond), 2: 632 (Paca), 691 (Ridout).

8. Jean B. Russo, *William Paca's Education: The Making of an Eighteenth-Century Gentleman and American Patriot* (Annapolis: HAF, 1999), i–ii. For many years Paca's principal biographers, Gregory A. Stiverson and Phebe R. Jacobsen, authors of *William Paca: A Biography* (Baltimore: Maryland Historical Society, 1976), and Jean B. Russo believed that Paca had studied law at London's Inns of Court. Recent research by Russo and Stiverson has led them to conclude that, although Paca may have planned to study in England, he never did (Jean B. Russo, personal communication to author, 30 Aug. 2007).

9. *BDML* 1: 164 (James Brice), 214 (Chase), 395 (Hammond).

10. *BDML* 1: 214 (Chase), 534–537 (Lloyds); James Haw, Francis F. Beirne, Rosamond R. Beirne, and R. Samuel Jett, *Stormy Patriot: The Life of Samuel Chase* (Baltimore: Maryland Historical Society, 1980), 9–16; Miller, "The Chase-Lloyd House," vi–viii, 74–75; Miller and Ridout, *Architecture in Annapolis*, 60.

11. Miller and Ridout, *Architecture in Annapolis*, 24–27, 136–139, 173–174; *BDML* 1: 99 (Adams), 2: 914 (Worthington); William V. Elder, "The Adams-Kilty House in Annapolis," *MHM* 60 (1965): 314–324; *Votes and Proceedings of the House*, Nov. 1785 [MSA SC M3197], 139. What happened to John Griffith's house, now 179 Duke of Gloucester Street, will be described in Chapter 6 of this book. Quotation from Miller and Ridout, 24.

12. Miller and Ridout, *Architecture in Annapolis*, 21–22, 161–162; Papenfuse, *In Pursuit of Profit*, 18; "Lot Histories," Parcel 25, Sects. I, III, Parcel 6, Sect. III; Morris L. Radoff, *Buildings of*

the *State of Maryland in Annapolis* (Annapolis: Hall of Records Commission, 1954), 71–72; Ware, *Anne Arundel's Legacy*, 103. Ferguson's house is now 30 West Street. Rutland's houses are 207 Hanover Street and 9 Maryland Avenue.

13. Papenfuse, *In Pursuit of Profit*, 53; Provincial Court Land Records, L. DD 5 [MSA S552-28], f. 35; Phebe and Bryce Jacobsen, "Cornhill/Fleet Street Lots," in "Lot Histories," Parcels 13, 14, 15; AN MCT (Land Records) 1721–1783, L. B [MSA M41-1], fs. 334, 336, 338, for instance; Miller and Ridout, *Architecture in Annapolis*, 179–184. The story of Bordley's alleged title is recounted in Chapter 2 of this volume.

14. Victor Hugo Paltsits, ed., *Journal of Benjamin Mifflin, the Record of a Tour from Phila to Delaware and Maryland, July 26 to August 14, 1762* (New York: New York Public Library, 1935), 13; "Journal of an Officer [Lord Adam Gordon] Who Travelled in America and the West Indies in 1764 and 1765," in Newton D. Mereness, *Travels in the American Colonies* (New York: Antiquarian Press, 1961), 408. "Antiquated" quote from Mifflin; "decay" quote from Gordon's journal.

15. Rufus Rockwell Wilson, ed., *Burnaby's Travels through North America* (3rd ed. 1798; reprint, New York: A. Wessells Co., 1904), 81; Radoff, *Buildings of the State*, 52–53, 81–85. "Indifferent" quote from Burnaby; Jefferson's words quoted by Radoff, 52; "Stadt" from the law, quoted in Radoff, 81.

16. Radoff, *Buildings of the State*, 52–53; Hanson's *Laws of Maryland*, AOMOL 203: 39–41; *AOMOL* 63: 78, 86–88; *Maryland Gazette*, 14 Oct. 1773 ; AN MCT (Minutes) 1789–1790 [MSA M44-10], 15, 28, 29; Auditor General (Day Book) 1785–1786 [MSA S149-2], 102; Annapolis Treasurer (Ledger) 1761–1788 [MSA M 69-1], 7, 15, 20. The structure on Duke of Gloucester Street built by public subscription in the 1760s was known over the years as Assembly Rooms or Ball Room, generally depending on its use at the time.

17. Among them: Radoff, *Buildings of the State*, 81–105; Morris L. Radoff, *The State House at Annapolis* (Annapolis: Hall of Records Commission, Publication No. 17, 1972), 1–25; Miller and Ridout, *Architecture in Annapolis*, 95–99; Rosamond Randall Beirne, "Two Anomalous Annapolis Architects: Joseph Horatio Anderson and Robert Key," *MHM* (1960): 183–200; Miller, "The Chase-Lloyd House," 18–19, 76, 116; Rosamond Randall Beirne, "The Chase House in Annapolis." *MHM* 49 (1954): 177–195; Rosamond Randall Beirne, "William Buckland, Architect of Virginia and Maryland." *MHM* 41 (1946): 199–218; Edith Rossiter Bevan, comp. "Early Architects and Craftsmen in Annapolis," unpublished manuscript, 1947; Barbara Allston Brand, *Hammond-Harwood House* ([Annapolis]: Hammond-Harwood House Assoc., 1979); Deering Davis, *Annapolis Houses, 1700-1775* (New York: Bonanza Books, 1947); Effingham C. Desmond, *A Pre-revolutionary Annapolis House — Part One: Designed by Matthew Buckland for Matthias Hammond, Esq.* (Russell F. Whitehead, ed., Monograph Series Recording the Architecture of the American Colonies and the Early Republic (New York:

Russell F. Whitehead, 1929) vol. 15, no. 4, p. 87; R. T. H. Halsey, *A Pre-revolutionary Annapolis House — Part Two: Designed by Matthew Buckland for Matthias Hammond, Esq.* (Whitehead, ed., The Monograph Series Recording the Architecture of the American Colonies), vol. 15, no. 5, p. 115; Mrs. Rebecca Key, "A Notice of Some of the First Buildings with Notes of Some of the Early Residents," *MHM* 14 (1919): 258–271.

18. Miller, "The Chase-Lloyd House," 76, 122–124; Beirne, "William Buckland," 211–217; Radoff, *The State House at Annapolis*, 3–4; Elder, "Adams-Kilty House," 317, 321–324; Miller and Ridout, *Architecture in Annapolis*, 27; Marcia Miller, personal communication, 12 May 2010.

19. *Maryland Gazette*, 22 June 1769, 10 Jan., 14 Feb. 1771, 23 July 1772 (dates of ads in the *Maryland Gazette*); Jean B. Russo, "'The Fewnesse of Handicraftsmen:' Artisan Adaptation and Innovation in the Colonial Chesapeake," in Robert Olwell and Alan Tully, eds., *Cultures and Identities in Colonial British America* (Baltimore: Johns Hopkins University Press, 2006), 182–183; Miller, "The Chase-Lloyd House," 102. Hepbourne quote from *Maryland Gazette* 22 June 1769.

20. Lorena S. Walsh, "Town and County Population Growth" in Walsh et al., "A Study in Urban Development," 10–11. Quotation from 11.

21. Stephen E. Patrick, "'I would not begrudge to give a few pounds more': Elite Consumer Choices in the Chesapeake, 1720–1785: The Calvert House Ceramic Assemblage," (M.A. thesis, College of William and Mary, 1990), 67.

22. Russo, "The Fewnesse of Handicraftsmen," 193–194. Quotation from 194.

23. *Maryland Gazette*, 19 Feb. 1767, 19 Nov. 1772, 23 May 1771, 21 July 1768, 7 Sept. 1769, 19 Aug. 1773, 28 Apr. 1774, 3 Oct. 1772, 10 Dec. 1772; Letzer and Russo, *The Diary of William Faris*, 21; "Lot Histories," Parcel 6, Sect. II (Claude), and Parcel 13, 45 Cornhill (Hepbourne), for instance.

24. *Maryland Gazette*, 30 July 1767, 1 Feb. 1770, 28 Feb. 1769, 10 Feb. 1774, 16 Dec. 1773; Miller, "The Chase-Lloyd House," 113, 127–129; Walsh, "Town and County Population," 6, 10; Russo, "The Fewnesse of Handicraftsmen," 194; Papenfuse, *In Pursuit of Profit*, 25.

25. Naval Officer Port of Entry Records, Port of Annapolis [MSA SC 5458-45-99], transcription and analysis by John F. Wing, 2009; John Wing, personal communication, 6 July 2009. At this time the Annapolis district covered the Western Shore from West River north and around the head of the Bay to include the Chester River (John Wing, personal communication, 11 May 2010).

26. *Maryland Gazette*, 22 Oct. 1767, 30 Aug. 1770, 15 Jan. 1767, 29 July 1773, 2 Apr. 1767, 26 Sept. 1771, 24 Sept. 1772, for instance. Ads for imported European and East Indian goods appear in almost every issue of the paper between the late 1760s and 1775.

27. Patrick, "Elite Consumer Choices in the Chesapeake," 56–

60; Ronald Hoffman, *Princes of Ireland, Planters of Maryland: A Carroll Saga, 1500–1782* (Chapel Hill: University of North Carolina Press for Omohundro Institute of Early American History and Culture, Williamsburg, Va., 2000), 215–217. Quotes from Hoffman, 216.

28. Papenfuse, *In Pursuit of Profit*, 53–73. Cornhill Street, the center of Wallace's new subdivision, joins Fleet Street just above Market Space.

29. Lillian B. Miller, ed., *The Selected Papers of Charles Willson Peale and His Family*, 5 vols. (New Haven: Yale University Press for the National Portrait Gallery, Smithsonian Institution, 1983) 1: xlix–li, 32–78, 133–134, 147, plate 2; Robert J. H. Janson-LaPalme, "Generous Marylanders: Paying for Peale's Study in England," in Lillian B. Miller and David C. Ward, eds., *New Perspectives on Charles Willson Peale: A 250th Anniversary Celebration* (Pittsburgh: University of Pittsburgh Press for the Smithsonian Institution, 1991), 11–27; F. Edward Wright, *Anne Arundel County Church Records of the 17th and 18th Centuries* (Westminster, Md.: Family Line Publications, n.d.), 51; *Maryland Gazette*, 28 Apr. 1763; Charles Coleman Sellers, *Portraits and Miniatures by Charles Willson Peale* (Philadelphia: American Philosophical Society, 1952, reprinted 1968), 36–38, 71, 278–281, 288–289; Karol A. Schmiegel, "'Encouragement Exceeding Expectation': The Lloyd-Cadwalader Patronage of Charles Willson Peale," in Lillian B. Miller and David C. Ward, eds., *New Perspectives on Charles Willson Peale*, 51, 54; Jane McWilliams, "From the Pages of the *Maryland Gazette*," *Evening Capital*, 9 Sept. 1972 (hereinafter, McWilliams column, *Evening Capital*, date). Both Lillian Miller (57n) and Janson-LaPalme (15) identify the "Charles Carroll Esq." on Peale's list of subscribers as Carrollton. It could have been Charles Carroll of Annapolis.

30. *Maryland Gazette*, 8, 15, 22 Sept., 6 Oct. 1774; Schmiegel, "Encouragement Exceeding Expectation," 64.

31. Papenfuse, *In Pursuit of Profit*, 29; David K. Hildebrand, "Musical Life in and around Annapolis, Maryland, 1649–1776" (PhD. diss., Catholic University of America, 1992), 108–110; Jane McWilliams, *"The Progress of Refinement": A History of Theatre in Annapolis* (Annapolis: Colonial Players of Annapolis, 1976), 2–3; *Maryland Gazette*, 4, 11 May, 2 Nov. 1769; John Eisenberg, "Off to the Races," *Smithsonian Magazine*, Aug. 2004 , 6.

32. *Maryland Gazette*, 6 Sept., 4 Oct. 1770, 17 June 1771; Eddis, *Letters from America*, xii, 48–49. Eddis quote from *Letters*, 48.

33. Rosamond Randall Beirne, "Portrait of a Colonial Governor: Robert Eden, I — His Entrance, II — His Exit," *MHM* 45 (1950): 158.

34. *Maryland Gazette*, 17 June, 5, 12, 23 Sept., 1771; "Lot Histories," Parcel 4, Sect. II, IV; Eddis, *Letters from America*, 20–21, 54–55; McWilliams, *"The Progress of Refinement,"* 4–6; Martha A. Chidsey, "The West Street Theatre, Annapolis, Maryland: 1771–1774" (Master's thesis, American University, Washington,

D.C., 1977). Eddis quote from *Letters*, 55, Green quote from *Maryland Gazette*, 12 Sept. 1771.

35. Boucher, *Reminiscences of an American Loyalist*, 65–66; Donald Jackson and Dorothy Twohig, eds., *The Diaries of George Washington*, 6 vols. (Charlottesville: University Press of Virginia, 1978) 3: 54–57; Capt. H. A. Baldridge, USN, "Washington's Visits to Colonial Annapolis," *U.S. Naval Institute Proceedings* 54 (Feb. 1928): 97. Quote re no room from Washington diaries, 55.

36. *Maryland Gazette*, 1 Sept., 1, 8 Oct. 1772; *History of Queen's County* (New York: W. W. Munsell & Co., 1882), 57–59; *New York Times*, 23 July 1876; Jackson and Twohig, *Diaries of George Washington* 3: 136–137; Baldridge, "Washington's Visits to Colonial Annapolis," 99.

37. Jackson and Twohig, *Diaries of George Washington* 3:205–206, 208; Baldridge, "Washington's Visits to Colonial Annapolis," 100; "Lot Histories," Parcel 25, Sect. IV. Jackson and Twohig place Washington's dinner with Sprigg at Strawberry Hill, but it is more likely that they dined at Sprigg's town house, which he had purchased from Hamilton's widow the previous year (see lot histories cited). Sprigg didn't get title to Strawberry Hill, on the west side of the mouth of College Creek, until 1780, although he occupied the land as early as 1777 (Provincial Court Land Records, L. DD 5 [MSA S552-28], f. 483; *AOMOL* 16: 128). Hamilton's house no longer exists; the location is now almost certainly within Naval Academy grounds (Glenn Campbell, personal communication, 29 Jan. 2008). Henrietta Margaret Ogle's nickname from Shirley V. Baltz, *Belair from the Beginning* (Bowie, Md.: City of Bowie Museums, 2005), 46.

38. Thomas T. Waterman, Washington Reed, Milton L. Grigg, and Howard Dearstyne, *Grissell Haw Lodging House Architectural Report, Block 29, Building 1 . . .* , rev. ed., Colonial Williamsburg Foundation Library Research Reports, no. 1560 (Williamsburg: Colonial Williamsburg Foundation, 1951, Colonial Williamsburg Digital Library, http://research.history.org/CWDigitalLibrary/RR1560.xml, accessed 5/12/10); *Maryland Gazette*, 16 Sept., 7 Oct. 1773; *Virginia Gazette*, 14 Jan. 1773. Baker's profession from *Maryland Gazette*, 16 Sept.; dentifrice quote from *Virginia Gazette*. McGinnis quotation from *Maryland Gazette*, 7 Oct.

39. *Maryland Gazette*, 19 Aug., 30 Sept., 7 Oct. 1773. Quotation from the *Gazette*, 19 Aug. For all Graham's advertised professional training and success, he was better known later for his trickery. "One of the most impudent quacks that ever lived," said a writer in the *British Medical Journal* in 1911. Apparently the medical education Graham advertised did not include a degree, and his unsubstantiated claims offended the legitimate medical community. After Graham's return to England in 1774, his public demonstrations with electrical machines, milk baths, earth baths, and other unusual treatments developed into obsessions that eventually caused him to be confined to his home in Edinburgh as a lunatic (William Read, "Some Notable Quacks,"

British Medical Journal (1911) 1: 1270; *Dictionary of National Biography* 22 [1890]: 323).

40. AN MAC (Bylaws and Ordinances) 1768–1791 [MSA M54-1], 45; *Maryland Gazette*, 11 Aug. 1768, 5 July, 4, 18 Oct. 1770.

41. *Maryland Gazette*, 28 Feb., 14 , 28 Mar., 12 Sept. 1771, 19 Nov., 17 Dec. 1772. Tootell's words in *Maryland Gazette*, 19 Nov. 1772.

42. Eddis, *Letters from America*, 21; *Maryland Gazette*, 17 Dec. 1772. "Poor Box" quote from *Maryland Gazette*.

43. *Laws of Maryland*, 1768, chap. 29; *AOMOL* 61: xcv–xcvi; *Laws of Maryland*, 1771, chap. 36; AALR, L. IB 3, f. 290; Tony Lindauer, communications to author, 28 and 31 Aug. 2002; Michael P. Parker, *Presidents Hill: Building an Annapolis Neighborhood, 1664–2005, Annapolis, Maryland* (Annapolis: Annapolis Publishing, 2005), 3; *Laws of Maryland*, 1773, chap. 9, in William Kilty, ed., *Laws of Maryland* (Annapolis: Frederick Green, 1799–1800) [MSA SC M3150]. Quote from 1768 law. Lindauer located the poor house at the corner of West Street and Taylor Avenue on land now part of the National Cemetery.

44. *Maryland Gazette*, 1 Oct., 3 Dec. 1767, 30 July 1772, 29 Apr. 1773; Joseph Towne Wheeler, "Booksellers and Circulating Libraries in Colonial Maryland," *MHM* 34 (1939): 118; Lawrence C. Wroth, *A History of Printing in Colonial Maryland, 1686–1776* (Baltimore: Typothetae of Baltimore, 1922), 128–129; an original first issue of William Goddard's paper is in the Ridout Papers, [MSA SC 910], box 20, folder17. Quotations on Tonry businesses from *Maryland Gazette*, 29 Apr. 1773.

45. Eddis, *Letters from America*, 13, 49–50. Eddis quote from 49.

46. For discussions of the politics of the period in Maryland, see especially Charles Albro Barker, *The Background of the Revolution in Maryland* (New Haven: Yale University Press, 1940; reprinted, n.p.: Archon Books, 1967), and Ronald Hoffman, *A Spirit of Dissension: Economics, Politics, and the Revolution in Maryland* (Baltimore: Johns Hopkins University Press, 1973).

47. Josephine Fisher, "Bennet Allen, Fighting Parson," *MHM* 38 (1943): 299–322 and *MHM* 39 (1944): 49–72; Bennett Allen to Lord Baltimore, 7 Jan. 1767, Calvert Papers #1302, MHS [MSA SC 422; M 208]; Aubrey C. Land, *The Dulanys of Maryland* (Baltimore: Johns Hopkins Press, 1968; originally published by MHS, 1955), 280–284, 328–329; William K. Paynter, *St. Anne's Annapolis, History and Times* (Annapolis: St. Anne's Parish, 1980), 22; David C. Skaggs, "Editorial Policies of the *Maryland Gazette*, 1765–1783" *MHM* 59 (1964): 345. Quote from Fisher, "Bennet Allen, Fighting Parson," *MHM* 39: 52.

48. Barker, *Background of the Revolution*, 313– 321; *Maryland Gazette*, 11 May 1769.

49. "Correspondence of Governor Eden," *MHM* 2 (1907): 227–229. Eden's words from 228.

50. Barker, *Background of the Revolution*, 321–323; Hoffman, *A Spirit of Dissension*, 84–89; Daniel Dulany, "Considerations on the Propriety of Imposing Taxes in the British Colonies, For the Purpose of Raising a Revenue, by Act of Parliament," *MHM* 7 (1912): 48–51; *Maryland Gazette*, 29 June 1769; *BDML* 1: 195 (Carroll, Barrister), 276 (Dorsey), 2: 912 (Worthington). Copies of letters and resolutions regarding nonimportation meetings in May and June 1769, including the names of the men who attended the meeting 20–22 June are printed in Appendix 1, *Proceedings and Acts of the General Assembly, AOMOL* 62: 457–462. Dulany's words from "Considerations," 48–49; initial quote, description of enemies, and boycott exemptions quoted from newspaper.

51. Barker, *Background of the Revolution*, 323–327; Hoffman, *A Spirit of Dissension*, 90–91; *Maryland Gazette*, 28 Sept. 1769, 1, 15, 23 Feb. 1770. Quotes from Dick and Stewart from newspaper, 15 Feb. 1770.

52. Barker, *Background of the Revolution*, 345– 369; Owings, *His Lordship's Patronage, AOMOL* 662: 14–18; Hoffman, *A Spirit of Dissension*, 92–125; Skaggs, "Editorial Policies of the *Maryland Gazette*," 343–345; Land, *The Dulanys of Maryland*, 301– 304; Hoffman, *Princes of Ireland*, 287–292; Peter S. Onuf, ed., *Maryland and the Empire, 1773, The Antilon–First Citizen Letters* (Baltimore: Johns Hopkins University Press, 1974).

53. Glenn E. Campbell, "The Comic Start and Tragic End of the Homony Club," paper delivered at the conference on "Public and Private Diversions in the Eighteenth Century," East-Central American Society of Eighteenth-Century Studies, U.S. Naval Academy, 27–30 Oct. 2005; Glenn E. Campbell, interview with author, 8 June 2006. Campbell quote from his 2005 paper.

54. Boucher, *Reminiscences of an American Loyalist*, 67.

55. *Maryland Gazette*, 13, 20, 27 May 1773; Barker, *Background of the Revolution*, 365–366; *BDML* 1: 395 (Hammond); McWilliams, column, *Evening Capital*, 22 Dec. 1973. Quote from "tradesman" from newspaper 13 May; description of city election and parade from the 20 May issue; county parade quote from 27 May issue.

56. *Maryland Gazette*, 30 Dec. 1773 and passim; Barker, *Background of the Revolution*, 368–369; Aubrey C. Land, *Colonial Maryland, A History* (Millwood, N.Y.: KTO Press, 1981), 296; Eddis, *Letters from America*, 78; Radoff, *Buildings of the State*, 20–21; *Maryland Gazette*, 5 Sept. 1771; Boucher, *Reminiscences of an American Loyalist*, 66; *Laws of Maryland*, 1774, chap. 11. Poem quotes from *Maryland Gazette*, 5 Sept. 1771; pew placement from 1774 law.

57. Miller and Ridout, *Architecture in Annapolis*, 81–84, 210; Miller, "The Chase-Lloyd House," 33–34, 143; *Maryland Gazette*, 17 Feb., 3 Mar. 1774. Hammond house quote from Miller and Ridout, 81.

58. Philip Vicker Fithian, *Journal and Letters, 1767–1774*, edited by John Rogers Williams (1900; reprint, Freeport, N.Y.: Books for Libraries Press, 1969), 153.

59. *Maryland Gazette*, 19, 26 May 1774; Eddis, *Letters from America*, 85; Barker, *The Revolution in Maryland*, 369–370;

Hoffman, *Princes of Ireland*, 294–296; Land, *The Dulanys of Maryland*, 309–310. Meeting quotations from *Maryland Gazette*, 26 May.

60. *Maryland Gazette*, 2 June 1774. Among those opposing the resolution but later active in the patriot cause were William Tuck, James Brice, John Sands, John Chalmers, Thomas Sparrow, and Thomas Hyde (Henry C. Peden, Jr., *Revolutionary Patriots of Anne Arundel County, Maryland* [Westminster, Md.: Family Line Publications, 1992], passim).

61. *Maryland Gazette*, 9 June 1774.

62. *BDML* 1: 66–68; *Maryland Gazette*, 30 June 1774. All quotations from the newspaper.

63. *BDML* 1: 68. All quotations from that page.

64. Ernest M. Eller, "Chesapeake Bay in the American Revolution," in Ernest McNeill Eller, ed. *Chesapeake Bay in the American Revolution* (Centreville, Md.: Tidewater Publishers, 1981), 8; Hoffman, *A Spirit of Dissension*, 127–129. Hoffman describes the Lower House factions jockeying for power during this period.

65. Memorial of Richard Jackson, 10 Mar. 1777, in "The Burning of the 'Peggy Stewart,'" *MHM* 5 (1910): 238; Thomas Ringgold to Samuel Galloway, 25 Oct. 1774, "Account of the Destruction of the Brig 'Peggy Stewart' at Annapolis, 1774," *Pennsylvania Magazine of History and Biography* 25 (1901): 253 (copy in Baltz collection, [MSA SC 5224-4-12]) (I am indebted to Shirley Baltz for this and many other sources used in this account.); Anthony Stewart handbill dated 17 October 1774 available online through the Hammond Harwood House website: www.hammondharwoodhouse.org/ Tea%20Lesson.htm (accessed 5/18/10); Joshua Johnson, London, to [firm of] Wallace, Davidson & Johnson, Annapolis, 4 Aug. 1774, CHAN CT Papers, Exhibits [MSA S528-15] online at Edward C. Papenfuse and M. Mercer Neale, "From Indignant Protest to Hesitant Revolutionaries: Maryland and the American Revolution, 1765–1776," *Documents for the Classroom*, [MSA SC 2221-1-2]; Eddis, *Letters from America*, 91–97. Eddis includes an affidavit from Richard Jackson, dated 17 October 1774, explaining how shipping procedures in London could keep a captain ignorant of the contents of his ship's cargo. Stewart's "leaky" from his handbill.

66. For other examples of tea import and sale, see Wallace, Davidson & Johnson Order Books [MSA S528-27/28] 16 Oct. 1773, online at http://mdhistory.net/msaref06/wdj_order_bks/ html/wdj_order_bks-0174.html (accessed 6/8/07); *Maryland Gazette*, 5 Sept. 1771, 28 May 1772, 20 May 1773, for instance.

67. *Maryland Gazette*, 20, 27 Oct. 1774; Jackson memorial, "Burning of the 'Peggy Stewart,'" 239–240; Robert Caldeleugh memorial, 10 Mar. 1777, in "The Burning of the 'Peggy Stewart,'" *MHM* 5 (1910): 242–243.

68. *Maryland Gazette*, 20, 27 Oct. 1774; Caldeleugh memorial, "Burning of the 'Peggy Stewart,'" 241–243; John Galloway to Samuel Galloway, 20 Oct. 1774, "Account of the Destruction of the Brig 'Peggy Stewart' at Annapolis, 1774," *Pennsylvania Magazine of History and Biography* 25 (1901): 249–251 (in Baltz

collection, [MSA SC 5224-4-12]); "Lot Histories," Parcel 13, Sect. IV A; Alexander Hamilton, Piscataway, to James Brown & Co., Glasgow, 31 October 1774, in Richard K. MacMaster and David C. Skaggs, eds., "Letterbook of Alexander Hamilton," *MHM* 61 (1966): 318–319; James Parker, Norfolk, to Charles Steuart, 1, 5 Nov. 1774, in Fisher Transcripts, Maryland Historical Society, MS 360 (Baltz collection, [MSA SC 5224-4-12]); Memorial of Anthony Stewart, 10 Mar. 1777, in "The Burning of the 'Peggy Stewart,'" *MHM* 5 (1910): 236; Eddis, *Letters*, 96. John Galloway's words from his letter, 249; Stewart's fears from "Burning," 236. The Stewart residence was the brick house still standing at 207 Hanover Street, which was built by Thomas Rutland c. 1769 ("Lot Histories," Parcel 25, Sect. III).

69. John Galloway to Samuel Galloway, 20 Oct. 1774, in "Account of the Destruction of the 'Peggy Stewart,'" 250; Eddis, *Letters from America*, 96; Jackson memorial, "Burning of the 'Peggy Stewart,'" 240–241. Ringleaders quote from Jackson in "Burning," 240; Eddis's words and windmill point quote from *Letters*, 96; Jackson's words from "Burning," 241.

70. John Galloway to Samuel Galloway, 20 Oct. 1774, "Account of the Destruction of the 'Peggy Stewart,'" 250–251; Thomas Ringgold to Samuel Galloway, 25 Oct. 1774, ibid., 254; Alexander Hamilton, Piscataway, to James Brown & Co., Glasgow, 31 Oct. 1774, "Letterbooks of Alexander Hamilton," 319; *Maryland Gazette*, 20 Oct. 1774; Eddis, *Letters from America*, 96–97. Quotes from John's letter, 250, 251; Ringgold's words from his letter; Hamilton's words from his letter; Eddis's words from his *Letters*, 97.

71. Hoffman, *Princes of Ireland*, 299; *BDML* 1: 338 (Galloway), 2: 695 (Ringgold); Hoffman, *A Spirit of Dissension*, 136–137. Quote re Carroll's reaction from Hoffman, *Princes*, 299.

72. Stewart memorial, "Burning of the 'Peggy Stewart,'" 235–237; Mechelle Kerns-Nocerito, "The Burning of the *Peggy Stewart*: Annapolis's Own Tea Party," in C. Jane Cox, ed., *Anne Arundel County's Lost Towns Archaeology Project Research Reports* (prepared for the Annapolis Maritime Museum, 2005, and used with generous permission of the museum), 25; "Lot Histories," Parcel 25, Sect. III; *American National Biography* (New York: Oxford University Press, 1999) 20: 743 (Stewart). Stewart's valuation of the brig from "Burning," 237. There is some question as to whether *Peggy Stewart* had made a prior voyage. See William L. Calderhead, "The Riddle of the 'Peggy Stewart,'" *Anne Arundel County History Notes* 19 (July 1988): 5–6; and Melbourne Smith and Thomas C. Gillmer, "The Colonial Brig *Peggy Stewart*," *Nautical Research Journal* 19 (1972): 211–221. I am grateful to John Wing for the second source.

73. *Maryland Gazette*, 20 Oct., 3 Nov. 1774. All quotations from 3 Nov. newspaper.

74. *AOMOL* 78: 6.

75. Eddis, *Letters from America*, 98–100, 106–108; Beirne, "Portrait of a Colonial Governor," 162–165; *Maryland Gazette*, 5, 19 Jan., 13 Apr., 25 May, 24 Aug. 1775; *BDML* 1: 70; "Correspon-

dence of Governor Eden," *MHM* 2 (1907): 2–4. "Land of trouble" quote from Eddis, 98; Eden's words from "Correspondence," 3.

76. J. Thomas Scharf, *History of Maryland*, 3 vols. (1879; reprint, Hatboro, Pa.: Tradition Press, 1967), 2: 184–185 (and inset). Quotations from text of the "Association," are from the inset.

77. *Maryland Gazette*, 9 Nov. 1775; "Correspondence of Governor Eden," 100–103; Eddis, *Letters from America*, 123, 125. "Non-associators" from newspaper; "reasonable" men quote from Eddis, 123; "mad-headed" from Eden, 100. The Liberty Tree mentioned by both Eddis and Eden was, traditionally, the ancient tulip poplar on the St. John's College campus that was felled in Hurricane Floyd in September 1999. See Edward C. Papenfuse, "What's in a Name? Why Should We Remember? The Liberty Tree on St. John's College Campus, Annapolis, Maryland," remarks on the occasion of designating the Liberty Tree a Maryland Treasure by the Maryland Commission for Celebration 2000, at St. John's College, 3 June 1999 (available online at http://www.msa.md.gov/msa/educ/html/liberty.html, accessed 5/18/10).

78. *Maryland Gazette*, 13 July, 10, 17, 31 Aug. 1775; "Correspondence of Governor Eden," 9–13; Eddis, *Letters from America*, 116–120; Land, *The Dulanys of Maryland*, 316–319; Papenfuse, *In Pursuit of Profit*, 14.

79. Land, *The Dulanys of Maryland*, 318; *BDML* 1: 164–165 (James and John Brice); F. Wright, *Anne Arundel County Church Records*, 103, 104; Joshua Johnson to John Davidson, 4 Sept. 1773, in Jacob M. Price, ed., *Joshua Johnson's Letterbook, 1771–1774* (1979) online at http://www.british-history.ac.uk/report.asp?compid=38792 (accessed 5/18/10); "Lot Histories," Parcel 12, Sect. IV, Parcel 17, Sect. IV; HAF, *William Paca House and Garden* (brochure, n.d.). Elizabeth Brice Dulany's nickname is taken from Jacob Price's bracketed editorial insert, "B[etty] Brice," in his edition of Joshua Johnson's letters cited above. Her childhood home remains today at 195 Prince George Street.

80. *BDML* 1: 331 (Frisby), 2: 617 (Ogle); Miller and Ridout, *Architecture in Annapolis*, 110–112; Baltz, *Belair*, 53; Radoff, *Buildings of the State*, 20, 85–86; *Maryland Gazette*, 1 Sept. 1774; Paynter, *St. Anne's Annapolis*, 27, 35–36.

81. *BDML* 1: 197 (Carrollton), 2: 691 (Ridout); Hoffman, *Princes of Ireland*, 206, 212; Land, *The Dulanys of Maryland*, 294; Robert L. Worden, "The Gardens at the Charles Carroll House of Annapolis," *Magnolia* 10 (Winter 1993):1–5; Mark Leone, "The Relationship between Archaeological Data and the Documentary Record: Eighteenth Century Gardens in Annapolis, Maryland," *Historical Archaeology* 22: 29–35; Mark Leone, *The Archaeology of Liberty in an American Capital: Excavations in Annapolis* (Berkeley: University of California Press, 2005), 70–80. Molly Ridout's nickname from Baltz, *Belair*, 46; Molly Carroll's from *BDML* 1: 197 (Carrollton).

82. Fred Shelley, ed., "Ebenezer Hazard's Travels through Maryland in 1777," *MHM* 46 (1951): 49.

83. "Correspondence of Governor Eden," 9–13; Land, *The Du-*
lanys of Maryland, 317–318; *Maryland Gazette*, 7, 28 Sept. 1775, 18 Mar. 1776; Radoff, *The State House*, 8; David M. Ludlum, *Early American Hurricanes, 1492–1870* (Boston: American Meteorological Society, 1963), 26–27; Eddis, *Letters from America*, 122–123. Name of hurricane from Ludlum, 26. Ludlum said it followed a track similar to Hurricane Hazel's in 1954. Some years after the death of Lloyd Dulany, Elizabeth married his nephew Walter Dulany, Jr., whom she had come to know well in England. He described her in 1784 as "a most charming woman [whose] company is peculiarly delightful to me." They eventually returned to America (Elizabeth Hesselius Murray, *One Hundred Years Ago: or the Life and Times of the Rev. Walter Dulany Addison, 1769–1848* (Philadelphia: Geo. W. Jacobs & Co., 1895), 67–70. Quotation from 69.) Walter Dulany, Jr., died in Kent County, Delaware (AALR, L. NH 4, f. 540). There is no evidence that Edmund Brice and Alexander Hanson were Loyalists fleeing Annapolis. Hanson was back in Maryland in 1778 (*BDML* 1: 404 [Hanson]).

84. Wheeler, "Booksellers and Circulating Libraries," 126; "Lot Histories," Parcel 13, Sect. XII; "Correspondence of Governor Eden," 97–99; *Maryland Gazette*, 13 July 1775, 15 Feb. 1776; Eddis, *Letters from America*, 116–125, 127; Papenfuse, *In Pursuit of Profit*, 78; Land, *The Dulanys of Maryland*, 317. Eddis quote from his letters, 127.

85. Baltz, *Belair*, 53–54.

86. Muster Rolls, *AOMOL* 18: 5–17, 570; Miller, *Papers of Charles Willson Peale*, 1: li; Ann Jensen, *The World Turned Upside Down: Children of 1776* (Centreville, Md.: Tidewater Press, 2001), 23; Larry S. Mickel, "Sentinel of the Severn, The Fort at Horn Point, Annapolis, 1776–1866," (unpublished manuscript), 4–7. (An abbreviated version of Mickel's paper was published by the Eastport Historical Committee in 1990.) *The Compact Edition of the Oxford English Dictionary* (1971) defines "matross" in U.S. usage as an artillery private.

87. *Maryland Gazette*, 14 Mar. 1776; Journal and Correspondence of the Council of Safety, *AOMOL* 11: 141; Jane McWilliams and Morris L. Radoff, "Annapolis Meets the Crisis," in Ernest McNeill Eller, ed. *Chesapeake Bay in the American Revolution* (Centreville, Md.: Tidewater Publishers, 1981), 410–411; Eddis, *Letters from America*, 137–141; *AOMOL* 11: 218, 232–233, 236–238. Captain's orders from Eddis, 139; council's words from *AOMOL* 11: 233.

88. *AOMOL* 11: 233; McWilliams and Radoff, "Annapolis Meets the Crisis," 412; *AOMOL* 78: 150–152. Council's words from *AOMOL* 11: 233; Convention's words from *AOMOL* 78: 151, 152.

89. McWilliams and Radoff, "Annapolis Meets the Crisis," 412–414; Eddis, *Letters from America*, 149–154, 157–164; *AOMOL* 78: 168–169; *Maryland Gazette*, 27 June 1776. Hostage quote and Eddis's words from *Letters*, 158, 159; Council's orders from *AOMOL* 78: 169; Montagu's instructions quoted in McWilliams and Radoff, 412–413.

90. Haw et al., *Stormy Patriot*, 67–68; Hoffman, *Princes of Ireland*, 307; David McCullough, *1776* (New York: Simon & Schuster, 2005), 112; Land, *Colonial Maryland*, 315–316. Quotation from Land, 315.

91. "America During the Age of Revolution, 1776–1789," page for 1776, American Memory, Library of Congress (http://memory.loc.goc/ammem/collections/continental/timelin2.html, accessed 5/13/10); Suzanne Ellery Green Chapelle, Jean H. Baker, Dean R. Esslinger, Whitman H. Ridgway, Jean B. Russo, Constance B. Schulz, and Gregory A. Stiverson, *Maryland, A History of Its People* (Baltimore: Johns Hopkins University Press, 1986), 65–69; Hoffman, *Princes of Ireland*, 301, 308–310. Quotation about independent states from American Memory.

92. *Maryland Gazette*, 11 July 1776.

93. McWilliams and Radoff, "Annapolis Meets the Crisis," 414–416; *AOMOL* 11: 145; *AOMOL* 12: 235–236; Mickel, "Sentinel of the Severn," 11–20; Radoff, *Buildings of the State*, 20. Mickel believed that hostility from residents caused several matross officers to transfer or resign, see specifically 13–14, 18–19.

94. *Maryland Gazette*, 1 Aug., 10 Oct., 5, 12 Dec. 1776, 27 Feb. 1777; *AOMOL* 12:421, 16: 140; Maryland State Papers (Series A) Convention Papers 1775–1777 [MSA S1004-1-93]; Maryland State Papers (Red Books) 1776–1783 [MSA S989-24]; Papenfuse, *In Pursuit of Profit*, 85–86. I am indebted to Jean Russo for James Lillycrap's story and to Orlando Ridout V for Tootell's ad in the *Gazette*, 5 Dec. 1776.

95. Jensen, *The World Turned Upside Down*, 27– 35, 58–59; *AOMOL* 18: 534, 630; McCullough, *1776*, 263.

96. Land, *Colonial Maryland*, 318–320; Hoffman, *Princes of Ireland*, 310–317; *Constitutional Revision Study Documents of the Constitutional Convention Commission of Maryland, June 15, 1968* (Annapolis: State of Maryland, 1968), 375–387, 605, 773. Hoffman quote from *Princes*, 313; Declaration of Rights from *Study Documents*, 605; Constitution Art. 23 from same, 773. The 1776 Constitution created a bicameral legislature composed of the indirectly elected Senate and the directly elected House of Delegates.

97. *Maryland Gazette*, 27 Mar. 1777.

98. Eddis to Eden, 23 July 1777, in "Correspondence of Governor Eden," 109; Phebe and Bryce Jacobsen, "Cornhill/Fleet Street Lots," 53 Cornhill, in "Lot Histories," Parcel 13; Mickel, "Sentinel of the Severn," 21–28. Eddis quote from his letter, 109.

99. Papenfuse, *In Pursuit of Profit*, 78–91; *Maryland Gazette*, 13 Mar., 17 Apr., 15 May 1777, 22 Sept. 1780, 28 Aug., 13 Sept. 1781, for instance. "Transformed" quote from Papenfuse, 78, "stench" quote from Papenfuse, 91. Papenfuse covers the effect of the war on the city in detail.

100. Johan David Schoepf, *Travels in the Confederation, 1783-84* (Philadelphia, 1911), 364 (estimates 400 houses in 1783); Shirley Baltz, "Annapolis on the Threshold," *MHM* 81 (1986): 223 (cites Noah Webster estimating 260 in 1786); Shirley V. Baltz, *Quays of the City: An Account of the Bustling Eighteenth Century Port of Annapolis* (Annapolis: Liberty Tree, 1975), 3 (cites Bennett Allen estimating 400–500 in 1767); Shelley, "Ebenezer Hazard's Travels," 48 had "small" city.

101. Papenfuse, *In Pursuit of Profit*, 86–87; Archives of Maryland (Biographical Series), John Bullen [MSA SC3520-13909]; "Lot Histories," Parcel 15, Sects. I, II, XII, Parcel 30, Sect. II or Parcel 10, Sect. I; Phebe and Bryce Jacobsen, "Cornhill/Fleet Street Lots," in "Lot Histories," Parcels 13, 14, 15; Anne Elizabeth Yentsch, *A Chesapeake Family and Their Slaves* (New York: Cambridge University Press, 1994), 274; Auditor General (Day Book) 1785–1786 [MSA S149-2], 99; Radoff, *Buildings of the State*, 38–40. The replacement prison, completed about 1800, was located on Calvert Street. Its own replacement was built in 1913 on the same spot (Radoff, 39–40). This last prison will be discussed again in Chapter 9.

102. Eddis, *Letters from America*, 213; *Maryland Gazette*, 21, 28 Aug. 1777; J. A. Robinson, "British Invade the Chesapeake, 1777," in Ernest McNeill Eller, ed., *Chesapeake Bay in the American Revolution* (Centreville, Md.: Tidewater Publishers, 1981), 360–362; Radoff, *The State House*, 9; McWilliams and Radoff, "Annapolis Meets the Crisis," 420–422; Mickel, "Sentinel of the Severn," 32–33; *AOMOL* 16: 338–340. Eddis's words from *Letters*; Wallace's from Radoff, *The State House*; governor's order from *AOMOL* 16: 339; governor's opinion from 340. For largest fleet, see McCullough, *1776*, 148. McCullough numbers the British fleet at New York in July 1776 at "nearly four hundred" and says "it was the largest expeditionary force of the eighteenth century." The force that sailed up the Chesapeake numbered 267 or perhaps 280 vessels and 18,000 soldiers (according to James Cheevers, personal communication to author, 7 Nov. 2007). William Eddis arrived in England in late December 1777 (*Letters*, 231).

103. Christopher Ward, *The War of the Revolution* (New York: Macmillan, 1952) 1: 331–361; McWilliams and Radoff, "Annapolis Meets the Challenge Crisis," 421–422.

104. AN MAC (Bylaws and Ordinances) 1768–1791 [MSA M54-1], 60.

105. Hanson's *Laws of Maryland*, 1763–1784, *AOMOL* 203: 176, 216; *Maryland Gazette*, 27 Aug. 1779. Quote re streets from *Gazette*.

106. AN MAC (Proceedings) 1783–1784 [MSA M47-6], 18; *Maryland Gazette*, 20 Aug. 1784; Radoff, *Buildings of the State*, 38; "Lot Histories," Parcel 29; AN MAC (Proceedings): 1783–1784 [MSA M47-6], 7, 10, 11, 18; 1789–1796 [MSA M47-7], 29–30 (at back of volume); 1819–1821 [MSA M47-16], Aug. 1820; and 1819–1821 [MSA M47-16], 12 Feb. 1821; "Williams' Ex'rs vs. The Mayor, etc. of Annapolis," in Thomas Harris and Reverdy Johnson, *Reports of Cases Argued and Determined in the Court of Appeals of Maryland in 1823, 1824, 1825*, vol. 6 (Annapolis: Jonas Green, 1825), 529.

107. Papenfuse, *In Pursuit of Profit*, 87–96; *Maryland Ga-*

zette, 25 Dec. 1777, 30 Apr. 1779; Wroth, *History of Printing in Colonial Maryland*, 93, 117–118.

108. Mickel, "Sentinel of the Severn," 34–40.

109. Letzer and Russo, *Diary of William Faris*, 22–23. Quotations from a letter quoted on 22.

110. Hoffman, *Princes of Ireland*, 354–373; Baltz, *Belair*, 49, 54–56; Ware, *Anne Arundel's Legacy*, 103–106; *BDML* 2: 726 (Sharpe); George Washington to Jonathan Boucher, 3 July 1771, in Jeanne Mozier, comp., *Archive of George Washington's Writings on Berkeley Springs & Vicinity, 1771*, online at http://www.berkeleysprings.com/GWarchives/1771.html (accessed 5/18/10), for instance. Molly Ridout's words quoted in Baltz, 56. The eighteenth-century Bath is now Berkeley Springs, West Virginia.

111. Jane Wilson McWilliams and Carol Cushard Patterson, *Bay Ridge on the Chesapeake, An Illustrated History* (Annapolis: Brighton Editions, 1986), 27–29.

112. Bryce biographical files [MSA SC 829]; Prerogative Court (Accounts) L. 69, f. 80; "Lot Histories," Parcel 6, Sect. IV.

113. "Lot Histories," Parcel 4, Sect. III; *Maryland Gazette*, 6 Sept. 1770, 6 June 1771.

114. "Lot Histories," Parcel 12, Sect. III.

115. *Maryland Gazette*, 17 Mar. 1774.

116. *Maryland Gazette*, 11 June, 1 Oct., 19 Nov. 1772, 14, 19 Aug., 16 Sept. 1773, 12 May 1780; Baltz, *The Quays of the City*, 46; Papenfuse, *In Pursuit of Profit*, 164, 254, 257–262.

117. McWilliams and Radoff, "Annapolis Meets the Crisis," 423–424; Harlow Giles Unger, *Lafayette* (Hoboken, N.J.: John Wiley & Sons, 2002), 36–56, 130–133, and passim for friendship between Washington and Lafayette; Myron J. Smith, Jr., and John G. Earle, "The Maryland State Navy," in Ernest McNeill Eller, ed., *Chesapeake Bay in the American Revolution* (Centreville, Md.: Tidewater Publishers, 1981), 210–211; Ward, *The War of the Revolution* 2: 556–559; Charles O. Paullin, "Plan of the Harbor and City of Annapolis, 1781," *U.S. Naval Institute Proceedings* 54 (July 1928): 569–571. Henry Margaret quoted in McWilliams and Radoff; quote about fish catch in Paullin, 571. The town known as Head of Elk changed its name to Elkton in 1787 (*Laws of Maryland*, 1787, chap. 31).

118. McWilliams and Radoff, "Annapolis Meets the Crisis," 423; McWilliams and Patterson, *Bay Ridge*, 29; Paullin, "Plan of Annapolis," 569, 571; Arthur Pierce Middleton, "Ships and Shipbuilding in the Chesapeake Bay and Tributaries," in Ernest McNeill Eller, ed., *Chesapeake Bay in the American Revolution* (Centreville, Md.: Tidewater Publishers, 1981), 128–129; Myron J. Smith, Jr., and John G. Earle, "The Maryland State Navy," 211; Marshall Booker, "Privateering from the Bay," in Eller, *Chesapeake Bay in the American Revolution*, 278–279. Henry Margaret's description of Lafayette quoted in McWilliams and Patterson; her fears quoted in McWilliams and Radoff, 424.

119. *Maryland Gazette*, 30 Aug., 13, 20 Sept. 1781.

120. James Thacher, M.D., *Military Journal of the American Revolution* (Hartford, Conn.: Hurlbut, Williams & Company, 1862; reprinted n.p.: Arno Press, 1969), 274–276. Thacher's words from 275.

121. McWilliams and Radoff, "Annapolis Meets the Crisis," 425–426; Abbé Robin, *New Travels through North America* (Philadelphia: Robert Bell, 1783; reprinted, n.p.: Arno Press, 1969), 50–51; H. Marion, *John Paul Jones' Last Cruise and Final Resting Place, The United States Naval Academy.* (Washington, D.C.: George E. Howard, 1906), 87. Since a crown was five shillings and a thousand crowns £250, the amount reported by Robin seems unlikely, compared to master craftsman William Buckland's annual salary of £60, even accounting for the changes in currency values (Miller, "Chase-Lloyd House," 129, for Buckland's income from Edward Lloyd).

122. David Ridgely, comp. and ed., *Annals of Annapolis* (Baltimore: Cushing & Brother, 1841), 243; Elihu S. Riley, *Souvenir Volume of the Ceremony of Unveiling the Monument Erected by the Sons of the Revolution to the Memory of the Soldiers and Sailors of France . . . April 18th, 1911* (Annapolis: Arundel Press, 1911), 3–4. Riley's words from *Souvenir Volume*, 4.

123. *Maryland Gazette*, 25 Oct., 22, 29 Nov. 1781; Edward C. Papenfuse, "Remarks to Board of Public Works, February 4, 1998," online at www.msa.md.gov/msa/speccol/4873/html/bpwremarks.html (accessed 5/18/10). "Express boat" from newspaper 25 Oct.; Parker occupation from Papenfuse; Greens' words from newspaper 29 Nov. 1781. Exactly when Governor Thomas Sim Lee moved into the former governor's house is uncertain, but since Lee's primary residence was in Prince George's County, it seems likely that he would have taken quick advantage of the state's confiscation of Eden's property. Upon his arrival in Annapolis on 21 November 1781, Washington was escorted to the governor's house, and the reception later that day at "the governor's elegant and hospitable board" almost certainly took place in the fine old home overlooking the Severn. Lee was definitely in Eden's house in the summer of 1782. *BDML* 2: 529 (Lee); "Government House, A Maryland Treasure," online at http://msa.md.gov/msa/stagser/s1259/141/278/html/govhse.html (accessed 5/18/10); Hall of Records Commission Meeting Minutes, 23 Mar. 1999, online at Hall of Records Commission (Agenda and Minutes) 09/22/1999[MSA SE14-11]; *Maryland Gazette*, 22, 29 Nov. 1781; *Journal of Baron Von Closen, Aide-de-Camp of Gen Rochambeau*, vol. 2, *1780–1782*, quoted in Marion, *John Paul Jones' Last Cruise*, 81–83. Samuel Green had joined his brother Frederick on the masthead of the *Maryland Gazette* 30 April 1779 (Wroth, *History of Printing in Colonial Maryland*, 93).

124. Hanson's *Laws of Maryland*, 1780–1781, chap. 45 (*AOMOL* 203: 269).

125. "Lot Histories," Parcel 4, Sect. I, II, Parcel 12, Sect. II, III, IV, Parcel 13, Sect. XII, Parcels 15 and 16, Sect. IX, Parcel 25, Sect. IX, Parcel 28, Sect. III, Parcel 31, Sect. I, Parcel 32, Sect. I, II, Parcel 34, Sect. IV, Parcel 35, Sect. 2; John H. Hemphill's Notes Collection, [MSA SC 563], box 13; *Maryland Gazette*, 12

July 1781; Beirne, "Portrait of a Colonial Governor," 297–298; Radoff, *Buildings of the State*, 71.

126. Thomas B. Hodgkin, "List of Outlawries, Western Shore," *MHM* 4 (1909): 287–288; John N. Hemphill, "The Loyalists in Maryland," unpublished manuscript in John H. Hemphill's Notes Collection, [MSA SC 563], box 13.

127. McWilliams and Radoff, "Annapolis Meets the Crisis," 427; Papenfuse, *In Pursuit of Profit*, 89; *Maryland Gazette*, 10 Sept. 1779, 26 May 1780, 5 Sept., 28 Nov., 5 Dec. 1782, 13 Mar. 1783; Baltz, *Belair*, 59. Brewer ad in *Maryland Gazette*, 5 Dec. 1782.

128. *Journal of Baron Von Closen*, 81–83. Quotation from 82.

129. Schoepf, "Travels in the Confederation," 364–369. Quotation from 366.

130. *Maryland Gazette*, 13 Mar., 17 Apr., 1 May 1783; Baltz, *Belair*, 60; Mary Grafton Dulany to Walter Dulany, Jr., 23 Apr. 1783, in Murray, *One Hundred Years Ago*, 67. Account of cannon volleys, toasts, and illumination from *Maryland Gazette*, 1 May 1783; "gallant," description of food and liquor, and sarcastic comment by Mary Grafton Dulany from Murray.

131. Robert J. Brugger, *Maryland, A Middle Temperament, 1634–1980* (Baltimore: Johns Hopkins University Press and the Maryland Historical Society, 1988), 125; Joyce W. McDonald, "The Congress and the Community," Part III, Appendix B, Annapolis: The Visitors' Perspective, Final Report, "Southern Urban Society After the Revolution: Annapolis, Maryland, 1782–1784," National Endowment for the Humanities Grant H69-0-178 [MSA SC 885], 1–3.

132. AN MAC (Proceedings) 1783 [MSA M47-4]. 1a–4a. "Capacity of Defense" and "Most Eligible Place" from 2a; resolution quoted from 3a.

133. McDonald, "The Congress," 3–14; *Votes and Proceedings of the House*, 1783 [MSA SC M3197], 18, 27, 31–32; *Maryland Journal and Baltimore Advertiser*, 22 Aug. 1783.

134. McDonald, "The Congress," 10, 15–16, 44; AN MAC (Proceedings) 1783 [MSA M47-4], 6a; AN MAC (Proceedings) 1783–1784 [MSA M47-5], 23.

135. McDonald, "The Congress," 17–24, 29–30; *Journal of the United States in Congress Assembled, Containing the Proceedings from the third day of November 1783 to the Third Day of June 1784* (Philadelphia: John Dunlap, n.d.), 9; Constance B. Schulz, "The Continental Congress in Annapolis," *Maryland Heritage News* 1 (Winter 1983): 11–12; Maryland State Archives, "The Road to Peace, August 1779–August 1784," online at http://www.msa.md.gov/msa/stagser/s1259/131/html/road.html (accessed 5/18/10).

136. "Washington's Resignation," *Bicentennial Celebrations, Annapolis, Maryland, December 23, 1983-January 14, 1984* (Annapolis: Maryland Heritage Committee, [1983]); John W. Huston, "'To Surrender . . . the Trust Committed to Me': Washington's Resignation in Annapolis," *Maryland Heritage News* 1 (Winter 1983): 4–6; William Wan, "Maryland to Unveil the Page that Began a New Chapter," *Washington Post*, 19 Feb. 2007.

137. Tradition holds that the welcoming delegation met Washington at the junction of Generals Highway (Md. Rt. 178) and the road west from Annapolis (Md. Rt. 450) at Three Mile Oak. For much of the twentieth century, the blackened stump of the once-noble tree, adorned by a plaque describing its role in history, remained on the south side of the intersection. (See Edward C. Papenfuse, et al., eds., *Maryland, A New Guide to the Old Line State* [Baltimore: Johns Hopkins University Press, 1976], 258.) The plaque now sits within the loop of the off ramp from U.S. Rt. 50/301 to Rt. 450.

138. *Maryland Gazette*, 25 Dec. 1783; Maryland State Archives, "The Road to Peace"; Huston, "To Surrender . . . the Trust"; "Washington's Resignation"; McDonald, "The Congress," 24–26; Jackson and Twohig, *The Diaries of George Washington*, 3: 55, 172; *BDML* 1: 299 (Eden), 411 (Harford); Beirne, "Portrait of a Colonial Governor," 297–298; Baltz, *Belair*, 61–62; George Washington, "Address to Congress on Resigning Commission," and James Tilton to Bedford Gunning, 25 Dec. 1783, in John C. Fitzpatrick, *Writings of George Washington from Original Manuscript Sources* 27: 285 (online at Electronic Text Center University of Virginia Library [http://etext.lib.virginia.edu/washington] in the vol. 27 section titled "Address to Congress on Resigning Commission," last accessed 1/25/09); *Maryland's Way: The Hammond-Harwood House Cookbook* (Annapolis: Hammond-Harwood House Association, 1963), 326. All quotations from the *Maryland Gazette*, 25 Dec. 1783 except Washington's toast and Tilton's words, both of which were quoted, with italics, from Tilton's letter in Fitzpatrick, *Writings*. I am indebted to Shirley Baltz for the lead to Tilton's letter.

139. Chapelle et al. *Maryland, A History of Its People*, 84–86; Washington, "Address to Congress," in Fitzpatrick, *Writings of George Washington*; "Washington's Resignation," *Bicentennial Bulletin* ; Huston, "To Surrender . . . the Trust," 6; James McHenry to Margaret Caldwell, (23 Dec. 1783), Paul H. Smith et al., eds., *Letters of Delegates to Congress, 1774-1789*, 25 vols. (Washington, D.C.: Library of Congress, 1976–2000), 21: 222; *Maryland Gazette*, 25 Dec. 1783. Washington's words quoted in Fitzpatrick.

140. Schulz, "The Continental Congress"; McHenry letter (23 Dec. 1783) in Smith et al., *Letters of Delegates* 21: 222; James Tilton letter, 25 Dec. 1783, in Fitzpatrick, *Writings of George Washington*; *Maryland Gazette*, 25 Dec. 1783; Baltz, *Belair*, 62. McHenry's words are from his letter; Mary Ridout's words quoted in Baltz.

141. Graham Hood, "Easy, Erect and Noble," *Colonial Williamsburg*, Summer 2002 (online at http://www.history.org/foundation/journal/Summer02/peale.cfm [accessed 6/25/07]). I am indebted to Matthew Grubbs for the reference to Hood's article.

142. Schulz, "The Continental Congress"; McDonald, "The

Congress," 29–31; "The Treaty of Paris — The Work of Peace," *Bicentennial Celebration, Annapolis, Maryland, December 23, 1983–January 14, 1984* (Annapolis: Maryland Heritage Committee, [1983]); Baltz, *Belair*, 62–64.

143. Schulz, "The Continental Congress"; David Howell to Jonathan Arnold, 21 Feb. 1784, in Smith et al., *Letters of Delegates to Congress*, 21:381; Baltz, *Belair*, 62, 64; *BDML* 2: 594 (Mercer); McDonald, "The Congress," 33–36, 40–43; David M. Ludlum, *Early American Winters, 1604–1820* (Boston: American Meteorological Society, 1966), 65, 152. Henry Margaret's words quoted in Baltz, 64; Molly's in Baltz, 62.

144. McDonald, "The Congress," 44–46; Edith Rossiter Bevan, ed., "Thomas Jefferson in Annapolis" *MHM* 41 (1946): 115–124. Edward Papenfuse identified the Dulany house mentioned in Jefferson's accounts (Bevan, 119) as that of the two Daniel Dulanys, Elder and Younger, which sat on the block now occupied by the Anne Arundel County Courthouse (personal communication to the author, 12 June 2007).

145. McDonald, "The Congress," 38–39. Quotation from 38.

146. Elbridge Gerry to Samuel Holton, 21 Apr. 1784, in Edmund C. Burnett, *Letters of Members of the Continental Congress*, 8 vols. (Washington, D.C.: Carnegie Institution of Washington, 1934), 7: 497–498. Quotation from 498.

147. Schulz, "The Continental Congress"; *Journal of Congress*, 515–517; McDonald, "The Congress," 46–47, 55.

148. McDonald, "The Congress," 49–56.

149. Beirne, "Portrait of a Colonial Governor," 302–303; Henry Francis Sturdy, *Seeing Historic Annapolis and the Naval Academy* (Baltimore: Pridemark Press, 1961), 10. (Earlier editions, some written in collaboration with Arthur Trader, were printed in 1937, 1938, 1949, and 1958.) Christy Gillmer Erdmann, personal communications to author 25, 26 Jan. 2008. I am indebted to Ann Jensen for the Sturdy reference and to Christy Erdmann and her brother Charley Gillmer, who grew up near Shipwright Street, for their memories of the legend as a particularly scary part of their neighborhood's Halloween celebrations.

150. Beirne, "Portrait of a Colonial Governor," *MHM* 45 (1950): 302–311.

151. *Maryland Gazette*, 2 Sept., 1784, 19 Jan. 1786; Johan David Schoepf's *Travels in the Confederation, 1783–84* (Philadelphia, 1911), 367–368; Baltz, *Belair*, 61; *BDML* 1: 411 (Harford). McHenry and miniature quoted in Baltz.

152. *Maryland Gazette*, 2 Dec. 1784; *Laws of Maryland*, Nov. 1784 session, chap. 12 in Hanson's *Laws of Maryland AOMOL* 203: 379; Unger, *Lafayette*, 190–204. "Elegant ball" quote from newspaper; naturalization declaration from the law; letters from Washington and Lafayette quoted in Unger, 203–204. Where did the road divide? If Washington followed his usual route, through London Town, he turned south from West Street onto what is now Spa Road. If he chose to take the road to Bladensburg and Alexandria, they would have diverged at Generals Highway,

when Lafayette turned north toward Baltimore. So, perhaps this affecting scene occurred at the present Westgate Circle — or perhaps near the site of the Westfield Annapolis Mall. Neither spot looks today anything like it did in 1784.

153. Papenfuse, *In Pursuit of Profit*, 133, 153–154; *Laws of Maryland*, 1777, chap. 3, in Hanson's *Laws of Maryland, 1763–1784, AOMOL* 203: 176; *Laws of Maryland*, Nov. 1779, chap. 11, in Hanson's *Laws, AOMOL* 203: 216; *Laws of Maryland*, Nov. 1784, chap. 49, in Hanson's *Laws, AOMOL* 203: 405.

154. "James Brice's Accounts as Treasurer of Corporation of the City of Annapolis" [MSA SC 530], 3, 5; AN MAC (Proceedings) 1783–1784 [MSA M47-6], 14–18; AN MAC (Proceedings) 1789–1796 [MSA M47-7], 37; *Maryland Gazette*, 25 Aug. 1768. Quotations from Proceedings [MSA M47-6], 14–15.

155. Ginger Doyel, *Gone to Market: The Annapolis Market House, 1698–2005* (Annapolis: City of Annapolis, 2005), 17–21; AN MAC (Proceedings) 1783–1784 [MSA M47-6], 12–14; AN MCT (Land Records) 1721–1783, L. B [MSA M41-1], f. 428; Brice Account Book [MSA SC 530], 6, 21; Radoff, *Buildings of the State*, 60. Although there is no extant legislation creating it, the office of city treasurer apparently dates from James Brice's appointment in 1784. Earlier entries in the treasurer's ledger, AN TR (Ledger) 1761–1788 [MSA M 69-1], appear to have been made by the sheriff.

156. Brice Account Book [MSA SC 530], 10, 12, 17; Shirley Baltz, "Annapolis on the Threshold," 224–225; *Laws of Maryland*, Nov. 1785, chap. 26, in William Kilty, ed., *Laws of Maryland*. Quotes about McCain's job and about wharf subscription from Account Book, 12 and 17 respectively.

157. Brice Account Book [MSA SC 530], 6, 21, 31, 33–34; Doyel, *Gone to Market*, 17, 20–23; AN MAC (Bylaws and Ordinances) 1768–1791 [MSA M 54-1], 96. Quotation from account book, 21.

158. Brice Account Book [MSA SC 530], 6, 10, 23.

159. William L. Calderhead, "Slavery in the Age of the Revolution," *MHM* 98 (2003): 307–310.

160. Brice Account Book [MSA SC 530], 28; *Maryland Gazette*, 6 Feb. 1783; Baltz, *The Quays of the City*, 35. Quotation from Account Book. The records do not reveal why Elizabeth Bordley kept a fire engine nor how she acquired it.

161. Carl N. Everstine, *The General Assembly of Maryland, 1776–1850* (Charlottesville, Va.: Michie Company, 1982), 107–109; Luigi Castiglione, *Voyage in the United States, 1785*, 86, 87 (Milan, 1790), 399–400 (translation in Baltz Collections, [MSA SC 1286 and MSA SC 5224-1-5]); *Maryland Gazette*, 19, 26 Jan. 1786; Papenfuse, *In Pursuit of Profit*, 137; *BDML* 1: 404 (Hanson), 2: 854 (Wallace).

162. *Maryland Gazette*, 19 Jan. 1786. Hanson's article in the *Maryland Gazette* was also published in the Baltimore *Maryland Journal*. He made similar arguments in a pamphlet entitled *Considerations on the Proposed Removal of the Seat of Government, Addressed to the Citizens of Maryland by Aristides* (Annapolis:

Frederick Green, 1786). In February 1786 John Eager Howard of Baltimore City offered Samuel Chase ten lots if he would move to Baltimore and an equal number if the state capital moved, too. Chase took the first ten, but didn't get the second (Haw et al., *Stormy Patriot*, 144–145).

163. Tench Francis Tilghman, "The Founding of St. John's College, 1784–1789," *MHM* 44 (1949): 75–82; *Laws of Maryland*, Apr. 1782, chap. 8, in Hanson's *Laws of Maryland*, *AOMOL* 203: 307; "History of [Washington] College," online at http://visit .washcoll.edu/aboutthecollege.php (accessed 5/20/10); *Laws of Maryland*, 1784, chap. 37, in Kilty's *Laws of Maryland*. "Appurtenances" quote from 1784 law, Sect. 7.

164. Tilghman, "Founding of St. John's College," 82–86; Charlotte Fletcher, "How King William's School Became St. John's College," *MHM* 91 (1996): 353; Charlotte Fletcher, "King William's School Survives the Revolution," *MHM* 81 (1986): 216–219; Radoff, *Buildings of the State*, 28–29. Radoff states that the consolidation of the two corporations was finalized by legislation in 1801, when the funds held by the rector, governor, trustees and visitors of King William's School were vested in the visitors and governors of St. John's College (Radoff, 29).

165. Tilghman, "Founding of St. John's College," 75, 85, 92; Tench Francis Tilghman, *The Early History of St. John's College in Annapolis* (Annapolis: St. John's College Press, 1984), 16–21; Radoff, *Buildings of the State*, 79–80. Quotation from Tilghman, "Founding," 75.

166. Paynter, *St. Anne's Annapolis*, 32–33; Isabel Shipley Cunningham, *Calvary United Methodist Church* (Edgewater, Md.: Lith-O-Press, 1984), 8–13; "Lot Histories," Parcel 25, Sect. VII; Radoff, *Buildings of the State*, 111. Quotations from Cunningham, 13 (blue church) and 11 (Hagerty).

167. Cunningham, *Calvary United Methodist Church*, 13–15; Calderhead, "Slavery in the Age of the Revolution," 303–324.

168. *Laws of Maryland*, 1790, chap. 46; Tony Lindauer, communications to author, 28 and 31 Aug. 2002; Parker, *Presidents Hill*, 3. Quotations about gaming and boundaries from the law.

169. One hot August day in 1766, ropemaker Robert Cook drank too much of the cold water "in the Spaw" and died before reaching Newington Ropewalk, just a few hundred yards away. *Maryland Gazette*, 14 Aug. 1766.

170. *Laws of Maryland*, Nov. 1785, chap. 44, and *Laws of Maryland*, 1790, chap. 47, in Kilty's *Laws of Maryland* ; Radoff, *Buildings of the State*, 20–22; Paynter, *St. Anne's Annapolis*, 35–37; Mickel, "Sentinel of the Severn," 14; *Maryland Gazette*, 31 Jan. 1782, 23 Mar. 1786. Quote about Hyde's house from *Gazette* 31 Jan. 1782; about altar from Paynter, 35, also in Radoff, 21. Hyde's "house of entertainment" is today's Maryland Inn, on Church Circle at the top of Main and Duke of Gloucester Streets.

171. Thomas Lee Shippen to William Shippen, 15 Sept. 1790, in Julian Boyd, ed., *The Papers of Thomas Jefferson* (Princeton:

Princeton University Press, 1965) 17: 464–467; "The Dome and the Lightning Rod," online at the Maryland State Archives, State House website (http://www.msa.md.gov/msa/mdstatehouse/ html/about.html accessed 5/16/10; Maeva Marcus et al., eds., *The Documentary History of the Supreme Court of the United States, 1789–1800* (New York: Columbia University Press, 1985) 1: 778; Letzer and Russo, *The Diary of William Faris*, 120. Quotations from Shippen letter, 464. Dr. Shaaff must have been a quick study, since he had arrived in Annapolis only two months earlier from medical school in Europe (Letzer and Russo, 120).

Chapter 4. Annapolis Alone, 1790 to 1845

1. Quoted in Elihu Riley, *The Ancient City: A History of Annapolis, in Maryland, 1649–1887* (Annapolis: Record Printing Office, 1887; reprint 1977[?]), 145. Riley cites a "Naval Commission" report for which he gives no date or other reference, but he uses this to describe the post-Revolutionary city.

2. Edward C. Papenfuse, *In Pursuit of Profit: The Annapolis Merchants in the Era of the American Revolution, 1763–1805* (Baltimore: Johns Hopkins University Press, 1975), 225, 235; Robert J. Brugger, *Maryland, A Middle Temperament, 1634–1980* (Baltimore: Johns Hopkins University Press, 1988), 132, 141. Quotation from Brugger, 132.

3. 1800 Federal Census, Anne Arundel County, District 2, analysis by Jean Russo. Annapolis had 220 houses valued at $100 or more in 1798 (1798 Federal Direct Tax, Anne Arundel County, Annapolis City, transcript by Clifton Ellis).

4. 1810 Federal Census, Anne Arundel County, District 2, analysis by Jean Russo.

5. William Priest, *Revell in the United States of America commencing in the Year 1793*, (London, 1802), 14–16; Joseph Scott, *A Geographical Description of the States of Maryland and Delaware* (Philadelphia, 1807), 74–77; John Melish, *Travels through the United States of America, 1806, 1809, 1810, 1811* (London, 1818), 142 (Oct. 1806); Anthony St. John Baker, *Memoires d'un Voyageur qui so repose* (London, 1850), 197 (June 1811); David Bailie Warden, "Journal of a Voyage from Annapolis to Cherbourg, on Board of the Frigate *Constitution*, 1 August to 6 September, 1811," *MHM* 11 (1916): 129–130. Quotations from Baker.

6. Donald Jackson and Dorothy Twohig, eds., *The Diaries of George Washington* (Charlottesville: University Press of Virginia, 1979) 4: 100–102; *Maryland Gazette*, 31 Mar. 1791.

7. Alexander J. Lourie, *"Have Honestly and Fairly Laboured for Money": William and Washington Tuck and Annapolis Cabinetmaking, 1795 to 1838* (M.A. thesis, University of Maryland, 2004), 3–4, 53, 101–111.

8. Donna Ware, "The Story of the Land," "The Story of the Building," prepared for groundbreaking ceremonies for the addition of the Court House (program, 1994).

9. Lourie, *"Have Honestly and Fairly Laboured for Money,"* 5, 94–95, 148–151, 162, 169–172.

10. Ibid., 55.

11. AN MAC (Proceedings) 1801–1811 [MSA M47-13], 141–142; *Laws of Maryland*, 1803, chap. 70.

12. AN MAC (Bylaws and Ordinances) 1792–1816 [MSA M54-2], 82, 52, 87, 47, 45, 141, 79, 180, 152, 214; AN MAC (Bylaws and Ordinances) 1768–1791 [MSA M54-1], 4–10 reverse; *Laws of Maryland*, 1796, chap. 30. Examples of garbage from Bylaws and Ordinances, 1792–1816, 87.

13. *Baltimore Journal*, 4 Oct. 1793; AN MAC (Proceedings) 1789–1796 [MSA M47-7], 57, 64, 67, 95–97 (at back of volume), AN MAC (Bylaws and Ordinances) 1792–1816 [MSA M54-2], 106. By 1846, the city had built a smallpox hospital on the hill west of Calvert Street (now Munroe Court), rented from Andrew Lamb (Michael P. Parker, *Presidents Hill: Building an Annapolis Neighborhood, 1664–2005, Annapolis, Maryland* [Annapolis: Annapolis Publishing, 2005], 15–16). The structure burned in 1852 (Baltimore *Sun*, 25 Nov. 1852). Twelve years later a new hospital was built, on land owned by William Brewer near what is now Taylor Avenue adjoining the present National Cemetery (AN MA [Proceedings] 1863–1869 [MSA M49-72], 4 Jan., 1 Apr. 1864).

14. Warden, "Journal of a Voyage," 133.

15. *Laws of Maryland*, 1797, chap. 91; ibid., 1800, chap. 75; James W. Cheevers, communication to author, 7 Nov. 2007; *Maryland Gazette*, 22, 29 Nov. 1804; Henry Adams, *History of the United States during the First Administration of Thomas Jefferson*, vol. 2 (New York: Charles Scribner's Sons, 1909), 268, chap. 12 (online at http://en.wikisource.org, last accessed 5/26/10); Katherine Cowan, "Finding Aid to Patterson-Bonaparte Collection," MHS PP70.

16. *Maryland Gazette*, 29 May, 30 Oct. 1806; Scott, *Geographical Description of Maryland and Delaware* (Philadelphia, 1807), 74–77. Quotation from Scott, 76. For the British ambassador to the United States, see *Maryland Gazette* 3 July, 4 Sept. 1811.

17. *Baltimore American*, 18 Sept. 1806 in Baltz Collection [MSA SC 5224-1-4]; *Maryland Gazette*, 29 Nov. 1804; 4, 11, 18 Sept. 1806; 29 May 1811, for example.

18. *Maryland Gazette*, 11 July 1810, 22 Oct. 1812; *Maryland Republican*, 25 Jan. 1819; Jane McWilliams, *"The Progress of Refinement": A History of Theatre in Annapolis* (Annapolis: Colonial Players of Annapolis, 1976), 7; AN MAC (Proceedings) 1801–1811 [MSA M47-13], 229, 232, 240; Melish, *Travels*, 142; John Rumsey to his wife, 22 Nov. 1799 and 13 Dec. 1799, Rumsey file, box 35, folder 6, Delaware Historical Society, transcript in Baltz Collection [MSA SC 5224-4-18]; Margaret Law Callcott, ed., *Mistress of Riversdale: The Plantation Letters of Rosalie Stier Calvert, 1795–1821* (Baltimore: Johns Hopkins University Press, 1991), 7–27. "Wire dancing" from Proceedings 1801–1811, 229.

19. Callcott, *Mistress of Riversdale*, 1–26. George Calvert was the son of Benedict Calvert and grandson of the Fifth Lord Balti-more. His sister was married to John Parke Custis, son of Martha Washington (ibid. 17).

20. Brugger, *Maryland, A Middle Temperament*, 142; Papenfuse, *In Pursuit of Profit*, 231–234; Louis F. Cahn, *Sesquicentennial: The Farmers National Bank of Annapolis, 1805–1955* (Annapolis: Farmers National Bank of Annapolis, 1955), 5.

21. Cahn, *Sesqui-centennial: Farmers National Bank*, 9; Marcia M. Miller and Orlando Ridout V, eds., *Architecture in Annapolis: A Field Guide* (Newark, Del.: Vernacular Architecture Forum, and Crownsville, Md.: Maryland Historical Trust Press, 1998), 72–73.

22. Larry S. Mickel, "Sentinel of the Severn: The Fort at Horn Point, Annapolis, 1776–1866," (unpublished manuscript), chap. 5.

23. *The Naval War of 1812, A Documentary History*, ed. William S. Dudley, vol. 1, *1812*, ed. Dudley (Washington, D.C.: Naval Historical Center, 1985), 26–27; *Maryland Gazette*, 2 July 1807, 23 Sept. 1809; Papers of Joseph Sands, treasurer of the Tammany Society, 1808–1809, Sands Collection [MSA SC 2095], folders 56, 57; E. Vale Blake, *The Tammany Society or Columbian Order from its Organization to the Present Time* (New York: Souvenir Publishing, 1901), 5–11. All quotations from the *Gazette*, 2 July 1807. Although both groups honored the same chief of a Delaware Indian tribe, the political Tammany Society appears to have had no direct connection with the Saint Tamina Society whose May Day celebrations were described in 1771 by William Eddis (William Eddis, *Letters from America*, ed. Aubrey C. Land [Cambridge: Belknap Press of Harvard University Press, 1969], 59).

24. For militia activity see, for instance, *Maryland Gazette*, 30 July, 6 Aug., 10 Aug., 24 Sept. 1807, 21 Jan. 1808.

25. *Maryland Gazette*, 3 Sept. 1807; Donald G. Shomette, *Pirates on the Chesapeake* (Centreville, Md.: Tidewater Publishers, 1985), 305–309; Riley, *The Ancient City*, 226–227; Adjutant General (Militia Appointments, L. 2 [MSA S 348-2; SR 2332], 30, 62, 69.

26. James W. Cheevers, personal communication to author, 7 Nov. 2007; Robert Harry McIntire, *Annapolis, Maryland, Families*, 2 vols. (Baltimore: Gateway Press, 1980, 1989), 1: 447. The General Assembly had awarded Lieutenant Mann a "handsome sword and belt," with "appropriate engraving" for his role in the capture of Derne, Tripoli, in 1805 (*Laws of Maryland*, 1806, Resolutions [*AOMOL* 608: 59]).

27. *Maryland Gazette*, 3 Sept. 1807.

28. Shomette, *Pirates on the Chesapeake*, 309–312. Shomette says (312) that *L'Eole* "was broken up at Annapolis."

29. AALR, L. NH 14, fs. 540, 543; *Maryland Gazette*, 30 Mar. 1808; Mickel, "Sentinel of the Severn," chap. 5. "Good shell lime" from *Maryland Gazette*. The city owned an undivided half of about three acres adjoining the mill. The Dulany estate owned the other half plus adjacent land (see deeds in NH 14).

30. *Naval War of 1812*, 1: 135–136; Scott S. Sheads, *The*

Rockets' Red Glare: The Maritime Defense of Baltimore in 1814 (Centreville, Md.: Tidewater Publishers, 1986), 10.

31. *Naval War of 1812*, 1: 153–154, 160–161; *Maryland Republican*, 8 July 1812.

32. J. Thomas Scharf, *History of Maryland*, 3 vols. (1879; reprint, Hatboro, Pa.: Tradition Press, 1967), 3: 32; William Calderhead, "Naval Innovation in Crisis: War in the Chesapeake, 1813," *American Neptune* 34 (1976): 207; *Maryland Republican* Collection, Maryland State Archives [MSA SC 3411] and "Guide to Maryland Newspapers," online at http:speccol.mdarchives .state.md.us/msa/speccol/catalog/newspapers/index.cfm, last accessed 2/13/2008; *Maryland Republican*, 21 June 1817.

33. *Maryland Gazette*, 8, 22 Oct., 12 Nov. 1812, 22 July, 26 Aug. 1813, 25 Aug. 1814; Riley, *The Ancient City*, 233–238.

34. Sheads, *Rockets' Red Glare*, 11–12; *The Naval War of 1812, A Documentary History*, ed. William S. Dudley, vol. 2, *1813*, ed. Dudley (Washington, D.C.: Naval Historical Center, 1992), 309–311, 314–315, 331–332; Scharf, *History of Maryland*, 3: 35–36. Gordon's quotation from *Naval War of 1812*, 2: 332; Winder's quotation from Scharf, 3: 35.

35. *Naval War of 1812*, 2: 339; Scharf, *History of Maryland*, 3: 37.

36. *Naval War of 1812*, 2: 339; Scharf, *History of Maryland*, 3: 40–44; Sheads, *Rockets' Red Glare*, 14.

37. *Maryland Gazette*, 13 May 1813.

38. *Naval War of 1812*, 2: 310.

39. *Maryland Gazette*, 5 Aug. 1813.

40. Stanley Quick, *Trident in the Sand*, (unpublished manuscript), chap. 5, 27; *Naval War of 1812*, 2: 383; Eric Smith, personal communication, 10 Jan. 2003. Fort Nonsense was probably the Revolutionary entrenchment on Beaman's Hill.

41. *Naval War of 1812*, 2: 382–384; Quick, *Trident in the Sand*, chap. 5, 27; *Maryland Gazette*, 26 Aug. 1813. Quotations from Warren and about fever from *Naval War of 1812*, 2: 382, 384.

42. Scharf, *History of Maryland*, 3: 70; Sheads, *Rockets' Red Glare*, 43–45; Walter Lord, *The Dawn's Early Light* (New York: W. W. Norton, 1972), 47–48; *The Naval War of 1812, A Documentary History*, ed. William S. Dudley, vol. 3, *1814–1815*. ed. Michael J. Crawford (Washington, D.C.: Naval Historical Center, 2002), 137–138. Cockburn quotation from *Naval War of 1812*, 3: 138.

43. Log of HMS *Menelaus*, ADM 52/4538, transcription by Stanley Quick; *Naval War of 1812*, 3: 231–235. "Battery," "attack," and "reconnoitered" quotations from *Menelaus* log, 22 Aug. 1814; Parker's report to Cochrane in *Naval War of 1812*, 3: 233. Captain Sir Peter Parker died in an engagement at Caulk's Field in Kent County the night of 30–31 August 1814.

44. General W. H. Winder to John Armstrong, Secretary of War, 18 July 1814, in Edward Duncan Ingraham, *A Sketch of the Events Which Preceded the Capture of Washington . . .* (Phila-

delphia: Casey and Hart, 1849), 49; Lord, *Dawn's Early Light*, 81–83; *Maryland Gazette*, 25 Aug. 1814; Scharf, *History of Maryland*, 3: 78. Scharf gives Beall 750 men; the *Gazette* says 1,000.

45. Lord, *Dawn's Early Light*, 112–136.

46. Ibid.,136–137; Scharf, *History of Maryland*, 3: 86–87. Lord's account of the battle is detailed and authoritative. "Ghosts" quotation from Lord (137), who is relying on an account of the battle by Jenifer Sprigg in a letter to J. Hughes, 25 August 1814, Library of Congress; Beall's description of his men's response reported in Scharf.

47. Lord, *Dawn's Early Light*, 171. Lord states that the fires in Washington were visible in Baltimore, so they must have been seen in Annapolis.

48. Lord, *Dawn's Early Light*, 235–238. Quotation on 238.

49. *Maryland Gazette*, 8 Sept. 1814; *Maryland Republican*, 27 Aug. 1814.

50. Lord, *Dawn's Early Light*, 247; Sheads, *Rockets' Red Glare*, 75. The number of ships appeared in the *Maryland Gazette* 22 September 1814 as "between 60 and 70."

51. Scharf, *History of Maryland*, 3: 102. Scharf identified his source only as "The Subaltern in America," but the author is identified by Scott Sheads (*Rockets' Red Glare*, 147) as George Robert Gleig, whose *Subaltern in America: Comprising his Narrative of the Campaigns of the British Army at Baltimore, Washington during the Late War* was published in Philadelphia and London in 1833.

52. Brugger, *Maryland, A Middle Temperament*, 183–185; Sheads, *Rockets' Red Glare*, 82–105; Lord, *Dawn's Early Light*, 295–296.

53. *Maryland Gazette*, 22 Sept. 1814; *Maryland Republican*, 24 Sept. 1814.

54. *Naval War of 1812*, 3: 60, 329–331, 364; *Maryland Gazette*, 22 Dec. 1814. "Free Settlers" from *Naval War of 1812*, 3:60.

55. Deposition of John Weedon, 27 May 1828, in Slavery, Slaveholding, and Flight in Antebellum Maryland Research Collection, Claims under the First Article of the Treat of Ghent, Frederick Grammer [MSA SC 5496-1-050705]; *Maryland Gazette*, 22 Dec. 1814; depositions of Elizabeth Neth, 25 Mar. 1828, Fielder Cross, 18 Apr. 1821, Benjamin Ogle (no date), letter from Lewis Neth, 25 Mar. 1828, Benjamin Ogle to Richard Forrest, 7 May 1821, in Claims under the First Article of the Treaty of Ghent, Henrietta Margaret Ogle [MSA SC 5496-1-050631]. Years later, the estate of Henry Margaret Ogle received $3,402 from the British government in compensation for slaves not returned to her (Jane Wilson McWilliams and Carol Cushard Patterson, *Bay Ridge on the Chesapeake, An Illustrated History* [Annapolis: Brighton Editions, 1986], 30).

56. John A. Grammer, Henry E. Mayor, Horatio Ridout, executors of the estate of Frederick Grammer, claim petition, 27 May 1828, in Claims under the First Article of the Treaty of Ghent, Frederick Grammer [MSA SC 5496-1-050705]; David

Stephen Heidler and Jeanne T. Heidler, eds., *Encyclopedia of the War of 1812* (Annapolis: Naval Institute Press, 2004), 358; Gilbert C. Russell to Frederick Grammer, 24 June 1818, and John Cromer to Frederick Gammer, 28 Jan. 1819, in Claims under the First Article of the Treaty of Ghent, Frederick Grammer [MSA SC 5496-1-050705]; Fielder Cross, deposition, 18 Apr. 1821, in Claims under the First Article of the Treaty of Ghent, Henrietta Margaret Ogle [MSA SC 5496-1-050631]; Dr. Henry Bishop, director of the Black Cultural Centre for Nova Scotia, personal communication, 15 Jan. 2003; David States, Canadian Park Service, personal communication, 16 Jan. 2003. Gilbert Russell paid Grammer $550 for James Stewart and told him that he doubted Stewart would try again to escape beause he had not been well treated by the British (Russell to Grammer, 24 June 1818, and Cromer 28 Jan. 1819).

57. Lord, *Dawn's Early Light*, 317–320, 336–337; *Maryland Gazette*, 16, 20 Feb. 1815; *Maryland Republican*, 18 Feb. 1815.

58. *Maryland Republican*, 18 Feb. 1815.

59. *Maryland Gazette*, 23 Feb. 1815.

60. *Maryland Gazette*, 21 Mar., 23, 30 May 1816, 20 Nov. 1817; *Maryland Republican*, 25 May, 8 June 1816; Susan Pearl, "More on Presidential Visits to Prince George's County," *Prince George's County Historical Society Newsletter* (copy in the Baltz Collection [MSA SC 5224-1-4]); James R. Heintze, "'Tyranny and Despotic Violence': An Incident Aboard the U.S.S. *Washington*," *MHM* 94 (1999): 31–54; Riley, *The Ancient City*, 253–254. Quotations from Seaton in Pearl ("decay" and "great ball") and the *Maryland Gazette* 30 May 1816 ("pomp").

61. Martha Brown Ogle Forman Diary, vol. 1, MS 403, Maryland Historical Society (copy in Baltz Collection [MSA SC 5224-1-4]). The "Spaw Spring and Ferry Branch" may have been the headwaters of South River, now crossed by Maryland Route 450. Most contemporary maps show the main road west from Annapolis to Bladensburg crossing the upper branches of South River and then swinging down to cross the Patuxent at Governor's Bridge. See Edward C. Papenfuse and Joseph M. Coale III, *The Maryland State Archives Atlas of Historical Maps of Maryland, 1608–1908* (Baltimore: Johns Hopkins University Press, 2003), figs. 69–72.

62. Isabel Shipley Cunningham, *Calvary United Methodist Church, Annapolis, Maryland, The First Two Centuries* (Edgewater, Md.: Lith-O-Press, 1984), 20; Carl N. Everstine, *The General Assembly of Maryland, 1776–1850* (Charlottesville, Va.: Michie Company, 1982), 387; *Laws of Maryland*, 1817, Resolution 30. Quotation is from a letter by Louis Gassaway to John Pitts, quoted in Cunningham, 20. Isabel Cunningham cautioned, in a conversation with the author 15 Mar. 2003, that the term "wicked" reflected only the Methodists' general disapproval of horse racing, dances, and similar recreational pursuits.

63. W. Harrison Daniel, "Methodist Episcopal Church and the Negro in the Early National Period," *Methodist History* 11 (Jan.

1973): 40–51; Cunningham, *Calvary United Methodist Church*, 12–28. Quotation from Daniel, 51.

64. Philip L. Brown, *The Other Annapolis, 1900–1950* (2nd ed. privately printed, 2000), 69; Daniel, "Methodist Episcopal Church," 52; James A. Henretta, "Richard Allen and African-American Identity," *Early America Review* 1, no. 4 (Spring 1997), online at http://www.earlyamerica.com/review/spring97/allen.html, last accessed 5/25/10; Janice Hayes-Williams, "Our Legacy," *The Capital*, 17 Mar. 2005; Janice Hayes-Williams, personal communications, 25 Jan., 8 Feb. 2003. Today Asbury United Methodist Church, at 87 West Street, occupies the site of the 1804 meeting house.

65. Cunningham, *Calvary United Methodist Church*, 13–24; Jacobsen, (re Mount Moriah Church); *Asbury United Methodist Church* (White Plains, N.Y.: Monarch Publishing, 1978), 3.

66. Cunningham, *Calvary United Methodist Church*, 21, 25, 27; *Asbury United Methodist Church*, 3; Janice Hayes-Williams, "Our Legacy," *The Capital*, 17 Mar. 2005; Janice Hayes-Williams, personal communications 25 Jan., 8 Feb. 2003.

67. Richard E. Israel, "Reverend Henry Lyon Davis and the Methodists," *Tieline* (St. Anne's Parish newsletter), Sept. 2004.

68. Emily A. Murphy, *"A Complete and Generous Education": 300 Years of Liberal Arts, St. John's College, Annapolis* (Annapolis: St. John's College Press, 1996), 17.

69. Robert L. Worden, *Saint Mary's Church in Annapolis, Maryland, A Sesquicentennial History, 1853–2003* (Annapolis: St. Mary's Parish, 2003), 19–21, 23; *Laws of Maryland*, 1825, Resolution 40. Quotation from Worden, 21.

70. Murphy, *"A Complete and Generous Education,"* 14–17.

71. *Constitutional Revision Study Documents of the Constitutional Convention Commission of Maryland, June 15, 1968* (Annapolis: State of Maryland, 1968), 604–605; Everstine, *The General Assembly, 1776–1850*, 108–109, 386. Designations of place of government are from 1836 amendment and from the 1776, 1851, 1864, and 1867 constitutions (*Study Documents*, 604–605).

72. AN MAC (Proceedings) 1801–1811 [MSA M47-13], f. 229 (Nov. 1810).

73. Michael J. Crawford, Early History Branch, Naval Historical Center, letter to author, 31 Jan. 2003; "Letters from the Secretary of the Navy, 1814–1817, Navy Commissioners Office," 56, 85, 173 (NARA, RG 45); *Annals of Congress, 14th Congress, 2nd session*, 2 Dec. 1816–3 Mar. 1817 (Washington, D.C.: Gales and Seaton, 1854), 1258–1275; *American State Papers: Documents Legislative and Executive of the Congress of the United States* (Washington, D.C.: Gales and Seaton, 1834) 1: 434–443. Quotation is from Crawford's letter. I am grateful to William S. Dudley, director of naval history at the Naval Historical Center 1995–2004, for his assistance in this research. Historian Charles E. Brodine, Jr., Early History Branch, Naval Historical Center,

was most helpful in providing materials from the National Archives.

74. AN MAC (Proceedings) 1811–1819 [MSA M47-15], 182; *Maryland Gazette*, 20 Nov. 1817. Quotation from *Gazette*.

75. *Maryland Gazette*, 20 Nov. 1817, 5 Feb. 1818.

76. *Votes and Proceedings of the House of Delegates of the State of Maryland, December Session 1817* (Annapolis: Jonas Green, 1818), 31, 52, 92–94, 117; *Votes and Proceedings of the Senate of the State of Maryland, December Session 1817* (Annapolis: Jonas Green, 1818), 33, 41. "Legislative aid" from House proceedings, 31; "obstruction" quotation from Senate proceedings, 33.

77. AN MAC (Proceedings) 1811–1819 [MSA M47-15], 193 (20 Apr. 1818); Riley, *The Ancient City*, 255; *Maryland Gazette*, 28 May 1818. Quotation from Riley.

78. [Jeremiah Hughes], *Annapolis Considered as a Suitable Situation, for a Great Naval Depot and Arsenal of Marine Stores*, (Annapolis: J. Chandler, 1818), also printed in the *Maryland Gazette*, 29 Jan., 5 Feb. 1818; *Observations on the Intended Establishment of a Naval Arsenal on the Waters of the Chesapeake Bay*, (Annapolis: J. Chandler, 1818). "Creeks," "labour," and "canal" quotations from Hughes, 29 Jan. 1818; "inner harbour" and "excavated by nature" quotations from *Observations*, 13.

79. *Annals of the Congress of the United States, 15th Congress, 1st Session*, 1 Dec. 1817–29 April 1818, (Washington, D.C.: Gales and Seaton, 1854), 268, 270, 300, 307. "Suitable stations" quotation from 300.

80. "Letters to the Secretary of the Navy, No 1, April 25, 1815 to June 18, 1822, Navy Commissioners Office," 467–468, NARA RG 45; "Miscellaneous Letters sent by the Secretary of the Navy, 1798–1886," roll 5, vols. 13–15 (1816 to 1827), 449, NARA microfilm no. 209. All quotations from Thompson's letter of 20 Nov. 1820 in "Miscellaneous Letters," 449.

81. Charles E. Brodine, Jr., Naval Historical Center, personal communication, 31 Jan. 2003; *Journal of the Proceedings of the Senate of the State of Maryland, December Session, 1827* (Annapolis: Wm. McNeir, 1828), 71; *Laws of Maryland*, 1835, Resolution 36.

82. Chancery Court (Records), L. 2 [MSA S517-4], fol. 595; *Maryland Gazette*, 11 Feb. 1819. Charter quotations from Chancery Record.

83. AN MAC (Proceedings) 1811–1819 [MSA M47-15], 162–196; Edward C. Papenfuse, ed., *A Historical List of Public Officials of Maryland . . . 1632 to 1990, Archives of Maryland*, new series, vol. 1 (Annapolis: Maryland State Archives, 1990), 337–338 (the *Historical List* is now continued to the present as *AOMOL*, vol. 76); Jean B. Russo, "City Officers, 1720–1989" (prepared for Historic Annapolis Foundation, 1990); *Maryland Republican*, 14, 28 June 1817; *Maryland Gazette*, 24 July 1817; AN MAC (Proceedings) 1795 to 1819 [MSA M47-8, 9, 10, 12, 13, 14, 15] passim for the condition of municipal records.

84. Chancery Court (Records), L. 2 [MSA S517-4], fol. 595.

C. Ashley Ellefson, an authority on the charter, does not agree with my interpretation of the franchise under the 1708 charter. Please see the discussion of the charter in Chapter 1.

85. *Constitutional Revision Study Documents*, 375, 393; David S. Bogen, "The Annapolis Poll Books of 1800 and 1804: African-American Voting in the Early Republic," *MHM* 86 (1991): 57–65.

86. Annapolis Election Judges (Poll Books), 1799/02 [MSA M32-1], 1800/10 [MSA M32-2], 1801/07 [MSA M32-3], 1801/09 [MSA M32-4], 1801/10 [MSA M32-5], 1802/03-1802/04 [MSA M32-6].

87. *Votes and Proceedings of the House of Delegates of the State of Maryland, December Session 1818* (Annapolis: Jonas Green, 1819), 3, 78; *Maryland Republican*, 9 Feb. 1819; *Maryland Gazette*, 11 Feb. 1819. Quotation from Stephens's memorial from House proceedings, 78.

88. *Votes and Proceedings of the House, December 1818* , 113–115; *Votes and Proceedings of the Senate of the State of Maryland, December Session 1818* (Annapolis: Jonas Green, 1819), 53; AN MAC (Proceedings) 1811–1819 [MSA M47-15], 162–196; Jean Russo, "City Officers."

89. *Laws of Maryland*, 1818, chap. 194; *Laws of Maryland*, 1822, chap. 211; *Constitutional Revision Study Documents*, 395. Quotation from *Laws*, 1818, chap. 194.

90. *Laws of Maryland*, 1818, chap. 194; author's analysis of city and county sheriffs, 1710 to 1773, in book files.

91. *Maryland Gazette*, 1, 8 Apr. 1819; *Maryland Republican*, 5 Oct. 1819.

92. AN MAC (Assessment Record) 1819 Real Property [MSA M71-1]; AN MAC (Assessment Record) 1819 Personal Property [MSA M71-2]. The personal property assessment was very specific and included black cattle, sheep, horses, silver plate, slaves, and "other property." It did not include business equipment or trade materials or household furnishings. Not all men were listed in the assessment records, and an adjustment has been made for this.

93. "Comparison of city officeholders before and after 1819 charter amendment," an analysis of city officials 1815 to 1825 in book files. See also Jane W. McWilliams, " 'Few Die and None Resign': The Charter Crisis of 1819," presented at *Looking Closer, 300 Years of Annapolis History*, symposium, St. John's College, 6 June 2008.

94. Jean B. Russo, "The Public Thoroughfares of Annapolis," *MHM* 86 (1991): 66–76; AN MAC (Proceedings) 1826–1831 [MSA M47-18], 15 Aug. 1828. Quotation from Proceedings.

95. AN MAC (Proceedings) 1819–1821 [MSA M47-16], 20 Dec. 1819, 27 Mar. 1820, 30 May 1821; *Laws of Maryland*, 1819, chap. 109; AN MAC (Proceedings) 1821–1826 [MSA M47-17], 192; *Laws of Maryland*, 1832, chap. 94; AN MAC (Proceedings) 1831–1840 [MSA M47-19], 128, 147; AN MA (Proceedings) 1843–1850 [MSA M49-1], 203.

96. G. M. Hopkins, *Atlas of Anne Arundel County, Maryland* (1878; reprinted by Ann Arundell County Historical Society and Anne Arundel Genealogical Society, 1994), 19–20.

97. AN MAC (Proceedings) 1819–1821 [MSA M47-16], 13 Sept. 1819; AN MAC (Bylaws and Ordinances) 1826–1843 [MSA M54-4], chap. 120, 46, 14 June 1831. Randall Street was undoubtedly named for John Randall, who died in 1826. Randall had been councilman, alderman, and mayor, and he lived for many years in the house on the northwest corner of the new street, facing the dock, that once had been Middleton's tavern (Russo, "City Officers"; "Lot Histories," Parcel 16, Sect. XIV.

98. AN MAC (Proceedings) 1826–1831 [MSA M47-18], 10 Apr. 1826, 17 Mar. 1827; *Laws of Maryland*, 1819 chap. 138. Quotation from the law.

99. Lewis Duvall, "Mayor's Report," for the year April 1819 to April 1820, in *Maryland Republican*, 18 Apr. 1820.

100. Phebe Jacobsen, "City Hall and Engine House," title search on 211 Main Street for Historic Annapolis Foundation, c. 1960, in "Lot Histories," Parcel 11; AALR, L. WSG 1, f. 196; Annapolis Treasurer (Ledger) 1761–1788 [MSA M69-1]; AN MAC (Proceedings) 1819–1821 [MSA M47-16], 13 Apr. 1820; AN MAC (Proceedings) 1789–1796 [MSA M47-7], 65, 95, 25 (in back of volume); AN MAC (Proceedings) 1801–1811 [MSA M47-13], 20 Dec. 1802; AN MAC (Proceedings) 1821–1826 [MSA M47-17], 11 Apr. 1822; AN MAC (Proceedings) 1819–1821 [MSA M47-16], 19 Nov. 1820. See also Miller and Ridout, *Architecture in Annapolis*, 186.

101. Andrew Burstin, "Celebrating Fifty Years of Independence," in Brian Lamb, ed., *Booknotes, Stories from American History* (New York: Penguin Books, 2002), 60–63; AN MAC (Proceedings) 1821–1826 [MSA M47-17], 109, 112; *Maryland Republican*, 14 Dec. 1824. For a general description of Lafayette's visit to the United States, see Harlow Giles Unger, *Lafayette*, (Hoboken, N.J.: John Wiley & Sons, 2002). "Nation's guest" from *Maryland Republican*, 14 Dec. 1824; Lafayette's response quoted from Proceedings, 112.

102. *Maryland Republican*, 21 Dec. 1824; *Maryland Gazette*, 16, 1824. Quotation from the *Maryland Republican*.

103. Letter from Samuel Griffith's grandson to R. R. Griffith, 27 Sept. 1891 (transcribed), gift of Ann Kennedy Masterson to the Calvary United Methodist Church archives. I am indebted to Patricia Blick and Glenn Campbell for this source.

104. *Maryland Republican*, 21, 28, 30 Dec. 1824; 30 Jan. 1819; *Maryland Gazette*, 23 Dec. 1824; "Lot Histories," Parcel 19, Sect. II. Louise Magruder's typescript history of Ogle Hall in this lot file states that Lafayette was "said to have called the drawing room of Ogle Hall the most beautiful in America." Williamson's Hotel is now the Maryland Inn. All quotations from *Maryland Republican*, 21 Dec. 1824.

105. Henry Matthews came to Annapolis from Washington County, Peter Shorter from Nova Scotia. See Jerry M. Hynson, *Maryland Freedom Papers, Volume 1, Anne Arundel County* (Westminster, Md.: Family Line, 1996), passim; Janice Hayes-Williams, "Our Legacy," *The Capital*, 12 May 2005, 28 Sept. 2006, 5 Feb. 2008, 19 Feb. 2009.

106. For instance, John Maynard bought his wife and her child in the 1830s and later manumitted them (AA CT [Chattel Records], L. WSG 2 [MSA C49-2], f. 38; AA CCT (Chattel Records) L. NHG 1 [MSA C50-1], 318; AA CT [Manumission Records] L. C 3 [MSA C109-3], f. 609; AA CCT [Manumission Records] L. D 4 [MSA C110-1], f. 112). For slaves living on their own in town, see Parker, *Presidents Hill*, 8. Statistics show that in 1850 free blacks in Maryland's ten largest cities outnumbered free blacks in adjoining counties (Barbara Jeanne Fields, *Slavery and Freedom on the Middle Ground: Maryland during the Nineteenth Century* [New Haven: Yale University Press, 1985], 34). Annapolis was fifth in urban population in Maryland in 1850.

107. 1798 Federal Direct Tax, Annapolis, transcript by Clifton Ellis, compared with the list of free black households on the 1800 Federal Census, compiled by Jean Russo, in book files; "Lot Histories," Parcel 6, Sect. VII, Parcel 23, Sect. IIB, Parcel 12, Sect. II, Parcel 10, Sect. IA, Parcel 14, Lot 19; *Maryland Gazette*, 24 Apr. 1800.

108. AN MA (Assessment Record) 1845 [MSA M72-2]; 1850 Federal Census, Annapolis District. Figures for free black property owners are based on individuals identified or known to be African American.

109. Elihu S. Riley, "Annapolis at the Advent of the Naval Academy," *Evening Capital*, 5 Dec. 1921.

110. Hynson, *Maryland Freedom Papers*, introduction and passim; for laws, see, for instance, *Laws of Maryland*, 1796, chap. 30; AN MAC (Bylaws and Ordinances) 1768–1791 [MSA M54-1], 4–10 reverse; AN MAC (Bylaws and Ordinances) 1792–1816 [MSA M54-2], 214.

111. The most complete study of African Americans in Anne Arundel County and Annapolis in the first half of the nineteenth century is William L. Calderhead, "Experiment in Freedom, Maryland's Answer to President Lincoln's Dilemma," (typescript, 1966, in book files). For background and general information on Southern blacks of this period, see Richard C. Wade, *Slavery in the Cities: The South, 1820–1860* (New York: Oxford University Press, 1964), and Loren Schweninger, *Black Property Owners in the South, 1790–1915* (Urbana: University of Illinois Press, 1997). For blacks in Maryland, see Jeffrey Brackett, *The Negro in Maryland* (Baltimore: Johns Hopkins Press, 1889); James Wright, *The Free Negro in Maryland, 1634–1860* (New York: Columbia University Press, 1921); and Fields, *Slavery and Freedom on the Middle Ground*.

112. Janice Hayes-Williams cited AN MAC (License Record) 1810–1818 [MSA M66-1] in a conversation with the author, 24 Jan. 2005. Ginger Doyel, *Gone to Market: The Annapolis Market House, 1689–2005* (Annapolis: City of Annapolis, 2005), 23.

113. Calderhead, "Experiment in Freedom," 57–58; *Maryland Gazette*, 25 Feb. 1819. Quotations from *Maryland Gazette*.

114. Calderhead, "Experiment in Freedom," 95–99.

115. *Maryland Republican*, 10 Feb. 1847; Carroll Greene, Jr., *Looking Back, Moving On: A Black Pictorial History of Anne Arundel County* (catalog for an exhibit at AFRAM '76 Gallery, 20 Dean Street, Annapolis, sponsored by the Maryland Commission on Afro-American History and Culture and the Maryland Bicentennial Commission, 1976). I am indebted to Janice Hayes-Williams for this source. Quotation from Greene. The City Hotel was the latest name for the house confiscated by the state as property of Loyalist Lloyd Dulany and operated by George Mann as Mann's Tavern.

116. Calderhead, "Experiment in Freedom," 101; Riley, "Annapolis at the Advent of the Naval Academy," *Evening Capital*, 29 Oct. 1921. Quotation from Riley.

117. See, for instance, Helen Buckler, *Daniel Hale Williams, Negro Surgeon* (New York: Pittman Publishing, 1954; 2nd ed., 1968). Dr. Williams (1856–1931) was the grandson of Henry and Ann Wilkes Price.

118. Wade, *Slavery in the Cities*, 141–142.

119. 1850 Federal Census, Annapolis District, Mortality Schedule.

120. AN MAC (Proceedings) 1831–1840 [MSA M47-19], 18 Apr., 13 May 1837. Quotation from 18 Apr. Proceedings. The house may have been at 176 Main Street, where Matthews later kept a tavern (see Miller and Ridout, *Architecture in Annapolis*, 190).

121. See, for instance, AN MCT (Minutes) 1783–1785 [MSA M44-7], 6; AN MCT (Minutes) 1792 [MSA M44-11], Mayor's Court Docket, 229.

122. Ted Steinberg, *Down to Earth: Nature's Role in American History* (New York: Oxford University Press, 2002), 159–161.

123. AN MAC (Bylaws and Ordinances) 1826–1843 [MSA M54-4], 52, 76, 95; AN MAC (Proceedings) 1831–1840 [MSA M47-19], 295, 305–311; Calderhead, "Experiment in Freedom," 13; Steinberg, *Down to Earth*, 161. "Distinguish" and "wave" quotations from Proceedings, 305–311; "run at large" quotation from Bylaws and Ordinances, 95.

124. *Maryland Republican* and *Maryland Gazette*, Sept., Oct. 1831, passim. Quotation is from the report of a meeting at South River on 5 October in the *Maryland Republican*, 29 November 1831.

125. *Maryland Gazette*, 6 Oct. 1831; *Maryland Republican*, 8 Oct. 1831.

126. *Laws of Maryland*, 1831, chap. 323.

127. Cunningham, *Calvary United Methodist Church*, 24–25; *Asbury United Methodist Church*, 3. Quotation from *Asbury*, 3, which is also quoted in Cunningham, 24.

128. Richard L. Hall, *On Afric's Shore: A History of Maryland in Liberia, 1834–1857* (Baltimore: Maryland Historical Society, 2003), 13, 444–505 (Hall says that of 1,400 blacks who emigrated to Liberia before 1830, only 200 were from Maryland); McIntire, *Annapolis, Maryland, Families*, 1: 569; Clayton Col-

man Hall, ed., *Baltimore, Its History and Its People* (New York: Lewis Historical Publishing, 1912), 2: 231.

129. "First Annual Report of the Female Sunday Schools of Annapolis, April 1819," in *Maryland Gazette*, 27 May 1819; AA BE (Special Reports) David S. Jenkins, "A History of the Colored Schools in Anne Arundel County, Maryland, and a Proposal for their Consolidation," [MSA CM 1172-3], 1–2. All quotations from newspaper.

130. Margaret Lynne Browne and Patricia M. Vanorny, *Piety, Chastity, and Love of Country: Education in Maryland to 1916* (Annapolis: Maryland State Archives, 1984), 4–5.

131. Chancery Court (Record), L. 136 [MSA S517-153], f. 376, cited in the title chain for 160 Green Street in Baltz Collection [MSA SC 5224-2-18]; Littleton Dennis Teackle, chairman, *Report of the committee appointed by the House of Delegates, in conjunction with a like committee on the part of the Senate to visit and inspect the seminary of the primary school in the city of Annapolis* (Annapolis: Jeremiah Hughes, 1830), 5–7; Dell Upton, "Lancasterian Schools, Republican Citizenship, and the Spatial Imagination in Early Nineteenth-Century America," *Journal of the Society of Architectural Historians* 55 (Sept. 1996): 238–253; Pat Melville, "A School House in Annapolis," *Archivists' Bulldog* 14, no. 17 (Sept. 2000). I am indebted to Robert Worden for this last source. The school house stood at what is now 160 Green Street (see title chain cited above). Quotations from Teackle's report, 7.

132. AN MAC (Proceedings) 1831–1840 [MSA M47-19], 435.

133. McWilliams, *"The Progress of Refinement,"* 10; *Maryland Gazette*, 18 June 1829, 15 Dec. 1831; Baltimore *Sun*, 9 Jan. 1843; AN MAC (Bylaws and Ordinances) 1826–1843 [MSA M54-4], 31; AN MAC (Proceedings) 1831–1840 [MSA M47-19], 120–121; AN MAC (Proceedings) 1826–1831 [MSA M47-18], 29 Dec. 1829, 14 June 1830.

134. AN MAC (Proceedings) 1831–1840 [MSA M47-19], 7–12, 72–74; *Maryland Republican*, 5, 8 Apr. 1828; AN MAC (Proceedings) 1821–1826 [MSA M47-17], 181, 182; AN MAC (Proceedings) 1826–1831 [MSA M47-18], 25 June 1830. "Substantial and permanent" from Proceedings, 1831–1840, 72–74.

135. AN MAC (Proceedings) 1821–1826 [MSA M47-17], 216, 226; AN MAC (Proceedings) 1826–1831 [MSA M47-18], 21 June 1826, 12 Jan. 1827; AN MAC (Bylaws and Ordinances) 1826–1843 [MSA M 54-4], 65; AN MAC (Proceedings) 1831–1840 [MSA M47-19], 120–121.

136. AN MAC (Proceedings) 1821–1826 [MSA M47-17], 79, 161–167; AN MAC (Proceedings) 1831–1840 [MSA M47-19], 72–7; AN MAC (Bylaws and Ordinances) 1826–1843 [MSA M54-4], 43, 10 June 1839. Boyle's comments quoted from Proceedings, 1821–1826, 79.

137. AN MAC (Bylaws and Ordinances) 1792–1816 [MSA M54-2], 141; AN MAC (Proceedings) 1789–1796 [MSA M47-7], 25 (at back of volume); AN MAC (Proceedings) 1821–1826 [MSA M47-17], 115, 212; AN MAC (Bylaws and Ordinances) 1826–1843

[MSA M54-4], 13, 15; AN MAC (Proceedings) 1826–1831 [MSA M47-18], 21 Nov. 1826. "Ladder and axe" from Bylaws, 1826–1843, 15.

138. *Laws of Maryland*, 1838, chap. 84; AN MA (Proceedings) 1843–1850 [MSA M49-1], 271; McIntire, *Annapolis, Maryland, Families*, 1: 569.

139. Union Hotel proprietor James Hunter was a member of the Concordia Lodge Number 17, International Order of Odd Fellows; see his obituary in the *Maryland Gazette*, 19 Nov. 1835; and IOOF website at www.ioof.org. By 1831 Annapolis had two temperance societies and there were more in the county; see *Maryland Republican*, 28 Oct., 1 Nov. 1831; *Laws of Maryland*, 1829, chap. 95.

140. Cunningham, *Calvary United Methodist Church*, 23 and passim; William K. Paynter, *St. Anne's, Annapolis, History and Times* (Annapolis: St. Anne's Parish, 1980), 46.

141. AN MAC (Proceedings) 1831–1840 [MSA M47-19], 119, 305–311; AN MAC (Bylaws and Ordinances) 1826–1843 [MSA M54-4], 51; AN MAC (Proceedings) 1840–1843 [MSA M47-20], 105; *Maryland Republican*, 13, 24 Jan. 1835. Quotation from Bylaws, 51.

142. *Laws of Maryland*, 1836, chap. 197.

143. Everstine, *The General Assembly, 1776–1850*, 555; *Laws of Maryland*, 1845, chap. 269. The General Assembly met in regular biennial sessions from 1842 until 1949 (Papenfuse, *Historical List*, 33). An over indulgence in internal improvements pushed the state close to bankruptcy in the early 1840s. Governor Thomas G. Pratt, elected in 1844, initiated cost-cutting measures throughout state government. For details on the crisis and Pratt's role, which garnered for him a special inscription on his tombstone in St. Anne's Cemetery, see Richard E. Israel, "A History of the Adoption of the Maryland Executive Budget Amendment" (2004), available online at *AOMOL* Fiscal Records.

144. *Laws of Maryland*, 1842, chap. 161.

145. James D. Dilts, *The Great Road: The Building of the Baltimore and Ohio, the Nation's First Railroad, 1828–1853* (Stanford, Calif.: Stanford University Press, 1993), 7–12, 26; Walter S. Sanderlin, *The Great National Project: A History of the Chesapeake and Ohio Canal* (Baltimore: Johns Hopkins Press, 1946), 22–39, 45, 59–60; Erie Canal history at www.nycanal.com; Brugger, *Maryland, A Middle Temperament*, 805.

146. AN MAC (Proceedings) 1826–1831 [MSA M47-18], 21 Nov. 1826; Dilts, *The Great Road*, 23.

147. *Laws of Maryland*, 1828, chap. 189.

148. *Laws of Maryland*, 1835, Resolution 64; George W. Hughes, *Report on the Location and Survey of the Potomac and Annapolis Canal by George W. Hughes, U. S. Civil Engineer, to the Governor of Maryland* (Annapolis: William M'Neir, printer, 1837) [MHS Rare PAM 5033], 1–42 (italics in source). All quotations from Hughes.

149. *Laws of Maryland*, 1835, chaps. 249, 395.

150. Dilts, *The Great Road*, 159–184. The Washington Branch opened 25 August 1835.

151. *Laws of Maryland*, 1836, chap. 298; Dilts, *The Great Road*, 177; Papenfuse, *A Historical List of Public Officials*, 1: 448.

152. AN MAC (Bylaws and Ordinances) 1826–1843 [MSA M54-4], 10 Sept., 1 Oct. 1838.

153. *Maryland Republican*, 25 May 1839; Dilts, *The Great Road*, 295.

154. AN MAC (Proceedings) 1831–1840 [MSA M47-19], 406, 412, 425; *Maryland Republican*, 23 Apr. 1839; *Maryland Gazette*, 2 May 1839; Simon J. Martenet, *Martenet's Map of Anne Arundel County*, 1860, Annapolis inset [MSA SC 1427-1-187] and Library of Congress Geography and Map Division, call number G3843.A5 1860.M3. Bryan's protest quoted from Proceedings, 406.

155. AN MAC (Proceedings) 1840–1843 [MSA M47-20], 82; Mame Warren, *Then Again . . . : Annapolis, 1900–1965* (Annapolis: Time Exposures, 1990), xx.

156. *Maryland Republican*, 29 Dec. 1840; David Ridgely, comp. and ed., *Annals of Annapolis* (Baltimore: Cushing & Brother, 1841), 231.

157. Benson J. Lossing, *The Pictorial Field-Book of the Revolution* (New York: Harper & Brothers, 1860) 2: 188–199.

158. Robert H. Burgess and H. Graham Wood, *Steamboats Out of Baltimore* (Cambridge, Md: Tidewater Publishers, 1968), xvii–xix.

159. Ridgely, *Annals of Annapolis*, 231. The importance of steam engineering in the decision to establish a naval school is covered by Henry Francis Sturdy, "The Establishment of the Naval School at Annapolis," *U.S. Naval Institute Proceedings* 72 (Apr. 1946): 5, and Sturdy, "The Founding of the Naval Academy by Bancroft and Buchanan," *U.S. Naval Institute Proceedings* 61 (Oct. 1935): 1369; also by Charles Todorich, *The Spirited Years: A History of the Antebellum Naval Academy* (Annapolis: Naval Institute Press, 1984), 12, and Jack Sweetman, *The U.S. Naval Academy: An Illustrated History*, 2nd ed., rev. by Thomas J. Cutler (Annapolis: Naval Institute Press, 1995), 11.

160. Todorich, *The Spirited Years*, 11–12; Sweetman, *The U.S. Naval Academy*, 6–11; *Journal of the House of Delegates, December Session, 1825* (Annapolis: J. Green, 1826), 62; *Laws of Maryland*, 1825, Resolution 17; *Maryland Gazette*, 14 Feb. 1826, 31 Dec. 1835; *Laws of Maryland*, 1827, Resolution 85; *Laws of Maryland*, 1835, Resolution 36; *Maryland Republican*, 25 May 1839.

161. Todorich, *The Spirited Years*, 12–17; Sweetman, *The U.S. Naval Academy*, 11–15.

162. Todorich, *The Spirited Years*, 16–17; Sweetman, *The U.S. Naval Academy*, 15–16; Sturdy, "Establishment of the Naval School," 5; Byron A. Lee, *Naval Warrior: The Life of Commodore Isaac Mayo* (Linthicum, Md.: Ann Arundell County Historical Society, 2002), 111–113, 165, 187–192.

163. Todorich, *The Spirited Years*, 17; "Documents, Legislative and Executive, of the Congress of the United States," *American State Papers* (Washington, D.C.: Gales and Seaton, 1834) 1: 492; "Documents, Legislative and Executive, of the Congress of the United States," *American State Papers* (Washington, D.C.: Gales and Seaton, 1860) 3: 463–468.

164. Todorich, *The Spirited Years*, 17–18.

165. Ridgely, *Annals of Annapolis*, 230–248; Murphy, "*A Complete and Generous Education*," 19–23. All quotations from Ridgely; about the fort on 248, about the African church on 245.

166. Elihu S. Riley, "Annapolis at the Advent of the Naval Academy," *Evening Capital*, 12, 19, 24 Dec. 1921. King George Street spring and "tangled garden" quotations from 12 Dec.; snowball description from 19 Dec.

Chapter 5. A Military Town, 1845 to 1870

1. Craig L. Symonds, *Confederate Admiral: The Life and Wars of Franklin Buchanan* (Annapolis: Naval Institute Press, 1999), 37, 40–50; BDML 2:537; Robert Harry McIntire, *Annapolis, Maryland, Families*, 2 vols. (Baltimore: Gateway Press, 1980, 1989), 1:433, 505. Ann Catherine's father, Edward Lloyd V, sold the house now known as the Chase-Lloyd House in 1826 ("Lot Histories," Parcel 19, Sect. I). The Buchanans sold their Scott Street house to the naval school in 1847 (AA Co. Land Records, L. JHN 2, f. 513).

2. Jack Sweetman, *The U.S. Naval Academy: An Illustrated History*, 2nd ed., rev. by Thomas J. Cutler (Annapolis: Naval Institute Press, 1995), 20, 76; McIntire, *Annapolis Families*, 1: 362, 448; Symonds, *Confederate Admiral*, 53, 70, 72.

3. Sweetman, *The U.S. Naval Academy*, 21–22.

4. Louis H. Bolander and Elinore G. Girault, "A Brief History of the First Presbyterian Church, Annapolis, Maryland." (typescript, 1936), 1–14, 17. (Elinore Girault was the daughter of Professor Girault [McIntire, *Annapolis, Maryland Families*, 1: 272].) See also John Ridout, "A Brief History of the Presbyterian Church in Annapolis," MSA SC 16.

5. McIntire, *Annapolis Families*, 1: 272.

6. Sweetman, *The U.S. Naval Academy*, 20–21, 76, 86, 88, 102; McIntire, *Annapolis Families*, 1: 434; J. Thomas Scharf, *History of Maryland*, 3 vols. (1879; reprint, Hatboro, Pa.: Tradition Press, 1967), 3: 574, 577; Baltimore *Sun*, 12 Dec. 1953; Jane W. McWilliams, "Eastport Notes," (typescript prepared for Historic Annapolis, 1983); Jane Wilson McWilliams, *The First 90 Years: A History of Anne Arundel Medical Center, 1902–1992* (Annapolis: Anne Arundel Medical Center, 1992), 5.

7. Sweetman, *The U.S. Naval Academy*, 23, McIntire, *Annapolis Families*, 1:434; Jane W. McWilliams, *Annapolis History Bibliography* (typescript, 2000), 77–78.

8. Ann Jensen, "Rebel Captain from Annapolis, the Last Confederate Raider," *Annapolitan*, Mar. 1990, 43; McIntire, *Annapolis Families* 1: 355, 732. "Passed Midshipman" was a rank held by men who had passed the lieutenant's exam and were waiting for a vacancy in that rank (Sweetman, *The U.S. Naval Academy*, 13).

9. McIntire, *Annapolis Families* 1: 441–442; John Taylor Wood, Diary, vol. 1, 15 to 24 Feb. 1860 (Southern Historical Collection #2381, University of North Carolina, Chapel Hill); Royce Gordon Shingleton, *John Taylor Wood, Sea Ghost of the Confederacy* (Athens: University of Georgia Press, 1979), 5–6; Edward Chauncey Marshall, *History of the United States Naval Academy* (New York: D. VanNostrand, 1862), 139. I am indebted to Ann Jensen for her copy of a transcript of Wood's diary.

10. McIntire, *Annapolis Families* 1: 179, 463, 574, 665; Park Benjamin, *The United States Naval Academy* (New York: G. Putnam's Sons, Knickerbocker Press, 1900), 428–429; Marshall, *History of the Naval Academy*, 139–140.

11. Records of the U.S. Naval Academy, Letters received by the Superintendent, 1845–87, box 1, folder 8, Civilians 1845–60, Special Collections, Nimitz Library, USNA; Letters sent by the Superintendent, May 9, 1849–July 27, 1853, vol. 4, pp. 378, 408, in Letters sent by the Superintendent of the U.S. Naval Academy, 1845–1865, Special Collections, Nimitz Library, USNA; Marshall, *History of the Naval Academy*, 140; Charles Todorich, *The Spirited Years: A History of the Antebellum Naval Academy* (Annapolis: Naval Institute Press, 1984), 128.

12. Marshall, *History of the Naval Academy*, 140; McIntire, *Annapolis Families*, 1: 131

13. Baltimore *Sun*, 18 Dec. 1852.

14. Letter to G. Hallock, Esq. (no date, no author), reprinted from the *Journal of Commerce* in *The Anglo-African Magazine, Vol. 1, 1859* (New York: Arno Press and *New York Times*, 1968), 367–368; AA CCT (Manumission Record) 1851–1866, L. D [MSA C110-1], f. 125; G. S. Blake to A. W. Smith, 16 June 1862, Letters sent by the Superintendent, Apr. 24, 1862 to Apr. 23, 1865, vol. 18, p. 52; *The African Repository*, vol. 40 (1864), available online through Google Books, accessed 5/31/10, 253; *First Annual Report of the Trustees of Public Reservations, 1891* (Boston: printed for the Trustees by Geo. H. Ellis, 1892), 50. I am indebted to Jennifer Bryan, head of special collections and archives at the Nimitz Library, USNA; Judy Cabral, vice president of programs and research, Kunta Kinte–Alex Haley Foundation; and James Cheevers, associate director / senior curator, USNA Museum, for valuable pieces of Benjamin Boardley's story.

15. James Cheevers, communication to author, 7 Nov. 2007; *Laws of Maryland*, 1831, chap. 323, and 1847, chap. 133; Symonds, *Confederate Admiral*, 73–74.

16. Todorich, *The Spirited Years*, 92–93.

17. Letters received by the Superintendent, 1845–87, box 1, folder 8, Civilians 1845–60. (Hohne got the job.)

18. Letters received by the Superintendent, 1845–87, box 1, folder 8; Letters sent by Superintendent, May 9, 1849–July 27, 1853, vol. 4, p. 494.

19. Letters received by the Superintendent, 1845–87, box 1, folder 8.

20. Letters sent by the Superintendent, May 9, 1849–July 27, 1853, vol. 4, pp. 449, 450.

21. Ibid., p. 499.

22. Symonds, *Confederate Admiral*, 79–80.

23. Sweetman, *The U.S. Naval Academy*, 26, 27, 30.

24. *Laws of Maryland*, 1858, chap. 55, 1865, chap. 87.

25. Todorich, *The Spirited Years*, 37; Sweetman, *The U.S. Naval Academy*, 35–36; Elihu S. Riley, "Annapolis at the Advent of the Naval Academy," *Evening Capital* 11 July 1921. Henry Matthews's tavern, at 176 Main Street, built by Matthews and Charles Shorter about 1834 (Miller and Ridout, *Architecture in Annapolis*, 190), was probably the second house on the property; the first was destroyed by fire in 1833.

26. Sweetman, *The U.S. Naval Academy*, 29–30, 35–40; Symonds, *Confederate Admiral*, 75. The term "yard" refers to the academy's grounds. After the Civil War, the term was not commonly used until revived in the second half of the twentieth century (James Cheevers, communication to author, 7 Nov. 2007).

27. Sweetman, *The U.S. Naval Academy*, 50. The quotation is from a letter about the affair from Goldsborough to Secretary of the Navy James C. Dobbins quoted by Sweetman.

28. Biography of William Wirt included with inventory of his papers at the Maryland Historical Society (www.mdhs.org/library/mss/ms001011.html, last accessed 5/31/10); McIntire, *Annapolis Families*, 1: 569; Elizabeth Philpot Blanchard Randall, *Alexander Randall of Annapolis, Maryland, 1903–1881* (n.p.: privately printed by Peter Randall, 1990), 14–15. Randall's first wife, Catherine Wirt Randall, died in January 1853. Her mother, who had lived in the Randall household for some years, remained there until her death in 1857. My thanks to Michael Parker for this addition to the McThorne story.

29. Sweetman, *The U.S. Naval Academy*, 77–78.

30. Ibid., 30; Symonds, *Confederate Admiral*, 78. Quotation from Symonds.

31. Symonds, *Confederate Admiral*, 81; Sweetman, *The U.S. Naval Academy*, 37–38; Baltimore *Sun*, 6 Dec. 1852.

32. Elihu S. Riley, *The Ancient City: A History of Annapolis, in Maryland, 1649–1887* (Annapolis: Record Printing Office, 1887; reprint 1977[?]), 268.

33. *Laws of Maryland*, 1845, chap. 216.

34. Sweetman, *The U.S. Naval Academy*, 25 (map), 45. Riley gives the total of the 1847 and 1853 purchases as 33 acres (*The Ancient City*, 267). These parcels and much of the land on the peninsula acquired by the academy through the nineteenth century once had been the New Town of 1718 or Thomas Larkin's subdivision north and west of New Town.

35. AALR, L. JHN 2, fs. 502, 503, 513, 578; L. JHN 3, f. 94; AN MA (Assessment Record) 1845 [MSA M72-2]. The fourth property sold cannot be linked definitively to the assessment record.

36. AALR, L. NHG 2, fs. 503, 506, 509, 511, 518, 524, 527, 530, 533, 536, 539, 542, 551, 606, 609; AN MA (Assessment Record) 1845 [MSA M72-2].

37. AALR, L. NHG 2, f. 516.

38. Sweetman, *The U.S. Naval Academy*, 24, 25, 44, 45.

39. *Laws of Maryland*, 1853, chap. 185.

40. *Maryland Republican*, 10 July 1847; Riley, *The Ancient City*, 268–272.

41. Baltimore *Sun*, 6 July 1858.

42. Baltimore *Sun*, 21, 22, 28 June 1858, 6 July 1858. "Beautiful city" quote from 22 June issue; quote about hotels from 28 June issue.

43. *Dictionary of American Biography* (1934), 7: 486–489; Baltimore *Sun*, 9 Nov. 1851. Quotation from the *Sun*.

44. Baltimore *Sun*, 9, 20 Nov. 1852; *National Intelligencer*, 10 Nov. 1852; USS *Princeton* and USS *Mississippi* in *Dictionary of American Fighting Ships* (online at the Naval Historical Center website [http://www.history.navy.mil/danfs, last accessed 5/31/10]); *Biographical Dictionary of U.S. Congress, 1788–1989*, 16; *Dictionary of American Biography* (1934), 7: 486–489.

45. Baltimore *Sun*, 18 Nov. 1852.

46. Sweetman, *The U.S. Naval Academy*, 57. Also called Lew Chew Islands, these are now known at Ryukyu Islands, of which the principal island is Okinawa (James Cheevers, communication to author, 7 Nov. 2007).

47. A Citizen of Annapolis, *A Correct Guide to Strangers Visiting the Ancient City of Annapolis*, . . . (1859). In the third edition of this guide Taylor acknowledged his authorship (Owen M. Taylor, *Annapolis Directory, or Stranger's Guide, Giving a Short Account of the First Settlement of the Ancient City, History of its Various Public Buildings* . . . (Annapolis: Owen M. Taylor, 1865). I am indebted to Charlie Cadle for a copy of this booklet.

48. Randall, *Alexander Randall*, 23; William K. Paynter, *St. Anne's Annapolis, Md.: History and Times* (Annapolis: St. Anne's Parish, 1980), 49–53, 109; Robert J. Brugger, *Maryland, A Middle Temperament, 1634–1980* (Baltimore: Johns Hopkins University Press, 1988), 251; Morris L. Radoff, *Buildings of the State of Maryland at Annapolis* (Annapolis: Hall of Records Commission, 1954), 22; Richard E. Israel, "St. Anne's 1858 Fire and Construction of Present Church," *Tieline* (St. Anne's Parish newsletter), Feb. 2008, 1, 7; St. Anne's Parish, Vestry Minutes, 13 Jan. 1866 [MSA SC 15-1-24]. Wells made his gift of the 1,537-pound bell on Christmas Eve 1865 (Vestry Minutes).

49. Robert L. Worden, *Saint Mary's Church in Annapolis, Maryland, A Sesquicentennial History, 1853–2003* (Annapolis: St. Mary's Parish, 2003), 34–39. One of the three priests named in the 1852 deed was Father John Neumann, then rector of Saint Alphonsus Church in Baltimore, later Bishop of Philadelphia, and now Saint John Nepomucene Neumann. The property was later transferred to the Redemptorists of Maryland, Inc.

50. Worden, *Saint Mary's Church*, 39–41. John Randall, a

merchant in town, became a faithful attendant at Redemptorist services and made a deathbed conversion to Catholicism (44).

51. Ibid., 47–51; Robert L. Worden, personal communication, 1 June 2010; *Saint Mary's Church, 1853–1928: Diamond Jubilee, Annapolis, Maryland* (Annapolis, 1928), 27–43; Marcia M. Miller and Orlando Ridout V, eds., *Architecture in Annapolis: A Field Guide* (Newark, Del.: Vernacular Architecture Forum, and Crownsville, Md.: Maryland Historical Trust Press, 1998), 142–143.

52. Isabel Shipley Cunningham, *Calvary United Methodist Church, Annapolis, Maryland, The First Two Centuries* (Edgewater, Md.: Lith-O-Press, 1984), 29–32; Baltimore *Sun*, 18 Sept. 1863, 1 Dec. 1863.

53. A Citizen of Annapolis, *A Correct Guide to Strangers*; *Asbury United Methodist Church* (White Plains, N.Y.: Monarch Publishing, 1978), 3.

54. AN MA (Proceedings) 1843–1850 [MSA M49-1], 301.

55. AN MA (Proceedings) 1852–1854 [MSA M49-3], folder 45, 1865 [MSA M49-10], 60. Quotation from MSA M49-3.

56. AN MA (Proceedings) 1852–1854 [MSA M49-3], folder 47.

57. *Laws of Maryland*, 1861, chap. 44.

58. AN MA (Proceedings) 1852–1854 [MSA M49-3], folders 3, 7.

59. AN MA (Proceedings) 1857 [MSA M49-6], folder 23.

60. AN MA (Proceedings) 1852–1854 [MSA M49-3], box 20, folder 32 [MSA M49-4], box 21, folder 32; Radoff, *Buildings of the State*, 62; Ginger Doyel, *Gone to Market: The Annapolis Market House, 1698–2005* (Annapolis: City of Annapolis, 2005), 28–29. Doyel believes the city built a new market house in 1819 (23).

61. *Annapolis Gazette*, 4 Oct. 1855. Not a direct descendant of the Green family's *Maryland Gazette*, which ceased publication in 1839, the *Annapolis Gazette* was published by successive owners from September 1854 until November 1874. The paper's owner in 1874 renamed it the *Maryland Gazette*. A descendant of that 1874 *Maryland Gazette* is published today by Capital Gazette Communications (Jane W. McWilliams, "The Older the Better: What Exaggeration Tells Us about Annapolis's History," Four Rivers Heritage Area Mythbusters Workshop, Historic London Town, 18 Nov. 2008 [text-only version of this talk online at the Four Rivers Heritage Area website: www.fourriversheritage.org (last accessed 5/29/10)]; Capital Gazette Communications, Inc., at www.hometownannapolis.com/contactus.html [last accessed 5/29/10]).

62. Radoff, *Buildings of the State*, 62; Doyel, *Gone to Market*, 28–29. Burch quoted in Doyel, 29.

63. Radoff, *Buildings of the State*, 115–117; *Laws of Maryland*, 1858, chap. 105. Quotation from the committee's report from Radoff, 115.

64. *Laws of Maryland*, 1854, chap. 306, 1858, chaps. 123, 214, 330.

65. "Report, By-Laws, and List &c. of Stockholders of the Annapolis Gas Light Company," (Annapolis: Robert F. Bonsall, printer, 27 July 1859), in AN MA (Proceedings) 1859 [MSA M49-7], folder 14; G. M. Hopkins, *Atlas of Anne Arundel County, Maryland* (1878, reprinted by Ann Arundell County Historical Society, 1994), 20. The Naval Academy in 1853 installed a steam and gas works that supplied heat and light to all buildings (Owen M. Taylor, *The History of Annapolis, Md.* . . . (Baltimore: Turnbull Brothers, 1872), 33; Marshall, *History of the Naval Academy*, 50).

66. Baltimore *Sun*, 10 Jan. 1859.

67. AN MA (Proceedings) 1858–1861 [MSA M49-7], folder 14 (17 Nov. 1859), folder 24; AN MA (Proceedings) 1862–1863 [MSA M49-9] folder 25 (10 Mar. 1862); AN MA (Proceedings) 1863–1869 [MSA M49-10] 20, 51, 164, 173, 185, 207, 222. Quotation from MSA M49-7, folder 14.

68. *Laws of Maryland*, 1852, chap. 369; AALR, L. NHG 10, f. 83; Phebe R. Jacobsen, "Center of the Storm: St. John's and Annpolis, 1860–1865," (unpublished manuscript, 1985, in the MSA library), 1.

69. *Annapolis Gazette*, 6 Dec. 1860, 28 Feb. 1861.

70. Joseph C. G. Kennedy, Superintendent of the Census, *Population of the United States in 1860* (Washington, D.C.: Government Printing Office, 1864); Author's analysis of the 1860 Census, Annapolis District (on microfilm [MSA M7202], 701–802), in book files. See Appendix 1, Table 2.

71. *Annapolis Gazette*, 19 Apr. 1860; David Carlyon, *Dan Rice, The Most Famous Man You've Never Heard Of* (New York: Public Affairs, 2001), xi–xii, 227, 275, 280–281, 288; Wood Diary, vol. 1, 23 Apr. 1860. "Mules" quotation from newspaper.

72. Baltimore *Sun*, 6, 8, 10 Aug. 1860; Daniel Othfors, "Great Eastern, 1860–1888" (online at http:/www.thegreatoceanliners.net/index2.html, last accessed 5/30/10. There are hundreds of sites with information on this ship.); Wood Diary, vol. 1, 5–11 Aug. 1860. Quotations about size of ship and number of visitors from Wood, 7 and 6 Aug. respectively; "greatest wonder" quote from the *Sun*, 8 Aug.

73. Wood Diary, vol. 1, 10, 12, 18 July 1860; *New York Times* 18 July 1860; David Todd, "The Total Eclipse of 1914," *Popular Astronomy* 22 (1914): 22–25 (online at www.adsabs.harvard.edu, last accessed 5/30/10).

74. Sweetman, *The U.S. Naval Academy*, 57; *Dictionary of American Naval Fighting Ships* (online at the Naval Historical Center website, http://www.history.navy.mil/danfs, last accessed 5/31/10).

75. Brugger, *Maryland, A Middle Temperament*, 270–272; Suzanne Ellery Green Chapelle, Jean H. Baker, Dean R. Esslinger, Whitman H. Ridgway, Jean B. Russo, Constance B. Schulz, and Gregory A. Stiverson, *Maryland, A History of Its People* (Baltimore: Johns Hopkins University Press, 1986), 152–153; Wood Diary, vol. 1, 24, 27 Oct. 1860.

76. Wood Diary, vol. 1, 20 July 1860.

77. Governor (Election Returns) 11/6/1860, Presidential Electors AA [MSA S108-37]; *Annapolis Gazette*, 1 and 8 Nov. 1860; Chapelle et al., *Maryland, A History of Its People*, 152–155. It should be noted that in 1860 the voter supplied his own ballot, which in practice meant a ballot printed by a political party. Since neither Lincoln's political party nor the electors pledged to him garnered much coverage in Baltimore and Annapolis newspapers, it is unlikely that the party was well organized in the state. The three votes for Lincoln's presidential electors in Anne Arundel County (one each in Annapolis and the first and second districts of the county) contributed to a total of 1,492 Republican votes in Maryland out of 168,739 votes cast. (Richard E. Israel, communications to author, 2, 27 Sept. 2007; *Annapolis Gazette*, 8 Nov. 1860.)

78. Riley, *Ancient City*, 284.

79. Ibid.; William L. W. Seabrook, *Maryland's Great Part in Saving the Union, The Loyalty of Her Governor, Thomas Holliday Hicks, and a Majority of Her People* (n.p.: privately printed, 1913), 2, 5; Edward C. Papenfuse, ed., *An Historical List of Public Officials of Maryland, Archives of Maryland*, new series 1: 324. Quotation from Seabrook, 5.

80. McIntire, *Annapolis Families*, 1: 93.

81. Bruce Catton, *The Civil War* (Boston: Houghton Mifflin, 1987, reprint of 1960 edition), 18–21.

82. Catton, *The Civil War*, 284. The shots were fired in Baltimore precisely eighty-six years after the first volleys of the Revolutionary War at Lexington and Concord, Massachusetts (Christopher Ward, *The War of the Revolution* (New York: Macmillan, 1952), 37–46).

83. Randall, *Alexander Randall*, 25. For details of these days in Baltimore, see Charles W. Mitchell, "'The Whirlwind Now Gathering': Baltimore's Pratt Street Riot and the End of Maryland Secession," *MHM* 97: 202–232. Events in Maryland during this period and through the war are covered by several books, among them Harold R. Manakee, *Maryland in the Civil War* (Baltimore: Maryland Historical Society, 1961), and Daniel Carroll Toomey, *Civil War in Maryland* (Baltimore: Toomey Press, 1983, 1988).

84. Alexander Randall Diary (MHS MS 652, vol. 8), 21 Apr. 1861.

85. In contrast to the city, the Second and Fourth Districts of Anne Arundel County, through which the train line ran, had voted overwhelmingly for Breckinridge, seen by many as the secessionist candidate (*Annapolis Gazette*, 8 Nov. 1860; Brugger, *Maryland, A Middle Temperament*, 270); Seabrook, *Maryland's Great Part in Saving the Union*,27.

86. Sweetman, *The U.S. Naval Academy*, 59–60.

87. Richard S. West, Jr., *Lincoln's Scapegoat General: A Life of Benjamin F. Butler, 1818–1893* (Boston: Houghton Mifflin, and Cambridge: Riverside Press, 1965), 4, 42, 47, 51–54. Rockets quotation on 54.

88. Marshall, *History of the Naval Academy*, 44–45.

89. "New York Seventh Regiment, Our March to Washington," *Atlantic Monthly* 7 (June 1861): 747.

90. *The War of the Rebellion: A Compilation of the Official Records of the Union and Confederate Armies*, (Washington, D.C.: Department of War, Government Printing Office, 1880–1901), series 1, vol. 2, p. 586. Hereafter in this chapter cited as *OR* with series, volume, and page.

91. West, *Lincoln's Scapegoat General*, 54–56; "New York Seventh," 747; Wood Diary, 21 Apr. 1861; William J. Roehrenbeck, *The Regiment that Saved the Capital* (New York: A. S. Barnes and Co.), 88. My thanks to Will Mumford for that last source. Quotation from "New York Seventh."

92. *OR*, ser. 1, vol. 2, p. 590.

93. "New York Seventh," 746–748. Quotation from 747.

94. Carl N. Everstine, *The General Assembly of Maryland, 1850–1920* (Charlottesville, Va.: Michie Co., 1984), 96; *Annapolis Gazette*, 28 Apr. 1861.

95. *OR*, ser. 1, vol. 2, p. 593; West, *Lincoln's Scapegoat General*, 56. Quotation from *OR*.

96. *OR*, ser. 1, vol. 2, pp. 589–90. "Northern troops" quote from 590 (italics in source); postscript quoted from 590.

97. *OR*, ser. 1, vol. 2, p. 591.

98. "New York Seventh," 748–749. Quotations from 748.

99. Letter from "L. S.," Washington, D.C., to the Worcester, Mass., *Weekly Bay State*, printed in that newspaper on 16 May 1861. I am indebted to Ron Coddington for this letter.

100. H. Magruder, "The U.S. Naval Academy and Annapolis During the Civil War, 1861–1865," *U.S. Naval Institute Proceedings* 71 (Aug. 1945), 911.

101. *Annapolis Gazette*, 25 Apr. 1861.

102. Everstine, *The General Assembly, 1850–1920*, 100.

103. "New York Seventh," 750.

104. West, *Lincoln's Scapegoat General*, 58–59.

105. *OR*, ser. 1, vol. 2, pp. 593–594. Quotation from 594.

106. *Annapolis Gazette*, 25 Apr. 1861.

107. Ibid.

108. *OR*, ser.1, vol. 2, p. 593.

109. West, *Lincoln's Scapegoat General*, 13, 44–46. Essay title from 13; Davis description from 45.

110. Sweetman, *The U.S. Naval Academy*, 62–63; Marshall, *History of the Naval Academy*, 46.

111. Wood Diary, vol. 2, 15, 21 Jan., 2 Feb., 6, 14 Mar., 21 Apr. 1861; Sweetman, *The U.S. Naval Academy*, 63; McIntire, *Annapolis Families* 1: 179.

112. Naval History Division, U.S. Navy, *Civil War Naval Chronology, 1861–1865* (Washington, D.C.: U.S. Government Printing Office, 1971), 1–11, and Tyrone Martin, *A Most Fortunate Ship* (Annapolis: Naval Institute Press, 1997), 317, both cited in email to author from William S. Dudley, 18 Jan. 2006; Sweetman, *The U.S. Naval Academy*, 63; Letter from "L. S.," Washington, D.C., to Worcester, Mass. *Weekly Bay State*; Benjamin, *The United States Naval Academy*, 234. Benjamin says the frigate left on 25

April. Seabrook (*Maryland's Great Part in Saving the Union*, 35) says *Constitution* "spread her sails and disappeared down the Chesapeake."

113. Marshall, *History of the Naval Academy*, 46; Wood Diary, vol. 2, 5 May 1861; Sweetman, *The U.S. Naval Academy*, 62–63. Quotation from Sweetman, 63.

114. Wood Diary, vol. 2, 25 Apr. 1861.

115. *Annapolis Gazette*, 25 Apr. 1861; *OR*, ser.1, vol. 2, pp. 779–780. Pratt's message from 780.

116. Abraham Lincoln to Winfield Scott, 25 Apr. 1861, in John G. Nicolay and John Hay, "Abraham Lincoln, A History: The Border States," *Century Illustrated Monthly Magazine* 36 (May 1888): 59.

117. Everstine, *The General Assembly, 1850–1920*, 101.

118. Ibid., 105; the text of the legislature's message to Marylanders appeared in the *Annapolis Gazette*, 3 May 1861.

119. "New York Seventh," 751.

120. *Annapolis Gazette*, 25 Apr. 1861.

121. Wood Diary, vol. 2, 23, 24, 29 Apr. 1861. Quotation from 29 Apr.

122. Randall, *Alexander Randall*, 25; McIntire, *Annapolis Families*, 1: 612; Cousin Ella to Sue Sands, 28 Apr. 1861, Sands Collection [MSA SC 732]. I am indebted to Ann Jensen for copies of letters used for this chapter and now in book files.

123. Martin Revell to Sue Sands, 29 Apr. 1861, Sands Collection [MSA SC 732].

124. *OR*, ser. 1, vol. 2, p. 600.

125. Ibid., 601.

126. Ibid., 605–607; *Annapolis Gazette*, 1 May 1861. Quote about entrenchments on Judge Brewer's farm is from the *Gazette*; all other quotations from *OR*.

127. *OR*, ser. 1, vol. 2, pp. 605–607; AN MA (Proceedings) 1863–1869 [MSA M49-10], 85; "Damages to Public Streets by the Military Rail Road," 11 June 1861 (NARA, RG 92, Consolidated Correspondence, box 225, Annapolis folder). I am indebted to Rock Toews for a copy of the city's statement of damages.

128. *OR*, ser. 1, vol. 2, p. 607.

129. Martin F. Revell to My friends, 1 May 1861, Sands Collection [MSA SC 732].

130. West, *Lincoln's Scapegoat General*, 62–63. Italics in source.

131. B. F. Butler to Capt. Blake, 24 Apr. 1861, Letters received by the Superintendent, 1845–87, box 5, folder 8, Civil War, 1861, Special Collections, Nimitz Library, USNA. This letter was printed in Benjamin F. Butler, *Private and official correspondence of Gen. Benjamin F. Butler during the period of the Civil War, Vol. 1, Apr. 1860–June 1862* (Norwood, Mass.: Plimpton Press [privately issued], 1917), 35–36, but that version inserted a word not in the original. I am indebted to David Haight for his careful research into Butler's Annapolis stay and his transcription of the letter to Blake.

132. Butler, *Private and official correspondence*, 80–81, 101–102, 114–115, 121–123, 194, 203–204; West, *Lincoln's Scapegoat General*, 70–75. The Butler silver may have arrived on 15 May with their son Paul (*correspondence*, 81, 92). Fortress Monroe was a federal fort at Hampton Roads, Virginia. It remained in Union hands throughout the war.

133. Elizabeth Randall and the younger children returned to Annapolis on 1 May (Alexander Randall Diary [MHS MS 652, vol. 8], 1 May 1861). The Sands family returned on Apr. 26 (Sue Sands Diary, Sands Collection [MSA SC 732]).

134. *Annapolis Gazette*, 3 May 1861.

135. Ibid., 9 May 1861.

136. Martin F. Revell to Dear Friend, 10 May 1861, Sands Collection [MSA SC 732].

137. Seabrook, *Maryland's Great Part in Saving the Union*, Foreword.

138. Quoted in *Annapolis Gazette*, 23 May 1861.

139. Lizzie J. Davis to Sue Sands, 1 May 1861, Sands Collection [MSA SC 732].

140. AN MA (Proceedings) 1858–1861 [MSA M49-7], 1 June 1861; *Annapolis Gazette*, 25 July 1861. Committee's task quoted from corporation proceedings. Italics in quotation from *Gazette* in source.

141. *OR*, ser. 1, vol. 2, pp. 638–639, 648, 759; West, *Lincoln's Scapegoat General*, 70–75.

142. AN MA (Proceedings) 1858–1861 [MSA M49-7], 9 Sept. 1861.

143. Riley, *The Ancient City*, 299; Sue Sands to Cousin Ella, 5 Sept. 1861, Sands Collection [MSA SC 732]; Sweetman, *The U.S. Naval Academy*, 24; *Annapolis Gazette*, 25 July 1861; *The United States Christian Commission for the Army and Navy, Work and Incidents, Second Annual Report* (Philadelphia: Apr. 1864), 173.

144. Helen E. Marshall, *Dorothea Dix, Forgotten Samaritan* (New York: Russell & Russell, 1967, reprint of 1937 edition), 180, 189–190, 203, 206–207, 210, and passim; Randall Diary, 18, 29 Aug., 16 Oct. 1861; Randall, *Alexander Randall*, 26.

145. Sue Sands to Cousin Ella, 5 Sept. 1861, Sands Collection [MSA SC 732]; *Annapolis Gazette*, 5 Sept. 1861; Randall, *Alexander Randall*, 27–28; "Hospital Memories," *Atlantic Monthly* 20 (1867): 147. Quotations re "dainties" from Sands letter.

146. Seabrook, *Maryland's Great Part in Saving the Union*, 44.

147. Sue Sands to Cousin Ella, 5 Sept. 1861, Sands Collection [MSA SC 732].

148. *OR*, ser. 1, vol. 5, p. 626; Sweetman, *The U.S. Naval Academy*, 65–66; Magruder, "The Naval Academy During the Civil War," 909. Burnside's orders from *OR*.

149. Baltimore *Sun*, 19 Nov. 1861.

150. "From the Junction to Annapolis," *New York Commercial Advertiser*, quoted in the Baltimore *Sun*, 24 Dec. 1861; *New York Times*, 17 Nov. 1861.

151. *OR*, ser. 1, vol. 5, p. 1019; "Hospital Memories," 145.

152. Baltimore *Sun*, 9 Jan 1862.

153. Dr. John Ridout to William G. Ridout, 14 Nov. 1861, Ridout Collection [MSA SC 910] box 4, folder 2; AN MA (Proceedings) 1858–1861 [MSA M49-7], 11 Nov. 1861, 9 Dec. 1861. The position of city health officer dated from about 1840 and continued into the twentieth century (Jean B. Russo, "City Officers, 1720–1989," prepared for HAF, 1990).

154. Baltimore *Sun*, 19 Nov. 1861; 11 Aug. 1862; *OR*, ser. 2, vol. 5, pp. 38–42, 58–69; Baltimore *Sun*, 23 May and 6 Oct. 1864, 11 Aug. 1865.

155. Baltimore *Sun*, 14 Jan. 1862; "When Samuel W. Brooks Was the Whole Government of Maryland," Baltimore *Sun*, 10 May 1908.

156. AN MA (Proceedings) 1858–1861 [MSA M49-7], folder 25; see, for instance, AN MA (Proceedings) 1862–1863 [MSA M49-7], 22 Apr. 1862, 15 Apr. 1863; AN MA (Proceedings)1863–1869 [MSA M49-10], 10 June 1863.

157. AN MA (Proceedings) 1862–1863 [MSA M49-7], 14 July 1862; Baltimore *Sun*, 7 Aug. 1862.

158. AN MA (Proceedings) 1862–1863 [MSA M49-7].

159. Baltimore *Sun*, 11 Aug. 1862; Sue Sands to Cousin Ella, 7 Sept. 1862, Sands Collection [MSA SC 732].

160. Dr. John Ridout to William G. Ridout, 11 Nov. 1861, Ridout Collection [MSA SC 910] box 4, folder 2; Baltimore *Sun*, 15 July 1862; Dr. John Ridout to William G. Ridout, 14 Nov. 1861, Ridout Collection [MSA SC 901] box 4, folder 2; Randall, *Alexander Randall*, 27.

161. Sue Sands to Cousin Ella, 16 Apr. 1862, Sands Collection [MSA SC 732].

162. Baltimore *Sun*, 14 June 1862.

163. Ibid., 22 July 1862.

164. *OR*, ser. 1, vol. 12, p. 346; ser. 2, vol. 2, p. 112, vol. 4, p. 94.

165. "When Samuel W. Brooks Was the Whole Government of Maryland," Baltimore *Sun*, 10 May 1908.

166. Magruder, "The Naval Academy During the Civil War," 912–913. For relatives in town, see for instance the case of Mrs. Hawley in the Baltimore *Sun*, 10 Sept. 1862.

167. Susan Waide and Valerie Wingfield, "Historical Note," in United States Sanitary Commission Records, 1861–1878, MssCol 3101, New York Public Library, Humanities and Social Sciences Library, Manuscripts and Archives Division, Jan. 2006; "Hospital Memories," 153–156; *The United States Christian Commission for the Army and Navy, Work and Incidents, First Annual Report* (Philadelphia, Feb. 1863) and *Second Annual Report* (Philadelphia, Apr. 1864), esp. 133–134, 172–175; Edward Smith, *Incidents of the United States Christian Commission* (Philadelphia: J. B. Lippincott, 1869), 54, 56, for instance; Lemuel Moss, *Annals of the United States Christian Commission* (Philadelphia: J. B. Lippincott, 1868), 320, 660, for instance. I am indebted to Robert Worden for the last two sources.

168. Letter from Massachusetts soldier published in *Boston Journal*, quoted in Baltimore *Sun*, 24 Oct. 1861, collection in book files. I am indebted to the late Jack Kelbaugh for sharing newspaper clips and notes from his Civil War files.

169. Letter to the *New York Commercial Advertiser*, quoted in Baltimore *Sun*, 24 Dec. 1861, in Jack Kelbaugh collection in book files.

170. Pvt. George Spencer to Dear Parents, 4 May 1863, from the Jack Kelbaugh collection in book files.

171. Baltimore *Sun*, 15, 22 July 1862; *OR*, ser. 2, vol. 4, p. 459.

172. *OR*, ser. 2, vol. 4, p. 345.

173. Baltimore *Sun*, 7, 8, 23 Aug. 1862; AN MA (Proceedings) 1862–1863 [MSA M49-7], 2 Sept. 1862.

174. *OR*, ser. 2, vol. 4, p. 459.

175. Sue Sands to Cousin Ella, 3 Aug. 1862, Sands Collection [MSA SC 732].

176. Baltimore *Sun*, 10 Sept. 1862; *OR*, ser. 2, vol. 5, p. 39. The location of this camp has been a topic of speculation by local historians for years. Evidence indicates it was about two miles from town, not on the railroad but probably on or near a road used by county farmers to come to town. The general consensus places it near the present Forest Drive in the vicinity of Spa Road and Chinquapin Round Road. Notes re Phebe Jacobsen Collection, MSA [MSA T1384], notes from Jack Kelbaugh, and land research by Tony Lindauer and the author, all in book files.

177. For prisoners from the battlefield, see for instance, Baltimore *Sun*, 22 July 1862; *OR*, ser. 2, vol. 4, p. 542. The first "flag of truce" steamer arrived in Annapolis on 24 September from Belle Isle (Baltimore *Sun*, 25 Sept. 1862).

178. Baltimore *Sun*, 24 July 1862. The grammar school of the college continued to meet, probably in McDowell Hall, until Aug. 1863 (Jacobsen, "Center of the Storm," 11–12).

179. Baltimore *Sun*, 25 Sept. 1862; *OR*, ser. 2, vol. 5, pp. 328–337.

180. *OR*, ser. 2, vol. 4., p. 691.

181. Ibid., 692, 696, vol. 5, pp. 39–42, 100–101.

182. *OR*, ser. 2, vol. 5, pp. 232, 328–337.

183. For instance: Camp Pawley, Baltimore *Sun*, 7 Aug. 1862; Camp Tompkins, Baltimore *Sun*, 15 July 1862.

184. Sue Sands to Cousin Ella, 17 Nov. 1862, Sands Collection [MSA SC 732]. Sue Sands and her family lived at the northwest corner of Prince George and Holland Streets (Ann Jensen, personal communication to author, 31 Mar. 2008). Their house was razed in 1942.

185. John Ridout to William G. Ridout, 20 Nov. 1862, Ridout Collection [MSA SC 910] box 4, folder 2.

186. *OR*, ser. 2, vol. 5, pp. 38, 330.

187. Samuel E. Duvall to Alexander Randall, 5 Jan. 1863; Albert Welch to Alexander Randall, 5 Jan. 1863, both in Slack/Beirne/Randall Collection of Randall Family Papers [MSA SC 1931 (M4809) items 99 and 100]. My thanks to Michael Parker for pointing these out to me. Duvall's home is shown on the 1860 Martenet map. Information about his job as ferry keeper from

Rod Cofield, personal communication to author, 28 Feb. 2008.

188. AN MA (Proceedings) 1862–1863 [MSA M49-7], 10 Mar. 1862 (filed in this folder but undated and from internal references clearly applicable to a date later than Mar. 1862); diary of Captain H. K. Ide, quoted in Jack Mellin, "Anne Arundel Vignettes," *The Capital*, 22, 29 Mar., 5 Apr. 1990.

189. Anna Key Bartow Cumyn, *The Bartow Family: A Genealogy*, quoted in Jane Wilson McWilliams and Carol Cushard Patterson, *Bay Ridge on the Chesapeake, An Illustrated History* (Annapolis: Brighton Editions, 1986), 33; Dr. John Ridout to William G. Ridout, 14 Nov. 1861, Ridout Collection [MSA SC 910] box 4, folder 2; McIntire, *Annapolis Families*, 1: 665. Anna's words from McWilliams and Patterson. The Steeles owned the same land that had once belonged to Henry Margaret Ogle (McWilliams and Patterson, 30–32).

190. Catton, *The Civil War*, 289; Adjutant General (Enrollment Records) 1862, Anne Arundel County, District 7 [MSA S352-27].

191. Wood Diary, vol. 2, 3 Sept. 1861; AALR, L. NHG 10, f. 275; Sue Sands letters 8, 17 Aug., 7 Sept., 1862, Sands Collection [MSA SC 732]. Wood joined former USNA superintendent Franklin Buchanan on CSS *Virginia* (Shingleton, *John Taylor Wood*, 28–29).

192. John Ridout to Ellen McElroy, 20 Aug. 1862, Ridout Collection [MSA SC 910] box 4, folder 2.

193. Adjutant General (Enrollment Records) 1862, Anne Arundel County, District 7 [MSA S352-27]; McIntire, *Annapolis Families*, 1: 215, 250, 271, 280, 353, 355, 409, 461, 562.

194. John Ridout to William G. Ridout, 20 Nov. 1862, Ridout Collection [MSA SC 910] box 4, folder 2.

195. *OR*, ser. 2, vol. 5, p. 614; McIntire, *Annapolis Families*, 1: 466; Jean Russo and Mark Letzer, communications to author, July 2002; Mark B. Letzer and Jean B. Russo, *The Diary of William Faris: The Daily Life of an Annapolis Silversmith* (Baltimore: Maryland Historical Society, 2003), 34, 73. William McParlin had been apprenticed to William Faris.

196. Baltimore *Sun*, 26 Jan., 16 Feb., 18 Apr. 1863; "Hospital Memories," 153–156.

197. "Hospital Memories," 145–146; "Reports of the Joint Committee on the Conduct and Expenditures of the War, Returned Prisoners," 38th session, Rep. Com. No. 68, U.S. Senate, Washington, D.C., 21 Apr. 1864, p. 18.

198. Mike Fitzpatrick, "A Dutch Doctor in the Union Army," *Military Images* 22 (Mar.–Apr. 2001): 27–30. My thanks to Mike Fitzpatrick for a copy of this article.

199. Randall, *Alexander Randall*, 27; "Hospital Memories," 145–146; Bob Zeller, "Souvenirs of Sickbed City," *Civil War Times Illustrated* 36 (May 1997), 36–39; *The Crutch*, 25 Feb. 1865 (weekly newspaper published in 1864 and 1865 at U.S. General Hospital Division 1 in Annapolis, archived online at *AOMOL*); L. Brockett, M.D., and Mrs. Mary C. Vaughan, *Heroines of the Rebellion, or Woman's Work in the Civil War, A Record of Hero-*

ism Patriotism and Patience (n.p.: Edgewood Publishing, 1867, online at Project Gutenberg, www.gutenberg.org), 241–245, 455–466. I am indebted to Will Mumford for allowing me to borrow his copy of this book, with its details of the Civil War hospital on the academy grounds and biographies of the nurses.

200. "Hospital Memories," 150–156; *The United States Christian Commission, Second Annual Report* (Philadelphia: Apr. 1864), 173.

201. Jack Kelbaugh, "Annapolis National Cemetery," (typescript, 1990); "Annapolis National Cemetery (AA-2128), Anne Arundel County, Maryland," Narrative Statement of Significance, National Register of Historic Places Nomination, Maryland Historical Trust; Jennifer M. Perunko, personal communication 8 Apr. 2010.

202. Nikolay Andreyevich Rimsky-Korsakov, *My Musical Life* (translated from the fifth revised Russian edition by Judah A. Joffe, edited and introduced by Carl Van Vechten (New York: Alfred A. Knopf, 1942), 40–59. Quotation from 47.

203. Baltimore *Sun*, 8 Feb. 1864; *The Crutch*, 13 Feb. 1864. The quotation is from *The Crutch*. League was charged with homicide and released on bail (Baltimore *Sun*, 8, 9, 11 Feb. 1864).

204. Michael Parker, "'And We — We placed the Hair —': Women and the Rites (Rights) of Dying in Annapolis, Maryland," paper presented at the annual meeting of the Popular Culture / American Culture Association, Boston, 5 Apr. 2007; Letter from MMC, "Hospital Nurse in Annapolis," 10 Dec. 1864, in Mary A. Livermore, *My Story of the War: A Woman's Narrative of Four Years' Personal Experience* (Hartford, Conn.: A. D. Worthington, 1896), 685–690 (online at Making of America Books, University of Michigan, http://quod.lib.umich.edu/m/moa, accessed 6/1/10). As a result of his Civil War experience, James S. Taylor began a family funeral business still in existence.

205. *OR*, ser. 2, vol. 5, p. 232; Baltimore *Sun*, 16 Feb. 1863; *OR*, ser. 2, vol. 5, pp. 328–337; Emily A. Murphy, *"A Complete and Generous Education": 300 Years of Liberal Arts, St. John's College, Annapolis* (Annapolis: St. John's College Press, 1996), 27–32; Jacobsen, "Center of the Storm," 11–12; AN MA (Proceedings) 1863–1869 [MSA M49-10], 8 Feb. 1864.

206. *OR*, ser. 2, vol. 5, pp. 328–337, 605–607. All quotations from 337, except complaint re roads, which is from 607.

207. Ibid., 605–607, 615; Baltimore *Sun*, 18 Apr. 1863. Quotation from *OR*, 607. See also Simon J. Martenet, *Martenet's Map of Anne Arundel County*, 1860 ([MSA SC 1427-1-187] and Library of Congress Geography and Map Division, call number G3843.A5 1860.M3), for the farm of C. S. Welch on the rail line at the head of Church Creek. Research by Tony Lindauer, David Haight, Rock Toews, Will Mumford, and the author places the third parole camp on the south side of West Street, east of Maryland Route 2 (book files).

208. *OR*, ser. 2, vol. 6, p. 134, vol. 7, p. 21.

209. See, for instance, AN MA (Proceedings) 1863–1869

[MSA M49-10], 10 June 1863, 11 May, 13 and 18 July 1863, 16 Sept. 1863, 14 Dec. 1863, 14 Mar. 1864; Baltimore *Sun*, 13 Sept. 1863.

210. Baltimore *Sun*, 16 Feb. 1863; AN MA (Proceedings) 1863–1869 [MSA M49-10], 26 July 1864, 12 Sept. 1864, Dec. 1865. Quotations from *Sun*.

211. AN MA (Proceedings) 1863–1869 [MSA M49-10], 11 May 1863; Baltimore *Sun*, 25 June, 7 Sept. 1863; Sweetman, *The U.S. Naval Academy*, 86. Quotation from *Sun*, 25 June 1863.

212. Scharf, 3: 559–569; Everstine, *The General Assembly, 1850–1920*, 181–190. Quotation from Scharf, 3: 561. See also Charles L. Wagandt, "Election by Sword and Ballots: The Emancipation Victory of 1863," *MHM* 59:143–164; Margaret Law Callcott, *The Negro in Maryland Politics, 1870–1912* (Baltimore: Johns Hopkins Press, 1969), 11–12.

213. *Annapolis Gazette*, 5 Nov. 1863; Governor (Election Returns) 1863/11/04 AA General [MSA S108-45]; Governor (Election Returns) 1861/11/06 AA General [MSA S108-42].

214. *Annapolis Gazette*, 19, 26 Nov., 3 Dec. 1863; *Archives of Maryland* (Biographical Series) Nicholson [MSA SC 3520-13137]; Riley, *The Ancient City*, 311. Quotations beginning "refusing" and "obeys" from newspaper, 26 Nov.; those beginning with "Secessionists" and "a number" from 19 Nov. issue; "take to oath" from 3 Dec.

215. Baltimore *Sun*, 11 Jan. 1864, *Annapolis Gazette*, 24 Dec. 1864.

216. John Ridout to [William G. Ridout] 21 Jan. 1864, Ridout Collection [MSA SC 910] box 4, folder 2; AN MA (Proceedings) 1863–1869 [MSA M49-10], 30 Dec. 1863, 21 Jan., 14 Mar., 1, 12 Apr., 9 May 1864; Baltimore *Sun*, 13 Jan. 1864. Ridout's words from his letter.

217. Everstine, *The General Assembly, 1850–1920*, 198; *Laws of Maryland*, 1864, chap. 5. The Convention convened in the State House on 27 April and adjourned on 6 September 1864 (*Constitutional Revision Study Documents of the Constitutional Convention Commission of Maryland, June 15, 1968* [Annapolis: State of Maryland, 1968], 445).

218. *Laws of Maryland*, 1864, chap. 15.

219. *Annapolis Gazette*, 14 Apr. 1864.

220. Ibid., 3 Mar. 1864.

221. Adjutant General (Muster Rolls) 30th Regiment, USCT, Companies A, B, C, E, F, G, H, I [MSA S936]; Company D's muster rolls in Adjutant General (Civil War Muster Rolls and Service Records) 1865 30th Reg. Co. D [MSA S936-55] are online through the Maryland State Archives Outreach and Education website "In the Aftermath of 'Glory'" document packet [MSA SC 2221-12-6] (hereafter in this chapter cited as Rolls, 30th Reg. Co. D); Janice Hayes-Williams, "Anne Arundel County USCT Slave lists," prepared for Kunta Kinte–Alex Haley Foundation, Inc., 2002.

222. Hayes-Williams, "Anne Arundel USCT Slave lists"; Rolls, 30th Reg. Co. D; 1860 Federal Census Index; AN MA (Assess-ment Records), Slaves, 1860 [MSA M72-4], Property, 1860 [MSA M72-3]; McIntire, *Annapolis Families*, passim.

223. Hayes-Williams, "Anne Arundel USCT Slave lists"; L. Allison Wilmer, J. H. Jarrett, and Geo. W. F. Vernon, *History and Roster of Maryland Volunteers, War of 1861–5* (Baltimore: Guggenheimer, Weil, 1899) 2: 233, 259; *OR*, ser. 1, vol. 33, pp. 1045–1046. See also the George Wells properties outside Annapolis on the 1860 *Martenet's Map of Anne Arundel County, 1860* (see n. 207).

224. *OR*, ser. 1, vol. 33, pp. 373, 678; Baltimore *Sun*, 24 Mar. 1864.

225. W. B. Stevens letter dated 18 Apr. 1864, quoted in John Mellin, "Anne Arundel Vignettes," *The Capital*, 26 Apr. 1990.

226. John Mellin, "Anne Arundel Vignettes," *The Capital*, 19 Apr. 1990; *OR*, ser. 1, vol. 33, p. 913.

227. Ohio drummer Samuel McClain to Lucinda McClain, 25 May 1864, and Samuel McClain's diary, 8 June 1864. Samuel McClain Papers MS 640, general Civil War manuscripts, Center for Archival Collections, Bowling Green State University (online at www.bgsu.edu/colleges/library/cac, last accessed 5/31/10). "Miserable place" from letter; "magnificent view" from diary.

228. *Annapolis Gazette*, 3 Mar. 1864.

229. Jack Kelbaugh Collection of Civil War Photographs, MSA [MSA SC 4325] passim.

230. *Annapolis Gazette*, 14, 21 Apr. 1864. "Spectacles" from ad in 21 Apr. issue.

231. *Annapolis Gazette*, 7, 14 Apr. 1864; Carlyon, *Dan Rice*, 320–321, 331–332, 344. Quotation from newspaper, 14 Apr.

232. Baltimore *Sun*, 20 Jan. 1864.

233. See, for instance, Alfred S. Roe, "Richmond, Annapolis, and home," paper read before the Rhode Island Soldiers and Sailors Historical Society (Providence: Rhode Island Soldiers and Sailors Historical Society, 4th ser., no. 17, 1892); Walter D. Kamphoefner and Wolfgang Helbich, eds., *Germans in the Civil War: The Letters They Wrote Home* (Chapel Hill: University of North Carolina Press, 2006), 93; Weddell Family Papers MS 484, Samuel McClain Papers MS 640, and Liberty Warner Papers MS 624 at the Center for Archival Collections, Bowling Green State University (online at www.bgsu.edu/colleges/library/cac, last accessed 5/31/10); Thomas F. Walter, "Personal Recollections" part 3, in *Grand Army Scout and Soldiers' Mail* (Philadelphia), vol. 3, no. 38 (30 Aug. 1884), 1–2 (online at http://freepages.military.rootsweb.com/~pa91/, last accessed 4/3/08). Quotation from Lt. George Weddell to "Brother," 17 June 1864 (Weddell Papers).

234. Manakee, *Maryland in the Civil War*, 76–77; Sue Sands to Cousin Ella, 18 Aug. 1864, Sands Collection [MSA SC 732].

235. *OR*, ser. 1, vol. 37, part 2, pp. 32, 94; Samuel McClain to Lucinda McClain, 7 July 1864 (Samuel McClain Papers, MS 640, at the Center for Archival Collections, Bowling Green State University). Private McClain, a farmer from Jefferson County, Ohio, turned hundred-day soldier and musician (drummer) with

the 144th Ohio Volunteer Infantry, was captured in Virginia in August and died in a Confederate prison camp near Salisbury, North Carolina, 16 December 1864 (Samuel McClain Papers, MS 640).

236. Manakee, *Maryland in the Civil War,* 77–81; Richard R. Duncan, "Maryland's Reaction to Early's Raid in 1864: A Summer of Bitterness," *MHM* 64 (1969): 255–257; "When Samuel W. Brooks Was the Whole Government of Maryland," Baltimore *Sun,* 10 May 1908.

237. *Annapolis Gazette,* 14 July 1864; Baltimore *Sun,* 11 July 1864. Quotes are from the *Sun.*

238. AN MA (Proceedings) 1863–1869 [MSA M49-10], 11 July 1864; *OR,* ser. 1, vol. 37, part 2, p. 219.

239. Sue Sands to Cousin Ella, 18 Aug. 1864, Sands Collection [MSA SC 732].

240. *Annapolis Gazette,* 14 July 1864; "Hospital Memories," 331–332. "Pickax" quotation from "Hospital Memories," 332; entrenchment description from newspaper.

241. *Annapolis Gazette,* 14 July 1864.

242. Michael Parker, *Presidents Hill: Building an Annapolis Neighborhood, 1664–2005* (Annapolis: Annapolis Publishing, 2005), 15; Magruder, "The Naval Academy During the Civil War," 909–913. Quotation from Parker.

243. Topographical map by Paul Lackey, Annapolis Department of Public Works, 10 May 2001, and walking tour of site by Michael Parker and the author, May 2001. Parker suggests that the elevated section of the Bay Ridge and Annapolis Railroad, between the main rail line and West Street, may have been built (1886) on the breastwork. The 1864 entrenchments may also have followed those built in 1755 (discussed in Chapter 2). The railroad embankment was destroyed in construction of Park Place.

244. Sue Sands to Cousin Ella, 18 Aug. 1864; Alexander Randall's diary, 13 July 1864, quoted in Parker, *Presidents Hill,* 15.

245. "Hospital Memories," 331–332; *The Haversack,* 20 July 1864, quoted in John Mellin, "Anne Arundel Vignettes," *The Capital,* 1, 8 Mar. 1990. Quotation from *The Haversack.*

246. "Hospital Memories," 332.

247. "When Samuel W. Brooks Was the Whole Government of Maryland," Baltimore *Sun,* 10 May 1908.

248. Catalina Oyler, "Biography of Helen M. Noye," in the finding aid for Helen M. Noye Hoyt Papers, William Clements Library, University of Michigan. I am indebted to Lou Ann Broad for this source.

249. *The Haversack,* 20 July 1864, from the collection of Jack Kelbaugh, quoted in John Mellin, "Anne Arundel Vignettes," *The Capital,* 1, 8 Mar. 1990; *Annapolis Gazette,* 14 July 1864.

250. *Constitutional Revision Study Documents of the Constitutional Convention Commission of Maryland, June 15, 1968* (Annapolis: State of Maryland, 1968), 445–451.

251. Everstine, *The General Assembly, 1850–1920,* 251; Governor (Election Returns) 04/06/1864 AA Constitution Conven-

tion Referendum [MSA S108-49]; Governor (Election Returns) 10/12/1864 AA Constitution Referendum [MSA S108-50].

252. Governor (Election Returns) 11/08/1864 AA General [MSA S108-60].

253. Louis H. Bolander, "Civil War Annapolis," *U.S. Naval Institute Proceedings* 63 (Nov. 1937): 1615–1616; *The Crutch,* 19 Nov. 1864.

254. "Hospital Memories," 334–336; Sue Sands to Cousin Mary, 8 Dec. 1864, Sands Collection [MSA SC 732]; Bolander, "Civil War Annapolis," 1616.

255. Kelbaugh, "Annapolis National Cemetery," 14 (table).

256. "Hospital Memories," 333, 336 (The anonymous author says that she is the sole survivor); Jack Kelbaugh, "Northern Hospital Nurses: Mary Young and Rose Billings Make the Ultimate Sacrifice in Civil War Annapolis," *Anne Arundel County History Notes* (Jan. 1994), 6, 19.

257. *New York Herald,* 5 Feb. 1865 (transcript from accessible.com, Item #11019); Rockford E. Toews, *Lincoln in Annapolis, February 1865* (Annapolis: MSA, 2009). Quotation from the newspaper.

258. Brockett and Vaughan, *Heroines of the Rebellion,* 128–129.

259. Randall, *Alexander Randall,* 29–30; *First Report of the President and Directors of the Annapolis Water Company* (Annapolis, 12 Feb. 1867), 2.

260. Baltimore *Sun,* 16 Feb. 1864; Riley, *The Ancient City,* 313; AN MA (Proceedings) 1863–1869 [MSA M49-72], 14 Mar., 1, 12 Apr. 1864. Quotation from the *Sun.*

261. See for instance AN MA (Proceedings) 1858–1861 [MSA M49-7], 1 June 1861; AN MA (Proceedings) 1863–1869 [MSA M49-10], 1 Apr. 1864; Sweetman, *The U.S. Naval Academy,* 83–84.

262. Randall, *Alexander Randall,* 29–30; *First Report of the President and Directors of the Annapolis Water Company* (Annapolis: 12 Feb. 1867), 2–3, 22; AN MA (Proceedings) 1863–1869 [MSA M49-10], 13 June, 11 July 1864. Alexander Randall noted the results of the survey in his diary on 28 May 1864 and wrote that he intended "at once to start a plan for a water company." (Quoted in Parker, *Presidents Hill,* 11). On 13 June, Randall was allowed a credit on his tax bill equal to the $106 he had paid for the survey (Proceedings) [MSA M49-10], 13 June 1864).

263. *Laws of Maryland,* 1865, chap. 123.

264. *Laws of Maryland,* 1865, chap. 123; BDML 1: 212 (Chase); McIntire, *Annapolis Families,* 1: 293, 569, 732; AN MA (Assessment Records) Property, 1860 [MSA M72-3]. Not only was Hester Chase the wealthiest woman in town, but the assessed value of her property in 1860 was fourth highest in the city, surpassed only by those of Alexander Randall, James Iglehart, and John Walton, who was the owner of the City Hotel. Together, the assessed value of their real and personal properties accounted for just over 7 percent of the city's total valuation of $857,400.

265. *First Report of the President and Directors of the Annapolis Water Company* (Annapolis: 12 Feb. 1867), 3–7, 13–17.

266. *Baltimore American*, 11 Apr. 1865 (copy from Ann Jensen in book files); AN MA (Proceedings) 1863–1869 [MSA M49-10], 10, 17 Apr. 1865; *The Crutch*, 15 Apr. 1865. All quotes from *The Crutch*.

267. "A Salute to Parole," *Annapolis Spectator* (Washington, D.C.: Woodward & Lothrop, Aug. 1964), 8; Baltimore *Sun*, 17 July 1865.

268. Baltimore *Sun*, 11 and 21 July, 2 Aug. 1865. Quotation from 21 July issue.

269. Ibid., 20 July, 7, 30 Aug. 1865. Quotation from 30 Aug. issue.

270. Ibid., 17 July, 8 Aug. 1865; Sweetman, *The U.S. Naval Academy*, 84.

271. Sweetman, *The U.S. Naval Academy*, 83; Baltimore *Sun*, 31 Aug. 1865. Quotations from the *Sun*.

272. Radoff, *Buildings of the State* , 71–76, 118; Sweetman, *The U.S. Naval Academy*, 83–85; Dr. John Ridout to William G. Ridout, 17 Mar. 1864, Ridout Collection [MSA SC 910] box 4, folder 2.

273. Radoff, *Buildings of the State*, 118–120; Taylor, *History of Annapolis*, 17.

274. Sweetman, *The U.S. Naval Academy*, 83–86. Both quotations from 84.

275. Bolander, "Civil War Annapolis," p. 1616, who quoted the journal of the officer of the day; Manakee, *Maryland in the Civil War*, 61.

276. Baltimore *Sun*, 24 Sept. 1866.

277. AN MA (Proceedings) 1863–1869 [MSA M49-10], 30 Dec. 1863, 21 Jan. 1864, 9 Jan. 1865; Taylor, *History of Annapolis*, 25.

278. City treasurer's report for 10 Apr. 1866 to 10 Apr. 1867, in *Report of the Mayor of Annapolis with an Exhibit of the Financial Condition of the City from the 10th of April 1865 to the Close of the Year 1870* (Annapolis: Advertiser Printing, 1871) in Md. Mss Coll. #176, Special Collections, UMD Libraries.

279. Ibid., for 10 Apr. 1866 to 10 Apr. 1867, 10 Apr. 1867 to 31 Dec. 1867, 31 Dec. 1867 to 31 Dec. 1868, and 31 Dec. 1868 to 31 Dec. 1869; Baltimore *Sun*, 23 Dec. 1867, 4 Sept. 1868; Taylor, *History of Annapolis*, 25–26. Taylor is very clear that the new structure had been built "since the late war on the site of the 'Old Ball Room.'"

280. Baltimore *Sun*, 11 Jan. 1868.

281. AALR L. SH 3, f. 66; Baltimore *Sun*, 4 Sept. 1868.

282. AN MA (Proceedings) 1863–1869 [MSA M49-10], 1 Sept. 1865; Paynter, *St. Anne's Annapolis*, 52. Quotation from Paynter.

283. Louis H. Bolander, "When Annapolis Was an Army Town," Baltimore *Sunday Sun Magazine*, 8 Nov. 1931; Baltimore *Sun*, 21 Sept. 1865 and 2 Sept. 1867.

284. *Laws of Maryland*, 1866 (Extra Session), chap. 144; *Laws of Maryland*, 1867, chap. 390. Previous laws set the drinking age at 21, see for instance *Laws of Maryland*, 1865, chap. 87.

285. Philip Brown, *The Mount Moriah Story, 1875–1973* (Annapolis: the author, 2000), 1–15; Jean Russo, "Peek at the Past: Mt. Moriah National Historic Landmark," *The Publick Enterprise*, Jan. (1st half) 1995; Richard Allen Embry, "Biblical History of Mt. Moriah A.M.E. Church," in *Souvenir Program in Commemoration of The Dedication of The New Mt. Moriah A.M.E. Church* (1973). Brown says Mt. Moriah was completed in 1875; Russo gives 1876 as the completion date. Brown, the church's historian, wrote that Frederick Douglass gave the address at the dedication. In a letter from Rev. S. L. Hammond in *The Christian Recorder* (Philadelphia, 5 Jan. 1867), this church is called "Union Chapel, Bethel connection." Rev. Hammond was its pastor.

286. Cunningham, *Calvary United Methodist Church*, 32–33; Taylor, *History of Annapolis*, 23. "Differences" quotation from Cunningham, 32.

287. Maryland Constitution of 1864, Article VIII; *Laws of Maryland*, 1865, chap. 160; AABE (Special Reports) David S. Jenkins, "History of the Colored Schools in Anne Arundel County, Maryland, and a Proposal for their Consolidation" [MSA CM1172-3]; Joseph Browne, "Black Schools in Anne Arundel County, 1865–1885" (unpublished manuscript, [no date], in Phebe Jacobsen files, MSA). Browne's article includes extensive material from Freedman's Bureau records in NARA RG 105.

288. AN MA (Proceedings) 1863–1869 [MSA M49-10]; 12 and 26 June 1865.

289. Browne, "Black Schools," 3.

290. Ibid., 4; Stanton School Fourth Grade, 1952–53, "Discovering Our School Community," (typescript, 1953).

291. Stanton School Fourth Grade, 1952–53, "Discovering Our School Community"; AALR, L. SH 3, f. 165; McIntire, *Annapolis Families*, 1: 83, 584; Browne, "Black Schools," 4, 22. Browne gives the size of the Stanton School building as 60 by 70 feet. A letter from an unnamed writer in Annapolis to *The Christian Recorder* (Philadelphia) 8 Sept. 1866, says it measured 48 by 48.

292. Browne, "Black Schools," 17, 22.

293. Ibid., 4–6, 23, 25, 34; Worden, *Saint Mary's Church*, 66. Quotation from Browne, 34.

294. J. William Swann, comp. "Black History Month, Thru' It All" (typescript, Feb. 1989), 25; Philip L. Brown, *A Century of "Separate But Equal" Education in Anne Arundel County* (New York: Vantage Press, 1988), 4–5; Miller and Ridout, *Architecture in Annapolis*, 178; W. E. B. DuBois, ed. "Economic Co-operation Among Negro Americans, Report of a Social Study made by Atlanta University . . . " (Atlanta: Atlanta University Press, 1907), 93–94, 127 (available online from the University of North Carolina Chapel Hill Libraries, Documenting the American South website at http://docsouth.unc.edu/church/dubois07, last accessed 6/1/10).

295. Parole School Fourth Grade, 1951–52, "Discovering Our School Community" (typescript, 1952).

296. Browne, "Black Schools," 4; Helen Buckler, *Daniel Hale Williams: Negro Surgeon* (New York: Pittman Publishing, 1954; 2nd ed., 1968), 55–56.

297. Browne, "Black Schools," 14–15.

298. Ibid., 11; AALR, L. SH 3, f. 165.

299. Browne, "Black Schools," 23–24.

300. *The Statistics of the Population of the United States . . . from the Original Returns of the Ninth Census* (Washington, D.C.: Government Printing Office, 1872), 163, 645; 1870 Federal Census Schedules, Maryland, Annapolis District [MSA M7233]; author's analysis of occupations by race from the 1860 and 1870 census schedules. See Appendix 1, Table 2.

301. 1870 and 1880 Federal Census Schedules, Maryland, Annapolis District; 1890 Federal Census Schedules, Maryland, Union Veterans and Widows, Anne Arundel County, Baltimore City; Marriage Record Index, MSA, Index 6 [MSA SE 27]; McIntire, *Annapolis Families*, vols. 1 and 2, passim. Analysis of these records is in book files.

302. Russo, "City Officers"; Baltimore *Sun*, 3, 4 Apr. 1866; Riley, *The Ancient City*, 316–317; *Constitutional Revision Study Documents*, 511, 662; W. W. Goldsborough, *The Maryland Line in the Confederate Army, 1861–1865* (online as *AOMOL* vol. 371), 156.

303. AA CCT (Charter Record) 1868–1882 SH 1 [MSA T2787-1], 1, 5, 8.

304. *Proceedings and Acts of the General Assembly, 1868* (*AOMOL* vol. 142, 1417) and *Proceedings and Acts of the General Assembly, 1872* (*AOMOL* vol. 190, 1380), for instance; Goldsborough, *Maryland Line in the Confederate Army*, 156; Owen Lourie, email to author, 11 Apr. 2008; McIntire, *Annapolis Families* 1: 250; Norman H. Plummer, *Maryland's Oyster Navy, The First Fifty Years* (Chestertown, Md.: Literary House Press, Washington College, for the Chesapeake Bay Maritime Museum, 1993), 18–19.

305. Riley, *The Ancient City*, 315; John D. Wissman, "Memorial Day, the Blue and the Gray at Annapolis" (typescript, 2009).

306. Emily Peake, "Civil War Veterans in St. Anne's, Cedar Bluff, and Locust Grove Cemeteries," (typescript, continuing biographical research). I am grateful to Emily Peake for a copy of her research and for discussions of these men and their lives in Annapolis.

Chapter 6. Great Expectations, 1870 to 1908

1. *Laws of Maryland*, 1870, chap. 202; *Laws of Maryland*, 1872, chap. 382; Baltimore *Sun*, 18 Apr. 1873; Jack Sweetman, *The U.S. Naval Academy: An Illustrated History*, 2nd ed., rev. by Thomas J. Cutler (Annapolis: Naval Institute Press, 1995), 102. The law says Acton's Cove, but the bounds go to Old Woman Cove. See also G. M. Hopkins, *Atlas of Anne Arundel County, Maryland* (1878; reprint by Ann Arrundell County Historical So-

ciety and Anne Arundel Genealogical Society, 1994), 19–20 (City of Annapolis). The new city line to the west probably included all the area designated as the "precincts" of the town in 1790.

2. Margaret Law Callcott, *The Negro in Maryland Politics, 1870–1912* (Baltimore: Johns Hopkins Press, 1969), vii, 21; Carl N. Everstine, *The General Assembly of Maryland, 1850–1920* (Charlottesville, Va.: Michie Co., 1984), 289–292. Maryland finally ratified the Fifteenth Amendment in 1973.

3. AN MA (Proceedings) 1869–1877 [MSA M49-11], 58, 87, 100, 116, 123; *Laws of Maryland*, 1876, chap. 207. The city continued with three wards until 1914, when the Third Ward was divided into the Third and Fourth Wards. See [James F. Strange], "Report of the Mayor of Annapolis on the State of Its Finances from July 1, 1913, to June 30, 1914, with Statement of Sinking Fund," *Reports of the Mayor of Annapolis, 1900–1913*, Maryland Collection, Special Collections, UMD Libraries.

4. J. Wirt Randall, *The Revised Code of the City of Annapolis, By-laws and Ordinances of the City . . .* (Annapolis: J. Guest King, published by authority, 1881), 30 (Article 11), in book files.

5. Callcott, *The Negro in Maryland Politics*, 16, 31–32.

6. Jean Russo, "Black Voting Rights in Maryland — post–Civil War" (report prepared for Historic Annapolis, Inc., 1988); Callcott, *The Negro in Maryland Politics*, 75–81. Quotations from Russo.

7. Annapolis Election Judges (Poll Book) 04/1871-04/1873 Ward 1 [MSA M32-50] and Ward 2 [MSA M32-51].

8. *Maryland Republican*, 8 Apr. 1871. The office of city recorder was modified by charter amendment in 1870 and renamed city counselor (*Laws of Maryland*, 1870, chap. 202). The *Maryland Republican* newspaper dated from 1809 when the term *Republican* referred to a political point of view that was later embraced by people calling themselves Democrats. The paper's philosophy didn't change markedly over time; the names of the country's political parties did. See, for instance, Robert J. Brugger, *Maryland, A Middle Temperament: 1634–1980* (Baltimore: Johns Hopkins University Press and Maryland Historical Society, 1988), 163–166, 306, 308; Suzanne Ellery Green Chapelle, Jean H. Baker, Dean R. Esslinger, Whitman H. Ridgway, Jean B. Russo, Constance B. Schulz, and Gregory A. Stiverson, *Maryland, A History of Its People* (Baltimore: Johns Hopkins University Press, 1986), 97–102, 205–207. See also *Maryland Republican*, 9 June 1883, for statement of the paper's adherence to "Democratic doctrine" throughout its history, with the exception of one "brief interval."

9. Russo, "Black Voting Rights"; Marcia M. Miller and Orlando Ridout V, eds., *Architecture in Annapolis: A Field Guide* (Newark, Del.: Vernacular Architecture Forum; Crownsville, Md.: Maryland Historical Trust Press, 1998), 17.

10. Baltimore *Sun*, 5, 8 Apr. 1873. Callcott (*The Negro in Maryland Politics*, 58) gives the ribbon for first elected African American to a Baltimore City councilman in 1890. Brugger (*Maryland, A Middle Temperament*, 420) tags the same Balti-

more man but mentions an unnamed Annapolis alderman as having been chosen by men of his race in 1873. Since only about 823 Annapolitans voted in the 1873 election and Butler received 425 votes, it seems certain that some of those votes came from whites.

11. *New York Times*, 6 Apr. 1875; *Maryland Republican*, 10 Apr. 1875. The *Republican*'s account of the fight mirrors almost verbatim the story in the *Times*. Quotation from the *Maryland Republican*.

12. *Laws of Maryland*, 1876, chap. 207; Jean Russo, "Blacks in the Annapolis City Government," (report prepared for Historic Annapolis, Inc., 1988).

13. AALR, L. SH 9, f. 9, quoted in David H. Croll, "The History of St. Philip's Colored Mission" (typescript, c. 1951).

14. William K. Paynter, *St. Anne's Annapolis, History and Times* (Annapolis: St. Anne's Parish, 1908), 67–70; EHT Traceries, Inc., "Annapolis Historic District Block Histories, Block 33A" (prepared for the Annapolis Historic District Commission, 1995), 8; Croll, "The History of St. Philip's Colored Mission." First Baptist Church was located at 121–123 Market Street on a lot sold to the congregation by William H. Butler. A part of the congregation moved to West Washington Street in 1916 and built the church that remains today. See Traceries, 8; Philip L. Brown, *The Other Annapolis, 1900–1950* (2nd ed. privately published, 2000), 80.

15. "History of Mount Olive," in J. William Swann, *Black History Month, Thru' It All* (privately published, 1989), 17; Pearl C. Swann, "Mt. Olive African Methodist Episcopal Church," in Rhonda Pindell Charles, comp., *Parole Week, Celebrating 130 Years of Spirit* (Annapolis: Walter S. Mills–Parole Elementary School Alumni and Friends Association, 1995). I am grateful to Norman Randall for sharing Mr. Swann's history.

16. Lillian Kipp, "St. Martin's (Francis Street) Remembered" (typescript, 1998), 5.

17. 1860 and 1870 Federal Census, Anne Arundel County, Annapolis District, Population Schedules, passim; David S. Hanner, communication to author 2 May 2008. In 1880, natives of Germanic states were the largest category of foreign born residents.

18. Analysis of the 1870 Federal Census, Anne Arundel County, Annapolis District, Population Schedule, using Maryland Indexes (Census of 1870, AA, Index) [MSA S1526] online from the Maryland State Archives. Included are those who gave their birthplace as Germany, Hesse, Bavaria, Hanover, Prussia, Württemberg, Saxony, or Baden. Sailors and marines living at the academy and priests and students at St. Mary's were not included in this analysis.

19. Isabel Shipley Cunningham, *Calvary United Methodist Church, Annapolis, Maryland, The First Two Centuries* (Edgewater, Md.: Lith-O-Press, 1984), 37, and passim; Clarence Marbury White, Sr., and Evangeline Kaiser White, *The Years Between: A Chronicle of Annapolis, Maryland, 1800-1900 . . .* (New York: Exposition Press, 1957), 60.

20. Robert L. Worden, communication to author, 23 June 2003; Jane W. McWilliams, "Charles A. Zimmermann, Notes on His Family and Career" (prepared for First Presbyterian Church, Annapolis, 2002); Michael P. Parker, communication to author, 6 Aug. 2007. Worden researched the Marriage Registry M#1, 1853–1902, St. Mary's Parish Records, and found twenty-two marriages in which at least one person was born in Germany. By comparison, he noted that forty-one marriages involved someone born in Ireland.

21. Kipp, "St. Martin's Remembered," 7.

22. Paynter, *St. Anne's Annapolis*, 67; Mame Warren, *Then Again . . . : Annapolis, 1900–1965* (Annapolis: Time Exposures, 1990), xviii; churches offering Sunday services as listed in the *Maryland Republican*, 15 May 1880, for instance. Quotation from Paynter.

23. Louis H. Bolander and Elinore G. Girault, "A Brief History of the First Presbyterian Church, Annapolis, Maryland" (unpublished typescript, 1936),14; Willard Mumford, "A Doctor and Professor's Dream: Excerpt from A Brief History of First Presbyterian Church, Annapolis," booklet (2006), 21; Michael P. Parker, *Presidents Hill: Building an Annapolis Neighborhood, 1664–2005* (Annapolis: Annapolis Publishing Co., 2005),190; Michael P. Parker, communication to author, 6 Aug. 2007. Quotation from Bolander and Girault.

24. Bolander and Girault, "First Presbyterian Church," 14–15; Parker, *Presidents Hill*, 190.

25. Jane W. McWilliams, "Eastport Notes," (typescript prepared for Historic Annapolis, Inc., 1983; revised for Eastport Historical Committee, 1993), 1–2; AA CCT (Charter Record) 1868–1882 SH 1 [T 2787-1], 5.

26. AA CCT (Plats) Plat B-301, Plat Book 11 [MSA C2259-142], f. 31; Phebe Jacobsen, "The Paca House" (report prepared for Historic Annapolis, Inc., 1967), 18–19.

27. AALR, L. SH 2, f. 419. The street numbers were reversed in 1938 (Ginger Doyel, personal communication to author, 19 May 2007).

28. Kipp, "St. Martin's Remembered," 5; AALR, L. SH 1, f. 336; Eastport Elementary School Fifth Grade, 1952–53, "Discovering Our School Community," (1953), 6; Robert Harry McIntire, *Annapolis, Maryland, Families*, 2 vols. (Baltimore: Gateway Press, 1980, 1989), 1: 318.

29. *Laws of Maryland*, 1870, chap. 122. The county made it a free bridge about 1877 (AN MA [Proceedings] 1869–1877 [MSA M49-11], 261).

30. AA CCT (Plats) Book 11, f. 31; McWilliams, "Eastport Notes," 4.

31. Eastport Fifth Grade, "Discovering Our School Community," 18; McWilliams, "Eastport Notes," 4; Kimberly P. Williams and Laura V. Trieschmann, "Cultural Resources of Eastport, Maryland, 1857–1949," National Register of Historic Places, Multiple Property Nomination Form (2002), Section E, 10–11. Murphy's Row is now Jeremy's Row.

32. Jane Wilson McWilliams and Carol Cushard Patterson, *Bay Ridge on the Chesapeake, An Illustrated History* (Annapolis: Brighton Editions, 1986), 42–45, 81. A tiny remnant of Bay Shore Drive remains today near the eastern end of Second Street behind the Annapolis Maritime Museum.

33. Ed Bosanko, *Buckets to Pumpers: Firefighting in the City of Annapolis, Maryland, 1755–1992* (Baltimore: John D. Lucas Printing, 1993), 16; Laura V. Trieschmann and Kimberly P. Williams, "First Baptist Church, AA 2294," National Register of Historic Places Application Form, 2002; Eastport Fifth Grade, "Discovering Our School Community," 41; Williams and Trieschmann, "Cultural Resources of Eastport,14; Joy Bolton, comp., *A History of Eastport Elementary School, 1886–1993* (prepared by the Eastport Elementary School History Committee, 1993), 3.

34. Charles James Murphy, letter to *Evening Capital*, 10 Oct. 1903; Warren, *Then Again*, xviii.

35. Elihu Riley, *The Ancient City: A History of Annapolis, in Maryland, 1649–1887* (Annapolis: Record Printing Office, 1887; reprint 1977[?]), 323; Hopkins, *Atlas of Anne Arundel County*, 19–20 (City of Annapolis).

36. Ibid.

37. Ibid.; Johns Hopkins University, *Maryland, Its Resources, Industries, and Institutions* (Baltimore, 1893), 365; *Maryland Republican*, 15 May 1880.

38. Chris Judy, "Data on the Maryland Oyster Fishery, 1870–1990" (Tidewater Administration, Maryland Department of Natural Resources, 1990).

39. Thomas C. Weeks, *First Biennial Report of the Bureau of Industrial Statistics and Information of Maryland, 1884–1885* (Baltimore: Guggenheimer, Weil, & Co. 1886), 206.

40. Weeks, *First Biennial Report*, 65–72. Quotation from 67.

41. *Maryland Republican*, passim, especially 14 July 1877, 4 May, 26 Oct 1878, 18 Jan., 7 June 1879.

42. AA CCT (Equity Papers) 593 [MSA C70-119]; AN MA (Proceedings) 1869–1877 [MSA M49-11], 259, 262, 264, 266; AN MA (Proceedings) 1877–1886 [MSA M49-12], 21, 56; *Maryland Republican*, 27 Mar., 7 July 1877.

43. AN MA (Proceedings) 1877–1886 [MSA M49-12], 13, 306, 311, 405, 458; AN MA (Proceedings) 1886–1892 [MSA M49-13], 135, 161–162, 241.

44. AN MA (Proceedings) 1877–1886 [MSA M49-12], 21, 65, 72.

45. AN MA (Proceedings) 1886–1892 [MSA M49-13], 202; AN MA (Proceedings) 1892–1898 [MSA M49-14], 382, 386; AN MA (Bylaws and Ordinances) 1897–1926 [MSA M51-4], 3, 21, 41; *Evening Capital*, 20 Mar. 1899; McIntire, *Annapolis Families*, 1: 214. This house is mentioned in Chapter 3 as begun by John Griffith.

46. Traceries, "Block Histories, Part of Blocks 28, 30, 31, and 32 (Charles Street)" (2001), 11–13; Traceries, "Block Histories, Block 33A," (1995), 7–11; Emily Peake, communication to author, 21 June 2003.

47. Riley, *The Ancient City*, 323; *Maryland Republican*, 7 July 1877.

48. *Maryland Republican*, 7, 14 July 1877.

49. Ann Jensen, "Rebel Captain from Annapolis, the Last Confederate Raider," *Annapolitan* (Mar. 1990): 42–46, 102–103; AALR, L. SH 14, f. 392; Miller and Ridout, *Architecture in Annapolis*, 168–169. The Commodore Waddell House stands today at 61 College Avenue.

50. Miller and Ridout, *Architecture in Annapolis*, 125–126.

51. *Maryland Republican*, 14 July 1877.

52. 1880 Federal Census, Anne Arundel County, Annapolis District, Population Schedules; Census Office, *Statistics of the Population of the United States at the Tenth Census* (Washington, D.C.: Government Printing Office, 1883), 419, 450.

53. *Evening Capital*, 14 May 1884, 7 Mar. 1912; McIntire, *Annapolis Families* 1: 1. The first issue came out on 12 May, but it does not survive on microfilm. Quotations from *Evening Capital*, 14 May 1884.

54. *Evening Capital*, 29 May 1884.

55. Annapolis Water Company, *The Thirtieth Annual Report of the President of the Annapolis Water Company To the Stockholders. Annapolis, March 30th, 1896* (Annapolis: Advertiser Print[ing], 1896), 4; *Evening Capital*, 29 May 1884; Sanborn Map Company, "Annapolis, Maryland" (New York: Sanborn Map and Publishing, 1885).

56. Thomas E. Martin, *Report of Thomas E. Martin, Mayor of the City of Annapolis, Together with the Treasurer's Exhibit of the Financial Condition of the City, For the Year Ending December 31, 1880, and the Report of the Commissioners of the Sinking Fund, to July 1st, 1880* (Annapolis: J. Guest King, Printer, 1881); AN MA (Proceedings) 1886–1892 [MSA M49-13], 487; *Laws of Maryland*, 1894, chap. 362; White and White, *The Years Between*, 50.

57. AN MA (Proceedings) 1886–1892 [MSA M49-13], 46, 53.

58. Annapolis Water Company, *The Thirtieth Annual Report* , 4–9; *Evening Capital*, 7 Aug. 1896.

59. AN MA (Bylaws and Ordinances) 1897–1926 [MSA M51-4], 13, 76; *Evening Capital*, 27 Sept. 1900, for instance; "Report of the Mayor of Annapolis on the State of its Finances from July 1st, 1903 to December 31st, 1904" in *Reports of the Mayor of Annapolis, 1900–1913*, Maryland Collection, Special Collections, UMD Libraries. Quotations from Bylaws, 76.

60. Arthur E. House, "From Steam to Electric to Diesel to . . . ?" *Railroading* 51 (1974): 17; [James Munroe], *Report of the Mayor of Annapolis, with an exhibit of the financial condition of the city, for the year ending December 31, 1872.* (Annapolis: J. Guest King, 1873). Quotation from Munroe.

61. House, "From Steam to Electric to Diesel," 16; *Maryland Directory and State Gazetteer* (Baltimore, 1887), 41; Roger B. White, "The W.B. & A.: A Short Outline of the Short Line," *Anne Arundel County History Notes* 5 (Apr. 1974): 3. The *Gazetteer* gives the half-hour figure; White says an hour.

62. White, "The W. B. & A.," 3; John E. Merriken, "Annapolis and Elk Ridge," (National Railway Historical Society) *Bulletin* 38 (1973): 22. (I am indebted to Robert L. Worden for this article.) Quotation from the Baltimore *Sun*, 9 Mar. 1887.

63. McWilliams and Patterson, *Bay Ridge on the Chesapeake*, 39–40, 71.

64. Ibid., 40; *Laws of Maryland*, 1884, chap. 487; Merriken, "Annapolis and Elk Ridge," 21.

65. McWilliams and Patterson, *Bay Ridge on the Chesapeake*, 76–78; [Rev. Henry Borgmann], *History of the Redemptorists at Annapolis, Md., from 1853 to 1903 with a Short Historical Sketch of the Preceding 150 years of Catholicity in the Capital of Maryland*, (Ilchester, Md.: College Press, 1904). Quotation from the *Evening Capital*, 28 June 1886, quoted in McWilliams and Patterson, *Bay Ridge on the Chesapeake*, 77.

66. Merriken, "Annapolis and Elk Ridge," 21–22; *Laws of Maryland*, 1886, chap. 54; McWilliams and Patterson, *Bay Ridge on the Chesapeake*, 40.

67. McWilliams and Patterson, *Bay Ridge on the Chesapeake*, 42, 79–81 passim, 49–51, 87.

68. Parker, *Presidents Hill*, 4–9, 17–28.

69. Delavan R. Bowen et al., *Murray Hill in Annapolis, Md.: Centennial 1890-1990* (Annapolis: Murray Hill Residents Association, 1990), 5–9; McIntire, *Annapolis Families*, 1: 474; E. L. Chinn, "Melvin's Plat of Murray Hill," plat, c. 1890 (Annapolis Department of Public Works).

70. Nancy Reams and Audrey Demas, "The History of Wardour," (typescript, no date); George T. Melvin, *The Beautiful Suburb of West Annapolis Adjacent to the City of Annapolis* (Annapolis: George T. Melvin, c. 1890); John Laing, plat for West Annapolis, 1890 (Annapolis Department of Public Works); E. L. Chinn, "Aldridges Revised and Corrected Plat of West Annapolis," plat, 1899 (Annapolis Department of Public Works).

71. Jane McWilliams, "The First Bridge over Weems Creek and Development of the Weems Creek Community," (report for the Maryland State Highway Administration Project Planning Division, 1995).

72. Bowen et al., *Murray Hill*, 9 and passim; Parker, *Presidents Hill*, 46–47 and passim.

73. McWilliams, "The First Bridge over Weems Creek"; McIntire, *Annapolis Families*, 1: 474; *Evening Capital*, 7 Aug. 1907; *Evening Capital: Historical and Industrial Edition* (Annapolis: Evening Capital Publishing, 1908), 17.

74. Brugger, *Maryland, A Middle Temperament*, 396–397; California EnergyQuest, "Energy Timeline" for the 1870s and 1880s, online at www.energyquest.ca.gov/time_machine/time_machine_date.php (last accessed 6/6/10); Jay S. Pifer, *The Allegheny Energy Evolution* (n.p.: Allegheny Power, Oct. 2001).

75. AN MA (Proceedings) 1877–1886 [MSA M49-12], 231, 235, 237, 240; *Maryland Directory and State Gazetteer* (Baltimore, 1887).

76. AN MA (Proceedings) 1886–1892 [MSA M49-13], 16.

77. Ibid., 29, 44, 122.

78. AA CCT (Charter Record) 1868–1882 SH 2 [T 2787-2], 245; AN MA (Proceedings) 1886–1892 [MSA M49-13], 128–131, 135, 140–141, 153, 155, 157–158; Matthew M. Palus, "The Context of Electrification in Annapolis in the Nineteenth Century: A Case Study in the History of Public Utilities and Modernization of the City," (paper prepared for Columbia University School of Anthropology, Jan. 2002), 8. See also Palus, "Building an Architecture of Power: Electricity in Annapolis, Maryland in the 19th and 20th Centuries" in Lynn M. Meskell, *Archaeologies of Materiality* (Oxford, UK: Blackwell Publishing, 2005), 162–189. I am indebted to Matthew Palus for copies of the electric company charters.

79. AN MA (Proceedings) 1886–1892 [MSA M49-13], 161.

80. Palus, "The Context of Electrification," 9.

81. *Evening Capital*, 2 July 1889; Arc lights were the result of an electrical spark crossing ("arcing") from one carbon rod to another, and the light they produced was bright, harsh, and unwavering. Incandescent lights, familiar today, use electricity to heat a filament for a gentler, softer illumination, but one which is still much brighter than gas or kerosene lamps (Palus, "The Context of Electrification," 11–12).

82. Everstine, *The General Assembly, 1850-1920*, 432; *Evening Capital*, 2 July 1889.

83. Helen Childs Corner, reminiscence in *The Publick Enterprise*, December (second half) 1987. The Sands House on Prince George Street was not wired for electricity until 1918 (Ann Jensen, communication to author, 9 Mar. 2004).

84. Palus, "The Context of Electrification," 13–17.

85. *Evening Capital*, 3 July 1889; AN MA (Bylaws and Ordinances) 1897–1926 [MSA M51-4], 99. Quotation from the newspaper.

86. AN MA (Proceedings) 1869–1877 [MSA M49-11], 150; AN MA (Proceedings) 1886–1892 [MSA M49-13], 157.

87. *The Telephone in Maryland* (Baltimore: Chesapeake and Potomac Telephone Co. of Maryland, 1974), 1–4.

88. AN MA (Bylaws and Ordinances) 1881–1897 [MSA M51-3], 143. The pole tax was lowered in 1897 to $1.00 on all poles in town (Bylaws, 158).

89. *Maryland Republican*, 14 Dec. 1879; Bosanko, *Buckets to Pumpers*, 8–9.

90. Baltimore *Sun*, 23, 24 Oct. 1883; *New York Times*, 23 Oct. 1883. I am indebted to Richard E. Israel for the *Times* article.

91. *Maryland Republican*, 27 Oct. 1883; Bosanko, *Buckets to Pumpers*, 10; AN MA (Proceedings) 1877–1886 [MSA M49-12], 356; Riley, "History of the Independent Fire Company," 4. Quotations from Proceedings.

92. AN MA (Bylaws and Ordinances) 1881–1897 [MSA M51-3], 52.

93. Bosanko, *Buckets to Pumpers*,16.

94. AN MA (Proceedings) 1877–1886 [MSA M49-12], 373.

95. Bosanko, *Buckets to Pumpers*, 15.

96. *Evening Capital*, 14 Feb. 1893, 23 July 1908; J. Leonard

and Harry W. Johnson, comps., *Johnson's Directory of Annapolis, Maryland for 1896–97 . . .* (Wilmington, Del.: Johnson Publishing, 1897).

97. AN MA (Proceedings) 1898–1901 [MSA M49-15], p 375; "Report of the Mayor of Annapolis on the State of Its Finances from July 1st 1902 to June 30, 1903 with the Treasurer's Exhibits," *Reports of the Mayor of Annapolis, 1900–1913*, Maryland Collection, Special Collections, UMD Libraries; AN MA (Bylaws and Ordinances) 1881–1897 [MSA M51-3], 51; Miller and Ridout, *Architecture in Annapolis*, 172.

98. "Report of the Mayor of Annapolis on the State of Its Finances from July 1st, 1903 to December 31st, 1904," *Reports of the Mayor of Annapolis, 1900–1913*, Maryland Collection, Special Collections, UMD Libraries; White and White, *The Years Between*, 70. Quotations from White and White.

99. Baltimore *Sun*, 23 July 1902.

100. Bosanko, *Buckets to Pumpers*, 18; Emily Holland Peake, "The Big West Street Fire of 1904," (Riva, Md.: Longview Cottage Press, [no date]); *Evening Capital*, 18 Apr. 1904. Quotations from the newspaper.

101. Baltimore *Sun*, 22 Dec. 1877.

102. Baltimore *Sun*, 15 June 1875; *New York Times*, 15 June 1875; J. Daniel Pindell and Lillian McGowans, "History, Simms Crossing," in Rhonda Pindell Charles, comp., *Parole Week, Celebrating 130 Years of Spirit* (Annapolis: Walter S. Mills–Parole Elementary School Alumni and Friends Association, May 1995). Quotations from the *Sun*, which quoted the jury's verdict.

103. Janice Hayes-Williams, "Our Legacy," *The Capital*, 6 June 2005; Baltimore *Ledger*, 29 Oct. 1898, quoting the *Carroll County Record*. Quotation from the *Ledger*.

104. *Evening Capital*, 21 Dec. 1906; Warren, *Then Again*, xx; *Washington Post*, 20 Dec. 2001, which noted that Smith's death was not technically a lynching because he wasn't hanged. On 20 December 2001, a memorial plaque was placed in Brewer Hill Cemetery where Davis had been buried in an unmarked grave.

105. Baltimore *Ledger*, 29 Oct. 1898; Hayes-Williams, "Our Legacy," *The Capital*, 6 June 2005; Parker, *Presidents Hill*, 44–45.

106. See, for instance, Cunningham, *Calvary United Methodist Church*, 34–38; Robert L. Worden, *Saint Mary's Church in Annapolis, Maryland, A Sesquicentennial History, 1853–2003* (Annapolis: St. Mary's Parish, 2003), 103; AN MA (Proceedings) 1901–1905 [MSA M49-16], 137, 138; White and White, *The Years Between*, 111–112; McWilliams and Patterson, *Bay Ridge on the Chesapeake*, 70–100 passim; *Evening Capital*, 15 July 1908.

107. Elihu S. Riley, "History of the Independent Fire Company from an Old Souvenir Program," (typescript, c. 1919); Barrett L. McKown, comp., *The Membership Registry of the John Paul Jones Chapter, Maryland Society of the Sons of the American Revolution* (Annapolis: The Chapter, 1983) 15; "Sketch of Annapolis and of Annapolis Lodge No. 622, B.P.O.E" (Baltimore: Printed by the Cushing Co., [c. 1902]); Baltimore *Afro-American*, 18 Apr.,

30 May 1896; Walter A. Downing, *History of the Severn Boat Club and the Annapolis Yacht Club, 1886–1972*, [1972]; *Evening Capital*, 14 Feb. 1893; *Report of the Mayor of Annapolis on the State of its Finances, and the Treasurers' Exhibits for the years 1883 and 1884* (Annapolis: Iglehart & Riley, City Printers, 1885); White and White, *The Years Between*, 77; *Johnson's Directory of Annapolis, 1896–97*.

108. Riley, *The Ancient City*, 325; "Report of the Mayor of Annapolis on the State of its Finances, and the Treasurers' Exhibits for the years 1883 and 1884," (Annapolis: Iglehart & Riley, City Printers, 1885); Michael P. Parker, "Circling the Square," talk given at the HAF lecture series, 27 Sept. 2006.

109. AN MA (Bylaws and Ordinances) 1897–1926 [MSA M51-4], 8; Richard "Jud" Henderson, *Chesapeake Sails, A History of Yachting on the Bay* (Centreville, Md.: Tidewater Publishers, 1999), 17, 37–38; Downing, *History of the Severn Boat Club*; White and White, *The Years Between*, 66–68; Emily Holland Peake, "Dr. William Bishop of Annapolis," *Anne Arundel County History Notes* 25 (Jan. 1994): 3–4.

110. *Evening Capital*, 11 July 1895; McWilliams and Patterson, *Bay Ridge on the Chesapeake*, 66, 92, 96.

111. AN MA (Bylaws and Ordinances) 1881–1897 [MSA M51-3], 125, 130, 163.

112. *Maryland Republican*, 1 July 1871; AA CCT (Charter Record) 1868–1882 SH 1 [T 2787-1], 8; Hopkins, *Atlas of Anne Arundel County*, 19–20. Quotations from the newspaper.

113. AN MA (Proceedings) 1869–1877 [MSA M49-11], 223, 227.

114. *Maryland Republican*, 7 July 1877.

115. AN MA (Proceedings) 1892–1898 [MSA M49-14], 114.

116. *Evening Capital*, 11 June 1895.

117. Baltimore *Afro-American*, 18 Apr., 6 May, 13 June 1896 (2nd ed.); White and White, *The Years Between*, 54–55, 68–69; McWilliams, "Charles A. Zimmerman"; McIntire, *Annapolis Families*, 1: 620; AN MA (Proceedings) 1886–1892 [MSA M49-13], 219, 220.

118. AN MA (Proceedings) 1877–1886 [MSA M49-12], 489; Morris L. Radoff, *The State House at Annapolis* (Annapolis: Hall of Records Commission, Publication No. 17, 1972), 35, 37; AN MA (Proceedings) 1886–1892 [MSA M49-13], 197, 199; *Evening Capital*, 21, 23 Apr. 1889.

119. Miller and Ridout, *Architecture in Annapolis*, 114; *Maryland Republican*, 15, 22 Feb. 1873; Jane McWilliams, *"The Progress of Refinement": A History of Theatre in Annapolis* (Annapolis: Colonial Players of Annapolis, 1976), 10–11.

120. McWilliams, *"The Progress of Refinement,"* 11; *Evening Capital*, 18 May 1903. Quotation from McWilliams.

121. *Maryland Directory and State Gazetteer* (Baltimore, 1887); Riley, *The Ancient City*, 320; *Evening Capital*, 2 Dec. 1901.

122. Baltimore *Afro-American*, 13 June 1896 (2nd ed.).

123. Thompson served on the city council from 1887 to 1893 and from 1901 to 1907; Butler, son of the state's first elected

black official, was himself elected alderman in 1893 and 1895 (Jean B. Russo, "City Officers, 1720–1989" [prepared for HAF, 1990]). For the Tawawa Society and Wilberforce University, see John Heyl Vincent, *The Chautauqua Movement* (Boston: Chautauqua Press, 1886), *42;* and Munroe H. Little, "The Extra-curricular Activities of Black College Students, 1868–1940," *Journal of African American History* 87 (Winter 2002): 45.

124. *[Masonic] Universal Lodge No. 14 F. & A. M. Celebrates Its 130th Anniversary* (souvenir booklet, 10 Sept. 1995); McIntire, *Annapolis Families*, 1: 311. I am indebted to William A. Hayes, chairman of the Universal Lodge anniversary event, for information on the lodge and Hart.

125. White and White, *The Years Between*, 17; Baltimore *Afro-American*, 18 Apr., 5 May, 13 June 1896 (2nd ed.).

126. Baltimore *Afro-American*, 30 May 1896.

127. *Evening Capital*, 31 Mar. 1891, 2 June 1897.

128. Annapolis *Negro Appeal*, 16 Feb. 1900. The *Negro Appeal* was published briefly in Annapolis and Baltimore City by the Reverend Dr. S. Timothy Tice, minister at Mt. Moriah AME Church ([MSA SC 3504]; *Afro-American*, 6 May 1896).

129. *Maryland Republican*, 10 Apr. 1875.

130. C. Vann Woodward, *The Strange Career of Jim Crow* (New York: Oxford University Press, Commemorative Edition, 2001), 31–65.

131. State Board of Education (Annual Report) 1870 [MSA MdHR 784195], 63; Bolander and Girault, "First Presbyterian Church," 14.

132. AA CCT (Equity Records), L. 11 [MSA CE431-20], f. 304; Sanborn Map Company, "Annapolis, Maryland" (New York: Sanborn Map and Publishing, 1885); State Board of Education, Annual Report, 1886 [MSA MdHR 812823], 72. Prior to the move, the boys' school was located at 160 Green Street (Shirley V. Baltz, title chain for 160 Green Street, in Baltz Collection [MSA SC 5224-2-18]). The Stockett House was almost certainly built between 1798 and 1812 by Nicholas Maccubbin Carroll and modified by Frank H. Stockett in the mid-nineteenth century. The school commissioners agreed to purchase the Stockett property in 1878, with payments to be made over time. The house and adjacent land were transferred to the county school commissioners by deed in 1887 (Jane W. McWilliams, "Who Built the Stockett House" and "Stockett House Chronology" [reports prepared for this book and for Patricia M. Blick, chief of historic preservation, City of Annapolis, Apr. 2010], in book files).

133. Anne Arundel County Board of Education (Special Reports) David S. Jenkins, "A History of the Colored Schools in Anne Arundel County, Maryland, and a Proposal for their Consolidation," [MSA CM1172-3], 8–11; Bolton et al., *Eastport Elementary School*, 4.

134. State Board of Education (Annual Report) 1881 [MSA MdHR 784198], 73; AA CCT (Charter Record) 1868–1882 L. SH 1 [MSA T 2787-1], 239. Quotation beginning "ladies" is from the

state board report; quotations beginning "useful" and "procure" are from the charter record.

135. Worden, *Saint Mary's Church*, 63–64; State Superintendent of Public Instruction (Annual Report) 1867 [MSA MdHR 812600], 71.

136. Emily A. Murphy, *"A Complete and Generous Education," 300 Years of Liberal Arts, St. John's College, Annapolis* (Annapolis: St. Johns College Press, 1996), 33–47.

137. State Superintendent of Public Instruction (Annual Report) 1867 [MSA MdHR 812600], 71; State Board of Education (Annual Report) 1869 [MSA Roll 283-1], 43–45, 1872 [MSA Roll 283-3], 14.

138. Emily Peake, communication to author, 25 July 2002; *Evening Capital*, 30 Sept. 1896. The Women's College changed its name to Goucher College in 1910 (*Goucher College, Academic Catalogue, 2005–2006* [online at www.goucher.edu/x15662.xml, last accessed 6/6/10], 5).

139. Croll, "History of St. Philip's"; Baltimore *Afro-American*, 6 May 1896; Worden, *Saint Mary's Church*, 2.

140. Worden, *Saint Mary's Church*, 85–86. The Drexel family continued its support for almost fifty years.

141. Margaret Green, interview by Mame Warren, 15 Jan. 1990, The Annapolis I Remember Collection [MSA SC 2140]; Joan C. Scurlock, "The Bishops of Annapolis," (unpublished typescript, 2000), 30, 50, 75; Baltimore *Afro-American*, 13 June 1896 (2nd ed.); Brown, *The Other Annapolis*, 55.

142. Everstine, *The General Assembly, 1850–1920*, 395; Philip L. Brown, *A Century of "Separate But Equal" Education in Anne Arundel County* (New York: Vantage Press, 1988), 7; State Board of Education (Annual Report) 1896–1897 [MSA MdHR 812881], xxxi. Quotation from state board report.

143. *Laws of Maryland*, 1896, chap. 275.

144. State Board of Education (Annual Reports), 1896 [MSA MdHR 784204], xxxii; Good, *High School Heroes*, 7. Quotation from board report.

145. Good, *High School Heroes*, 9.

146. Ibid., 5–10; White and White, *The Years Between*, 100–101.

147. White and White, *The Years Between*, 100–101.

148. AN MA (Proceedings) 1892–1898 [MSA M49-14], 374; *Laws of Maryland*, 1898, chap. 276. Quotation from law.

149. Baltimore *Ledger*, 3 Dec. 1898, 1 Mar. 1899; Good, *High School Heroes*, 25, 123–124; Jenkins, "A History of the Colored Schools," 24. Brown, *A Century*, 8. Quotation from the *Ledger*, 1 Mar. 1899. Brown and Jenkins date the opening to 1900 but differ on building details.

150. Jenkins, "A History of the Colored Schools," 29.

151. Ibid.; Baltimore *Afro-American Ledger*, 20 Jan. 1906, 8 Feb. and 26 Dec. 1908, 23 Jan. 1909. The Baltimore *Ledger*, published in 1898 and 1899, merged with the older *Afro-American* in 1900 to become the *Afro-American Ledger*. Since 1915, the same newspaper, still published today in Baltimore

City, has been known as the *Afro-American* (see newspaper collections at the Maryland State Archives, MSA SC 4974, 4973, 3666, 4972).

152. State Board of Education (Annual Report) 1905 [MSA MdHR 784211], 80; ibid., 1907 [MSA MdHR 784214], 127; Hulda Lundin, "Needlework as Taught in Stockholm," in Mary K. O. Eagle, ed., *The Congress of Women: Held in the Women's Building, World's Columbian Expositions, Chicago, U.S.A., 1893* (Chicago: Monarch Book Co., 1894), 104 (available online at http://digital.library.upenn.edu/women/eagle/congress/lundin.html, last accessed 6/6/10).

153. State Board of Education (Annual Report) 1908 [MSA MdHR 784215], 161, quoted in Jenkins, "A History of the Colored Schools," 16–17.

154. *Laws of Maryland*, 1906, chap. 166.

155. Good, *High School Heroes*, 35–36; *Evening Capital*, 9 Sept. 1907, 14 Sept., 15 Oct. 1908. Quotation from the 15 Oct. issue.

156. USNA *Lucky Bag*, (Special Collections and Archives, Nimitz Library, USNA), 1894, 1895, 1896, 1898, 1897, for instance; Emily Peake, communication to author, 26 Mar. 2008.

157. USNA *Lucky Bag*, 1897; James W. Cheevers, communication to author, 7 Nov. 2007; Annapolis City Directory, 1910 (*AOMOL*: 542). The Cochran-Bryan Preparatory School flourished in Annapolis for at least two decades before World War II (Emily Peake, communication to author, 26 Mar. 2008, USNA *Lucky Bag*, 1935, 510). Severn School, in Severna Park, opened in 1914 as a prep school for the academy (James Cheevers, communication to author, 11 Feb. 2009; www.severnschool.com (last accessed 6/6/10).

158. Emily Peake, communication to the author, 26 Mar. 2008.

159. AN MA (Proceedings) 1869–1877 [MSA M49-11], 160; *Maryland Republican*, 17, 24 Oct. 1874; *Frank Leslie's Illustrated Weekly*, 1 Nov. 1874. "Centennial tea" from *Maryland Republican*, 17 Oct.

160. Jane W. McWilliams, "The Older the Better, What Exaggeration Tells Us about Annapolis's History," Four Rivers Heritage Area Mythbusters Workshop, Historic London Town, 18 Nov. 2008. The *Annapolis Gazette* dated from 1854. It was not connected to the Green family's *Maryland Gazette*.

161. Riley, *The Ancient City*; David Ridgely, *Annals of Annapolis . . .* (Baltimore: Cushing & Brother, 1841); McIntire, *Annapolis Families*, 1: 583–584, 587; Anne Arundel County Historical Society, *Hand-book of the City of Annapolis and U.S. Naval Academy* (Annapolis: Maryland Republican Steam Press, 1888).

162. Walter Edgar McCann, "The Finished City," *Frank Leslie's Monthly*, Mar. 1888, 295–302.

163. *Evening Capital*, 26 Mar. 1888.

164. T. Henry Randall, "Colonial Annapolis," *Architectural Record* 1 (Jan.–Mar. 1892): 309–344.

165. [St. John's College] Alumni Association, *1789–1889:* *Commemoration of the One Hundredth Anniversary of Saint John's College* (Baltimore: W. K. Boyle & Son, 1890).

166. Elihu S. Riley, ed., *Memorial Volume: Celebration of Two Hundredth Anniversary of the Removal of the Capital of Maryland from St. Mary's to Annapolis, March 5, 1894* (Annapolis: King Bros., State Printers, 1894), 19, 20, 22; *Encyclopedia Britannica*, 15th ed. (1974) 3: 602–603; Riley, *The Ancient City*, 63. Carl Everstine suggests that the planners might have decided to celebrate in 1894 because the General Assembly would not be in session in 1895. He notes that the first Annapolis session of the Assembly met on 28 February (Old Style), which would be 11 March (New Style) (Everstine, *The General Assembly, 1850–1920*, 416, 419).

167. *Evening Capital*, 5 and 6 Mar. 1894. Quotation from 6 Mar. issue.

168. *Evening Capital*, 6 Mar. 1894.

169. Radoff, *The State House*, 41–44, 49, 53, 55, 58–59; Everstine, *The General Assembly, 1850–1920*, 424–427. See also DeCourcy W. Thom, "The Restoration of the Old Senate Chamber in Annapolis," *MHM* 2 (1907): 326–335; DeCourcy W. Thom, "The Old Senate Chamber," *MHM* 25 (1930): 365–384; J. Appleton Wilson, "Restoration of the Senate Chamber," *MHM* 22 (1927): 54–62.

170. Orlando Ridout V, "Economics as a Force in Historic Preservation: Annapolis: Origins of a Preservation Movement in Maryland's Capital City" (lecture, Preservation Forum, Newport, R.I., Nov. 2000), 5–7.

171. Riley, *The Ancient City*, 257; Riley, *Memorial Volume*, 165; Hopkins, *Atlas of Anne Arundel County*, 19–20; *Evening Capital*, 25 Mar. 1890; Jean Russo, "USNA Title Search" (Research Files, "Archaeological Survey," USNA Legacy Project, Department of Anthropology, UMD, College Park, Md., 1994–1995), 14.

172. *Laws of Maryland*, 1898, chap. 370.

173. *Evening Capital*, 25 Mar. 1890.

174. *Evening Capital*, 16 Jan. 1896; Sweetman, *The U.S. Naval Academy*, 135. Quotation from the newspaper.

175. Edmund Morris, *The Rise of Theodore Roosevelt* (New York: Modern Library edition, 2001), 433–434; Sweetman, *The U.S. Naval Academy*, 127, 135; "Colonel Robert Means Thompson, USNA 1868," biography online at www.usna.com, accessed 6/6/10. See also the drawings of Flagg's "Study for the Proposed Rebuilding of the United State Naval Academy. . ." in Senate Document No. 288, 54th Congress, 1st session.

176. *Evening Capital*, 5, 6, 7 Feb. 1896. Quotation from 5 Feb. issue.

177. *Laws of Maryland*, 1896, Joint Resolution No. 4.

178. Russo, "USNA Title Search," 14–16.

179. Lt. Cdr. E. K. Moore to Superintendent, 14 Jan. 1899, USNA Department of Buildings and Grounds, vol. 445, 260 (National Archives, Record Group 405). I am indebted to James

W. Cheevers, associate director and senior curator of the USNA Museum, for a copy of this document.

180. AN MA (Proceedings) 1892–1898 [MSA M49-14], 249.

181. Senate Document No. 213, 55th Congress, 2nd session, "Acquiring Certain Property in Annapolis as Annex to the United States Naval Academy," in AN MA (Land Record Papers) [MSA M75-18]; Russo, "USNA Title Search," 17.

182. *New York Times*, 15 May and 10 June 1898; Morris, *The Rise of Theodore Roosevelt*, 643–644, 688–689.

183. Sweetman, *The U.S. Naval Academy*, 139; Baltimore *Sun*, 18, 21 July 1898; Mame Warren and Marion E. Warren, *Everybody Works But John Paul Jones: A Portrait of the U.S. Naval Academy, 1845–1915* (Annapolis: Naval Institute Press, 1981); Worden, *Saint Mary's Church*, 93–94; White and White, *The Years Between*, 108. Worden calculates the number of Spanish prisoners at the Naval Academy as seventy-nine officers and fifteen servants (Robert Worden, email to author 27 Apr. 2010). I am also grateful to Dr. Worden for the *Sun* articles. About 1,700 of Admiral Cervera's men were sent to Seavey's Island, Portsmouth, New Hampshire (Baltimore *Sun*, 18 July 1898; Lieutenant R. H. Jackson, USN, "Seavey's Island Prison and Its Establishment," U.S. Naval Institute *Proceedings* 25: 413–416).

184. Sweetman, *The U.S. Naval Academy*, 167, 213; Elihu S. Riley, "Links between Annapolis and the Naval Academy," *Evening Capital*, 18 Mar. 1922. This was the last of Riley's reminiscences; he died on the day it was printed.

185. Warren, *Then Again*, xx; Lt. Cdr. A. P. Calvert, USN, "The U.S. Naval Engineering Experiment Station, Annapolis," *U.S. Naval Institute Proceedings* 66 (Jan. 1940): 49–51; Julie Belding, *A History of College Avenue–Heritage Baptist Church, 1903–1978*, 5; Jane Wilson McWilliams, *The First 90 Years: A History of Anne Arundel Medical Center, 1902–1992* (Annapolis: Anne Arundel Medical Center, 1992), reprinted in Catherine H. Avery and Jane W. McWilliams, *A Century of Caring, A History of Anne Arundel Medical Center, 1902–2002* (Annapolis: Anne Arundel Medical Center, 2002), 17, 20; Murphy, *"A Complete and Generous Education,"* 54–56; Pat Burkhardt, communication to author, 20 July 2003; Morris L. Radoff, *Buildings of the State of Maryland at Annapolis* (Annapolis: Hall of Records Commission, 1954), 134; Sweetman, *The U.S. Naval Academy*, 142–144; James Cheevers, communications to author, 21 July 2003, 7 Nov. 2007.

186. Michael Parker, "A Rose for Miss Lucy (and Miss Hessie): Philip B. Cooper and the Hammond-Harwood House," *Anne Arundel County History Notes* 23 (Jan. 1992): 17–18; Oscar Booth, "Annapolis in Fiction," *Anne Arundel County History Notes* 26 (Jan. 1995): 1; Winston Churchill, *Richard Carvel* (New York: Macmillan, 1899).

187. Belding, *College Avenue–Heritage Baptist Church*, 1–5.

188. McWilliams, *The First 90 Years*, 1–17; Scurlock, "The Bishops of Annapolis," chart of the descendants of William Henry Bishop; Phebe Jacobsen, "Bishop Notes" in MSA SC 1456–1950.

189. Bowen et al., *Murray Hill*, 13–15; Parker, *Presidents Hill*, 32–37 and specific houses; Sanborn Map Company, "Insurance Maps of Annapolis and Eastport, Anne Arundel County, Maryland," (New York: Sanborn Map Co., Oct. 1908); Warren, *Then Again*, 29.

190. Baltimore *Afro-American Ledger*, 26 May 1906.

191. *Evening Capital*, 22 Oct. 1908.

192. Warren, *Then Again*, 3, 6; Ann Jensen, "The Jews in Annapolis: Transitions and Traditions, A History of Perseverance, Achievement and Service," *Annapolitan*, July 1989, 78.

193. McIntire, *Annapolis Families*, 1: 278; AA CCT (Minutes) L. SH 3 [MSA C92-5], 363.

194. Jensen, "The Jews in Annapolis," 38–39, 46, 78–79; Eric L. Goldstein, "Our History," in *Looking Back . . . Moving Forward, Congregation Kneseth Israel, From Strength to Strength, 1906–1996* (program for the congregation's ninetieth anniversary, 10 Nov. 1996); Eric L. Goldstein, "Surviving Together: African Americans and Jews in Annapolis, 1885–1968," (Younger Scholars Research Essay, National Endowment for the Humanities, 1991), 6–7.

195. White and White, *The Years Between*, 18.

196. Goldstein, "Our History"; Jensen, "The Jews in Annapolis," 39, 46, 78; *Evening Capital*, 13 Sept. 1906, quoted in Goldstein. Quotations from Goldstein.

197. Goldstein, "Our History"; Jensen, "The Jews in Annapolis," 39; Russo, "City Officers."

198. Jensen, "The Jews in Annapolis," 79; *Laws of Maryland*, 1900 chap. 157.

199. See, for instance, the *Evening Capital*, Aug. 1900, passim, and the Annapolis *Negro Appeal*, 16 Feb. 1900.

200. Bureau of the Census, *Population 1910*, Vol. 2 (Washington, D.C.: Government Printing Office, 1913), 830; Thomas E. Martin, *Report of Thomas E. Martin, Mayor of the City of Annapolis, Together with the Treasurer's Exhibit of the Financial Condition of the City, For the Year Ending December 31, 1880, and the Report of the Commissioners of the Sinking Fund, to July 1st, 1880* (Annapolis: J. Guest King, Printer, 1881), 8. Quotation from Martin.

201. Bernard Kalnoske and Sharon Cyrus, "Annapolis Police Department, History, 1708–1997" (typescript, 1966; updated to 1992 by Gary Simpson and to 1997 by Zora B. Lykken, 1–3; AN MA (Proceedings) 1905–1908 [MSA M49-17], 377–380.

202. Kalnoske et al., "Annapolis Police Department," 1–3.

203. Ibid., 2–3; AN MA (Bylaws and Ordinances) 1881–1897 [MSA M51-3], 82, 83, 99, 113, 170; AN MA (Bylaws and Ordinances) 1897–1926 [MSA M51-4], 19, 68, 102; *Evening Capital*, 12 May 1900; AN MA (Proceedings) 1886–1892 [MSA M49-13], 197; Matthew G. Forte, *American Police Equipment* (Upper Montclair, N.J.: Turn of the Century Press, 2000) 21, 24.

204. John H. Thomas, *Report of the Mayor of Annapolis on the State of its Finances, from January 1st, 1894, to December 31st, 1894, with the Treasurer's Exhibits* (Annapolis: Advertiser Print[ing Co.], 1895).

205. AN MA (Proceedings) 1886–1892 [MSA M49-13], 324, 333; AN MA (Bylaws and Ordinances) 1897–1926 [MSA M51-4], 44, 53; AN MA (Proceedings) 1892–1898 [MSA M49-14], 192; AN MA (Bylaws and Ordinances) 1881–1897 [MSA M51-3], 100, 153.

206. AN MA (Proceedings) 1886–1892 [MSA M49-13], 324, 333; White and White, *The Years Between*, 32; AN MA (Bylaws and Ordinances) 1881–1897 [MSA M51-3], 100; Ginger Doyel, *Gone to Market: The Annapolis Market House, 1698–2005* (Annapolis: City of Annapolis, 2005), 34–37.

207. AN MA (Proceedings) 1886–1892 [MSA M49-13], 471, 480; AN MA (Bylaws and Ordinances) 1897–1926 [MSA M51-4], 41.

208. AN MA (Proceedings) 1886–1892 [MSA M49-13], 135; *Report of the Mayor of Annapolis on the State of Its Finances from January 1st, 1900 to December 31st, 1900, with the Treasurer's Exhibits, and the Report of the Health Office for the Year* (Annapolis: Advertiser & Capital, 1901), 11; *Report of the Mayor of Annapolis on the State of Its Finances from July 1st, 1901 to June 30th, 1902, with the Treasurer's Exhibits and the Report of the Health Officer for the Year* (Annapolis: Evening Capital Press, 1902), 6. Quotation from 1901–1902 mayor's report.

209. "Report of the Mayor of Annapolis on the State of its Finances from July 1st, 1903 to December 31st, 1904," *Reports of the Mayor of Annapolis, 1900–1913*, Maryland Collection, Special Collections, UMD Libraries.

210. *Evening Capital*, 21 Aug., 17 Sept. 1900. At this time, it appears that the dump was along College Creek near St. Anne's Cemetery. By 1914, the city was dumping garbage in the head of Spa Creek year round. Whether summer garbage went there prior to that is not clear. (See also "Report of the Mayor of Annapolis on the State of Its Finances from July 1, 1913, to June 30, 1914 with Statement of Sinking Fund," *Reports of the Mayor of Annapolis, 1900–1913*, Maryland Collection, Special Collections, UMD Libraries.)

211. AN MA (Bylaws and Ordinances) 1897–1926 [MSA M51-4], 53, 89, 95.

212. *Evening Capital*, 26 Apr. 1893, 4 Nov. 1896, 10 May 1904, 6, 21 Aug. 1900; "Report of the Mayor of Annapolis on the State of its Finances from January 1, 1897 to December 31, 1897 with Treasurer's Exhibits" *Report of the Mayor of Annapolis 1883–99*, Maryland Collection, Special Collections, UMD Libraries; *Report of the Mayor of Annapolis on the State of Its Finances from January 1st, 1900 to December 31st, 1900, with the Treasurer's Exhibits, and the Report of the Health Office for the Year* (Annapolis: Advertiser & Capital, 1901); AN MA (Bylaws and Ordinances) 1897–1926 [MSA M51-4], 50.

213. *Report of the Mayor of Annapolis with an Exhibit of the Financial Condition of the City from the 10th of April 1865 to the Close of the Year 1870* (Annapolis: Advertiser Print[ing Co.], 1871); *Laws of Maryland*, 1878, chap. 390; *Laws of Maryland*, 1894, chap. 383.

214. AN MA (Bylaws and Ordinances) 1897–1926 [MSA M51-4], 3; *Evening Capital*, 13, 14 Dec. 1897. Quotation from newspaper 14 Dec.

215. *Laws of Maryland*, 1898, chap. 370; AN MA (Bylaws and Ordinances) 1897–1926 [MSA M51-4], 6.

216. *Laws of Maryland*, 1900, chap. 188; *Evening Capital*, 28 Apr., 12, 15 May 1900; AN MA (Bylaws and Ordinances) 1897–1926 [MSA M51-4], 31. Quotation beginning "duly" from the law; quotation beginning "five" from the newspaper 15 May. Technically female property owners could vote in city elections prior to 1819, but there is no evidence they did so.

217. *Laws of Maryland*, 1906, chap. 553; AN MA (Bylaws and Ordinances) 1897–1926 [MSA M51-4], 100; *Evening Capital*, 17 Apr., 18 July 1906. Quotation from newspaper 18 July.

218. *Laws of Maryland*, 1908, chap. 727; AN MA (Bylaws and Ordinances) 1897–1926 [MSA M51-4], 109; *Evening Capital*, 26 Feb., 21, 22, 23, 24, 27 July 1908. Quotations from newspaper 24 July.

219. *Evening Capital*, 8 Aug., 21 Nov. 1907; Court of Appeals, Briefs and Reports, October term, 1907, Appeal of Equity Court case 2963, filed 13 Nov. 1907; Anne B. Jeffers, Hester A. Harwood, et al. vs. Mayor, Counselor, and Aldermen of the City of Annapolis, *Reports of Cases Argued and Adjudged in the Court of Appeals of Maryland*, vol. 107 (1907–1908) (Frederick, Md.: Charles H. Baughman, publisher, 1909). Quotation from Briefs and Reports, Opinion of John G. Rogers, dated 2 Nov. 1907.

220. White and White, *The Years Between*, 85; Michael Parker, "A Rose for Miss Lucy (and Miss Hessie)," 17. Quotation from White and White.

221. *Laws of Maryland*, 1872, chap. 425; AN MA (Proceedings) 1886–1892 [MSA M49-13], 364, 369, 383; AN MA (Proceedings) 1898–1901 [MSA M49-15], 146, 149, 156; *Evening Capital*, 25 Aug. 1899; AN MA (Bylaws and Ordinances) 1897–1926 [MSA M51-4], 14; *Evening Capital*, 19 Apr. 1904, 21, 22, 24 June 1907; AN MA (Bylaws and Ordinances) 1897–1926 [MSA M51-4], 107, 108. The original franchise was modified 2 July 1907, see AN MA (Proceedings) 1905–1908 [MSA M49-17], 359. The WB&A was a reorganization of the AW&B and a corporate descendant of the Annapolis and Elk Ridge Railroad.

222. John E. Merriken, *Every Hour on the Hour: A Chronicle of the Washington, Baltimore & Annapolis Electric Railroad* (Bulletin 130, Central Electric Railfans' Association, Dallas, Tex.: LeRoy O. King, Jr., 1993), 138–139; *Evening Capital*, 18 Nov. 1907.

223. *Evening Capital*, 21 June 1907.

224. Merriken, *Every Hour on the Hour*, 139.

225. Merriken, *Every Hour on the Hour*, 6, 28, 139–140; *Evening Capital* 24 June 1907. Naval Academy Junction was the station on the WB&A electric line at Odenton not far from, but different from, Annapolis Junction on the old B&O line between Baltimore and Washington (Merriken, *Every Hour on the Hour*, 2, 151).

226. *Evening Capital*, 11 July, 10 Oct. 1908. In September the adult trips dropped to 3,940, but children's trips remained high at 1,250. See statistics in the paper for 10 Oct.

227. *Evening Capital*, 16 Feb. 1910; Merriken, *Every Hour on the Hour*, 31–33, 140, 171–176. For description of a particularly gruesome trolley accident, see Parker, *Presidents Hill*, 43–44.

228. White and White, *The Years Between*, 84–85.

229. Merriken, *Every Hour on the Hour*, 68–69; *Evening Capital*, 20 June 1910.

230. *Evening Capital*, 20 July 1908.

231. House, "From Steam to Electric to Diesel," 18.

232. Baltimore *Sun*, 22 Nov. 1908.

233. AN MA (Proceedings) 1907, 199th Anniversary of Annapolis Charter [MSA M49-18]; *Evening Capital*, 18 and 23 Nov. 1907.

234. *Evening Capital*, 8, 10, 17, 23, 24 Sept., 1, 8, 9, 16, 17, 22 Oct., 2, 5, 6, 11 Nov. 1908. The issues of the paper are missing from the available microfilm for the rest of 1908 and most of 1909. Quotation from the *Evening Capital*, 23 Nov. 1907.

235. *Evening Capital*, 17 Sept., 1 Oct., 11 Nov. 1908. Randall's committee met for twenty years, hoping that they could garner enthusiasm and funds to build the elaborate fountain, but they never did. The only parts of the plan to be realized were the cornerstone of Schular's fountain and the granite horse trough. Both of these are now located in the small park adjoining the Market House (Parker, "Circling the Square").

236. *Evening Capital*, 16 and 22 Oct. 1908; Baltimore *Sun*, 21, 22 Nov. 1908.

237. *Evening Capital: Historical and Industrial Edition* (Annapolis: Evening Capital Pub. Co., 1908).

238. Baltimore *Sun*, 21 and 22 Nov. 1908. Quotations from the 22 Nov. issue.

239. *Evening Capital*, 5 Nov. 1908; Baltimore *Sun* 23 Nov. 1908.

240. Baltimore *Sun*, 22 Nov. 1908.

241. Baltimore *Sun*, 24 Nov. 1908; "Bicentenary Charter Celebration, Program of Exercises, November Twenty-first, Twenty-second, and Twenty-third, Nineteen Hundred and Eight" (Reverend Smiley Collection, Sands House).

Chapter 7. Promise Denied, 1908 to 1940

1. Quoted in Carl N. Everstine, *The General Assembly of Maryland, 1850–1920* (Charlottesville, Va.: Michie Co., 1984), 546. For an examination of Jim Crow legislation in the South, see C. Vann Woodward, *The Strange Career of Jim Crow* (New York: Oxford University Press, Commemorative Edition, 2002). Maryland's situation is discussed in Margaret Law Callcott, *The Negro in Maryland Politics, 1870–1912* (Baltimore: Johns Hopkins Press, 1969) and in Everstine, 535–564.

2. Callcott, *The Negro in Maryland Politics*, 115. This law was called the Poe Amendment.

3. Ibid., 137.

4. *Laws of Maryland*, 1908, chap. 26 (known as the Straus Amendment); *Maryland Manual, 1905* (Baltimore: Wm. J. C. Dulany Co., [1905]), 306; Callcott, *The Negro in Maryland Politics*, 126–128.

5. *Journal of Proceedings of the House of Delegates, January Session, 1908* (Geo. W. King, 1908), 977, 1211, 1353; *Journal of Proceedings of the Senate of Maryland, January Session, 1908* (Geo. W. King, 1908), 1097, 1459, 1714.

6. *Laws of Maryland*, 1908, chap. 525.

7. Maryland Constitution (1867), Article I, Section 1, as printed in *Constitutional Revision Study Documents of the Constitution Convention Commission of Maryland, June 15, 1968* (Annapolis: State of Maryland, 1968), 516.

8. *Afro-American Ledger*, 12 June 1909.

9. AN MA (Assessment Records) 1897–1910 A-G [MSA M72-9], 12, 27, 50, 45, 59, 60, 66, 86, 89, 118. By 1908 the Butler and Bishop fortunes were assessed to the female heirs of the by-then-deceased William H. Butler and Dr. William Bishop.

10. AN MA (Proceedings) 1908–1912 [MSA M49-19], 188.

11. AN MA (Assessment Records) 1897–1910 A-G [MSA M72-9], H-S [MSA M72-10] (No entries appear for Anderson, Brown, and Howard.); *Anderson v. Myers et al., Howard v. Same, Brown v. Same*, 182 Fed 223 (1910); Pension records for John B. Anderson in Maryland State Archives, *Documents for the Classroom*, MSA SC 2221-8-14; AA CCT (Test Book) 1892–1920 [MSA T1119-1], 5; William H. Howard biography in MSA SC 3520-13931; F. E. Gould and P. R. Halleron, *Annapolis City Directory, 1910 (AOMOL: 542)*. The lower court report reversed the antecedents of Howard and Brown, but this is corrected in *Myers and Others v. Anderson, Same v. Howard, Same v. Brown*, 238 US 368 (1915), 378. Confirmation of the father/grandfather issue appears in Howard's biography, which shows his father as born c. 1854 and thus too young to vote in 1868. Clarence M. Jones was not mentioned in the court cases.

12. AN MA (Proceedings) 1908–1912 [MSA M49-19], 201. J. Albert Adams attended the last meeting of the previous council on 12 July. (Ibid., 200.) Myers was elected again in 1911 (Jean B. Russo, "City Officers, 1720–1989" [prepared for HAF, 1990]). There are no extant poll books or election returns for the city from 1885 until 1949 (MSA M32 and M101).

13. *Maryland Manual, 1910–1911* (Baltimore: John Murphy Co. [1911]), 193; *Evening Capital*, 3, 4 Nov. 1909 (quotation from 3 Nov.); Everstine, *The General Assembly, 1850–1920*, 553.

14. Everstine, *The General Assembly, 1850–1920*, 564 (known as the Digges Amendment); *Maryland Manual, 1912* (Baltimore: John Murphy Co. [1912]), 232; *Archives of Maryland*,

New Series, Historical List (Annapolis: MSA, 1990) 1: 17 (hereafter in this chapter cited as *Historical List, Md. Arch.* 1).

15. *Dictionary of American Biography* (New York: Charles Scribner's Sons, 1964), 1: 427–428; Jane L. Phelps, "Charles J. Bonaparte and Negro Suffrage in Maryland," *MHM* 54: 331–352; *Baltimore American*, 29 June 1921.

16. Baltimore *Sun*, 17 Aug. 1912; *Historical List, Md. Arch.* 1: 493; *Anderson v. Myers et al.*, 182 Fed 223 (1910); *Afro-American Ledger*, 15 Oct. 1910.

17. Baltimore *Sun*, 17 Aug. 1912 (J. W. Randall), 14 Apr. 1936 (Daniel Randall), 12 Mar. 1936 (Soper); *Myers et al. v. Anderson*, 238 US 365 (1915). Edgar Gans died in 1914 before the Supreme Court's decision (Baltimore *Sun*, 21 Sept. 1914). The Randalls were sons of Alexander Randall; J. Wirt Randall died in 1912.

18. *Myers et al. v. Anderson*, 238 US 365 (1915). The Oklahoma case was *Gwinn v. United States*, 238 US 347 (1915). See articles and editorials in the *Evening Capital*, 22, 24 June 1915, the Baltimore *Sun*, 22, 23 June 1915, and the *New York Times*, 22, 23 June 1915.

19. Russo, "City Officers."

20. Callcott, *The Negro in Maryland Politics*, 133–137; David C. Holly, *Tidewater by Steamboat* (Baltimore: Johns Hopkins University Press, 1991), 173–175.

21. *Laws of Maryland* 1908, chap. 292; John E. Merriken, *Every Hour on the Hour* (Dallas, Tex.: Leroy O. King, Jr., 1993), 26.

22. AALR, Ls. FAM 187, f. 201, JHH 203, f. 11, JHH 216, fs. 31, 449, 567, for instance; Robert L. Worden, *Saint Mary's Church in Annapolis, Maryland: A Sesquicentennial History, 1853-2003* (Annapolis: St. Mary's Parish, 2003), 110, 210 (fn 39). My appreciation to Norma Worden for the deed references.

23. Philip L. Brown, *The Other Annapolis, 1900-1950* (2nd ed. privately published, 2000), passim; Leslie A. Mobray, *"Strong Faith . . . Strong Families": The Clan of Maggie Carter Johnson and George Washington Johnson, Sr.* (privately printed, 2008), 12. "Preventing 'coloreds'" quotation from Mobray, 12; Brown's words from his book, 91.

24. *Evening Capital*, 19 Feb. 1918, 24, 25, 26, 27, 28 Feb. 1919, 3 Mar. 1919; Delavan R. Bowen et al., *Murray Hill in Annapolis, Md.: Centennial 1890-1990* (Annapolis: Murray Hill Residents Association, 1990), 17–19; *John Snowden v. State of Maryland*, 133 Md 625 (1919). On 10 June 2000, members of the Snowden family and others, confident of his innocence, placed a memorial on his grave in Brewer Hill Cemetery. John Snowden received a posthumous pardon from Governor Parris N. Glendenning on 31 May 2001 ("Justice Delayed Is Justice Denied," program from the dedication ceremony, 10 June 2000; *Washington Post*, 1 June 2001). Attorney A. Theodore Brady, whom Snowden graciously acknowledged in his last statement as having "done what he could for me," was the same Delegate Brady who introduced the city's grandfather clause into the General Assembly in 1908 and was elected state senator in 1909. His defense of John Snowden does not seem to have diminished his role as county Democratic leader. Eight months after Snowden's death, Brady was elected to a second term as state senator, after which he served as state's attorney for the county until shortly before his death in 1935 (*Evening Capital*, 28 Feb. 1919, *Historical List, Md. Arch.* 1; William J. McWilliams diary, 28 June 1933 (private collection); Baltimore *Sun*, 18 Feb. 1935 [quotation from *Evening Capital*]). I am indebted to William J. McWilliams, Jr., for allowing me to use his father's diaries.

25. James Cheevers, communication to author, 7 Nov. 2007; *New York Times*, 8 Mar. 1891; "USS *Holland* (Submarine Torpedo Boat #1), 1900-1913," online at www.history.navy.mil/photos/sh-usn/usnsh-h/ss1.htm (last accessed 6/11/10).

26. Wilson D. Leggett, Jr., Rear Adm., USN, "The U.S. Naval Engineering Experiment Station," *U.S. Naval Institute Proceedings* 77 (May 1951): 516–535; E. J. King, "Historical Perspective: The United States Naval Engineering Experimentation Station, Annapolis, Maryland," *Naval Engineers Journal* 107 (Mar. 1995): 61–72; A. Calvert, Lt. Comdr., USN, "The U.S. Naval Engineering Experiment Station, Annapolis," *U.S. Naval Institute Proceedings* 66 (Jan. 1940): 49–51. Will Mumford and Emily Peake, communication to author, 10 June 2010. Quotation from Leggett, 518.

27. Robert W. Murch, Lt. Cdr., USN Ret. "N. A. S. Annapolis." *U.S. Naval Institute Proceedings* 77 (Oct. 1951): 1068–1071; Jack Sweetman, *The U.S. Naval Academy: An Illustrated History*, 2nd ed., rev. by Thomas J. Cutler (Annapolis: Naval Institute Press, 1995), 165–166; Thomas Ray, "Naval Aviation, The Beginning," *U.S. Naval Institute Proceedings* 97 (Jan. 1971): 32–42; Thomas Ray, "The First Three," *U.S. Naval Institute Proceedings* 97 (July 1971): 34–43; Thomas Ray, "Annapolis, Md.: The Navy's First Aerodrome," *U.S. Naval Institute Proceedings* 97 (Oct. 1971): 34–41; Ann Jensen, "Pioneers of Naval Aviation," *Annapolitan* (Nov. 1988): 60–63.

28. "Record of Proceedings of a Board of Investigation convened at the U.S. Naval Academy, Annapolis, Md., by order of the Secretary of the Navy, to inquire into Outbreak of Typhoid Fever," 5 Jan. 1911, Office of the Superintendent, General Correspondence, 1907–1922 (1907–1911), box 45, folder 16, #1664, Diseases at N. A. 1908–1910, USNA Archives, Nimitz Library, USNA. In 1911, Remsen's complaints that the airplanes would annoy his cows slowed construction of the aerodrome (Murch, "N. A. S., Annapolis," 1070).

29. Donna Lobos, "The United States Naval Academy Dairy, Gambrills, Md." *Anne Arundel County History Notes* 34 (July 2003): 3–5, 9–10, and 35 (Oct. 2003): 6–7. Lobos says the Gambrills dairy was in "full operation by April 1915" (ibid., 35: 6). For the continued history of the farm, see the remainder of her article in *Anne Arundel County History Notes* 35 (Jan. 2004 and Apr. 2004).

30. Sweetman, *The U.S. Naval Academy*, 167, 208.

31. *Evening Capital*, 23 Apr. 1913; Michael P. Parker, *Presidents Hill: Building an Annapolis Neighborhood, 1664-2005,*

Annapolis, Maryland (Annapolis: Annapolis Publishing Co., 2005), 36–38.

32. *Evening Capital*, 7, 8 Nov. 1916. Quotations from the paper of 7 Nov.

33. *Evening Capital*, 6, 7, 8 Nov. 1916.

34. Everstine, *The General Assembly, 1850–1920*, 593.

35. *Evening Capital*, 6, 7 Mar. 1918; Parker, *Presidents Hill*, 62–63.

36. *Evening Capital*, 7, 8, 9, 11, 12, 16 Mar. 1819; Mame Warren, *Then Again . . . : Annapolis, 1900–1965* (Annapolis: Time Exposures, 1990), xxi. County commissioner's quotation from the 7 March paper; saloon sign quote from Warren.

37. *Evening Capital*, 16 Mar. 1918.

38. *Random House Dictionary of the English Language*, 1st ed. (1966), 1929; www.archives.gov/education/lessons/volstead-act/ (accessed 6/11/10). The Eighteenth Amendment was nullified by the Twenty-first Amendment, passed by Congress 20 February 1933, ratified 5 December 1933 (Everstine, *The General Assembly, 1850–1920*, 592).

39. *Annapolitan Club of the City of Annapolis, Incorporated* (Annapolis: Annapolitan Club, 1964).

40. *Evening Capital*, 13 Sept. 1933. Although the repeal of Prohibition was the point of the election, Marylanders actually voted for delegates to a ratifying convention. The Maryland convention ratified the repealing amendment a month later (Richard J. Israel, communication to author, 10 Sept. 2007).

41. Sweetman, *The U.S. Naval Academy*, 167–169.

42. L. S. Howeth, Capt. USN (Ret.), *History of Communications-Electronics in the United States Navy* (Washington, D.C.: Bureau of Ships and Office of Naval History, 1963), 241, 253, 530; "Radio Transmitter Facility," undated, unsigned manuscript in book files; *Evening Capital*, 5 Mar. 1918; Jane Wilson McWilliams, *The First 90 Years: A History of Anne Arundel Medical Center, 1902–1992* (Annapolis: Anne Arundel Medical Center, 1992), reprinted in Catherine H. Avery and Jane W. McWilliams, *A Century of Caring: A History of Anne Arundel Medical Center, 1902–2002* (Annapolis: Anne Arundel Medical Center, 2002), 23–24.

43. Virginia Schaun, "Banking, Industry and Commerce," in James Bradford, ed., *Anne Arundel County, A Bicentennial History* (Annapolis: Anne Arundel County and Annapolis Bicentennial Committee, 1977), 98; *Evening Capital*, 19 Feb. 1919; Mark A. Albe, "Saunders Range, Harundale's Missing Piece of Maryland's Military History," *Anne Arundel County History Notes* (Spring 2008): 1–2, 5–11.

44. *Maryland in the World War, 1917–1919, Military and Naval Service Records*, 2 vols. (Baltimore: Maryland War Records Commission, 1933), 209 and passim; Maryland Office of Planning, "Population of Maryland's Regions and Jurisdictions, 1790–1990," (2000). In 1920 Baltimore County had a population of 74,817; Baltimore City, 733,826; Anne Arundel County, 43,408.

45. *Maryland in the World War*, 94 and passim; "Report of General John J. Pershing, 1 September 1919" in Frank J. Mackey and Marcus Wilson Jernegan, *Forward–March!*, 2 vols. (Chicago: Disabled American Veterans of the World War, 1934), unpaged; *Evening Capital*, 10 Sept. 1917, 6 Nov. 1918. For the war service of Annapolis High School football players, see Jane E. Good, *High School Heroes, A Century of Education and Football at Annapolis High School, 1896–2003* (Bowie, Md.: Heritage Books, 2004), 62–70.

46. *Maryland in the World War*; France America Pindell, interview by author, 27 Oct. 2003.

47. Analysis of the service records of the Annapolis men from *Maryland in the World War*, and Robert Harry McIntire, *Annapolis, Maryland, Families*, 2 vols. (Baltimore: Gateway Press, 1980, 1989); Mackey and Jernegan, *Forward-March!* For statistics on the spread and virulence of the 1918 flu, see Gina Kolata, *Flu: The Story of the Great Influenza Pandemic of 1918 and the Search for the Virus That Caused It* (New York: Farrar, Straus and Giroux, 1999), 1–33. See also Albert W. Crosby, *America's Forgotten Pandemic* (Cambridge: Cambridge University Press, 1989), and John M. Barry, *The Great Influenza: The Epic Story of the Deadliest Plague in History* (New York: Viking, 2004).

48. See the service records of the mentioned doctors and nurses in *Maryland in the World War*.

49. Ralph F. Nolley, *The Boys of Annapolis and Anne Arundel County Who Are Serving Uncle Sam* (Baltimore: Maryland War Record Portrait Books [Ralph F. Nolley, publisher], 1918), unpaged; Parker, *Presidents Hill*, 63–64; Ann Jensen, communications to author, 6, 15 May 2008; *Evening Capital*, 2, 3, 4, 11, 19 Oct., 9 Nov. 1918 and passim. Ann Jensen said Jack Flood told her that belly bands were thought to protect the abdomen so soldiers in trenches wouldn't get colds.

50. Emily A. Murphy, *"A Complete and Generous Education": 300 Years of Liberal Arts, St. John's College, Annapolis* (Annapolis: St. John's College Press, 1996), 62–63; *Evening Capital*, 7 Oct. 1918.

51. *Evening Capital*, 19 Feb. 1919.

52. *The American Experience: Influenza 1918*, PBS television program, transcript at http://www.pbs.org/wgbh/amex/influenza/filmmore/transcript/index.html (accessed 6/11/10); John F. Kelly, "Autumn 1918, Washington's Season of Death," *Washington Post*, 22 Jan. 2004; Kolata, *Great Influenza Pandemic*, 7, 19. Quotation from Alfred W. Crosby interview in Kolata, 7.

53. Daniel Vincent Gallery to "Dear Papa," 21 Sept. 1918, in Anne Marie Drew, ed., *Letters from Annapolis, Md.: Midshipmen Write Home, 1848–1969* (Annapolis: Naval Institute Press, 1998), 133.

54. *Evening Capital*, 2, 3, 4, 16 Oct. 1918; Jack Flood, interview with Mame Warren, 19 Jan. 1990 [MSA SC 2140]; *Maryland in the World War*, 473. Quotation from the newspaper 4 Oct.

55. Thomas C. Worthington, communication to author, 20 Feb. 2004.

56. *Evening Capital*, 7, 8, 9, 11, 14, 16 Oct. 1918; *The American Experience: Influenza 1918*. Quotations from *Evening Capital* obituaries, 11 and 16 Oct., respectively. "The strongest members" comment was made by Dr. Alfred Crosby, author of *America's Forgotten Pandemic*, on the PBS program cited above.

57. *Evening Capital*, 11, 12, 24 Oct. 1918.

58. *Evening Capital*, 10, 11, 19 Oct. 1918.

59. *Evening Capital*, 3, 5, 7 Oct. 1918. Quotation from 7 Oct.

60. William Oliver Stevens, *Annapolis, Anne Arundel's Town* (New York: Dodd, Mead, 1937), 324; *Annapolis City Directory, 1910* (AOMOL: 542).

61. Emily Peake, communication to author, 18 Feb. 2004; Department of Health, Bureau of Vital Statistics (Death Records, Counties), Anne Arundel County, Oct. 1918 [MSA S1179-2325, S1179-2326] passim; *Evening Capital*, 2 Nov. 1918. Anne Arundel County registered 1,123 deaths in October 1918. Roughly 70 percent were soldiers who died at Camp Meade. By actual count, 108 death certificates listed Annapolis, Eastport, Parole, Weems Creek, or the Naval Academy as the address of the deceased and either the flu or pneumonia as the cause of death. (Quotation from the *Evening Capital*, 2 Nov. 1918.

62. *Evening Capital*, 18, 26 Oct., 2 Nov. 1918. Quotation from 2 Nov. paper.

63. See analysis of service records and families for these men in book files; *Evening Capital*, 2, 4, 6, Nov. 1918.

64. *Evening Capital*, 4, 7 Nov. 1918; Jack Flood interview 19 Jan. 1990. Quotation from the newspaper 7 Nov.

65. *Evening Capital*, 11, 12 Nov. 1918. Quotation from the newspaper 12 Nov.

66. Histories of these organizations at www.vfwmaryland.org, www.mdlegion.org, and www.fra.org, (accessed 6/11/10); McIntire, *Annapolis Families*, 1: 541; Janice Hayes-Williams, "Our Legacy," *The Capital*, 7 Aug. 2008.

67. See Appendix 1, Table 4, census chart for 1910 to 1940; *Laws of Maryland*, 1914, chap. 155; Parker, *Presidents Hill*, 35; *Evening Capital*, 13 Apr. 1910. The city divided the Third Ward to create the Fourth Ward in 1914. "Report of the Mayor of Annapolis on the State of Its Finances from July 1, 1913, to June 30, 1914, with Statement of Sinking Fund," *Reports of the Mayor of Annapolis, 1900–1913*, Maryland Collection, Special Collections, UMD Libraries.

68. Analysis of the 1920 Federal Census Schedules for Annapolis, in book files.

69. Ann Jensen, "For a Better Life: A History of Italians in Annapolis," *Annapolitan* (Oct. 1992); Warren, *Then Again*, 2.

70. Ann Jensen, "The Greeks in Annapolis," *Annapolitan* (Oct. 1988); Warren, *Then Again*, 90, 93; *Annapolis City Directory, 1910* (AOMOL: 542); The Reverend Protopresbyter Kosmas Karavellas, communication to author, 27 Mar. 2008; *Saints Constantine and Helen Greek Orthodox Church, Consecration, October 20–21, 2001, Annapolis, Maryland*, 17–18; "History of the Philiptochos" online at www.philoptochos.org/history/index.html (last accessed 6/11/10). Quotations from the directory.

71. William K. Paynter, *St. Anne's Annapolis, History and Times* (Annapolis: St. Anne's Parish, 1980), 79; *Evening Capital*, 20 Nov. 1918; Eric L. Goldstein, "Our History," in *Looking Back . . . Moving Forward, Congregation Kneseth Israel, From Strength to Strength, 1906–1996* (program for the congregation's ninetieth anniversary, 10 Nov. 1996).

72. Isabel Shipley Cunningham, *Calvary United Methodist Church, Annapolis, Maryland, The First Two Centuries* (Edgewater, Md.: Lith-O-Press, 1984), 39–47, 59–61; *Evening Capital*, 31 Mar. 1902; "Historical Note," Henry Powell Hopkins Papers, Hornbake Library, UMD (online at www.lib.umd.edu/archivesum, accessed 6/7/10).

73. Philip Richbourg, "Historical Sketch [of First Church of Christ, Scientist]" (typescript in book files, no date).

74 "Age, for Cities of 10,000 or More: 1920," *Department of Commerce, Fourteenth Census of the United States, State Compendium, Maryland* (Washington, D.C.: Government Printing Office, 1924), p. 21, Table 8 (Of the total of 4,579 females in Annapolis, 62% were 21 or older.); *Random House Dictionary of the English Language*, 1st ed. (1966), 1929.

75. *Evening Capital*, 28 Apr., 12 May 1900, 21, 22, 24 July 1908. Quotation from 24 July newspaper.

76. *Evening Capital*, 23 May 1916, William O. Stevens, "A Suffrage Oasis," *The Independent* 86 (Apr. 1916): 142; "Our History," Annapolis and Anne Arundel County YWCA, online at www.annapolisywca.org/our-history.php (last accessed 6/11/10). I am indebted to Michael Parker for a copy of Stevens's article.

77. *Evening Capital*, 10 Sept. 1917.

78. *Evening Capital*, 8 Nov. 1916, 4 Nov. 1920.

79. *Evening Capital*, 13, 14 July 1925; McIntire, *Annapolis Families*, 1: 526, 752. Barbara Neustadt was elected to the City Council in 1973 (Jean Russo, "City Officers").

80. *Evening Capital*, 11 Jan. 1921.

81. *Annapolis City Directory, 1910* (AOMOL: 542); *Annapolis City Directory, 1924* (AOMOL: 538).

82. "Report of the Mayor of Annapolis on the State of Its Finances From July 1st, 1910 to June the 30th, 1911 with Statement of Sinking Funds," *Reports of the Mayor of Annapolis, 1900–1913*, Maryland Collection, Special Collections, UMD Libraries; AN MA (Bylaws and Ordinances) 1897–1926 [MSA M51-4], 140.

83. Horace Jewell Fenton, "A Sigh for the Old Annapolis," *Sunday Sun Magazine*, 3 June 1928.

84. Emily Peake, communication to author, 13 Jan. 2004. Three Mile Oak is at the junction of Routes 178 and 450, where, traditionally, George Washington was greeted by his generals on 19 Dec. 1783.

85. AN MA (Bylaws and Ordinances) 1897–1926 [MSA M51-4], 179; *Evening Capital*, 13 May 1913, 27 June 1914; Parker, *Presidents Hill*, 49–50; Bowen et al., *Murray Hill*, 19. Quotation from Parker, 50.

86. *Evening Capital*, 27 July 1925.

87. AN MA (Proceedings) 1931–1935 [MSA M49-24], 9 Nov. 1931.

88. *Evening Capital*, 24 Oct. 1918. The Wells house was the colonial Adams-Kilty house (William V. Elder III, "The Adams-Kilty House in Annapolis," *MHM* 60: 319; McIntire, *Annapolis Families*, 1:749).

89. Charles T. LeViness, *A History of Road Building in Maryland* (Baltimore: State Roads Commission of Maryland, 1958), 132; *Laws of Maryland*, 1914, chaps. 32, 619, and Joint Resolution 7; *Evening Capital*, 5 Mar. 1918, 15, 17, 18 July 1927. The Defense Highway is Maryland Route 450.

90. Warren, *Then Again*, xxi; Philip B. Perlman, "The Story of the Annapolis-Claiborne Ferry Company and Transportation across Chesapeake Bay," statement before the Public Service Commission, Jan. 22, 1940 (Annapolis: George W. Phillips, [no date]); Public Service Commission of Maryland, "In the matter of the Claiborne-Annapolis Ferry Company. Investigation of the rates, charges, services, property and affairs. Case no. 4316. Before the Public Service Commission of Maryland. Opinion and order no. 35800, filed May 29th, 1940" ([Baltimore,] 1940); Joseph Sherbow, "Before the Public Service Commission of Maryland, Case no. 4316, In the matter of the Claiborne-Annapolis Ferry Company. Investigation of the rates, charges, services, property and affairs. Brief by People's Counsel" (Baltimore: Daily Record Co., 1940); *Evening Capital*, 19, 20 June 1919. Quotation from the newspaper 19 June.

91. Perlman, "Annapolis-Claiborne Ferry Company"; LeViness, *Road Building in Maryland*, 147. The new route from Sandy Point to Kent Island, inaugurated in 1943, reduced travel time across the Bay to twenty-five minutes (Warren, *Then Again*, xxii).

92. John J. Flood, "City Dock, Echoes of the Past," *Annapolitan* (Oct. 1987): 39.

93. Robert Barrie and George Barrie, Jr., *Cruises Mainly in the Bay of the Chesapeake* (Bryn Mawr, Pa.: Franklin Press, 1909), 30–32, 69–71, for instance; Warren, *Then Again*, 184.

94. Robert K. Headley, "Early Movies in Annapolis, 1901–1922," *Anne Arundel County History Notes* 34 (July 2003): 1–2, 6–8; Sanborn Map Co., "Insurance Maps of Annapolis and Eastport, Anne Arundel County, Maryland" (New York: Sanborn Map Co., Oct. 1908). My thanks to Janice Hayes-Williams for spotting the theater on West Washington Street.

95. Warren, *Then Again*, xx; *Evening Capital*, 9Aug. 1911. Quotation from the newspaper.

96. *Evening Capital*, 17 Jan. 1919; Warren, *Then Again*, xx–xxi, 37.

97. Headley, "Early Movies in Annapolis," 8; Roger White, "Circle Theater," *Anne Arundel County History Notes* 26 (Oct. 1994): 7–8, 17; Emily Holland Peake, *Going to the Movies* (Riva, Md.: Longview Cottage Press, 2002). "Movie palace" quotation from Headley.

98. "Made in Maryland: Movies Filmed in Baltimore and Maryland," baltimoresun.com, 1 Nov. 2006 (www.sunspot.net/entertainment/movies/bal-artslife-mdmovies07,0,5657208.story?coll=bal-local-headlines, last accessed 6/11/10); Sweetman, *The U.S. Naval Academy*, 176.

99. See, for instance, Arthur A. Ageton, Lt., USN, "Annapolis, Mother of Navy Men." *U.S. Naval Institute Proceedings* 61 (Oct. 1935); Kendall Banning, *Annapolis Today, 1879-1944* (Annapolis: United States Naval Institute, 1957, 5th rev. ed.); James Cheevers, "Annapolis," *American History* 30 (Nov.–Dec. 1995).

100. C. Herbert Gilliland, "The Naval Academy in Fiction, 1884–2008," Naval History Symposium, Annapolis, 20 Sept. 2007.

101. Jane W. McWilliams, *Annapolis History Bibliography* (unpublished typescript, 2000) for full citations.

102. Parker, *Presidents Hill*, 77–78; *Evening Capital*, 28 Oct. 1922. Quotations from the newspaper.

103. Parker, *Presidents Hill*, 78–79; *Evening Capital*, 28 May 1923, 30 Jan. 1925, 14 June 1927; Lemuel K. Taylor, communication to author, 27 Oct. 2007. Quotation from *Evening Capital*, 14 June 1927.

104. Plat of Parole Street, Annapolis Department of Public Works; *Laws of Maryland*, 1914, chap. 619; *Evening Capital*, 2 Nov. 1914; Parker, *Presidents Hill*, 42–43.

105. Sherri Marsh, "Marley Neck School and the Julius Rosenwald Fund," AA-2066, Inventory of Historic Properties, Maryland Historical Trust; plat of Hicks property, Annapolis Department of Public Works; France A. Pindell, interview 27 Oct. 2003.

106. Pearl C. Swann, "Mt. Olive African Methodist Episcopal Church," in Rhonda Pindell Charles, comp., *Parole Week, Celebrating 130 Years of Spirit* (Walter S. Mills–Parole Elementary School Alumni and Friends Association, May 1995); Parole School Fourth Grade, 1951–52, "Discovering Our School Community," 8–9; "History of Mt. Olive," in J. William Swann, *Black History Month, Thru' It All*, (privately published, 1989), 17.

107. Bishop Wilbert L. Baltimore, "King's Apostle Holiness Church of God, Inc., Our History" (unpublished typescript, 1998); "History of King's Apostles Holiness Church of God, Annapolis, Maryland" in Charles, *Parole Week*.

108. Irene S. Mills, "History of Cecil Memorial United Methodist Church," in Charles, *Parole Week*; Swann, *Black History Month, Thru' It All*, 21.

109. J. Daniel Pindell and Lillian McGowans, "History, Simms Crossing," in Charles, *Parole Week*.

110. See Charles, *Parole Week*; France A. Pindell, interview 27 Oct. 2003.

111. Plat of Neuva-Villa Park, 1924, Plat 94, Plat Bk. 3, 29 [MSA S1235-1056]. The plat uses this spelling.

112. See, for instance, the plat of Davis's Addition to Germantown, 1910, Annapolis Department of Public Works; plat of

subdivision of W. M. Owings tract, 1921, Anne Arundel County Plat Book 15, f. 22; Grade 5, Germantown School, "Discovering Our School Community," 16–19, 43; Edward Hall III, interview by Elizabeth Hughes, 6 June 2003, communicated to author. My thanks to Elizabeth Hughes for sharing Edward Hall's interview and the 1921 Owings plat. Germantown native Bernard "Bunny" Gessner said the name Germantown came about because several German immigrants had truck farms there before 1900 (Bernard Gessner, interview by Mame Warren, 6 Apr. 1990, The Annapolis I Remember Collection [MSA SC 2140]).

113. *Evening Capital*, 25 Sept. 1911, 7 Mar. 1912; Elliot Abhau, Colby Rucker, and Ginny Vroblesky, *Listening to Our Trees: A Walking Tour of West Annapolis and Wardour* (Annapolis: A Rocha USA, 2004), 20, 23–26; Nancy Reams and Audrey Demas, "The History of Wardour" (typescript, no date); plats of Wardour Bluffs and Wardour, 1907, 1909, 1915, 1927, Annapolis Department of Public Works.

114. Ed Bosanko, *Buckets to Pumpers: Firefighting in the City of Annapolis, Maryland, 1755–1992* (Baltimore: John D. Lucas Printing Co., 1993), 24, 27; Cunningham, *Calvary United Methodist Church*, 38–39. According to Cunningham, the congregation seems to have disbanded about 1930 and the church was sold in 1933.

115. Joy Bolton, comp., *A History of Eastport Elementary School, 1886–1993* (prepared by the Eastport Elementary School History Committee, Apr. 1993), 6–7, 9–11; Sanborn Map Company, "Insurance Maps of Annapolis and Eastport, Anne Arundel County, Maryland" (New York: Sanborn Map Co., Dec. 1913); *Laws of Maryland*, 1908, chap. 411.

116. *Evening Capital*, 29 Nov. 1909; plat of Boucher, Jefferson, etc., 1918, Annapolis Department of Public Works; plat of Brashears estate, 1919, Annapolis Department of Public Works.

117. National Register of Historic Places Nomination, AA-36, Section 7, 7–9, Chance Boatyard; "Historic Boatyards of Eastport/Spa Creek," Exhibit, Barge House Museum (1998); *Evening Capital*, 14 Dec. 1918.

118. Norwood S. Wetherhold, *The History of St. Luke's Episcopal Church, Eastport, Maryland* (1996); Sanborn Map Company, "Annapolis and Eastport, Anne Arundel County, Maryland," (New York: Sanborn Map Co., Oct. 1921); Sanborn Map Company, "Annapolis, Maryland, including West Annapolis, Eastport, South River Park, Edgewater Beach, Parole, Bay Ridge, Pines on the Severn, and Herald Harbor," (New York: Sanborn Map Co., Apr. 1930).

119. AALR L. FSR 91, f. 386; *Evening Capital*, 28 May 1931, 2 June 1936.

120. Good, *High School Heroes*, 76–81.

121. Philip L. Brown, *A Century of "Separate but Equal" Education in Anne Arundel County* (New York: Vantage Press, 1988), 21; David S. Jenkins, "A History of the Colored Schools in Anne Arundel County, Maryland, and a Proposal for their Consolidation" in AA BE (Special Reports) [MSA CM1172], 31, (Minutes)

1924–1935 [MSA T2622-2], 169. Jenkins dates the high school to 1919.

122. AALR, L. FSR 28, f. 57. My thanks to Janice Hayes-Williams for this reference.

123. AA BE (Minutes) 1924–1935 [MSA T2622-2], 140, 167.

124. *Laws of Maryland*, 1929, chap. 203; AA BE (Minutes) 1924–1935 [MSA T2622-2], 110, 114, 115, 121.

125. *Evening Capital*, 11, 12 Feb. 1930; Good, *High School Heroes*, 117–119; AA BE (Minutes of Building Commission) 1930–1935 [MSA T3207-1], 1.

126. AA BE (Minutes of Building Commission) 1930–1935 [MSA T3207-1], 1–36; Good, *High School Heroes*, 120–121. St. John's quotation from Minutes, 17; site description from Minutes, 34 and 35.

127. AA BE (Minutes of Building Commission) 1930–1935 [MSA T3207-1], 13, 18, 29 for instance. Quotation from 13.

128. AA BE (Minutes of Building Commission) 1930–1935 [MSA T3207-1], 65, 67; AN MA (Proceedings) 1931–1935 [MSA M49-24], 14 Dec. 1931; Good, *High School Heroes*, 121.

129. AA BE (Minutes of Building Commission) 1930–1935 [MSA T3207-1], 49, 65. Quotations from 49.

130. Susan G. Pearl, communication to author, 23 Mar. 2010; National Register of Historic Places Nomination, AA-12, Wiley H. Bates High School, prepared by Michael Justin Dowling, Aug. 1989, Sect. 7, p. 1; Jenkins, "A History of the Colored Schools," 24. Jenkins says that eight rooms and an assembly hall were built at a cost of $69,150; Brown, *A Century of "Separate but Equal"* (33) says seven rooms and a gym at a cost of $58,596. The file for Bates (labeled "Stanton" but clearly Bates) in the archives of the Julius Rosenwald Fund at Fisk University in Nashville, Tennessee, shows a total cost for the school's construction of $59,600, with $1,100 from the community, $3,600 committed by the Rosenwald Fund, and $54,900 from public funds (Susan Pearl, communication 23 Mar. 2010).

131. *Evening Capital*, 28 Nov. 1932; AA BE (Minutes) 1924–1935 [MSA T2622-2], 230. Quotation from newspaper. Both Good (*High School Heroes*) and Brown (*A Century of "Separate but Equal"*) date the opening of Bates to 1 January 1933, but the first day of January 1933 was a Sunday. Errol Brown, in a telephone conversation with the author, 20 October 2004, said classes began in the new school right after Christmas vacation, 1933.

132. Jenkins, "A History of the Colored Schools," 33–34; Brown, *A Century of "Separate but Equal,"* 93; Myra Bryan, "Moving an Eight Room School," in Grade 4, Stanton School, "Discovering Our School Community" (1953), 26–27.

133. *Evening Capital*, 15 Sept. 1932; Good, *High School Heroes*, 121; AA BE (Minutes of Building Commission) 1930–1935 [MSA T3207-1], 76, 80. Food quotation from the newspaper; lab description quotations from Minutes, 80.

134. AA BE (Minutes of Building Commission) 1930–1935 [MSA T3207-1], 18, 29 for instance; Germantown Elemen-

tary School 5th Grade, "Discovering Our School Community" (typescript, 1953), 31; "Report of the Mayor of Annapolis on the State of Its Finances from July 1, 1913, to June 30, 1914, with Statement of Sinking Fund," *Reports of the Mayor of Annapolis, 1900–1913*, Maryland Collection, Special Collections, UMD Libraries; *Evening Capital*, 22 Sept. 1924, 30 Jan. 1927, 30 Jan. 1928; AN MA (Proceedings) 1931–1935 [MSA M49-24], 9 Nov. 1931, 1 Dec. 1933, 5 Jan., 12 Feb., 9, 12–14, 23 Mar., 6 Apr., 3 May, 9, 23, 27 July, 23 Aug., 8 Oct., 12 Nov., 10 Dec. 1934. The term "odorless" was generally applied to reduction incinerators; see, for instance, *Evening Capital* 30 January 1928 and council proceedings 1 December 1933. The incinerator closed in 1949, and Mayor Rowe reported that garbage was sent to the county dump (Mayor Roscoe C. Rowe, "A Report to Annapolis, Md.: A Report to the Counselor, Aldermen and Citizens of Annapolis, Maryland, for the Fiscal Year July 1, 1949–June 30, 1950"). The city maintained a landfill on Maryland Route 450 adjoining the reservoir property from 1960 to 1995. An adjacent landfill operated from 1949 to 1960 (Evaluation Report on Statement of Interest: Interest in Becoming the Developer for the Annapolis Renewable Energy Park, submitted to the City Council by Bob Agee, acting director of public works, 21 Sept. 2009, 10).

135. AN MA (Proceedings) 1931–1935 [MSA M49-24], 3 Mar., 23 July, 23 Aug. 1934. The incinerator today serves the city Public Works Department on Spa Road.

136. *Evening Capital*, 30 Dec. 1931.

137. USNA *Lucky Bag*, 1935, Special Collections, Nimitz Library, USNA; *Evening Capital*, Nov. 22, 1937.

138. Richard E. Miller, *The Messman Chronicles: African Americans in the U. S. Navy, 1932–1943* (Annapolis: Naval Institute Press, 2004),61; Brown, *The Other Annapolis*, 33–35.

139. Miller, *The Messman Chronicles*, 63–65; "Cumberland II," Dictionary of American Fighting Ships online at www.history.navy.mil/danfs/ (accessed 7/19/10); Alexander Eucare, interview by Mame Warren, 28 Apr. 1990, and Carroll Hynson, Jr., interview by Mame Warren, 22 Jan. 1990, The Annapolis I Remember Collection [MSA SC 2140].

140. AN MA (Proceedings) 1931–1935 [MSA M49-24], 12 Nov. 1934; *Evening Capital* 13 Feb. 1935; analysis of 1930 Federal Census schedules for Annapolis, in book files; Warren, *Then Again*, xii, xxii. Oliver's quotation from the newspaper.

141. *Laws of Maryland*, 1935, chap. 60. A *Time* magazine article 25 February 1966 stated that Maryland's miscegenation law was one of the last in the country still in effect. The law was repealed in 1967 (*Laws of Maryland*, 1967, chap. 7).

142. Miller, *The Messman Chronicles*, 62–66.

143. *Evening Capital*, 30 Dec. 1931, 17 Feb., 12, 19 Oct. 1932.

144. *Laws of Maryland*, 1933, chap. 482; AN MA (Proceedings) 1931–1935 [MSA M49-24] 22 Mar., 18 May, 14 Aug., 11 Dec. 1933, 6 Apr. 1934.

145. AN MA (Proceedings) 1931–1935 [MSA M49-24] 8 Feb. 1932, 4 Apr., 19 Oct. 1933.

146. AN MA (Proceedings) 1931–1935 [MSA M49-24], 28 Apr., 13, 27 Nov., 1, 8, 14 Dec. 1933, 27, 31 Jan., 12 Feb. 1934, 15 Apr. 1935; *Laws of Maryland*, Special Session, 1933, chaps. 2, 72.

147. *Evening Capital*, 19 Oct., 17, 28 Nov. 1932.

148. *Evening Capital*, 19 Oct. 1932.

149. See, for instance, *Evening Capital*, 13, 19, 31 May 1933.

150. *Evening Capital*, 12 Nov. 1932, 15, 19, 20, 27 May, 6 June 1933; Sweetman, *The U.S. Naval Academy*, 188–189. Quotation from 27 May newspaper.

151. William J. McWilliams diary, 4 Mar. 1933; analysis of 1930 Federal Census schedules for Annapolis, in book files. The percentage of radios to households was highest in affluent Wards 2 (67%) and 3 (57%); in Ward 4, fewer than 25 percent of the families had a radio. Yet, there were families living in $7-a-month rental housing who owned a radio. Quotation from diary.

152. Sweetman, *The U.S. Naval Academy*, 192–193; James W. Cheevers, "Buildings and Grounds of the Naval Academy Through the Years," lecture at St. John's College, 17 Feb. 2004, for the Anne Arundel County Trust for Preservation and St. John's College Lecture Series; Baltimore *Sun*, 31 Aug. 1938, 16 July 1939.

153. AN MA (Proceedings) 1931–1935 [MSA M49-24] 8 Jan. 1934, 14 May 1934; AN MA (Proceedings) 1936–1941 [MSA M49-25] 11 Nov. 1935; *Evening Capital* 8 July 1934, 7 Feb. 1936, 13 Apr., 11, 12 Aug. 1937; Jenkins, "A History of the Colored Schools," 24; AA BE (Minutes of Building Commission) 1930–1935 [MSA T3207], loose papers in front of volume relating to Public Works Administration school projects in 1939 and 1940; Morris L. Radoff, *Buildings of the State of Maryland at Annapolis* (Annapolis: Hall of Records Commission, 1954), 128; Robert J. Brugger, *Maryland, A Middle Temperament, 1634–1980* (Baltimore: Johns Hopkins University Press, 1988), 510; National Register of Historic Places Nomination AA-36, for Chance Boatyard, 26; William J. McWilliams diary, 25 Mar. 1935, 30 July, 3, 12 Aug. 1937; Warren, *Then Again*, xxii; Louis N. Phipps, "Report of the Mayor of Annapolis of the City's Business for the Period From July 1, 1938 to December 31, 1938," AN MA (Reports and Minutes) 1894–1959 [MSA M102-2].

154. Peake, *Going to the Movies*, 7; Tom Worthington, communication to author, 20 Feb. 2004; Jack Flood, interview with Mame Warren, 19 Jan. 1990, The Annapolis I Remember Collection [MSA SC 2140]; Ann Jensen, "Remembering Hell Point," *Annapolitan* (Nov. 1989): 38–43, 62, 64, 66.

155. AN MA (Proceedings) 1931–1935 [MSA M49-24] 18 May 1933; AA BE (Minutes) 1924–1935 [MSA T2622-2], 152; *Evening Capital*, 13 Apr. 1937; Les Trott, interview by Mame Warren, 22 Jan. 1990, The Annapolis I Remember Collection [MSA SC 2140].

156. France A. Pindell, interview with the author, 27 Oct. 2003; Warren, *Then Again*, 87; Claudia Graham Cullimore, interview with Sharie Valerio, 22 Mar. 1990, and Les Trott, inter-

view by Mame Warren, 22 Jan. 1990, The Annapolis I Remember Collection [MSA SC 2140]; Eastport Historic Walking Tour, Site 13 (Barge House Museum and City of Annapolis, c. 2003). Quotation from France Pindell.

157. Leo Pickens, "Of Kings, Levelers, Nymphs and Killer Bees: Glimpses of Our Athletic Past and Present," talk at St. John's College, 8 Mar. 2005, for the Anne Arundel County Trust for Preservation and St. John's College Lecture Series.

158. Pickens, "Of Kings, Levelers, Nymphs and Killer Bees"; Murphy, *"A Complete and Generous Education,"* 79–111.

159. Russo, "City Officers"; *Evening Capital*, passim. Quenstedt was mayor 1929 to 1935.

160. "Annapolis Water Company," (typescript, c. 1990); James F. Strange, "Report of the Mayor of Annapolis on the State of Its Finances From July the 1st, 1911 to June the 30th, 1912 with Statement of the Sinking Fund," *Reports of the Mayor of Annapolis, 1900–1913*, Maryland Collection, Special Collections, UMD Libraries; *Evening Capital*, 7 Mar. 1912; *Laws of Maryland*, 1912, chaps. 86, 118.

161. Sanborn Map Company, "Insurance Maps of Annapolis and Eastport, Anne Arundel County, Maryland" (New York: Sanborn Map Co., Dec. 1913).

162. "Annapolis Water Company," (typescript, c. 1990); *Laws of Maryland*, 1918, chap. 205; *Laws of Maryland*, 1920, chap. 568; Samuel Jones, "Report of the Mayor of Annapolis on the State of the City's Finances From July 1, 1921 to June 30, 1922 with Statement of Sinking Funds," The Report of the Mayor of Annapolis 1921–22, Maryland Collection, Special Collections, UMD Libraries; *Laws of Maryland*, 1922, chap. 349; *Laws of Maryland*, 1927, chap. 245; Sanborn Map Company, "Annapolis, Maryland, including West Annapolis, Eastport, South River Park, Edgewater Beach, Parole, Bay Ridge, Pines on the Severn, and Herald Harbor" (New York: Sanborn Map Co., Apr. 1930); *Laws of Maryland*, 1929, chap. 32; *Laws of Maryland*, 1931, chap. 534; *Laws of Maryland*, 1933, chap. 98; *Evening Capital*, 25 May 1931; Parker, *Presidents Hill*, 59.

163. Sanborn Map Company, "Annapolis and Eastport, Anne Arundel County, Maryland" (New York: Sanborn Map Co. , Oct. 1921); *Laws of Maryland*, 1922, chap. 349; Charles W. Smith, "Report of the Mayor of Annapolis on the State of the City's Finances From July 1, 1924 to June 30, 1925 With Statement of Sinking Fund," AN MA (Reports and Minutes) 1894–1959 [MSA M102-2]; *Laws of Maryland*, 1927, chap. 245; *Evening Capital*, 25 May 1931. Quotation from the newspaper.

164. *Laws of Maryland*, 1931, chap. 534; *Evening Capital*, 27 May, 2 July 1931, 16 May 1933; AN MA (Proceedings) 1931–1935 [MSA M49-24] 20 July, 10 Aug. 1931, 8, 15 May, 17 July 1933; *Laws of Maryland*, 1933, chap. 98.

165. *Evening Capital*, 27 May 1931, 13 Apr. 1937; AN MA (Proceedings) 1931–1935 [MSA M49-24] 12 Nov. 1934; William J. McWilliams diary, 1 Apr. 1935; Louis N. Phipps, "Report of the Mayor of Annapolis of the City's Business for the Period From July 1, 1938 to Dec. 31, 1938," AN MA (Reports and Minutes) 1894–1959 [MSA M102-2].

166. Merriken, *Every Hour on the Hour*, 95–103. Merriken targets Mayor Quenstedt as anti-train and blames him for the railroad's trouble in Annapolis. City Council minutes and the newspapers confirm his assertion regarding Quenstedt's position and contentiousness, but it is clear Quenstedt did represent the attitude of most of the town as far as train removal was concerned. (See, for instance, *Evening Capital*, 24 Feb. 1932; AN MA (Proceedings) 1931–1935 [MSA M49-24] 29 Aug., 21 Oct. 1932.) Walter Quenstedt was appointed warden at the House of Correction in February 1935; he served out his mayoral term and then retired from politics (*Evening Capital*, 9 Feb. 1935).

167. AN MA (Proceedings) 1931–1935 [MSA M49-24] 31 Apr. 1931, 13 June, 11 July, 8, 22, 29 Aug., 2, 12 Sept., 10, 21, 26 Oct. 1932, 13, 27 Mar., 10 Apr. 1933, 14 May 1934, 4 Mar., 12 Aug., 9 Sept. 1935; *Evening Capital*, 17 Feb., 11, 24, 27, 28 Oct., 2 Nov. 1932, for instance; Merriken, *Every Hour on the Hour*, 103–111; Warren, *Then Again*, xxi, xxii.

168. Marshall Langton Price, M.D., to Austin L. Crothers, Governor of Maryland, 24 Jan. 1911 (including test reports), in "Severn River Oyster Contamination Report," State Board of Health [MSA MdHR 810791].

169. George W. Stiles, Jr., "The Value of the Shellfish Industry and the Protection of Oysters from Sewage Contamination," *Yearbook of the United States Department of Agriculture, 1910* (Washington, D.C.: Government Printing Office, 1911), 372, 375–377.

170. Terra Ziporyn, *Disease in the Popular American Press: The Case of Diphtheria, Typhoid Fever, and Syphilis, 1870–1920*, Contributions in Medical Studies, no. 24 (New York: Greenwood Press, 1988), 75, 79–88, 90; George Soper, "The Work of a Chronic Typhoid Germ Distributor," *Journal of the American Medical Association* 48 (June 1907): 2019–2022, reprinted in Barbara G. Rosenkrantz, ed., *The Carrier State* (New York: Arno Press, 1977). A second paper by Soper, "Typhoid Mary," originally published in 1919, is also included in *The Carrier State*.

171. McWilliams, *The First 90 Years*, 21; Abram S. Berenson, ed., *The Control of Communicable Diseases in Man* (Washington, D.C.: American Public Health Association, 1985), 420.

172. *Yearbook of the United States Department of Agriculture, 1912* (Washington, D.C.: Government Printing Office, 1913), 54, 56; *Laws of Maryland*, 1914, chaps. 777, 818.

173. *Laws of Maryland*, 1920, chap. 180.

174. "Report of the Annapolis Sewer Commission to Governor Albert C. Ritchie and General Assembly, March 15, 1922," [MSA MdHR 811556].

175. *Laws of Maryland*, 1931, chap. 104; *Laws of Maryland*, 1933, chap. 2; *Evening Capital*, 28 May 1931.

176. *Laws of Maryland*, 1931, Resolution No. 9. John Harvey Kellogg, who developed cornflakes cereal with his brother, wrote

of the dangers of eating oysters, in *The Natural Diet of Man* (Battle Creek, Mich.: 1923).

177. See, for instance, Annapolis Metropolitan Sewerage District Map, Oct. 1931 [MSA SC 1427-1-19]; AALR, L. FSR 94, f. 242; *Evening Capital*, 12 Feb. 1932.

178. Abel Wolman and Arthur E. Gorman, *The Significance of Waterbourne Typhoid Fever Outbreaks, 1920–1930* (Baltimore: Williams & Wilkins, 1931), 60; *Evening Capital*, 13, 24 Feb. 1932.

179. AN MA (Proceedings) 1931–1935 [MSA M49-24], 11 Apr. 1932, 20 Sept. 1932, 7, 13 Feb. 1933; *Evening Capital*, 12 Oct., 23 Nov. 1932.

180. *Evening Capital*, 19 May 1933; AN MA (Proceedings) 1931–1935 [MSA M49-24] 23 Mar. 1934.

181. AN MA (Proceedings) 1931–1935 [MSA M49-24] 23, 30 Aug. 1934, 6 Oct. 1935; Louis N. Phipps "Report of the Mayor of Annapolis on the City's Business From July 1st, 1935 to June 30, 1936," AN MA (Reports and Minutes) 1894–1959 [MSA M102-2]; *Evening Capital*, 6, 7, 13 Feb. 1936.

182. William J. McWilliams diary, 5 Sept. 1936; *Evening Capital*, 7 Jan. 1937. Quotation from the newspaper.

183. Dennis Claude, communication to author, 3 Jan. 2004.

184. Hugh R. Riley, "Industrial Annapolis, This Year and Next" in the *Evening Capital*, 1 Jan. 1919; *Laws of Maryland*, 1920, chap. 686; *Evening Capital*, 21, 22, 23 June 1920.

185. *Laws of Maryland*, 1922, chap. 523; Baltimore *Sun*, 10 Apr. 1928; AN MA (Proceedings) 1931–1935 [MSA M49-24] 9 Oct. 1933.

186. Baltimore *Sun*, 22 Jan., 10 Oct. 1933; AN MA (Proceedings) 1931–1935 [MSA M49-24] 17 July, 9 Oct. 1933; *Evening Capital*, 8, 10, 13 Nov. 1933.

187. AN MA (Proceedings) 1936–1941 [MSA M49-25] 18 July 1935; *Evening Capital*, 5, 6, 7 Feb. 1935, 6 Feb. 1936; Louis N. Phipps, "Report of the Mayor of Annapolis of the City's Business for the Period From July 1, 1938 to Dec. 31, 1938," in AN MA (Reports and Minutes) 1894–1959 [MSA M102-2]; Baltimore *Sun*, 10, 11 Apr. 1938.

188. Barrett L. McKown, ed., *The Annapolis and Anne Arundel County Public Library: A History* (Annapolis: Public Library Association of Annapolis and Anne Arundel County, 1987), 10–14; *Evening Capital*, 6, 8, 10 Jan. 1921; AN MA (Proceedings) 1931–1935 [MSA M49-24], 8 Jan. 1934.

189. AN MA (Proceedings) 1931–1935 [MSA M49-24], 6 Aug. 1932; McKown, *Annapolis and Anne Arundel County Public Library*, 17; *Evening Capital*, 17 Feb. 1936.

190. *Evening Capital*, 15, 17 Feb. 1936. Rug quotation from the 15 Feb. paper; "convenient" from the 17 Feb. paper.

191. McKown, *Annapolis and Anne Arundel County Public Library*, 17–18; Brown, *The Other Annapolis*, 66; Stanton School Fourth Grade, "Discovering Our School Community" (typescript, 1953) 31–32. McKown dates the branch's opening to 1938.

192. *Evening Capital*, 16 Jan. 1934, 8 Jan. 1936; Bowen et al., *Murray Hill*, 29; Glenn Campbell, "Restoration without a Rockefeller," talk prepared for HAF lecture series and delivered 11 and 18 Oct. 2006.

193. William J. McWilliams diary, 6, 19 Dec. 1935, 2, 3 Jan. 1936.

194. *Evening Capital*, 8 Jan. 1936; William J. McWilliams diary, 7 Jan. 1936. "Very nice" from McWilliams, who attended the event with his wife and father. Other quotations from newspaper.

195. Campbell, "Restoration without a Rockefeller"; Arthur Trader, "Map Prepared for the Company for the Restoration of Colonial Annapolis," 22 Feb. 1936, Annapolis Department of Public Works; Elmer M. Jackson, Jr., *Annapolis* ([Annapolis], 1936–37).

196. Stevens, *Annapolis, Anne Arundel's Town* (see n. 60 above).

197. *Evening Capital*, 22 Apr. 1937; William J. McWilliams diary, 23 Apr. 1937; Philip Kopper, *Colonial Williamsburg* (New York: Harry N. Abrams, Publishers, in association with the Colonial Williamsburg Foundation, 1986), 190–191; "Charleston and Preservation" from www.nps.gov/nr/travel/charleston/preservation.htm (last accessed 6/11/10). McWilliams quotations from his diary; Chorley quote from "Charleston and Preservation."

198. William J. McWilliams diary, 19 Dec. 1935, 28 Jan. 1936.

199. Campbell, "Restoration without a Rockefeller"; Glenn Campbell email to author 24 July 2006; Lot Histories, Parcel 11, Sect. II.

200. *Evening Capital*, 13 Apr., 13, 14 May 1937; Radoff, *Buildings of the State*, 120, 130.

201. Radoff, *Buildings of the State*, 130–131; Orlando Ridout V "Economics as a Force in Historic Preservation: Annapolis, Origins of the Preservation Movement in Maryland's Capital City," lecture at Preservation Forum, Newport, R.I., Nov. 2000; *Evening Capital*, 3, 7, 8, 11, 12, 13, 15, 16 Oct. 1937. Nice's quotation quoted by Radoff, 131.

202. Ridout, "Economics as a Force in Historic Preservation"; Radoff, *Buildings of the State*, 131–132; Baltimore *Sun*, 8 Apr., 23 Sept. 1938; Baltimore *Evening Sun* 19 Feb. 1940, 18 July 1941. Hopkins quotation from Radoff, 133; *Sun* reporter's quotation from 18 July 1941 paper.

203. LeViness, *Road Building in Maryland*, 107–108, 112–113; Dennis Claude, communication to author, 3 Jan. 2004. First quotation from William Tell Claude's son Dennis; second quoted passage from LeViness, 108.

204. *Washington Post*, 28 Apr. 1940; *Evening Capital*, 29 Apr. 1940. Quotation from the *Post*.

205. *Laws of Maryland*, 1937, chap. 118; *Evening Capital*, 3, 9 July 1937, 8 July 1969; *Washington Post*, 20 June 1937; McIntire, *Annapolis Families*, 1: 342; Mary K. Root, "History of the Book Lovers Club, 1921–1946" (typescript [MSA SC 583]).

206. *Washington Post*, 20 June 1937; AA BE (Minutes) 1924–

1935 [MSA T2622-2], 149–150; *Evening Capital*, 22, 24, 25, 26 Mar. 1930; Baltimore *Sun*, 20 Mar. 1930.

207. *Evening Capital*, 3, 9, 10, 12, 13 July 1937. Quotation from 12 July paper.

208. Eleanor Roosevelt, "Women Must Learn to Play the Game as Men Do" *Redbook*, Apr. 1928, quoted in Blanche Wiesen Cook, *Eleanor Roosevelt: Volume One, 1884–1933* (New York: Viking, 1992), 367.

209. *Evening Capital*, 13 July 1937.

210. AN MA (Proceedings) 1931–1935 [MSA M49 24], 4 Feb. 1935; *Evening Capital*, 5 Feb. 1935, 16 Oct. 1937. (The Civitan Club report has not been found. It was apparently not made public.) By 1940 the chairman of the AHA was William F. Stromeyer, a graduate of Annapolis High School and St. John's College and former army officer and high school and college coach. (*Evening Capital*, 12 Aug. 1940; Good, *High School Heroes*, 52.)

211. *Evening Capital*, 12 Aug. 1940; Warren, *Then Again*, xxii; Brown, *The Other Annapolis*, 22–27.

212. *Evening Capital*, 12 Aug. 1940; Roxanna White, "How Annapolis is Solving a Ticklish Housing Problem," Baltimore *Sun*, 21 Jan. 1940.

213. *Evening Capital*, 12 Aug. 1940; Baltimore *Sunday Sun*, 25 Aug. 1940.

Chapter 8. A Threatened City, 1940 to 1960

1. Jack Sweetman, *The U.S. Naval Academy: An Illustrated History*, 2nd ed., rev. by Thomas J. Cutler (Annapolis: Naval Institute Press, 1995), 195–197; Robert W. McNitt, *Sailing at the U.S. Naval Academy: An Illustrated History* (Annapolis: Naval Institue Press, 1996), 73; Mame Warren, *Then Again . . . : Annapolis, 1900–1965* (Annapolis: Time Exposures, 1990), xxii. Quotation from Sweetman, 195.

2. Captain Richards T. Miller, USN (Ret.), "Sub Ships, Annapolis," *U. S. Naval Institute Naval History* 13 (May–June 1999): 51; Mike Miron, "Annapolis Yacht Yard: A History," (typescript compiled in July 1996 from a series of his articles in *The Publick Enterprise*, 15 Mar. 1996 to 1 July 1996), 9; Captain Richards T. Miller, USN (Ret.), communication to author, 3 Feb. 2005.

3. Miller, "Sub Ships, Annapolis," 52–55; Miron, "Annapolis Yacht Yard," 27–32. The AYY men who worked in Leningrad in 1944–1945 were "Hugh 'Connie' Clayton, a boatbuilder and engine man; George Helde, an electrician; and Charles Adler, a hull specialist" (Miron, 28).

4. *Maryland in World War II*, vol. 1, *Military Participation* (Baltimore: War Records Division, Maryland Historical Society, 1950), 229–230; www.goddardmemorial.org (last accessed 6/15/10).

5. *Maryland in World War II*, 1: 233.

6. Beatrice Martin Buchheister, communication to author, 27 July 2004; James W. Cheevers, "U.S. Naval Academy Buildings and Grounds," (typescript, 2004); *Maryland in World War II*,

1: 234. "Homoja" was derived from the last names of the officers who conceived the idea of using Quonset huts in this fashion: Admirals Frederick K. Horne, Ben Moreell, and Randall Jacobs (James Cheevers, email to author, 4 Oct. 2004).

7. Judith Robinson, Laura Bobeczko, Paul Lusignan, and Jeffrey Shrimpton, *Public Housing in the United States, 1933–1949: A Historic Context*, 2 vols. (U.S. Department of Housing and Urban Development, U.S. Department of the Interior, National Park Service, National Register of Historic Places, Oct. 1999) 2: 46; *Evening Capital*, 22, 27, 28 Aug. 1940; Baltimore *Sun*, 2 Nov. 1940; *Time*, 2 Sept. 1940; *Washington Post*, 2 Dec. 1940; J. Winfree Smith, *A Search for the Liberal College: The Beginning of the St. John's Program* (Annapolis: St. John's College Press, 1983), 67–68. Then assistant secretary of the navy, Franklin D. Roosevelt had received an honorary degree from St. John's in 1920, according to the obituary of Judge Robert Moss (*New York Times*, 20 Aug. 1940). I am indebted to Richard E. Israel for this clipping.

8. Robinson et al., *Public Housing in the United States*, 2: appendix 4; *Evening Capital*, 27 Nov., 5 Dec. 1941. The Federal Public Housing Administration transferred Bloomsbury Square to the Annapolis Housing Authority in 1951 (Robinson et al., 2: 94; AN MA [Resolutions] 1951–1970 [MSA M96-1], 1951–1955 folder, 13 Feb. 1951).

9. David Brashears, *Riding the Honeysuckle Horse: Growing Up in Eastport and Annapolis in the Forties and Early Fifties* (n.p.: Xlibris, 2005), 28; Helen Fisher Leitch, communication to author, 17 Mar. 2005.

10. William J. McWilliams diary, 7 Oct. 1941 (private collection); *Evening Capital*, 28 Nov. 1941; Miron, "Annapolis Yacht Yard," 17, 36; Bill Casey interview by Michael Miron, 4 Apr. 1996 (transcript in book files); Plats of Eastport Manor, dated May 1944 (Annapolis Department of Public Works) and Jan. 1945 (AA Co. Plat Book 18, 41). Quotation re Nelson from McWilliams diary; "trailer-homes" from *Evening Capital*, 28 Nov. 1941; "cardboard houses" from Casey interview.

11. See, for instance, Jane Wilson McWilliams and Carol Cushard Patterson, *Bay Ridge on the Chesapeake: An Illustrated History* (Annapolis: Brighton Editions, 1986), 147; Lorraine Wycherley Shaw, speaking at "Story Sunday," 49 West Coffeehouse, sponsored by Remember, Inc., 6 Mar. 2005; Will Mumford, email to author, 29 Mar. 2005.

12. Ann Jensen, "Remembering Hell Point," *Annapolitan* (Nov. 1989): 39–43, 62–66; Charles M. Potter and Charles M. Carlson, "Appraisal Report, Extension U. S. Naval Academy, Annapolis, Maryland," 25 June 1941 (copy courtesy Ann Jensen, Sands House, Annapolis). The name Hell Point is almost certainly a corruption of Hill's Point, location of the seventeenth-century home of Captain Richard Hill (Tony Lindauer, communication to author, 13 Sept. 2005; Ann Jensen and Jean Russo, communications to author 15 Sept. 2005).

13. Jensen, "Remembering Hell Point," 64–66; *Evening Capital*, 15, 16 Oct. 1941, 13 Mar. 1962; Warren, *Then Again*, 118–121; Cheevers, "U.S. Naval Academy Buildings and Grounds." Fisher's words from the newspaper, 15 Oct.

14. *Maryland in World War II*, vol. 3, *Home Front Volunteer Services* (Baltimore: War Records Division, Maryland Historical Society, 1958), 30–33, 55–57, 74–76, 189–190; *Evening Capital*, passim, 19 May 1942, for instance; Brashears, *Riding the Honeysuckle Horse*, 27–29; William J. McWilliams diary, 7, 8, 9 Dec. 1941. Quotation from McWilliams, 9 Dec. 1941.

15. William J. McWilliams diary, 22 Dec. 1941; Brashears, *Riding the Honeysuckle Horse*, 21; Shirley Hall Atwell, *Dean Street* (n.p.: privately published, 2004), 25; McWilliams and Patterson, *Bay Ridge on the Chesapeake*, 147.

16. Miron, "Annapolis Yacht Yard," 16; *Maryland in World War II*, 1: 227; Richard E. Israel, communication to author, 14 Aug. 2004. Mr. Israel related a conversation he had had with Marie Sims, who lived on Shaw Street and went to work in the Naval Academy kitchen during the war. She retired from the academy more than twenty-five years later.

17. Tom Worthington, communication to author, 20 Feb. 2004.

18. Roxanna White, "Farming at Bates High School," Baltimore *Sun*, 20 June 1943.

19. Beatrice Martin Buchheister, communication to author, 27 July 2004.

20. Analysis of Anne Arundel County list of war dead in *Maryland in World War II*, vol. 4, *Gold Star Honor Roll* (Baltimore: War Records Division, Maryland Historical Society, 1956), 29–39, and relevant entries in Robert Harry McIntire, *Annapolis, Maryland Families*, 2 vols. (Baltimore: Gateway Press, 1980, 1989); Rhonda L. Barrett, USNA Alumni Association, communication to author, 28 July 2004.

21. See, for instance, Jane E. Good, *High School Heroes: A Century of Education and Football at Annapolis High School, 1896–2003* (Bowie, Md.: Heritage Books, 2004), 128; *Evening Capital*, 14 Aug. 1945; Emily Peake, communication to author, 21 Sept. 2004. Good states that forty-two AHS graduates died in WWII, but because the school drew students from outside Annapolis, not all of these men can be counted in the city statistics.

22. *Evening Capital*, 5, 7, 8 May 1945; William J. McWilliams diary, 8 May 1945. Quotations from newspaper 8 May.

23. William J. McWilliams diary, 14 Aug. 1945; *Evening Capital*, 15, 16 Aug. 1945. Quotations from newspaper 15 Aug. The Japanese bell, which cracked under midshipmen's battering, was the one given to Commodore Matthew Perry by the regent of the Loo Choo Islands and presented to the academy by Perry's widow in 1858 (James W. Cheevers, communication to author, 7 Nov. 2007, also mentioned in Chapter 5).

24. *Evening Capital*, 5 Sept. 1945; Robert J. Schneller, *Breaking the Color Barrier: The U.S. Naval Academy's First Black Midshipmen and the Struggle for Racial Equality* (New York: New York University Press, 2005), 194. Quotation from the newspaper.

25. *Evening Capital*, 31 May 1951. Quotation from the memorial plaque.

26. *Evening Capital*, 4, 5, 12 June 1945; Baltimore *Sun*, 13 June 1945; Warren, *Then Again*, xxii. McCready quotation from the Baltimore *Evening Sun*, 12 June 1945, quoted in *Then Again*; "bone and sinew" quote from an editorial in the *Evening Capital*, 4 June 1945.

27. Smith, *Search for the Liberal College*, 67–79; Delavan R. Bowen et al., *Murray Hill in Annapolis, Md.: Centennial 1890-1990* (Annapolis: Murray Hill Residents Association, 1990), 33; *Washington Post*, 5, 20 June 1945. St. John's position quoted in Smith, 70.

28. Smith, *Search for the Liberal College*, 70–73; Baltimore *Sun*, 13 June 1945; *Washington Post*, 27 July 1945, 23 May 1946.

29. *Evening Capital*, 15, 17 Aug. 1945; *Washington Post*, 3 Oct. 1945, 23 May 1946. Quotation from *Evening Capital*, 17 Aug. 1945.

30. Sweetman, *The U.S. Naval Academy*, 202–203; William J. McWilliams diary, 10 Oct. 1945.

31. *Washington Post*, 3 Oct. 1945, 23 May 1946; *Evening Capital*, 28 May 1946; Sweetman, *The U.S. Naval Academy*, 203–204. Quotations from *Evening Capital*.

32. Smith, *Search for the Liberal College*, 79–87; Emily A. Murphy, *"A Complete and Generous Education": 300 Years of Liberal Arts, St. John's College, Annapolis* (Annapolis: St. John's College Press, 1996), 118–127. Smith points out that the new school never came about.

33. Jack Ladd Carr, interview by Mame Warren, 3 Feb. 1990, The Annapolis I Remember Collection [MSA SC 2140]; Murphy, *"A Complete and Generous Education,"* 123, 127, 137–138. Carr said that half his class, which entered in September 1946, were veterans.

34. See Appendix 1, Table 5, 1940 to 1980 census chart.

35. Plats for the named subdivisions are in Annapolis Department of Public Works files, also plats for Melrose Heights on Boucher Avenue (1947), Tower View on Tyler (1947), and the Annapolis Airport subdivision on Bay Ridge Avenue (1947), which became Victor Haven in 1953.

36. *Census of Population: 1950*, vol. 2, *Characteristics of the Population, Part 20, Maryland* (Washington, D.C.: U.S. Government Printing Office, 1952), 46.

37. Baltimore *Sun*, 1 Dec. 1946; *Evening Capital*, 25 Jan., 8 July 1947; Emily Peake, communication to author, 9 Dec. 2003. The new Spa Creek bridge had been in the works before the war (William J. McWilliams diary, 8 Oct. 1941; *Evening Capital*, 27 Nov. 1941). It opened on 9 July 1947 (*Evening Capital*, 9 July 1947).

38. Plat of McGuckian subdivision, on Chinquapin Round Road (1942), Gilmer Development, off Forest Drive (1947), and

Rosewood, on Forest Drive (1949) in Annapolis Department of Public Works files.

39. Annapolis Department of Public Works plat files.

40. For example, *Evening Capital*, 8 Aug. 1947; Ronnie Carr, communication to author, 23 Sept. 2004; Lorraine Wycherley Shaw, speaking at "Story Sunday," 49 West Coffeehouse, sponsored by Remember, Inc., 6 Mar. 2005.

41. *Washington Post*, 11 May 1944, 11 Feb. 1948, 17 Sept. 1949; *Evening Capital*, 22 Nov. 1961; Bowen, *Murray Hill*, 35. The term "expressway" from *Washington Post*, 30 Nov. 1950.

42. *Washington Post*, 17 June 1953, 16 June 1954, 22 Nov. 1961; *Evening Capital*, 21, 22 Nov. 1961; Rudolf Lamy, communication to author, 20 July 2005; Warren, *Then Again*, xxiii. Link quotation attributed to Governor Tawes in the *Evening Capital*, 21 Nov. 1961; worker's quotation from the 22 Nov. 1961 issue of the *Post*. John Hanson, of Charles County, was president of the Continental Congress 1781–1782 (*BDML* 1: 405).

43. Baltimore *Sun* (Arundel Edition), 7 Dec. 1983; Jean Russo, "West Street Power Station," (typescript, 1988) in HAF files; Michael P. Parker, *Presidents Hill: Building an Annapolis Neighborhood, 1664–2005* (Annapolis: Annapolis Publishing Company, 2005), 180; Warren, *Then Again*, xxii; *Evening Capital*, 19 July 1949.

44. Charles T. LeViness, *A History of Road Building in Maryland* (Baltimore: State Roads Commission of Maryland, 1958), 147–148; *Laws of Maryland*, 1950, chap. 105; J. Roger Fredland, "Transportation," in James C. Bradford, ed., *Anne Arundel County, Maryland: A Bicentennial History, 1649–1977* (Annapolis: Anne Arundel County and Annapolis Bicentennial Committee, 1977), 40–41; *Washington Post*, 16, 17 July 1952. Quotation from LeViness, 148.

45. Fredland, "Transportation," 40; author's personal knowledge; *Time*, 27 Aug. 1951.

46. *Evening Capital*, 7 May, 19 July 1949; Warren, *Then Again*, xxiii.

47. Catherine H. Avery and Jane W. McWilliams, *A Century of Caring: A History of Anne Arundel Medical Center, 1902–2002* (Annapolis: Anne Arundel Medical Center, 2002), 57, 61–74, 183.

48. *Evening Capital*, 19 July 1949; Philip L. Brown, *The Other Annapolis, 1900–1950* (2nd ed. privately published, 2000), 43–44; Avery and McWilliams, *A Century of Caring*, 64–65, 76; Jude Thomas May, *Achieving the American Dream: The Life of the Honorable Aris T. Allen, M.D.* (Baltimore: Gateway Press, 1990), 168–169 and passim.

49. Ronnie Carr, communication to author, 23 Sept. 2004; Avery and McWilliams, *A Century of Caring*, 71–78, 87.

50. Avery and McWilliams, *A Century of Caring*, 64–65, 76, 94.

51. Elmer M. Jackson, Jr., "Communications," in James C. Bradford, ed., *Anne Arundel County, Maryland: A Bicentennial History, 1649–1977* (Annapolis: Anne Arundel County and An-

napolis Bicentennial Committee, 1977), 56–57; *Evening Capital*, 22 Jan. 1947; Dave Hughes, "DCRTV.com," at www.dcrtv.com/ mb0801d.html (last accessed 6/14/10).

52. *Evening Capital*, 21 Jan. 1947; Eric L. Goldstein, "Surviving Together: African Americans and Jews in Annapolis, 1885–1968" (Younger Scholars Research Essay, National Endowment for the Humanities, 1991), 36; Anne Arundel County Field Book of Assessments, 1952–1955, District 2 [MSA CE 42,040], 1139; *Sunday Capital*, 12 Jan. 1997; *The Capital*, 8 July 1997.

53. Jackson, "Communications," 56–57; William J. McWilliams diary, 8 Mar. 1940, 3 Dec. 1941, 7 Nov. 1945, 15 Jan. 1948.

54. Warren, *Then Again*, 184; Walter A. Downing, *History of the Severn Boat Club and the Annapolis Yacht Club, 1886–1972* (Annapolis: privately published, [1972]), 20–23; Richard "Jud" Henderson, *Chesapeake Sails: A History of Yachting on the Bay* (Centreville, Md.: Tidewater Publishers, 1999), 37–38; William J. McWilliams diary, 12 Aug. 1937.

55. Warren, *Then Again*, xxii; Henderson, *Chesapeake Sails*, 38; Program, Annual Annapolis Yacht Club Regatta, 27, 28 Aug. 1937 (in book files); *Washington Post*, 18 Aug. 1940. The New London race became the Newport–Annapolis race, alternating years with the Newport–Bermuda Race. Since 1957, when the route was reversed, the race has been the Annapolis–Newport race (Henderson, *Chesapeake Sails*, 43, 48).

56. *Washington Post*, 18 Aug. 1974; Downing, *History of the Severn Boat Club*, 46; William J. McWilliams diary, 12 July 1946; Henderson, *Chesapeake Sails*, 42–48.

57. Sweetman, *The U.S. Naval Academy*, 193, 205–206; Henderson, *Chesapeake Sails*, 47, 231–234, 237–240.

58. Sarah Corbin Robert, "Report of the Three-hundredth Anniversary Celebration of Annapolis, Maryland, Prepared for the Annapolis Tercentenary Commission" (typescript with published materials inserted, Oct. 1949), passim; *Official Program, 300th Anniversary Celebration, May 22–27, 1949, Annapolis, Maryland* (a copy is included in Robert, "Report"). Quotation from Robert, 4.

59. *Evening Capital*, 11 May 1923; Robert L. Worden, email to author, 10 May 2003. Sarah Corbin Robert was principal author of the seventh edition of *Robert's Rules of Order*, published in 1970 (www.robertsrules.com).

60. Robert, "Report of the Three-hundredth Anniversary Celebration," 36–44, 173; DeMey's position found at www.usna .edu/USNABand/History/timeline/acmorris.htm (last assessed 5/26/08). Quotation from Robert, 40. Levitt went on to a career as a writer and director of episodes in television series such as *All in the Family*, *Three's Company*, and *Maude* (www.imdb.com/ name/nm0991368 [last accessed 6/14/10]).

61. Robert, "Report of the Three-hundredth Anniversary Celebration," 44–53. See also *Evening Capital* issues for the week of the celebration, 23–27 May 1949.

62. *Evening Capital*, 7, 22–23 June 1949.

63. *Evening Capital*, 6 Nov. 1940, 5 Nov. 1941, 4 Dec. 1950; Public Administration Service, "Report of the Survey of the Organization and Administration of the City of Annapolis," (unpublished typescript, 1941). Haley quote from *Evening Capital*, 6 Nov. 1940.

64. *Laws of Maryland*, 1945, chaps. 873, 937, 1054; *Evening Capital*, 5 May 1945.

65. *Evening Capital*, 1, 4, 5, 12 June 1945. Quotations from the 5 June newspaper.

66. Public Administration Service, "Report of the Organization of Annapolis"; *Evening Capital*, 5 Nov. 1941, 7 May 1949; *Laws of Maryland*, 1949, chap. 696. The PAS report at Enoch Pratt Free Library in Baltimore indicates that a separate report on annexation was done at the same time. The annexation report has not been found, but some of its conclusions are described in the *Evening Capital* for 5 November 1941. First quotations relating to the PAS study are from *Evening Capital*. The word "cumbersome" was attributed to the report; other quotations are the words of the newspaper. "Examine and study" quotation from 1949 law.

67. *Evening Capital*, 19 July 1949, 22 May, 18 Dec. 1950; McIntire, *Annapolis Families*, 1: 646; Mayor Roscoe C. Rowe, "A Report to Annapolis, Md.: A Report to the Counselor, Aldermen and Citizens of Annapolis, Maryland, for the Fiscal Year July 1, 1949–June 30, 1950," 9.

68. AN MA (Bylaws and Ordinances) 1949–1958 [MSA M51-6], Misc., 8; *Evening Capital*, 22 May 1950; *Laws of Maryland*, 1951, chap. 569. Quotation from ordinance.

69. *Evening Capital*, 7 Apr., 19 July 1949, 22, 23, 24 May 1950; Rowe, "A Report to Annapolis," 3; Ann Jensen, "Joseph Axelrod: How It All Got Started," *Annapolitan* (Mar. 1980): 17. Quotation from newspaper, 24 May 1950.

70. *Evening Capital*, 23 May (extra edition), 24 May 1950; Baltimore *Sun*, 24 May 1950.

71. AN MA (Bylaws and Ordinances) 1949–1958 [MSA M51-6], Misc., 11, Building, 1 (which gives official figures for population and assessed value); *Evening Capital*, 5 July, 30 Dec. 1950, 2, 9 Jan. 1951; Baltimore *Sun*, 24 May, Dec. 31, 1950; Rowe, "Report to Annapolis," 3; "Annapolis Digesting Newly Annexed Areas," *National Geographic Society Bulletin* (Mar. 1951). Quotation from the *Evening Capital*, 2 Jan. 1951. Among the adjustments necessitated by annexation were several name changes: Asbury Mission Church in Parole became Cecil Memorial Methodist; Taylor Street in downtown became Pinkney, and Division Street next to the Federal Cemetery became Taylor; Severn Avenue in West Annapolis became Melvin. Chestnut Street between Duke of Gloucester and Compromise was renamed in memory of Lt. Arthur L. Newman, USN, killed in World War II, and the road east from Old Solomon's Island Road (Route 2), parts of which were known by different names, was standardized as Forest Drive.

72. House of Delegates Bill No. 167, 1951 Bill Book, Department of Legislative Services; *Evening Capital*, 30 Nov., 1, 6, 11, 18 Dec. 1950. See also *Evening Capital*, 5 Nov. 1941 for William J. McWilliams's comments on "clearing politics from the 'money end' of the essential services in the administration." About this time, Anne Arundel County was considering a county manager and department system of government (*Evening Capital*, 12 July 1949). I am indebted to Richard E. Israel for a copy of House Bill No. 167.

73. Jean B. Russo, "City Officers, 1720–1989" (prepared for HAF, 1990); *Archives of Maryland*, new series, 1: 48, 338; *Evening Capital*, 20, 21, 23 June 1949. "Affable" from Memorandum for the Under Secretary of the Navy from Rear Admiral E. E. Herrmann, Superintendent of the Naval Postgraduate School, 21 March 1951, Records of the Superintendent, General Correspondence, General Records of the Superintendent, Post Graduate School, box 1, folder 9, USNA Archives, Nimitz Library, USNA.

74. *Evening Capital*, 5 Nov. 1941, 23 May 1950, 1 Jan. 1951. "Friends" from newspaper, 23 May 1950; second quotation from 1 Jan. 1951.

75. See, for example, *Evening Capital*, 8 Jan., 1, 13 Feb., 7 Mar. 1951; House of Delegates Bill No. 167, 1951 Bill Book, Department of Legislative Services; *Journal of Proceedings of the House of Delegates*, Jan. session 1951, 173, 672.

76. *Laws of Maryland*, 1951, chaps. 569, 493, 491. Over succeeding years, the city charter did pick up some of the revisions recommended in 1951. City employees were brought into a civil service system in 1962, for instance, and the Department of Public Works was established in 1970 (AN MA [Charter Amendments] 1955–1970 [MSA M95-1], fld. 1962; AN MA [Ordinances and Resolutions] 1968–1973 [MSA T3197-2] Misc., 20).

77. *Evening Capital*, 31 Jan. 1951; *Washington Post*, 30 Mar. 1951. Quotation from the *Post*. Although the *Post* cites a figure of $5 million in the Senate bill, the final appropriation was $3 million (*Washington Post*, 31 May 1952, 20 Aug. 1958; *Evening Capital*, 3 June 1952).

78. Memorandum for the Under Secretary of the Navy (see n. 74).

79. Records of the Superintendent, General Correspondence, General Records of the Superintendent, Post Graduate School, box 1, folder 8, and folder 9, USNA Archives, Nimitz Library, USNA; *Evening Capital*, 2, 10, 13 Mar. 1951. Quotations from the newspaper, 13 Mar. 1951. Naval schools in Newport and Anacostia were also scheduled to join a general line school already in Monterey.

80. *Evening Capital*, 1, 15 Mar. 1951; Memorandum for the Under Secretary of the Navy (see n. 73); Helen Fisher Leitch, communication to author, 17 Mar. 2005. "Shower" quotation from Helen Leitch; the other quotations from Admiral Herrmann's very frank memorandum.

81. *Evening Capital*, 27 Mar. 1951; News Release from USNA

and Severn River Command, 25 Oct. 1951, Records of the Superintendent, General Correspondence, General Records of the Superintendent, Post Graduate School, box 1, folder 10; Carroll Hynson, Jr., interview by Mame Warren, 22 Jan. 1990, The Annapolis I Remember Collection [MSA SC 2140].

82. *Laws of Maryland*, 1941, chap. 847; Good, *High School Heroes*, 146–147, 153; Richard B. Callahan, communication to author, 24 Oct. 2001; AN MA (Bylaws and Ordinances) 1949–1958 [MSA M51-6], Misc., 5; McIntire, *Annapolis Families* 1: 746, 755. Quotation from city ordinance cited.

83. Baltimore *Sun*, 10 Aug. 1947; Richard B. Callahan, communication to author, 24 Oct. 2001; AN MA (Bylaws and Ordinances) 1927–1949 [MSA M51-5], 403; *Evening Capital*, 9 July 1949, 5, 6 Dec. 1950. USO stands for United Service Organizations.

84. *Laws of Maryland*, 1953, chap. 326; *Evening Capital* 14, 18, 20 May 1953; AN MA (Bylaws and Ordinances) 1949–1958 [MSA M51-6], Taxes, 7; Richard B. Callahan, communication to author, 24 Oct. 2001; AN MA (Resolutions) 1951–1970 [MSA M96-1], folder 1951–1955, 28 July 1955; MSA (Municipal Charter Amendments) 1955–2001 [MSA T251-1], Annapolis Charter Amendments 1955–1960, 3 Sept. 1958. The 1953 property tax total does not include state, county, and school taxes. In 1951, those nonmunicipal taxes came to $1.51 per $100 (AN MA (Bylaws and Ordinances) 1949–1958 [MSA M51-6], Building, 1).

85. See Good, *High School Heroes*, 134 and passim; AA BE (Special Reports), "The $7,000,000 Bond Issue and the Need for Additional Funds" [1949] [MSA CM1172-4]; Appendix 1, Table 5, census chart for 1940–1980; Katherine M. Kibler, "Public Education," in James C. Bradford, ed., *Anne Arundel County, Maryland: A Bicentennial History, 1649–1977* (Annapolis: Anne Arundel County and Annapolis Bicentennial Committee, 1977), 120–121; AA BE (Minutes) 1955/06/29-1957/04/03 [MSA CM1391-8], 13 Feb. 1957; AA BE (Minutes) 1957/05/10-1959/03/24 [MSA CM1391-9], 5 Apr. 1958; George H. Callcott, *Maryland and America, 1940 to 1980* (Baltimore: Johns Hopkins University Press, 1985), 242; *Laws of Maryland* 1955, chap. 205, 1957, chap. 823; AA CCT (Grand Jury Papers) 1959–1966 [MSA C2137-3], April Term, 1959.

86. Annapolis Elementary School Fifth Grade, 1952–1953, "Discovering Our School Community" (1953), 95; AA BE (Special Reports), "The $7,000,000 Bond Issue and the Need for Additional Funds" [1949] [MSA CM1172-4], 12, 16; Philip L. Brown, *A Century of "Separate but Equal" Education in Anne Arundel County* (New York: Vantage Press, 1988), 39; Good, *High School Heroes*, 157–158; *Evening Capital*, 21 Oct. 1950. Green Street school quotation from "The $7,000,000 Bond Issue," 12; Bates quotation from Good, 157.

87. Germantown Elementary School Fifth Grade, 1952–53, "Discovering Our School Community" [1953], 45; AA BE (Special Reports), "The $7,000,000 Bond Issue and the Need for

Additional Funds" [1949] [MSA CM1172-4], 20; Richard B. Callahan, communication to author, 24 Oct. 2001.

88. Joy Bolton, comp., *A History of Eastport Elementary School, 1886–1993* (prepared by the Eastport Elementary School History Committee, Apr. 1993), 21; Elaine Hollidayoake, communication to author, 1 Apr. 2005; Parole School Fourth Grade, 1951–1952, "Discovering Our School Community," 11–12; Dedication Program, Parole School, 3 May 1953, in Rhonda Pindell Charles, comp., *Parole Week: Celebrating 130 Years of Spirit* (Walter S. Mills–Parole Elementary School Alumni and Friends Association, May 1995); AA BE (*Schools Meet the Challenge*) 1953–1968 [MSA T2623], vol. 3, no. 1 (Sept. 1955); AA BE (Minutes) 1955/06/29-1957/04/03 [MSA CM1391-8], 4 Jan. 1956.

89. Annapolis Roads, for instance, was enlarged in the 1950s, see Anne Arundel County Plat 1116 (Plat Book, 23, 33); Plat 1089 (Plat Book 23, 14), Plat 1128 (Plat Book 23, 38), Plat 1337 (Plat Book 26, 27).

90. See, for instance, AA CCT (Grand Jury Papers) 1959–1966 [MSA C2137-3], April Term, 1959, 1962, October Term, 1963, 1964, 1966; AA BE (Minutes) 1962/09/07-1965/06/17 [MSA CM1391-11], Apr. and May 1965; AN MA (Ordinances and Resolutions) 1973–1977 [MSA T3197-3] (Resolutions), 51 (8 July 1974).

91. Brown, *A Century of "Separate but Equal,"* 104–119; AA BE (*Schools Meet the Challenge*) 1953–1968 [MSA T2623], vol. 2, no. 9 (May 1955), vol. 3, no. 1 (Sept. 1955); AA BE (Special Reports) David S. Jenkins, "A History of the Colored Schools in Anne Arundel County, Maryland, and a Proposal for their Consolidation" [MSA CM1172-3]. Supreme Court decisions quoted in Brown: "inherently," 105 and "deliberate," 109.

92. AA BE (Minutes) 1955/06/29-1957/04/03 [MSA CM1391-8], 29 July 1955; AA BE (*Schools Meet the Challenge*) 1953–1968 [MSA T2623], vol. 3, no. 1 (Sept. 1955); Brown, *A Century of "Separate but Equal,"* 59–60; *Evening Capital*, 15 June 1955; *The Capital*, 1 Dec. 1994.

93. Brown, *A Century of "Separate but Equal,"* 116–119; AA BE (Minutes) 1955/06/29-1957/04/03 [MSA CM1391-8], 1 Mar. 1956; AA BE (Minutes) 1955/06/29-1957/04/03 [MSA CM1391-8], 2 May 1956; AA BE (*Schools Meet the Challenge*) 1953–1968 [MSA T2623], vol. 3, no. 9 (May 1956). Quotations are from the report in the board minutes and also in Brown, 117–119. The Eastport schools immediately dropped their racial designations and were distinguished by their addresses: Fifth Street and Third Street (Bolton, *A History of Eastport Elementary School*, 9, 22).

94. AA BE (Minutes) 1955/06/29-1957/04/03 [MSA CM1391-8], 2 May 1956; AA BE (*Schools Meet the Challenge*) 1953–1968 [MSA T2623], vol. 3, no. 9 (May 1956); AA BE (Minutes) 1962/09/07-1965/06/17 [MSA CM1391-11], 6 Feb. 1963. Quotation on feasibility from *Schools Meet the Challenge*; other quotations from the 1956 minutes.

95. Callcott, *Maryland and America*, 244–245. Quotation from 244.

96. Bolton, *A History of Eastport Elementary School*, 22–25; AA BE (Minutes) 1957/05/10-1959/03/24 [MSA CM1391-9], 9 Apr. 1958, 4 June 1958, 2 July 1958; AA CCT (Grand Jury Papers) 1959–1966 [MSA C2137-3], April Term, 1960, Oct. 1961; Sheila Finlayson, *Looking Back: Brown vs. Board of Education* (video, AACPS-TV, 2004), Elaine Hollidayoake, communication to author 1 Apr. 2005.

97. Brown, *A Century of "Separate but Equal,"* 122–123, 129–131; AA BE (Minutes) 1955/06/29-1957/04/03 [MSA CM1391-8], 7 Mar. 1956, 6 Mar. 1957; Good, *High School Heroes*, 38; AA BE (Minutes) 1957/05/10-1959/03/24 [MSA CM1391-9], 10, 16 May, 5 June 1957; May, *Achieving the American Dream*, 251–254. Quotations from May, 252.

98. Robert L. Worden, *St. Mary's Church in Annapolis, Maryland: A Sesquicentennial History, 1853–2003* (Annapolis: St. Mary's Parish, 2003), 136–140; AA CCT (Grand Jury Papers) 1959–1966 [MSA C2137-3], April Term, 1959, April Term 1960, October Term 1964. The Catholic convent, built in the early 1760s, had once been the home of Upton Scott (Marcia M. Miller and Orlando Ridout V, eds., *Architecture in Annapolis: A Field Guide* [Newark, Del.: Vernacular Architecture Forum; and Crownsville, Md.: Maryland Historical Trust Press, 1998], 147–150).

99. Worden, *St. Mary's Church*, 134–136.

100. Robert Worden, email to author, 16 July 2009.

101. Schneller, *Breaking the Color Barrier*, ix–x, 15–41, 85–106, 114–117, 193–194, 208–209, 222, 238–239, 254–255; Joseph "Zastrow" Simms, letter to the editor, *The Capital*, 22 May 2008.

102. Sweetman, *The U.S. Naval Academy*, 104, 207–208, 237–238. Quotation from 238.

103. Smith, *Search for the Liberal College*, 92–93; Jack Ladd Carr interview by Mame Warren, 3 Feb. 1990, The Annapolis I Remember Collection [MSA SC 2140]; Baltimore *Sun*, 11, 12 Nov. 2004. Dyer's quotations from the 11 Nov. *Sun*. The white veterans that Everett H. Wilson says served next to blacks in war (*Sun*, 11 Nov.) were veterans of the Korean War, 1950–1953, in which the U.S. Army first fielded racially mixed units (Juan Williams, *Thurgood Marshall, American Revolutionary* [New York: Time Books, 1998], 169–170; Jerry Hynson, communication to author, 5 May 2005. Hynson was recruited from Baltimore's Douglass High School and graduated from St. John's in 1959.)

104. Warren, *Then Again*, xxiii. See Murphy, *"A Complete and Generous Education,"* 138–147; *Evening Capital*, 27 Oct. 1950.

105. Sweetman, *The U.S. Naval Academy*, 238, 243–245.

106. AA BE (Minutes) 1957/05/10-1959/03/24 [MSA CM1391-9], 8 Nov. 1957, 5 Mar. 1958, 5 June 1959; AA BE (Minutes) 1959/05/06-1962/09/05 [MSA CM1391-10], 14 June 1961, 6 June 1962; Bowen et al., *Murray Hill*, 21; Greater Baltimore Committee Planning Council, *Comprehensive Master Plan: Annapolis, Maryland, 1962, A Report to the City of Annapolis Planning and Zoning Commission*, ([Baltimore]: The Council, 1962), 26–27; James Cheevers, communication to author, 7 Nov.

2007; "History of St. Paul Lutheran Church, 31 Roscoe Rowe Boulevard, Annapolis, Maryland 21401," (typescript, no date); William Hunter Shannon, "Tradition and Change in Non-Public Education," in James C. Bradford, ed., *Anne Arundel County, Maryland: A Bicentennial History, 1649–1977* (Annapolis: Anne Arundel County and Annapolis Bicentennial Committee, 1977), 132–133; Jayne Karsten, *Through Many Eyes: The Evolution of a School* (Annapolis: Key School, 2009), 2–10, 42–45.

107. *Evening Capital*, 5 Dec. 1950, 2 Mar. 1951, 15 May 1952; Sweetman, *The U.S. Naval Academy*, 208–209; Rear Admiral Wilson D. Leggett, Jr., USN, "The U.S. Engineering Experiment Station," *U.S. Naval Institute Proceedings* 77 (May 1951): 517; "U. S. Military Personnel Who Died from Hostile Action in the Korean War, 1950–1957," available online at www.archives.gov/research/korean-war/casualty-lists/md-by-town.html (last accessed 6/15/10).

108. Sweetman, *The U.S. Naval Academy*, 213.

109. Dean Johnson, "An Historical Look Back, Admiral Heights Since 1862," (typescript, c. 1988); *Washington Post*, 11 May 1944, 11 Feb. 1948; Sweetman, *The U.S. Naval Academy*, 213, 222; *Dedication: Navy-Marine Corps Memorial Stadium, September 26, 1959* (official program of the event).

110. House of Delegates Bill No. 167, 1951 Bill Book, Department of Legislative Services.

111. AN MA (Bylaws and Ordinances) 1949–1958 [MSA M51-6], Streets, 4; *Evening Capital*, 12 June, 15 Nov. 1951; *Annapolis, Maryland Con Survey Directory, 1949*; *Polk's Annapolis Maryland Directory*, 1954; Jefferson Cleveland Grinnalds Papers, #2167, Division of Rare and Manuscript Collections, Cornell University Library.

112. See, for instance, *Laws of Maryland*, 1927, chap. 705; 1933, chap. 599; 1935, chap. 448; Mary D. McHenry and Anne S. Agee, "Protective Zoning and Historic Preservation," in James C. Bradford, ed., *Anne Arundel County, Maryland: A Bicentennial History, 1647–1977* (Annapolis: Anne Arundel County and Annapolis Bicentennial Committee, 1977), 189–190; Beverley Jack, communication to author, 27 Apr. 2005; *Evening Capital*, 10, 12, 13, 14, 15, 16 Nov. 1951, 4 Jan. 1952.

113. AN MA (Proceedings) 1947–1953 [MSA M49-27], 279–281; McIntire, *Annapolis Families*, 1: 602; *Washington Post*, 12, 17 Jan. 1952.

114. *Evening Capital*, 5, 6 Mar. 1952; Murphy, *"A Complete and Generous Education,"* 74; McIntire, *Annapolis Families* 2: 110; AALR, L. JHH 649, f. 523. All quotations from the newspaper, 6 Mar.

115. *Evening Capital*, 4, 7, 8, 30 Apr. 1952. Quotation from 8 Apr. issue.

116. *Evening Capital*, 8, 11, 29 Apr. 1952. Cooperation quotation from 11 Apr. issue; Ellington's "teeth" remark quoted by Weigle in a speech to the Chamber of Commerce reported in the paper on 29 April.

117. *Evening Capital*, 8, 29 Apr. 1952; McIntire, *Annapolis*

Families, 1: 273; Charles E. Emery, *Photogenic Annapolis* (Baltimore: Camera, Inc., 1948); Gregory A. Stiverson, "Remarks on the Formation and Early Preservation Efforts of Historic Annapolis, Inc.," delivered at the St. Clair Wright Preservation Lecture Series, sponsored by the City of Annapolis, 27 Apr. 2004; Glenn E. Campbell, emails to author 6, 9 May 2005; Glenn E. Campbell, "Restoration without a Rockefeller," talk prepared for HAF lecture series and delivered 11 and 18 October 2006; "Proceedings and Minutes of The Company for the Restoration of Colonial Annapolis" in HAF archives. "Dormant" from *Evening Capital*, 8 Apr. 1952.

118. AN MA (Bylaws and Ordinances) 1949–1958 [MSA M51-6], Building, 17, 19; *Evening Capital*, 15 May, 10 June 1952; *Washington Post*, 16 May 1952. The 1952 historic district lay within Hanover and Wagner Streets, College Avenue, Church Circle, and Duke of Gloucester Street (Donna C. Hole, communication to the author, 19 July 1005).

119. According to Arthur A. Libby, the Board of Review did not even meet between 1957 and 1964 (Arthur Allen Libby, "The Politics of Historic Preservation: A Case Study of the Annapolis Historic District" [M.A. thesis, UMD, 1970], 65).

120. *Evening Capital*, 7 Mar. 1952, for instance; Miller and Ridout, *Architecture in Annapolis*, 57–59; "Lot Histories," Parcel 11, Sect. I.

121. *Evening Capital*, 7, 15 June 1955; Warren, *Then Again*, 179; Marion Warren, interview by author, 7 Nov. 2004; Stiverson, "Remarks on Historic Annapolis, Inc."; Harry W. Hill, *Maryland's Colonial Charm Portrayed in Silver* (Baltimore: Waverly Press, 1938); Sweetman, *The U.S. Naval Academy*, 208, 270; William Stamp, "Admiral's Country: Annapolis," Baltimore *Sunday Sun*, 13 Mar. 1957. Quotation from Stamp.

122. Historic Annapolis, Inc., *Tour Book* ([Annapolis]: Historic Annapolis, Inc., [c. 1953]); Stiverson, "Remarks on Historic Annapolis, Inc."; Ann Jensen, "The History and Evolution of Preservation in Annapolis," *Historic Preservation Forum* 13 (Fall 1998), 33–34; Anne Saint Clair Wright, *Historic Annapolis* (Annapolis: Barton-Gillet, 1959); "Annapolis Waterfront Square" in *Historic Preservation* 10, no. 2 (1958), 36–37.

123. Stiverson, "Remarks on Historic Annapolis, Inc."; Annapolis Roundtable Conference, 24–25 June 1960, sponsored by Historic Annapolis, Inc., National Trust for Historic Preservation, and Washington Center for Metropolitan Studies; *Washington Post*, 26 June 1960, 5 May 1962; Second Annapolis Roundtable Conference, 4–5 May 1962, sponsored by Historic Annapolis, Inc., and Washington Center for Metropolitan Studies; *Evening Capital*, 4, 5 May 1962. Kenneth Chorley, former president of Colonial Williamsburg, was a panelist at the 1960 conference.

124. *Washington Post*, 10, 11, 28 Mar. 1962; *Evening Capital*, 12, 14 Mar. 1962. Quotation from the *Post*, 28 Mar. 1962.

125. Sweetman, *The U.S. Naval Academy*, 215–219; *Washington Post*, 18, 28 Mar. 1962. Underwood quote from *Post*, 28 Mar.

126. *Evening Capital*, 12, 14 , 27 Mar. 1962; *Washington Post*, 15, 18 Apr. 1962. Quotations from the *Evening Capital*, 12 Mar. The editor of the *Evening Capital*, Elmer Jackson, was president of the Chamber of Commerce (*Washington Post*, 18 Apr. 1962).

127. *Washington Post*, 28 Apr. 1962; Alton Waldron, interview by Matthew Palus for HAF, 14 Apr. 2003.

128. Marion Warren, interview by author, 7 Nov. 2004.

129. *Evening Capital*, 12 Dec. 1962; Ann Jensen, communication to author, 12 Sept. 2005; Sweetman, *The U.S. Naval Academy*, 218–219; Jack Ladd Carr, interview by Matthew Palus for HAF, 15 Jan. 2003. By 1965, the academy extended across almost 330 acres of land, more than a third of which had been filled in along the shorelines of the Severn River and Spa and College Creeks (Chesapeake Division, Naval Facilities Engineering Command, *United States Naval Academy Master Plan Update* (c. 1989), 31 and figure 6.

130. Janice Hayes-Williams, African-American Legacy Tour, 11 May 2005; Jack Ladd Carr interview by Matthew Palus for HAF, 15 Jan. 2003; Charles Haste interview by Mame Warren, 13 Apr. 1990, The Annapolis I Remember Collection [MSA SC 2140]; Harvey Poe interview by Matthew Palus for HAF, 4 Nov. 2002.

131. May, *Achieving the American Dream*, 204–209; *Evening Capital*, 7 May 1949, 10 Nov. 1951, 18 Apr. 1952. Allen quotation from May, 209.

132. *Evening Capital*, 7 May 1949, 9, 18 July 1949, 18, 22, 25 Apr., 11 June, 2 July 1952; Charles Haste interview by Mame Warren, 13 Apr. 1990, The Annapolis I Remember Collection [MSA SC 2140].

133. *Washington Post*, 30 Mar. 1951, 31 May 1952, 20 Aug. 1958; Carl N. Everstine, *The General Assembly of Maryland, 1776–1850* (Charlottesville, Va.: Michie Co., 1982), 555; *Archives of Maryland*, new series, 1: 33–34; Callcott, *Maryland and America*, 107; Richard E. Israel, communication 10 Sept. 2007. "Budget session" from Everstine.

134. Jane Jacobs, *The Death and Life of Great American Cities* (1961; reprint, New York: Vintage Books, 1992), 270–271 and passim; *Evening Capital*, 7, 18, 22 Apr., 3 June 1952.

135. *Evening Capital*, 18 Apr. 1952; Greater Baltimore Committee Planning Council, *Comprehensive Master Plan: Annapolis*, 13–14; AN MA (Ordinances and Resolutions) 1959–1968 [MSA T3197-1] (Resolutions), 3, 9 Mar. 1959. Quotation from master plan, 13.

Chapter 9. The City Preserved, 1960 to 1975

1. C. Edward Hartman II, interview, 26 Feb. 2005; Richard O. "Rick" Franke, interview, 20 Jan. 2005. All quotations from Franke interview.

2. Stuart Walker and Robert Reeves, "Severn Sailing Association, 1954–2004" (1972); Stuart Walker, communication to author, 11 Nov. 2004.

3. Walter Downing, *A History of the Severn Boat Club and the*

Annapolis Yacht Club, 1886–1972, 20, 42–48; *Washington Post*, 18 Aug. 1974.

4. Baltimore *Sun* 4 June 1989; Joy Bolton, comp., *A History of Eastport Elementary School, 1886–1993* (prepared by the Eastport Elementary School History Committee, Apr. 1993), 24. In *The Capital*, 12 May 2009, members give the founding date as 1959.

5. Hartman interview, 26 Feb. 2005; Rolph Townshend, "Remarks at the presentation of Racing Trophies at the 2008 Alberg-30 Dinner," Solomons, Md., 12 Jan. 2008; Richard "Jud" Henderson, *Chesapeake Sails: A History of Yachting on the Bay* (Centreville, Md.: Tidewater Publishers, 1999), 190–194. "Easy for people" quote from Hartman; quote about Albergs from Henderson, 194.

6. Hartman interview, 26 Feb. 2005; Franke interview, 20 Jan. 2005.

7. Jane McWilliams, "Land and People," in James C. Bradford, ed., *Anne Arundel County, Maryland: A Bicentennial History, 1649–1977* (Annapolis: Anne Arundel County and Annapolis Bicentennial Committee, 1977), 8; *Evening Capital*, 4 Dec. 1965. Quotation from *Evening Capital*.

8. *Evening Capital*, 8 Apr. 1952; AN MA (Bylaws and Ordinances) [MSA M51-6], Streets, 21, 24, 32, 34, 35, 40, 67, 68, for instance.

9. AA BE (Minutes) [MSA CM1391-11], 6 Sept. 1964; *Washington Post*, 26 Feb. 1965, B7; *Evening Capital*, 10, 13, 14 June 1967; Baltimore *Sun*, Aug. 9, 1967. Quotation from *Washington Post*.

10. AA CCT Plat 1627 (Americana Annapolis Apartments); AA CCT Plat 1896 (Marine Terrace, later Severn House Apartments); AA CCT Plat 1770 (Admiral Farragut Apartments); Housing Authority of Annapolis website at www.hacamd.org/harbourhouse.html (last accessed 6/18/10); AA CCT Plat 1841 (Georgetown East).

11. AA CCT Plat 1981 (Tecumseh Townhouses); Peg Wallace, communication to author, 6 July 2002; Michael Miron, "Boatyards of Spa Creek: A One Hundred Year History," slide show given at Cultural Heritage Alliance Winter Lecture Series at Maryland Hall for the Creative Arts, 10 Mar. 1998; Tom Vesey, "Annapolis: A Port for Commuters" in *Washington Post*, 6 Oct. 1982; Joel McCord, "The Man Who Transformed Annapolis," Baltimore *Sun*, 14 May 1989; *The Capital*, 23, 26 Oct. 2001. Sadler quotation from Miron slide show.

12. Ann Jensen, *"For the Love of It": Fifty Years of Community Theatre in Annapolis* (Annapolis: Colonial Players of Annapolis, 1998), 3–5, 8–18, 25, 37, 42, 45; Beth Whaley, interview, 6 Oct. 2004.

13. Lorraine Wycherley Shaw and Beth Whaley, speaking at "Story Sunday," 49 West Coffeehouse, sponsored by Remember, Inc., 6 Mar. 2005; James Cheevers, email to author, 11 Nov. 2004; Charles Regis Michaud, "The Performing Arts," in James C. Bradford, ed., *Anne Arundel County, Maryland: A Bicenten-* *nial History, 1649–1977* (Annapolis: Anne Arundel County and Annapolis Bicentennial Committee, 1977), 149; Ned Criscimagna and Katherine Hilton, "A History of the Annapolis Chorale," online at www.annapolischorale.org/history.htm (last accessed 6/18/10). Shaw's words from "Story Sunday" talk.

14. Whaley, interview, 6 Oct. 2004.

15. Ibid.; Beth Whaley, Ellen Moyer, and others speaking at "Story Sunday," sponsored by Remember, Inc., 6 Mar. 2005; Ellen Moyer, interview by Matthew Palus for HAF, 14 Mar. 2003; Jensen, *For the Love of It*, 25, 33.

16. Joel B. Persels, communication to author, 26 May 2005; Maryland Federation of Art website at www.mdfedart.org (last accessed 6/18/10).

17. Michaud, "The Performing Arts," 150.

18. Ibid., 145; Jensen, *For the Love of It*, 25; Ellen Moyer, speaking at "Story Sunday," sponsored by Remember, Inc., 6 Mar. 2005; Beth Whaley, communications to author, 27 May, 2 June 2005; Hartman interview, 26 Feb. 2005.

19. Whaley interview, 6 Oct. 2004; Ellen Moyer and others speaking at "Story Sunday," sponsored by Remember, Inc., 6 Mar. 2005.

20. Matthew Palus, "'Preservation Was a Fight!': An Oral History of Historic Preservation and Progressive Reform in Annapolis City Government," paper presented at symposium *Looking Closer: 300 Years of Annapolis History*, St. John's College, 6–7 June 2008 (revised 8/20/08), 5–6.

21. Greater Baltimore Committee Planning Council (hereafter GBCPC), *Comprehensive Master Plan: Annapolis, Maryland, 1962, A Report to the City of Annapolis Planning and Zoning Commission.* ([Baltimore]: The Council, 1962); Mame Warren, *Then Again . . . : Annapolis, 1900–1965* (Annapolis: Time Exposures, 1990), 190–191. Quotation from the report, 96.

22. *Washington Post*, 26 June 1960; "Program Announcement" for Annapolis Roundtable Conference on Historic Preservation in Modern City Planning, 24–25 June 1960, Carvel Hall, Annapolis, in HAF archives; Robert D. Calkins, "Annapolis—Past and Future," paper presented at the conference, then published (Washington, D.C.: Washington Center for Metropolitan Studies, 1960). Kenneth Chorley, by then retired as president of Colonial Williamsburg, sat on the first panel at this conference ("Program Announcement"). I am grateful to Glenn Campbell of Historic Annapolis Foundation for the roundtable program.

23. Jack Ladd Carr, interview by Mame Warren, 3 Feb. 1990 [MSA SC 2140]; *Washington Post*, 13 Oct. 1960; GBCPC, *Reconnaissance Report /Old City of Annapolis*, (Baltimore: GBCPC for the Committee for Annapolis, 1960). "Rejuvenating the . . . city" from the *Washington Post*; "rich cultural . . . " and "Spa Road Bypass" from *Reconnaissance Report*, 1 and 12 respectively. David Wallace, director of the GBCPC, had been principal planner for Baltimore's Charles Center in the mid-1950s and was later credited with that city's Inner Harbor plan (*Philadelphia Inquirer*, 20 July 2004).

24. MSA (Municipal Charter Amendments and Annexations) [MSA T251] Annapolis Charter Amendments 1955–1960, 1 July 1959; AN MA (Charter Amendments) [MSA M95-1], folder 1962, 11 June 1962; AN MA (Ordinances and Resolutions) [MSA T3197-1] (Misc.), 13; City of Annapolis Planning and Zoning Commission, Minutes, 2/10/1960 to 12/5/1963, (City Planning and Zoning Office), vol. 1, 1–4.

25. GBCPC, *Comprehensive Master Plan*; AN MA (Ordinances and Resolutions, Original) [MSA T2389-4], Ordinance O-17-75 Comprehensive Plan for Zoning. "Historic heritage" quotation from introduction to master plan.

26. Carr interview by Warren, 3 Feb. 1990.

27. *Evening Capital*, 4 May 1962.

28. GBCPC, *Comprehensive Master Plan*, 55–56.

29. *Washington Post*, 17 May 1962, 2 Oct. 1964; *Evening Capital*, 12 Dec. 1962, 24 Nov. 1965. Quotation from *Evening Capital*, 24 Nov. 1965.

30. *Washington Post*, 9 Nov. 1960, 18 Oct. 1962, 22 Dec. 1963; Ann Jensen, "The History and Evolution of Preservation in Annapolis," *Historic Preservation Forum* 13 (Fall 1998): 34; *Laws of Maryland*, 1961, chap. 620; Barbara A. Perry, "Jacqueline Kennedy: First Lady of the New Frontier," speech at University of Virginia, 14 Dec. 2004, available online at www.researchchannel .org/prog/ (last accessed 6/18/10). "President's Park" quotation from the *Washington Post*, 18 Oct. 1962; Kennedy quotation from Perry.

31. Jack Sweetman, *The U.S. Naval Academy: An Illustrated History*, 2nd ed., rev. by Thomas J. Cutler (Annapolis: Naval Institute Press, 1995), 219; Vice Admiral Richard J. Naughton, "Academic Renovations — A Success Story," *Shipmate*, Mar. 2003, 6, 8.

32. *Evening Capital*, 28, 29 July 1964; Michael Everett et al., Annapolis Dock Area Historic Renewal (School of Architecture, Ohio University, 1965). The project was undertaken by third-year architecture students during the 1963–1964 school year.

33. Arthur Allen Libby, "The Politics of Historic Preservation: A Case Study of the Annapolis Historic District" (M.A. thesis, UMD, 1970), 64–72.

34. AN MA (Ordinances and Resolutions)[MSA T3197-1] (Misc.), 94; Libby, "The Politics of Historic Preservation," 65–67, 86–90.

35. John Carl Warnecke and Associates, "Annapolis — Yesterday, Today and Tomorrow," report dated 21 Mar. 1965 in HAF archives; *Evening Capital*, 22 Mar. 1965. All quotations from report.

36. *Laws of Maryland*, 1965, chap. 202.

37. Robert L. Spaeth, "Annapolis: Seat of Government," in James C. Bradford, ed., *Anne Arundel County, Maryland: A Bicentennial History, 1649-1977* (Annapolis: Anne Arundel County and Annapolis Bicentennial Committee, 1977), 202; Libby, "The Politics of Historic Preservation," 34–37, 90; *Washington Post*, 1 Dec. 1965; George H. Callcott, *Maryland and*

America, 1940 to 1980 (Baltimore: Johns Hopkins University Press, 1985), 190–191.

38. *Washington Post*, 19 May 1965; Roger W. Moyer, interview by Matthew Palus for HAF, 11 Oct. 2002; Roger W. Moyer, interview by Beth Whaley, 10 May 1990 [MSA SC 2140]; Jack Ladd Carr, interview by Matthew Palus for HAF, 15 Jan. 2003; Allen Freeman, "Preservation Pioneer St. Clair Wright Dies," *Historic Preservation News* 33 (Dec. 1993–Jan. 1994): 11–12. "Empty stores" quotation from Freeman; quotation re letter writing from 2002 interview with Moyer.

39. *Evening Capital*, 3, 5, 7 July 1965; Stewart L. Udall, "Remarks at Presentation of the Registered National Historic Landmark Plaque and Certificate for the Colonial Annapolis Historic District, Maryland, July 7, 1965," *City Designated National Landmark* (Brochure, [1965]). Quotation from Udall's "Remarks."

40. Russell Wright, *A Report on the Preservation and Restoration of the William Paca House, 186 Prince George Street, Annapolis, Maryland* (Annapolis: Historic Annapolis Foundation, 1999), 33–36.

41. William Grovermann, interview by Matthew Palus for HAF, 14 Oct. 2002; Alton (Red) Waldron, interview by Matthew Palus for HAF, 14 Apr. 2003; Wright, *Report on Paca House*, 37–39; *Laws of Maryland*, 1965, chap. 198.

42. *Evening Capital*, 3 July, 10 Aug., 15 Dec. 1965; Cherrill Anson, "Clash of Centuries," Baltimore *Sun* 12 Sept. 1965; AN MA (Ordinances and Resolutions) [MSA T3197-1] (Streets), 33; Donald Kimelman, "Annapolis Receives a Facelifting," Baltimore *Sun*, 12 Nov. 1972.

43. Roger Moyer interview by Palus, 11 Oct. 2002.

44. Libby, "The Politics of Historic Preservation," 50–52.

45. Ibid., 52–53; *Evening Capital*, 15 Feb., 14, 15 Mar. 1966. Mullikin's words from *Evening Capital*, 14 Mar.

46. Libby, "The Politics of Historic Preservation," 53–54; *Evening Capital*, 13 Sept. 1966. All quotations from council meeting 12 Sept. as quoted in the *Evening Capital*, 13 Sept.

47. *Evening Capital*, 14, 17 Mar. 1967; Libby, "The Politics of Historic Preservation," 55–56.

48. AN MA (Ordinances and Resolutions) [MSA T3197-1] (Building), 11; *Evening Capital*, 9 May 1967.

49. Libby, "The Politics of Historic Preservation," 56; *Evening Capital*, 3 July 1965, 3 Sept. 1966, 13 June 1967; GBCPC, Report, 1960.

50. Libby, "The Politics of Historic Preservation," 56–59; Marcia M. Miller and Orlando Ridout V, eds., *Architecture in Annapolis: A Field Guide* (Newark, Del.: Vernacular Architecture Forum; and Crownsville, Md.: Maryland Historical Trust, 1998), 120–122; Harvey Poe, interview by Matthew Palus for HAF, 4 Nov. 2002.

51. Harvey Poe, communication to author, 28 June 2008.

52. Libby, "The Politics of Historic Preservation," 56–59; Roger Moyer interview by Palus, 11 Oct. 2002; Pringle Symonds, "Creation of a Historic District in Annapolis," *Antiques* (Jan.

1977), 147. Quotations from Libby, 58, who references *Poe v. City of Annapolis*, AA CCT (Nov. 1967) in the files of the City Council.

53. Libby, "The Politics of Historic Preservation," 58–59. Hillman's words (on 59) were taken from an interview conducted by Libby 24 Jan. 1969.

54. Ibid., 59; Eric L. Goldstein, "Surviving Together: African Americans and Jews in Annapolis, 1885–1968" (Younger Scholars Research Essay, National Endowment for the Humanities, 1991), 42–43; biography of Robert Lamb Hart at www.harthowerton.com/leadership_bios.html?id=0 (last accessed 6/18/10); Robert Lamb Hart and William Strubee, *Annapolis* (Annapolis: printed for the Old Town Task Force, May 1967).

55. Harvey Poe, communication to author, 28 June 2008.

56. Libby, "The Politics of Historic Preservation," 59–60.

57. Ibid., 60–61, 108–114. Preservationists' concern quote from Libby, 61. "Hysteric Annapolis" from Libby, 114 (this author remembers it as "Hysterical Annapolis"). Hyatt quoted in Libby, 110.

58. Ginger Doyel, *Gone to Market: The Annapolis Market House, 1698–2005* (Annapolis: City of Annapolis, 2005), 90–96, 99–100; Libby, "The Politics of Historic Preservation," 77– 80; Warren, *Then Again*, xxiii; Baltimore *Sun*, Sept. 1, 1959; AN MA (Ordinances and Resolutions) [MSA T3197-1] (Resolutions), 24, (Misc.), 134; *Evening Capital*, 5 Apr., 13 June 1967. Quotation from the *Capital*, 5 Apr. 1967.

59. Jesse Nalle, interview by Matthew Palus for HAF, 1 Apr. 2003.

60. Libby, "The Politics of Historic Preservation," 79–80. Jackson quotation from Libby, quoting Jackson interview by Libby 20 Mar. 1969.

61. Doyel, *Gone to Market*, 100–102; *Washington Post*, 5 Dec. 1968. Quotations from the *Post*.

62. *Evening Capital*, 31 Aug. 1968.

63. Doyel, *Gone to Market*, 102–103, 106; Libby, "The Politics of Historic Preservation," 80–81, 97–99; *Washington Post*, 5 Dec. 1968; Baltimore *Sun*, Sept. 1, 1959; AN MA (Ordinances and Resolutions) [MSA T3197-2] (Resolutions), 4. Morris L. Radoff quoted most of the 1784 deed in his 1954 *Buildings of the State of Maryland at Annapolis* (Annapolis: Hall of Records Commission, 1954), 60–61, which St. Clair Wright no doubt consulted (Jean Russo, communication to author, Sept. 2005). The elected city counselor office was abolished in favor of an appointed city attorney as of 1945 (*Laws of Maryland*, 1943, chap. 691).

64. Emily Peake, communication to author, 13 Jan. 2004; Doyel, *Gone to Market*, 106–107; Libby, "The Politics of Historic Preservation," 98–99; *The Capital*, 20 June 2006. Merrill was the public face of the Capital-Gazette Press, which he bought with "several partners" (*The Capital*, 20 June 2006). See *The Capital*, 18 June 2006, for a full account of his career.

65. *Evening Capital*, 17 May 1969.

66. Harvey Poe, communication to author, 28 June 2008.

67. Callcott, *Maryland and America*, 191, 217, 227; *Evening Capital*, 14 Feb. 1966.

68. *Evening Capital*, 13, 14 May 1968, 21 May 1969; AN MA (Ordinances and Resolutions) [MSA T3197-1] (Misc.), 143. The 1968 redistricting was based on voter rolls. Reapportionment by population occurred after the 1970 census and was in place by the 1973 municipal election.

69. *Evening Capital*, 5, 9, 12, 17, 19, 20, 21 May 1969; Annapolis Supervisor of Elections (Election Returns) [MSA M101], 1969 folder, "Voters Registration 17 March 1969" and "Ward Summaries." Moyer's opponent was Republican Jean H. Losure.

70 *Evening Capital*, 5, 9, 12, 17, 19, 20, 21 May 1969.

71. Donna C. Hole, communication to author, 20 Sept. 2005; *Evening Capital*, 23 May 1969; Libby, "The Politics of Historic Preservation," 101–102. Quotations from Hole.

72. Doyel, *Gone to Market*, 106–107; *Evening Capital*, 17 July 1969, 2 Aug. 1972; Ginger Doyel, "The Market House, Part X" (unpublished typescript, 2004). I am indebted to Ginger Doyel for the reference to the 1968 Market House case in Circuit Court Equity Papers No. 19,173 [MSA T71-376].

73. Thelma Sparks, communications to author, 8 Oct. 2004, 17 May 2005.

74. Baltimore *Sun*, 11 Nov. 2004; interviews by Mame Warren with Carroll Hynson, Jr., (22 Jan. 1990), Charles Haste (13 Apr. 1990), and Mary Wiseman (30 Apr. 1990) [MSA SC 2140].

75. Wiseman, interview by Warren, 30 Apr. 1990.

76. Ibid.; Michael P. Parker, *Presidents Hill: Building an Annapolis Neighborhood, 1664–2005* (Annapolis: Annapolis Publishing Co., 2005), 123; Philip L. Brown, *The Other Annapolis, 1900–1950* (2nd ed. privately published, 2000), 124; Jean Russo, "Dr. Theodore H. Johnson, Jr.," typescript for HAF, 1993.

77. Parker, *Presidents Hill*, 123; Marita Carroll interview by Beth Whaley, 16 May 1990 [MSA SC 2140]; Marita Carroll, communication to author, 7 July 2005. Quotation from Carroll interview 16 May 1990.

78. Wiseman, interview by Warren, 30 Apr. 1990; Carroll, interview by Whaley, 16 May 1990; Parker, *Presidents Hill*, 123; Warren, *Then Again*, 197.

79. Robert J. Brugger, *Maryland, A Middle Temperament, 1634–1980* (Baltimore: Johns Hopkins University Press, 1988), 608–609; Callcott, *Maryland and America*, 154–156; *Evening Capital*, 11, 13, 15, 18, 20, 22, 24, 25, 27 Nov., 1, 2 Dec. 1961; Baltimore *Sun*, 12, 19, 26 Nov., 3 Dec. 1961; *Washington Post*, 12, 14, 20, 23, Nov., 3 Dec. 1961. Most of the students arrested in Annapolis ended up paying a $50 fine.

80. Wiseman, interview by Warren, 30 Apr. 1990; Carroll, interview by Whaley, 16 May 1990; *Evening Capital*, 4, 9, 11 Dec. 1961; *Washington Post*, 3, 5 Dec. 1961; Baltimore *Sun*, 5 Dec. 1961; Warren, *Then Again*, 197. Carroll quotation from her interview.

81. Norman Randall, interview, 10 Apr. 2001; *The Capital*, 24

June 1996; 22 Nov., 8 Dec. 2000. Major Norman Randall retired in 1996 with the department's second highest rank.

82. AN MA (Charter Amendments) [MSA M 95-1], folder 1962.

83. *AOMOL* 171: 239–241; *Washington Post*, 12 Mar. 1963; *Laws of Maryland*, 1963, chap. 227.

84. *Washington Post*, 28 Aug. 2003; "Civil Rights Act of 1964" at www.ourdocuments.gov/doc.php?doc=97 (last accessed 6/18/10); AA BE (Minutes) [MSA CM1391-11], 3 June, 1 July, 6 Sept., 1964, for example; AA CCT (Grand Jury Reports) [MSA C2137-3], October Term, 1964. Quotation from grand jury papers.

85. AA BE (Minutes) [MSA CM1391-11], 3 Feb., 14 Apr., 5 May 1965; Maryland State Advisory Committee to the United States Commission on Civil Rights, "Report on School Desegregation in 14 Eastern Shore and Southern Maryland Counties," Feb. 1966 (typescript), 4.

86. AA BE (Minutes) [MSA CM1391-12], 19 Aug., 21 Oct. 1965, 17 Mar. 1966; *Washington Post*, 28 Aug. 2003; Maryland Advisory Committee, "Report on School Desegregation," Feb. 1966, 4–5; Philip L. Brown, *A Century of "Separate but Equal" Education in Anne Arundel County* (New York: Vantage Press, 1988), 132–135. Quotation from school board minutes, 17 Mar. 1966.

87. *Evening Capital*, 6 Sept. 1966.

88. Brown, *A Century of "Separate but Equal" Education*, 136–138, 146–147; AA BE (Minutes) [MSA CM1391-12], 3 Aug. 1966; Randall, interview, 3 Apr. 2001; Errol Brown, in *Looking Back: Brown vs. Board of Education* (video, AACPS-TV, 2004); Jane E. Good, *High School Heroes: A Century of Education and Football at Annapolis High School, 1896–2003* (Bowie, Md.: Heritage Books, 2004), 169, 175–177, 179. Quotation from Brown, *A Century*, 138.

89. Personal communications to author from Errol Brown (20 Oct. 2004), Jonathan W. Greene (23 July 2005), and Kirby McKinney (26 July 2005). From 1965 until the new Annapolis Senior High School opened on Riva Road in 1979, Annapolis High comprised the 1932 high school (Maryland Hall), the 1953 junior high (Severn Hall), and a 1956 shop and music building later modified for physics and chemistry (Chesapeake Hall). Wiley H. Bates Junior High School on Smithville Street closed in 1981 and the name was transferred to the 1953 junior high building on Chase Street.

90. Brown, *A Century of "Separate but Equal" Education*, 140–142; AA BE (Minutes) [MSA CM1391-12], 21 July, 1 Sept., 5 Oct. 1966, 8 Feb., 16 Mar., 5 Apr., 3 May, 7, 15, 27 June, 5 July 1967, for instance; *Evening Capital*, 15, 16 Mar., 12, 14 June 1967, 6 May 1968; *The Capital*, 12 Nov. 1995.

91. Walter Cronkite biography at www.nationmaster.com/encyclopedia/Walter-Cronkite (last accessed 6/18/10); Callcott, *Maryland and America*, 68, 160–166; Maryland Office of Planning, Governor's Census 2000 Outreach and Promotion, "Census 2000" (brochure [2000]); Brugger, *Maryland, A Middle Temperament*, 618–619, 625–628.

92. Richard B. Callahan, communications to author, 24 Oct. 2001 and 20 July 2005; Janice Hayes-Williams, "Our Legacy," *The Capital*, 5 Apr. 2007; Roger Moyer, communication to author, 20 July 2005; Randall, interview, 3 Apr. 2001; Joseph "Zastrow" Simms, interview, 21 July 2005; *The Capital*, 16 May 1999.

93. *Evening Capital*, 5, 6, 8 Apr. 1968; Roger Moyer, communication to author, 20 July 2005; Randall, interview, 3 Apr. 2001; Simms, interview, 21 July 2005. Carmichael quotation from newspaper, 5 Apr.; Simms's words from interview. See also *Pip & Zastrow, An American Friendship*, a documentary by Victoria Bruce and Karin Hayes for Urcunina films (2006) (see http://pipandzastrow.com).

94. *Evening Capital*, 8, 9, 10 Apr. 1968; Roger Moyer, communication to author, 20 July 2005; Simms, interview, 21 July 2005. Quotations from Moyer.

95. *Evening Capital*, 9, 10, 11 Apr. 1968; Simms, interview, 21 July 2005; Roger Moyer, interview by Palus, 11 Oct. 2002. Simms's quotation from interview.

96. *Evening Capital*, 11 Apr. 1968; Roger Moyer, communication to author, 20 July 2005; Goldstein, "Surviving Together" 46–47; Simms, interview, 21 July 2005.

97. Simms, interview, 21 July 2005; National Register of Historic Places Nomination, Stanton Center, AA-864, Maryland Historical Trust; Kirby McKinney, communication to author, 26 July 2005; T. Norwood Brown to Project Area Committee, 11 Sept. 1969, in Mullin and Lonergan, "Part One Application for Loan and Grant, Town Center Urban Renewal Project, Annapolis, Maryland," Sect. R-217 (Annapolis Urban Renewal Authority, Mar. 1970).

98. Carl Snowden, communications to author, 23 and 24 June 2005. Quotation from 24 June.

99. *Evening Capital*, 23 Jan. 1968, 13 Feb. 1970; Carl Snowden, communications to author, 23, 24 June 2005; Brown, *A Century of "Separate but Equal" Education*, 142; Good, *High School Heroes*, 177–180; Randall interview, 3 Apr. 2001; Carlesa Finney, in *Looking Back, Brown vs. Board of Education* (video, AACPS-TV, 2004). The word "rampaged" was used by the 13 February *Evening Capital*, by Brown, 142, and by Good, 178. I am indebted to Norman Randall for a copy of the 13 February 1970 newspaper.

100. Sweetman, *The U.S. Naval Academy*, 224; Barry Mason Shambach, letter, 3 Sept. 1967, in Anne Marie Drew, ed., *Letters from Annapolis, Md.: Midshipmen Write Home, 1848–1969* (Annapolis: Naval Institute Press, 1998), 200–201.

101. *Evening Capital*, 14 Feb., 17 Dec. 1966, 4, 5 Nov. 1969.

102. Beatrice Martin Buchheister and Rida Dawson Aycock, communications to author, 11 Jan. 2005; Mame Warren, communication to author, 11 Jan. 2005.

103. Sweetman, *The U.S. Naval Academy*, 224.

104. Author's analysis of "Records on Military Personnel Who Died, Were Missing in Action or Prisoners of War as a Result of the Vietnam War," 1956–1998, RG 330, NARA; Robert Harry McIntire, *Annapolis, Maryland Families*, 2 vols. (Baltimore: Gateway Press, 1980, 1989), 1: 158, 189, 285, 543, 722.

105. *Washington Post*, 9 Nov. 1960; *Laws of Maryland*, 1961, chap. 755; GBCPC, *Comprehensive Master Plan*, 13–14, 20–21, 84–85, 122–124.

106. AN MA (Ordinances and Resolutions) [MSA T3197-1] (Misc.), 58, 11 Mar. 1963; Spaeth, "Annapolis: Seat of Government," 198–199; *Evening Capital*, 28 July 1964; McIntire, *Annapolis Families* 1: 530, 424, 469, 270, 730. Quotations from ordinance.

107. GBCPC, *Comprehensive Master Plan*, 20–21.

108. Ed Bosanko, *Buckets to Pumpers: Firefighting in the City of Annapolis, Maryland, 1755–1992* (Baltimore: John D. Lucas Printing Co., 1993), 53; *Evening Capital*, 1 Dec. 1950; Haste, interview by Warren, 13 Apr. 1990; *Polk's Annapolis City Directory, 1959*, 7; Goldstein, "Surviving Together," 37–39, 48–49.

109. *Washington Post*, 9 Nov. 1960; *Laws of Maryland*, 1961, chap. 755; Historic Annapolis, "Data supplied to J. C. Warnecke & Associates, 23 Oct. 1964," Report 3, p. 2, in HAF archives; AN MA (Ordinances and Resolutions) [MSA T3197-1] (Misc.), 58; *Evening Capital*, 28 July 1964; Spaeth, "Annapolis: Seat of Government," 198–199. Quotation re Area One from 1963 city ordinance.

110. *Evening Capital*, 28 July 1964.

111. *Evening Capital*, 31 Jan. 1951, 16 Sept. 1965, 11 Apr. 1967, 10 June 1967; *Washington Post*, 16 Sept. 1967; AN MA (Charter Amendments) [MSA M 95-1], folder 1964, 17 July 1961. Quotation re Arundel Center from *Evening Capital*, 16 Sept. 1965.

112. Janice Hayes-Williams, "Our Legacy," *The Capital*, 28 July 2005.

113. Spaeth, "Annapolis: Seat of Government," 195; *Evening Capital*, 16 Mar. 1967. Quotation from the newspaper.

114. *Evening Capital*, 11 Apr. 1967, 29 Jan. 1970; City Planning Associates, Inc., "Town Center Urban Renewal Area, Land Use and Project Area Conditions Map," prepared for Annapolis Urban Renewal Authority 19 May 1966 (copy in HAF archives); AN MA (Ordinances and Resolutions) [MSA T3197-1] (Misc.), 104, 11 Oct. 1965; St. Philip's Episcopal Church archives; Marvell Parker, communication to author, 21 July 2005; *Polk's Annapolis City Directory* for 1959 and 1969.

115. Minutes of the Project Area Committee, 16 Sept. 1969, in Mullin and Lonergan, "Part One Application," Mar. 1970.

116. *Evening Capital*, 11 Sept. 1966, AN MA (Contracts and Agreements) [MSA T2390-12], box 18, 12 Oct. 1970. Ortland quote from the newspaper.

117. *Evening Capital*, 14, 15 Feb., 15 Mar., 11 Sept. 1966.

118. *Evening Capital*, 11 Jan. 1968, 12 May 1969, 29 Sept. 1970; AN MA (Ordinances and Resolutions)[MSA T3197-1] (Resolutions), 19, 12 Sept. 1966; Minutes of the Project Area Committee, 22 Aug., 16 Sept., 13 Nov. 1969, in Mullin and Lonergan, "Part One Application," Mar. 1970). Quotations from Project Area Committee minutes 16 Sept. 1969. John T. Chambers replaced Brown on the council (*Evening Capital*, 12 May 1969).

119. *Evening Capital*, 30 Jan. 1970; Minutes of the Project Area Committee, 24 Feb. 1970, in Mullin and Lonergan, "Part One Application," Mar. 1970. Quotes taken from newspaper.

120. Moyer, communication to author, 20 July 2005.

121. *Evening Capital*, 14, 15 Feb. 1966, 15 May 1968, 29 Sept. 1970. Quotation from 15 May 1968 issue.

122. AN MA (Ordinances and Resolutions) [MSA T3197-2] (Resolutions), 1, 12 June 1968; Housing Authority of the City of Annapolis website, www.hacamd.org/harbourhouse.html (last accessed 6/19/10); Marlene Shevenell, communication to author, 3 Nov. 2004.

123. *Evening Capital*, 29 Sept. 1970; AA CCT Plat 1979 (Newtown Nineteen); Murphy and Williams and Annapolis Office of Planning and Zoning, *Housing Study, Annapolis Maryland* (Nov. 1972), (Records of the Department of Housing and Urban Development, RG 207); Office of the Assistant Secretary for Community Planning and Development; Final Grant Reports, 1951–1981; #035300 [box 2626], NARA II), 92–94, table 27; AA CCT Plats 2032 (Newtown Nineteen), 2192 (Annapolis Woods [now Bay Ridge Gardens]), 2227 (Newtowne Twenty-Two), 2262 (Bywater Estates), 2396 (Bywater Estates, Sect. 2); Nalle interview, by Palus, 1 Apr. 2003; Roger Moyer, communication to author, 20 July 2005. All quotations from Murphy and Williams, 92.

124. *Evening Capital*, 5 Nov. 1974; "Housing Authority of the City of Annapolis," from city files, Jan. 2005; Housing Authority of City of Annapolis, "Communities," online at www.hacamd.org (last accessed 6/19/10).

125. Murphy and Williams and Annapolis Office of Planning and Zoning, *Housing Study, Annapolis Maryland* (Nov. 1972), 104–105, 121–125. "Filtering" from 104, 125; housing value quotation from 122.

126. Mrs. J.M.P. Wright to director, Office of Urban Technology and Research, letter dated 30 June 1969, and Mrs. Wright to Carl Feiss, memorandum re meeting 4 Aug. 1970, in HAF Archives; Baltimore *Sun*, 13 Nov. 1972. Design quotation from memorandum.

127. David Riley, "Annapolis: White Sails in the Sunset," *Washington Post Magazine*, 3 June 1979; Murphy and Williams and Annapolis Office of Planning and Zoning, *Housing Study, Annapolis Maryland* (Nov. 1972), 122, 149–150. "Market forces" is a quotation from Riley; quotation re economics from 1972 housing study, 150.

128. Baltimore *Sun*, 13 Nov. 1972.

129. Grovermann, interview by Palus, 14 Oct. 2002.

130. Riley, "Annapolis: White Sails in the Sunset."

131. HAF website, www.annapolis.org (last accessed 6/19/10); Orlando Ridout IV, interview by Matthew Palus for HAF, 18 Dec. 2002; Grovermann, interview by Palus, 14 Oct. 2002.

132. AN MA (Ordinances and Resolutions) [MSA T3197-3] (Resolutions), 71, 9 Dec. 1974; *Evening Capital*, 13, 19 Jan., 19 June 1976; Patricia Barland, communication to author, 27 June 2005; Spaeth, "Annapolis: Seat of Government," 199; Riley, "Annapolis: White Sails in the Sunset."

133. Patricia Barland, communication to author, 27 June 2005; Roger Moyer, interview by Palus, 11 Oct. 2002.

134. Michael J. Clark, "Annapolis," *Sunday Sun Magazine*, 10 Oct. 1982.

135. M. Turner et al., Department of Housing and Urban Development, Office of Regional Fair Housing and Equal Opportunity, Title VIII Systemic Discrimination Unit, "Final Investigation Report," Exhibit 8A, R.O. File No. 03-82-11-085 (200), Anne Arundel Coalition of Tenants v. Annapolis Housing Authority, dated 15 Nov. 1982 (copy courtesy of Fredric J. Muir); Fredric J. Muir, "Annapolis on the Bay: Camelot or Crisis? Housing and Community by Race and Population: 1950–1988," (typescript dated 4 May 1989); Carl Snowden, communications to author, 23, 24 June 2005; Haste, interview by Warren, 13 Apr. 1990; Parker, *Presidents Hill*, 125–126; Riley, "Annapolis: White Sails in the Sunset."

136. Planning and Zoning Commission of the City of Annapolis, "Comprehensive Plan, Annapolis, Maryland," 1975 (Annapolis Planning and Zoning Office and MSA T2389-4); Riley, "Annapolis: White Sails in the Sunset"; Baltimore *Sun*, 23 Apr. 1978; Danielle Matland, communication to author, 2 Aug. 2005; Lillian McGowan, communication to author, 29 Aug. 2005; Roger Moyer, interview by Palus, 11 Oct. 2002; Patricia Barland, communication to author, 27 June 2005. Quotation re isolated housing from "Comprehensive Plan," 107; Moyer's words from interview by Palus.

137. Jean B. Russo, "City Officers, 1720–1989" (prepared for HAF, 1990); AN MA (Ordinances and Resolutions) [MSA T3197-2] (Misc.), 54, 13 Dec. 1971; *Evening Capital*, 14 Sept. 1965, 9, 12 May 1969, 13, 14 Dec. 1971. "One-man, one-vote" from *Evening Capital*, 14 Sept. 1965; "present tradition" from newspaper, 14 Dec. 1971. Redistricting after the 1980 census was challenged in court, with the result that the City Council redrew ward lines to create two wards with black majorities of more than 70 percent. Carl Snowden, a principal in the lawsuit, was elected from the redrawn Ward 5 in 1985 (Baltimore *Sun*, 12 Dec. 1985; Carl Snowden, communications to author, 23, 24 June 2005).

138. Muir, "Annapolis on the Bay"; Carl Snowden, communications to author, 23, 24 June 2005; Janice Hayes-Williams, communication to author, 8 July 2005; Carr, interview by Palus, 15 Jan. 2003.

139. Muir, "Annapolis on the Bay," 18.

140. Joe O'Connor communication to author, 28 June 2005; Janice Hayes-Williams, "Our Legacy," *The Capital*, 28 July 2005.

141. Franke, interview, 20 Jan. 2005; AN MA (Ordinances and Resolutions) [MSA T3197-2] (Misc.), 18 (8 June 1970); *Evening Capital*, 2, 5 Oct. 1970; *The Capital*, 31 July 2005. Quotation from Franke interview.

142. Franke, interview, 20 Jan. 2005; AN MA (Ordinances and Resolutions) [MSA T3197-2] (Misc.), 44 (12 July 1971); *Evening Capital*, 12 Oct. 1972; *The Capital*, 31 July 2005; Norma Grovermann, interview by Matthew Palus for HAF, 16 Oct. 2002; *New York Times*, 6 Oct. 1972.

143. Murphy and Williams and Annapolis Office of Planning and Zoning, *Housing Study, Annapolis Maryland* (Nov. 1972), 121–133; AN MA (Ordinances and Resolutions) [MSA T3197-2] (Resolutions), 40, 102. "Intolerable delays" from council resolution 8 May 1972, 102.

144. AN MA (Ordinances and Resolutions) [MSA T3197-2] (Resolutions), 45; AA CCT Plat 2658 (Saltair).

145. Bernard Kalnoske, Sharon Cyrus, Gary Simpson, and Zora B. Lykken, "Annapolis Police Department, History, 1708–1997" (typescript [1997], in book files), 5–7; *Evening Capital*, 17 Nov. 1960, 9 Nov. 1965; *The Capital*, 10 May 2004. *Evening Capital*, 17 Nov. 1960 gives the number of police officers as of that date as forty-three.

146. Kalnoske et al., "Annapolis Police Department," 7; MSA (Municipal Charter Amendments and Annexations) [MSA T251], Annapolis Charter Amendments 1960–1987, 2 Apr. 1974. Quotation from Kalnoske, 7.

147. Bosanko, *From Buckets to Pumpers*, 57, 60–61; AN MA (Bylaws and Ordinances) [MSA M51-6], Fire, 21; Charles Cadle, communication to author, 15 Aug. 2005.

148. Michael P. Parker, communication to author, 6 Aug. 2007.

149. Bosanko, *From Buckets to Pumpers*, 61–62; *Evening Capital*, 11 Mar. 1971; Charles H. Steele, communication to author, 12 Aug. 2005.

150. Bosanko, *From Buckets to Pumpers*, 59–61; Steele, communication to author, 12 Aug. 2005; Charles Cadle, communication to author, 15 Aug. 2005.

151. Bosanko, *From Buckets to Pumpers*, 60, 63–66; Steele, communication to author, 12 Aug. 2005.

152. *Evening Capital*, 25 Feb. 1972, 13 Dec. 1974; Steele, communication to author, 12 Aug. 2005.

153. Michael Parker believes that the election of Republican former sheriff, Joe Alton, as state senator in 1962 was a harbinger of the end of the Phipps machine (Parker, communication to author 6 Aug. 2007).

154. Roger Moyer, interview by Palus, 11 Oct. 2002; *Evening Capital*, 5, 6, 9, 12, 13, 19, 21 May 1969; AN MA (Ordinances and Resolutions) [MSA T3197-2] (Misc.), 20.

155. AN MA 1968–1973 (Ordinances and Resolutions) [MSA

T3197-2] (Misc.), 50, (Resolutions), 100; Spaeth, "Annapolis: Seat of Government," 198; Stephen Burgenski, communication to author, 11 Aug. 2005.

156. AN MA (Ordinances and Resolutions) [MSA T3197-2] (Misc.), 74, 87; *Evening Capital*, 15 May, 12 June 1973.

157. AN MA (Ordinances and Resolutions) [MSA T3197-2] (Misc.), 54; *Evening Capital*, 13 Dec. 1971. Quote from newspaper.

158. *Evening Capital*, 13, 14 Dec. 1971. Spaeth's comment from the 14 Dec. issue.

159. *Evening Capital*, 26 Feb., 15 May 1973; McIntire, *Annapolis Families*, 1: 744. Not until another redistricting in 1985 did the city regain a second black aldermen.

160. *Evening Capital*, 15 May, 12 June 1973; *The Capital*, 24 Mar. 2005; *Washington Post*, 26 Mar. 2005. Neustadt quote from *Evening Capital*, 12 June 1973.

161. *Evening Capital*, 12 June 1951, 6, 7 May 1969, 10 Dec. 1970, 11 Mar. 1971, 24, 25 Feb. 1972; AN MA (Bylaws and Ordinances) [MSA M51-6], Streets, 5, 27, 70; AN MA (Ordinances and Resolutions) [MSA T3197-2] (Misc.), 55, 60, 61, 62, 83, (Resolutions) 94, 113; Annapolis Planning and Zoning Commission, *Downtown Parking in Annapolis* (Annapolis: Mar. 1969); AN MA (Contracts and Agreements) [MSA T2390-12] Agreement between city and James H. Wilson, 6 Nov. 1972; Roger Moyer, interview by Palus, 11 Oct. 2002. Moyer quotation from interview.

162. Philip L. Brown, *The Mount Moriah Story, 1875–1973: The Mount Moriah African Methodist Episcopal Church of Annapolis* (Annapolis: privately published, 2000), 47–50; AN MA (Ordinances and Resolutions) [MSA T3197-2] (Misc.), 48; Delavan R. Bowen et al., *Murray Hill in Annapolis, Md.: Centennial 1890–1990* (Annapolis: Murray Hill Residents Association, 1990), 43. See map of historic districts at end of color illustrations gallery.

163. Pringle Hart Symonds, "Creation of a Historic District in Annapolis," *Antiques* (Jan. 1977): 147; Jean Russo, "A Peek at the Past: Mt. Moriah National Historic Landmark," *Publick Enterprise* (Jan. [1st Half] 1995); AN MA (Ordinances and Resolutions) [MSA T3197-2] (Resolutions), 115, [MSA T3197-3] (Resolutions), 5; *Evening Capital*, 15, 16 May 1973.

164. Pringle Hart Symonds, communication to author, 20 May 2006.

165. Joni L. Jones, "The Banneker-Douglass Museum: Background and Potential," lecture at HAF black history month seminar, Bates Legacy Center, 7 Feb. 2009.

166. *Mayor and Aldermen of the City of Annapolis et al. v. Anne Arundel County, Maryland et al.*, 271 Md. 265 (September term 1973); Symonds, "Creation of a Historic District in Annapolis," 147; Russo, "A Peek at the Past." Court's quotation from 217 Md. 265, p. 297. Mt. Moriah became the Banneker-Douglass Museum of African-American History in 1984 (Russo, "A Peek at the Past").

167. Brown, *The Mount Moriah Story*, 49; Julie Belding and Florence Haney, *A Centennial History, College Avenue/Heritage Baptist Church, 1903–2003* (Annapolis: Heritage Baptist Church [2003]), 33–34; Isabel Shipley Cunningham, *Calvary United Methodist Church, Annapolis, Maryland: The First Two Centuries* (Edgewater, Md.: Lith-O-Press, 1984), 71–73.

168. *The Capital*, 15 May 2005; Marvell Parker, communication to author, 21 July 2005.

169. Lillian McGowan, communication to author, 29 Aug. 2005.

170. Lillian Kipp, "St. Martin's (Francis Street) Remembered" (typescript, Feb. 1998), 8; "St. Martin's Evangelical Lutheran Church" (brochure, 2000); Eric L. Goldstein, "Our History," in *Looking Back . . . Moving Forward, Congregation Kneseth Israel: From Strength to Strength, 1906–1996* (program for ninetieth anniversary of Congregation Kneseth Israel, 10 Nov. 1996).

171. Judy Graham, communication to author, 28 Oct. 2002; Willard LaRose, "History of Evangelical Presbyterian Church in Annapolis," (typescript, 1985); "The History of the Holy Temple Cathedral," (typescript, undated). Both in book files.

172. Barrett L. McKown, ed., *The Annapolis and Anne Arundel County Public Library: A History* (Annapolis: Public Library Association of Annapolis and Anne Arundel County, 1987), 25, 36; *Evening Capital*, 8, 9 Nov. 1965; Richard Wade, "Government Services: A Barometer of Growth," in James C. Bradford, ed., *Anne Arundel County, Maryland: A Bicentennial History, 1649–1977* (Annapolis: Anne Arundel County and Annapolis Bicentennial Committee, 1977), 224. Jackson quotation from *Evening Capital*, 9 Nov. 1965.

173. AN MA (Ordinances and Resolutions) [MSA T3197-2] (Resolutions), 91; *Evening Capital*, 29 Feb. 1972.

174. Roger White, "Circle Theater," *Anne Arundel County History Notes* 26 (Jan. 1995): 9; Robert K. Headley, "Early Movies in Annapolis, 1901–1922," *Anne Arundel County History Notes* 34 (July 2003): 8.

175. Miron, "Boatyards of Spa Creek"; Ben A. Franklin, "Annapolis Boat Yard Slides Into History" *New York Times*, 11 July 1974. Quotation from Franklin article.

176. AN MA (Ordinances and Resolutions) [MSA T3197-3] (Resolutions), 34, 35; Franklin, "Annapolis Boat Yard Slides Into History"; *Evening Capital*, 9 July, 5 Nov. 1974. Quotation is of Frank Pierce Young in *Evening Capital*, 9 July 1974.

177. *Washington Post*, 16 Sept. 1967; Wallace, McHarg, Roberts and Todd, "Development Plan for State Facilities, Annapolis, Maryland: A Study for the State of Maryland" (4 Sept. 1968) [MSA MdHR 20074106]. Quotation from the *Post*.

178. *Washington Post*, 13 Apr. 1972. The replacement building is today the Legislative Services Building, facing Lawyers' Mall.

179. *Washington Post*, 13 Apr. 1972, 13 Jan. 1973; Phoebe Stanton, "The Annapolis Project: Form Battles Function," Baltimore *Sunday Sun*, 2 July 1972; AN MA (Ordinances and Resolutions) [MSA T3197-2] (Resolutions), 96, 124. Eight of the sixteen-foot-tall marble columns were rescued from the grounds

of the Maryland Correctional Institution for Women at Jessup and placed in front of the new Robert F. Sweeney Courthouse in August 2000 (*The Capital*, 19 Aug. 1999, 3 Dec. 2000). The Tiffany dome was first installed in the Legislative Services Building in 1976 but was moved to the rotunda of the Miller State Office Building in May 2000 (*The Capital*, 11 June 2010); "Exhibits in the Maryland Senate Office Complex 2004, Annapolis, Maryland," exhibit brochure (Annapolis: MSA, Jan. 2004).

180. Spaeth, "Annapolis: Seat of Government," 202–204; Maryland Department of General Services, *1975 Annual Report*, 12; "Map of Government Buildings in Central Annapolis," online at www.msa.md.gov/msa/mdmanual/37mun/annapolis/html/mapgovbldg.html (last accessed 6/19/10).

181. AN MA (Ordinances and Resolutions) [MSA T3197-3] (Resolutions), 11, 30, 45. These resolutions mark the changes in ownership of the taverns noted.

182. Barbara Guinn, "Beauties of Annapolis Not Too Far From Home," *Washington Post*, 29 July 1973; William Gildea, "The Yachting Way of Life," *Washington Post*, 18 Aug. 1974; Alice Lynn Booth, "Joining the Annapolis Crowd," *Washington Post*, 14 Aug. 1975; Marjorie Hunter, "What's Doing in Annapolis," *New York Times*, 7 Sept. 1975.

183. Donald Kimelman, "Annapolis Receives a Facelifting," Baltimore *Sun*, 12 Nov. 1972; Booth, "Joining the Annapolis Crowd"; Earl Arnett, "Annapolis: An Uneasy Balance," Baltimore *Sun*, 26 July 1974; Annapolis Planning and Zoning Commission, "Comprehensive Plan, Annapolis, Maryland, 1975." Apostol quote from the Baltimore *Sun* 26 Apr. 1974.

184. Tilden Atwell, communication to author, 19 Nov. 2004; Richard Callahan, communication to author, 24 Oct. 2001.

185. AN MA (Ordinances and Resolutions) [MSA T3197-2] (Misc.), 66, (Resolutions), 111, [MSA T3197-3] (Misc.), 54, (Resolutions), 36, 51, 57.

186. AN MA (Ordinances and Resolutions) [MSA T3197-3] (Misc.), 31, 37; *Evening Capital*, 31 Dec. 1974. The plan was re-adopted and confirmed in February 1975 (Ordinances and Resolutions) [MSA T3197-3] [Misc.], 37). Quotations from pages 1 and 2 of "Comprehensive Plan" in AN MA (Ordinances and Resolutions, Original) [MSA T2389-4], O-17-75.

187. Quotation from David Rusk, *Cities without Suburbs: A Census 2000 Update* (Washington, D.C.: Woodrow Wilson Center Press, 2003), 130.

Epilogue

1. Sharon A. Kennedy, personal communication, 29 June 2009.

2. Susy Aldayuz, personal communication, 7 Sept. 2009.

Index

Page numbers in *italic* refer to illustrations or tables.

Larkin, Thomas, 29–36, 39, 50–51
Lazenby, F. Marion, 284
Lazenby, Joseph D., 297, 325
League, William T., 182
Lee, Thomas Sim, 104
Leocha, Victor S., 353
Leonard, Barbara, 321
Lerner, Eugene, 341–342
Leverette, George, 349
Levitt, Alan J., 307–308
Levy, John J., 282
Liberty Tree, 91, *320*
libraries: 17th-century, 21; 18th-century,
 45, 57; 20th-century, 284–285, 272,
 236, 366
Lillycrap, James, 95
Lincoln, Abraham, 168, 171, 180, 194;
 election of, 166, 191; in Annapolis, 192
Linthicum, Louise, 270
Little Red School House, 199
Lloyd, Ann Catherine, 151
Lloyd, Edward (settler), 6–8, 10–11, 73, 374
Lloyd, Edward, IV, 73, 74, 76, 81, 87
Lloyd, Edward (governor), 151
Lloyd, Philemon, 36
Lockwood, Henry H., 151–53, 155, 172,
 189, 205
Lockwood, John A., 151–153
Lockwoodville, 153, 201, 232, 235
London Town, 12, 20, 41, 115
Long, Robert, 112
Long, Sowell, 48
lotteries, 46, 62, 68, 71, 118
Lowndes, Lloyd, 227, 247
Loyalists, 9, 78, 88, 105

MacCarthy, Albert H., 326
Maccubbin, James, 74
Maccubbin, Moses, 111
Maccubbin, Nicholas, 65
Maccubbin, Richard, *56*
Maccubbin-Thompson house, 287
Macedonia A.M.E. Church, 197, 199,
 204, 266
Mackubin, James, 112
Mackubin, Lola, 153
Macnemara, Michael, 64, 71
Macnemara, Thomas, 26, 36, 41
Madison, James, 116, 128
Maggio, Tony, 336
Magruder, John R., 166, 168, 169, 174, 193
Magruder, Peter H., 169, 190, 224, 285

Magruder and Company, 162
Magruder family, *235*
Malone, Mary, 197
Mann, George, 105, 107, 123
Mann, George Washington, 122
Mann, Mary Buckland, 123
Mann's Tavern, 107, 108, 111, 118, 148.
 See also City Hotel
Marcy, Samuel L., 151
Marcy, William Larned, 148, 151
maritime trades, 5, 20, 42, 46–48, 117,
 212; boatyards and marine railways,
 100, 130–131, 161, 206, *207*, 263–264,
 269, 270, 291–292, *305*, *306*, 307,
 333, *366*; chandleries, 36; ropewalk,
 47, 82; shipbuilding, 47–48; zoning
 for, 324. *See also* oysters
market, fish, 239
market days: 17th-century, 20, 22; 18th-
 century, 26, 35, 112; 19th-century, 238
market houses: 17th-century, 14, 62;
 18th-century, 20, 35, 36, 56–57, 92,
 112, *134*, 225; 19th-century, 133, *134*,
 139, 148, 161, 220; 20th-century, 273,
 274, 344–345, *346*, 347, 365, 368
Marriott, Elizabeth, 61
Martin, George, 129
Martin, William, 309
Martin, William J., 337
Maryland Commission on the Capital City
 (MCCC), 338, 342
Maryland Hall for the Creative Arts, 336
Maryland Historical Trust, 337, 340,
 358, 365
Maryland Inn, 36, 367–368
Mason, John Thomson, 166
Massie, Samuel P., Jr., 320
Matthews, Gloria, 362
Matthews, Henry, 141, 144, 154
Mayer, Frank B., 232
Maynadier, Henry, 134
Maynard, John, 198
Mayo, Isaac, 147–148
Mayor's Court, 24–26, 29, 55, 64, 68, 71,
 74, 100, 133
McCain, Marmaduke, 112
McCready, William U., 292, 296, 309, 313
McCullough, Samuel Thomas, 200
McDowell, John, 114, 129
McGinnis, John, 81
McGuckian farm, 271
McGunnegle, Wilson, 153

McHenry, James, 106–107, 108, 110
McKinney, Lacey, 348
McParlin, Thomas A., 181
McThorne, Henry, 154
McWilliams, William J., 285, 288
Meade, Russell, 353
Meek, John, *93*, 98
Melvin, George T., 215, *217*, 230, 242, 276
Melvin, Ridgely P., 248, 281, 287
Mercer, John Francis, 108, 130–131
Merony, Henry, 57, 76
Merriken, Zack, 261
Merrill, Philip, 344
Methodists, 114–115, 117, 128–129, 142,
 149, 158, 160, 206, 253, 270. *See also*
 individual churches
Middleton, Ann, 101
Middleton, Horatio Samuel, 48, 53, 54,
 60, 64, 65, 101
Middleton Tavern, 48, 60, *363*, 367
Mifflin, Benjamin, 48, 51, 57
Mifflin, Thomas, 107–108
Miller, John, 141
Mills, Wright, 67
Monro, Sarah, 42
Monroe, James, 109, 130, 131, 135
Moore, William "Dinty," 275, *279*
Moreell, Ben, 297, 328
Moss, James, 8
Moss, Maggie Boone, 260
Moyer, Ellen, 307
Moyer, Roger W. "Pip," 339–345, 347, 351,
 354, 357, 359, 361, 363, 365
Mt. Moriah A.M.E. Church, 128, 196–198,
 203–204, 257, 290, 365, 387
Mt. Olive A.M.E. Church, 197, 204, 266
Mueller, Michael, 160
Muir, John, 78, 121–122
Mullaney, Tommy, 255
Mullavell's Bowling Saloon, 188
Mullikin, Kent, 342
Munroe, Grafton, 150
Munroe, James, 202, 213
Murphy, Charles J., 206
Murphy, James J., 257
Murphy's Row, 206
Murray, Daniel, 130–131
Murray, Ella Rush, 249
Murray, James, 95, 134, 145, 151, *207*, 215
Murray, Walter, 58
Murray Hill, 215, *218*, 222, 236, 241, 258,
 282, 321

216, 219, 244, 269, 280, 300; in town, 146, 172, 242-244, 277, 280

Randall, Alexander, 144, 146, 154, 159, 161, 162, 163, 164, 166, 167, 171, 174, 176, 180, 190, 193, 195, 209, 212, 231

Randall, Burton, 164, 174

Randall, Catherine Wirt, 164

Randall, Daniel R., 164, 248

Randall, Elizabeth Blanchard, 164, 167, 174, 181

Randall, Eliza H., 161

Randall, Henry (son of Alexander), 231

Randall, J. Wirt, 164, 245, 248

Randall, John, 74, 123, 132, 134, 142, 144, 164

Randall, John, Jr., 159

Randall, Norman, 349

Randall, Richard, 142

Randall, Wyatt, 164

Rathell, Catharine, 76

Rawlings, John, 74

Rawls, William L., 248

Reading, Thomas, 23

Reckord, Milton A., 256

recreation, 52, 60-61, 144, 223, 242, 256, 314-315, 330, 351-352, 357, 368; fishing and hunting, 102, 109, 110; marinas, 263-264, 266, 304, 305, 331, 333; parks, 224, 225, 245, 270, 275, 314-315, 316, 368, 370; power boats, 270, 291, 305, 366-367; sailing, 87, 164, 223, 264, 275, 276, 304, 306, 307, 331-332, 333, 360, 361; swimming, 144, 223-224, 264, 282, 368

Redemptorists, 159, 161, 162, 181, 249, 266, 387. See also St. Mary's Roman Catholic Church

Reed, Bill, 348

Reeves, Joseph Mason, 261

Remaley, Clarence A., 324

Revell, James, 186, 222

Revell, Martin, 172, 173, 186

Revolutionary War, 95-104; bicentennial of, 339, 358, 369; Loyalists, 47, 78, 90-93, 99, 104-106, 127; politics before, 83-84, 87-92, 93-95; veterans of, 135, 137

Reynolds, William, 54, 57, 74, 122, 135, 284

Reynolds Tavern, 284-285, 366

Rich, John Baldwin, 302

Richardson, Eloise, 285

Richardson, Raymond L., 303

Richardson, Thomas, 47

Richardson, William, 364

Ridgely, David, 104, 148, 230

Ridgely, Henry, 6

Ridgely, John, 120

Ridout, John, 40, 62, 72, 73, 81, 93, 138

Ridout, John (physician), 151, 166, 176, 180-181, 187, 194-195

Ridout, Mary Ogle, 92, 101, 108, 138

Ridout, Orlando, IV, 313, 326

Ridout, Samuel, 132

Rigg, Nancy Walton, 297

Riley, Elihu S., 104, 117, 139, 155, 174, 200, 209, 219, 225, 230, 231, 259

Rind, William, 45, 57, 60, 69

Rivers, Ann, 54

Robert, Sarah Corbin, 307, 309, 325

Roberts, William, 48, 65, 71

Robertson, Matthias, 129

Robicheau, Adolphe, 307

Robin, Abbe, 104

Rochambeau, Compte de, 104

Rodgers, John, 123, 128, 131

Rodgers, John (naval aviator), 251, 252

Rodget, Barton, 47

Roe, Henry, Jr., 142

Rogers, Archibald C., 325

Rogers, George, 302

Rogers, John, 95

Root, Adrian, 184, 189, 191

Rosenthal, William, 154

Ross, John, 64, 71, 72

Rouse, John G., Jr., 343

Rowe, Roscoe C., 276, 301, 309, 310-311, 313, 324, 325

Rummells, Stephen, 139

Rumney, Edward, 48

Rusbatch, Samuel, 77

Russell, Jeanette, 318

Russell, John, 257

Russians, visit of, during Civil War, 182-183

Russo, Jean, 76, 138, 339

Rutland, Thomas, 73

Saint John Nepomucene Neumann, 160

Salem Methodist Episcopal Church, 160, 197-198, 387

Sands, James, 163, 172

Sands, John, 112

Sands, Joseph, 134

Sands, Sue, 173, 176, 179, 180, 186

Sands, William, 93, 98

Sangston, Lawrence P., 367

Sasscer, Lansdale G., 297

Satterthwaite, Marian, 354, 357

Saunders, James, 20

Sausser, Peter, 150

Schenck, Robert, 185, 186, 191

Schlossman, Melvin B., 309, 343

schools: 17th-century, 19, 20-22; 18th-century, 21-22, 37, 54, 60-61, 62, 74, 106, 113-114; 20th-century, 266, 270, 274, 315; African-American, 142, 198-199, 226-229; boys' primary, 142, 226; girls' primary, 142, 152, 226, 226-230; high, 270-272; overcrowding of, 270-271, 315-317; private, 121, 227, 321; racial integration of, 317-321, 347, 349-350, 352; in suburbs, 206, 266, 269, 270; USNA preparatory, 227, 229-230, 272. See also individual schools

Schuler, Hans, 245, 246

Schwallenberg, John, 362

Scott, John Day, 93, 98

Scott, Joseph, 121

Scott, Upton, 64, 65, 71, 72, 109, 150

Scott, Winfield, 171, 172

Seabrook, William, 166, 173, 174

seafood, 1, 48, 274, 345, 373; industry, 168, 204, 212. See also market houses; oysters; recreation

Sedlacek, Mary, 256

Seidewitz, Edwin, 226, 236

Sellers, David F., 285

servants, 4, 8, 34-35, 41-44, 54, 60, 76, 77, 89, 94, 118; and Transportation Act of 1718, 41

Seward, William H., 168, 192

sewers and sewerage, 213, 224, 241, 280, 280-283, 308, 309-310, 313-314, 333, 337, 358, 363-364. See also annexation

Seymour, John, 24-28, 64

Shaaff, John T., 116

Sharpe, Horatio, 51, 52-54, 58, 62, 67-68, 72, 73, 85, 99, 101

Shaw, John, 100, 110-111, 113, 118, 119, 120, 122, 150

Shaw, Lorraine Wycherly, 334

Shipley, Frank M., 302

ships and shipping, 13, 23, 44-46, 48, 49, 76

shipyards and shipbuilding: colonial, 20, 46–48; 19th-century, 130–131, 206, 207; 20th-century, *269, 306*, 307, 333; Annapolis Yacht Yard, 291–293, 305; Chance Marine Construction Company, 263–264, 269, 270, 291; John Trumpy and Sons, *305*, 366–367

Shorter, Charles, 139, 141, 142, 198, 199, 203

Shuttleworth, John, 82

Sigsbee, Eliza Lockwood, 153

Simmons, Lillian, 255

Simms, Joseph "Zastrow," 351–352, *359*

Simpson, Matthew, 160

Sinnott, Peter, 76

slaves, 24, 40–42, 44, 48, 60, 62, 74, 76, 77, 104, 112–113, 115, 127–128, 129, 137–141, 148, 153, 162, 164, 166, 170, 186–188, 191, 198–199, 203, *381–382*; laws relating to, 40, 44, 99, 118, 139, 141, 187, 191; trade in, 40–41, 49, 76, 77, 373

Slayton, Charles C., 309

Sligh, William, *55*

Smallwood, William, *93, 95*, 107

Smiley, James L., 270

Smith, John and Lucy, 138–139

Smith, John, Jr., 139, 141

Smith, Malcolm, 344

Smith, Samuel, 126

Smith, William E., 228

Smith, Wright, 223

Snowden, Carl, 352

Snowden, Hazel G., *357*

Snowden, John, 249

Society of Friends, 10–12, 15–16

Sons of Liberty, 68

Southgate, William S., 159, 215

Spaeth, Robert L., 345, 364

Sparks, Thelma, 347

Sparrow, Thomas, *87*

Spa View Heights, 249, 258, 271, 272, 282

Speer, Talbot, 344

sports, 223, 226, 276, 314, 322, 350; baseball, 196, 223, 275, *278*; basketball, 304, 350, 352; bicycling, 223, *224*; crew, 223; football, 223, 245, 275, 297, 314, 323–324; ice-skating, 144; roller-skating, 223; sailing, competitive, 223, *275, 276*, 304, *306*, 307, 331–332. *See also* horse racing

Sprigg, Richard, 81, 85, 108, 114

Sprigg, Sophia, 108

Spriggs, Bertram E., 337

Spriggs, Charles L., 276

Sprogle, Daniel M., 154

Ss. Constantine and Helen Greek Orthodox Church, 259, 388

Stamp Act, 45, 62, 65, 67–68, 83, 87

St. Anne's Church, 22, 23, 34, 51, 57, 60, 64, 84, 81, 86, 92, 110, 115, 129, 158–160, 196, *197*, 204, 245, 259, 270, 387

Stansbury, John, 112

Stansbury, Rebecca, 161

Stanton School, 198–99, 226–229, 250, 270–271, 274, 317, 318, 319, 352

State House, 18, 20, 21, 60, 92, 104, 106, 107, 117, 121, 127–128; construction of, 19–20, 74, 99, 116; fires in, *19*, 23, 24, 29, 30, *55*, 164, 193; renovation of, 118, 161, 232

St. Augustine's Church, 319

Steele, Anna Key (daughter of Henry Maynadier), 180

Steele, Charles H., 362–363

Steele, Henry Maynadier, 180

Steele, J. Nevitt, 245

Steele, Mary Nevett, 137

Stephen, John, 131, 132–133

Stephens, Isaac, 129

Stephenson, Francina Augustina, 92

Steuart, George, 64, 65, 68, 71, 81, 92

Stevens, Samuel, Jr., 137

Stevens, William Oliver, 257, 260, 285

Stewart, Alexander, 35

Stewart, Anthony, 47, 78, 84, 85, 86, 88, 89–90, 105

Stewart, James, 127

Stewart, Jean, 89

Stier, Henri, 121

Stiles, George W., Jr., 280–281

Stilwell, James R., 364, 196

St. John's College, 21, 126, 128, 129, 130, 135, 148, 151, 154, 158–159, *159*, 161, 176, 200, *202*, 222, 227, 229, 230, 231, *233*, 236, 246, 256–258, 271, 273, 292, 304, *320*, 334, 344, 347, 348, 352; and admission of African Americans and women, 321; burials there, 104; during Civil War, 175, 176, 179, 181, 184, *185*, 187, 194, 195, 198, 227; establishment of, 113–114; Great Books program at, 276, *279*, 297; preservation and, 267, 268, 285, 325–326; sports at, 245, 275, 276, *279*; and U.S. Naval Academy, 292, 296–298. *See also* King William's School

St. Martin's German Evangelical Lutheran Church, 204, 206, 222, 366

St. Mary's Roman Catholic Church, 130, 149, 159–160, 181, 199, 204, 235, 259. *See also* Redemptorists

St. Mary's schools, 199, 227, 321, 340; racial integration of, 319

St. Mary's Seminary, 181, 200

Stockett, Frank, 226; house of, 227–229

Stoddert, James, 31, *32*, 33, 34

Stone, Thomas, 90, 95, *97*, 114

Stone, William, 2, 6–10

St. Philip's Episcopal Church, 204, 329, 349, 366

Strachan, William, 47

Strange, James F., 258, 282

street lights, 161, 218–220, 253, 270

street names, origins of, 18, 32, 35, 48, 51, 74, 134, 206, 209, 215, 266, 301. *See also* annexation

streets: created, 14–15, 18–19, 74, 133, 135, 209, 301; curbed, 134, 142, 185; garbage in, 45, 56, 118, 160, 239, 261; opened, closed, or obstructed, 51, 64, 68, 100, 134, 156–157, 209, *214*, 232–233, 235, 294, 328–329; paved, 157, 235, 239, 241, 274, 277, 289, 358; repaired, 107, 118, 176; rutted or damaged, 51, 56, 64, 118, *197*; and sidewalks, 134, 144, 266, 274, 285, 358; signs for, 144; traffic light on, 261. *See also* urban renewal

Stribling, Cornelius, 154, 158

Strohm, Matthew, 200

Stromeyer, William F., 292

Strong, Leonard, 9

Sturdy, Henry F., 109, 153, 284, 325

Sullivan, John, 113

Sutton, Ashbury, 47, 48

Suydam, Eliza Gracie, 284

Swann, Richard, 161, 205

Sycamore Point, 201, 206, *207*, 264, 331, 366

Symonds, Pringle, 358, 365

Tasker, Anne Bladen, 78

Tasker, Benjamin, Jr., 40, 45, 58, *59*

Tasker, Benjamin, Sr., 33, 35, 36, 53, 54, 62, 64, 68, 71